Ansel Adams

ANSEL ADAMS

A Biography

Mary Street Alinder

An Owl Book
Henry Holt and Company
New York

Henry Holt and Company, LLC
Publishers since 1866
115 West 18th Street
New York, New York 10011

Henry Holt® is a registered trademark
of Henry Holt and Company, LLC.

Library of Congress Cataloging-in-Publication Data
Alinder, Mary Street.
Ansel Adams: a biography / Mary Street Alinder
p. cm.
Includes bibliographical references and index.
ISBN 0-8050-5835-4
1. Adams, Ansel, 1902–84. 2. Photographers—
United States—Biography. I. Title.
TR140.A3A79 1996 95–44741
770'.92—dc20 [B] CIP

Henry Holt books are available for special promotions and
premiums. For details contact: Director, Special Markets.

First published in hardcover in 1996 by
Henry Holt and Company

First Owl Books Edition 1998

Designed by Lucy Albanese

Printed in the United States of America

3 5 7 9 10 8 6 4

Frontispiece: *Ansel Adams, Point Lobos, California, 1982.*
Photograph by Jim Alinder.

For Jim

CONTENTS

Contents

PREFACE

Ansel Adams sometimes joked that I remembered more about his life than he did. Having read the thousands of letters he had written and received, studied proof prints of all forty thousand of his negatives, worked closely with him and lived through the roller coaster of his last years, I did know Ansel very well. His achievements as a great photographer and environmentalist were singular, but the truth of what drove him to create his inimitable images and to fight his consequential battles will doubtless evaporate with the passage of time. While he was joined by an incredible cast of people who shared these adventures, even today, those who truly knew him are few in number. Now, with his afterimage still fresh, I must share what I have learned.

Although this biography has been carefully researched throughout, the tenor of the book changes when, in the late 1970s, I entered

Ansel's world as his executive assistant, because from that point on it is told from the inside. My job—directing Ansel's staff, producing his autobiography, and taking care of him—was not a simple matter of nine-to-five. I was on call seven days a week, twenty-four hours a day, from his Carmel studio to the White House, from Ansel's vigorous days to his repeated hospitalizations. Following his death, in 1984, I spent the next four years completing many of the projects he had left unfinished, formed in spirit though not fully in substance.

Carefully considered, this book is personal in the telling. Beyond knowing the man, beyond admiring the work, I loved Ansel as if he were my son, and at times he called me Little Mother. If I lack absolute objectivity, I have nonetheless tried to achieve a balance resonant with the truth as I have seen it.

The question I am most often asked is, "How did you get to work for Ansel Adams?" My husband, Jim, and I first met Ansel in 1967, when we attended a summer workshop at the University of Oregon on Group f/64, the venerated standard-bearers of straight photography. The teachers included original group members Ansel Adams, Imogen Cunningham, Willard Van Dyke, and Brett Weston. Jim and I arrived weary after driving for a night and a day and a night from Albuquerque; then, as now, we would rather purchase a book or a print than pay for a motel room.

Jim and I are very much children of the sixties. We met and were married in Somalia, where Jim was posted as a Peace Corps volunteer and where I ventured between college semesters to visit my family. (My father worked there on behalf of the U.S. government in the field of education.) After Somalia, Jim and I resumed our pursuit of higher education at the University of New Mexico, he in photography and I in English.

Civil rights, the Vietnam War, and the women's movement: events mandated an involved generation. Art photography was also in ferment. It was an exciting place to be. The perception of photography students was probably unanimous: rich and famous Ansel Adams was the fat cat of photography. In this we voted with the majority, finding that his images of a great America did not speak to us. They

were irrelevant icons. America was napalm and Nixon, Montgomery and King. Our concerns were immediate and deadly; the Sierra Nevada did not have social significance. Later, we saw that it did (and still does).

But in 1967 we pledged allegiance to full-frame, assaultive imagery. We were fired by protest and by the injustices of our country. Ansel's decades of critical leadership in the environmental movement were either little known to the photography community or judged immaterial. At the Group f/64 workshop, Ansel appeared to be in every way a monolith: unapproachable because he was unrelatable, an anachronism.

Imogen Cunningham, in contrast, was always a woman of today. At the age of ninety-one, she was an enchantress who rode around in a VW camper wearing hippie clothes just like ours, though hers were ironed. During the days of Group f/64, she had produced powerful close-ups of leaves and flowers, but thirty-five years later she was photographing the street people of San Francisco. Imogen was *relevant.*

Although our respect for Ansel was limited by his apparent disregard of the turmoil of the real world, we had enough sense of the history of photography to hold him in awe, and were mostly silent in his presence. In the panel discussions, Ansel romanticized the past, and Imogen gave him hell, insisting on the unvarnished truth: "Oh, Ansel, it wasn't like that at all!" And so she became our heroine, playing David to his Goliath.

But on our return to New Mexico, I kept thinking of Ansel's unabashed life's credo: the devotion to beauty. The University Art Museum purchased and placed on long-term display his most famous photograph, *Moonrise, Hernandez, New Mexico,* and I found I could not just walk by it: each time it stopped me.

In addition to doing coursework and engaging in activism, I became the editor of the student-run literary and art magazine. In 1968, Jim received the first Master of Fine Arts degree in photography awarded by the university. I was still a few credits shy of a bachelor's degree when we moved to the University of Nebraska, Lincoln, where

Jim had been hired as an assistant professor to teach photography in the Department of Art. Over the next nine years, with maturing crops of undergraduate and graduate students, we traveled the country to partake in almost any photography event or workshop held. Jim became recognized as a photographer and curator of exhibitions and was very active in the Society for Photographic Education, editing its journal and serving on its executive committee for many years, eventually as chair.

I moved to Lincoln with great anticipation; I was ready to nest. I attended university classes throughout my pregnancy, though I had to have special permission from each department—a shocking rule. (The head of anthropology turned out to be Preston Holder, another original member of Group f/64.) Although we remained involved in peace causes, when Jasmine was born, my life became totally wrapped up in her. We taught ourselves natural childbirth but had to travel seventy miles, to Omaha, to find a hospital that would allow Jim in the delivery room and would let me give birth without drugs.

Back in Lincoln, I soon began a one-woman crusade for open delivery rooms, rooming-in, and the Lamaze method. I became a certified childbirth educator, began teaching the first Lamaze childbirth courses offered in the state, formed a parenting organization (which still exists today), commenced classes for single parents, and ultimately initiated the first teacher-training program for the Plains states.

Did giving birth change me that much? Maybe some sort of linkage with life past and future became undeniable when we became a family of three—as if I now felt that life on earth must be positive, or what was the point? At Oregon, Ansel had stated that the ugliness, tragedy, and meanness of the world were all too apparent, but that we could be restored by beauty. The making and the giving of beauty were his life's work.

I read Nancy Newhall's biography of Ansel's early years, *The Eloquent Light*, as well as the *Daybooks of Edward Weston*. I learned that Edward and Ansel, the two great leaders of mid-twentieth-century photography, had chosen opposite ways of life, Edward's as simple as

Ansel's was complex. With shock I discovered that it was Ansel who had lived what I had come to define as the good life—that is, a moral life. My requirements for a hero were tough, for I demanded not only a superb artist but a responsible citizen.

In 1974, Jim and I took off on a long-awaited sabbatical with our full family, now three children strong, to photograph America. Ansel had asked Jim to judge a competition for the Friends of Photography in Carmel, so we worked that into our itinerary. With the jurying accomplished, Ansel invited both of us for cocktails at his home. Little did he know we were camping with an infant, a two-year-old, and a four-year-old; either we had to bring them along or one of us had to stay at the campsite.

The five of us arrived and were warmly greeted by both Ansel and his wife, Virginia. Potential disasters were everywhere, from graceful crystal bowls containing floating flowers to tiny Baccarat animals and fragile shells; at least Ansel's photographs hung safely above our children's reach. Somehow, all three little ones behaved wonderfully. Years later, when we had become part of Ansel and Virginia's household, as I opened the front door for the nightly group of cocktail guests, it was easy to remember the special first time for us, and the thrill of being generously welcomed into that spectacular space in the Carmel Highlands.

Shortly before we left that night, Ansel said to Jim, "We will gladly pay you the judging fee of five hundred dollars, or you can choose any one of my prints." To his everlasting credit, Jim turned to me without hesitation and asked, "What photograph would you like?" Without a doubt, it would be *Moonrise*. We returned to Lincoln and placed our framed print over the fireplace, so no longer did I have only the memory of the one I had so loved in New Mexico.

Although I finally earned my B.A. from the University of Nebraska, with Jim and the kids attending my graduation, childbirth education continued to be my career. I decided that I needed more legitimacy, since I had been criticized for being neither a doctor nor a nurse. I won a fellowship, but I felt there was no way I could begin medical school in Omaha with three children, so I returned to the university to become

a registered nurse, graduating in June 1977. I am detailing my convoluted story here simply because it would turn out to be important to my relationship with Ansel that I was this strange combination of English major and registered nurse.

At about this same time, Jim was offered a job that he truly wanted, as executive director of the aforementioned Friends of Photography, with Ansel as president and chairman of the board of trustees. Lincoln was an idyllic city in which to raise three small children, but we were ready for a big change, if not for the shock of Carmel housing prices. I immediately found a job at the local hospital, working the night shift in the maternity area.

Jim thrived at the Friends. From the beginning, he and Ansel were comfortable with each other and worked closely and well together. Over the course of a steady succession of social occasions, Ansel and I became much better acquainted. After a year, I resigned from the hospital to accept a position as manager of the Weston Gallery in Carmel, where I learned a great deal about the business of photography and happily also saw firsthand the extraordinary qualities of original prints by Edward and Ansel and many others. As good as that job was, when Ansel asked me to direct his staff, in 1979, I jumped at the opportunity.

Ansel hired me for a number of reasons, the first being that we got along so well. Second, I was knowledgeable about photography, both its aesthetics and history, and possessed the finely honed organizational skills of a working mother. Third, he was curious about all things medical; during my year at the hospital, it was not unusual for him to stop by my area for a chat. In me, he now had a personal nurse. Fourth, my avocation is serious cooking, and Ansel's was eating. Finally, and most important, Ansel had not yet written one word of his autobiography, though his 1978 deadline had come and gone. With my background as an editor and writer, I was to "make Ansel write his autobiography." And I did.

ACKNOWLEDGMENTS

The writing of this book, first begun eight years ago, has made me come to grips with Ansel and with his enormous impact both on the world and on me personally. I could not have made this journey without the kind assistance of many.

My mother, Mickey, taught me that the library was my friend. How right she was. The Center for Creative Photography at the University of Arizona is the repository of Ansel's archive as well as the archives of many of his compatriots. Luckily, I had been allowed to wallow in all this biographical richness when it still lay behind closet doors at Ansel's house, but for this book I needed additional research, as well as confirmation of earlier knowledge, and the highly professional staff of the Center was generous with its time and its intellect, especially Amy Rule, archivist, Leslie Calmes, assistant archivist, and Terry Pitts, director.

I am also highly appreciative of both the collections and the staffs of the Bancroft Library, University of California, Berkeley, especially Willa K. Baum, the Division Head of the Regional Oral History Office, and Cici Nickerson; the Beinecke Library, Yale University; the San Francisco Public Library; the Stockton Public Library; and the libraries at the University of Michigan and Stanford University. The treasure trove of the Yosemite National Park Research Library is almost hidden above the Yosemite Museum; there I fell into the helpful arms of skilled librarian Linda Eade, the park's very knowledgeable historian, James B. Snyder, and the museum's curator, David Forgang.

I am indebted to many fine scholars whose work has contributed greatly to my understanding of Ansel Adams, but I would like especially to acknowledge Nancy Newhall, Ansel's brilliant first biographer, whose *The Eloquent Light* and "The Enduring Moment" provided essential information; Beaumont Newhall, who overwhelmed me with his generous sharing of knowledge; and the Regional Oral History Office at the Bancroft Library, particularly Ruth Teiser and Catherine Harroun, whose interview with Ansel ran to 747 pages.

For their very valuable perceptions of Ansel, I would like to thank Robert Baker, Ruth-Marion Baruch, Peter C. Bunnell, Liliane De Cock, Phyllis Donohue, Patricia Farbman, Marj Farquhar, Tim Hill, Pirkle Jones, Fumiye Kodani, Doris Leonard, Pete Merritt, Sue Meyer, Beaumont Newhall, Ted Orland, Rondal Partridge, Terry Pitts, Chris Rainier, David Scheinbaum, Willard Van Dyke, Maggi Weston, Charis Wilson, and Don Worth. Their interviews greatly enhanced and balanced this prose portrait. In addition, a few dear souls volunteered to read drafts of this book: the comments of John Breeden, P. Kay Dryden, Bryan McCann, Naomi Schwartz, and my always supportive and loving parents, Mickey and Scott Street, proved invaluable.

I am grateful to colleagues and friends for their assistance, especially Alice and Gilbert Alinder, Susanna Barlow, Ted Benedict, Alan Coleman, Heidi Endemann, Peter Farmer, Peter Farquhar, Joseph Holmes, Linda Lichter, Richard Lutgen, Christi Newhall, Wendy Platt, Shirley Sargent, David Scheinbaum, Jonathan Spaulding, Sjaan Vanden Broeder, Barbara Van Dyke, and Richard Zakia.

During the nine years I worked for Ansel, including the period following his death, I was part of a hardworking team. I treasure those colleagues: Victoria Bell, King Dexter, Phyllis Donohue, Rod Dresser, Pam Feld, Sabrina Herring, Fumiye Kodani, Stuart Lobenberg, Bob Millman, Chris Rainier, Alan Ross, John Sexton, Judy Siria, and Bruce Witham.

Over an expanse of time and a variety of projects, Virginia Adams has always generously answered my questions. She is a hero to me in many ways, in part for forging a career and raising children while standing by a man who may not have deserved such faithfulness. Anne Adams Helms's research into her family's genealogy has been impeccable and provided important historic information.

In my camp at all times has been Charles Ferguson, my friend and, lucky for me, my attorney. His wise and considered counsel provided a framework within which I was able to determine how best to pursue the telling of Ansel's life story. I value the additional advice expertly provided by Fred Koenigsberg and Steve Betensky.

Miriam Altshuler, my agent and perceptive adviser, brought the manuscript to Ray Roberts, senior editor at Henry Holt. Ray and I had previously worked easily and successfully together on both Ansel's autobiography and the book of letters. Ray knew Ansel, lived through many of the events of those same last years, and understood better than almost anyone else the story recounted here. Ray has been this book's necessary and loyal champion, and I am very thankful to him for his reliably sage advice. I am grateful to others at Holt for their expertise: to Muriel Caplan for her legal acumen, to Raquel Jaramillo and Lucy Albanese for their aesthetics, and to Ben Ratliff, Lisa Goldberg, and Camillo LoGiudice. Dorothy Straight brought her masterful editor's blue pencil to bear on the text. She is the best. I am truly appreciative of the publishing house of Henry Holt, which has provided all needed support for this complex undertaking.

For their perceptive and caring support during my life's lowest ebb, enabling my recovery from depression, I am grateful to Tim Franklin and Lee Goldman.

Our children, Jasmine, Jesse, and Zachary, have always seemed to

understand about their working mom. Although during my years with Ansel and company I was often too engrossed in my job, they have never once criticized me for being less than they needed. For this book, both Jasmine, a promising scholar in the history of art who is pursuing her Ph.D. at the University of Michigan, and Zachary, a committed environmentalist who is working toward a master's degree at Stanford University, have provided essential research at their respective university libraries. Each has also read the manuscript more than once and has improved the book immensely.

Central both to this book and to my life is my husband, Jim. For years I flopped along on the text, making slight progress in fits and starts as I wrote in the off hours from my real job; then, two years ago, Jim gave me the gift of time, the only thing that would allow me to complete the book. Without Jim, I would not be in photography; without Jim, I might be stuck back at the Walter Keane level of art appreciation; without Jim, I would be a lesser version of me. Jim not only has read each draft but has been involved with every aspect of the manuscript. Ansel would not have come into my life without Jim, and neither would have this book.

And finally, somehow, I must thank Ansel himself, though words cannot come close. I do know the debt I owe him as my teacher and my friend. He will never leave me, and I can never leave him.

Ansel Adams

1

SAN FRANCISCO

It started with a low, faraway rumble, as if a thunderstorm were brewing in the distance. At first the house gently trembled, its shaking increasing with the tempo of the earth. Four-year-old Ansel Adams jerked awake as his small bed was buffeted from wall to wall; Nellie, his nanny, grabbed the bed and held it to her own.[1] The bedroom's west-facing window burst into fragments. A deafening noise smothered the senses as the great earthquake laid claim to San Francisco at 5:12:05 A.M. on Wednesday, April 18, 1906.[2]

After seventy-five seconds of terror, it stopped. The violent release of pent-up pressure caused by the colliding North American and Pacific tectonic plates had displaced the earth from nine to twenty-one feet, with a force measuring 8.25 on the Richter scale, probably the largest quake ever to hit California.[3] San Francisco was in shambles and afire within minutes thanks to exploding gas mains.[4] Although firm

numbers have never been established, between 500 and 3,000 people are thought to have died.

Nellie led Ansel by the hand across the second-floor hallway to his parents' bedroom, where they found his mother, Olive, sitting straight up in bed, her eyes riveted on the new view of the Golden Gate afforded by the absent fireplace. Its bricks had shattered her husband's new greenhouse below. Ansel's father, Charles, was in Washington, D.C., on business.

Olive pulled herself together and surveyed the wreckage. She found they had been very lucky, despite the fact that her neat rows of canned fruits, vegetables, pickles, and preserves were smashed into a fragrant mess, and most breakables had broken. Olive toted up the damage: one chimney missing, two fireplaces and the greenhouse lost, the plaster walls riddled with cracks, and woodwork hanging wildly from walls.[5] At first inspection the house seemed structurally sound, but in fact its foundation had been damaged.[6] Kong, the family's Chinese cook, had suffered a concussion; dazed, he began lighting a fire in the ruined fireplace, which could have burned the house down if Olive had not stopped him just in time.[7]

Olive Adams was a woman devoted to order and routine. The first task, she determined, would be to make breakfast. The kitchen stove was carried outside, wood was lighted, and a small hold on normalcy was regained.

The strongest aftershock hit at 8:14:28 A.M., when Ansel was playing in the garden. The earth flung his small body skyward, and gravity then dashed it face-first into a low wall, breaking his nose bloodily to the left (a political tendency Ansel would affirm to his last days). When the family doctor finally arrived, he advised Olive that it would be best to wait until the boy matured before setting his nose. The quake instantly rendered Ansel a mouth breather, his face forever slightly asymmetrical—a condition that he later playfully claimed became permanent simply because he never *did* mature.

In 1906, San Francisco had a population of 410,000, making it the largest city in the American West. The earthquake and the firestorm that followed it inflicted damage estimated at between 350 million and

one billion dollars, plunging the city into an immediate economic depression. A huge portion of the population was left homeless. Two hundred thousand took shelter in Golden Gate Park alone, one mile south of the Adams home; another refugee camp was based in the forested Presidio, the military post just north of them. The Adamses' house provided temporary shelter for more family members and friends than it could hold, and their camps spilled out across the neighboring dunes.[8]

San Francisco burned for three full days. With a sense of wonder, Ansel observed the curtain of smoke far to the east and the stream of newly homeless people carrying their remaining possessions. As night descended, the view shifted to walls of distant flame. The fire's progress was finally halted at seven o'clock on Saturday morning, April 21, little more than three miles away from the Adamses'.[9] Years later, Ansel recalled that the earthquake and fire constituted his closest experience with acute human tragedy, even though he was at a safe remove from the cataclysm.[10]

Only small amounts of accurate news, and masses of inaccurate bulletins, reached the East Coast and the ears of Charles Adams. Some reports had San Francisco in total ruin and in addition hit by a tidal wave. Charles Adams boarded the first train west, changed in Chicago, and kept on going. When the train stopped in Reno, the stationmaster handed out letters and telegrams addressed to the worried passengers, including one from Olive's father assuring Charles that the rest of the family was all right.[11] He traveled from Oakland across the San Francisco Bay by ferry, arriving in the city on Monday, April 23, five days after the earthquake. Acquiring a pass that allowed him to move through the devastation, he walked across the city to a joyous homecoming, finding his family safe and his home nearly intact.[12]

Charles's father, William James Adams, had arrived in San Francisco in 1850 at the age of twenty-one from his home in Thomaston, Maine, soon after learning of the California Gold Rush.[13] After giving mining an unsuccessful try, he put his entrepreneurial mind to work and decided that he could make money supplying the other miners. He opened a wholesale grocery in Sacramento, and was a man of affluence by the time he sold it, in 1856. He returned home to Maine to find a

wife, settling on a wealthy young widow named Cassandra Hills McIntyre, who at just twenty years old was proudly possessed of luxuriant, dark, curly locks. The next year, in 1857, the couple boarded a ship bound for their new home in San Francisco; by taking the ocean route, William hoped to spare his bride the dangers of a cross-continental trip. Instead, when they journeyed over the Isthmus of Panama, she caught Chagas' disease (caused by a tropical parasite) and permanently lost her beautiful hair.[14] Cassandra must have truly wondered what she had got herself into when they arrived in San Francisco and found that it had just been struck by a particularly violent earthquake (not, however, as large as the one to come in 1906; the city was already optimistically rebuilding).

With enterprise, William almost at once established a lumber business, which he structured vertically, so that he owned timberlands, sawmills, and a fleet of ships. Quickly growing San Francisco clamored for this precious commodity. It seems especially ironic that the family wealth of a man who would one day become one of America's greatest conservationists should have been based on what Ansel himself would later condemn as the rape of the land: the harvesting of virgin redwood forests.

The 1870 San Francisco Directory listed an "Adams, Blinn & Co., lumber, and office Puget Sound Line Packets."[15] By this time, the successful William Adams had built Fair Oaks, a twenty-three-room home on fifty-four acres in the countryside of Menlo Park, thirty miles south of the big city.[16] The 1886 directory listed "William J. Adams" in large type, and then, below the name, offered: "lumber dealer and shipping merchant and proprietor Washington Mills (Seabeck), office Pier 17, Steuart, res. Menlo Park."[17]

Not confining his business to lumber, William also purchased significant real estate in the city's downtown. San Francisco's streets were crisscrossed by privately built streetcars that provided transportation across the expanding city;[18] William acquired a franchise and built one of the city's major lines, the Ferries and Cliff Cable Car Road.[19]

William and Cassandra had five children—three daughters and two sons. When the elder son, William, refused to join his father's business, choosing instead to practice medicine, it was left to Charles

Hitchcock Adams, the youngest child, born in 1868, to assume that role. As the times dictated, the three daughters—Cassandra, Sarah, and Olive—were never considered; their lots were to be placed in solid marriages with undiluted allegiance to their husbands.[20]

Charles was the good son. Endowed with a sensitive soul and an intellect that was captured by the sciences, especially astronomy, he entered the University of California, Berkeley, in 1886 but completed only two years of study before his father summoned him to his future. Sentenced to an unhappy life of business to which he was totally unsuited, Charles would suffer disastrous consequences.

We will never know what possessed Charles to marry Olive Bray in 1896. Six years his senior, she must have seemed adventurous compared to most of the women he knew when he was introduced to her at a San Francisco social event. Then, too, one of his older sisters was named Olive, and perhaps the name was comforting to him.[21]

Olive, nicknamed Ollie, and her sister, Mary, came from Carson City, Nevada, a rural small town of the Old West that offered a stark contrast to the sophisticated city. Ollie's father, Charles Bray, had headed west from his home in Baltimore to seek his fortune. At some point on his journey he had met Ohio-born Nan Hiler, ten years his junior. They were married in 1861 in Iowa, where Ollie was born the next year.[22] The young family joined a wagon train and arrived in Nevada by 1864, soon settling in Carson City, where Bray established a livery stable and drayage company to haul goods.[23] Due to repeated unsound investments, the Brays were genteelly impoverished.[24]

Ollie was a member of the Browning Society, which obliged her to spend certain evenings reading aloud the verse of that famous and romantic couple Robert and Elizabeth Barrett Browning. Ollie played the piano, was an accomplished painter of china, and, to round out her skills, could drive a team of horses.

Her sister, Mary, had unwisely fallen in love with the local doctor, a married man who stayed with his wife. Mary never recovered to love another; she became a living stereotype of the lonely spinster, a woman of quiet temperament, assigned the drudgery of bookkeeping for their father.[25]

Olive and Charles's only child, Ansel Easton Adams, was born late

in the day on Thursday, February 20, 1902, in his parents' rented flat at 114 Maple, in the upper-middle-class San Francisco neighborhood called the Western Addition.[26] Little Ansel, unable to pronounce "Charlie," christened his dad "Carlie," and Carlie stuck as a nick-name. Ansel's birth was the single most wondrous event of Carlie Adams's life, and he seemed always to be aware of that, treasuring his son with a steady tenderness. Carlie affectionately called his son Ants, and Ansel called him Pop.[27]

Carlie was determined that his son would grow up in a healthier en-vironment than San Francisco, with its filthy air polluted by the smoke of soft coal mixed with fog. A little more than five miles west of his downtown office, he purchased three contiguous lots on Twenty-fourth Avenue, each one twenty-five feet wide, for nine hundred dollars.[28] They were nothing more than sand dunes, but they afforded a splendid view of the Golden Gate and, across the straits, the distant Marin head-lands. With wood from the family lumber mills, he built a solid, two-storied, shingled and stuccoed house protected by gardens on either side.

The Adamses moved in on April 2, 1903.[29] In the front yard, Carlie planted a Norfolk Island pine, their Christmas tree; still standing, it now towers above the neighborhood. Carlie neglected to purchase the one remaining lot to the north, so convinced was he that a house would never be allowed on its unsubstantial ground. Not for the last time, he was wrong: before long, the lot was sold, a house was built, and almost all of their grand view disappeared.

Nearby, Lobos Creek wended its way northward past the Adams house on its way to the Pacific. The creek became Ansel's secret fort. He explored every inch and came to know intimately its nooks and crannies. He marveled at its residents—beetles, butterflies, polliwogs, and frogs—and assembled meticulous displays of bugs impaled on pins while his parents collected the wildflowers that grew on the banks, to use as specimens for Ollie's china painting.

As Ansel grew older, his world expanded to include Baker Beach, a half mile away at the foot of Lobos Creek, and the sea cliffs that stretched west to Land's End. With easy agility, he scampered up and down the crumbling bluffs, scouring the shore for driftwood that he

proudly bore home for the fireplace. He loved to watch the fog drift in and out, modulating the sun's light. Weekends were often spent with the senior Adamses at Fair Oaks, while vacations were enjoyed at a friend's mountain retreat in the redwoods above Santa Cruz.[30]

Ansel was a lonely child, more comfortable with adults than with others his own age.[31] He made few friends. He looked rather like a skinny squirrel, with eyes that bulged a bit and ears that stuck out. These features, combined with his twisted nose and open mouth—whether for breathing or to allow for his almost constant chatter—made him seem strange to other children.

Ansel had to be in motion at all times; otherwise he would twitch with frustration, his mind flitting along with his body. He had no patience for games, though he did briefly attempt roller skating and golf.[32] Today he would be classified as hyperactive, but then he was seen as a significant behavior problem.

For a time, the family business, Washington Mills, had been perhaps the most successful lumber company in San Francisco, and William himself regarded as the "Grand Old Man of the Lumber Industry."[33] But William did not believe in insurance, and not long after Carlie and Ollie's marriage, the business suffered a decline brought on by a succession of fires and shipwrecks. Undocumented reports put the total loss at twenty-seven ships and six sawmills.[34] At least this is the version of the story that Carlie told Ansel's early biographer, Nancy Newhall, when she interviewed him before his death, in 1951, and that she then recounted in her 1963 biography of Ansel's early years, *The Eloquent Light.* Ever the gentleman, Carlie may have preferred this "Act of God" script, complete with its biblical-style disasters, to a recitation of his family's loss by less dramatic means.

In a contradictory 1947 interview, Carlie remembered that their fortune had been lost due to the financial depressions of 1897 and 1907.[35] In October 1907, a worldwide financial panic led to a stock-market crash and serious runs on banks, triggering early demands for the repayment of loans.[36] William was heavily mortgaged, thanks in part to the great earthquake and fire of a year earlier, in which his San Francisco offices had burned to the ground.[37]

When the seventy-eight-year-old William died, on August 2, 1907,

Carlie was left with little money, large mortgages on the few remaining properties, and a resolve to maintain the family honor. To compound his problems, Ollie's sister, Mary, and father, Charles, both penniless, came to live with them, staying until their own deaths, his on December 29, 1919, and hers on August 1, 1944.[38]

Carlie was, by all accounts (including his own), no businessman. By 1911, the family holdings were reduced to one mill site, at Hadlock, Washington, on Puget Sound. Carlie journeyed there, accompanied by ten-year-old Ansel, to establish the Classen Chemical Company. While Carlie worked, Ansel had a great time clamming, crabbing, and playing with baby chicks that ate out of his hand.[39]

As a boy, Carlie, too, had traveled with his father to visit their lumber mills, where he had become intrigued by the mountains of sawdust and challenged himself to figure out a commercial outlet for the stuff. Later, while studying chemistry at the University of California, he had devised a method for making 200-proof, industrial-quality alcohol from sawdust and had been granted a patent for the process.[40] Ingeniously, he had also found a way to mix the cellulose by-product with a variety of nutrients to serve as an additive to cattle fodder.

On his 1911 trip to Hadlock, with sawdust still cheap and abundant, Carlie was determined to make a success of his patent. To finance this venture, he had formed a partnership with his attorney, George Wright, and his sister Sarah's husband (and his own son's namesake), Ansel Easton, a man of independent means.

The processing of sugarcane likewise yielded industrial-quality alcohol. When Classen began successful manufacture with its rival process, a group of threatened Hawaiian sugar interests purchased a majority share in the company, buying out both Easton and Wright. Quickly, the new controlling owners fired the Classen staff and, as Ansel remembered it, physically ruined the factory.[41] In a cruel twist, Carlie was left holding 46 percent of the now-worthless stock, devastated emotionally and financially, betrayed by his brother-in-law and his attorney.[42]

Knowledge of his uncle's treachery was kept hidden from Ansel, who learned of it only in 1932. Until that point, he had always gone by

his full name, Ansel Easton Adams, but from then on he no longer used his middle name, first calling himself Ansel E. Adams and then, by 1934, banishing "Easton" and its initial *E* forevermore.

Years later Ansel would recall, "I guess I was about twelve or thirteen when it happened. Well, I knew something had happened, because we went from [having] a cook and a maid and a governess to doing it all [ourselves]!"[43] Ollie and Aunt Mary now shared the cooking responsibilities, becoming quite adept, even to the extent of mastering the art of making mayonnaise with a strong arm and a good whisk.[44]

Carlie had to find a job. From about 1912, he worked for five years as a traveling salesman for the West Coast Life Insurance Company, a discouraging and exhausting occupation. Some days he covered a route of twenty miles, with few contracts, if any, to show for it at day's end.[45]

Eventually he found more solid employment as the secretary of San Francisco's Merchants' Exchange, a position he retained from 1917 to 1940. Throughout these uniformly trying years, Carlie faithfully returned daily to 129 Twenty-fourth Avenue to be greeted by his adoring son, the only apparent reason for his devotion to hearth and home. Ollie proved to be a stern and critical woman whose condemnation of her husband only accelerated as the years and his failures progressed. The addition of a commiserating Aunt Mary and a stern Grandfather Charles made for a grim household indeed.

Astronomy became Carlie's release from his daily worries. He acquired a three-inch telescope and delighted in slowly scanning the heavens each fogless night. He included Ansel in his hobby, and together they traveled to Mount Hamilton's Lick Observatory, southeast of San Jose, for serious viewing. Carlie joined the Astronomical Society of the Pacific and served as its secretary-treasurer for twenty-five years, from 1925 to 1950, for which office he received a salary of one hundred dollars a month. He became one of the most valued members in the history of the organization.[46]

On one issue, Carlie stood firm: he was adamant that Ansel should not suffer the same life he had. Whereas Carlie himself had been required to serve the family, he encouraged Ansel to explore a greater va-

riety of life's possibilities, unencumbered by many traditional expectations. Money was tight, but Carlie saw to it that there would always be enough for his beloved son.

Until Ansel was nine, Carlie and Aunt Mary shared responsibility for his home schooling. Ansel always loved books; at first his doting father read to him, and then, at a very young age, Ansel learned to read for himself. He enjoyed Bret Harte and Washington Irving. When he was eight, his Aunt Mary gave him *The Children's Plutarch*, a multi-volume series that included *Tales of the Greeks* and *Tales of the Romans*.[47] He became enthralled by the stories of Alexander, Pericles, Alcibiades, Demosthenes, Antony, Caesar, and Brutus.[48] These were role models to guide a young mind in a heroic direction.

Although Ansel was raised under nineteenth-century strictures of modesty and decorum, his upbringing was nonetheless invested with a liberal dose of humanism. His parents' approach to child rearing was influenced by the views of Herbert Spence, whose book on the subject was the only one that was kept through the years by the family. The Dr. T. Berry Brazelton of his day, Spence stressed the importance of a balanced life, physical as well as mental, for the optimal development of the child.

Carlie and Ollie did not belong to a church; Ansel later recalled fondly that he had been raised a "heathen."[49] Carlie longed to embrace the ideals espoused by his spiritual mentor, Ralph Waldo Emerson, by living a life close to nature. Emerson, who died in 1882, presented a philosophy that combined European romanticism with American pragmatism, developed during the tough establishment of a new country. He popularized the concept of transcendentalism, the belief that all living creatures are linked to a universal soul.[50]

As a Unitarian minister, Emerson celebrated the importance of the individual, suggesting that man might interface directly with God, without the need for formalized religion or its anointed personnel. Emerson proposed that religion—indeed, all experience—was meaningful only on a personal level; since each person was unique, individualism and nonconformity were, he believed, the normal order of things. He demonstrated, both through his writing and by his example,

the responsibility and power of such an independent person to act consciously and morally.[51]

Emerson's teachings resonated with Carlie, who read his books into thumb-worn condition.[52] Carlie's first commandment would have read, "Live each day bound by the highest moral standards as exemplified by the natural world." Carlie molded his son into a direct expression of Emersonian ideals, raised above all to adore nature, the straightest path to the eternal. Emerson's doctrine of social responsibility was manifested in Carlie's adherence to the old frontier tradition of passing along whatever he learned that might be of benefit to others, a virtue that would prove an important tenet in his son's life as well.

During the years when Carlie worked as a traveling salesman, Aunt Mary was in charge of her nephew's education. She was a follower of Robert Green Ingersoll, a writer, lecturer, and "famous agnostic" who held that there was "no darkness but ignorance."[53] Aunt Mary owned a well-read copy of Ingersoll's *The Ghosts and Other Lectures,*[54] to the inside of which she had permanently attached a lengthy newspaper clipping with excerpts from a speech delivered by Ingersoll on April 12, 1896, at the Militant Church in Chicago. He preached,

> The firmament inlaid with suns is the real cathedral. The interpreters of nature are the true and only priests. . . . Let us flood the world with intellectual light.[55]

The sentiment expressed in these lines, echoing his father's ideology, served as a foundation for all of Ansel's beliefs. He would spend his life translating this philosophy, a combination of Emerson and Ingersoll (with the later addition of Edward Carpenter), through the prisms of his own experience and vision.

In 1911, Ansel was finally enrolled in the neighborhood Rochambeau School. Whenever he had to sit in the classroom, he would fidget, yearning to be set loose in the wonderful outdoors. When questioned by his teachers, he often gave inappropriate responses punctuated by hysterical laughter. Rochambeau was judged unsuitable, and there followed a succession of private schools, each of which

Ansel was eventually asked to leave due to his inattention and misbehavior.

Extremely unhappy, Ansel grew emotionally unstable and cried easily. The family doctor advised that he spend two hours every afternoon in his darkened bedroom to quiet his nerves, but the nature-loving boy could not tolerate this remedy.[56] School, too, stood in sharp contrast to his chosen world of Lobos Creek. In the classroom he felt enchained. Education based on rote memorization seemed senseless to Ansel, who had already found consequential meaning in the natural world all about him.

Although he was thought a failure at school, in truth Ansel was unusually bright. He began a neighborhood newspaper called the *West Clay Park Snooper,* which continued to be published for many decades.[57] When he was ten, he haunted the offices of the contractor engaged in developing the surrounding lands, Mr. Stephen A. Born, a generous soul who taught him drawing, drafting, and perspective. Born also fed the young boy's hunger for adventure, once taking him for a hair-raising ride in his REO automobile, applying the pedal to the metal to reach a speed of eighteen miles an hour, and warning that if a wheel came off, they would be crushed to jelly. Ansel shivered with delight.[58]

At the age of twelve, Ansel became captivated hearing a neighbor, sixteen-year-old Henry Cowell, practice on the Adamses' piano, an old upright that turned out to be just a bit better than the one at Cowell's own house. (Cowell would go on to become a noted composer, teacher, and pianist.) Before this, Ansel had amused himself and his family by concocting an astonishing one-man band, striking chords on the piano with his right hand while depressing the volume pedal with his right foot, thumping a drum with his left foot, and blowing a harmonica held in his left hand.[59] But listening to Cowell was life-changing.

Ollie bought her son a book of piano music, and he immediately sat down at the keyboard and taught himself to read music and to play. His father wrote in 1914 that it happened almost overnight.[60] Until he was seventeen or so, Ansel was possessed of a so-called photographic memory: he could look briefly at a page of text, or music, and then recite it. This was of great value in his musical studies. Always con-

vinced that Ansel was special, his father now knew he was a prodigy.

When he discovered his deep affinity and natural talent for music, Ansel also discovered himself. Perhaps as instinctive as the need to reproduce is the compulsion to find and create patterns, to impose order on the chaos of life.[61] Music did just that for Ansel in his youth, as photography would later. Its boundaries described his safe haven, a place where he could feel, for the first time, the huge passions and emotions that surged inside him, and performance became an appropriate means to give those feelings expression. Until then, his life had seemed aimless and confused, but with the realization that he could create beauty through the piano, he found his first unmediated link to the eternal.

Ansèl profited from a slow progression of music teachers: Marie Butler, Frederick Zech, and Benjamin Moore. Each, in turn, insisted upon dedication and discipline. Technique was built upon technique; fluid expression could be achieved only through total mastery of craft. His musical study provided Ansel with a structured approach to life. He became determined to make music his career; his goal was to become a classical pianist.

In 1915, Ansel's enlightened father, believing, with Emerson, that life experience was the best teacher, presented his unusual son with an equally unusual present: a one-year pass to San Francisco's Panama Pacific International Exposition, scheduled to open on Ansel's thirteenth birthday. This and his musical studies were to constitute his schooling for the year. In the end, the enticements of the former proved more compelling.

The Exposition celebrated San Francisco's recovery from the earthquake and fire, proclaiming the city ready to receive at its docks the flood of ships expected with the opening of the Panama Canal. It was a spectacle, boasting not only the latest achievements in industry, science, and the arts but also an amusement park called the Zone, just the thing for a very active thirteen-year-old. There was a roller coaster, a carousel, a huge trampoline, and the Aeroscope, a large car that carried its passengers 285 feet above the ground.[62]

Ansel was a daily participant in the fair. No shy flower, he per-

formed his first public, if unscheduled, piano concerts at the Nevada Building, before what his father remembered as being standing-room-only crowds.[63]

Ansel attended lectures and thought nothing of rising to ask questions of the learned speakers, one of whom was an East Coast museum curator whose expertise included architecture. Sixty years later, though the curator's name did not come to mind, Ansel recalled their interaction:

ANSEL: "I don't understand."

CURATOR: "What is it that bothers you?"

ANSEL: "There are really no straight lines in nature."

The curator digested this for quite a while, then responded.

CURATOR: "I can't answer you on that—there are straight lines in nature, in some cases."

ANSEL: "Yes, I know, there are some straight lines in crystals, and fracture planes, but 99.9 percent of nature is a fluid thing, which isn't the least bit concerned with a straight line. There isn't a straight line on the body."

For that, the curator had no reply. However, two weeks later Ansel ran into him, and he congratulated his young questioner on his perspicacity.[64]

Thanks to his regular visits and his enormous curiosity (with its accompanying stream of questions), Ansel became known to many of the exhibitors. Some generous soul invited him to work as a demonstrator at the Dalton Adding Machine display, but it was the Underwood Typewriter presentation that attracted him time and again. The impressive exhibit featured a huge working typewriter that was 1,728 times bigger than the company's standard machine.[65] To Ansel's amazement, the technician in charge of the Underwood exhibition disclosed to him the

secret behind its magical revolving stage show explaining the history of writing.[66] Ansel treasured this confidence.

At the Exposition's Palace of Fine Arts, Ansel viewed what was said to be the "best and most important collection of modern art that has yet been assembled in America."[67] This proclamation asserted that the West had outdone the famed 1913 Armory Show in New York, acclaimed as the most significant international exhibition of painting and sculpture yet produced.[68]

Although not much of the art presented at the Exposition has subsequently proved to be of great consequence, there were some important exceptions. Ansel did see an exhibition of pictorial photography that included three prints by Edward Weston, though they had no impact on him at the time.[69] He also saw paintings by the impressionists Monet, Pissarro, and Renoir, as well as work by such masters as Munch, Rodin, Rousseau, Turner, Goya, Tiepolo, Van Dyck, and Tintoretto. The Italian futurists Balla, Boccioni, Carra, and Severini, among others, were displayed here for the first time in the United States.[70] The futurists had refused to participate in the Armory Show because they were denied their own separate exhibition space, so their presence in San Francisco was considered to be a coup.[71]

Back at home, Ansel arrayed a rainbow of crayons before himself and made an abstract drawing, *Complementary Dynamism of Mr. C. H. Adams*, titled and dated 1915 in the thirteen-year-old's bold, immature script. The futurist portrait of his father was apparently inspired, in both content and title, by Balla's *Dynamic Decomposition of a Motor in Rapid Movement*, then on view at the Exposition.

When asked years later what influence these exhibitions had had upon him, Ansel replied, "I can remember . . . reacting very strongly to many of the paintings, and reacting very badly to the sculpture. The paintings were abstract; you could do what you wanted with them in your mind. But in sculpture you had a tangible thing, like a rock or a tree. I had a terrible time with some of the sculpture."[72]

Reading, music, astronomy, Emerson, Ingersoll, the Panama Pacific International Exposition, Lobos Creek, and the great Pacific: a rich broth simmered in Ansel's mind. Carlie took him for a long walk out on

the sand dunes, and companionably, they gazed at the Pacific as it entered San Francisco Bay through the Golden Gate. Ansel confessed that as much as he loved music, he was not sure it would be the best choice for his life, or the best thing he could accomplish in this world. With quiet passion, his father urged him to take as long as he needed to find his future, even if it meant twenty-five years. Carlie was determined that Ansel's life would not be wasted as he believed his own to have been.[73]

2

YOSEMITE

In the spring of 1916, Ansel found himself sentenced to bed to recuperate from a pernicious cold. Aunt Mary tried to keep the fourteen-year-old entertained with a variety of books. One in particular, *In the Heart of the Sierras* by J. M. Hutchings, struck a resonant chord with her nephew.[1] Ansel was riveted by the book's adventurous tale, set in Yosemite Valley and "PROFUSELY ILLUSTRATED," as its title page proclaimed, with 152 maps, engravings, and photographs.

Ansel's very active imagination was held captive by Yosemite, with Hutchings's book confirming for him the tantalizing prospect revealed in a diorama featured in the Southern Pacific's exhibition at the Panama Pacific International Exposition. Although the walk-through stage sets had merely hinted at the true grandeur to be personally experienced at the giant redwoods, Mount Shasta, Lake Tahoe, and Yosemite Valley, they were truly impressive.[2]

Yosemite's national reputation as a place like no other had begun nearly seventy years earlier, when rumors of a spectacular cleft in the Sierra Nevada circulated about California. Two gold miners, side-tracked by bear hunting, stumbled upon a valley overlook in October 1849. One kept a diary that described the valley below as being "enclosed by stupendous cliffs rising perhaps 3,000 feet from their base which gave us cause for wonder." To them, the immense slab of granite that was Half Dome looked like a loaf of bread neatly sliced in half.[3]

Yosemite Valley had been home to Native Americans for some four thousand years, and to the Ahwahneeches for at least the last eight hundred. They called themselves the people of the Ahwahnee, or place of an open mouth, their name for their grand home hidden in the mountains.[4]

In the mid–nineteenth century, settlers came in waves to California, drawn by tales of prosperity. Native Americans, trying to protect their ancestral lands, proved troublesome to the interlopers, and the federal government gave notice to the tribes of the central Sierra that they were to report for relocation to a reservation on the Fresno River. When this arrogant offer was ignored by the Ahwahneeches, the Mariposa Battalion was formed and authorized by the state to make the tribe comply. A company of men entered Yosemite Valley on or around March 27, 1851.[5] Describing the experience, Dr. Lafayette Bunnell, the battalion's medic, wrote, "None but those who have visited this most wonderful Valley, can even imagine the feelings with which I looked upon the view that was there presented . . . and, as I looked a peculiarly exalted sensation seemed to fill my whole being."[6]

How Yosemite got its name is a matter of conjecture. Perhaps Bunnell, in his attempts to communicate with the Ahwahneeches, erroneously concluded that their name for the valley was Uzamati (actually their name for grizzly bear) and through that mistake, and a small twist of tongue, it became known as Yosemite.[7] Other theories posit that the name was selected as an ursine metaphor for the belligerent Ahwahneeches, or, alternatively, that the vain white soldiers appropriated the word to refer to their own grizzly-bear-like bravery.[8] A fourth version is the most interesting. To the Ahwahneeches, the phrase "Yo-che-ma-te"

meant "some among them are killers." The name Yosemite may thus have been the Ahwahneeches' chilling description of the Mariposa Battalion, a reminder even today of the violent usurpation of the valley.[9]

No sooner had most of the Ahwahneeches been removed from the valley than curiosity seekers appeared. Writers produced adulatory tomes, and if they did not do full justice to Yosemite, they nevertheless made this much clear: a great religious experience awaited the visitor. By the time the first stagecoach road was completed in 1874, 2,656 tourists had visited the valley, now scattered with newly blazed trails and simple inns. Only fifty Native Americans remained, most of whom were employed as maids or trail laborers.

The author of the book that so excited Ansel, J. M. Hutchings, wrote and published many promotional articles about Yosemite's glories in his position as editor of *California Magazine*. In April 1864, he became the valley's major hotel proprietor and was acknowledged as the impresario of Yosemite.[10]

In 1864, at a time when the country had been torn asunder by the cataclysm of the Civil War, President Lincoln signed into law a congressional act placing Yosemite Valley under the protection of the state of California in the very first instance of preservation of scenic lands for the nation.[11] This affirmation of the future was accomplished with the stroke of a pen, not with a sword. California was mandated to "accept this grant upon the express conditions that the premises shall be held for public use, resort, and recreation [and] shall be inalienable for all time."[12] Mankind's prevailing attitude for eons had been that land that was not used—be it for hunting, tilling, or building—had no value;[13] perhaps America had to finally run out of land, the entire country conquered clear to the Pacific, before there could be an awareness that something must be saved.

By 1916, Yosemite had been transformed into a vacation spot, with all the necessary comforts. His imagination fired by Hutchings's book, Ansel realized that the park was only two days' journey from San Francisco. His father had been promising a real vacation, and Ansel now insisted it must be Yosemite. Carlie made reservations, and on June 1, 1916, Carlie, Ollie, and Ansel boarded the train in Oakland. Aunt

Mary stayed at home with Grandpa Bray because she couldn't bear to leave Blinkers, the cat.[14]

The train trip was a grand event for Ansel. The changing scenery enchanted him, from the grimy sections of the city to the rolling, grass-covered hills from which the train emerged into the great San Joaquin Valley. They disembarked in Merced and enjoyed a proper lunch at a hotel before boarding the Yosemite Valley Railroad, nicknamed the Shortline to Paradise, bound for El Portal, the gateway to Yosemite.

Heat rippled off the earth. The Adamses were wearing conventional traveling attire, covered in layers from head to toe, ruinously over-dressed in the one-hundred-degree-plus air. Ollie relented just a bit, permitting outer appearances to slip somewhat by agreeing that Ansel and Carlie could remove their jackets. She herself, however, maintained propriety, in bloomers, high-necked blouse, and all. Decorously, she allowed that she felt a little damp.[15]

The night they spent at the luxurious four-story Del Portal Hotel, with its two dining rooms, pool room, music room, bar, and barber shop, seemed endless to Ansel, who awoke at dawn, bursting with impatience to board the large and completely open touring bus that would take them into the valley proper.[16] The rough gravel road climbed two thousand feet in ten miles, joining the old Coulterville Road (completed in 1874 as the first route into the valley for wheeled vehicles) for the final leg.[17] Hats tied firmly to heads and heavy clothes were obligatory protection against the clouds of dust that swirled about them, which even the park's administrators warned against, acknowledging, "The one great drawback to the visitor's pleasure is the fact that he is driven over rough roads so dusty that when he arrives at his destination his dearest friend could not recognize him."[18] But this same air also held the sweet fragrance of pine.[19] Ansel reveled in it all.

The bus rumbled along the banks of the Merced River, revealing little until they found themselves on the valley floor, turned a bend, pulled into a scenic turnout, and beheld Valley View. Ansel's first vantage point set his very small self into humbling perspective, as he saw everything not from the grand heights of Inspiration Point—the most dramatic and popular entrance into Yosemite, where the great natural

stone monuments appear at eye level—but instead from the base of the valley itself, looking up and up and up. El Capitan loomed above him on the left, and Bridal Veil Fall tumbled down the precipitous cliff on his right. Between these two landmarks, the vertical granite walls of Yosemite Valley marched in recession, punctuated by occasional domes and spires and capped at their very end by a glimpse of the top of Half Dome. Ansel's bright eyes flitted from wonder to wonder, but the impression that would last his lifetime was that of soaring gray granite cliffs. An early guest at Hutchings's hotel in 1871 had recorded his own view of the scene, noting, "It seemed to me as though we were in a huge Sarcophagus for the almost perpendicular wall of granite seemed to shut us in, their crests varying from two to five thousand feet."[20] Those same confining walls seemed to hold nothing but promise for Ansel.

The Adams family arrived at Camp Curry and alighted upon a platform, where they were feather-dusted by the young staff and greeted by the owner, David Curry, whose thunderous proclamation "Welcome to Camp Curry!" echoed off the close-by cliffs and proved him worthy of his title, "The Stentor of Yosemite." (Upon their departure, Curry provided a theatrical sendoff by shouting "Farewell!" likewise at a decibel level well above that of mere mortal man.)[21]

David and his wife, Jennie, had opened their small camp with a total of seven tents at the foot of Glacier Point in 1899 as an economical alternative to the pricey Sentinel Hotel. When the Adamses arrived in 1916, tourism in Yosemite was booming. Camp Curry had grown steadily thanks to its attractive prices and warm, family atmosphere, and by 1916, the Currys could accommodate nearly a thousand guests at a time. Carlie, Ollie, and Ansel were but three of the ten thousand people who stayed at Camp Curry that year.[22]

While planning their Yosemite vacation, Ansel's parents had studied Camp Curry's twelve-page-long brochure for 1916, which promised

ice cream daily, chicken every Sunday, . . . two pianos, a barber shop, the only swimming tank in the Valley, and the largest and best hardwood dancing floor in Yosemite— experts say it is not surpassed in California—all for $2.50 a

day or $15.00 per week. All roads formerly led to Rome. All roads now lead to Camp Curry.[23]

Porters, college students from Stanford and Berkeley on summer vacation, wheeled the Adamses' luggage to Tent 305, which had a wooden floor, a canvas roof and sides, real beds with clean sheets, and a washbasin. Baths, though available, were not included in the room rate, but the Currys assured visitors that bathing in the Merced River was free.

Camp Curry was known for its nightly campfire and evening programs boasting professional entertainers who told stories, acted out skits, played the piano, and produced various theme pageants, including a Hawaiian extravaganza complete with hula dancers. The practice was on temporary hiatus in 1916, but sanctions were lifted the following year, and each night's festivities ended with a bellow from the camp to "Let the Fire Fall!" whereupon a huge bonfire would be pushed off the edge of Glacier Point 3,214 feet above, to tumble, sparks flying, to its demise on a rocky ledge below. This Hollywood-style spectacular, begun in 1872, had been stopped, if only briefly, by government men of good sense.[24] As an adult, Ansel would swear that he had felt the Fire Fall to be a blight upon the natural wonder of Yosemite from the first moment he witnessed it.[25]

To record their vacation, his parents gave Ansel his first camera, which he took everywhere. The rapport among Ansel, the camera, and Yosemite was immediate. His long-smothered energy was finally allowed to burn. He hiked down the Tenaya Canyon and up the steep switchback trail to the top of Yosemite Falls, returning to camp hot and exhausted every afternoon to jump in the swimming pool. Although nearly friendless at home, at Camp Curry he found playmates and learned to play croquet and pool. Upon his arrival in Yosemite, Ansel had been a sickly, enervated fourteen-year-old; once there, he soon found health, happiness, and companionship.

The next year, Ansel came back to Camp Curry with his mother. Money was tight, so Carlie remained behind to toil diligently at his new job at the Merchants' Exchange. Ansel's letters "To Pop" were brimful

with enthusiasm, reporting that in the first two weeks he hiked fifty-five miles, and not long after that, 175.[26] Ollie's postals had a different tone, suggesting that it was taking all her strength to control their rambunctious son, to the extent that she had to block the door of their tent at night with a chair to keep him from sneaking out.[27]

Ansel was such a live wire that everyone in camp soon knew him; given that there were a thousand other guests, that was quite a feat. A frequent hiking companion at that time recommended that Ansel consider going into the law: he was such a chatterbox that he would surely be able to talk a jury to death.[28]

A retired geologist and amateur ornithologist named Francis Holman invited Ansel on a camping trip to Merced Lake above Yosemite. Uncle Frank, as Ansel called him, became his guide to the outdoors; over the next summers, he would teach his young charge camping, climbing, and a serious respect for the fragile qualities of wilderness.[29]

The two left Camp Curry on July 7, 1917, with a mule loaded with their tent, bedrolls, camping equipment, and food. Uncle Frank ensured they would have good grub, packing a side of bacon, coffee, sugar, hardtack, and pancake flour; he expected fresh-caught trout to supply the protein for breakfast and dinner. That night was Ansel's first away from his parents. He would be gone three nights more on this, his first trip into the High Sierra.[30]

With confidence, the next summer, his third, Ansel came to Yosemite alone. Money had become even tighter in the Adams household, and there was enough only for a vacation for Ansel. He was just sixteen years old, but his parents felt comfortable placing him in the charge of Jennie Curry, who was commonly known as Mother Curry, and Uncle Frank. Yosemite's spell on Ansel had grown. Insisting he needed more time there, Ansel arrived on May 25 and proudly inaugurated the just-filled swimming pool.[31]

At five the next morning, he and Uncle Frank left on a full day's hike to Mount Starr King. When Uncle Frank decided to climb its ice-covered peak by cutting footholds with his ice ax, Ansel, who had promised his parents that he would be very careful, retreated to a nearby meadow to watch.[32]

Soon enough, however, Ansel was accompanying Uncle Frank on every ascent, the two foolishly roped together and ignorant of mountaineering techniques such as belaying. Their climbing practices meant that if one had slipped, the other would certainly have been pulled down as well, or, even worse, been cut in half by the narrow cord.

They had more than one close call. One morning they left their campsite at four-thirty, intending to climb Red Peak. More than fifty years later, Ansel could still remember the events of that day as if it had been yesterday:

> We were going up with the old ice pick and the window sash cords, chopping little steps. It was frozen snow, it wasn't ice, and about a thousand steep feet of it. About eight hundred feet up, I slipped. And of course I started to slide—it was about 60 degrees to 70 degrees steep—pulled Mr. Holman off his feet, and we both went down. He was yelling, "Keep your feet front—front! Don't roll!" And finally we got down. We were sliding face-down, and if you just touched your hands to the frozen snow it would take the skin off. We were really going awfully fast. And there was a whole lot of rock and snow piled at the bottom, and we went right through that—but missed all the rocks! Mr. Holman sort of sat there and rubbed the snow out of his eyes and said, "Well, we'll go right up again." That was the best philosophy. So back we went.[33]

For Ansel, the schism between the healthy world of Yosemite and his humdrum life in San Francisco became even more pronounced. During the autumn of 1918, the Spanish influenza pandemic hit the city, and by the middle of October, the schools, churches, and theaters were closed and people were required by law to wear gauze masks at all times. Thousands died in San Francisco alone, and half a million in the United States; the worldwide toll was twenty-two million, twice the number that died in all of World War I, which ended on November 11 of that year.[34]

The killer flu continued its devastation during the first months of 1919. Ansel became infected and fell very ill. His concerned parents bundled their thin, hollow-eyed son off to stay with his aunt Sarah and uncle Ansel, whose ranch, east of Oakland on the sunny slopes of Mount Diablo, would, they believed, provide a healthier climate than fogbound San Francisco.

Aunt Sarah loaned Ansel a biography of Father Damien, the Catholic priest who had devotedly cared for the lepers on the Hawaiian island of Molokai. After reading that book, still weak in body and mind from the flu, Ansel became phobic. Germs were everywhere, he felt, and terrified that he would catch something, especially leprosy, he did whatever he could not to touch anything. When there was no alternative but to grasp a doorknob or shake hands with someone, he was compelled frantically to seek a washbasin and immediately wash his hands.[35]

When he had recovered somewhat from the flu, he begged his parents to allow him to go to Yosemite. He was sure there was no leprosy there. Although his doctor advised against the trip, his parents consented to a one-month stay after Ansel agreed to monitor his pulse rate and to hike only on level ground. He arrived totally exhausted at Camp Curry, where he was again placed under the care of Mother Curry and Uncle Frank. Slowly, steadily, every day he gained strength and could walk a bit farther.[36]

His parents were startled to learn that Uncle Frank and their recently gravely ill son were planning to visit Lake Merced, the site of their first trip together in 1917. They needn't have worried overly, however, as the hundred-foot-deep lake, brimming with fish, was at the relatively low altitude of 7,200 feet, and its sheltered location made it just about the warmest spot in the High Sierra.[37]

They set out early in the morning, Uncle Frank walking and Ansel riding most of the thirteen miles. They began on the John Muir Trail, which climbs easily out of the east end of Yosemite Valley, beneath the broad southern base of Half Dome. Following the north bank of the Merced River, strung with a series of lovely alpine glens—Little Yosemite Valley, Lost Valley, and Echo Valley—they emerged to see

Merced Lake glowing under the late-afternoon sun. It was at times like this that Uncle Frank, generally a man of action, not of words, might allow himself to remark, "Pretty fine, my boy."[38]

Uncle Frank cooked up oatmeal mush and flapjacks for breakfast, and for dinner they ate trout grilled over the fire and flavored with the pungent wild onion that grew abundantly about their camp. Ansel's appetite returned. He was no longer gaunt, but instead tanned and happy. His phobias vanished, never to reappear. When they met him at the station in San Francisco, Carlie and Ollie found a very different Ansel from the fever-weakened, almost skeletal son who had journeyed off just a few weeks earlier.[39]

Ansel would forevermore credit Yosemite's healing powers with his recovery.[40] Nature became his religion, and Yosemite and the surrounding Sierra Nevada his temple. As he returned to restore himself each summer till the end of his life, Yosemite remained central to his self-concept, as it had been for Uncle Frank, who in poor health at the age of seventy-five, finally had to give up his own Yosemite summers in 1941.[41] Lucky Ansel to have been befriended by Uncle Frank, a perfect teacher at this crucial, highly formative time!

Ansel's inextricable link with Yosemite then existed only in his mind, but later it would have a place in the memory of a nation. Another man, John Muir, is also closely identified with Yosemite. Muir was a robust Scotch immigrant who, by the time he walked from Oakland to Yosemite in 1868 at the age of thirty, had already trekked a thousand miles from Kentucky to the Gulf of Mexico. He loved the intimate sound and feel of his footfalls upon the earth and the revelations that came because of his slow pace and sharp eye.

Muir was awestruck by his first glimpse of Yosemite, but he was never speechless. He admired

> the noble walls—sculptured into endless variety of domes and gables, spires and battlements and plain mural precipices—all a-tremble with the thunder tones of the falling water. . . . The great Tissiack, or Half-Dome, rising at the upper end of the valley to a height of nearly a mile, is nobly proportioned and life-like, the most impressive of

all the rocks, holding the eye in devout admiration, calling it back again and again from falls or meadows, or even the mountains beyond,—marvelous cliffs, marvelous in sheer dizzy depth and sculpture, types of endurance.[42]

In Yosemite, Muir found work as a shepherd with a flock of two thousand sheep that he labeled "hoofed locusts." The sheep's devastation of the land, a ruminant-caused scorched earth, radicalized Muir, who resolved to rid Yosemite of the sheep and other livestock as well as the tilled fields of hay and wheat that had already changed the character of the valley.

To earn a basic living, he worked for J. M. Hutchings. He built a water-powered sawmill and then ran it, producing lumber for Hutchings's many projects using trees felled only by nature, not by man. In his spare time, Muir studied the geology and flora and fauna of Yosemite and the Sierra, keeping detailed notebooks on his finds and becoming an acknowledged expert on and self-proclaimed protector of nature. His articles on his experiences in the natural world began to appear in *Scribner's* and other national magazines.

Although he moved away from Yosemite in 1874, Muir returned frequently, often guiding parties of the rich and powerful. In 1889, he camped in the valley with Robert Underwood Johnson, editor of *Century* magazine. The state of California was either unable or unwilling to protect the valley from the complete ruination that Muir felt was fast approaching. Believing that Yosemite could be saved only by national protection, he persuaded Johnson to spearhead a campaign to accord it national-park status. Barely thirteen months later, on October 1, 1890, Yosemite became America's second national park, following the establishment of Yellowstone in 1872.[43]

Muir's books, beginning in 1894 with *The Mountains of California*, probably did more than anything else to sensitize the nation to the plight of the American wilderness. Through his lyrical prose, he introduced and excited his readers to the great lands of America. His championing of Yosemite was so effective that the park became a priority on many an American's vacation schedule.

With Muir as its first president, the Yosemite Defense Association

was founded on June 4, 1892, under the name Sierra Club, by a group of twenty-seven California residents.[44] Its charter was to rally those who loved the Sierra to learn about it, enjoy it, and protect it.

When Yosemite became a national park, the U.S. Army became its administrator.[45] The military proved unsuited, however, to protect meadows, creeks, and valleys, or raptors, sparrows, and coyote. A defensive guard of rangers was called for, not soldiers. In 1916, the same year that Ansel first saw Yosemite, Congress created the National Park Service to govern, under the direction of Stephen T. Mather with the assistance of Horace Albright, the sixteen national parks and twenty-one national monuments that had been designated by that time.[46]

Under the National Parks Act, it was the mandate of the new service to "conserve the scenery and the natural and historic objects and the wildlife therein and to provide for the enjoyment of the same in such manner and by such means as will leave them unimpaired for the enjoyment of future generations."[47] This commandment goes to the heart of most of the environmental battles of the twentieth century, pointing up the issue of use versus preservation.

As an old man, Ansel would recall a story told by his good friend William Colby, who served on the Sierra Club's board of directors from 1900 to 1949. Standing with Muir at Glacier Point one day, the valley spread before them, Colby had heard his companion ask, "Won't it be grand when one million people can see what we are seeing today?" Ansel found Muir's naïveté astounding: though he deplored the effects of thousands of grazing sheep, he could not foresee the destruction that would be caused by those visitors, with their cars, tents, and trailers, their campfires, grocery stores, restaurants, doctors, police, and jail.

Historian Alfred Runte has observed, "Too late Americans realized that seeing was not saving and that making observation easier exacted a price."[48] Perhaps Yosemite was condemned to ruination by its geology, which made it a narrow valley with outlets only at its western end. It is testimony to the endurance of granite and the power of nature that after absorbing a flood tide of admirers, the valley still possesses at least a modicum of magic.

Ansel was just fourteen when Muir died at age seventy-eight.

Strangely, considering the strength of Muir's legacy, Ansel never saw him as a mentor[49] and did not even read his work until he was about eighteen. To Ansel's taste, Muir's writing was florid rather than fantastic, exemplifying the pompous grandiosity that afflicted too much writing on the natural scene.[50]

Ansel never trusted words to describe something as profoundly visual as the "Range of Light"—Muir's name for the Sierra, and the one phrase of his that Ansel did find perfect. Ansel believed that his photographs were distillations, not translations, of Yosemite and the Sierra, and that through his images the mountains could communicate directly with the viewer. Prose such as Muir's, he felt, imposed an unnecessary and obscuring layer of interpretation between man and nature.

John Muir set the wheels of environmental protection in motion. He is acknowledged as the father of the American environmental movement, and the conservation of Yosemite must be credited more to him than to anyone else. So, though Muir and Ansel never met, what would Yosemite be without Muir? And without Yosemite, whatever would have happened to Ansel Adams?

3

THE DEVELOPMENT
OF VISION

Despite its familiar landmarks, from El Capitan and Bridal Veil Fall to Half Dome, and its relatively manageable dimensions— seven miles long and one mile wide—Yosemite has consistently defeated those who have tried to picture it. Photographers, not painters, have been its most successful interpreters. Photography has further had an enormous impact upon Yosemite's history, first in the park's recognition and then in the conflicting areas of commercial development and wilderness preservation. Yosemite, Ansel Adams, and photography are inextricably linked. But there were other artists before Ansel.

Nineteenth-century armchair travelers were a large and lucrative audience for photographers. Everyone wanted to see what the Wild West really looked like, and photographs of famous places were collected and mounted in albums. Each new discovery added to the ex-

citement and to the belief that America, with its splendid natural wonders, was surely the future of the world. And there was no greater glory than Yosemite Valley.

By a serendipitous coincidence, exploration of the American West began just as photographers were discovering the great possibilities of their medium. Photographs poured back east and into Europe. New settlers made their way to California, no longer fearing the nightmare of the unknown but bolstered by visions of real places.

Photography escaped from the studio into the outdoors with the invention, in 1851, of the collodion wet-plate process, which required much shorter exposure times than daguerreotypes or calotypes, the two dominant early methods. But collodion wet plate was surely not easy: a glass plate had to be coated with the light-sensitive emulsion in total darkness, after which it was placed in a light-tight holder, exposed in the camera, and then removed and developed while it was still wet. Photographers may have been able to advance into the field, but they remained chained to their darkrooms, or rather, their portable dark tents or dark wagons. There were a great many things that could go wrong.

Expeditions to remote sites such as Yosemite were added gambles because the glass plates had to be hauled over rough trails and up and down boulders and cliffs as the photographer struggled to obtain the transcendent view. Too often, the plates shattered into shards before the safety of home could be reached.

Carleton Watkins, who arrived in the valley in 1861, became a master of the collodion wet plate. He had chanced into photography in 1854 but grew so adept that within ten years he had established his Yosemite Gallery in San Francisco, where he sold his famous views. Not only was Watkins aesthetically and technically up to the severe challenge of Yosemite, but he also had great physical courage. He traveled with up to two thousand pounds of equipment, including a mammoth glass-plate camera thirty inches square and a yard deep, which could produce negatives (and therefore contact prints) as large as eighteen by twenty-two inches.[1] In these grand photographs, the monumental character of Yosemite was displayed with the impressive dignity and size that previously had been the province only of

painters.[2] There had been other, even earlier photographers, but Watkins was the first of the greats. Across the country, it was generally agreed that all photographic landscapes must be measured against the standard set by him,[3] and few since have matched his accomplishments.

Watkins's photographs provided the convincing visual proof that prompted Congress to recognize Yosemite's importance and the need for its preservation. In consequence, the landmark Yosemite Act of 1864 granted the valley and the Mariposa Grove of Big Trees to California.[4] The broader concept of creating national parks grew out of the mood of Congress and the American people, and had its roots in this earlier protection of Yosemite.

Sadly, Watkins himself was stalked by poverty, losing his gallery and most of his negatives to bankruptcy in 1874. Still determined, he returned to the same sights and rephotographed them in an attempt to build a new archive of material. But his downfall continued with his blindness in 1903 and the destruction of his glass plates and most of his prints in the 1906 San Francisco earthquake.[5] His family eventually committed him, a broken man, to a mental hospital, where he died in 1916 and was buried in an unmarked grave.[6]

Watkins had a competitor for the title of best nineteenth-century Yosemite photographer. Eadweard Muybridge, also from San Francisco, first worked in the valley in 1867, returning to his studio with 260 glass plates.[7] When he went back to Yosemite in 1872, he took along a mammoth plate camera. His finished prints, also made with collodion wet plates, were as beautiful as Watkins's. Muybridge exhibited this work in a rival San Francisco gallery and quickly became the next Yosemite sensation.[8]

Muybridge's life story is almost unbelievable, for his Yosemite success was really only the beginning. In 1872, the then-governor of California, Leland Stanford, bet a friend twenty-five thousand dollars that at some point in time a galloping horse had all four feet off the ground, and he hired Muybridge to prove him right. Muybridge constructed a series of trip shutters that took a sequence of still photographs, which furnished the hard evidence that won Stanford his bet.

In 1874, Muybridge killed his wife's lover, was found not guilty by reason of justifiable homicide, and judiciously fled the country for a few months to photograph in Central America. For the rest of his life (he died in 1904), he eschewed landscape photography to concentrate on "stop-motion" studies of people and animals, images that were to become basic subject matter for artists and an influential precursor of the motion picture.[9]

The next Yosemite photographer of note was George Fiske, whose prints captured a valley bustling with people and business. Fiske established a studio in Yosemite and in 1880 became the first photographer to live there year-round.[10] He made the initial extensive winter studies of the park, from snow-topped granite domes to traceries of ice on branches.

Whereas Watkins and Muybridge had scrambled like mountain goats, positioning their huge tripods and cameras under harrowing conditions to obtain views most mortals could never personally experience, Fiske, perhaps because he was older, loaded his cameras and tripods into a wheelbarrow (dubbed Cloudchasing Chariot) and followed the flat valley floor. Photographing from the same trails where tourists hiked, he sold them what they themselves had seen.[11] By 1890, however, Kodak had made it easy for every tourist to take pictures, and Fiske's sales had begun steadily to decline.[12]

Painters were slow to arrive in Yosemite; surely this was the first time photographers had coopted such a great, new subject. Albert Bierstadt, Thomas Hill, William Keith, and Thomas Moran, the last of the great American romantic landscapists, painted Yosemite with a vigor coupled with vast imagination. But theirs was a dying vision: landscape had become the province of photography. The public wanted to see how it really was, and it was believed that photography could be trusted where painting could not. The French painter Paul Delaroche, upon viewing a photograph for the first time, is reputed to have pronounced, "From today painting is dead!"[13] His prediction was coming true; painting had to reinvent itself.

For the most part, the painters had been schooled in Europe, while few photographers had any art background at all. The European land-

scape was tamed by graceful steeples and towers, its hills studded with villages whose shape changed with the contours of the land beneath them, not vice versa, as in America. Rules of composition could be followed by placing the vertical of a building here for emphasis or the curve of a road there for balance.

The landscape of the American West, in contrast, was sheer chaos; it was not called "wild" for nothing.[14] Famous for his detailed and dramatic oils, Albert Bierstadt saw his popularity dwindle with the ascent of photography during the late nineteenth century. The public had thought that Bierstadt's canvases depicted a real world, and viewers and critics alike became angry when his paintings' unfaithfulness to reality was revealed.[15] One writer complained of a particular work in 1879, "Setting aside the question of its artistic qualities, it represents a scene that is physically impossible."[16]

Later, Ansel's photographs would be likened to Bierstadt's paintings, a comparison that would confound and anger the photographer, who believed that the painter had tarted up the supremely beautiful natural world with inaccurate geography and scale, in some instances literally moving mountains to better fit his canvas, and that he had imposed overly dramatic lighting.[17] The grown-up Ansel could not stand Bierstadt's work.[18]

The efforts of the painters who followed paled next to those early and energetic, if largely unsuccessful, attempts. Landscape has not been the subject of most twentieth-century American painting and is commonly dismissed as a nineteenth-century romantic concern.

From his first days with a camera, fourteen-year-old Ansel approached photography seriously. As a young child, he had watched his father train his Kodak Bullseye camera upon wildflowers, capturing them so that Ollie could paint them back into life's colors on china. Lying in bed, Ansel had witnessed the phenomenon of the camera obscura as a tiny opening between the window shade and the window projected upside-down pictures of the outside world on his ceiling, the opening acting as a lens and his unlit bedroom as the camera. When Ansel asked his father about this image in his bedroom, Carlie opened up the Bullseye and demonstrated how it worked.[19] Ansel grew famil-

iar with photography through his father's approach to it—as a useful tool—but when he decided to make an exposure, a passion not unlike Carlie's for astronomy blossomed in him.

Soon after his arrival in Yosemite in 1916, Ansel sent two photographs that he had made with his Kodak #1 Box Brownie to his aunt Mary, telling her that he would go broke at the pace he was snapping pictures.[20] At the beginning of the twentieth century, Kodak had introduced and marketed the Box Brownie as a child's camera, with six exposures on each roll of film. That children could make photographs was part of the Kodak revolution. Just twenty-eight years before Ansel ventured to Yosemite, George Eastman had invented the handheld camera and standardized film and processing equipment. Photographs could now be made by anyone; even a child could press the button and let Kodak do the rest. After a month in the photographic treasure trove of Yosemite, Ansel had taken a great many pictures.

On their return home to San Francisco, Ollie assembled Ansel's photographs into an album as a souvenir of the family's vacation. In a flowing script, she titled each in white ink on the dark pages. It is clear from these initial images that even then Ansel did not just snap away, but instead attempted to arrange what he wanted to capture within the space of his viewfinder. These photographs show an awareness of composition and an understanding of near-far relationships, with many containing a close foreground subject posed against Yosemite's majestic cliffs.

Two images are particularly interesting to consider.[21] One is Ansel's first photograph of the entire valley from Inspiration Point, a location he would return to again and again. The day was clear and bright, and he made a straightforward image of El Capitan, with Bridal Veil Fall and a sliver of Half Dome to the east—all in all, the same photograph snapped by thousands before him and millions since.

However, Ansel's portrait of El Capitan is amazing. Framed by the leafy branches of foreground trees, its face rises to fill the image with pale-gray granite; there is nothing to indicate the outsize scale that is the dominant trait of the mountain. This is not a simple snapshot recording El Capitan, but something more. Here contrasting form, tex-

ture, and tone have been considered. Ansel had had no formal training in art or composition, but this one photograph provides an indication of his innate visual abilities, giving credence to the theory that great artists are born, not made.

Following his first summer in Yosemite, Ansel found part-time employment with a photo finisher in San Francisco, from whom he learned rudimentary darkroom technique. His work there over the winters of 1917 and 1918[22] constituted the total of his photographic schooling.

Until the late 1920s, his piano studies continued to form the center of his education. Photography was largely relegated to his summers in Yosemite; the other months of the year were consumed by hours of daily practice, frequent lessons, and attendance at all the classical concerts of note given in San Francisco.

Ansel was told, and came to believe, that he must acquire the impeccable technique that was possible only through complete mastery of his instrument. He also learned not to confuse technique with art, which was an expression above and beyond. Intuitively, Ansel applied these lessons to his photography as well. Music demanded rigorous, regular practice and fluency on the instrument. Adapting the same discipline to photography eventually earned Ansel an unmatched knowledge of its technique; he approached both media with the attitude that constant hard work was essential for success.

A typical day for Ansel in San Francisco began with breakfast with Carlie, Ollie, Grandfather Bray, and Aunt Mary. After Carlie left for work, at about eight-thirty, he would sit down at the piano in the living room and practice until ten-thirty or so, when he would make tea for himself and the others. He then returned to the piano until lunch, at noon, after which he was back at the keyboard again until about four, when he generally escaped to the outdoors for a couple of hours before dinner.[23]

In 1917, Ansel satisfied enough requirements to earn his one and only nonhonorary degree, graduating from the Kate M. Wilkins Grammar School at age fifteen. After this, Carlie abandoned all further efforts to fit his square peg of a son into the round holes of formal schooling.

When Ansel returned to Yosemite in June of 1917, he took with him

his first serious photographic equipment: a tripod and two cameras, one of which used glass plates (most likely a four-by-five-inch view camera), and the other a Vest Pocket Kodak, a small folding camera more suitable for snapshots.[24] The fifteen-year-old was beginning to establish personal standards for his photographs, writing to his aunt that the quality of print finishing available in the valley was not good enough, so he would have to do it himself when he returned to the city.[25] The following year, he packed the basic chemistry he would need to develop films himself in Yosemite.

His initial exposure to photography as a creative art, beyond what was on display at the 1915 Exposition, came from the prints he saw each summer in Yosemite's artists' studios. Four of these—Boysen's, Pillsbury's, Jorgensen's, and Best's[26]—exhibited and sold photographs, but for the most part, they offered undistinguished, popular views. Ansel read all the photographic magazines he could lay his hands on[27] and attended two camera-club meetings, which he found impossibly boring. It was at one of these, however, that he met William Dassonville, known in the Bay Area for his hand-coated photographic papers as well as for his soft-focus landscapes. Ansel once credited Dassonville with teaching him that photography could be art.[28]

Ansel's photography quickly progressed from simple shots for the family album to images in which he took artistic pride. In 1918, the sixteen-year-old entered a print in *Photo-Era*'s advanced competition for architectural subjects and was awarded an honorable mention (one of fifteen given) for *A San Francisco Residence*.[29] Like the majority of photography magazines published in the first years of this century, *Photo-Era* had a pictorialist orientation and was aimed at the hobbyist.

Pictorialism—that is, photography that evoked the qualities of painting—was then the predominant fashion in photography, prized by magazines, competitions, and salons. This was the style that Ansel first tried to emulate. A recurrent criticism of photography was that it was mechanical, produced by a machine and not by the artist; by the turn of the century, some photographers had concluded that their prints must imitate already sanctioned art forms, such as painting, drawing, or etching.

Pictorialism had no truck with reality but instead muted the truth of hard lines with soft focus, diffused light, and textured papers. Some pictorialists even applied brushstrokes or an etching stylus to wet emulsion, so that the effects created by the photographer's hand sometimes overshadowed those achieved by the lens.

In an attempt to make photographs of "serious" subjects, photographers composed images based on grand themes. These prints often bore titles such as *Motherhood*, or reenacted historic or mythic moments such as the banishment of Adam and Eve from the Garden of Eden, as in Imogen Cunningham's *Eve Repentant*, of 1910.[30]

Ansel's energies had been focused on the technical mastery of photography, but as he achieved that, he began thinking about the medium's expressive potential from the pictorialist point of view. In 1920, he wrote to his father from Yosemite to tell of his plan to photograph the Diamond Cascade. Using classical art-composition lingo, he described his intentions in terms of "line," "tone," "form," and "texture," his superficial understanding picked up in his readings of the pictorialist-oriented press.[31]

Remaining completely within the pictorialist tradition, Ansel chose a soft-focus lens to achieve his desired image of the Merced River corseted by narrow, rocky borders.[32] The finished photograph depicts a bright arrow of water penetrating the surrounding dark banks; the soft focus renders the subject so abstract that it cannot be identified without a caption. *Diamond Cascade* is the extreme example of Ansel's short period of experimentation with photographic impressionism.[33]

Over the next four years, Ansel would make use of such other pictorialist conventions as the bromoil process, in which an oily ink was applied to the paper by roller or brush to produce prints with marked painterly, as well as charcoal, qualities.[34] Ansel experimented with many aspects of photography, adding a Korona view camera to his backpack (with its attendant six-and-a-half-by-eight-and-a-half-inch glass plates and heavy tripod) and making photographs through microscopes and telescopes. He tried out a variety of printing stock, from parchmentlike sheets to matte-surfaced, golden-toned papers, and attached his photographs to textured, colored mounts ranging in hue

from buff to deep chocolate. He began signing his prints, at first just "Adams," but soon "Ansel Easton Adams" or "Ansel E. Adams," with a curlicue-ending flourish.

Visually, the great majority of these images were unremarkable and lacked a consistent style. In 1922, two of his photographs were reproduced in the *Sierra Club Bulletin,* one a completely lackluster picture of two deer with the photographer's empty sleeping bag in the foreground, and the other a traditional landscape, *View from Lyell Meadows, Lyell Fork of the Merced River,* with the requisite foreground (river), middle ground (forest and mountains), and background (sky) divided into neat thirds.[35]

This was the second time Ansel's work was published.[36] The first publication of one of his images occurred in 1921, when his straightforward architectural study *Le Conte Memorial Lodge—Yosemite Valley* appeared in the San Francisco magazine *Overland Monthly* in unharmonious partnership with an overwrought poem by one R. R. Greenwood ("His were the bird notes of the crystal morn, / The Son of winds that frolic on the height / Was blended with the forest's call forlorn").[37]

Also in 1922, Best's Studio in Yosemite began selling Ansel's landscapes, and in so doing became the first public space in which his photographs were exhibited. Most of the images were quiet studies that gave little indication of the drama Ansel would soon coax from the same scenery. Taken with a Zeiss Miroflex camera, these photographs were contact prints measuring approximately three and a quarter by four and a quarter inches, made on Kodak Parchmyn paper that produced dull prints of limited tonal range.

Ansel's first known venture into the commercial photographic world had taken place in 1920. The family's next-door neighbor, Miss Lavolier, taught kindergarten at the Baptist Chinese Grammar School (children of Asian ancestry were then still segregated in separate schools), and she asked if Ansel would take the class picture in the classroom. Unfazed by his own lack of experience with artificial-light photography, he agreed.

The appointed hour arrived, and with it Ansel, three view cameras, a tripod, and flash equipment. This was before the invention of flash-

bulbs, and long before high-speed film or electronic flash. Adequate light for an indoor exposure had to be achieved through a controlled explosion of magnesium, known as flash powder. The lively six-year-olds were corralled, placed in some kind of order, and bade to smile at the birdie, in this case Ansel, doing his best imitation of a mockingbird. Ansel ignited the magnesium, and, as he later put it, "The light was truly apocalyptic!"[38] Smoke billowed, children screamed and vanished under their desks, and the fire department was summoned. Ansel had overestimated the amount of magnesium needed by sixteen times too much! It was a wonder that he lived. When calm had been restored, Miss Lavolier ushered her students outside, and Ansel finally took some successful pictures without benefit of flash.[39] It is doubtless that with this event Ansel's dedication to natural-light photography was cemented.

Hoping to come out of the whole episode with a profit, Ansel offered prints of the children in three sizes: six-and-a-half-by-eight-and-a-half, five-by-seven, and four-by-five.[40] A dozen copies of the largest size, for example, cost five dollars mounted or four dollars unmounted, with hand-coloring a bit extra (courtesy of his china-painting mother).

A glimmer of Ansel's mature vision showed in his making of *Banner Peak and Thousand Island Lake*, of 1923.[41] With thunder seeming imminent, roiling clouds fill the sky above sculpted Banner Peak, its contours still described by sunlight. Thousand Island Lake lies quietly at the mountain's base, rimmed by a foreground of brush and boulders. Each element joins together to form the stronger whole of a dramatic picture. Although Ansel believed his soul was at one with the Sierra, he could not yet reliably produce what he saw before him in a finished print. He chalked up this, the first of his dramatic landscapes, to luck.[42]

The artistic success of *Banner Peak and Thousand Island Lake* depends largely upon its clouds. It is in fact the earliest of Ansel's photographs to have clouds in the sky; his previous landscapes, like those of nineteenth-century photographers, all had blank skies, owing to the hypersensitivity of photographic emulsion to the color blue, which meant that that shade was rendered as white in the finished print. But shortly before Ansel left the valley for the trip to Banner Peak, Yosemite photographer A. C. Pillsbury had obtained some of the first

glass plates to be coated with a panchromatic emulsion, which was equally sensitive to all colors, including the previously unobtainable blue.[43] The actual clouds in a scene could now be captured. Although his funds were limited, Ansel bought some panchromatic plates and used one for the Banner Peak exposure.[44] Clouds appear only sporadically in his images from this time until 1932, however, as he continued to use mostly the less expensive orthochromatic plates.

Each passing year found Ansel approaching photography with greater seriousness. In a letter written on September 28, 1923, he declared that from that day forward he would seek to achieve the highest standards of art in his work, without compromise and following purely photographic values.[45]

What was Ansel's definition of "purely photographic" in 1923? Primarily he meant no hand-coloring. Hand-colored pictures were popular with the tourists in Yosemite, and his mother had tinted some of his early prints, but Ansel prophetically proclaimed that black-and-white was photography's true dominion.[46] "Purely photographic" did not yet refer to the use of only photographic techniques, a restriction that he would come to embrace fully a few years later.

Ansel's term "purely photographic" did not spring forth from a void. The world of creative photography that he involved himself in had long been engaged in self-examination. Ever since its announced invention, in 1839, photography had been accused of being little more than a mimetic device, though this view met with swift opposition. British historian Lady Elizabeth Eastlake wrote in 1857 that photography did not replicate reality, but rather interpreted it.[47]

After Eastlake's time, the struggle to establish photography as an independent art form moved onto a broader front. British photographer Peter Henry Emerson was an early defender of "pure photography," admonishing those who could not accept a photograph that looked like a photograph to "leave us alone and not try and foist 'fakes' upon us."[48] Emerson was one of photography's most important spokesmen until the end of the century.

At nearly the same time, Alfred Stieglitz appeared on the scene. Stieglitz was the self-appointed leader of the creative-photography

movement in America from the turn of the century until his death, in 1946. Born in Hoboken, New Jersey, in 1864 to a wealthy family, assured of an independent income and thus free of the demands of a job, he determined to explore the extent of his own creative abilities through art.[49] It was fortunate indeed for photography that it became his chosen medium.

After studying the chemistry and optics of photography in Berlin, Stieglitz returned to New York City in 1890 and joined the moribund Society of Amateur Photographers of New York, whose members were contemplating converting it into a bicycle club. Aghast, Stieglitz plunged in and by 1896 had merged his now-revitalized group with the Camera Club of New York, making it the largest photographic organization in America.[50]

In 1902, having decided that he must roust photography from its secondary status in the art world, Stieglitz began a movement that he called the Photo-Secession. Its aim was to define creative photography, both in word and by example. Photography had not yet clearly identified itself as an art form separate from others and was still hiding its innate characteristics behind the pictorialist sham; Stieglitz's goal was "to compel [photography's] recognition, not as the handmaiden of art, but as a distinctive medium of individual expression."[51]

Stieglitz's protégé and fellow Photo-Secession leader was the painter and photographer Edward Steichen. Born in 1879, fifteen years after Stieglitz, Steichen became quite the enfant terrible in American photography, first presenting his work to the older man (who was then but thirty-six) in 1900 while on his way to Europe. When Stieglitz bade him farewell with the words, "Well, I suppose now that you're going to Paris, you'll forget about photography and devote yourself to painting," Steichen emphatically replied, "I will always stick to photography!"[52]

Employing such techniques as soft-focus, etching, bromoil, and platinum, Steichen's photographs gathered awards and acclaim in salon after salon, both in Europe and in the United States. Settling into a proper studio in Paris, he soon made friends with Rodin and other important artists and became a member of the art cognoscenti, while still maintaining close ties to Stieglitz.

Stieglitz was a brilliant photographer, and while his colleagues in

the Photo-Secession continued in the pictorialist tradition, he developed a different way of seeing. To prove that his results were not obtained by means of expensive equipment, he worked with a snapshot camera, choosing the streets of New York for his subject matter (a decidedly unpictorialist choice) and photographing daily events, recording the energy and beauty of the great city during winter storms and spring rains.

In 1904, Sadakichi Hartmann, a respected critic of the arts, reviewed a huge, three-hundred-print exhibition of the Photo-Secession, which had been juried by Stieglitz, Steichen, and Joseph T. Keily. The resulting landmark article, "A Plea for Straight Photography," defined a straight photograph as one made using little or no manipulation. This could be achieved if the photographer was patient enough to wait for the ultimate moment of the scene before him, when every aspect was perfect, from light to composition.[53] Easier said than done: even when Ansel reached the peak of technical proficiency, he never made a perfect negative. Either some edge needed slight cropping or a rock or some other element had to be darkened by burning. There was always something.

From 1903 to 1917, Stieglitz published *Camera Work,* the journal of the Photo-Secession, often described as the most important and beautiful publication in the history of photography. In 1905, he opened the Little Galleries of the Photo-Secession, which became known as "291," after their address on New York's Fifth Avenue.[54]

Steichen was Stieglitz's remarkable "eye" in Europe, sending back entire exhibitions of the new and startling work of the cubists and fauvists to his mentor, who introduced, in their premier American shows, Rodin (1908), Matisse (1908), Toulouse-Lautrec (1909), Cézanne (1911), and Brancusi (1914).[55] In 1911, he presented the first solo exhibition anywhere by Picasso.[56] Stieglitz now commanded the attention of the entire art world.

In 1910, to critical acclaim, Stieglitz curated the monumental six-hundred-print retrospective International Exhibition of Pictorial Photography for the Albright Gallery in Buffalo, New York. At the conclusion of this show, he completely renounced pictorialism and abandoned the Photo-Secession, charging that it had not progressed far enough.

The real problem was that photography had been so accustomed to emulating impressionist painting that when painting took off in the direction of abstraction, most photographers were left behind, still immersed in their pictorial haze. Searching for photographers who he believed photographed with a unique and personal vision, and were committed to expressing photography as an art, Stieglitz found only himself. Until 1916, his New York gallery continued to display paintings, sculptures, and prints by others, but the only photographs shown were by Stieglitz.

With his exhibition of Paul Strand's photographs in the spring of 1916, Stieglitz gave signs of hope for the future of the medium, in the form of a new photography influenced by the new painting. Viewing the work of Picasso and Braque at "291"as well as at the Armory show had radicalized Strand's vision. Through the eye of a cubist, he photographed the streets of New York, taking on the same subject as Stieglitz but obtaining very different results. By breaking up the picture into flat planes, he pioneered a new visual approach.

If Stieglitz photographed the city's streets, Strand turned to its alleys and other aspects that had been seen as even more unworthy of the camera. Strand had been taught photography by the great documentarian Lewis Hine, whose poignant images of children working in mills and factories had helped establish American child labor laws.[57] Strand's New York, unlike Stieglitz's, was often unattractive, but it found strong subjects in the faces of interesting characters: working folk and the unemployed, or a blind beggar caught unaware with one open eye. In a foreshadowing of Strand's later commitment to communism, most of the image area of *Wall Street, 1915* is dominated by the grand, massive, and impassive face of the Morgan Bank, impervious to the column of anonymous New Yorkers moving ephemerally across its base.[58]

Strand described his version of Stieglitz's philosophy in "Photography," an article published in 1917 in the magazine *Seven Arts*.

> The full potential power of every medium is dependent
> upon the purity of its use, and all attempts at mixture end
> in such dead things as the color-etching, the photographic

painting and, in photography, the gum-print, oil-print, etc., in which the introduction of handwork and manipulation is merely the expression of an impotent desire to paint.[59]

There is no definite indication that fifteen-year-old Ansel Adams saw Strand's article, but the boy's ardent reading of the current photographic literature makes it a possibility. He certainly had read it by 1933, when he owned a copy of the issue of *Camera Work* in which Stieglitz had reprinted it.

Ansel slowly moved from "fuzzy-wuzzy" pictorialism (as he would later describe it) to the straight-photography camp. By 1925, having decided that the pictorialist approach was not appropriate to the clean, hard Sierra granite he had chosen as his subject, he had forsaken the soft-focus lens and the bromoil print. He was at least aware of Stieglitz by this time; for Christmas 1925, a family friend gave him a copy of the book *Musical Chronicle (1917–1923)*, whose dedication page read, "To Alfred Stieglitz."[60] But Stieglitz did not directly affect the direction of Ansel's creative development until their first meeting, in 1933.

Leaving the familiar pictorialist territory, Ansel took inspiration from the writings of English poet and philosopher Edward Carpenter, who reaffirmed his earlier affinity for Emerson and Ingersoll. Ansel was introduced to the writings of Carpenter by his best friend, Cedric Wright. Their intense comradeship began in 1923, when Ansel joined the Sierra Club's summer outing party for a few days at Tuolumne Meadows, above Yosemite Valley's north rim. There he encountered Cedric, a serious musician dedicated to the study of the violin. After getting the basics out of the way (they agreed that Bach and Beethoven were the greatest composers) and finding that they shared an abiding love for the Sierra, they discovered the remarkable coincidence that they both considered photography their hobby. Ansel sat with the audience of Sierra Clubbers about the evening campfire as Cedric stood, violin under his chin, and serenaded the evening. Like Ansel, Cedric had a reputation as a pundit. After devising the first portable latrines

for the Sierra Club, Cedric dubbed them Straddlevariouses.[61] The two men found each other completely simpatico.[62]

Even loftier-minded than Ansel, Cedric set new standards for his young friend, quoting Walt Whitman, Elbert Hubbard, and Carpenter. Cedric was blessed with an assured family income and had a barn-like house in Berkeley, "party central" for Sierra Clubbers and musicians, that had been designed for him by the famed architect Bernard Maybeck. From the rafters that soared above its huge main room hung a swing (and mind you, this was forty years before the sixties). Built-in couches upholstered with loose pillows lined its walls. Immensely impressed by the highly personal space Maybeck had created for Cedric, Ansel resolved that someday he would have Maybeck design a home for him as well. In the interim, Ansel could often be found at Cedric's. In this era, before bridges connected San Francisco with either Marin County to the north or the East Bay (Berkeley and Oakland), it took him two hours to get to Berkeley and another two hours to get back, combining streetcar, train, and ferryboat.[63]

Cedric entertained with ease, serving his guests—the sophisticated as well as the unsophisticated—what he believed to be the best chow in the world: the usual Sierra Club camp dinner of spaghetti and meatballs, French bread, tossed salad, and cookies and Jell-O for dessert. The coffee was boiled, thick and rich. The only thing missing was the mountains.

Ansel idolized Cedric, whom he saw as intelligent, accomplished, and worldly. Cedric became his guide to the tantalizing world of wine, women, and song, and to the young artistic achievers living in Berkeley. Although Cedric was wed, first to Mildred and then to Rhea, and though he had three children, he seems not to have let his marriages get in the way of his quest for the ideal woman. For Ansel, Cedric proved to be a potent influence in matters of the heart as well as philosophy.[64]

Together, the two friends reflected on line after line of Carpenter, who instructed, "Never again will Art attain to its largest and best expressions, till daily life itself once more is penetrated with beauty."[65] An unwritten pact was made between them: they would devote their lives to the creation of beauty.

For Ansel, the summers of both 1925 and 1926 were consumed by extended journeys with cameras, mules, and friends into the Kings Canyon area of the Sierra, never without his pocket edition of Carpenter's book *Towards Democracy*.[66] His letters during this period were peppered with quotes:

> *In the first soft winds of spring, while snow yet lay on*
> > *the ground—*
> *Forth from the city into the great woods wandering,*
> *Into the great silent white woods where they waited in their*
> > *beauty and majesty*
> *For man their companion to come:*
> *There, in vision, out of the wreck of cities and*
> > *civilizations, . . .*
> *I saw a new life, a new society, arise.*
> *Man I saw arising once more to dwell with Nature.*[67]

Carpenter's beliefs reaffirmed Ansel's own feeling that nature was the source of all goodness and man's best friend, nourishing life by providing beauty. An ordered nature conformed to an organic logic and pattern, but these largely eluded man's comprehension. Nature was meaningful in a way that few could perceive, for one can seldom glimpse more than a small portion of the universal mysteries. Ansel's goal, whether on the piano or through the camera, was to express something of what nature revealed to him.[68] First with Carlie and Aunt Mary's help, then with Cedric's, Ansel worked out his philosophy before he established its full expression through his art.

Ansel returned to San Francisco in the fall of 1925 and, affecting Carpenter's style of capitalizing words of central importance, wrote that he was pledging his life to "Art."[69] The end results of his summer in the Kings River Canyon were a consistent group of directly seen, sharply focused, and cleanly composed images. His ground glass narrowed and isolated the scene before him in such a way that the natural world appeared uncomplicated and understandable. Many of the best images were portraits of individual mountains, standing tall and apart from their surroundings, with characteristics so unique that one could never

be mistaken for another. This represented a strong first step toward a personal vision.

Ansel's musical studies had been getting short shrift. It was difficult for him to keep up the charade of making music his life's work when it meant spending long hours shackled to a piano in San Francisco. Just as his mind had been drawn to the blue skies, clouds, and fog flowing past the windows when he was in school, so did it wander in the mountains as he sat at the piano, his fingers on the keys. Ansel's siren and muse were Yosemite and the Sierra, not Bach and Beethoven.

After days away from the piano, he would experience physical pain each time he returned for three to four hours of practice. He finally concluded that his hands were all wrong: too small to span many keys and, with his thinly padded fingertips, more suited to the violin than the piano.[70] Glumly, he commiserated with Cedric, who had a pianist's large hands, not a violinist's.

As the decade of the twenties progressed, Ansel's future was further shaped by his urge to establish his own home and studio modeled upon Carpenter's ideals, just as had Cedric, though he lacked his friend's income. Ansel continued to live with his parents, earning only small sums from the piano teaching that he had begun in 1923, as well as occasional photographic jobs.

During the late spring of 1926, at a party at his house in Berkeley, Cedric introduced Ansel to Albert Bender, who owned a small insurance agency and devoted his considerable energies, and not so considerable income, to the support of artists and fine books.[71] Albert Bender was to change the course of Ansel's life.

Born in Dublin in 1866, Albert had arrived penniless in America in 1883 and had gone on to build one of the most respected San Francisco insurance practices of his day. An exemplar of hybrid vigor—his father was a rabbi, his mother Catholic—Albert was a small man of regal bearing, with an aquiline nose and hooded eyes, his suit never complete without a flower in the jacket's lapel.

When Ansel met him, Albert was a lonely man, still grieving over the death, three years earlier, of his true love and first cousin, the painter Anne Bremer. Bremer had studied in Paris for more than ten

years and returned to the United States committed to the new modern art, which she is credited with having introduced to San Francisco. She became president of the Sketch Club, founded for and by women artists in 1887 and dedicated to providing members with studio space and semiannual exhibitions.[72] Bremer brought her cousin Albert into the center of San Francisco's art scene.

Scandalously, Bremer and Bender maintained adjoining apartments. After she died, he changed nothing, keeping her rooms as a memorial except during his thrice-yearly blowouts to celebrate his particular trinity of holidays: Yom Kippur, the Chinese New Year, and Saint Patrick's Day, which he insisted was his birthday and on which he would bestow blessings upon all while dressed as a cardinal, complete with red cap.[73]

Albert's generosity was the stuff of legends. His pockets bulged with an endless supply of trinkets—rings, necklaces, brooches, and small carved figures—that he dispensed to those he met throughout the course of his day, be they building janitors or esteemed authors.[74] He kept artists from starving and poets from dying of John Barleycorn thirst. Before meeting Ansel, Albert provided financial support to poets Robinson Jeffers and Ina Coolbrith and photographer Edward Weston, among many others.[75]

Cedric had already built up each man to the other before his pivotal introduction. That night, Ansel showed Albert photographs from his high-country trips of the past summers to the Kings River—images of Roaring River Falls, Paradise Valley, and Marion Lake. A confirmed city boy, with all that implies, Albert had no interest in these as illustrations of places, but admired them as art, plain and simple.

After viewing the photographs, Albert asked Ansel to bring them to his office the next morning, when he would see what he could do about them. With great anticipation, given Albert's reputation, Ansel pushed open the door to room 412, 311 California Street, at ten o'clock on Monday, April 11, 1926. The office was a mess. Albert's desk seemed useless, piled as it was under a jumble of papers, though its owner could ferret out what was necessary at its appointed time. Other visitors arrived and were dealt with, and phone calls were taken. Despite the hubbub, Ansel was not offended because Albert acted as if the pho-

tographs were more important than anything else in his obviously busy life.[76]

With a smile aimed right at Ansel, Albert declared that the pictures were worthy of a portfolio. He decided there should be one hundred copies (plus ten for the artist), each containing eighteen prints and selling for fifty dollars.[77] After a quick assent from Ansel, and without any break in the action, Albert announced, "I must see the boys about this; we'll get up a little subscription," and on the spot he began telephoning his friends, wealthy patrons of the San Francisco arts.[78] Mrs. Sigmund Stern agreed to take ten portfolios, as did her son-in-law Walter Haas, both of Levi Strauss riches, and Albert bought ten for himself. By lunch, fifty-six portfolios had been sold, though not one print had yet been made.[79] Ansel departed with a check for five hundred dollars in his pocket.[80]

Albert assured Ansel that his unmannered photographs of nature would be taken seriously by those who mattered.[81] Ansel, who had never earned enough money from either performing or teaching piano to afford him independence from his parents, suddenly saw that photography could provide the necessary means.

Proud of his new protégé, Albert touted Ansel about town, where he became known for his impromptu piano performances at parties. He met influential people who in turn introduced him to more of their kind. The July 1927 issue of the *Overland Monthly* described him to its readers: "Mr. Adams is a San Franciscan of unusual abilities in several professions. Already he is a musician of acknowledged ability and a great social favorite."[82]

Wealthy San Franciscans soon began to hire Ansel to make their portraits and to photograph their homes. The tony San Francisco store Gump's engaged his services to produce still-lifes of crystal for their catalogs, though his first job for that august establishment was a disaster. His assignment was to make a copy of a lithograph of Jesus; as he positioned his camera, the lens fell out and went straight through Christ's head. Ansel had to pay Gump's seventeen dollars, the lithograph's wholesale price.[83] Fortunately, he made few such mistakes, and a thin photography-produced income stream began to flow.

The great documentary photographer Dorothea Lange, who became a longtime friend of Ansel's, also knew Albert and believed he ruined her friend:

> His art patronage was a kind of a joke. . . . He harmed a
> few people in this respect. He inoculated Ansel with the
> idea that an artist had to develop his patrons, and Ansel
> became a "little brother of the rich," under Albert's guid-
> ance. Ansel became somewhat their entertainer and it
> wasn't good for him.[84]

There is some truth in what she said. Ansel would forevermore search for his ideal patron, beyond Albert—an enlightened someone who would lift the burden of finances from the back of this creative artist. It was evident in a certain unbecoming obsequiousness he displayed when he was around the rich, whatever their personal achievements (or lack thereof). Albert Bender had, without hesitation, steered Ansel firmly away from the piano and toward photography as a career; it was not only the promise of money, but also Albert's approbation that fired the young man's confidence.

4

MONOLITH

While Ansel's photography steadily progressed, his personal life was often in shambles. This perhaps should not be surprising, considering that his most immediate experience with male-female relationships was the example of his parents, a formal and proper couple who usually addressed each other as "Mrs. Adams" or "Mr. Adams." When they were in the privacy of their own home, and only the family was present, names were softened to Ollie and Carlie. They did not express their feelings with hugs or kisses; emotions were held at bay, kept remote. In the 747-page transcript of his oral-history interview, Ansel mentioned his mother only rarely, and his aunt Mary, a central figure in his upbringing, not at all.

Although Ollie emotionally dominated her husband at every turn, Carlie cast her qualities in a positive light, at the same time calling himself a failure.[1] It was understood that Carlie had not met her standards, and it was now up to Ansel to achieve them.

Having no good model for a real-life relationship, Ansel worshiped idealized love, the purest of feelings above the physical plane. When he met Virginia Best in Yosemite in 1921, he saw her as good raw material, and planned to mold her into his perfect woman.

Virginia, born on January 18, 1904, was the blond, blue-eyed daughter of Harry Cassie Best, the owner of Best's Studio, and Anne Rippey Best. Her parents had met in Yosemite in late May 1901, when the then thirty-seven-year-old Harry, on an extended camping trip, fell in love with the twenty-two-year-old woman who ran Lippincott's photographic tent studio. Within two months of their meeting, Harry and Anne were married at the base of Yosemite's Bridal Veil Fall, called Pohono by the Ahwahneeches.[2]

In the year of Ansel's birth, 1902, Harry Cassie Best established his painting studio in Yosemite, in a simple 720-square-foot, one-story wooden building whose exterior had been painted to resemble stone.[3] The self-taught Best was a Western landscape painter in the oversentimentalized tradition, whose paintings lacked the fine technique and atmosphere commanded by artists of Bierstadt's level. In service to a conventional imagination, Best painted such gems as *Ramona Going through the Wild Mustard* and *Innocence*, mannered portraits of exceptionally large-eyed, pretty young women dressed in tantalizingly sheer, diaphanous gowns.[4] Best employed a photographer to snap vacationers at Mirror Lake and sold various photographic views, which he called "fotografs," along with his paintings and the usual variety of Yosemite souvenirs.

Because of her parents' migratory behavior—the family spent winters in southern California and summers in Yosemite—Virginia missed a lot of school and was always struggling to make up work. She, like Ansel, never earned a high school degree. Fragile health afflicted Anne Best, and when she died of tuberculosis, in 1920, sixteen-year-old Virginia assumed her mother's place as housekeeper and cook, a role she had already in large part shouldered in deference to Anne's disabilities.[5] In 1927, Best built a new weatherized studio that included a sales gallery and a darkroom with living quarters in back so that he and his daughter could live in Yosemite all year long.[6]

Ansel was introduced to Harry Cassie Best during the summer of 1921. Still determined to be a classical pianist, but at the same time loving the outdoors of Yosemite, Ansel needed to find a piano for practice. There were only two in the valley, one of which was Best's old Chickering upright, which he graciously agreed to allow Ansel to use. That was how Ansel met the seventeen-year-old Virginia, herself a real Yosemite girl, well versed in natural history and possessed of a deep love for the outdoors. In addition, she had a rich contralto voice. According to Virginia, "It took me quite a while before I realized that it wasn't only the piano that brought him down to the [studio]. . . . Because I just really wasn't emotionally ready to get interested in anybody, and didn't believe anybody'd be interested in me."[7]

Ansel fell hard for Virginia, and she, eventually, for him. For the first year it was nothing more than friendship, but after his return to Yosemite the next summer, Ansel was compelled to write to his father that he was in love with a girl who reminded him of his mother.[8]

Virginia was unhappy as her father's helper. Harry kept her busy working from early morning until she flopped exhausted into bed each night, and she longed to be married and to have her own home.

During their long winter separations, Ansel and Virginia exchanged frequent, detailed letters. Whenever his seemed to dwell too much on photography, Virginia would admonish him to remember that his destiny lay in music. She considered photography an unworthy use of his brilliant talents.[9] Ansel reassured her that photography would remain nothing more than a hobby. He shared his dreams of the home and studio they would build, a warm refuge with a fireplace where friends would love to gather.[10] Although no wedding date was set, by 1923 they considered themselves engaged. When Virginia consulted a Ouija board about their future, however, it prophesized that they would not marry until 1927; consolingly, Ansel replied that it would certainly be sooner than that.[11] He applied himself to his musical studies with added vigor.[12]

Suddenly, though, Ansel's ardor for Virginia cooled. In November 1923, he cautioned her that his first allegiance must be to his family; finances were precarious, and duty bound him to assist his father

in every way possible.[13] Not coincidentally, Ansel had recently begun his friendship with Cedric Wright, and through him, and his Bohemian lifestyle in Berkeley, was meeting many other young artists and musicians, some of them his new friend's students, some of them female.

In the summer of 1925, Ansel was invited to join Professor Joseph LeConte II, son of the famed geologist and Sierra Club leader, and his family on a six-week pack trip into the Kings River Sierra. It was during these travels, and the next summer's, that Ansel honed his camera eye.

Joe Junior, as Professor LeConte was known, had been a childhood friend of Carlie's. His son, Little Joe, and daughter, Helen, would also be going on the trip. Helen was told by her father that she could invite one girlfriend. When Virginia discovered that it was not to be she, she asked Helen, "Why didn't you ask me, too?" Helen later remembered, "Well, they [Ansel and Virginia] were supposedly engaged. But at the same time, Ansel was madly in love with a lot of Cedric's pupils. We couldn't tell if he was engaged to them or to her or what, and my father didn't want any other women along, anyhow."[14]

The campers woke each morning at five and hit the trail by seven, all looking forward to Professor LeConte's famous lunch. His reputation for serving up the best trailside vittles was no small part of Ansel's decision to sign on: though skinny, he always loved to eat. These lunches were hardly the usual Sierra fare, to be consumed during a short rest period: the mules were loaded with an entire side of bacon, a huge Edam cheese, a big ham and lots of hardtack, canned fruits and vegetables, and a variety of Knorr's dried soups. At noon every day, Professor LeConte would produce fluffy hot biscuits courtesy of his reflector oven, along with such tasty items as corned beef, boiled potatoes, and fried onions.[15]

In his spare moments, Ansel pored over his pocket-size edition of Carpenter's *Towards Democracy*. Upon his return to San Francisco that fall, he wrote Virginia a letter embellished with such Carpenterian platitudes as, "The path that God would send me shining fair." Ansel informed her that he had spent the nest egg he had been accumulating for their marriage on a new Mason and Hamlin grand piano. At the end

of this letter, Ansel, a pagan by his own description, had the temerity to announce that he intended to throw himself upon the mercy of God to determine his future.[16] Virginia must have seen this split coming, but it was terrible for her anyway.

In fact, Ansel had given his life not to God but to a pretty violinist named Mildred Johnson. His infatuations with Mildred, Dorothy Minty, Margaret Colf, and a string of others never lasted long, so great was the pressure of his intense adulation. Each young woman in turn simply got worn out by his attempts to control most aspects of her life.[17]

Ansel seemed able to assume only one of two roles when relating to another: he was always either the teacher or the student. He found no one but Virginia who was willing to put up with his endless lecturing on education, conduct, and discipline. For her part, Virginia coped in a passive-aggressive way, listening thoughtfully to everything he said and then doing pretty much as she wanted.

Somehow, despite and throughout his wanderings, Virginia remained determined to marry Ansel, and sent him her poems and snips of aromatic pine boughs to remind him of what she was fond of describing as "my world." That world, of course, was Yosemite, the key to her eventual success with him.

But in San Francisco during the winter of 1925–26, following his breakup with Virginia, Ansel toiled at his piano lessons and earned some money as a music teacher, offering ten lessons for ten dollars.[18] He formed the Milanvi Trio, composed of violinist Mildred, pianist Ansel, and dancer Vivienne, whence the name. Announcements were printed, and they were booked for a smattering of engagements, but Ansel was a failure as an accompanist, inevitably drowning out the violin and racing ahead of the dancer.[19] He had an elegant calling card printed with the inscription "Ansel Easton Adams, Piano," in a serifed font. But in the end, he felt dismally stalled at a local level of mild musical recognition. No one ever "discovered" him, and the future lost its promise. As the string of women evaporated, his disenchantment with the music scene increased, until he finally dismissed it as tawdry and unworthy of his involvement.[20]

Ansel returned to Yosemite and to the arms of the unspoiled, ever-patient, and welcoming Virginia. They traveled to Carmel for a brief

getaway during which, on Easter, April 17, 1927, they managed to elude whatever chaperon they must have had and made love for the first time. Virginia was stricken with adoration. She discovered her own intense physical needs and yearned to be with Ansel all the time.[21]

It was a momentous time in Ansel's life in more ways than one. Just one week earlier, on Sunday, April 10, he had made the biggest artistic breakthrough of his life.[22] Just as those who had first gazed on Yosemite had been at a loss to truly describe it, so had Ansel been. He knew that not one of his photographs communicated the great feelings he had for that landscape.

Still hard at work on his first portfolio, which had been set into motion exactly one year earlier by Albert Bender, Ansel had determined that he must make an image of Half Dome from a vantage point that had become firmly seated in his imagination. If it is possible for anything to dominate such a spectacular valley, Half Dome does: it is Yosemite's greatest jewel, an incomparable shape rising abruptly from the valley's floor. The massive form measures three-quarters of a mile tall and four-tenths of a mile thick, with a broad top spreading across thirteen acres.[23]

Ansel's destination was the "Diving Board," which offered what he believed to be the best view in Yosemite.[24] A rock slab projecting out over the valley nearly four thousand feet below, it provides both a panorama to the west and a tremendous view of Half Dome's towering western face.[25] A few years earlier, he had hiked there with Uncle Frank, and now he longed to return because he knew there were pictures to be made.[26]

Ansel invited four friends along on the full-day journey, including Virginia and Cedric. This was no easy walk but rather a rigorous scramble (as they fondly termed such challenging excursions), much of it free of trails though not of snow. For traction, the others relied on the stickiness of the soles on their hiking shoes, while Ansel swore by black basketball sneakers.[27]

One of the group, Arnold Williams, a professional photographer employed by Yosemite Park and Curry Company, sent an account of the trip to various newspapers.[28] He noted:

We started from the floor of Yosemite Valley by the Glacier Point long trail. A short distance up the trail we took the steep climb toward Sierra Point, leaving the latter trail about one-half way up. From this point we were away from all beaten trails until our return late in the evening to the trail near Vernal Falls.

The day was excellent for picture making. Each member of the party had opportunities galore to excel their previous efforts in securing unusual as well as attractive views of Yosemite Valley, the canyon's rim and the face of Half Dome. We had many thrills en route to the Diving Board but were well repaid for our efforts by the pictures secured.[29]

Compounding the arduousness of Ansel's journey was his backpack, which contained his six-and-a-half-by-eight-and-a-half-inch Korona view camera and a couple of lenses and filters, but just a dozen Wratten Panchromatic glass plates. A heavy wooden tripod was tied onto the backpack with rope. He was twenty-five years old, six feet tall, and hardly strapping, weighing a mere 125 pounds.[30] He wore a well-seasoned leather jacket, Levi's, sunglasses, and a snappy fedora.[31] Ansel stopped to photograph as they climbed, using a long-focus lens to rein in distant Mount Galen Clark.[32] Virginia, a courageous climber able to keep up with, and sometimes surpass, her male companions, carried a motion-picture camera; she was clothed in hiking pants, a heavy sweater, and a warm knit cap.[33]

They arrived at the Diving Board only to find the sun too high and Half Dome still in shadow. As they waited for the light, they ate lunch and Ansel made several more exposures, including a charming image of the distant, tiny figure of the intrepid Virginia standing on the end of the Diving Board, with thousands of feet of air beneath her.[34]

Ansel was left with only two remaining glass plates to make the image that had been the reason for this journey. At two-thirty, as light from the westward-drifting sun began directly to illuminate the face of Half Dome, he focused his Korona, which was fitted with a slightly wide-angle lens and a K2 yellow filter to reduce the atmos-

pheric haze. After determining the exposure, he set the lens, inserted the glass-plate holder, removed the dark slide, and then squeezed the cable release.

Ansel's epiphany occurred after he made that exposure. Perhaps inspired by one of Carpenter's maxims, "The object of the Fine Arts is to convey an emotion,"[35] he realized that the negative he had just made would not contain the information needed for the finished print he saw in his mind's eye, one that would communicate the powerful emotions he felt in Half Dome's presence.[36] He later termed this concept visualization—the notion that the photographer should know how the finished print will look before the negative is even exposed. Visualization became the new cornerstone of his photographic philosophy.[37]

By the simple addition of a deep-red filter over the lens, which greatly increased the tonal contrasts, Ansel altered apparent reality to achieve his visualization of Half Dome. With this one act, Ansel stepped beyond the traditional photographic boundaries of the day. The sky was no longer light and bright; instead, it became a black velvet background for the smooth outline of the shattered, flat-planed face of Half Dome, rising majestically above its snowy shoulders. Looking at this image, we see Half Dome not with our own eyes but through Ansel Adams's soul.

This was hardly the first time Ansel had skewed the scene before him. Various pictorial conventions, such as the soft-focus lens and the Bromoil print, certainly changed reality as well, and a case in point is his soft-focus 1921 print *A Grove of Tamarack Pine* (later entitled *Lodgepole Pines*). His whole life long, Ansel had a soft spot in his heart (some might say in his head) for this picture and the memories it held. The soft-focus lens refracted the highlights, producing a glowing luminosity that captured the mood of a magical summer afternoon,[38] but in adopting this technique, Ansel surrendered the most basic quality (and strength) of photography: the ability of a lens to provide an image of acute sharpness.

In the world of straight photography toward which Ansel was moving, filters were prescribed only for making subtle contrast corrections. Ignoring those rules, Ansel instead employed the deep-red filter to radically transform his image from day into night. The historian Frederick

R. Karl asserts that "any artist hoping to be Modern must develop beyond influences, must leap into unknown territory which then becomes his. That 'leap' which the artist is able to make becomes his membership card in the avant-garde."[39]

Monolith is Ansel's most significant photograph because with this image he broke free from all photography that had come before. Nothing in it smacks of pictorialism, or of Stieglitz, Strand, or Edward Weston. With its extreme manipulation of tonal values, it was definitely beyond the dicta of straight photography; this was a new vision, and it was his. In every sense of the word, he was now an important artist, with the concept of visualization representing his breakthrough. Within a month of making *Monolith*, he ceased all mention of a musical future in his correspondence. Years would pass, however, before he would dare permanently to venture so far away from the "straight" path; perhaps this photograph scared him, both in its strength and in the implication of where it could take him in photography.

Ansel came to the idea of visualization on his own, though in 1922 Edward Weston had hinted at the same theory in a speech before the Southern California Camera Club, saying, "I see my finished platinum print on the ground glass in all its desired qualities, before my exposure."[40] These words were not published until 1980, but the idea, which Weston would later term previsualization, was nonetheless in the photographic wind.

Ansel can be credited with the first published definition of visualization, written in April 1934 for *Modern Photography 1934–35: The Studio Annual of Camera Art*. Before exposing the negative, he explained, "The photographer visualizes his conception of the subject as presented in the final print."[41]

During the same momentous day-hike to the Diving Board, Ansel secured three images for the impending portfolio, including the picture of Mount Galen Clark and the one of Virginia, entitled *On the Heights*. The excursion proved so successful that two weeks later, on Sunday, April 24, the group of comrades took off on another challenging hike, this time determined to be the first that year to climb the repetitive switchbacks of the Four Mile Trail from the valley floor to Glacier Point.[42]

At Glacier Point, where the drifts were up to eight feet high, Ansel

set up his tripod, its legs sunk almost all the way up in snow, and screwed the Korona view camera in place. The result was another strong photograph for the portfolio, *From Glacier Point*, with Half Dome in three-quarter profile dramatically framed on the top and left side by the dark silhouette of a tree.

In addition to these four, Ansel selected fourteen other images for the portfolio, most made during his trips to the Kings River Canyon Sierra. All were from glass plates, save one on film. Glass plates recalled the nineteenth century; by now most photographers had switched to sheet film, with the light-sensitive emulsion coated on a sturdy piece of cellulose acetate, but for several years to come Ansel would remain convinced that glass plates produced better negatives.[43]

The portfolio was at last taking shape. Albert engaged the Grabhorn Press, staffed by world-respected designers and fine printers, to create an elegant presentation for the photographs. Black silk lined with gold satin was chosen for the portfolio covers, with the name embossed in gold on the front. A buff-colored, rough-textured, handmade paper folder encased each print, with the title typeset in black.[44]

Convinced that few people other than Bender's contacts would buy a portfolio if it was described as containing photographs, Jean Chambers Moore, the publisher, insisted on a different name. She was probably right: no market then existed for photographs as art, rather than as souvenirs of places or trips. They christened the portfolio *Parmelian Prints of the High Sierras*. The name was derived either from Parmelia, a genus of lichen, or, as Ansel later claimed when asked what it meant, from "nothing. The publisher didn't want to use the word 'photograph,' so she concocted this little kind of a bastard combination of Greek terms from black—'melios.' I don't even think that is an accurate use of the term, but she liked it, so it was used."[45] Ansel later considered his own abandonment of the word *photograph* cowardly, and he rued the day he was talked into using the word *Sierras*. In Spanish, *sierra* is a plural form meaning one mountain range; the added *s* denotes several ranges and as used here is incorrect.[46]

Ansel made all the Parmelian prints on Kodak Vitava Athena Grade T Parchment, a cream-colored, gelatin-silver paper that is translucent when held up to the light. It was available commercially from 1925 to

1928. Formed of intense blacks with modest tonal separation, the silver image appears to sit within the matte, slightly textured paper, rather than on top of it, as would be the case with modern, glossy stock. This choice of paper cast a pictorialist pall over the sharp focus of seventeen of the eighteen prints. (The exception is the soft-focus *Grove of Tamarack Pines*.)

With the publication of *Parmelian Prints of the High Sierras* in the late summer of 1927, Ansel's career as a photographer looked both viable and appealing.[47] Although Ansel later remembered that he completed about a hundred sets, some were destroyed in a warehouse fire, leaving approximately seventy-five that were sold and delivered.[48] Their sale at fifty dollars apiece grossed him about $3,750, a handsome sum in 1927, even after the expenses of paper, processing, packaging, typography, and production were deducted. For those with less fluid finances, Ansel also offered individual Parmelian prints at five dollars apiece. Over the next three years, from the spring of 1927 to the spring of 1930, he sold 1,943 photographs.[49]

Forever cavalier toward Virginia's feelings (with their Carmel tryst, she believed she had made the ultimate commitment), Ansel continued to come and go as he pleased, soon embarking on his first trip to the Southwest, with Albert Bender. Virginia kept her spirits up by entertaining Cedric; fleeing to Yosemite following the disintegration of his first marriage, he stayed with the Bests and endeared himself to the lady of the house, who came to treasure him as a close friend.[50] When her period (which she code-named Grandmother, the slang term commonly used at the time) was late, Virginia confided in Cedric. Although it was during Prohibition, he secured some whiskey that they hoped would ensure a visit from Grandmother, which at last arrived.[51]

In July, Ansel was finally to become a member of his first full Sierra Club outing. Joining an outing was simplicity itself; the only requirements were membership in the club, payment of the trip's fee, and bringing a sleeping bag and a duffle packed with clothing. Virginia begged him to allow her to go along, promising that she would not bore him or get in his way. He agreed, and those few weeks, undocumented by letters, were probably the best period of their life together.

Ansel had finally accumulated some savings from the sales of *Parmelian Prints of the High Sierras*. On little notice, he, Cedric, and Dorothy Minty presented themselves at the Bests' Yosemite door on December 26, 1927. Immediate marriage to Virginia had not been on Ansel's mind, but Cedric had made it his earnest project and at last convinced his friend that the time was right.[52] Ansel proposed, and Virginia accepted.

They were wed before eighteen guests in front of the fireplace at Best's Studio at three in the afternoon on January 2, 1928.[53] Attired in hiking clothes, Cedric served as best man and violinist Minty and pianist Ernst Bacon performed the third movement of a Cesar Franck sonata.[54] With no chance to leave the valley to shop, Virginia was married in her best dress, which came from Paris but unfortunately was black. Certain this was a bad omen, Ansel's mother wept.[55] She and Carlie had brought the wedding ring, a gold band set with small diamonds, from San Francisco; Cedric had briefly lost it in the snow as he wrapped chains around the tires on Ansel's car. Ansel wore the only pants he had brought—knickers—and his black basketball sneakers.[56] Their union was announced in a local paper with a grim choice of words: "A beautiful romance terminated in Yosemite Valley Sunday when the Reverend Luther Freeman of Pomona united Miss Virginia R. Best to Ansel E. Adams."[57]

Following a celebratory dinner, the newlyweds left with Cedric for Berkeley, where they spent their wedding night on a cold, uncomfortable single cot. But they were on a mission. The next day they had an appointment with Cedric's architect, the great Bernard Maybeck. With the addition of their wedding money, they hoped to be able to realize their shared dream of a home and studio.

A short time later, Maybeck presented his drawings to the young couple. He had responded better to Virginia than to Ansel, and so had centered the house around her needs as a combination singer/housewife. Ansel's requirements for a studio and darkroom were neglected in order to provide a suitable kitchen and singing space for Virginia. Within days, they received the estimate for construction costs, which far exceeded their budget. There was no more talk of Maybeck.[58]

Ansel devised a plan: the first three years of their marriage would be

devoted to the development of their respective arts. Hoping to save up enough money for their own home, they moved in with his parents, where they stayed for the next two years. Virginia later maintained, "It wasn't so bad." She had waited for him for nearly seven years already, throughout the ups and downs of their sporadic courtship, and her commitment to their marriage was total.[59]

Inspired by his status as head of a new household, and by the promise accorded his portfolio, Ansel began behaving like a professional photographer. Knowing that the members of the Sierra Club were a prime audience for his photographs, he took out a full-page advertisement in the 1928 *Sierra Club Bulletin*[60] to announce that

Parmelian Prints

BY

ANSEL EASTON ADAMS

*Are available at his Studio at
No. 129 Twenty-fourth Avenue,
West Clay Park, San Francisco
California*

Mountain Subjects—chiefly of
the High Sierra. Motion Picture
Reels of the Sierra are also
available.

PORTRAITS AND
SPECIAL PHOTOGRAPHIC STUDIES
MADE BY APPOINTMENT
Telephone Evergreen 3575

Not everyone was happy with his career decision, however. Ansel later recalled,

> When I got doing more and more photography, and finally decided [I was] going to be a photographer, [my mother] was very upset. "You're not going to be just a photographer, are you?" She was thinking of me being a musician, because photography was not known as an art by people of her age and type. If anything, it was something down on Filmore Street where you'd go and get a family portrait for a few dollars.[61]

In absolute agreement that they needed to have a home separate from his family, Ansel and Virginia sadly concluded that they had enough funds either to buy land or to build a house, but not both. In an act of adulterated kindness, Ollie gave them her dahlia garden. They hired a neighborhood architect known for designing theaters and with him created a very Maybeck-like brown shingled house, with an open, two-storied living/music room and a loft with two bedrooms. Ansel and Virginia held their housewarming on May 4, 1930, lighting a fire in the fireplace under a mantel inscribed with Edward Carpenter's words, "O Joy Divine of Friends."[62] The fulfillment of their goal exacted its price: forsaking the independence they had longed for, they would now be physically bound to his parents for the rest of their lives, in houses twenty feet apart, at 129 (Carlie, Ollie, and Mary) and 131 (Ansel and Virginia) Twenty-fourth Avenue, San Francisco.

Ansel continued his traveling ways, leaving Virginia at home because they could not afford her costs, too. They wrote to each other frequently during his many absences. Her letters were adoring, entreating him to come home to her arms as soon as he could, while his repeatedly admonished her to improve herself and often scolded her for her lack of application.

Dismissing Ansel's three-year plan, Virginia wanted first of all to establish a comfortable home for her man and to raise babies. Ansel was not really interested in having children; certainly he was in no

rush. He wanted his wife to be an equal, a companion, a liberated woman. He encouraged Virginia to forget the housework and look toward a career in music, a goal that though enlightened for the times, was asynchronous with Virginia's own dreams. He had forgotten his earlier likening of Virginia to his mother, and all that might portend. The marriage of Ansel and Virginia was in trouble right from the start.

5

SOUTHWEST

In addition to introducing Ansel to the movers and shakers of San Francisco, Albert Bender also brought him into the society of artists and writers in Carmel and Santa Fe. Although he did not drive, he owned a new Buick, and relied on the kindness of his friends and acolytes, such as Ansel, to chauffeur him wherever he wanted to go, whether on a one-day drive to Carmel or all the way to New Mexico.[1]

Robinson Jeffers made a huge impression on the young photographer from the first time they met, in 1926. With his wife, Una, Jeffers lived in Carmel, at the edge of the Pacific, in the medieval isolation of Tor House, a fortresslike compound he had built himself, stone by stone, complete with a forbidding tower. The writer, his home, its setting, and his poetry were all similarly pared down, austere, without extras.[2]

Jeffers needed a likeness of himself for his next book. Inexperi-

enced in the area of portraiture, Ansel photographed him using intense side lighting with a wide-open shutter that provided no depth of field. The result was a soft, gauzy image that did not speak truthfully of its sitter; in it Jeffers's strong, angular features seem unnaturally gentled, and a shy smile curves upward upon his lips.[3] Maybe the poet saw himself differently than did others, for he chose Ansel's portrait for the frontispiece of the collection.

Letterpress printing was one of Albert's passions, and soon it became one of Ansel's as well. In 1928, at Albert's invitation, Ansel joined San Francisco's Roxburghe Club, an association devoted to fine printing.[4] The high standards he gleaned from his fellow members, many of whom were top printers and designers, were religiously applied to his subsequent books. He understood the importance of paper quality, of hand-set type from exquisite fonts, of inks, design, and layout—things few authors cared about—and he managed these variables just as he controlled his photographs. For many years, Ansel supplied images for keepsakes published by the Roxburghe Club and the Book Club of California, all costs for which, including Ansel's own fee, were underwritten by Albert.

In May 1927, Ansel drove Albert and his friend the writer Bertha Damon nearly three thousand miles, to Santa Fe, Taos, and the Grand Canyon, returning through Santa Barbara. It was a tough ride, over paved roads that dissolved to dirt washboards, with the car constantly filled with dust. Bertha bought everything she could get her hands on, while Albert, ever the gentleman, rode in back, perspiring without complaint as his friend's purchases crowded in on him, accepting this as the price to be paid for traveling with her.[5]

Ansel was entranced by Santa Fe and Taos, by the old adobes, the Indian pueblos, the snow-capped Sangre de Cristo mountains, and the cosmopolitan world of artists and writers shown him by Albert. He took few pictures during this trip, but when he returned the next year, he would be ready.

Albert introduced Ansel to the noted writer Mary Austin; he was convinced that the two of them should collaborate on a book. Mary was a formidable woman, physically as well as mentally, her strength hard

won through a difficult life. Ansel's first impression was that she was almost as wide as she was tall.[6] "She was a commando!" he laughed. "She thought she was the most beautiful woman in the world."[7] At her request, Ansel made some formal photographic portraits for her to use in promoting her many lecture tours. Whether out of tact or a premonition of doom, Ansel, unable to transform the homely author into the beauteous creature she believed she was, did not send her the prints until 1929. As he had feared, Mary was appalled at the pictures; a large portion of her income came from her lectures, and Ansel's portraits did not invite a second look, except out of curiosity.[8]

Mary was born in 1868 and educated as a teacher, though writing was her true love. An unhappy marriage had yielded her only child, Ruth, who was profoundly retarded. (The neighbors thought it improper that Mary should send her daughter to a friend's house during the day so that she could write.)[9] From 1892 to 1906, Mary had lived in one of the most beautiful places on earth, California's Owens Valley. The eastern edge of the Sierra Nevada rises to a height of over fourteen thousand feet along the valley's western side, the perimeter only slightly softened by the rolling Alabama Hills. The Sierra captures the snows of winter and blocks the lands for five hundred miles to its east in a perpetual rain shadow, relenting only to yield its spring melt into streams leading into the Owens River.[10] The White Mountains, home to some of the oldest living things on earth, the bristlecone pines, guard the valley's eastern side.[11] Mary's first important book was her story of this valley, *The Land of Little Rain*, published in 1903; it was a bestseller and established her reputation.

Through irrigation, the valley had become productive, green, and lush. But this was all dependent upon the very river slated to be hijacked in 1904 by Los Angeles for its urban needs. Unsatisfied with the river, the city even took the valley's groundwater to slake its thirst.[12] Mary's book was a memorial to the people who had worked its lands and to the disappearance of livestock, orchards, and cultivated fields. Ansel, too, came to love the Owens Valley, seeing it as the western trip wire for the Sierra. For him, as for Mary, it held glorious splendors even when parched.

In 1924, Mary had moved to Santa Fe, attracted by the landscape and by its people, including her friend Mabel Dodge Luhan, who had established herself in Taos. Mabel and Mary were both powerful personalities, and for the sake of their friendship, Mary wisely chose to place some distance between them. She built a small adobe that she named Casa Querida (Beloved House), with a library and a writing office designed for her work.

Ansel was entirely thrilled when Mary agreed to collaborate with him on a book about Taos Pueblo, the religious center for the Taos Indians. Built a thousand years ago of earth, straw, and water (the three elements of adobe), it is believed by its residents to be the oldest continuously inhabited community in the United States.[13]

Ansel and Virginia arrived on Mary's doorstep in March 1929 to begin work on the book. Tongue in cheek, Albert warned his friend about the problems she would face with her two houseguests:

> I am writing you a confidential letter today about Ansel and Virginia Adams. These young people have practically every virtue in the catalogue of righteousness, and there is only one thing about which you should not be unaware, and that is their appetite. Please do not let them go hungry. They need food every hour in large quantities, and if you have no mortgage on your house now, you will have at the time of their departure. If the circulatory system permits, I think a special pipe should connect with Ansel's room, through which a cup of coffee could be furnished day or night.[14]

After a time, Mary introduced Ansel and Virginia to Mabel, who graciously provided a guest room for them at her compound in Taos. Mabel had married Tony Lujan, a member of Taos Pueblo, in 1923.[15] (She insisted on spelling her name differently from her husband's because she said it made it easier for her friends to pronounce.) With Tony, a member of the tribal council, negotiating the terms, Ansel was given complete access to the pueblo for a fee of twenty-five dollars plus one copy of the finished book.

An eager beaver, Ansel photographed early and late, in good weather and foul. A sandstorm blew on May 12, but even when an old Native American reproached him, warning that the east wind brought evil, he would not stop. Within hours, Ansel was doubled over in excruciating pain, suffering from a ruptured appendix. Surgery and a two-week convalescence in Albuquerque returned him to health, and then it was back to Taos for an additional two weeks of photography.[16] He and Virginia finally returned to San Francisco after three and a half months in New Mexico.

Taos Pueblo was published in late 1930, combining Mary's fourteen pages of text with twelve of Ansel's original photographs.[17] Each element was executed independently, with neither contributor seeing the other's work. Mary's words resonated in synchrony with Ansel's images, their meter echoing the steady thump of drums. Powerful descriptions dominated her portrait of a matriarchal culture for which she felt great sympathy.[18]

Ansel's participation in the project was impeded by the fact that he did not yet possess a darkroom equal to his abilities. He struggled with the small room in his parents' San Francisco basement that had been the quarters of the cook in more halcyon days. The making of the 1,296 prints necessary for the book consumed weeks of his time during 1930.[19] An old eight-by-ten-inch view camera served as a rudimentary enlarger, while the light source was the sun, captured via a hole punched through the wall: an aluminum reflector was positioned outside to direct the sunshine through a diffusing screen and into the enlarger. He was able to print with this assembly only from eleven in the morning until three in the afternoon, while the sun was at its strongest. As the intensity of the sunlight varied, so did Ansel's printing exposures. Stormy days, with their huge fluctuations of brightness, were anathema; he prayed for gray, foggy days, when the light would remain fairly constant.[20]

For the photographs, Ansel got William Dassonville to coat the special rag paper that was being used for the text with a silver-bromide emulsion; the result was a printing paper known as Dassonville Charcoal Black, which produced tones recalling those of a charcoal draw-

ing. The warm, buff-colored hue and rough texture of the paper, combined with the simple and limited tonal range of the emulsion, proved effective in translating the feel of the very earthy pueblo.

Ansel pictured Taos Pueblo as if it were a mountain range, immutable and ageless, then moved his camera closer to compose the images as he did many of his Sierra subjects, the frame purposefully filled by one object. Two of the book's photographs (neither actually taken at Taos Pueblo) speak more strongly than the others: *Saint Francis Church, Ranchos de Taos*, in which the adobe church, a monument of indigenous architecture located several miles south of the pueblo, appears isolated, as if it were a soft extrusion of the earth below; and *A Man of Taos*, a portrait of Tony Lujan wrapped in his traditional robes, exuding pride and presence.[21]

Tony's portrait, in which his eyes fix knowingly on the camera lens, was made in Ansel's San Francisco studio, when Mabel and Tony visited in 1930. Tony caused quite a ruckus in Ansel's upscale neighborhood when he insisted on sitting on the curb in front of the house, swathed majestically in blankets and beating his drum. Ansel thought it quite wonderful.[22]

Some of the *Taos Pueblo* images suffer from a staged and formal feeling. Years later, when Ansel was making new prints of *Winnowing Grain*, Virginia complained that the photograph had always looked unnatural to her.[23] Before a background of the pueblo, a woman holds a basket with upraised arms, its rim highlighted by sun as the grain pours to the ground. Ansel, with an embarrassed shrug, admitted that he had asked the woman to pose and had positioned her strategically for the sake of the composition.[24] Ansel saw the pueblo and its people as possessing an unusually fine quality of nobility; his mistake in some of the photographs consisted in his not allowing them to speak for themselves, without the intervention of his artifice.

Taos Pueblo was a financial success thanks to the largesse of Albert Bender, who bought ten copies out of the edition of 108. The selling price of seventy-five dollars was steep, even for such a special, handmade book, but the run was sold out within two years.[25]

Reviews of *Taos Pueblo* praised both photographs and text, though

Mary consistently reminded Ansel that he was simply the illustrator of her much more important prose.[26] This never bothered Ansel, who was grateful to have been able to work with such a fine writer.

With *Taos Pueblo* about to appear, Ansel returned to New Mexico to stay once again at Mabel's. A figure of consequence in the international art world for many years, Mabel had hosted earlier salons in New York and Florence, both of which had proved a magnet for writers and artists.[27] Wealthy, independent, and smart, she had "discovered" Taos with a vengeance, building a sprawling adobe mansion networked with guest rooms. Somewhat improbably, she and Tony had fallen truly and deeply in love. He was the strong, silent type, given to occasional profound utterances punctuated by drumbeats, while she filled in his silences. When they wed, he was already married to a Pueblo woman. On Mary Austin's insistence that she do the right thing, Mabel made payments to his first wife, and Tony kept both conjugal beds warm.[28] Confounding nearly everyone, Mabel and Tony stayed together until their respective deaths, in 1962 and 1963.

Mabel used her Taos estate, named Los Gallos for the painted ceramic cocks perched above its spacious courtyard, as a web to attract artists and writers of consequence.[29] She fed off her guests' energy, both intellectually and sexually, and was said to be insatiable in the latter department. Ansel later termed her "hypersexed," though he firmly stated that he never fell for her: "I must say that my hyper was very different from her hyper," he mused.[30]

When Los Gallos's regular visitor D. H. Lawrence died, his widow, Frieda, fearing that Mabel would take her husband in death as she had done in life, mixed his ashes directly with the concrete that shaped his tomb.[31] Una Jeffers, for her part, attempted to kill herself with a shotgun in the bathtub at Los Gallos when she learned of Mabel's plans for her husband, Robinson; the failed suicide got the Jefferses out of harm's way in Taos and back to their home in Carmel.[32]

At Los Gallos, Ansel met key figures from Alfred Stieglitz's circle in New York, including Georgia O'Keeffe, John Marin, and Paul Strand, a high-powered group. Struck by the contrast between John Marin's simplicity of spirit and the conversational convolutions of the Luhan/Lujan

household, Ansel found the painter fascinating.[33] Marin did not talk about his art; he just did it.

A native of New Jersey, Marin had spent most of the period from 1905 to 1911 in Europe, an obligatory destination for anyone who described himself or herself as a serious artist. In Paris in 1909, Marin met Steichen, who in turn presented the thirty-nine-year-old painter to Stieglitz. A few months later, Marin was given his first solo show at Stieglitz's current gallery, An American Place, and with that event found himself assured of a spot in the inner circle.

On being introduced to Ansel at Mabel's in 1930, Marin took an instant dislike to this loud, boisterous man with the black beard, but he completely reversed his assessment when Ansel sat down at the piano and began to play. Marin found the quality of even one note so sublime that he welcomed Ansel as a true friend.[34]

Ansel noticed that the painter ventured out many mornings without paper, pencils, or paint. He learned that it took Marin two or three weeks of quietly sitting in a place before he was ready to work; then there would be a flurry of production resulting in ten to fifteen watercolors. Ansel spent a morning watching Marin paint, the first time he had ever directly observed another artist working—an artist whose expressions moved him deeply.[35] Marin dipped his thumb in the paint and then with utter confidence stroked the paper, creating in three emphatic moves, in brief silhouette, the Taos mountains lying before them.[36]

When it came to subject matter, Marin, like Ansel, responded most strongly to the landscape.[37] Marin borrowed from the futurists the use of slanting, dynamic lines, and from the cubists the willingness to float a subject in space, so that unpainted areas were as carefully composed as painted ones.[38] Ansel agreed with the others at Mabel's that Marin's watercolors placed him in the first rank of American artists.[39]

Ansel found himself a welcome houseguest wherever he traveled. He exuded high spirits and was always ready with a joke. He loved performing on the piano and was no snob about the instrument: any piano would do. In addition to his elegant Bach, he could be relied upon to throw in some musical comedy, sounding the repetitive chords of the

Danube Waltz with a strategic plop of his narrow bottom on the keys or, with a devilish grin, producing whole sonatas with an orange clutched in each hand.

Ansel was so much fun, in fact, that parties seemed to revolve around his energetic outpourings. His arrival in town signaled a binge of nightly merrymaking. With just a bit of encouragement and a few sips of bourbon, Ansel would lose whatever strictures his mother had inculcated. Following in Cedric's footsteps, he believed that marriage did not disallow the appreciation of women. He smoked cigarettes and drank with abandon, though it was rare that he imbibed enough to interfere with his early reveille. As a precaution, he was known to glug quantities of olive oil before an alcoholic evening commenced.[40]

On this trip in the summer of 1930, Ansel was in particularly great form. In San Francisco, his young wife was ensconced in their newly built dream home/studio; he had landed a major commercial client, Yosemite Park and Curry Company; and his first book was about to be published.

At Mabel's, Ansel shared Los Gallos's two-bedroom gatehouse with Paul and Becky Strand. Georgia O'Keeffe, whom he had met the year before, was also about. But his discussions were mostly with Strand, the first serious photographer with whom he had talked extensively. Ansel knew that Strand's photographs were exhibited in New York and admired by such notables as Alfred Stieglitz.

Although Ansel had met Edward Weston (who was just as committed to photography as Strand) at Albert Bender's in 1928, their first meeting had not impressed either man. Weston's memory of Ansel was of a fine pianist and weak photographer, and in turn, Ansel remembered that he had not responded to Weston's photographs.[41] Soon, however, they would become lifelong comrades.

Having brought no prints with him to Taos in 1930, Strand shared his recent negatives. Placing him in front of a window and cautioning him to hold them only by their edges, slowly, one by one, Strand passed Ansel his precious sheets of eight-by-ten-inch film. Ansel was riveted, finding each exposure perfect and every composition ideal.

In discussing technique, Strand stressed the importance of glossy

printing papers. He explained that the matte papers Ansel had always favored absorbed light and thus reduced the intensity of tonal values. Glossy papers, by reflecting light, rendered more fully and clearly the qualities of each photograph. Ansel became an immediate convert; Strand's rationale was the catalyst that enlisted him fully into the straight-photography camp.[42]

Ansel later recalled his time with Strand as an eye-opening experience, revealing to him for the first time the full potential of his chosen medium. In his autobiography, Ansel claimed that it was this exchange that caused him finally to commit to photography as a career.[43] Written fifty years after the fact, those words probably benefited from the passage of time and a romantic memory, for by this time Ansel—San Francisco studio and all—was already professionally established as a photographer.

But as important as his time with Strand was, Ansel's contemporaneous writing concentrated on Marin, describing their meeting as the singular event of the trip, and his paintings as revelatory; in 1933, in letters to both Stieglitz and Strand, he would avow that viewing Marin's watercolors had been his greatest art experience.[44] Still, seeing Strand's negatives served to confirm aesthetic decisions Ansel had already made, while talking with him verified his belief that photography could be a noble and an intellectual occupation.[45]

As proud as Ansel had been of *Taos Pueblo*, he was now forced to concede that it was compromised. No matter how straight the vision or how fine the focus, his prints did not have the purity of Strand's or Stieglitz's. In a letter to Virginia from New Mexico, Ansel announced that he had discovered a new outlook—one that could not be described in words but would have to be expressed in his photographs.[46]

6

STRAIGHT PHOTOGRAPHY

Hᴵˢ photographs are like portraits of the giant peaks, which seem to be inhabited by mythical gods," decreed the *Washington Post* of the Smithsonian Institution's *Pictorial Photographs of the Sierra Nevada Mountains by Ansel Adams*.[1] On display during January and February 1931, Ansel's first solo museum exhibition featured sixty prints grouped into three categories: Sierra Nevada, Sierra Nevada Winter, and Canadian Mountains.[2]

Francis Farquhar, a fan of Ansel's photographs from his years as editor of the *Sierra Club Bulletin*, most likely made the arrangements. Farquhar had once worked for the National Park Service in Washington and still counted among his friends some of that city's powerful.[3] Concurrent with the exhibit, Farquhar promoted his young friend in the first serious article written on the art of Ansel Adams.

> Ansel Adams is emphatically a realist. . . . The composi-
> tion is not a conscious arrangement of the artist; it is in-
> herent in the object itself. It is the artist's genius which
> enables him to perceive at once the arrangement of
> masses, the flow of lines, and the texture of surfaces in the
> object of vision, whether it be a mountain, a landscape, a
> building, a cloud, a tree, a human form or face, or any-
> thing whatsoever.[4]

It seems hard to believe that Farquhar, a real Sierra Club hero, could
have worked as an accountant in his everyday life.

When the photographs came back from the Smithsonian, Ansel
placed them on exhibition at his San Francisco home, complete with a
beautifully printed list of titles. The negatives, all made between 1921
and 1930, were a summation of everything he had achieved in photog-
raphy up to that date.

With a decade of his work hung about him, Ansel found himself
in an excellent position to do some self-evaluation, and once more
he concluded that he fell short of the standards set by Strand. He
was not ashamed of the photographs, but their concentrated pres-
ence convinced him that he could go further. Ansel sensed that he
was about to experience a momentous breakthrough. He awoke one
spring morning fresh from dreams that had revealed photography
as it should be, a powerful expression loyal to its innate strengths,
to the best qualities of lens, camera, and the photographer's eye.
New subjects, new printing—pure photography was his for the
taking![5]

With Strand's advice still ringing in his ears, Ansel began to use
glossy papers.[6] Deciding he could not reconcile new doctrine with old
content, he also changed his subject matter. Perhaps he saw his work
of the past few years as primarily illustrative of the Sierra, often for the
purposes of others, particularly the Sierra Club; because the intent was
not pure, he believed, neither could the subject matter be pure, much
less the results. He began photographing commonplace objects found
around the docks and beaches of San Francisco, from lichen-encrusted

anchors to a beautifully lit, casual pile of ropes on a dock.[7] Photographed under natural light, his first close-up detail from nature, entitled *Leaves, Mills College*, of 1931, revealed the precise magnification provided by a lens, at once an important strength and characteristic of the medium.[8]

Ansel was not breaking new ground with his sharply focused images of found objects or common scenes; since photography's beginnings, practitioners from Daguerre to Watkins had celebrated the acute qualities of the lens, though for years at a time this tradition had fallen out of fashion (as witness the long-dominant pictorialism). With his newly discovered style, Ansel had decided to matriculate in the school of pure, or straight, photography. If his first, albeit lovely, efforts were hardly pioneering, it would not take him long to make his own mark in that tradition.

Ansel's immersion in serious photography deepened when, in late 1931, he accepted a position as photographic critic for the *Fortnightly*, a short-lived San Francisco review of literature, music, and the arts.[9] This was the first time that the city's art community had felt a need for a photography critic: the M. H. de Young Memorial Museum's new young director, Lloyd Rollins, had unhesitatingly launched a revolutionary initiative to include photography within that grand museum's halls, scheduling exhibitions of work by Eugène Atget, Edward Weston, Imogen Cunningham, and Ansel Adams.

For the reviews, Ansel challenged himself to write criticism from a photographic point of view. His weak art-historical background was probably a plus because it meant he was not hampered by the analytic vocabulary constructed for painting and sculpture, or the definitions and symbols used by more traditionally grounded critics. Most important, the four reviews he wrote in late 1931 and early 1932 gave him the opportunity to put into words his own photographic philosophy; to judge from this evidence, Ansel's aesthetic of straight photography was now fully determined.[10]

The first column centered on an exhibition of photographs by the Frenchman Atget, who had died only four years before. Ansel was impressed by his portraits of his Parisian environment, of the streets,

buildings, and gardens of the fabled city. Working just after dawn, Atget had captured a world that was hauntingly unpeopled, with very public spaces transformed into private ones. Ansel's glaring lack of knowledge of the history of photography was all too evident in his suggestion that Atget's photographs might be the first example of photography as an art form; apparently he was not yet aware of the contributions made by such artists as Emerson, Timothy O'Sullivan, Gustav LeGray, Julia Margaret Cameron, and Watkins, among many others.[11] In Ansel's defense, in 1931 few people in the entire world knew much of anything about the history of the medium.

A month later, highly recommending the Edward Weston exhibition, Ansel counseled that viewers should bring to it a fresh outlook, one unadulterated by preconceptions formed through the experience of other arts. He lavished praise on Weston's photographs, with one equivocation: he loved the images of rocks but not those of vegetables. A particularly curvaceous green pepper, a fully splayed cabbage leaf, the innards of a halved artichoke: each was made precious by Weston's closely placed, incisively sharp lens. The rocks asserted themselves, immutable, but the vegetables had been arranged by the photographer; Ansel found them contrived.[12]

In his struggle to establish his own vision in the context of straight photography, Ansel committed his own share of contrivances in the work he produced at this time. To make *Scissors and Thread*, for example, he dropped the thread time and again over the scissors until their pattern pleased him,[13] while for another studio photograph, called *Still Life*, he placed a hard-boiled egg in an egg slicer and pressed its wires into the white just to the point of penetration.[14]

Ansel eventually did find his own way in the still-life genre: two years after his Weston review, he made *Rose and Driftwood*, one of his most sublimely beautiful images.[15] Ollie had brought him a spectacular white rose from her garden; in his studio, Ansel gently laid it upon a piece of driftwood and took its picture, using the available light from a nearby window to capture each finely veined petal contrasted against the coarse grain of the darker wood. For all that Ansel had railed against Weston's vegetables, he soon had a change of heart.

In such photographs as *Rose and Driftwood* and *Still Life*, Ansel applied conventional techniques commonly used in still-life painting, carefully juxtaposing various objects for the best effects of composition, texture, and form. Weston, in contrast, in posing a single object—one pepper or one shell—against his usual blank background, broke from tradition.[16]

After Ansel's *Fortnightly* review appeared, Weston wrote him a brilliant, carefully considered response. Instead of antagonizing his critic, he persuasively defended his still lifes, culminating with the assertion, "Photography as a creative expression . . . must be 'seeing' plus."[17] Although Weston claimed to be photographing only the thing itself, strenuously denying other associations, many felt that his photographs were evocative of something beyond the actual subject matter, so that shells became phalluses and peppers the nude female form. O'Keeffe suffered the same criticism for her paintings of flower details, with their sexy stamens and pistils.

Ansel's last published review for the *Fortnightly* was of Imogen Cunningham's exhibition. He wrote glowingly of her sense of visualization but had the temerity to criticize her use of light and, with the zeal of the newly converted, chastise her for her choice of matte-finished paper.[18]

To Imogen, Ansel, sixteen years her junior, was definitely the young upstart. She had been selected by Weston to exhibit at the very important 1929 *Film und Foto* exhibit in Stuttgart, Germany. The show was based on the idea that pictures made by a camera could "be one of the most effective weapons against . . . the mechanization of spirit," a worry that haunted the world during the early years of automation.[19] Imogen possessed a sharp and ready tongue and took a backseat to no man; her reaction to Ansel's suggestions for improvement can only be imagined.

Following the birth of her three sons (one in 1915 and a set of twins in 1917), Cunningham found herself tied to hearth and home, with "one hand in the dish pan, the other in the darkroom," as she recalled.[20] Her camera's subjects had to come from her backyard; they included plant forms and flowers, as well as her rambunctious boys. She built her repertoire on such ordinary material.

In 1920 and 1921, she photographed the neighboring Mills College amphitheater, producing a strong and very straight composition of curving lines and shadows, an amazingly modern image. Using sharp focus, she framed the striped flank of a zebra, a cypress snag at Point Lobos, and a single morning glory, all before Weston renounced pictorialism. Although it is Edward Weston who is usually credited with the first major accomplishments in modern straight photography, his earliest Point Lobos cypress negative was not made until 1929.

Cunningham made her famous image *Two Callas* and the extreme close-up *Magnolia Blossom* in 1925, a couple of years before Weston zeroed in on his first shell (1927) or vegetables. Georgia O'Keeffe had begun her famous series of flowers in 1919, but Cunningham stated that she did not see these until much later when she was in New York in 1934.[21] Instead, she may have been influenced by two photographic close-ups of flowers reproduced in the pages of *Vanity Fair* in 1923, one by Charles Sheeler, the other by Edward Steichen.[22]

If Ansel and Imogen's friendship would always be somewhat prickly, Ansel and Edward discovered they were worthy comrades and began using each other, through letters and visits, as a sounding board to fine-tune their definitions of photography. They agreed on most photographic matters and began a close friendship that lasted until Edward's death, in 1958.

Their major, ongoing argument centered upon the relationship of the artist to society. Edward felt that he must keep his distance and live a sheltered life, focusing all his energies on his art. Ansel was forever up to his neck in the business of life, scrambling to make time to concentrate on his own photography. Neither man ever won the other over to his position.

Driven by the events of the past year, Ansel now made a large number of new images. His own solo exhibition at the de Young, during February of 1932, featured three galleries displaying eighty photographs, on a much greater diversity of subjects than his Smithsonian show of just one year earlier, which had been little more than an extended portrait of the Sierra.[23]

In a statement written for the de Young show, Ansel declared that he

had two rules: one, the completed image must directly reflect how the subject appeared in the camera; and two, he had to see the finished photograph in his mind before the shutter was released (his concept of visualization).[24] This was straight, or pure, photography for Ansel in 1932.

But this philosophy did not take into account his nagging belief that ultimately an artist must go beyond the obvious reality to communicate the full emotional power of a scene. Just as he had earlier had to master photographic technique before he could produce consistently strong images, so now he had to understand the rules of straight photography completely before he could apply them to the making of his own vision.

Considering the de Young exhibit, a San Francisco reviewer, apparently well versed in the tenets of straight photography (perhaps through Ansel's own *Fortnightly* articles), held Ansel to his own gospel and found some of the images to be less than catholic. He accused the photographer of "making studiously arranged compositions of inanimate objects which seem to us to lack a relationship with everyday life that one looks for in photography."[25] Ouch!

Four months later, in June 1932, the Courvoisier Galleries in San Francisco presented another solo exhibition of Ansel's photographs. The reviewer for the *San Francisco Examiner* queried,

> Is photography an art? It certainly is not, if the photographer is not an artist. More than that, it is only art of a lowly genre, if the photographer insists on reading his own moods into Nature.
>
> Ansell [*sic*] Adams does not do that. But when the frost etches lovely conceits in the graining of an old tree stump or cleaves the granite into cubistic monoliths, then he is interested and his camera registers his interest in studies which lovers of beauty will prize.... Adams lets Nature do her own work, and her work and his are both good.[26]

This was evidence that though museums were still dragging their heels about recognizing photography, art critics in most major cities were ready to take it seriously.

Lloyd Rollins continued his support of photography at the de Young with two subject-oriented competitions, *A Showing of Hands* and *California Trees*. Ansel commandeered the hands of friends and family as subjects and photographed his wife's threading a needle and peeling potatoes.[27] This Hands exhibition accounts for the amazing preponderance, in the archives of northern California photographers, of images of hands made in 1932, most of them object lessons in the futility of assigning a creative artist a specific subject.

The intent of the second exhibition was "to stimulate interest in trees as features of our landscape, to encourage their preservation, and to suggest, via photographic art, their beauty and spiritual appeal."[28] Of the eight hundred photographs submitted, 160 were hung in the de Young from September 21 to October 21, 1932. Edward Weston claimed the hundred-dollar first prize for an image of a Joshua tree, and second prize went to Oakland photographer Alma Lavenson for her *Snow Blossoms*. Ansel was awarded twenty-five dollars and fourth prize for his *Sugar Pine*, while seventh (and last) place went to Willard Van Dyke, a student at the University of California, Berkeley, and acolyte of Edward's, for his *Detail of Madrone*. Also exhibiting were Henry Swift and John Paul Edwards, both soon to become associated with the others.[29] It is probable that these two competitive shows sorely tried the patience of such photographers as Van Dyke, Weston, and Ansel. His sponsorship of "theme" exhibitions was a strong indication that Rollins did not fully understand their very serious intent.

With another young photography zealot named Mary Jeannette Edwards (daughter of John Paul), Willard Van Dyke opened a photography gallery in Oakland. Called 683 Brockhurst after its address (a tip of the hat to Stieglitz's earliest gallery, nicknamed 291), it quickly became the congregating place for Bay Area photographers. On September 6, 1932, Willard and Mary Jeannette held an open meeting to discuss forming a serious camera club.[30] Ansel, Imogen, Edward, Sonya

Noskowiak (Edward's student and current lover), and John Paul Edwards all showed up, eager to debate the state of photography.

It may have been that night that Willard photographed a pensive Ansel sitting slumped on a sofa, a coffee cup in one hand and his chin in the other, as he attempted to sober up before his long trip home to San Francisco. With Prohibition still the law of the land, Willard and Mary Jeannette served a lethal drink they called the Five-Star Final, made from the pure grain alcohol they used to dry negatives mixed with the juice from five lemons, water, and a dose of glycerin.[31] It was known to pack a wallop.

Although Edward was acknowledged as the senior member of this bunch, it was Ansel and Willard who insisted that they must take a united stand in favor of straight photography. Willard later remembered that Weston did not want to be listed as a member of the group because he was not a joiner; he consented to stay only after Willard argued that his leaving would be a "slap in your friends' faces."[32] The strongest statement, they agreed, would be made by their exhibiting together. They talked of renting a space in San Francisco but abandoned the idea after realizing that such a separate venue might undermine Lloyd Rollins.[33] Rollins responded by offering the group a show.

Preston Holder, Willard's roommate at Berkeley, recalled that the group met only three or four times, on occasions that were probably more social than official. Holder reminisced that at a party at Ansel's in San Francisco, determined to devise a suitable name for the group,

> Willard and I got good and drunk . . . and on the way back to Oakland, I thought of that design, you know the "f" that looks like that Bauhaus stuff and makes very nice graphics. And I said, "Will, that's what that group should be, f/64, because that's what you want to stop down to anyway and that's a good rationale for it, a catchy name and a good symbol." Willard agreed.[34]

In contrast, Willard remembered that he proposed "U.S. 256," the old system name for f/64 in the new aperture-marking system. He said that Ansel responded, "U.S. 256 is not good, it sounds like a highway." Willard continued, "He then took a pencil and made a curving 'f' followed by the dot and 64. The graphics were beautiful and that was that."[35] At first, it was written "Group f.64," in the style of the old aperture notation, but that was soon updated to the new notation with its slash, "Group f/64." To those familiar with Ansel's handwriting, the *f* in the Group f/64 exhibition invitation appears nearly identical to his own typical, very musical-looking *f*.[36]

The core group of six photographers decided to invite a few other like minds to join them for the duration of the exhibition, first anointing San Francisco businessman and amateur photographer Henry Swift (who collected prints by some of the others) as a full partner. Edward suggested a small list of names, including Consuela Kanaga and Alma Lavenson.[37] Kanaga, a photojournalist who had found a sponsor in Albert Bender, had made a strong series of portraits of African Americans.[38] Bender was also a family friend of Lavenson, whom he had introduced to Kanaga, Weston, and Cunningham, her strongest influence. Lavenson had made a number of graphic compositions of the industrial port of Oakland, a quite suitable f/64 choice.[39]

In the end, Kanaga, Lavenson, Weston's son Brett, and Preston Holder were also invited to exhibit, bringing the total to eleven photographers. Although just twenty-one years old, Brett Weston had studied photography with his father for seven years and was already clearly accomplished. The weak photographic link was Holder, who made up for his artistic shortcomings with his ebullient personality.[40]

Partly because he lived closer to the de Young than the others, and also due to his high energy, Ansel played a central role in organizing the exhibition itself. His account of cash receipts is recorded in Virginia's neat hand under the date December 2, 1932, crediting Weston, Cunningham, Edwards, Swift, and Van Dyke with contributing ten dollars each to the Group f/64 deposit.[41] (Weston pleaded that Noskowiak be allowed participation without paying her share because he could not spare another ten dollars.) Assuming that the honorable

Ansel himself also anted up, six of the full members seem to have shared equally in the expenses, putting up money in service to their cause. Ansel was also responsible for seeing to the exhibition announcements.

Historically, most avant garde movements in modern art, including surrealism, futurism, and dadaism, have proclaimed themselves with manifestos. So, too, did Group f/64, whose creed was actually nailed to the de Young's gallery walls:

> The name of this Group is derived from a diaphragm number of the photographic lens. It signifies to a large extent the qualities of clearness and definition of the photographic image which is an important element in the work of members of this Group. . . . The Group will show no work at any time that does not conform to its standards of pure photography. Pure photography is defined as possessing no qualities of technique, composition or idea, derivative of any other art form.[42]

Although its content was surely ratified to some extent by the others, all or most of the one-page statement was written by Ansel, not by Willard, who has also been championed for that honor. It is true that the type used seems to match that on both Ansel's and Willard's typewriters at the time, but one small, though critical, style element is different: the manifesto has one and a half spaces between lines and either one or two spaces after each period. These peculiarities are completely consistent with documents produced by Ansel. For his part, Willard invariably used either single or double spaces between lines and always left two spaces at the end of his sentences.

Moreover, a copy of the manifesto has been found with corrections in Ansel's hand that were incorporated into the final draft.[43] This version contains a number of mistakes that have been x'd out, a frequent Ansel practice. Willard appears to have been a better typist, rarely making mistakes and, when he did, almost never using *x*s to cross them out.

The manifesto capitalizes a number of nouns not normally treated to

such emphasis, an affectation Ansel had picked up from his reading of Carpenter, whose influence may also be seen in Ansel's British spelling of such words as *technic* (for *technique*), also adopted by Willard.[44] The *F* in "Group F/64" is capitalized in the manifesto (though not in the invitation), whereas in letters from this period, Willard consistently used a lowercase *f*, for "f/64."

In a 1955 gang interview with Imogen and Dorothea Lange, Ansel was asked, "Who thought [Group f/64] up and gave it the name?" He responded, "It's usually mixed up, and I think it ought to be cleared up. I remember as early as 1930 trying to get a group together who would function with straight prints. . . . I motivated it, Willard Van Dyke clarified it, Edward Weston subscribed to it."[45] When Imogen was asked who had drafted the manifesto, she said, "Ask Ansel. He must have written it. Nobody else would."[46]

The Group f/64 manifesto was a declaration of war on the photographic infidel: the pictorialists. During a 1983 interview with Ansel, Willard Van Dyke, and the historian Beaumont Newhall, I asked Willard why Group f/64 had been formed.[47] He answered, "We had agreed to do our own thing and were surprised at the reaction by the Pictorialists and [William] Mortensen to what we were doing. We didn't have a sense of gospelizing."

At that point Ansel interjected, "I did! I had a sense of mission. A simple, straight print is one of the most beautiful expressions possible."

Willard then added, "We were reacting against bad taste. Not all Pictorialists were [bad], but Mortensen . . . was—his work was disgusting."

William Mortensen was the outspoken leader of the opposition and the symbol of everything that Group f/64 opposed. Even though they themselves had started out as pictorialists, Imogen, Edward, and Ansel believed they had evolved into a higher species, photographically speaking. The quite influential Mortensen taught, published numerous books on technique, and wrote for photographic magazines. Many of his own photographs were dramatizations of historical persons or fictional themes; he depicted Cinderella, for example, as a well-endowed

naked lass perched coyly with crossed legs, dangling her glass slipper from her hand.

For Ansel, the Group "confirmed my own ideas—seeing other work and 'seeing' for the first time. I finally enjoyed and understood Edward Weston. The vibrations of the group increased my understanding and gave me confidence."[48] Willard recalled that as the youngest member, he found it "tremendously satisfying to come to Ansel Adams and Edward Weston and discuss prints—have them give [my work] serious consideration. Then Imogen Cunningham would make a wisecrack that would pare it right down."[49]

Group f/64 was formed not merely in reaction to the pictorialists, but as a response to the challenge everywhere posed by modern art, as painters, graphic artists, and a handful of Eastern photographers, among them Paul Strand and Charles Sheeler, moved beyond pictorialism and struck out on their own. Group f/64 was an expression of modern art in photography, its aim to marry everyday subject matter to a clear, sharp camera vision rather than to the precise edges of line in paint.

Group f/64 had two commandments. The first of these held that there was but one God, and its manifestation was detail. The photographic lens could capture minutiae better than any other art form, begging the question, If God dwells in the details, are photographs our best window on God? Ansel would say yes.

The second commandment admonished, thou shalt not covet any other art by imposing its presence upon photography. The last sentence of the manifesto is crucial to an understanding of this second commandment. "Pure" photography did not mean there could be no manipulation whatsoever; some intervention was allowed, even expected, in making negatives and prints, provided that it conformed to a prescribed list of techniques that were judged to be photographic in nature.

A choice of lens, for example, could be used to alter spatial relations and relative scale, but the soft-focus lens was verboten because it obscured detail and thus violated the first commandment. The tonal contrast of the negative could be enhanced or diminished by different

combinations of exposure and development, a concept that would later become the basis of Ansel's famed Zone System. Dodging and burning during the printing of the image were permitted in order subtly to lighten or darken local areas of the photograph.

Filters altered tonal relationships. If the filter's effect was relatively mild—that is, if it did not serve to transform the scene into a new reality—it was deemed acceptable. According to Group f/64 member John Paul Edwards, "K1 and K2 color filters provide an ample range of color correction for nearly all subjects."[50] The key word here is *ample*; Edwards clearly believed that excursions further afield, into more dramatic filter effects, were beyond the limits of permissible behavior for the photographic purists of Group f/64.

Clouds can be separated from their blue backgrounds by means of yellow (K1 and K2) filters. However, when a red filter is placed in front of the camera lens, pale skies become intensely black, while the use of a blue filter creates the opposite effect, yielding a white sky bleached of all detail. Light- and medium-yellow filters were kosher in f/64; the others were not.[51]

In their landmark de Young show, six of the original gang of seven exhibited nine prints each, Ansel showed ten, and the four invitees, four. Everyone placed a price of ten dollars on each photograph, with the exception of Edward, who asked fifteen. Attempting to show that he could do it all, Ansel selected three portraits, three details, one architectural study, and three landscapes, a bravura display that was consistent in content with his other exhibitions in the early 1930s.

Ansel evidently considered f/64 to be a state of mind, not an unbreakable doctrine. It is unlikely that any of his ten photographs in this exhibit, or very many in his whole lifetime, were actually made with the aperture set at f/64; research has in fact uncovered only one image by him documented as having been exposed at that setting, whose tiny size requires an extremely long exposure.[52]

Three of Ansel's images from the Group f/64 exhibition are more important than the other seven. *Nevada Fall, Yosemite Valley* is a direct expression of the Group f/64 practice of filling the picture space with

the object itself. Ansel had been doing this for years, but his earlier photographs of waterfalls were static compositions.[53] In this image, Nevada Fall cascades powerfully out of the picture plane and right at the viewer. For quite a while, Ansel judged this his best landscape photograph.[54]

The Golden Gate Before the Bridge is another image that remains unforgettable.[55] Ansel awoke one San Francisco morning in late April 1932 to the sight of billowing white clouds above the Golden Gate. He had just purchased his first eight-by-ten-inch view camera, a Folmer Universal. Grabbing his new equipment, he drove out toward Land's End, parked, and then hiked along a trail down to the edge of the cliff, where the panorama of sky, clouds, and ocean played above the horizon of the green hills of Marin County, across the strait.[56]

Ansel scaled the earth to man size and the sky to infinity. The shore and ocean of the Golden Gate, the entrance to San Francisco Bay, comprise only a quarter of the image area. The sky, mounded with clouds, dwarfs the earth below.

As memorable as we find the clouds in a few of Ansel's earlier pictures, *The Golden Gate Before the Bridge* signals the inception of consistently detailed and great skies. His Folmer Universal view camera used sheet film rather than glass plates, and he could now afford panchromatic film (which was widely available and much cheaper than glass) The Kodak Super-Panchromatic that he chose for *The Golden Gate Before the Bridge* was almost all he began to use at this time. With the sky presenting a whole new subject possibility, Ansel's lenses could move their focus from the land to the heavens.

In early 1932, Ansel still calculated his exposure times by "experience," backing that up with a significant amount of bracketing, or making several negatives of each subject at different exposures. To respond to the problem that had been posed by the Golden Gate, and using money from the print sales of the image he made there, Ansel purchased his first Weston light meter, which enabled him finally to quantify the amount of light reflected from various portions of his subject.[57] No more guesswork would be required.

The third photograph of significance in the Group f/64 exhibit, *Frozen Lake and Cliffs*, is a masterpiece, and one of the earliest abstract photographs made directly from nature.[58] Mirrored ghostly upon the inky waters, a shattered black cliff descends into a partially frozen lake. The reflection is separated from its source by a band of white ice, a crumpled crust of grayed snow, and a tumble of scree. John Szarkowski, for thirty years director of the Department of Photography at New York's Museum of Modern Art, described it as an "astonishing [and], it seems to me, unprecedented photograph."[59]

On the 1932 Sierra Club outing to Sequoia National Park, Ansel had set up his four-by-five-inch view camera at the base of Eagle Scout Peak, with Precipice Lake at its feet. Virginia stripped down to her bathing suit and paddled about in the still waters, which were dotted with patches of melting ice, while Cedric Wright positioned his camera quite near Ansel's. Cedric was later to exclaim that he was shocked to see Ansel's image, so very different was it from, and so much more beautiful than, what he himself had seen.

To make *Frozen Lake and Cliffs*, Ansel selected a long-focus lens that isolated the scene, eliminating the sky and telescoping cliff, ice, and water into an insistently two-dimensional, flat image. According to Szarkowski, "This is not a landscape for picnics, or for nature appreciation, but for the testing of souls."[60] Placed side by side with 1921's *A Grove of Tamarack Pines* (or *Lodgepole Pines*), it demonstrates a decade of amazing growth and an entirely new aesthetic. With *Frozen Lake and Cliffs*, Ansel spoke once more in the powerful, stylized language he had discovered with *Monolith*, though this time he did it without filters.

Ansel's prints from the early 1930s differ in significant aspects from the later, and more widely shown, interpretations of the 1960s through 1980s. The early print of *Frozen Lake and Cliffs* that was seen at the Group f/64 exhibition made for an intimate experience. The four-by-five-inch negative was enlarged to approximately eight by ten inches; the tonal values were soft, with detail in all areas. Later prints, such as those viewed by Szarkowski, can be coldly forbidding, the ice seeming of brittle whiteness, the cliff and melted lake glazed with forceful black and gray.

Unfortunately, photography did not enjoy a long relationship with the de Young Museum. Less than four months after the Group f/64 exhibition, Rollins was fired by his board of trustees (he apparently landed on his feet, moving to Texas as the director of the Dallas Museum of Fine Arts, though his term there was also fairly short).[61] His termination was a direct result of his commitment to mounting photographic exhibitions, which took up wall space that some trustees believed should be reserved for the canvases of "true" artists—that is, painters.[62] Few photographs would be shown at the de Young for decades after Rollins's dismissal.

If the concept of straight photography did not begin with Group f/64, Group f/64 nonetheless brought it to the attention of the world. The influential humorist and cartoonist James Thurber rose to the challenge in 1934 in a *New Yorker* essay entitled "Has Photography Gone Too Far?":

> A controversy about controlled photography is now raging in the land. . . . You could have knocked me down with an old box-style Brownie No. 1 Kodak when I discovered . . . that the Camera Club has been "arguing the question of straight versus controlled photography for fifty years." Without, apparently, getting anywhere. . . . It seems to me that more control should be exerted upon the subjects before they are photographed and less upon the plates afterwards.[63]

This was straight photography interpreted for the lay person.

Group f/64 was a landmark in the history of photography in that for one short period, in the autumn of 1932, it marshaled some eleven of the medium's most influential and important artists, all from quite diverse backgrounds, under one philosophical banner. Together they swore allegiance to the unmanipulated, straight print, made using purely photographic methods. Although they stayed together as a group only briefly, the individual members would each go on to press his or her own version of the cause.

Edward Weston has always been seen as the group's philosophical leader, whose own photography had evolved from salon-winning pictorialism in the teens and early 1920s to revealing, sharply focused portraits of people, seashells, trees, and vegetables by 1932. But Imogen Cunningham had found her way to straight photography before Weston. Their friendship began in 1920, and they looked at each other's work and engaged in photographic discussions, both in person and via the mail.[64] The difference was that Cunningham did not proceed to have *her* thoughts published. Who, then, influenced whom?

Cunningham was already an important artist by 1932. Her opinions were of consequence, and her photographs had been groundbreaking for years. Both Lavenson and Kanaga looked to her for guidance, and Dorothea Lange would later say that Cunningham had provided her with ongoing advice and support.

Cunningham has never been given due credit for her influence on the other members of Group f/64 or, indeed, for her importance as a photographer. It does not help that though she is recognized in Beaumont Newhall's magnum opus, *The History of Photography*, her name is nowhere mentioned in John Szarkowski's important 1989 history, *Photography Until Now*. An overview of the photographers whom the latter author championed during his tenure at MoMA reveals few who expressed traditional values of beauty in their work, as did Imogen.

Group f/64 was one of the first art movements, perhaps the earliest, to comprise such a substantial proportion of active women artists— four women to seven men in the de Young exhibition. Gender seemed to have no bearing upon membership. Following the Russian Revolution, women were involved in the constructivist movement, whose aim was to bring the revolution to the people through posters and other propaganda, but how much of this was art? Credit has been given to the surrealists for their inclusion, but women did not exhibit to a significant extent with that group until 1935; though a few works by women had found their way into surrealist shows by 1929, a woman's major role was to serve as muse, not as creator.[65]

The Great Depression challenged American political and social values and prompted many American artists to take action. Two op-

posing camps formed, one believing in art for art's sake and the other championing art for *life's* sake.[66] In photography the simplified form of this schism could be represented by Group f/64 on the one hand (art for art's sake), and Walker Evans, Dorothea Lange, and their colleagues at the Farm Security Administration on the other (art for life's sake).

This split presented an ethical and ideological dilemma for at least one member of Group f/64. Willard Van Dyke moved to New York and became a filmmaker, an avant garde idealist convinced that

> We had to change the world. We couldn't have people starving. I thought that film could promote change faster than still photography. I was wrong. Your photographs [talking to Ansel] awakened a sense of wilderness. Dorothea [Lange] and Walker [Evans] increased the sensitivity of people. Motion pictures are ephemeral . . . they're up there on the screen and then they're gone.[68]

Preston Holder, for his part, mused, "I had hopes for that group, that it would activate some of those people to do some socially aware things. But I was the only one in the group who agreed on my plan of what f/64 should be."[68]

Edward Weston and Ansel persisted in working as they always had, undaunted by criticism charging them with photographing rocks and trees while the world was being destroyed about them, believing that it was exactly during such tragic times that the inspiration of beauty was most needed.[69]

Their critics chose a path more directly conscious of the human condition, demanding that the artist reveal what was evil and wrong, finding anything less to be gravely irresponsible. The argument continues today. Dzevad Karahasan, a Bosnian writer, recently contended, "The decision to perceive literally everything as an aesthetic phenomenon—completely sidestepping questions about goodness and truth—is an artistic decision. That decision started in the realm of art, and went on to become characteristic of the contemporary world."[70]

If Ansel's photographs did not acknowledge the world's troubles, his personal actions did. Ansel held true to the f/64 tenets, keeping his creative photography pure and separate from both his commercial jobs and his environmental causes. But his activist role in the Sierra Club allowed him to respond to the demands that he clearly heard: to be involved with and responsible to the earth and man.[71]

7

SIERRA

Ansel's wellspring, Yosemite and the Sierra, moved his soul, changed his life, and focused his dreams. Heaven was to be found right here on earth. It did not take long for him to discover, however, that far from being eternal, nature in fact lay hostage to man. What he witnessed in Yosemite Valley, now desecrated by a pool hall, bowling alley, golf course, bars, curio shops, and lengthening lines of automobiles, convinced Ansel that he must become a defender of the earth's continued existence; he must fight to protect it for all those who would follow, and especially for the children who could be cured, as he had been, by the healing power of the wilderness.[1]

The protection of the Sierra was a central concern of the Sierra Club, which Ansel had joined in 1920 as a prerequisite of the summer job he would hold for the next four years, as custodian of the club's Yosemite headquarters. From the LeConte Memorial Lodge, dedicated

to the memory of the "original" Joe—Professor Joseph N. LeConte, geologist, conservationist, and founding member—Ansel took his first steps into the established world of conservation.[2] What was more, he no longer had to feel so guilty about his months in the valley: his parents revered the word *work*, and he was even getting paid!

In 1921, he opened on May 15 and closed on August 20. That spring, the weather was still frosty, and snow surrounded the lodge. He began by rolling out his bedroll on the lodge's one small cot, then proceeded to sweep out the mice and prepare for his duties in the months ahead, when he would answer questions, provide access to the lodge's small library and botanical collections, set out salt licks for deer, and lead tours about the valley.[3]

Ansel was also responsible for laying down and then removing the clamps that secured the climbing cables on the side of Half Dome, a tradition begun in 1875 to enable ordinary folk, straining to their max, to attain its summit.[4] The clamps weighed about five pounds each; Ansel would load his backpack with ten at a time and then pull himself to the top of Half Dome to begin the tedious task. This job required him to go up and down Half Dome so many times that he probably still holds the record for total number of ascents. It took six full days of work each spring to position the clamps, and six more in the fall to remove them.[5]

All of Ansel's responsibilities fell within the club's original stated mission:

> To explore, enjoy and render accessible the mountain regions of the Pacific Coast; to publish authentic information concerning them; to enlist the support and cooperation of the people and the government in preserving the forests and other natural features of the Sierra Nevada.[6]

Although committed to these anthropocentric purposes, John Muir, William Colby, and the club's other early directors had been well aware of the threats posed to existing wilderness areas—already diminishing quickly at the century's turn—by the material demands of man. In the late nineteenth century, two thousand sheep had grazed the length of

the Middle Fork of the Kings River Canyon, devouring a lush country and turning it into a barren one. The Sierra was heavily pockmarked by mines, a few still active but most abandoned. California's grand landscape was under attack from all sides.

Muir and Colby reasoned that if enough people experienced the Sierra for themselves, public support would grow and the lands could be protected. Annual group treks, the Sierra Club outings, began in 1901. The earliest participants were chiefly professors and students from the University of California at Berkeley, whose vocations allowed them luxurious quantities of summer vacation time. Members hiked and camped along a designated route for two to four weeks.

No small enterprise, the outings at times numbered upward of a couple hundred people and a hundred head of pack mules and horses, the very definition of the term "high-impact camping." Their dusty and smoky spoor billowed about them, visible for miles and miles.

Aside from a few days' participation in 1923, Ansel could not afford to join an outing until 1927, when he and Virginia participated for the entire month. Enjoying the young man's vibrant good humor and exuberant energy, and valuing his personal experience in the Sierra and photographic talent, Colby, the club's president and leader of the outings, appointed Ansel the official photographer for the 1928 trip to the Canadian Rockies, waiving the normal fees and making the trip possible. From then on, Ansel rarely missed an outing.

Ansel earned a reputation as a fine companion around the nightly campfire and was designated director of the evening entertainment. Often this meant his conducting the assembled in a few songs (though not singing himself) and then turning the floor over to Cedric, who might perform a movement from a violin sonata, or to Virginia, who would sing a song or two, perhaps giving her sonorous and moving rendition of "Down in the Valley."[7] Since he had already hiked much of the Sierra, Ansel was also assigned the additional task of mapping out each day's route, enabling him to chart it with an eye for the best photographic territory. For some reason, he was also in charge of the Lost and Found, maybe because he already had to carry so much equipment.

On July 18, 1931, the outing, two hundred members strong, as-

cended to Benson Lake, a few days' hike above Yosemite Valley. With a broad sandy beach, trees for shelter, waters filled with hopping trout, and granite slopes all around, the lake was to be their home for three days. The group's sheer numbers and rowdy behavior shattered the peace of two women, Lillian Hodghead and Ada Clement, who had already been camping there for three weeks. Their detailed diary of their trip and the Sierra Club's invasion reads, in part, "The first contingent of 'hikers' came at about eight this morning, and immediately began to shout and splash around in the Lake, and swarm around the rocks, fishing. How do people stand it, traveling with a noisy crowd like that for a month?"[8]

Sensitive to this disturbance of their peace, Colby invited the two women to attend all the group's meals. Wandering over to the club's camp, Lillian and Ada, who cooked over an open fire and kept food cold by immersion in the lake, were astonished to witness this version of camp life, which included a "kitchen with three big sheer iron stoves and a large low camp fire with big cans full of vegetables; the chef slicing onions very dexterously at his cabinet which has a folding top that lets down and exposes five or six shelves where his seasonings are kept."[9]

The two women were cofounders of the San Francisco Conservatory of Music and were acquainted with Ansel and Virginia, whom they invited over to their more modest campsite for a dinner of spaghetti and hot biscuits. At the last minute Ansel had to cancel due to serious rehearsals for a campfire entertainment he had written, entitled "Exhaustos," which was to premiere the next evening, Monday, July 20.

An energetic keeper of the Sierra Club flame, Ansel joyfully continued the outing tradition of screwball theatrical productions. In 1905, outing members had created "Sack-o-Germea," whose title combined the Native American Sacajawea with the name of a popular cereal. During rainy days on the 1931–1933 outings, Ansel composed deathless prose for a series of mock Greek tragedies—"The Trudgin' Women," "Exhaustos," "The Oxides," and "The Mules"—which he credited to that well-known ancient poet Oresturphannies.[10]

Lillian and Ada not only attended the final afternoon rehearsal of

"Exhaustos," but returned for dinner and the full performance that night.

> The "Auditorium" is a beautiful place surrounded by huge Fir trees and at the back, a big rugged rock with niches suitable for seats. . . . We stayed to dinner—it was amusing to see them all eating, filing around and being helped "Cafeteria Style"—very well seasoned food. . . . Then the evening performance; a huge bonfire to which all the men contributed. . . .
>
> The tragedy went off very well. Ansel Adams, as the "Spirit of the Itinerary" floating in, draped in a sheet with a wreath around his head and carrying a lyre—a work of art made from a crook of boughs and strung with wires. A violinist behind the scenes synchronized her playing perfectly with his motions. The character of "Privus Counsellus" made up with a shovel, burlap and a roll of toilet paper on his head was a marvelous conception—the King "Dehydrus" had extraordinary whiskers made from steel wool, the Queen "Citronella" was very resplendent in a grand batik drapery and had a necklace of tin can tops and earrings of electric flashlight bulbs. The Princess "Climb-An-Extra" and Prince "Rycrispos" who had a stunning brown body like a young Greek athlete, made a very pretty picture and after their grand love scene under the Aspen tree, the tree marched off in back of them.[11]

When the Sierra Club members finally bundled up their sleeping rolls and moved on, early on the morning of Tuesday, July 21, Lillian and Ada sighed with relief,

> Heavenly peace. The Sierra Club has departed. . . . Late in the afternoon we took a short walk. The beautiful forest is much trampled and looks in many places as though a swarm of locusts had swept over it—the aftermath of the

Sierra Club. We visited their Camp, and they had left everything in clean condition considering what a horde of people lived in one spot; found their delicious cold spring and also the lyre used by Ansel Adams in "Exhaustos."[12]

As an only child, Ansel craved friendship, and the Sierra Club became his extended family. His brothers and sisters were his comrades of the trail; they shared a deep commitment to the earth and pledged to guard it with all their energies. He could use his camera to create, as he could his piano, but the difference was that he could also hike with his camera, and return each evening to a warming campfire surrounded by good friends. The Sierra Club provided a very social and structured way to wander in the American wilderness, and Ansel got paid for going along: for his work on behalf of the 1935 outing, he received $250.[13]

Ansel routed the 1934 outing through the Lyell Fork of the Merced River, his favorite place in the Sierra. The group camped in an idyllic meadow below a ripple of peaks, among which was an unnamed knobby one, handsome enough but not the highest or the grandest in the Sierra. Around that evening's campfire, an enthusiastic bunch that had just climbed the no-name mountain proclaimed that from this time forth it would be known as Mount Ansel Adams. Although he rarely mentioned it, Ansel was secretly thrilled that he would be a mountain one day.

When Ansel returned to San Francisco each fall, his social life centered around a circle of Sierra Club friends, including Cedric Wright, David and Anne Brower, Francis and Marj Farquhar, Dick and Doris Leonard, and Ed and Peggy Wayburn, all of whom would eventually become important to the American environmental movement.[14]

It must be emphasized again how important the Sierra Club was in every facet of Ansel's life. Respect for him within the club grew as his photographs and articles appeared in the *Sierra Club Bulletin* with increasing frequency. His reports as custodian of the LeConte Lodge were published each year from 1921 to 1924, and his portfolios and books were announced and reviewed. When *Parmelian Prints of the High Sierras* appeared in 1927, Professor Joseph N. LeConte II (Little

Joe), himself an accomplished photographer, wrote a glowing appraisal for the *Bulletin*.[15] A few pages later, Ansel's own advertisement announced the availability of the portfolio and told readers how to contact him for its purchase.

Ansel was appointed to the editorial board of the *Bulletin* in 1928, a position he would hold for forty-three years. He was becoming well known to the membership, which numbered about two thousand stalwarts from 1920 to the mid-1930s. These lovers of the Sierra were Ansel's prototypical audience, and with that in mind, he wisely produced portfolios commemorating the outings of 1928, 1929, 1930, and 1932. These were meant to be instant albums, a record of places hiked and camped; at thirty dollars apiece and containing upward of twenty-five photographs, they were excellent mementos, though few of the images have stood the artistic test of time.

Virginia fully shared her husband's enthusiasm for the Sierra Club. She was elected to the board of directors for a two-year term in 1932, but following the birth of their first child, in 1933, she found that she didn't have enough time to serve effectively, and resigned. In 1934, she was again nominated, as was Ansel. She campaigned for him, and he for her; Virginia must have been better at it, because he won.[16] Once elected, Ansel would serve as a director for thirty-seven years, from 1934 until 1971. His term saw him metamorphose from lover of nature into environmental activist.

Although such events are commonplace now, Ansel was one of the first to devise a celebration of nature when, in 1934, he organized the first Yosemite Wildflower Festival. He chose wildflowers as a symbol of natural beauty under siege by man. Ansel employed movies, hikes, and lectures to teach the public of the importance of protecting native plants. The National Park Service, the U.S. Forest Service, the Yosemite Park and Curry Company (YP&CC), and the Sierra Club always seemed to be at odds with one another, with the two federal agencies each holding fast to an opposing philosophy: the Park Service, led by Stephen Mather, talked of preservation, while the Forest Service, directed by Gifford Pinchot, advocated controlled use. These differing positions ensured conflict at almost every environmental turn. An early

proponent of the win-win philosophy, Ansel believed that if people of good faith worked together, a solution could be found for almost any problem.[17]

Emboldened by the success of the Wildflower Festival, in June 1935 Ansel presented the Yosemite Conservation Forum. A panoply of leaders agreed to cosponsor the event, from the director of the Park Service to the presidents of Stanford University and the University of California. In keeping with the inclusionary concept, such groups as the Garden Club of America and the Girl Scouts and Boy Scouts were also represented. Ansel constructed a program encompassing legislation, education, landscape, and highways, with a mini-conference to talk about building a Pacific Crest Trail that would run from Alaska to Mexico.[18]

Sadly, the final outcome of the Conservation Forum was the precise opposite of what Ansel had intended: it merely led to greater division among the participants. Don Tresidder, president of YP&CC and Ansel's good friend and sometime employer, argued that national parks should be made accessible for the maximum enjoyment of millions. He reminded the shocked audience that roads were good, and that the building of more lodges meant that more people could enjoy the great outdoors in comfort.

The superintendent of Yosemite reacted by walking out. So dismayed was he by Tresidder's use of the Conservation Forum to promote business interests that he withdrew his support, and that was the end of it.[19] The Conservation Forum was not Ansel's last freelance effort on behalf of the cause, but after its conclusion he channeled most of his energies directly into Sierra Club projects.

Ansel's affections embraced the entire Sierra, stretching far beyond Yosemite's boundaries to include the Kings River Canyon. Yosemite Valley is only one of a great system of deeply carved river valleys that spread across California's Sierra Nevada. To Yosemite's north is San Francisco's water supply, the dammed and damned Hetch Hetchy, an exquisite valley drowned to quench the city's thirst in 1913 despite the valiant efforts of John Muir.[20] To Yosemite's south, the three-pronged Kings River flows from the Sierra's heights and west through sculp-

tured canyons and flat meadows stretching over five hundred square miles. Considered plain by those who measure everything against Half Dome, Kings Canyon is more subtly adorned by nature and had been a favorite destination for the early leaders of the club; Muir led the second outing there in 1902, and subsequent outings followed during the summers of 1906, 1910, 1913, 1920, 1922, 1925, 1932, and 1935.

Ansel hiked and photographed extensively in the Kings, in 1925 and 1926 writing to Virginia from Marion Lake, which he said was of indescribable beauty and the peak experience of the entire trip. He added that he hoped his photographs would come close to doing it justice.[21] Much of the 1926 *Sierra Club Bulletin* was devoted to the Kings River Canyon and reports of the past year's outing. Editor Francis Farquhar chose six of Ansel's photographs to illustrate the articles.

The establishment of Kings Canyon as a national park had been a top priority for the Sierra Club for many years. The routing of the 1935 outing there was of genuine significance; as the group camped in the magnificent canyon, leaders from the Park Service spoke passionately about the proposed park, urging the outing members to join their campaign.

As happened all too often, a power struggle between the Park Service (overseen by the Department of the Interior) and the Forest Service (controlled by the U.S. Department of Agriculture) had blocked the preservation of Kings Canyon. The Forest Service controlled the Kings Canyon lands and protested that it was a better steward than the Park Service, which would take over if the canyon achieved national-park status. Returning from the 1935 outing, Sierra Club members pledged to join with the Park Service. Now all that was left was to get the legislation passed.[22]

In January 1936, Congress held hearings on the establishment of Kings Canyon National Park. The Sierra Club sent Ansel to act as its lobbyist;[23] he proved to be the perfect selection, and a prime center of attention. Dressed in black jeans and black shirt, wearing a big Stetson (not the usual Washington garb) and armed with an array of photographic landscapes of the Kings River Canyon, he dazzled the assembled senators and representatives.

Not wanting to rely solely on his photographs, Ansel had carefully studied the issues and presented both the history and current facts of the Kings Canyon situation, but it was his visual message that was most persuasive. Previously, in Washington, Kings had been dismissed as "just another canyon"; politicians from Los Angeles had fought hard to establish dominion over it, intending to make of it another Hetch Hetchy, in which to store the water pumped from the Owens Valley until it was needed in the city. Through Ansel's photographs, members of Congress now saw that there was more to Kings Canyon than an empty hole to fill. It held a rich array of wilderness. Its mountain lakes, waterfalls, granite cliffs and high peaks, remnants of glaciers, clear skies—pure, clean, and American—were all given long-distance life in Ansel's crisp prints. But even this was not yet enough.

During his days in Washington, Ansel made contacts that would turn out to be important to him personally. In 1936, the Interior Department published a photographically illustrated booklet on Yosemite containing not a single Adams photograph;[24] until his January testimony, he had been an unknown in Washington. That now changed.

In 1938, Ansel published his third book and first book of landscapes, *Sierra Nevada, the John Muir Trail*.[25] A large proportion of the images in the exquisitely produced volume had been made in Kings River Canyon. With pride, Ansel sent a copy to Secretary of the Interior Harold Ickes, who presented it to President Roosevelt. In these two, the campaign for the Kings Canyon National Park found the champions who would make the difference: with the leadership of both Roosevelt and Ickes, the battle was won in 1940, and the treasure of Kings Canyon was added to the real national wealth, our national parks.[26] While Ansel would have been quick to protest that he was only one of many advocates on Kings Canyon's behalf, it would not likely have become a national park when it did were it not for his visual testament and his tenacity.

8

RECOGNITION

In December 1932, during the de Young's Group f/64 exhibi-
tion, Virginia discovered that she was pregnant with their first child.
Her father gave the young couple a gift of a thousand dollars to enable
them to travel to the East Coast before the impending responsibilities
of parenthood made it impossible. Ansel hoped that in the hub of the
art world, New York City, he could make his fortune.[1] Armed with po-
tent letters of introduction from Albert Bender and the estimable Mrs.
Sigmund Stern, on Sunday, March 6, 1933, he and Virginia embarked
upon a train trip across Depression-stricken America.

Their first stop was Santa Fe, where they found themselves grounded.
Two days after inspiring the country with his inauguration speech, with
its famous line "the only thing we have to fear is fear itself," President
Franklin D. Roosevelt closed all the nation's banks for a full week.[2]
Ansel and Virginia were traveling with bank checks, and it took them

almost two weeks to secure their funds. They bunked with friends and hopped from party to party as their many Santa Fe and Taos buddies happily entertained them.

Back on track, and after stops in Chicago, Detroit, Buffalo, and Rochester, they arrived in a rainy New York City on the morning of Tuesday, March 28.[3] The weather was bleak and the streets stank, piled high with garbage thanks to a strike. They found and rented an inexpensive studio at the Pickwick Arms Club Residence at 230 East Fifty-first Street, at a rate of sixteen dollars a week, service included.[4]

After settling in, the pregnant Virginia retired for a nap. Ansel took a brisk walk, then picked her up for lunch and a visit to the Museum of Modern Art (MoMA) and the Julien Levy Gallery. That first night they met Don Tresidder, president of YP&CC, for drinks and dinner at the 21 Club, the most famous speakeasy in Prohibition-era New York, followed by a Broadway show.[5]

The next morning, leaving Virginia at the Pickwick Arms to unpack, Ansel charged off, intent upon showing his photographs to Alfred Stieglitz at his gallery, An American Place.[6] Strand, Marin, and O'Keeffe had alerted Ansel to his importance, while Albert Bender had characterized Stieglitz as an "intellectual talking machine, but nevertheless . . . the chief man in America to have raised photography to a high plane."[7]

Stieglitz had founded An American Place in 1929, the same year that MoMA, funded by Rockefeller money, opened its doors. It was no coincidence: Stieglitz believed it was important to offer a strong alternative to what the bright young men (most under thirty years old) at MoMA planned to present. He was certain their prejudice would run against American artists and toward the Europeans.[8] Stieglitz feared that the artists he had been promoting, including Georgia O'Keeffe, Paul Strand, Arthur Dove, Marsden Hartley, and John Marin, would be ignored by the museum. Strand and O'Keeffe encouraged him to open a space where their work would be assured of a New York audience.[9] An American Place attained an almost immediate status as an influential gallery that was sympathetic to artists—provided, of course, that the artist was accepted by Stieglitz.

Stieglitz had married Georgia O'Keeffe in 1924, after a passionate six-year courtship.[10] He adored her and created the most superb collective portrait ever made of one woman through his intense and personal photographs, lingering on the curve of her shoulders, the stretch of her neck, the grace of her hands, the fullness of her breasts, and the directness of her gaze. Twenty-three years older than O'Keeffe, Stieglitz suffered a heart attack in 1928; the following year, he came to the depressing realization that she was physically distancing herself from him, more content in New Mexico than in New York.[11]

Stieglitz had a well-earned reputation as a curmudgeon who would not suffer fools. Rationing his words to describe himself, he proclaimed, "I was born in Hoboken. I am an American. Photography is my passion. The search for Truth my obsession."[12]

Ansel entered An American Place in 1933 clutching his letter of introduction from Mrs. Stern, a portfolio of prints (High Sierra landscapes and Group f/64 subjects), and a copy of *Taos Pueblo*.[13] Stieglitz greeted him with a scowl, and then things got worse. Glancing at the letter from Mrs. Stern, Stieglitz sniffed, "All she's got is money."[14] With a warning that he was too busy to be bothered, he allowed that if Ansel came back in a few hours, he might look at his work. Hopes dashed and offense taken on Mrs. Stern's behalf, Ansel huffed back to their room and advised Virginia that they were leaving the city. He had no idea of the current difficulties faced by Stieglitz, whose black mood was even blacker than usual.

The previous November, unable to carry out a commission to paint a mural across the walls and ceiling of the second-floor women's room at Radio City Music Hall, O'Keeffe had suffered a nervous breakdown. Stieglitz had become irate after she independently signed the contract for this huge job that he felt was beneath her talents and for which she was to be paid a paltry fee of fifteen hundred dollars. (He had recently sold two of her paintings to the Whitney Museum of American Art for a total of nearly six thousand.)[15]

On February 1, 1933, Stieglitz agreed to have O'Keeffe admitted to a private New York mental hospital, where she was diagnosed as suffering from a rather unspecific condition termed psychoneurosis. She

was acutely depressed. Just a couple of days before Ansel's arrival, O'Keeffe had been discharged and immediately boarded a southbound ship to recover in the warmth of Bermuda for two months. These events had emotionally depleted Stieglitz, who had been allowed to visit her for only ten minutes each week while she was hospitalized. He blamed his wife's problems on menopause.[16] Feeling abandoned, he had had little interest that morning in viewing the portfolio of an unknown photographer from California.

Sensibly, Virginia insisted that Ansel give Stieglitz one more chance. His return visit to An American Place later that afternoon went even better than he could have dreamed. Bidding him to sit down, Stieglitz took Ansel's portfolio, untied the three black ribbons that held it shut, and slowly examined each print. There was only one chair in the gallery, and Stieglitz was sitting on it. Finding no option, Ansel lowered himself onto the radiator, trying to ignore the hot water coursing through its pipes. Whenever he tried to comment on one of the images, Stieglitz would glare him back into silence. Finally, Stieglitz tied the portfolio shut, paused, and then, with great thoughtfulness, untied it and began studying each print again. He gave the same careful attention to *Taos Pueblo* and expressed great appreciation for the elegant simplicity of both the design and the images.[17] By now, Ansel's bottom, still perched on the radiator, had been baked into corrugation. His discomfort was quickly forgotten, however, when Stieglitz, with a direct look, pronounced the work among the finest he had seen.[18]

Having fully relented, Stieglitz now expounded upon his theory of the equivalent, the centerpiece of his photographic philosophy.[19] Years earlier, in his journal *Camera Work*, he had published an essay by Marius de Zayas on the 1911 Picasso show, in which the author had written that the artist's intention was "that the picture should be the pictorial equivalent of the emotion produced by nature."[20] Stieglitz applied this idea to his own work, though its personal application had taken years to reach maturity.

Angered by a critic's insinuation that half the power of his portraits sprang from the hypnotic spell he cast over his sitters, Stieglitz in 1922 determined to demonstrate that he could make important photographs

of subjects over which he had no control—subjects that were there for anyone to use. That summer, he began photographing clouds in relationship to the earth. Later that year he exhibited *Music: A Sequence of Ten Photographs* and spoke of the images as being the visual equivalents of the symphony of sound he experienced in his mind while gazing upward: some clouds communicated the delicacy of violins and flutes, others the timbre of oboes, and still others the volume of brass instruments.[21]

The next year, Stieglitz let loose the earthly anchor and photographed clouds and sky without reference to land. To a friend he remarked, "Several people feel I have photographed God. May be."[22] For all that this might be their deepest goal, most artists would think it too grandiose, too egocentric to speak of such achievement. But not Stieglitz.

Stieglitz's theory of the equivalent helped Ansel's photographic dreams take flight. Beyond his straightforward shots of mountains and board fences, rocks and rusted ships, Stieglitz promised that Ansel could discover more if only he would put his emotions into the creation of each photograph. Stieglitz solidified the commitment first inspired in Ansel by Edward Carpenter, to reveal the greater reality that surrounds us, but of which too few are conscious. Ansel now believed that he, too, could capture this evanescence on film, as a proof for all to see, a glimpse of the intrinsic beauty that is life's foundation.

Stieglitz came away from their afternoon together impressed by this very Western man and his work. If their differences were readily apparent, they nonetheless shared a deeper kinship: each was totally committed to the art of photography. Although he did not offer Ansel an exhibition, Stieglitz urged him to write and visit whenever possible.

Upon his return to San Francisco, Ansel began a faithful correspondence with Stieglitz that ultimately led to a warm friendship.[23] Stieglitz was Ansel's connection to the big-time world of art, but he was more than that, too: he was Ansel's ideal. Stieglitz lived his life completely dedicated to art. He brooked no compromise either by himself or by his followers (for no one was considered a colleague). Every artist that Stieglitz decided to promote was worshipful of him; anything less would be treachery. In that tradition, Ansel was a star. He truly idolized

Stieglitz, fully embracing his philosophy as his own. In return, Stieglitz accepted the role of mentor.

In the greatest compliment he could have paid, Ansel now attempted to model his life after Stieglitz's. In the late summer of 1933, he leased a space near Union Square in downtown San Francisco, at 166 Geary Street, and opened the Ansel Adams Gallery, devoted to the exhibition of fine art photography, painting, and sculpture, the same combination to be found at An American Place. This move must have seemed foolhardy to Ansel's family and friends, and all the more so as it was during the depths of the Depression.

Although he faced a huge task in readying the gallery for its announced opening date, September 1, Ansel refused to even consider giving up the Sierra Club outing. Depositing his nearly full-term wife in Yosemite, he bounded off into his mountains, leaving her father to cope with the situation. On the first of August, Virginia gave birth to their first child, Michael. It was a relatively easy birth, and her father stayed with her during most of the labor. She neither needed nor wanted anesthesia; when, at one point, her doctor told her it would be all right for her to scream, she calmly replied that she saw no need to. Without a touch of acrimony, she wrote to give Ansel the news of their beautiful, perfect son, "mailing" her missive with a hiker who was departing for the high country.[24] In a few days' time, an excited Ansel dashed back to the valley with a kiss for his forbearing wife. In a letter to Cedric full of busting buttons, Ansel proudly described his son's violin fingers.[25]

Taking little time to consider his new bonds of family, Ansel insisted on an immediate return to San Francisco to prepare for his imminent gallery opening. The inaugural show, of works by Group f/64—the original seven plus Consuela Kanaga—pulled in an enthusiastic San Francisco audience; nearly five hundred people attended during its two-week run.[26]

Finding cooperative artists proved troublesome, however. Strand, Stieglitz, and Charles Sheeler all declined his invitation to show their work. Strand responded that he felt exhibitions extorted the artist by providing free entertainment to an unworthy public,[27] while Stieglitz

refused because he did not have enough prints to risk shipping any across the country.[28] Committed to showing only new work, Sheeler begged off because he had no darkroom in which to make prints, and the only three paintings he had done were already fully booked.[29]

In addition to his own photographs, Ansel showed work by photographers Edward Weston and Anton Bruehl, sculptor Ralph Stackpole, and painters Jane Berlandina, Jean Charlot, Marguerite Thompson Zorach, and William Zorach. Sales were pitiful. Ansel reported to Charlot that he had sold two oil paintings and two lithographs for a total of $135. Subtracting $46 for the expense of announcements and reproduction photographs and $29.66 for his commission, he rounded off the net total of $59.34 and sent Charlot a check for $60.[30] After eight months, unable to make a go of it, Ansel gave up on the gallery.

His photographic career fared much better. Ansel's first New York exhibition opened in November 1933 at the Delphic Studio, the site of Edward Weston's premier solo show in 1930.[31] Although the director of the gallery, Alma Reed, enthusiastically reported sales of eight prints for $120, Ansel never received any money; the sales just covered Delphic's expenses for the announcements and framing. On the plus side, Ansel received his first review in the *New York Times*, which pronounced that "Photography by Ansel Adams, a Californian, strikingly captures a world of poetic form. His lens has caught snow-laden branches in their delicate tracery; shells embedded in sandstone; great trees and cumulus clouds. It is masterly stuff."[32] Though brief, the notice could not have been more positive.

If Group f/64 had dissolved, it was hardly forgotten.[33] Ansel continued to proselytize at every opportunity, finding a perfect vehicle when *Camera Craft* magazine hired him to write a series of four articles under the general title "An Exposition of My Photographic Technique," beginning in January 1934. This represented a great victory for straight photography because *Camera Craft* had long been the platform of Group f/64's archenemy William Mortensen. Ansel's radical ideas warred page-by-page, month after month, with Mortensen's expositions on "Creative Pictorialism."[34] As uncomfortable as Ansel was to be in such close publishing proximity to the "Devil," Mortensen must have

felt assailed in his own castle by this callow youth named Adams. Although he continued to pump out books, Mortensen saw his popularity and reputation as the greatest teacher of technique wane as Ansel's waxed.

In April 1934, Ansel published an extended essay entitled "The New Photography," in *Modern Photography 1934–35*. He began by giving a brief history of the medium and concluded by crowning its ultimate achievement (in his estimation): straight photography.[35] Although he was taken to task for his less-than-precise version of the history of photography, in the main Ansel received high praise for his essay in a review by MoMA librarian Beaumont Newhall.[36] His audience was growing.

In the wake of Group f/64, Ansel's final salvo was the publication of his first book on photographic technique, *Making a Photograph*, in 1935.[37] In ninety-six amply illustrated pages, complete with a darkroom design, Ansel took the amateur by the hand and demonstrated how he or she could become a straight photographer. Serving as stunning examples for his readers, Ansel's photographs had been finely reproduced, varnished to a high brilliance, cut out, and then individually glued in place. To this day, people mistake those reproductions for original prints. A delighted Stieglitz wrote to Ansel, "I must let you know what a great pleasure your book has given me. It's so straight and intelligent and heaven knows the world of photography isn't any too intelligent—nor straight either."[38] Along with the critical acclaim came some very welcome royalties: Ansel's first check from the publisher totaled a pleasing $315.20.[39]

Nineteen months after Michael's birth, on March 8, 1935, Anne Adams was born. Once again, Ansel was elsewhere, this time photographing snow scenes in Yosemite while Virginia stayed behind in San Francisco. Ansel cabled to express his love and congratulations; he planned to remain in the valley to finish the project but promised he would come home in a few days.[40] He had no time for babies, even his own.

After a lapse of almost three years, Ansel headed back East in January 1936, ostensibly to testify in Washington on behalf of the Sierra

Club, an opportunity that provided the critical financing for a trip that would prove pivotal. Ansel first stopped in New York, where he wanted to show Stieglitz his more recent photographs. On the evening of his arrival, Ansel luckily chose to go to the movies, where he spied O'Keeffe. After accepting a big hug from him—a departure from her normal reserve that shocked her companion, David McAlpin—she invited Ansel to come back with them to the apartment she shared with Stieglitz. McAlpin, a Rockefeller heir, served as a trustee of MoMA.

Rarely empty-handed, Ansel arrived with his portfolio. Most likely, he was carrying such work as two very different still lifes, *Burnt Stump and New Grass* (1935), of brave new shoots set against charred bark, and *Americana [Cigar Store Indian]* (1933), a composition formed of the random, bizarre items found in close proximity on a city street.[41] The response from these three very important people was immediate, confirming Ansel's belief that he was making the best photographs of his life.[42]

After leaving him hanging for only a few days, on Friday, January 17, Stieglitz offered Ansel his long-sought show, to be hung at An American Place the coming November. Ansel was ecstatic; planning for this event would be the focus of his entire year.

But his trip had just begun. Dr. Bauer, director of the Zeiss Camera Company in the United States, presented Ansel with a new Zeiss Juwell three-and-a-quarter-by-four-and-a-quarter-inch camera and a Zeiss Double Protar lens, Ansel's first important freebies. Bauer hoped, as would many other photographic manufacturers in years to come, that Ansel Adams would make some great photographs using his equipment. An excited Ansel crowed that it was the world's greatest camera.[43] In gratitude for the gift, he contributed testimonial articles for *Zeiss Magazine*.[44]

Ansel's good fortune in New York was capped off by a dinner with Paul Strand, who showed him prints so dazzling as to render him speechless—a highly unusual condition for Ansel—and swearing that no words could do them justice.

On the way home, he stopped in Chicago, where the esteemed Katharine Kuh Gallery also requested an exhibition for November.

Displays of such great modern painters as Wassily Kandinsky, Paul Klee, Alexander Calder, and Emil Nolde had been mounted on that gallery's walls. Kuh promised Ansel important introductions and some guaranteed jobs to enable him to return to Chicago during his show.

Ansel returned to San Francisco full of energy, ready for what he believed would be the best year of his life. Still, he did not have the luxury of concentrating solely on the coming exhibitions: there was now another mouth to feed. In demand as a commercial photographer, he was commissioned to do a book documenting Dominican College in San Rafael, California. Always on the lookout for more images for the approaching shows, he found one even in that assignment: *White Cross, San Rafael* was included among his work at An American Place.

Once again, nothing, not even Stieglitz, could cause Ansel to give up his annual July Sierra Club outing. He invited the new photographic assistant, Patsy English, whom he had hired to help with his exhibits. Refusing to be left at home again, Virginia insisted on going along; thankfully, Ansel's parents were always ready to baby-sit their two grandchildren. The three joined two hundred others at the starting point: the village of Giant Forest, fifty miles east of Fresno in Sequoia National Park. One participant anticipated the trip as a "ticket to star-shine, moonshine, and crystal-shine" and was "excited to be armed with only the certainty of one's own strength and well being" (not to mention a hundred fully loaded mules).[45]

Ansel planned the route, and after a few grueling days of ever up-ward trails, the outing party found itself in the lunar landscape of the High Sierra, above tree line with little vegetation to soften the earth's skeleton or a man's in a sleeping bag. It was the duty of each outing's freshman members to build and maintain the nightly bonfire, and this year's bunch, with naive zeal, produced a barely controlled inferno for their first effort. The recorder of the trip recalled that "everyone was toasted into a pleasant stupor, while Ansel, trapped between the ring of Sierrans and the fiery furnace, had to issue his trail directions on the trot . . . with his jeans threatening to go up in smoke at any moment."[46]

Even though the trip was cursed with a bounty of rain, Ansel made six negatives that he would include in the American Place show. Four,

in deference to the soft, cloud-filtered light, were studies of weathered wood, two of old ghost-town buildings and two tree details.

Virginia loved the outings almost as much as Ansel did; at thirty-four, she remained an intrepid climber, on this trip achieving the summit of Mount Whitney for the second time, along with 162 others. She had been one of the first women to ascend its eastern slope.

Ansel was never one for "racking up" mountains, as he put it. Preferring vantage points conducive to a heavy camera and tripod, he made a gentle, glowing photograph, *West Slope of Mount Whitney, Sierra Nevada*, bathed in the warm rays of the late-afternoon sun.[47] This and an image of an explosive cumulus cloud dominating the Kern Plateau, entitled *Clouds, Sierra Nevada, California*, were two of only four landscapes exhibited at his Stieglitz show.[48]

Soon after his return from the Sierra, Ansel entered the darkroom in the basement of his San Francisco house and stayed there until the work for both the Stieglitz and the Kuh shows was completed. More than any other photographic artist of his time, Ansel championed the importance of print quality, and he was determined to make the most beautiful prints of his life for Stieglitz.

To that end, he painstakingly assembled the perfect ingredients, changing the printing paper he had used since 1931, Novobrome, to Agfa Brovira Glossy Doubleweight. The new paper possessed more silver and thus offered a greater quality of light, producing bright, sparkling whites and more intense blacks.[49] Variations of images were propped up, examined, and compared.[50] Only the best survived.

Ansel trimmed every print with precision, then dry-mounted each onto very white, shiny Bristol Board. Attending to every detail, he had new labels commissioned in a plainly elegant design, proclaiming "A Photograph by Ansel Adams." One was glued to the back of each print. He needed forty-five prints for Stieglitz and thirty-four for Kuh. Ansel had once bragged that if pushed, he could make three hundred prints in one day when working on a commercial project; it was a measure of his dedication to achieving the very best for these shows that it took him seven weeks to complete the requisite seventy-nine prints.

When Ansel shipped the American Place show off to Stieglitz on

October 11, he was fully content. He wrote Stieglitz that with the making of each print he had summoned up the essential emotions he had experienced when he made the negative: method acting applied to photography. He believed these photographs to be more alive than any he had previously made.[51]

Every negative used for the American Place exhibition had been taken during the previous five years. Four had been in the Group f/64 show, and most were in the Group f/64 style: close-ups of battered wood, cemetery stones, and rusted anchors. Stieglitz liked imagery that reflected his own concerns and provided a sense of mood and place. For him the natural world was relevant only in how it related to man; he scorned the West and its scale-breaking grandeur. Mindful of this, Ansel selected only pictures that Stieglitz had expressed a liking for, or ones in a similar style. He was discovering that recognition by Stieglitz could be as confining as it had originally seemed liberating. The inventory of prints that Ansel shipped to Chicago was nearly identical to the one sent to New York, though for Katharine Kuh, he included three prints that did not go to Stieglitz, *Monolith, Rose and Driftwood,* and *Still Life,* plus a three-panel screen entitled *Leaves, Mills College.*

From October 27 to November 25, 1936, Ansel's photographs hung at An American Place, in the first solo exhibition by a photographer other than Stieglitz himself since Paul Strand's 1932 show.[52] Ansel was now a leading artist in the United States, and he took his new position seriously. His statement for the show explained that these images had been created from the meeting of the world's outer reality with the unique personal reality of the artist. Ansel termed the resulting photographs examplars of superreality.[53]

His exhibition earned a substantial notice in the *New York Times,* in which the reviewer remarked that "a skier spotted with snow, a rocky butte against a cloudy sky with great clarity of foreground foliage, the pattern of a pine cone or bark on a tree, a leathery face: these and kindred subjects reveal his personal use of the camera and clarifying ability. Some unusually interesting work."[54]

Financially, too, the show was a big success, with at least nine prints sold.[55] Stieglitz disliked even giving the appearance of being a

salesman, preferring to "place" prints with duly appreciative buyers. Customers first had to prove to him that they were worthy; they then had to pay whatever price he demanded (which depended upon who was buying; Stieglitz believed that the rich should pay a premium). He usually insisted upon a thousand dollars each for his own photographs or Paul Strand's, an outrageous price during the 1930s and 1940s. But whereas Stieglitz and Strand often made only one print from a negative, Ansel held to no such stricture, assuming the contrarian position that one of photography's greatest strengths was reproducibility, the ability to make many prints from one negative. Stieglitz priced most of Ansel's photographs at thirty dollars, though he sold *The White Tombstone* to the wealthy David McAlpin for a hundred dollars, Ansel's highest selling price for a single print for many years to come. The same photograph carried a price tag of twenty-five dollars at the Kuh Gallery.

But Stieglitz was not yet finished with the prospective buyer. After a check for the full amount was made out directly to the artist, Stieglitz required that a second check be contributed to the "Rent Fund" of An American Place, which in the case of McAlpin and *The White Tombstone* meant an additional forty-nine dollars.[56]

The White Tombstone is a haunting image of a carved and Tudor-arched headstone bearing a profiled figure of a young woman, her head bent in sorrow. Sculpted as a grieving memorial to Lucy Ellen Darcy, who died in 1860 at the age of twenty-six, the stone had subsequently been etched by age and nature.[57] The camera's tilted viewpoint in Ansel's photograph seems to suggest that the world has been permanently pushed askew by the tragedy of Lucy's death.

With confirmed paying jobs awaiting him in Chicago courtesy of Katharine Kuh, Ansel boarded the train from San Francisco on Saturday, November 7. He spent nearly a week in the city, basking in the accolades of the critics and making some money as well. Kuh arranged seven sittings for portraits and a couple of days' work photographing corsets and brassieres for Paris Garters. Ansel happily tackled this bizarre range of assignments, grateful for the income.[58]

On Saturday, November 14, he lectured to the Chicago Camera Club. A newspaper notice of the event described him as the "noted

California photographer," and an accompanying photograph depicted the thirty-four-year-old Ansel, now balding, with broad brow, hooded eyes, prominent nose underlined by a dark mustache, and a tiny apostrophe of a beard beneath his lower lip, looking a bit like Mandrake the Magician. Staring off into space, he confidently posed with his new 35mm Zeiss Contax camera held in his smooth, handsome hands.

The proudly displayed Contax was his latest toy. Ansel was amazed by the ease and portability of the little camera, such a change from his cumbersome eight-by-ten. Shortly after receiving it, he took the Contax into the High Sierra for a month and managed to shoot two dozen rolls of film, about 864 exposures, a revelation for a photographer used to the time-consuming project of making a negative with a view camera. In an article for *Camera Craft*, Ansel touted the Contax as the single piece of equipment most responsive to the hurly-burly of real life.[59]

Ansel arrived in New York too late in the evening to visit An American Place, but the next day he crossed the gallery's threshold and became transfixed by Stieglitz's presentation, from the soft gray walls (a color selected by O'Keeffe) to the thoughtful sequencing of image next to image. Most were hung in a line, but a few were grouped in twos or threes, and a few were double-hung, one above another.

Proper lighting is imperative for photographs if the subtle nuances of tone and detail are to be revealed. The six-foot-tall windows at The Place were sheathed in white shades made softly luminous by the sunshine that moved through the surrounding skyscrapers of midtown Manhattan. The shades unrolled from the bottom up to allow regulation of the natural light, which was supplemented by rows of floodlights, their intensity controlled by reflectors; the effect produced recalled the "quality of light of a cathedral."[60] Anointed by Stieglitz, whose praise provided the deepest affirmation and whose intellectual reinforcement had been critical for him, Ansel had achieved the pinnacle of success in the established art world.

After just four days in New York, Ansel had to return to Chicago for a few days for another round of portrait making and a commercial assignment for a paper factory, and then it was on to Carlsbad, New Mexico. This promised to be another lucrative stop for Ansel, with paying

jobs for the Southern Pacific Railroad and the possibility that if he made good photographs in Carlsbad Caverns, the U.S. Department of the Interior would buy them.

Ansel spent the better part of a week entombed in the caverns, and emerging each evening only made him feel more like a bat. Photographing there proved a frustrating experience: he was repelled by the Park Service's theatrical lighting, which laid bare what should not have been seen and kept in shadow aspects that deserved revelation. Ansel also found offensive the repetitive boom of the ranger's voice as he momentously expressed important thoughts about the meaning of life for each new band of tourists. Doubtful that he could capture any of the natural splendor of the caverns, Ansel wrote to beseech Stieglitz to pray for him.[61] He also sent his deepest thanks for the exhibition that had reinvigorated him and trumpeted that he was heading in an exciting and new direction; he chose the word *joy* to describe his state of mind (despite the cavern experience).

Finished with Carlsbad, Ansel finally traveled home, arriving in San Francisco on Thursday, December 10, 1936, to a mountain of personal troubles.

9

LOSING HEART

Ansel's future seemed golden, but what looked like the best of times was actually the worst, and it was all because of love. In early 1936, now an established commercial photographer, he had been hired by the Southern Pacific Railroad to shoot promotional pictures of their posh new passenger cars. Extras were needed, and on a whim, Patsy English, a friend of someone at the modeling agency, joined in the crowd.

Patsy stood out, at least to Ansel, who asked her to work as a model for him on an advertising campaign for his major client: Yosemite Park and Curry Company (YP&CC) was clamoring for new pictures depicting pretty tourists making the most of their Yosemite experience. Although she had no professional training, Patsy agreed, and she proved so adept that Ansel asked her back for a number of shooting sessions. She bunked at the Best home in the valley along with Ansel and Virginia. Ansel was thirty-four, Virginia thirty-two, and Patsy twenty-two years old.

Swamped with orders for stock prints from YP&CC, Ansel decided it was time to hire an assistant: Patsy. Patsy was inexperienced in photography, but she possessed a full measure of energy and was ready and willing to learn. She later remembered that Ansel "needed to make two dozen of this and two dozen of that. He taught me to do the fixing and washing while he printed. This is when I learned about quality. I watched while he exposed and printed and I came to understand. I was very receptive and had the same kind of taste as he did."[1]

Patsy stayed on as Ansel's assistant as he made the prints for the American Place and Katharine Kuh Gallery shows. She was struck by the severity of his self-criticism, as he often reacted to a freshly made print by saying, "I can do better than that," whereupon he would return to the darkroom to try it again.

Throughout the year, as she modeled and assisted in the darkroom and on the road as he went off to make new photographs for the upcoming shows, Patsy was paid, though not royally, and received an occasional print.[2] Her favorite from the Stieglitz show was *The White Tombstone*; when Ansel discovered that this was Stieglitz's preference as well, it only increased his estimation of Patsy.

Patsy was excited about life. She was young, smart, and lovely, and she looked great in jeans. Unlike Virginia, she took Ansel's guidance as a gift rather than a wearisome improvement lecture. Although she found his face and body more than a bit reminiscent of Ichabod Crane's, she grew enamored of Ansel—his vibrant personality, his great artistry, his patient teaching. (His most attractive physical feature, she thought, was his beautiful hands.) Possessed of sympathetic personalities, they agreed on most matters, including the importance of her establishing her own career.[3]

Ansel, for his part, fell head over heels in love. He believed it was Patsy's presence that inspired him to make the prints for Stieglitz, prints that at last conveyed the intensity he had been seeking. With her spirit beside him, he could conquer the world. Forget Virginia, with her pedestrian, wifely demands, forget the children, whom he didn't really relate to, forget the old folks in San Francisco, forget the trap he found himself in: Ansel decided that he must leave Virginia for Patsy.

On the evening of October 14, 1936, just three days after Ansel shipped his prints to Stieglitz for the show, Patsy attended a dinner party at Ansel and Virginia's San Francisco home. Harry Cassie Best carried his seventeen-month-old granddaughter, Anne, upstairs, placed her in her crib, and then keeled over, dead of a heart attack. While Ansel saw to the children, Virginia called an ambulance and ordered Patsy to stand at the curb, wave it down when it arrived, and try to keep the emergency crew quiet to avoid waking Ansel's parents, asleep next door. Virginia knew she had to remain strong, and the elder Adamses' grief and shock would be unbearable.

An emotional wreck, Patsy stood sobbing by the side of the street. The ambulance crew came and made their way upstairs, out of sight of the guests in the living room, who had no idea what was going on and continued to chat as if nothing had happened. Patsy recalled that Virginia remained eerily calm throughout, almost stonily cold, though her neck was streaked bright red from the bottled-up emotion.[4]

With her father's death, Virginia inherited Best's Studio. If he remained with Virginia, Ansel would now have his own photography gallery and house smack-dab in the middle of his treasured Yosemite. He loved and respected Virginia as the mother of his children, but his passion for Patsy was immense. This situation posed an impossible conundrum for Ansel.

To compound the problems, Virginia discovered that she was pregnant again. After much debate and open discussion at their home, she checked into the University of California Hospital in San Francisco for a quiet curettage (abortion), having concluded that it was difficult enough raising two children almost single-handedly;[5] a third was out of the question.

Three weeks after Harry's death, with the two women demanding that he choose between them, Ansel literally skipped town, determined that nothing would keep him from visiting his Chicago and New York exhibitions. Letters poured from his trusty portable typewriter to the two women, neither of whom realized, until years later, that he was sending near duplicates to them both.[6]

Ansel returned to San Francisco on December 10 and immediately

crash-landed in bed, under the spell of his catchall affliction, the flu.[7] Rather than feeling ebullient about his successes in the East, he felt defeated by his personal life. Both Patsy and Virginia told him that his time was up. He and Virginia became embroiled in such a vehement argument that both collapsed and had to be hospitalized in separate rooms in Dante Hospital.[8] Emotionally drained and no longer able to run on empty, Ansel lay despondent in his hospital bed, unable to make a decision and unwilling to face either woman.[9] He knew what his choices were—either start a new life with Patsy or hoist the burdens of family—but he was tempted just to light out in a simple escape. There was everything to lose either way: his soul or his honor. In the end, he did not have the strength for the struggle.[10]

Patsy came to visit Ansel in the hospital, but as she climbed the stairs to his floor, she was met by his friend Ted Spencer, who delivered a verbal "Dear John" to her, explaining that Ansel had decided not to leave Virginia. Patsy continued on to Ansel's room, where she found him subdued and a bit stuttery as he briefly informed her that he was staying with his wife, adding that he hoped they could still be friends.[11] Remembered Patsy, "And that was that."[12]

Released from the hospital just before Christmas, Ansel only grew more depressed over the holidays. In despair, he wrote to Cedric that he wished he could somehow reclaim his lost happiness.[13] In the middle of January 1937, Virginia entered San Francisco's Saint Francis Hospital to have her tonsils removed;[14] shortly before her release, Ansel was admitted to the same hospital complaining of abdominal pains, thus deftly missing her return home.[15] He was diagnosed with infectious mononucleosis, a potent virus that plays havoc with the body's immune system and left him even more exhausted physically and mentally than he had been in December.[16] The only treatment was then, as it is now, rest, with recovery in two to three months.

When he was discharged, two weeks later, he had run out of time and excuses and had to act to save his marriage. Leaving the children with Carlie, Ollie, and Aunt Mary, Ansel and Virginia drove to Palm Springs for a week of sun and rest, in hopes of the honeymoon they had never had.[17]

Upon their return, convinced that the damp and foggy San Francisco climate was not helping—not to mention the lack of privacy, with his parents and aunt next door—Ansel and Virginia moved their young family of four to the sunnier clime of Berkeley.[18] Unfortunately, their rental house sat directly on the Hayward Fault; within days a tremor rumbled convincingly beneath them, shaking both the house and its occupants to their foundations.[19] In no time they were restored to the mixed comforts of 131 Twenty-fourth Avenue.

The doctor had ordered Ansel not to return to work yet, but the medical bills began arriving,[20] and his immediate plunge back into the rat race of making a living in photography seemed their only financial hope. Life resumed as miserably as before.

Virginia, as was her wont, simmered and stewed for the next few years. She might not have turned out to be Ansel's dream girl, but then, he was no longer the romantic poet and musician with whom she had fallen in love. Photography did not impress her; photographers had been employed by her father her whole life, and she had never seen much merit in what they did.[21] In snapshots taken during these years, her mouth, so soft and shy in earlier photographs, has begun its downward journey, its corners set low in resignation. Virginia, who for years had patiently listened to Ansel's admonishments, now could not stand to hear them.[22]

The rumor mill busily continued to churn out stories of Ansel's transgressions, not just with Patsy, but Virginia never took any of it seriously because in her experience he was not very good in bed and did not have much of a sexual appetite. She was quite certain that he had not consummated his relationship with Patsy. There was a part of Virginia that always loved Ansel, primarily for his mind, which she considered his best feature.[23]

Patsy could not help but overhear various women at different social occasions discussing Ansel, who they all agreed was notorious for his many affairs; their gossip chilled her. It was her belief that Virginia condoned his wandering eye because he would stay in their marriage only if she allowed him this freedom.[24]

By the time I began working for Ansel, in 1979, the quiet buzz was

that Ansel had once had a torrid affair with one Patsy English. Mystery
is best applied to fiction, so I asked her if she had slept with Ansel, and
if so, whether she had become pregnant. I knew she was telling the
truth when she responded with a quick laugh and said, "Well, if I did,
it would have had to have been the Virgin birth!" Of Ansel's decision
to remain with Virginia, Patsy succinctly said, "Ansel did not have the
courage to leave her."[25]

Patsy met photographer Nathan Farbman in 1938, and they were
married in November of that year. Her photography training served her
well, as she first assisted "Farb" (her nickname for him) and then,
when he went off to war, took his place for such clients as the Matson
Line. In peacetime, Farb was hired full-time by *Life*, and Patsy was em-
ployed as a stringer. They traveled widely, enjoying prolonged overseas
assignments, and had three sons.

About every ten years, Patsy Farbman would pay a visit to Ansel
and Virginia, as they kept faint track of each other's lives. She felt
lucky to have wed Farb and not Ansel. It saddened her to find, when
she visited Ansel in the 1960s, that his most graceful feature, his
hands, were distorted by arthritis, the ends of his fingers bent almost
perpendicular to their joints.[26]

Ansel and Virginia's marriage never truly healed. Ansel centered
his life on his San Francisco house and studio, a distanced father to his
son and daughter, who were raised by their mother in Yosemite. In
early 1937, still struggling with the demons of family versus passion,
Ansel was plagued by nightmares of desolate emptiness.[27] The emo-
tional and physical depression that had claimed him the previous
December continued to hold him tightly in its cold grip for two
years more. To top it off, financial ruin loomed as his important eight-
year relationship with YP&CC, a critical source of income, came to
an end.

If Albert Bender had given Ansel the fateful nudge toward a career
in photography, during the years of the Great Depression it was
YP&CC that kept his dream alive. In 1925, the feud between the two
major Yosemite concessionaires (the Yosemite National Park Company
and the Curry Company) had ended with their merger. While a handful

of small businesses, such as Best's Studio, managed to hang on, YP&CC established a near monopoly on tourist services in the park.[28]

The president of the new company was Don Tresidder, who had worked his way up during summers at Camp Curry from porter to marriage to the Currys' daughter, Mary, earning his way through Stanford Medical School in the process.[29] As the facilities for tourists grew, Tresidder came to understand the need for keeping beds filled all year long, not just during the overpopular summer. Ensuring winter visitation required a multidimensional marketing effort.

In July 1927, Yosemite's luxurious Ahwahnee Hotel opened its doors, in response to Stephen Mather's decree that deluxe lodgings must be built to care for notable guests.[30] To attract visitors over the Christmas holidays, Tresidder proposed staging some sort of Christmas entertainment. In 1928, this took the form of a loosely constructed banquet/pageant based on a Washington Irving tale about an eighteenth-century English Christmas repast at the manor house of the Squire of Bracebridge.[31] All parts were to be acted by locals, and Ansel was typecast in the role of the Lord of Misrule.[32] Dressed in striped knickers and a jester's cape, and cap festooned with bells, Ansel was the perfect picture of a fool, but it was his faithful black basketball shoes, bound securely to his feet with ribbons, that turned out to be the crucial component of his costume.

In an effort to loosen up the actors, the cast party was held before, not after, the performance, and its aim was admirably met. Fortified by a few convivial bourbons stirred with icicles pulled from the roof's eaves, Ansel made quite an entrance into the Ahwahnee's grand dining room, a truly spectacular, voluminous space punctuated by massive wrought iron chandeliers and stone columns. To the amazement of most, and the fright of some, Ansel scampered up a steep forty-foot pillar, his sneakers earning slight purchase on the rounded boulders. Achieving the summit, he reveled with abandon, remaining in character but coming perilously close to breaking his neck.

Ansel was an instant star, his antics to be recounted for years to come, though, through the clearing fog of morning, he swore he would never do anything like that again.[33] Deciding to harness this tremendous force of nature, Tresidder appointed Ansel to direct the following

year's Bracebridge and, in addition, retained his services as a part-time freelance photographer.[34]

For the next extravaganza, Ansel asked Jeannette Dyer Spencer to design the set and costumes. Jeannette and her architect husband, Ted, had assisted Arthur Pope and his wife, Phyllis Ackerman, in the interior design of the Ahwahnee. Jeannette had a master's degree from the Sorbonne, where she had established the definitive dating of the glorious stained glass windows of St. Chapelle (1243–1248). For the Bracebridge, she created a huge, translucent pseudo-stained-glass window of painted parchment paper that filled the hotel's large west bay and served as a glowing, richly colored backdrop for the performance. Her versions of stained glass roundels decorated other windows in the dining room, and Ted constructed the rest of the set; all are still used each Christmas, nearly seventy years later.[35]

Taking his inspiration from Irving's story, Ansel wrote a musical script based on a persistent 4/4 beat and incorporating a variety of fine old English carols. The event is presided over by the nonsinging Squire and his Wife, proudly played for many years by the Tresidders. Other characters include a Performing Bear, a Minstrel, the Parson, the Lord of Misrule, and the Major-domo, a role that Ansel wrote for himself. The important vocal part of the Housekeeper was long sung by Virginia.

The central premise of the Bracebridge is that the members of the audience are the expected guests of the Squire and thus part of the performance, seated throughout the resplendent dining room. Quiet interludes of minstrel music are followed by rousing choruses of "Wassail!"[36] Ansel's one and only *Life* cover was a candlelight portrait of the Minstrel strumming her lute; sadly, his credit was buried.[37]

Ansel's first photographic charge for YP&CC was to show the public the potential of Yosemite under snow. He was savvy enough to present two offers to Tresidder. For one price, YP&CC would own the negatives; for half that amount, Ansel would retain ownership but would agree to make any and all prints they required.[38] Tresidder chose the second option.[39]

Ansel photographed twirling ice skaters on Yosemite's six-thousand-square-foot rink, cross-country skiers dwarfed by sequoias (one of the few times that Virginia served as his model), horse-drawn sleighs, a

challenging toboggan run, and even the sport of skijoring, which is something like waterskiing except with no water and no boat, just a skier being pulled by a galloping horse.[40]

Since most of the snow lay above the valley floor, ski-touring in the high country became a popular pastime for a growing number of hardy souls. There were no ski lifts; to be able to ski down from the top, the skier first had to climb up. It was definitely a demanding sport. In February 1930, Ansel accompanied Yosemite's Swiss ski instructor, Jules Fritsch, for two days' skiing around Tuolumne Meadows to scout possible locations for a high-country ski center. With his new four-by-five-inch camera, Ansel made a series of elegant images: Jules carving a figure eight on the side of Lembert Dome; Jules in the midst of gravity-defying, graceful leaps off snowy hillocks.[41]

Ansel made a dazzling set of ski pictures for Tresidder on Dassonville Charcoal paper. Because so much of the subject was snow, and this paper did not register subtle nuances of tone, each image was reduced to a nearly featureless pale field engraved with the simple, curving lines of the skis' tracks and accented by the black silhouettes of the skiers. The simplification of tonal values resulted in graphic images that were stronger than those that would have been obtained printing the same negatives on glossy paper with a full range of tones.[42]

YP&CC immediately put Ansel's photographs to use, and from 1931 through 1937 hired him for up to four months a year, giving him an assured annual income of between one and two thousand dollars during the country's hard times.[43] The one exception was 1933, when YP&CC simply could not afford any extra expenses, including Ansel.

No longer confined to just winter photography, Ansel was now responsible for photographing everything that went on in Yosemite. His photographs appeared on Ahwahnee menu covers, on company stationery, in magazine advertisements, in scrapbooks, and in displays at YP&CC's Yosemite, San Francisco, and Los Angeles offices. Ansel's framed landscapes hung from the walls of two Yosemite Lodge restaurants.

In 1935, YP&CC commissioned him to make some photographic murals for an exhibit at the San Diego Fair, advancing him funds that

he used to remodel his San Francisco darkroom to accommodate the larger format.[44] Murals were definitely in the artistic "air"; in the midst of the Depression, the U.S. Government employed artists to paint them in many public buildings, and private companies and museums soon followed suit. At the head of the muralist list were the Mexican artists, including Diego Rivera and José Clemente Orozco, who had staked out this idiom as their turf. It seemed that no city with a claim to culture could rest until it had hired Rivera to sit on stool and scaffolding, detailing his inimitable vision of the working peoples of the world.

Stimulated by the challenge, photographers began projecting their negatives into huge enlargements. In 1932, MoMA hung an exhibition called *Murals by American Painters and Photographers*,[45] which included the work of fifty-three of the former and twelve of the latter (including Berenice Abbott, Charles Sheeler, and Edward Steichen). It marked the first time photographs were exhibited at the museum.[46]

YP&CC's assignment provided the impetus for Ansel's extended venture into the theory and practice of making very large prints and, by the next year, photographic screens.[47] By 1940, with the publication of his article "Photo-Murals" in *U.S. Camera*, Ansel was considered an authority on the subject of what he had come to call "enlargements with a vengeance."[48]

Ansel's halcyon days with YP&CC came to a difficult end as the result of a darkroom fire in the summer of 1937 that destroyed almost all of his YP&CC negatives. Buoyed by an insurance settlement, Ansel reassured Tresidder that he could make new negatives at no cost to the company.[49] But soon YP&CC's head of advertising, a Mr. Stanley Plumb, began asserting himself, insisting upon a negative-by-negative accounting to ensure a complete replacement. If a thousand negatives had burned, he argued, Ansel should make a thousand new negatives. Rankled by the apparent lack of trust, Ansel objected; he believed that he was obliged to supply a variety of excellent images, not a set quantity for the sake of numbers.[50] Ansel wrote to the sympathetic Stieglitz to complain that Big Business, as personified by YP&CC, was crucifying the artist, in the person of one Ansel Adams.[51]

The following year, Ansel's employment by YP&CC was signifi-

cantly reduced.[52] Since the income from Best's Studio was not enough to support the family, the Adamses depended upon YP&CC's paycheck; relations grew so strained that at one point Virginia suggested to Plumb that she be allowed to substitute for Ansel and make any necessary photographs during the coming winter.[53]

Plumb pushed Tresidder to clear up the matter of who owned Ansel's YP&CC negatives. Plumb felt that as work-for-hire, they belonged to YP&CC, but Ansel had been clear about the negatives' ownership from the very beginning. He forcefully reiterated that they belonged to him, though he promised that he and, after his death, Best's Studio would continue to supply the company with all the prints it needed.[54] That was not the answer that either Plumb or Tresidder wanted, and they finally concluded that Ansel was more trouble than he was worth.[55]

One day, in a Yosemite gift shop, Ansel spotted a book for sale, entitled *The Four Seasons in Yosemite National Park*.[56] He picked up a copy and opened it to find that the credit read, "Photographed by Ansel Adams, Edited by Stanley Plumb," and that it had been published in 1936. Ansel hit the roof. His agreement with YP&CC specified that if his images were sold in any way, he was to share in the fee, and this was the first he had heard of the book.

Attorneys stepped in. On April 25, 1939, Ansel signed an agreement to drop all claims against YP&CC for the sum of five hundred dollars. Landscape negatives were deemed sacrosanct, owned fully by Ansel and no one else, but commercial-activity negatives were another story. Ansel kept custody of them, but they were the ultimate property of YP&CC.[57] This spelled the end of Ansel's work for YP&CC; from this point on, he mostly just filled orders for new prints from old negatives.

With both his personal and his professional life in shambles, Ansel held on to one thing: his hope of having a second show at An American Place. On his every trip to New York (and there were many), Ansel visited his mentor, though he rarely brought new work. He was crushed to learn that Stieglitz planned to exhibit photographs by Eliot Porter in late 1938: only a few short years before, Porter, then but a fledgling

photographer, had asked Ansel to critique his work. Porter later acknowledged that when, in turn, he viewed Ansel's prints, he had become acutely embarrassed at the realization of how much finer they were than his own.[58]

At An American Place, a gentle picture of Porter's sleeping infant son hung next to his photographs of birds and landscapes from Maine and Austria (more intimate and quiet than Ansel's strongest work). To add to Ansel's suffering, David McAlpin purchased seven photographs, money that Ansel must have felt could have been better spent on Adams prints.[59]

Ansel inevitably rushed into and out of New York, working on so many deals, commercial and artistic, that Stieglitz scolded him to concentrate on his own work and stop frittering away his energies on all the other nonsense in his life. Resisting Stieglitz's suggestion that he move to New York to assume his mantle of leadership, Ansel insisted on living in California. In Stieglitz's opinion, Ansel was bourgeois, with a wife, two kids, and mounting debt; he continued to "waste his time" on the Sierra Club, and by writing books, teaching workshops, and giving lectures. And what was worse, to finance it all, he not only accepted commercial assignments, he beat the bushes for them.

According to O'Keeffe, none of the prints that Ansel made in the coming years compared in beauty to those in his 1936 show.[60] To no avail, McAlpin pleaded with Stieglitz to offer him another exhibition, on the theory that it might stir Ansel's thickened creative juices.[61] But Stieglitz would show an artist for a second time only if he felt he or she had something new to say within the limits of his own aesthetic.

Ansel could neither get the Sierra out of his blood nor continue to exclude it from his imagery, however much Stieglitz might disapprove.[62] His greatest personal joys came from his rambles with his camera in the mountains, not from photographing fences and old doors in the city.

Anathema to Stieglitz's belief that art was for the appreciative and intelligent few, Ansel was a popularizer who made his photographs and his teachings available, in numbers and price, to all who were interested. *Making a Photograph* explained the basic craft of photography

to anyone who cared to read it, and its author's articles in *Camera Craft* magazine found an audience of thousands.

In the late 1920s, Ansel's vision had been molded by the Sierra; in the early 1930s, he had become the quintessential f/64 photographer, his photographs clearly reflecting the group's parameters, just as the images in the Stieglitz exhibition had mirrored Stieglitz's aesthetic as much as Ansel's own.

As Ansel came to understand that he could no longer satisfy Stieglitz, he was free to move on. But for the first time he found himself in uncharted waters, on his own, no longer bound by the photographic requirements of others. He realized he must make photography that was uniquely his, and his alone. It scared the hell out of him.

10

FRIENDS

Just in time, good news quietly crept in. Soon after New Year's 1937, the Museum of Modern Art asked Ansel to provide six photographs for its first major photographic exhibition. The letter from the exhibition's young curator, Beaumont Newhall, proved to be life-changing.[1]

Initially hired as the museum's librarian by MoMA director Alfred H. Barr, Jr., in November 1935, Beaumont had soon come to be regarded as the resident photography expert. As a brilliant young academician at Harvard, he had strangely failed his doctoral orals, perhaps because his interests ranged far beyond the limited, static boundaries that that institution defined as valid art-historical concerns. He was absorbed in serious study of the art and history of photography, a medium not then accepted within those ivy-clad walls.[2]

In May 1936, Barr announced to Beaumont that five thousand dol-

lars had been earmarked for a photography exhibition, one that was to fill all four floors of the museum—what the director called a Big Top show. It would be accorded the same respect as the van Gogh and cubism and abstract art exhibitions of the past year. Barr offered him the position of exhibition curator, and without missing a beat, Beaumont proposed mounting a retrospective view of the history of photography under the title *Photography 1839–1937*.[3] Barr agreed, and Beaumont, not quite twenty-eight years old, was thrust into the center of creative photography.

Eighteen thirty-nine is as good a date as any—and a better date than most—for the beginning of photography. In 1725, a German chemist named Johann Heinrich Schulze discovered that silver nitrate, when exposed to light, turns black. Photography is based upon that principle: a photograph is made of shades of black set against white printing paper. But it would take over a century more for the medium's invention.

The idea of photography was explored without success for decades. Thomas Wedgwood, son of the famous English potter, had made photographs by 1802, though a major problem stumped him: the image could be viewed for only a few minutes under candlelight before it faded away. It was impermanent, unfixed.

On January 7, 1839, Louis-Jacques-Mandé Daguerre's process for making permanent, unique images on silver-coated copper plates, known as the daguerreotype, was given freely to the world by the French government. With Daguerre's formula, anyone could become a photographer, though making a daguerreotype was far from easy or safe. Daguerreotypes must be developed over the lethal fumes of mercury—thus eliminating, by their early death, its practitioners. Daguerre's process was based upon the work of his deceased partner Joseph Nicéphore Niepce, whose 1826 image of the view from his studio's second-floor window, the oldest existing photograph, can be seen at the University of Texas, Austin.[4]

Even as Niepce and Daguerre were developing the daguerreotype, a gentleman scientist in England, William Henry Fox Talbot, was inventing a photographic process based on a paper negative, which

would become known as the calotype. His breakthrough came thanks to Sir John Herschel's advice that he try sodium thiosulfate to fix the image. Although the calotype was not as clear or as sharp as the daguerreotype, multiple prints could be made from its paper negative. After two decades of supremacy, the daguerreotype bowed to its less difficult and less hazardous British cousin, for which a method had been devised to make the silver emulsion stick to glass to create a transparent negative base.

Beaumont Newhall knew that photography's roots were in Europe and that a trip there would be essential for the preparation of the planned MoMA exhibition. Elated, he informed his fiancée, Nancy Wynne Parker, that since he now had a stable job, they could be married and their honeymoon underwritten. A graduate of Smith College who was just as passionate about art as Beaumont, Nancy served as art editor of the periodical *The New Frontier*, worked as a painter and sculptor, and attended classes at New York's Art Students League.[5]

Barr and Newhall agreed that a blue-ribbon oversight committee should be assembled to assure the photographic community that *Photography 1839–1937* would be a serious undertaking. Beaumont first approached Stieglitz, who said no to everything: no, he would not serve on the committee; no, neither the exhibition nor its catalog could be dedicated to him; and no, he would not lend any of his photographs.[6]

Stieglitz's initial hostility to MoMA had not dimmed. And here came another of the museum's immature young staff, educated in traditional art history, with no real knowledge of photography, arrogantly chosen to describe the medium's first ninety-eight years. In addition, Stieglitz had predicted MoMA's usual European bias, and Beaumont's first priority was, indeed, a trip to the continent. Not until after Thanksgiving, seven months into the project, did Beaumont turn his focus to American photographers. In the end, seventy-seven photographers were included in the show's contemporary-photography portion; only twenty-seven were from the United States.[7]

Beaumont attributed a great deal of his enthusiasm about photography to Ansel's 1935 book *Making a Photograph*.[8] In his 1993 autobi-

ography, Newhall called it a "staggering" book and said that after read-ing it, he had signed on board the good ship Straight Photography.[9] Ansel replied quickly and affirmatively to Beaumont's invitation to par-ticipate in the show, contributing not only his own work but an album of albumen prints by the great nineteenth-century photographer Timo-thy O'Sullivan that he had been recently given by Francis Farquhar.

From its opening on Saint Patrick's Day 1937, *Photography 1839–1937* was huge both in size (841 pieces) and in success. Entry was gained through a camera obscura, a darkened room fitted with a lens that projected the scene outside upon one wall (in this case, the receptionist at the museum's information desk). The reviewer for the *New York Times* advised, "After that you emerged . . . prepared for whatever the exhibition might unfold."[10] While most praised the show, the *New York Sun*'s critic mourned, "They say that if you are lost at sea, you should swim with the tide. I suppose I shall have to swim with the modern museum and give up paintings—at least temporarily—until this second edition of the dark ages has passed and we shall have been blessed with another Renaissance."[11]

Photography 1839–1937 served notice that photography had ar-rived as a field of serious endeavor for both artist and historian. Beau-mont's catalog for the exhibit, published in an edition of three thousand copies, soon sold out. Such an all-inclusive history was clearly needed, and he set to work on a better book.

Just as *Making a Photograph* had spurred on Beaumont, Ansel him-self, after viewing the traveling version of *Photography 1839–1937* in San Francisco, was inspired to write "The Expanding Photographic Universe: A New Conception of Photography as a Form of Expression," his chapter in the book *Miniature Camera Work*.[12] Stieglitz congratu-lated him on this essay; it is not surprising that he liked it, since in it Ansel drew a comparison between Stieglitz's photographs and the fres-coes of Michelangelo.

More glad tidings came Ansel's way. He was offered total sponsor-ship of a book of his Sierra landscapes by Walter Starr, a longtime leader of the Sierra Club. The book was to be a memorial to Starr's son, Walter, Jr., nicknamed Pete, who had loved the Sierra more than any-

thing and had fallen to his death while solo climbing in the Minarets.[13] At the time of his death, Pete had nearly finished his definitive *Starr's Guide to the John Muir Trail and the High Sierra Region*, which his father completed and had published. Through a fund endowed by Walter, the Sierra Club keeps it in print today, and it is still stuffed into many a backpack.[14]

Sierra Nevada: The John Muir Trail finally gave Ansel the chance to demonstrate in book form what he could do in photography. The subject matter was all his, and Starr was committed to the best production quality money could buy. Although it was the winter of 1937 and he was still struggling with the demons of depression, Ansel impatiently waited for the winter snows to lift so that the Sierra could become accessible to his lens. In early July, he took off for Tuolumne Meadows and then into the Minarets. He returned home with 350 large-format exposures.[15]

Word came that Edward Weston had been awarded a Guggenheim Fellowship, the first for a photographer. Supported by its two-thousand-dollar stipend, Edward, accompanied by his companion Charis Wilson (they would marry two years later), would have the opportunity to photograph the American West from April 1, 1937, until April 1, 1938.[16] Completely proud and happy for his colleague, Ansel offered assistance of all kinds and begged the couple to come to Yosemite so he could take them off to the High Sierra, where Edward had never been.

Edward and Charis's first concern was how to ration their funds so that they could live for one whole year. Knowing they would have to camp, Ansel advised them on the absolute essentials: a two-man tent, sleeping bags, a tarp, and a simple set of pans and dishes. When they inquired as to where they could obtain dehydrated vegetables, Ansel scoffed, dismissing those as unacceptable vittles. After years of personal experience, he had determined that the staples of a camping pantry were salt, sugar, bacon, flour, jelly beans, and whiskey.[17]

That May, Ansel and Virginia busily made ready Best's Studio for the first summer season under their management, following Harry Cassie Best's death the previous October.[18] The permit to operate the concession had expired with Best, but the Park Service granted Ansel

and Virginia a one-year extension on a closely supervised trial basis.

Ansel vowed that the gallery would serve as a showpiece of what a responsible concession should be in a national park. First they rid the studio of all cheap gewgaws, a sizable portion of Harry's inventory. Then they divided the studio into two rooms, the first selling books, cameras, film, and postcards and providing a photo-finishing service, and the second designated an art gallery. Ansel encouraged painters and photographers to interpret Yosemite so that Best's Studio could then exhibit their work.

But what almost immediately brought in nearly ten thousand dollars a year was the sale of about a hundred different Yosemite images of Ansel's, printed by an assistant in massive numbers.[19] Prices depended on size and ranged from $1 (or three for $2.50), to $1.50 (three for $4), to a high of $4 apiece. These "special-edition prints" were anathema to the sales practices of Stieglitz. What Ansel termed his "exhibit prints," made and signed by him and suitable for museum exhibition, were priced from $10 to $25.[20]

Committed to achieving the highest quality possible in all aspects of the business, Ansel secured the Meriden Gravure Company of Connecticut to print the black-and-white postcards that sold for three for ten cents. He meanwhile discontinued the lucrative practice of photographing people at Mirror Lake, believing that it distracted from the quality of the experience for those visiting that lovely spot.

Arriving in Yosemite on July 20 for their promised High Sierra sojourn, Edward and Charis found Ansel's new, automated darkroom boasting rockers, printers, and dryers as well as a full-time photographic assistant, Imogen Cunningham's son Rondal (Ron) Partridge, who bragged about the equipment, "You just sit down and watch [it] work."[21] Ansel's setup stood in sharp contrast to Edward's own photographic simplicity: Weston did not even possess an enlarger, but used just a bare light bulb to expose the negative in its printing frame.

Despite their planned early departure the next morning, they were a party-hearty crew of six, with the inclusion of Ron and two young mountain climbers named David Brower and Morgan Harris. Virginia, as usual, stayed at home to look after the studio and the children.

Everyone fell into bed after midnight and was out the door before six in order to make the one-way-at-a-time control of traffic over the Tioga Pass to Mono Basin.

Marveling at the granite-domed landscape about Tenaya Lake, with its junipers improbably rooted in the slightest of cracks, Edward itched to set up his camera, but Ansel had not scheduled time for photographing along the way. They pressed on to Mono Lake and then down Highway 395 to the turnoff for Mammoth Lakes and beyond, parking at Agnew Meadows. They loaded the three mules that were waiting for them, then headed off under foot power to their campsite overlooking Lake Ediza, six miles away and at an elevation of ten thousand feet.

Charis was but twenty-four years old, twenty-eight years younger than Edward, but the altitude affected her more than it did anyone else. A great sleepiness came over her, and she had to be prodded up the trail. She was conscious enough to notice the swarms of mosquitoes, though Ansel reassured her that there would be none at Lake Ediza because it was too high for them. Her account of their first evening is delightful:

> Ansel had explained the mosquitoes on our arrival: these were just the few that had followed us up; when they were annihilated all would be well. We had killed ten thousand apiece now, so Ansel offered a new theory: they didn't like smoke; as soon as we got the fire started we would have peace. A big campfire was built before the tent, a smaller cooking fire near by. Oh, how those varmints hated smoke! Just had to call all their uncles and cousins to come play in it, too. Ansel made a last effort: they would go away at night when it got too cold.[22]

The mosquitoes never relented for the entire week of their trip. Charis wrapped a sweater about her head and tied the sleeves under her chin. She coated her face with applications of lemon juice and refused to wash after she determined that the combination of built-up grime and

citrus proved an effective deterrent. Edward photographed a grim Charis, squatting exhausted on the rough ground, knees akimbo, face deadpan for the camera.[23]

Ansel and Edward worked independently, going off each morning with cameras and tripods. Edward found it tough to load his eight-by-ten-inch film holders in the required safety of a film-changing bag; in an act of great friendship (as any view-camera photographer would tell you), Ansel volunteered to load both his and Edward's holders each night while Charis and Edward protected him as best they could from those dastardly mosquitoes. Evenings ended with convivial hot toddies.

Ansel made at least three photographs on this trip that he deemed worthy of the upcoming book, including one taken the very last day at the Devil's Postpile, an unusual basalt cliff composed of geometric columnar shafts.[24] All three of these images are descriptive, not transforming. Edward made a couple of pictures of note, but as he had predicted, a return trip to Tenaya Lake later that year would yield even more.

On July 26, they hiked out, camping their last night at Red's Meadow. Edward cooked dinner. Although he lived a self-described simple life, Edward took certain creature comforts very seriously, notably sex, coffee, and food. That night, Edward created a stew loyally described as "succulent" by Charis.[25]

EDWARD WESTON'S
RED'S MEADOW STEW

Place in iron skillet:
 one can beef stew
 one can corned beef hash
 one can tomatoes
 one can sugar peas
Simmer until reduced and thickened.

After a last full day of photographing, they headed back over the Tioga Pass, arriving in Yosemite at ten o'clock at night. Not knowing

when to expect them, Virginia had roasted two chickens hours earlier, which they attacked with relish. Suddenly, a pale, stricken face appeared at the window, yelling "Fire!" Everyone sprang from the table and rushed outside to see flames crackling through the roof of Ansel's new darkroom. Ansel and Edward locked eyes. Ansel just said one word: "Negatives!" One brave soul climbed up to the roof and forced a fire hose down into the burning interior, then someone else wielded a fire extinguisher.[26]

Ansel, Edward, Charis, and Ron grabbed boxes and boxes of negatives. All had been stored in paper envelopes that offered scant protection. Some smoldered; others were charred at the edges. A bathtubful of water was drawn and armload after armload gently laid in, steam rising while Ansel carefully sorted through the damage, saving what he could.[27]

Sometime in the wee hours of the morning, Ansel suggested that they call it a night.[28] They trooped back and raided Virginia's refrigerator, then settled down with drinks to unwind. Ansel took his glass to the piano and played and played and played all the Bach he could remember. Charis recalled that "of the group, Ansel looked least like a ruined man."[29] A few months later, Edward would write to Ansel, "You, and *your work*, mean a lot to me. Realize that I have almost no one who speaks my language."[30] Ansel felt exactly the same way about him.

A small can of Eastman Kodak ribbon magnesium, Ansel's old nemesis, had been sitting on the shelf directly behind the dry-mount press. The Zeiss Camera Company in Germany had sent a darkroom assistant to Yosemite in appreciation of the articles Ansel had written for them. A rigid Teutonic soul who had not endeared himself to anyone, this assistant was the guilty party.[31] It does not take much heat to ignite magnesium, which goes off in a small explosion.

Ansel lost at least five thousand negatives that night, primarily his work for YP&CC and his early soft-focus plates.[32] The fire charred the top edge of *Monolith*'s glass plate; from then on, Ansel had to crop, or cut off, that portion of the image whenever he made a print. In the early 1930s, he had used nitrate-based film, negatives made on which, such as *Frozen Lake and Cliffs*, are highly flammable. By chance, these were

stored at some distance from the blaze; if they had been set on fire, Ansel probably would have lost everything.

Ansel also almost lost *Clearing Winter Storm*, which would become one of his most famous photographs. Beginning in 1916, Ansel had photographed from the vantage of Inspiration Point again and again before finally making this, his most satisfying visualization. During the fire, its eight-by-ten-inch film negative got quite warm, and when it was plunged into the bath, water spots took up permanent residency. *Clearing Winter Storm*'s sky is generally blurry, the film grain reticulated to a greater extent than normal, possibly due to the negative's exposure to heat just below its combustion point.

Ansel was notoriously bad at dating his own negatives, believing that dates were of no importance to his creative work, though he kept immaculate records of each negative's f/stop, lens, and exposure. Over time, Ansel forgot that *Clearing Winter Storm*'s negative had been through the fire, and erroneously dated the photograph to 1944 in show after show and book after book.[33] He always disliked printing this negative and made few prints from it for many years, but he did not make the connection between its physical problems and its past. The likeliest date for the negative is January 1935. (He could not have made it in the winter of 1936–37 because he spent almost all of that time in San Francisco and Berkeley, much of it in the hospital.) That month was blessed with unusually spectacular weather and huge amounts of snow; during the brief periods of respite between the nearly constant storms, Ansel made many photographs.

Weather proved to be everything to *Clearing Winter Storm*. From the lip of a great swoop of cliff, glazed with snow, plunges the brilliantly white Bridal Veil Fall in a long, thin line. These forms on the right of the photograph balance El Capitan on the left, its face partially veiled in gray, vaporous mists. Clouds modulate the scene, extending far down the valley and obscuring Half Dome but adding a soft texture to the normal hardness of a place described mostly in granite.

Happy days with friends continued as Ansel took off on September 14, 1937, to join David McAlpin (as his guest), Georgia O'Keeffe, and Godfrey and Helen Rockefeller (Godfrey was McAlpin's cousin) in

New Mexico.[34] Carting three cameras (five-by-seven Juwell, four-by-five Korona, and 35mm Zeiss Contax) and an entire case of film, he soon found himself with the others at the Ghost Ranch in the picturesque Chama Valley, northwest of Santa Fe. A dude ranch might have seemed an unlikely setting for the very private O'Keeffe, but since she first laid eyes on its landscape of brightly striped cliffs, in 1934, she had claimed it as her artistic home. She spent long summers there, faithfully returning each fall to Stieglitz and New York.[35]

Ansel responded to the landscape as well, impressed by the vast skies looming over mesas of red and pink, so very different from his Sierra.[36] He found the thunderclouds astonishing, piled one upon another, just begging to be photographed. He made forty exposures of them in one day alone.[37] He thought he had made his best photographs ever; in fact, they were not his best, though some were very good.

Although Ansel was immersed in the visual action about the Ghost Ranch, and O'Keeffe regretted having to interrupt work on a number of paintings, the group left on September 27 on a well-planned trip through what they called Indian Country. Their guide, Orville Cox, was the head wrangler at the Ghost Ranch and an authority on the life and culture of the native peoples.[38] They visited Canyon de Chelly National Monument, the Grand Canyon, Monument Valley, and Laguna and Zuni pueblos, then continued on up into southwestern Colorado. During these travels, Ansel did make some great photographs.

Canyon de Chelly is a deep river canyon that wanders into the past. Cliff dwellings of its Anasazi residents, who vanished centuries ago, are perched in its perpendicular walls. After a day in the canyon, the six travelers were flushed out by a sudden and violent storm that brought flash flooding. When they arrived at a canyon overlook, Ansel whipped out his 35mm camera and took snapshots of his high-spirited companions lined up at the cliff's edge to gain a view that included a distant line of Navajo on horseback, singing as they rode. Through a soft wind, the late-afternoon sun shone with a particular radiance.[39]

Hearing light banter between O'Keeffe and Cox, Ansel turned his camera horizontally upon the pair and made one exposure with Cox bent slightly forward and obscuring O'Keeffe's face. Quickly, Ansel

knelt and made a second picture of Cox shyly looking at the ground while O'Keeffe slyly regarded him with a particularly flirtatious-seeming glance. For years, people have assumed that something was going on between them, but the truth is that Ansel was just at the right place at the right time, and by his framing fatefully isolated the two of them in a relationship that never was.[40] Henri Cartier-Bresson would later describe this as a "decisive moment," one of those split seconds when action and composition are stopped by the photographer at exactly the perfect time.

In the Colorado mountains, winter had already arrived. Aspen trees stood naked, white as skeletons without their clothes of leaves. Ansel photographed one grove whose trees' bare trunks danced lyrically like musical notes up and down the hillside. *Aspens, Dawn, Dolores River Canyon* was the first photograph by Ansel that Nancy and Beaumont Newhall owned; it was displayed on their living-room wall as early as 1940.[41]

Ansel, McAlpin, O'Keeffe, and the Rockefellers had such a grand time together that they agreed to meet again the next year for an Ansel-guided trip of Yosemite and the Sierra. Letters among Ansel, O'Keeffe, and McAlpin flew furiously across the country in preparation for the visit.[42]

O'Keeffe never spared Ansel the scourge of her wit. When he sent proof prints of their Southwest trip to the other participants, O'Keeffe reprimanded him for giving away work to people who could very well afford to pay for it.[43] Like Stieglitz, she constantly criticized him for not concentrating on what was most important: his art.[44] In addition, she counseled that he should make but one great, defining print from each negative, and no more.[45]

Ansel was taken aback by her charges and suggestions. Perhaps O'Keeffe did not know that McAlpin had paid for his portion of the Southwest trip. With McAlpin, Ansel thought of the big picture: he was much more interested in McAlpin's potential as a complete benefactor than as a source of relatively small amounts of income from the sale of a few pictures. In his letters to McAlpin over many years of correspondence, beginning in 1938, Ansel made it perfectly clear that he was

more than ready to follow the holy path of Stieglitz if only he could be freed from the necessity of earning a living.[46]

In the meantime, Ansel determined that if Best's Studio could move into the profit column, Virginia and the children would be taken care of, and he could then pursue his "assignments from within," as he termed his creative work, rather than "assignments from without," or commercial jobs. Throughout the winter and spring of 1938, he remained in Yosemite, dedicating himself, with a few exceptions, to making a success of their business.

Edward and Charis showed up on February 9, though Ansel had warned them that the valley was not a pretty sight: there was no snow. That night it began snowing and did not let up for two and a half days. They were all snowbound in Ansel and Virginia's snug and well-provisioned home. Edward and Charis were happy as clams, but Ansel was driven to distraction with no electricity, no darkroom, no telephone, no mail. As soon as the road was plowed, he took off for San Francisco, leaving Edward to run wild alone in that absolute winter wonderland.[47] Weston made a wonderful photograph of Ansel's darkroom peeping out of not a blanket but a fat down comforter of snow.

Awaiting Ansel in San Francisco was a fun but inconsequential project, just the kind that perturbed O'Keeffe. He had been asked by the Spencers, organizers of the Parillia, the artist's ball, to compose a few bars of music for a dance performance at the event.[48] A benefit for the Department of Architecture and Design at the San Francisco Museum of Modern Art, the Parillia had earned a reputation as a wild night justified by charity. Its theme for 1938 was "Europa and the Bull."[49] Clothing was of the costume and optional variety; naked male and female chests abounded.[50]

Inspired by an immense old Chinese temple drum of William Colby's, whose bass voice might have challenged Yosemite's thunderstorms, Ansel previewed his composition for the Spencers, who liked it so much that they insisted he write an entire score.[51] Pianist though he was, Ansel composed the music for performance by percussion only, including timpani parts that were too demanding for all but two musicians in the entire city.[52] For the actual performance, Ansel wore a toga

to direct the bands of dancers who stepped through the rooms, including a naked woman carried upon a litter: Europa en route to her meeting with the bull.[53] Certainly, O'Keeffe and Stieglitz were right that Ansel frittered away too much of his time.

By mid-July 1938, Ansel was yearning for the arrival of O'Keeffe, McAlpin, and the Rockefellers, all due in early September, and confided to Stieglitz that he was lonely for the kind of friendship that he found with people of the quality of O'Keeffe.[54] He was most anxious to see her response to his landscape, sure that its beauty would compel her to paint.[55]

Ansel himself longed desperately for inspiration for his photography. He hoped that some would rub off on him from O'Keeffe and Stieglitz, as happened when he was with Edward. Although he kept on with his life and its multifarious projects, he continued in a profound depression. Nothing had filled the hole in his heart left by Patsy. He had made many negatives since his show at An American Place, but few prints; he associated the darkroom with Patsy. Those prints that he did make seemed to him dull and lifeless.[56]

The group rendezvoused in Carmel, and Ansel took them to spend an evening with Edward, Charis, and their twenty-six cats.[57] By the sixth of September, they arrived in Yosemite, where Ansel had reserved the best rooms at the Ahwahnee. Their first full day in the park, they drove to the sequoia grove in Mariposa for lunch and then up to Glacier Point for dinner. Under a full moon, Ansel lay the expanse of the High Sierra at their feet. This was the best present he could give such friends.

McAlpin dismissed the scene as bleak, a reaction that bewildered Ansel.[58] Then, to his even keener disappointment, Ansel discovered that O'Keeffe had not brought any painting or sketching materials. She saw this as a vacation, pure and simple.[59]

On September 11, they headed out on horseback along the Tenaya Creek Canyon, then zigzagged up the steep trail to Snow Creek Valley and pressed on to their first campsite, at Tuolumne Meadows.[60] Ansel had taken care of everything, hiring a crew of four men, including a good cook and guide, plus fourteen mules to haul the food, gear, and

photography equipment they would need for the seventeen-day trip.

Ansel's itinerary traced out what he considered to be the best route possible. From Tuolumne, they went on to Cathedral Lake and Fletcher Lake, crossed Vogelsang Pass, and continued along the Maclure Fork of the Merced River to the Isberg Pass Trail. The centerpiece of the trip was their campsite at the Lyell Fork of the Merced. When Ansel let it slip that the mountain above them would someday be named Mount Ansel Adams, O'Keeffe would not let him live it down, ribbing him mercilessly that now she knew why he had really brought them there.[61]

Too soon for Ansel, time was up. Horses and riders threaded their way down past Washburn Lake, Nevada Fall, and Vernal Fall, then along Happy Isles to the valley floor. The next day Ansel drove them to San Francisco for a farewell dinner and overnight at the Fairmont Hotel, and then they were gone.[62]

With their departure, Ansel had to face his real financial life worries. He received a commission to make some huge murals (a total area of two thousand square feet) of other photographers' negatives for the upcoming San Francisco 1939 World's Fair.[63] Although this was not what he really wanted to do with his time, the money it paid allowed him to purchase a mercury-argon enlarger with a twenty-thousand-volt transformer, which made a great difference in his prints, investing them with a quality previously unequalled in terms of their increased tonal range and contrast.[64] (In future years, Ansel would progress to a tungsten light source and then a Ferrante codelight; today, fiber-optic sources are top-rated.)

Almost at the same time, he switched from the Agfa Brovira (silver-bromide) paper he had used since the Stieglitz exhibition to higher-contrast silver-chloride papers. In addition, he began toning his prints with both selenium and gold to increase their permanence and add a hint of warm color, arguing that subtle toning brought greater force to the image.[65] Untoned prints became anathema to him, and from this time on he found it difficult to enjoy Edward's work, which was always untoned and whose blacks, Ansel complained, possessed a greenish cast that struck him as ghoulish.[66]

Ansel had felt that without the inspiration of Patsy in the darkroom,

his prints no longer sang with light, but the new enlarger, silver-chloride paper, and toning changed all that, as did the passage of time and with it his acceptance of his situation. He washed that woman right out of his hair with a total change of equipment from what he had used when they worked together. Giddy with delight, he trumpeted the good news that his new prints were a thousand percent better than before in letters to Edward, McAlpin, and O'Keeffe.[67]

While studying piano twenty years earlier with his teacher Marie Butler, he had learned how important was the relationship of each note to the one before it and the one after. Now he applied the same concept to his photography. In Group f/64 he had learned to play all eighty-eight notes, in photographic tonal terms; at that time, it had been his goal that every print should move from bright white to deep black, with as many intermediate shades as possible joining the display. He now concluded that a bravura performance was not necessarily consistent with the best expression of all prints; what was most important was the relationships between the tones, not their range.

For the publication of *Sierra Nevada: The John Muir Trail*, which finally appeared in late 1938, Ansel employed everything he had learned about fine printing from Albert Bender. When the picture proofs arrived in Yosemite that summer, Ansel laid a trimmed proof next to one of his original trimmed photographs and dared all who visited to tell which was which.[68] He proved such a stickler that the book was delayed seven months to allow for the reprinting of those images that were not of the quality he sought. All fifty photographic plates were tipped in to each copy, as in *Making a Photograph*.[69]

It was a big book, weighing ten and a half pounds and measuring seventeen by twelve and a half inches. The reproductions were nearly eight by ten inches, or contact size for most. Only five hundred copies were printed, at a publication price of just fifteen dollars. Today the book is difficult to find and can command well over a thousand dollars.

Although some of their cohorts in the Eastern intelligentsia remained unmoved by these photographs of the natural world, skewering them with such musings as Where are the people?[70] Stieglitz proclaimed them perfect, and the toughest audience of all, O' Keeffe, sent

warm compliments.[71] (Given their responses, it seems a conundrum that Ansel's "perfect" photography did not rate another American Place show.) Expressing the opinion of a man at home in those mountains, Francis Farquhar wrote, "Here, in bright light and in rare clarity, is to be found the very essence of the Sierra."[72] With the publication of *Sierra Nevada: The John Muir Trail*, Ansel was roused from his depression for good.

11

PROGRESS

Spurred on by his photographic trips with Ansel and the almost constant stream of letters between them, David McAlpin had been badly bitten by the photography bug. In February 1939, he sent a thousand dollars each to MoMA and the Metropolitan Museum of Art, stipulating that it be used for the purchase of photographs.[1] Keeping his intentions to himself, he cast his bread upon the two ponds and watched to see what would happen. The reactions spoke directly of the very different personality of each museum.

The Metropolitan held a meeting of its trustees to decide if photography was worthy of its august walls. Perhaps the board's conservative scale was tipped by the gift, for it conferred upon photography the title of "Art." The money was carefully parceled out over the next few years for important purchases of historical consequence (that is, Photographs by Dead Photographers).[2]

At MoMA, meanwhile, the money burned a hole in Beaumont's pocket. He walked out the museum's doors, crossed Fifth Avenue, and strode four blocks north to the Delphic Studios, where he bought out the entire fifty-print show of László Moholy-Nagy for five hundred dollars, the museum's first major acquisition of photography.[3]

Newhall's purchase appalled Ansel, who had every right to feel midwife to the McAlpin/Photography relation. For Ansel, Moholy's vision was ugly, and so was its expression in his prints: weak tonal range, unspotted, overenlarged, cut-and-pasted (precursor of the Starn Twins).[4] These photographs represented the degeneration of photography and were the opposite of everything Ansel stood for.[5]

A highly influential artist and educator, Moholy had taught at the Bauhaus in Germany during the 1920s, left Germany to escape Hitler in 1934, and finally settled in America, where he founded the New Bauhaus in Chicago in 1937, followed by the School of Design in 1939.[6]

Moholy worked in most media, but photography was his focus. Compared to many of the other arts, photography was new and unencumbered by stultifying tradition. He reveled in that freedom and declared open season on all existing convention.[7] Moholy challenged what a photograph could be, making photograms, or cameraless pictures, by exposing a sheet of printing paper covered with various objects to light in the darkroom. He positioned his camera to capture unusual viewpoints, shooting from the ground, from high above, even sideways, but rarely from the typical straight-on vantage.[8]

Of the true avant-garde, Moholy believed that art should be used for social change.[9] Ansel, in contrast, felt that art must be created free from any intention other than the creation of beauty. On one thing they would agree, however: Moholy's statement that "Art is the most complex, vitalizing, and civilizing of human actions. Thus it is of biological necessity."[10]

Ansel had never come face to face with Beaumont Newhall. Now, with what he saw as the Moholy fiasco, he deemed it time for a showdown. For their part, Beaumont and Nancy were just as curious about Ansel, and they agreed to meet him for lunch in front of the museum in

May 1939. As they approached, both Newhalls were startled to see a tall, thin man dressed in black performing a juggling act with a shiny silver tripod. Thrilled with his new gadget and oblivious to the spectacle he made, Ansel put the tripod through its paces, tilting the head every which way, shooting it up to its full height and then collapsing it to tabletop size.[11]

With some trepidation, the Newhalls identified themselves, and the sartorially mismatched trio set off for lunch at the Café St. Denis, Beaumont dressed in tweeds, Nancy in a stylish suit, hat, and heels, and Ansel wearing his black cowboy hat pulled low on his forehead, his tripod bouncing off the sidewalk with each step. The lunch proved a lovely beginning, with nonstop talk about photography oiled by a few drinks, the atmosphere companionably thick with smoke from all three's cigarettes. The friendship between Beaumont and Nancy and Ansel, and the projects it was to inspire, would become the most significant of their professional lives.

Ansel was in New York to attend the opening of MoMA's new building at 11 West Fifty-third Street and its inaugural exhibition, *Art in Our Time*. Beaumont was the curator for the photographic portion, dubbed "Seven Americans," featuring photographers who had begun working in the past twenty years: Berenice Abbott, Ansel Adams, Harold Edgerton, Walker Evans, Man Ray, Ralph Steiner, and Brett Weston.[12]

After lunch, Beaumont shepherded Ansel through the show, and Nancy returned to their apartment to work on an essay on modern American architecture. At about four, Nancy's phone rang, and the caller identified herself as Georgia O'Keeffe. Nancy's heart almost stopped: O'Keeffe was her favorite painter. O'Keeffe coolly asked Nancy, whom she addressed as Mrs. Newhall, to inform Beaumont and Ansel that they were invited for cocktails, adding that Nancy was not invited because she was not important, was simply a wife. Nancy reacted humbly. She delivered the message to Beaumont and Ansel and returned to her writing.[13]

Ansel and Beaumont happily accepted O'Keeffe's invitation and arrived to find McAlpin rounding out the group of five. Over drinks,

McAlpin suggested that they have supper at his club, the River House, after which he announced that he had rented a speedboat to whisk them to the newly opened World's Fair. Stieglitz declined and returned home to bed, but O'Keeffe and her three escorts sallied forth. As they approached the site, fireworks embroidered the sky, lighting their up-turned faces, each filled with anticipation.

When they got to the fair, O'Keeffe and McAlpin settled into rolling chairs to tour the grounds, but Ansel and Beaumont would have none of that. They scampered ahead, behind and at the sides of the chairs, egging each other on with acrobatic leaps and twists and impromptu races.[14] The sillier one acted, the crazier the other would become. Ansel had thought Beaumont a staid New Englander, but found that he was instead the Heckle to his Jeckle. Their friendship, though based on photography, was strengthened by their mutual love of fun, which made it easy for them to have a good time when they were together. Before that night they had respected each other; now they trusted each other, each an only child finding his true brother.

During that full month of May that Ansel spent in New York, he discovered that "that man from the museum," as Stieglitz described Beaumont, had flaws other than his admiration of Moholy. Although he was flattered that eight of his photographs had been included in the total of fifty-three for "Seven Americans," he did not like Beaumont's installation, which displayed each photographer's work on a different-colored panel. To Ansel's eye, the colors warred with the images rather than set them off, as had the pale-gray walls at An American Place. Beaumont defended his presentation, arguing that the museum was an experimental laboratory on behalf of art—and besides, he asked, didn't Ansel find black-and-white photographs on white walls boring?[15] No.

Ansel was not the only photographer to question Beaumont's installation. Walker Evans was so upset that his work was to be placed on a red panel that he threatened to remove his photographs from the show unless Beaumont let him hang them himself. Beaumont agreed, and Evans mounted each of his prints on a very large white mount board that covered up every bit of red.[16]

Evans was a photographic presence to reckon with. One of the pla-

toon of photographers who worked for the Farm Security Administration during the Depression, he unemotionally documented rural America, placing his unflinching camera directly before each subject, be it a billboard, an old house, or a worn face.

When Evans was awarded the first-ever solo photography exhibition at MoMA in 1938, Ansel took offense.[17] Perhaps adding to his ire was the fact that he and Evans were the same age, and it was Evans who first got the big museum show, even though Ansel had been honored by Stieglitz, who had no use for the other man.

Like Ansel, Evans counted Paul Strand among his greatest influences. However, Evans had been deeply affected by Strand's subject matter, in particular a photograph of a blind woman with a crude sign hung around her neck.[18] Ansel never talked about Strand's subject matter; rather, he revered Strand's technique and composition.

Ansel returned to California in mid-June 1939 to a summer lineup of commercial jobs, as well as preparations for a solo exhibition at the San Francisco Museum of Modern Art, scheduled to open on September 19. Ansel was eager to play to his own home crowd, writing to both Stieglitz and McAlpin that until this show, he had been a prophet ignored in his own land.[19]

Fortune magazine commissioned him to do two stories, one on the Del Monte Forest in Monterey and the other on the Pacific Gas & Electric Company. Ansel traveled fifteen hundred miles to fulfill these assignments; on his return he shipped off 120 prints, more than enough for two major picture stories. The magazine was known to pay handsomely, and he awaited the check that he expected would support him for three or four months.[20] As can be typical in such situations, however, *Fortune* chose to use only a few images, for which Ansel finally received two hundred dollars.[21]

That summer, Ansel also photographed both the new Patent Leather Bar at the Saint Francis Hotel and Picasso's *Guernica* (temporarily on view in San Francisco) and produced a photographic portfolio of the murals of Maurice Sterne (one of Mabel Dodge Luhan's exes) and another of the sculpture of Benny Bufano.

For years now, Virginia had played only a minor supporting role in

Ansel's life. Responding to her complaints, he decided to develop some joint projects for the two of them. They began work on a children's book, with photographs by Ansel and text by Virginia, that took as its subject their own children. *Michael and Anne in the Yosemite Valley* was published in 1941.[22] The book shares an idyllic day in the life of six-year-old Michael and four-year-old Anne, who live in Yosemite Valley, where they play Indians, see deer, birds, and bear, and visit a newborn colt. At the end of the day, their faces scrubbed and shining, seated at their formally appointed dining-room table (set with candles, crystal salt and pepper shakers and ashtray, the salad course before them and two Ritz crackers on each bread plate), they are invited by their daddy to join him on a camping trip to Tenaya Lake. Dreaming of the High Sierra, they fall asleep as a full moon rises over the valley.

Virginia and Ansel also combined their talents to create the *Illustrated Guide to Yosemite Valley*, which was first published in 1940 but proved so popular that updated editions continued to be released through 1963.[23] Containing everything from the geologic history of Yosemite to detailed accounts of roads and trails, illustrated with Ansel's photographs and clear, graphic maps, the book enabled the newcomer to discover Yosemite through the experience of the Adamses.

Working with the San Francisco Museum of Modern Art on his autumn 1939 show proved a real challenge for Ansel. Learning that the exhibition had been assigned the usual corridor space reserved for photography, Ansel made a scene: either they gave him a proper gallery, or the exhibition was off. The museum capitulated.[24] He had to raise another ruckus before the museum agreed to purchase glass in the same size as his prints; it had planned simply to use the odd sizes it had on hand. The problem was not resolved until Ansel contributed half the money. He also had to pay for the announcements, but he could not afford a catalog.

Acting as his own curator, Ansel planned this show as a retrospective of his work over the past few years, titling it *Recent Photography of Ansel Adams*. He opened the exhibit with a mural of a tombstone incised with a hand whose index finger pointed heavenward or, in this case, toward a Stieglitz quote stenciled on the wall: "Wherever there is

light one can photograph." Next came a selection of New England images that he had made while photographing with McAlpin, then some photographs of Sierra mining towns. Only eleven images were Yosemite landscapes.[25] Clearly, Stieglitz's web still held Ansel tightly as he chose pictures along the same lines as those he had shown at An American Place three years earlier.

On the evidence of this exhibition, Alfred Frankenstein, the esteemed art critic for the *San Francisco Chronicle*, declared the city's native son a living master.[26] Having heard similar raves from the press in New York and Chicago, Ansel happily received the local accolades as long overdue.

That fall of 1939, Tom Maloney came from New York to visit Ansel in San Francisco. As publisher of *U.S. Camera* magazine—the biggest, glossiest, and most popular photo magazine of the day—Maloney had his fingers in many photographic pies. Ansel drove him down to Carmel to meet Edward, with terrific results: Maloney agreed to publish a book of Edward's Guggenheim photographs, with text by Charis, to be called *California and the West*.

Talking his customary mile a minute, Maloney also made some deals with Ansel. He appointed him an editor of *U.S. Camera*, along with Edward Steichen, Paul Outerbridge, and Anton Bruehl, and offered to sponsor Yosemite photographic workshops under his direction.

Maloney had something else in the works as well. The year before, in 1938, San Francisco had decided it was time to party, announcing a two-year-long Golden Gate International Exposition to celebrate the completion of the city's two great bridges, the Golden Gate and the Oakland Bay.[27] The 1939 version of the fair boasted a huge fine-arts section, but to Ansel's dismay, fine photography was ignored. (The huge murals he had made for the fair in 1938 had been in the service of illustration.) Maloney now threw his weight behind the initiative to include a major photography exhibition in 1940.

In early April 1940, Ansel received a phone call from the head of fine arts for the fair, who offered him a position as director of the photography exhibition. With the title came six galleries, sixteen hundred dollars, and a secretary, "a very attractive Italian girl who spells 'f' with a 'ph.' "[28] Ansel leapt at the chance.

Proper stationery was always an Adams priority, and by April 15 his letterhead was ready, announcing "A PAGEANT OF PHOTOGRAPHY" at the top, and "ANSEL ADAMS DIRECTOR" below it in smaller type. Opening day was set for May 25; Ansel had just five and a half weeks to mount a massive and, he hoped, important show.

Emulating Beaumont's exhibition scheme for *Photography 1839–1937*, Ansel organized the six galleries thematically: History of Photography; Technological Photography; Color Photography; Contemporary Photography—American; Contemporary Photography—California; and History of the American Movie (the only section he did not curate). The inclusion of a gallery of Technological Photography did not exactly square with his campaign to establish photography as a fine art, but Ansel had been influenced in this matter by Beaumont. The addition of non-art photography, though in a separate section, was one of Beaumont's consistent curatorial choices throughout his career.

Pulling this show off in such a short time, Ansel knew, would require a prodigious amount of work. First he contacted his mentor, praying for a coup, but Stieglitz declined to send his photographs even after Ansel implored him, "God, Stieglitz, this is the chance to do something. I'll paint the gallery any way you say. We have guards; it'll be perfectly safe. And if you'd only—"[29]

It certainly helped that Ansel was friends with almost all the photographers he invited, because it was asking a lot to expect exhibition-quality prints to be shipped to him on such short notice. Edward Weston, Paul Strand, and, surprisingly, Moholy-Nagy all came through. Ansel still did not like Moholy's photographs, but he knew they were considered important by the art establishment.[30]

Ansel was forever proud of *A Pageant of Photography*. Forty-two years later, he remembered, "Boy that was an awful hard job, but it was a contribution, and that's what brought, for the first time, photography in many of its approaches, to the attention of the people in the West."[31] Indeed, millions viewed the exhibition—which was millions more than had seen Beaumont's own *Photography 1839–1937* during its San Francisco run.[32]

Ansel dedicated the exhibition's handsome catalog (which modestly

contained only one image by its curator) "To Alfred Stieglitz who has devoted his strength and spirit to the advancement of photography." One major snafu occurred in printing the catalog: in Beaumont's essay, "Photography as an Art," a few lines were inadvertently dropped, so that instead of reading,

> Alfred Stieglitz received his first medal from Emerson. He too discovered that photography has its limitations. Instead of accepting defeat, he has for over fifty years been promoting photography, trying to understand it and then overcoming the problems of photographic reproduction.

the catalog actually read,

> Alfred Stieglitz received his first medal from Emerson. He too discovered that photography has its limitations. Instead of accepting defeat, he has for over fifty years been overcoming reproduction.[33]

In New York, Beaumont opened his newly arrived copy of the catalog and settled down for a good read. A jolt coursed through him as he caught the error. He determined that he must go to Stieglitz immediately, before he read it for himself, and explain that it was a mistake and not in his original text. Very straightforwardly, he told Stieglitz, "A colossal mistake has been made. I can't blame Adams, although he was responsible for the book and the printer. But look, I want to show it to you before you find it." After reading it, Stieglitz calmly replied, "You know, I think that's a very fine statement. Perfectly true. Perfectly true."[34] It was a rare indication that Stieglitz was actually possessed of a sense of humor.

Although deeply embarrassed by this mistake, Ansel kept its importance in perspective. He remembered a historical precedent at the 1915 Panama-Pacific Exposition, where the description of the Brazilian Pavilion in the catalog had instructed readers to "Go into the patio and enjoy coffee and mate." The crucial acute accent in the name of the beverage maté had been omitted.[35]

The realities of day-to-day life continued in Yosemite. Best's Studio was not thriving; with war in the air, few people traveled, most preferring to stay close to home. In 1940, two other businesses competed with Best's for the same market for photographic supplies, print finishing, and print sales: Yosemite Falls Studio and Boysen Studio.[36]

On each of his trips east, Ansel had visited Washington, D.C., to meet with officials in the National Park Service, building friendships and security for Best's Studio's continued status as a concession. Confident of the regard in which he was held in Washington, back home in California, Ansel fired off stinging letters of criticism about decisions that he felt compromised Yosemite's integrity: stringing power lines across valley meadows, cutting additional roads through valley forests, adding more and more campgrounds to accommodate eager crowds.[37] His actions upset Virginia, who could not understand how he could place Best's future in such jeopardy by chancing the alienation of the very people from whom they needed approval.[38]

The May 1940 issue of *U.S. Camera* carried a full twelve pages touting the *U.S. Camera* Yosemite Photographic Forum, to be held that summer under the personal direction of Ansel Adams. Next to a full-page portrait of Ansel's face, deep laugh lines already etched about his eyes, a caption claimed, "Ansel Adams is not only one of America's great photographers, he is also one of the few who can lucidly present his experience and ability in a way that makes him a great photographic teacher."[39] It was all true.

Assisting Ansel would be such photographic luminaries as Edward Weston, Dorothea Lange, Charles Kerlee (a photo-illustrator), and Rex Hardy, Jr. (a photographer for *Life*). The cost of the workshop, not including room and board, was fifty dollars for one week, eighty-five for two, or all four weeks for $150.

But as Virginia could probably have told them, Americans were not traveling. Even with the promise of such a star-studded faculty, only twelve participants signed up. The workshops proceeded in abbreviated form: only Ansel and Edward taught, with Charis serving as the photographic model.

The same summer, Nancy and Beaumont Newhall decided to vacation in California.[40] After a grueling cross-country train trip without

benefit of sleeper seats, they arrived, unbathed (both) and unshaven (Beaumont), in San Francisco. They told their taxi driver that they needed a hotel, and it must have a bath. The place where he deposited them was scruffy-looking, but at least it had hot running water.

After making themselves presentable, which for Nancy meant donning a snappy white suit and broad-brimmed straw hat, they telephoned Ansel at Skyline 1-1282—a fitting exchange name, they thought. When they told him they had already checked into a hotel and gave him their address, he shrieked at them to stay put until he could get there.[41] They had landed in a notorious brothel, and Ansel feared for their lives. He drove down in his new Pontiac station wagon, scooped up the Newhalls and their luggage, and took them to the Saint Francis.

Ansel appointed himself their tour guide and bodyguard, convinced these New Yorkers were babes in the woods in his particular forest. He took them home to meet the family: Virginia, Michael, Anne, and, next door, Carlie, Ollie, and Aunt Mary. They had cocktails at the Top of the Mark and watched the fog creep in through the Golden Gate, blanketing the city beneath them as the sun set. They visited Ansel's *Pageant of Photography* show and judged the content excellent but the installation rather boring: none of the brightly colored walls that they preferred, and the photographs hung à la Stieglitz, all in a line, rather than in various patterns, as Beaumont arranged images at the museum. On exhibition design they continued to be at odds with their friend.[42]

Ansel escorted them down to Carmel to meet Edward and Charis, and on the way followed the slow and scenic Highway One along the coast. Just about noon, north of Santa Cruz, he pulled the car off the road and suggested that the Newhalls join him for a spate of photography. They stood on a sheer cliff that dropped cleanly to a small rocky beach below. Entranced by the white surge of surf as it moved with each wave across the dark, wet sand, Ansel tilted his four-by-five-inch camera steeply downwards. Moholy's influence had spread to Ansel, even if unconsciously.

Deciding that only a sequence of images could provide an adequate equivalent to what he was seeing, he exposed nine sheets of film using

a long-focus lens (a 250mm Dagor). Because of the telescoping of visual planes caused by the lens, and because there was no horizon to serve as a reference, each exposure revealed a two-dimensional and nearly abstract pattern of light and shadow. Anticipating the resolution of each wave proved difficult, but back in his darkroom, Ansel concluded that five negatives were suitable for the sequence.[43]

And what a pain it was to print! This is why there are so few sets of *Surf Sequence*, probably twenty-five at most. Ansel required that each finished print appear to be graced by the same light, though over the twenty minutes it took to make the negatives, the sun's intensity and position changed. Ansel had to call on all his darkroom skills of legerdemain to make the values consistent. Each print in the sequence also had to have the same measurements as all the others; Ansel began with the image that needed the most cropping and then cropped the rest to those dimensions, with little compromise to any photograph.[44]

Surf Sequence (1940) was a continuation of the aesthetic that Ansel had discovered with *Monolith* (1927) and expressed again in *Frozen Lake and Cliffs* (1932). With these photographs, he transcended his role as respected conduit of America's landscape and became the interpretative oracle of a higher dimension.

Ansel would not let Beaumont and Nancy miss Yosemite, though they regarded it as a place of postcard pretensions that they believed they could do without.[45] But Yosemite took them by surprise. As the car rounded each new bend, they were staggered by fresh marvels: Half Dome, El Capitan, waterfalls, forests, the Merced River. Nancy found that Virginia had transformed Best's Studio into an extraordinary shop. Classical music played, a fire burned in the big stone fireplace, and the glass cases held a tempting array of fine Indian silver and turquoise jewelry alongside the expected photographic equipment. Piles of Navajo rugs lay next to cases of fine books all germane to the location, on subjects ranging from Yosemite to the national parks to environmental concerns. One of Ansel's folding photographic screens concealed the stairway to the family's simple living quarters behind the studio. Through its windows wafted the deep voice of Yosemite Falls, not far distant, and the perfume of incense cedar.[46]

After each day's exploration of Yosemite with Ansel, they returned to long hours of drinks, dinner, and conversation. The main subject became MoMA and photography, as together they constructed a plan for a formal Department of Photography. There was no precedent; it would be the first of its kind in a museum.

Early one evening, soon before the Newhalls were to depart, Ansel drained the last of the bourbon in his glass, rose from his chair on the porch, flung the remaining ice cubes into the bushes, and announced that he was going to telephone McAlpin, who not only was the money man but also had direct access to the museum's board of trustees.[47] Ansel's excitement carried without diminution over the transcontinental line to New York, there to catch fire.

12

A DEPARTMENT
OF PHOTOGRAPHY

Events progressed rapidly following the Newhalls' return to New York in the late summer of 1940. With the museum's consent, McAlpin donated money to found a department of photography, with himself as chair of the advisory committee and Beaumont as curator. But McAlpin's agreement was conditional: he would do it if, and only if, Ansel consented to be his vice chairman and came to New York for six months to get things going.[1] McAlpin would pay his expenses, plus a stipend.[2] Eager to continue this particular adventure, Ansel accepted, though for only two, not six, months.

Everyone believed that America's entry into the war was exceedingly close. Ansel, McAlpin, and Newhall were determined to open the department and mount its first exhibition as soon as they could, fearing that if war came it might be quite some time before they would have another opportunity. On short notice, they succeeded in reserving 150

running feet of museum space for two weeks, from December 27, 1940, to January 12, 1941.[3]

McAlpin asked Ansel how much money he would need to be paid while working on setting up the department. Ansel answered that three hundred dollars a month should suffice; he was hoping just to break even.[4] Although he was always near desperation for money, Ansel would accept no more than an equitable sum for the equivalent amount of work.

Ansel's train pulled into New York just past dawn on October 14, 1940, after three nights of cross-country travel. A taxi dropped him and his considerable luggage at the curb in front of the Newhalls' apartment, where he was to stay. Glancing at his watch and glumly deciding it was too early to wake them, he sat down on his suitcase to wait, his overcoat, typewriter, briefcase, tripod, flash equipment, and four cases full of cameras and film piled about him. Meanwhile, the Newhalls were wide awake inside and wondering where Ansel could be. One look down from their window told the story.[5] They ran down the stairs, greeted him with hearty hugs, and trudged back up with his accoutrements.

Ansel settled in comfortably with the Newhalls. For one thing, they were all three "cat people." Ansel's San Francisco domicile was ruled by the imperious Bill and the unruly Thunderpot, while the Newhalls shared their quarters with a feline genius named Euripides, who preferred to use the toilet, not a litter box, completing each visit with a futile paw-thrust toward the toilet paper.

Ansel plunged into a frenzy of activity. One of his responsibilities was to court the support of the photographic community for the fledgling department. Tom Maloney threw a grand cocktail party in his honor, attended by two hundred photographers, where Ansel pressed the flesh and spread the gospel. He spoke at the Clarence White School of Photography and at the Photo League, the vanguard photography "club" in New York. Beaumont and Ansel also visited with executives at Eastman Kodak to garner support, both moral and financial. Finally, Ansel was expected to keep Stieglitz informed and involve him in any way possible.[6]

Ansel took charge of readying the gallery they had been given for the first exhibition. He had the walls painted gray, and floating panels built to hang the pictures on, painted a shade lighter than the walls. In a nod to the Newhalls' penchant for color, the ceiling was cobalt, and one small alcove a pale blue.[7]

Co-curated by Beaumont and Ansel, the inaugural offering, *Sixty Photographs: A Survey of Camera Esthetics*, was a historical overview exploring the potential of creative photography.[8] The process of selecting the photographs, all from the museum's burgeoning collection, strained Beaumont and Ansel's friendship, but each relented enough to allow for the other's differing opinion.[9] Time and Ansel's influence had eroded Beaumont's Harvard-instilled European bias: of the thirty-one photographers whose work was chosen for this show, twenty-two were living Americans, though three of this number, Moholy-Nagy, Lisette Model, and Henwar Rodakiewicz, were recent émigrés from Europe. Eight deceased photographers, five European and three American, were shown: Eugène Atget, Mathew Brady, Peter Henry Emerson, David Octavius Hill and Robert Adamson, Henri LeSecq, Timothy O'Sullivan, and Clarence White.

Even from a perspective more than half a century distant, the list of photographers remains impressive. In addition to those mentioned above, it included Berenice Abbott, Ansel Adams, Ruth Bernhard, Henri Cartier Bresson, Harold Edgerton, Walker Evans, Arnold Genthe, Dorothea Lange, Helen Levitt, Dorothy Norman, Eliot Porter, Man Ray, Charles Sheeler, Peter Stackpole, Edward Steichen, Alfred Stieglitz, Paul Strand, Luke Swank, Brett Weston, and Edward Weston.[10]

Every time, the eye stops at Luke Swank. Luke who? Swank was an architectural photographer whose prints of the famous Kaufmann House, known as Fallingwater, were already on exhibit at the museum as part of a Frank Lloyd Wright show. Of all thirty-one names, his is the only one not linked to a body of work that has endured as a significant contribution to photographic art.

Ansel himself made the prints exhibited for the elderly Arnold Genthe, who admitted that he had no good existing examples, and for Dorothea Lange, represented by her great *Pea Picker Family*, now

known as *Migrant Mother*.[11] Beaumont insisted upon including Moholy's *From the Radio Tower, Berlin*, of 1928, though Ansel argued that it was a lousy print. Moholy graciously acceded to their request for the negative, and Ansel turned his full darkroom powers upon it, only to find that his version revealed details in the shadows and highlights that distracted from the impact of the image. He tore up his effort and grudgingly agreed to exhibit the original print.[12]

Ansel took little credit for the exhibition, stepping aside so the spotlight could shine on Beaumont. The exhibit and new department were described in the catalog in an article signed by Beaumont alone, and since he had to be in Yosemite to direct the Bracebridge, Ansel was not even present at the opening brouhaha with its attendant press coverage.

New Yorkers were definitely interested in photography. Five hundred people, considered a big turnout, came to the exhibition's opening.[13] But though *Time* heralded the importance of the new department, which put the medium on equal footing with painting and sculpture, praise was not forthcoming from the entrenched photographic press.[14] In an indication that the road for the first-ever department of photography would not be smooth, Tom Maloney authored a scorching review of *Sixty Photographs*. Noting that Beaumont had to continue his duties as librarian in addition to serving as curator of photography, Maloney questioned the museum's commitment and warned that in reality, photography got no respect at MoMA.[15] And as to the selection of the sixty photographs, he complained about the bias toward the "ultramodern."[16]

To understand how photographically conservative was the influential Maloney, a close friend of the powerful Edward Steichen (who had become the most successful commercial photographer in America), one must take a closer look at what it was that he condemned. The offending photographs were by Cartier-Bresson (a prime example of one of his "decisive moments," *Children Playing in Ruins*), Man Ray (a cameraless photogram, or, as Man Ray egotistically preferred to call it, a Rayograph), Moholy-Nagy (*From the Radio Tower, Berlin*), and Edward Weston (*Tide Pool, Point Lobos*), all long since acknowledged as masterpieces of photography.

Just before it was time for Ansel to return home, he and Beaumont agreed that it was high time for Nancy to meet Stieglitz, though she protested mightily, calling the old man a "sadist, a Svengali . . . a charlatan!"[17] Each taking an arm, they pulled her along to the encounter she had long dreaded. Confounding her expectations, Stieglitz was not simply cordial, but charming.[18] Stieglitz loved the attention of pretty and intelligent women, and Nancy fit right in. She visited Stieglitz at An American Place almost daily for the next two years and soon decided to write his biography, a project that she unfortunately never completed.

In Yosemite, on March 4, 1941, Ansel received a telegram informing him of the death earlier that morning of Albert Bender.[19] Ansel was deeply saddened and full of guilt because all his recent activity had left little time for Albert. He had not even known that he was sick.

Ansel at once drove to San Francisco. Albert had left instructions for his friends to hold a true Irish wake, complete with rivers of Scotch and piles of sandwiches, before the funeral at Temple Emmanuel. Ansel manned the last, early-morning hours of the vigil as nameless people of the night—watchmen, police, and elevator operators, all given a hand up at some time by Albert—came by to pay their respects. Even Ansel, who felt he had known Albert very well, was surprised by the multitude of people, of every race and creed, that his friend had helped. Five thousand mourners attended Albert's funeral.[20]

In April 1941, Ansel returned to New York and to the ecstatic Newhalls: Nancy was newly pregnant, the baby due in November. New York City was now gripped by fear. It appeared that Hitler's blitzkrieg might conquer England, and many were convinced that New York, an island of skyscrapers especially vulnerable to aerial bombardment, would be next. But still, Ansel sensed that most Easterners hoped America could stay out of the war.

As usual, Ansel larded his time on behalf of MoMA with more lucrative commercial jobs. On assignment for *Fortune* to photograph Union Carbide's carbon arc furnaces in Alloy, West Virginia, he found huge tracts desecrated by man's ravenous appetite for resources, consequences to the land be damned.[21]

His months in the East left him appalled at the natives' general apathy toward the world's condition. He believed it had something to do with the blighted landscape, paved as it was with concrete, scarred by factories and mines, clouded by pollution, and coated with a dense population. Ansel reasoned that Easterners held the American earth in contempt. All he had to do was look out any window in New York City to see the perpetration of ugliness, and therefore the wanton destruction of natural beauty. He held the abiding conviction that the American people would become empowered if they could experience the vast wealth of beauty west of Chicago, still boasting clean air and great open spaces with an array of untouched landscapes. Photography could show them the way.[22]

Ansel proposed two exhibitions to Beaumont, *Photographs of the Civil War and the American Frontier*, to illustrate a necessary American war and the expansionism that had followed, and *Image of Freedom*, a photographic competition centering on the question, "What, to you, most deeply signifies America?" Both ideas were greeted enthusiastically.[23]

Ansel journeyed back to Yosemite for the early summer but returned to New York in August. Beaumont and Nancy, now bulging proudly with their baby, welcomed him with great joy. Projects for the department progressed along with her pregnancy.

Ansel continued to act as the department's outreach teacher. When the Detroit Miniature Camera Club invited him to lead a workshop in late August, he and Beaumont felt it would be righteous work.[24] That members of such clubs, some of the last remaining bastions of pictorialism, were willing to pay the mouthpiece of straight photography to learn at his knee struck both men as evidence of significant movement.

The Detroit workshop had a radical effect on the life of one Harry Callahan, a young clerk at Chrysler and amateur photographer who took Ansel's counsel seriously. Previously cognizant only of pictorialist traditions, Callahan felt freed by Ansel's call to straight photography: view-camera negatives exposed into unmanipulated contact prints of superb technique, on glossy paper, of subjects from the life and earth about him. Shyly and wisely, Callahan declined to share his pho-

tographs at the class critique. Instead, he took copious notes and during the next year adopted the master's technique as faithfully as possible.[25] Others in the workshop became so upset that one man said it took him ten years to recover from Ansel's "merciless" comments.[26]

Ansel showed them his newly made *Surf Sequence*, and its impact on Callahan was enormous. He reacted to Ansel's sequence from nature by applying the principle to his own urban world. In Highland Park, a factory town just north of Detroit, Callahan set up his camera to frame a stairway running up the side of a particularly geometric wall, and made a series of exposures as people ebbed and flowed.[27]

The writer John Pultz has observed that where Ansel had photographed a closely viewed near-abstract of bright grasses emerging from a dark, still pond, Callahan responded by making an image of even higher contrast and completely reversed values, with dark weeds set against a field of absolute whiteness: snow. Years later, when Ansel saw this print, he insisted on buying *Weeds in Snow* from Callahan, whose work during the next year would expand into his own unique style. He became one of the most important photographers of the mid-century as well as one of the medium's most significant teachers, from the Institute of Design in Chicago to the Rhode Island School of Design.

In early September, Ansel returned to New York to assist with the judging for *Image of Freedom*, though he excused himself as an actual jury member. One hundred prints were selected and purchased for twenty-five dollars apiece for the museum's permanent collection. Each print competed anonymously, but at the end it was discovered that all four photographs submitted by an unknown photographer named Minor White had been chosen. The Newhalls and Ansel were struck by the name, which they thought particularly appropriate for a photographer.[28]

Image of Freedom was not the first photographic theme show at MoMA, and it certainly would not be the last. In 1940, the museum had sponsored *War Comes to the People*, a photographic document, by Thérèse Bonney, of the war's effects on Finland, Belgium, and France. Bonney's exhibition was widely regarded as bad photography in the name of a good cause.[29] That Ansel and Beaumont would use their new

department to promote photography whose purpose was primarily propaganda, and not art, shows that even these good souls could be overcome by the need to help.

Feeling like a boomerang, Ansel returned home to San Francisco on October 1 and then headed to Yosemite for just a few days before leaving on a two-month-long trip to the Southwest for a full slate of commercial assignments. The Newhalls cabled tragic news: their baby had died in utero at eight months' gestation. Nancy was told that it had drowned inside her in her hemorrhaging blood; an emergency cesarean section had been necessary to save her life.[30] As soon as he heard, Ansel telegraphed his deep concern to both of them, following up with a good long, affectionate letter.[31]

On December 7, 1941, as the Japanese attacked Pearl Harbor, Ansel was photographing a new Ted Spencer–designed building.[32] Ansel hoped to be commissioned into the military so that his photographic skills could be directly applied toward winning the war; since he would be turning forty in February 1942 and was seen by the government as the sole support of six people (Virginia, Michael, Anne, Carlie, Ollie, and Mary), he was not considered draft material.

Around the time of Ansel's birthday, a phone call from Edward Steichen buoyed his spirits. A director of aerial reconnaissance during World War I, discharged with a bevy of hero's medals, the sixty-two-year-old Steichen had been commissioned as a lieutenant commander at his own insistence. His mission was to form a special photographic unit to document the Navy's use of aircraft. Steichen offered Ansel the job of building and directing a state-of-the-art photographic darkroom and laboratory in Washington, D.C., where the unit's films would be processed and printed. Ansel replied that he would be honored to serve in that capacity, under two conditions: he asked to be commissioned as an officer and advised Steichen that he would not be free until July 1.[33]

To his increasing consternation, Ansel heard nothing further from Steichen, even after he cabled him in June to request clarification of the situation based on their earlier discussion.[34] Ansel did not fully fathom the exigencies of wartime. Steichen waited for no one; he needed his men immediately. All five members of his unit, who came to

be known as Steichen's Chickens since he acted very much the mother hen to his brood, were commissioned as officers and working by early April.[35]

The military decided it could find some use for Ansel as a civilian and gave him a variety of assignments that he judged less than central to the winning of the war. Frustrated, he went from job to job, teaching photography to the troops at Fort Ord, making prints of top-secret negatives of the Japanese forces in the Aleutian Islands, documenting the Ahwahnee Hotel before it was transformed into a Navy convalescent hospital, and photographing soldiers on maneuvers in Yosemite Valley.[36] Artillery guns arrayed before Half Dome provided an eerie subject.[37]

Beaumont, meanwhile, knowing that his time as a civilian was limited, curated a string of exhibitions under the banner of the Department of Photography, including a wonderful little show in December 1941 called *American Photographs at $10*, where original prints by Ansel Adams, Berenice Abbott, Walker Evans, Helen Levitt, László Moholy-Nagy, Arnold Newman, Charles Sheeler, Brett Weston, and Edward Weston could be purchased for a mere ten bucks.[38] (Oh, for a time machine and just a hundred dollars!)

Ansel returned to New York in later February to oversee *Photographs of the Civil War and the American Frontier*. Although Mathew Brady has often received credit for many of the greatest Civil War photographs, Beaumont and other historians knew that Brady himself had made few exposures (for one thing, he was nearly blind). Instead, he employed a brilliant cadre of photographers who went out on assignment, bringing back negatives that Brady copyrighted under his own name. One of these assistants, Alexander Gardner, finally rebelled, leaving Brady in 1863 to become the official photographer for the Army of the Potomac. Gardner in turn hired other photographers, including Timothy O'Sullivan and George Barnard, to create the greatest photographic document of the Civil War, the two-volume *Photographic Sketchbook of the War*. Each photographer received full credit for his pictures.[39]

For much of photography's history, people have assumed that photographs never lie. Beaumont was no less susceptible than most to this

fallacy, vaunting the medium's inherent ability to tell the truth through the example of Gardner's famous *Home of a Rebel Sharpshooter, Gettysburg, 1863.* In this image, a young soldier lies dead, sprawled faceup, his eyes closed, his mouth slightly open, frozen in the motion of his last breath; his jacket is unbuttoned to reveal white shirttails, his rifle propped against the rocky lair that ineffectively sheltered him. This photograph has long been an icon of war and death, and Beaumont's reaction to it was heartfelt:

> Gardner's dead sharpshooter, his long rifle gleaming by his side, is not imagined. This man lived; this is the spot where he fell; this is how he looked in death. There lies the great psychological difference between photography and the other graphic arts; this is the quality which photography can impart more strongly than any other picture making.[40]

Is the power of the photograph diminished today by our knowledge that Gardner moved the body, arranging it to better satisfy his sense of composition? The viewer's perception of an image is completely altered when the possibility of artifice literally enters the picture. The truth about photography is that almost from its inception, photographers have manipulated subject matter, negatives, and prints, whether by moving a soldier's body, scratching detail into the emulsion, printing clouds from a different negative into a previously cloudless sky, or printing parts of several negatives into a seamless, though far from real, whole. Now, with the current technology of digital imaging, no photograph can be trusted to tell the truth about a situation.

After years of further research and experience, Beaumont became more than wary of any photograph's veracity. One of his most popular and often repeated lectures was "The Unreality of Photography," in which he revealed and addressed the medium's inherent nature.[41] Ansel firmly believed in the righteousness of photography to reveal not the obvious truths, but those that lie deeper, and that may be discovered by a photographer with a sensitive eye coupled with a searching

mind. For Ansel, it was one thing to increase an image's power by manipulating tonal values and emphasis through framing and lens choice; he would have thought it quite another to digitally move Half Dome so that it might provide a more "satisfactory" composition.

William Henry Jackson, born in 1843, had photographed the American West for the Hayden Survey between 1870 and 1878; his images of Yellowstone had been influential in the establishment of Yellowstone National Park in 1872.[42] Ansel and Beaumont found the ninety-eight-year-old Jackson living in a New York hotel, very much alive and "full of beans."[43] Again dissatisfied with the quality of older prints, Ansel borrowed a group of Jackson negatives and used them to make "new and improved" prints for the exhibition.

When *Photographs of the Civil War and the American Frontier* opened on March 3, 1942, Jackson was the guest of honor. Making the rounds of the exhibit, he stopped in front of a mammoth eighteen-by-twenty-two-inch plate photograph of an old cart at the Laguna Pueblo and, remarking that it was quite good, asked who had made it. Because Jackson was hard of hearing, Ansel shouted back that he, Jackson, had. With a twinkle in his eye, the old man allowed as how now he remembered.[44] When they came to a group of O'Sullivan photographs, Ansel yelled to ask if Mr. Jackson had known him. Jackson nodded sure, adding that he and O'Sullivan had often traded negatives. At that remark, Ansel caught Beaumont's eye, knowing that this piece of information would forever bedevil his historian's soul.[45]

McAlpin was commissioned as lieutenant commander in the Navy and assigned a desk job in Washington, much to his frustration. His absence from New York was keenly felt. As Beaumont's draft number came closer to being called, he enlisted, hoping that way to get a better assignment. In August 1942, he left for basic training as a first lieutenant in the Army Air Forces.[46] With Beaumont's abrupt departure, Nancy was appointed assistant in charge of photography by a reluctant museum administration, which would have preferred simply to close the department for the war's duration.[47] Ansel assured Nancy that as long as he was free to do so, he would help her however he could. Nancy kept the department alive through the war years, though its

power as an independent entity, negligible even at the war's beginning, steadily eroded.

From boot camp in Florida, Beaumont was sent to Air Force Intelligence School in Pennsylvania. He called and begged Nancy (who needed no begging) to come down for his graduation on October 31; both had a premonition that he would be shipped out immediately. Nancy asked the museum for a short leave of absence and was berated for even considering taking such a trip when she was so new at the job. Heartsick, she wrote Ansel about her predicament.[48] A true friend to both Nancy and Beaumont, he told her to stick by her guns. He affirmed her priorities—Beaumont was number one and photography was number two—and reminded her that she was the center of her husband's world.[49] In the end, Nancy went to Beaumont, and the museum fumed, but nothing more. Ansel held dear Beaumont and Nancy's relationship, so different from his own marriage.[50]

Just before Beaumont left for Egypt, and then Italy, where he worked as an analyst of photographic aerial reconnaissance (a role of vital importance in the winning of the war), he, Nancy, and Ansel drew up a five-year plan for the department. They had not yet presented even one solo exhibition. They had long hoped that the first photographer to be so honored would be Stieglitz, but they finally had to conclude that Stieglitz would continue his teasing game of "Maybe I will, maybe I won't" forever. They decided to offer retrospectives to Paul Strand, Edward Weston, and Ansel, in that order.[51]

In early 1942, Edward Steichen had begun his move to take over the department. Shortly before Steichen reentered the Navy, McAlpin invited him to direct a major exhibition for MoMA, with the assurance that he would have "carte blanche."[52] Neither the Newhalls nor Ansel had been consulted about this unilateral decision. Steichen took the proffered ball and ran all one hundred yards as impresario of the massive exhibit *Road to Victory*. Featuring a text by Carl Sandburg and designed by Herbert Bayer, formerly of the Bauhaus, the exhibit hosted huge crowds from May 21 to October 4, 1942. The museum touted *Road to Victory* as a "spectacular use of photomurals scaled and planned in space and sequence to arouse an emotional response."[53]

Even the art critic of the *New York Times* responded as intended, finding it all "magnificent and stirring and timely. . . . A portrait of a nation, heroic in stature. . . . As such needless to say, it is art."[54] Plain and simple, it was propaganda for the good guys.

In the estimation of Beaumont, Nancy, and Ansel, *Road to Victory* was awful and did not belong in a museum of art. They could not see the similarities between it and their own *Image of Freedom*. From their perspective, there were huge differences between the two shows, first in the person of Steichen himself, whose very touch desecrated the medium; and second, in Steichen's lack of respect for the essential qualities of a photographic print, and his insistence upon enlarging many images to such an extreme that the photographic grain took on a pointillist effect.[55]

Because of the war, Ansel was unable to travel to New York for nearly two years; in that time, letters had to suffice. After his long absence, he arrived at MoMA in April 1944 loaded with energy and enthusiasm, planning on a two-month stay. Never one to waste a moment, let alone a day, Ansel bounced back and forth between the Delaware Camera Club and MoMA, presenting a total of ten lectures in ten days, all sellouts.

To celebrate its fifteenth birthday that May, MoMA gave over its entire building to one exhibition that included all the departments, *Art in Progress*.[56] Ansel assisted Nancy with photography's contribution, 274 prints from the young department's growing permanent collection of more than two thousand. Their selection reflected the content of the collection itself, which was strongest in the work of contemporary American masters from Stieglitz onward. Stieglitz had fifteen prints in the show, Strand twelve, Weston twenty-five, and Ansel nineteen.

Over many dinners at the Newhalls' favorite restaurant, Café St. Denis (also a Stieglitz haunt), just down the block from their apartment, with the sad murmur of homesick French men and women singing nostalgically over their red wine in the background, Ansel began to confide to Nancy his life's story and his hopes for his future. This was the start of their work together on his biography.[57]

At dawn on June 6, 1944, the Allied forces began their invasion of the European continent. On tenterhooks, the world awaited the outcome of D day. Ansel and Nancy spent the afternoon with Stieglitz, Ansel photographing him in his gallery as Nancy showed him a group of photographs Beaumont had made while stationed in Egypt.[58] After dinner, Ansel and Nancy joined the crowds thronging Saint Patrick's Cathedral. Probably for the first time, and perhaps for the last, Ansel lighted candles and prayed.[59]

Back in April, when Ansel first arrived in New York, he had known after only one look at Nancy's tired and pale face that she must come back with him to California in June for a badly needed vacation. He had a tough time convincing her, but she finally acquiesced when he suggested that it could be a working vacation: she could fit in a few days with Edward in Carmel to plan his upcoming retrospective. With the promise of such benefits, the museum consented to give her some time off. Nancy and Ansel wrote to Beaumont in Italy to ask his permission, which he granted without hesitation. Then Ansel phoned Virginia, who agreed to drive down and pick them up on their arrival in Los Angeles.[60] Nancy wrote to Beaumont,

> It's really touching and flattering that Ansel seems to prefer to be with me, just as he loved living our quiet life two years ago. I think we really are his dearest friends, and even with just me instead of both of us, he gets a feeling of being sustained. He said the other day that the three of us could never really fight, however much we might disagree.[61]

Ansel had a few appointments in Chicago, so Nancy agreed to meet him there, at the station, just before train time late in the day on June 8. Emotionally tattered by the growing pressures of the museum, she was full of misgivings about the trip and sure that she should remain at her post in New York. The museum's funding had grown so tight that the department could no longer afford an assistant; Nancy was it, and with her away, there was no one at all.

The sleek train *City of Los Angeles* seemed to strain with eagerness to begin the journey. Lights blazed from every window, and the air was mysterious with steam. Ansel spotted a bedraggled Nancy staggering along with suitcase, typewriter, briefcase, camera, and tripod, and welcomed her with a huge bear hug that almost knocked off her designer hat. Already an old hand on the train, he showed her to her compartment, and then they walked back to the bar for a drink. Ansel had a smaller compartment in what he considered to be an ideal location, immediately past the bar. They spent three days on the train, working at their respective typewriters, stopping to enjoy cocktails, dinner, cigarettes, and conversation long into the evening.[62]

Virginia met them in Los Angeles and insisted that Nancy sit in the front seat for their drive to Yosemite via the Owens Valley, which would give her her first view of the great eastern wall of the Sierra. Nancy stayed with Ansel and Virginia in Yosemite for almost a month, setting up her typewriter on a little table under the incense-cedar trees and spending many hours photographing and working in the darkroom with Ansel as he taught her basic technique.[63]

Ansel was convinced that Nancy needed strengthening, both in mind and in body, to help her better contend with the machinations of the men at the museum. His program for her could be described as an early version of Outward Bound. Daily she would sit down at her typewriter, only to be pulled away by the insistent Ansel. First he took her on hikes, crossing tumbling creeks on fallen logs that seemed to her as narrow as tightropes; then he made her climb steep talus slopes from which she could only manage to descend on her seat. A confirmed New Yorker, she protested that life in Manhattan had not equipped her for this.[64]

Not long after their return one day to the valley floor, Ansel shanghaied her to a practice cliff that he scrambled up in five minutes. He lowered a rope to her and coached her up from handhold to foothold while she swore under her breath.[65] She wanted to give up, but Ansel praised each upward advance until she pulled herself safely onto the small granite ledge, where she was rewarded by the sight of streaks of crystalline quartz and alpine flowers, ferns and moss tucked into its

ANSEL ADAMS

corners. Nancy was hooked. When Ansel informed her that the only way down was to rappel, she was a little less dumbstruck than she would have been when this adventure began. Successfully back on terra firma, she felt that now she was the master of her fears.[66]

After spending a few days with Edward and Charis Weston in Carmel and meeting with Imogen Cunningham in San Francisco and Dorothea Lange in Berkeley, Nancy returned to New York with a new confidence and an updated three-year plan that she and Ansel had devised for the department. Its highlights included the Strand retrospective, blocked out for April 1945, followed by Edward's in 1946 and then Ansel's own in 1947.[67]

The challenges that Ansel had put before Nancy in Yosemite had been great learning lessons. Like the Cowardly Lion, she had persevered and found her own courage. She had previously been petrified of heights, but no longer: while visiting Stieglitz shortly after her return to New York, she flung open a window during a violent thunderstorm, boldly stuck out her head, and looked straight down to the street far below, as rain and lightning raced through the air. She chuckled, thinking how relatively easy it would be to rappel down the seventeen stories.[68]

Ansel left California on January 15, 1945, for a full three months of work back east. A major assignment to picture the uses of gas in industry for the Columbia Gas Corporation in Columbus, Cincinnati, and Pittsburgh more than covered the expenses for the entire trip, yielding a fat paycheck of twelve hundred dollars. Using color film and his five-by-seven-inch view camera, he photographed in factories producing such diverse products, through the benefit of gas, as crackers, crankshafts, and propellers. In Columbus, he was so intent upon making a picture of newly made, nearly molten anchor chains that in the intense heat his pants caught fire.[69] The nasty burn he suffered was treated with radioactive paste, a poultice that would have later consequences.

Ansel arrived in New York on February 1, 1945, to quite a welcome. In the basement darkroom he had designed for MoMA based on his own workspace in Yosemite, he found Paul Strand, who had no dark-

180

room of his own, in residence, making prints for his upcoming show. Brett Weston had been assigned by the Signal Corps to photograph New York, so he was headquartered at the museum as well. In addition to the Strand show, Nancy was coordinating a museum-sponsored six-week-long workshop given by Ansel for professionals and advanced amateurs, as well as an extensive evening lecture course.[70]

Ansel's events, not only full but oversubscribed, were a great success and raised a good deal of money for the department.[71] Classes ran for nine hours on Tuesdays, Wednesdays, and Thursdays, with all-day Saturday field trips and night lecture sessions on Mondays and Fridays.[72] The publisher Willard Morgan was so impressed that he contracted with Ansel to write a series of books on photographic technique. Nancy had hired a stenographer, Lee Benedict, to record the entire workshop, and when he read her transcription, Ansel decided that even given the many projects to which he was already committed, he could "write" the books by hiring Lee, along with her little machine, to be his ever-present sidekick. She consented to meet him in Yosemite in late May.[73]

Ansel had one more goal to achieve on this trip: he had booked a recording studio to make a set of records of him playing the piano. Diligent practice was essential, and though he had a room at the Gotham Hotel, Nancy agreed to let him have a rented Steinway baby grand piano delivered to her apartment. This was accomplished by means of a crane that swung the instrument through her window.

At the end of each day, Ansel, often accompanied by friends such as Strand or Marin, would return to Nancy's for an hour or more of practice. Ansel did not know how to make a quiet entrance; at the doorbell, he did not just buzz but beeped the rhythmic opening bars from Beethoven's Fifth Symphony. Afraid of being taken too seriously, he would purposely finish each evening's recital before the end of a piece, and always on a wrong note. This was invariably followed by his favorite sound effect, his rascally donkey bray.

It did not take many repetitions of this performance before residents throughout the entire apartment building became angry. Unbeknownst to Nancy and Ansel, they could hear everything through the thin walls.

It turned out that many of them were professional musicians, and they would sit up in bed to listen to Ansel play but would become frustrated when he never finished a composition, ending instead with an unintelligible profanity. To make peace, Ansel promised that henceforth he would always properly complete the music, cut out the donkey embellishment, and keep to a ten o'clock curfew.[74]

Ansel completed the recordings on the night of April 3. Of the ten pieces, he was most proud of Mozart's "Rondo à la Turca" from Sonata no. 9, a Scriabin Prelude, and Bach's "Arioso," C Major Prelude, and "Jesu Joy of Man's Desiring." Fifteen sets of records were pressed, three for his family and the others for his best friends: the Newhalls, McAlpins, Wrights, Strands, and Spencers. That night, finally finished, he collapsed from exhaustion. Shocked to see this monument to energy struck so low, Nancy pushed him into a cab and ordered him to go directly back to his hotel and to bed.[75] Ansel left for California the next day, with two weeks of meetings, lectures, and workshops—in Memphis, Detroit, Chicago, and St. Louis—standing between him and home.

At 2:41 A.M. on May 7, 1945, Germany surrendered unconditionally to the Allies.[76] Major Beaumont Newhall returned home almost immediately, though he was not officially released from the Army Air Force until September 20. On leave, he picked up Nancy and headed for California, where they were to spend a second honeymoon with Ansel and Virginia in Yosemite. They had a great time photographing and hiking, and Nancy demonstrated her newly acquired mountaineering skills. The Newhalls' talks with Ansel were intense and, as always, centered on photography.

Ansel tried to convince them that no creative person should live in the East, which was a constant drain on the soul. Everything could be better accomplished in the West. He longed for Beaumont and Nancy to relocate to California and proposed that together they open an institute for photography or publish a journal to rival *Camera Work*.

But Beaumont was ready to tackle MoMA once more, to raise funds and build a staff and a collection, and in October, he returned as curator of the Department of Photography. Citing nepotism, the museum re-

fused to allow him to keep Nancy on as his assistant, though she continued to work on Edward's 1946 retrospective.[77]

Beaumont discovered a museum quite different from the one he had left. During the war, MoMA's trustees had summarily demoted Alfred Barr, the gentle spirit who had been the founding director. No longer a quiet place of scholarly gentlemen, MoMA was now positioning itself in the modern world: the museum as big business.[78]

Without consulting the advisory committee (or Beaumont himself), the trustees appointed Edward Steichen director of the Department of Photography over Beaumont, who they felt should stay on in the number-two post, as curator. Steichen was the most famous living photographer in the world, and his ideas received rapt attention. With the support of his good friend Tom Maloney, Steichen promised to garner a hefty infusion of a hundred thousand dollars from photographic manufacturers to start the department's postwar years with an economic bang, and he projected a bevy of theme shows guaranteed to pack MoMA's galleries and fill its coffers. One trustee explained the situation to Beaumont: Steichen's plans were guaranteed to be popular, like the Harvard football team, while Beaumont's projects were a lesser attraction, like the rowing crew.[79]

Beaumont was astounded. Steichen represented the antithesis of what he, Nancy, and Ansel had been working to achieve at the museum; in their view, Steichen treated photography as a tool by which to manipulate easy emotions, rather than as a unique and profound art. After exchanging a series of anguished letters with Ansel, Beaumont realized there was no way he could work for a man with such goals.[80] Ansel advised him to quit.[81]

On March 7, 1946, Beaumont resigned. He wrote Ansel, "The Rubicon is passed. The die is cast."[82] The entire photography advisory committee soon quit in protest.[83] As a side effect, though Strand and Weston were given their solo retrospectives, Ansel's was canceled. Not until seventeen years after Steichen's 1962 retirement would Ansel have his only solo exhibition at the museum to which he had given so much. Once—if briefly—a place that took photography as seriously as it did the other arts, MoMA now became the home of the photographic

spectacle. Although Steichen would also present such important modern artists as Robert Frank and Aaron Siskind, the huge shadow of such a show as *The Family of Man* would darken his very real accomplishments at MoMA.[84] For Ansel and the Newhalls, the appointment of Edward Steichen was a huge setback to the promotion of photography as a fine art.

13

MOONRISE

For many, *Moonrise, Hernandez, New Mexico* is the greatest photograph ever made. Step into the picture.[1] You are standing on the shoulder of Highway 84, a two-lane blacktop some thirty miles from Santa Fe. Under the last light of day, you see the village of Hernandez, nestled along the tree-lined banks of the Rio Chama, flowing down to meet the Rio Grande. Sage covers the ground. Burning piñon drifts its warm, woodsy odor from chimneys. Across the river, in the distance, stands the church of neighboring San Juan pueblo.

It is plain to see that the builders of Hernandez had reverence for God and for the earth. The adobe for the rounded walls of their sanctuary, San Jose del Chama, founded in 1835, and for their homes was extracted from the ground beneath their feet. It is Sunday. In church today, the priest and the congregation prayed for America; they could not know that Pearl Harbor was just a month away.

Hernandez's citizens are descendants of a few Spanish-American families with names such as Roybal and Borrego; they tend small farms that yield crops of chile and corn. A *horno*, or traditional adobe oven, sits in one backyard, waiting for morning. Heaps of golden cobs dry on the flat rooftop of one house, a ladder leaning against its wall. The corn was harvested a month ago, at night, under the light of the harvest moon; the husks are sharp, cutting hands that pick them by day, but their tough fabric softens in the dew of evening.[2] Never-forgotten ancestors rest in the cemetery directly behind the backyards, the promise of life everlasting proclaimed by each white cross.

The great vault of the sky places Hernandez in appropriate perspective, conveying its relative insignificance. Even the snowcapped Truchas Mountains only serve to punctuate the meeting of heaven and earth. A broad brushstroke of brilliant white clouds spans the horizon, while just above, the waxing moon looks down with its kind smile. You realize that the night is velvety-black and yet you can see. Each object in the scene appears to be lighted from within: village, graveyard, church, and sagebrush. Through *Moonrise*, the viewer stands beyond mankind to witness humanity's reach for the stars, for redemption, for God.

Moonrise was made on a typical Adams shooting expedition in the autumn of 1941. He had contracted to make photographs for the Department of the Interior, and piggybacked that task onto assignments for the U.S. Potash Company near Carlsbad, New Mexico, and a commission to make a dozen color images for a Standard Oil promotion.[3]

In 1935, Secretary of the Interior Harold Ickes secured $110,000 for the decoration of the department's new building in Washington, D.C.[4] At first he thought of painted murals, but in 1936, when he first met Ansel, Ickes learned that besides the small, lovely prints the photographer brought with him, he could also make large photographic murals.

In his exhibition at the Katharine Kuh Gallery in Chicago the same year, Ansel displayed a folding screen composed of three six-foot-tall photographic panels, the whole entitled *Leaves, Mills College*. It did not sell and was returned to Ansel. Ickes bought the screen for his office,

paying Ansel's special government price of $250, a fifty-dollar discount.[5] Sometime later, the screen was damaged, and Ickes requested a second one from Ansel, who sent as a replacement a very beautiful image of snow-laden branches, *Fresh Snow*.[6]

In late August 1941, Ickes hired Ansel as a "Photographic Muralist, Grade FCS-19," for daily compensation of $22.22 (the highest rate then paid to a consultant), plus four cents a mile and five dollars per diem to cover room and board.[7] The contract, specifying that he was to work no more than 180 days, was in effect from October 14, 1941, to July 2, 1942. Offering the possibility of nearly four thousand dollars' pay for half a year's work (not including the money he would make when he actually made the murals), the Mural Project looked to be an enormous financial windfall for Ansel.

His assignment was to photograph the lands and Native Americans under the Department of the Interior's jurisdiction. He planned to make some thirty-six murals, which would hang in an emotionally progressive sequence intended to positively influence the congressmen, lobbyists, and government officials who would walk past them daily.[8]

Ansel had barely returned to California after six weeks in the East, but he was eager to be off again, and quickly. The continuing years of neglect by her husband had drained Virginia of her huge reservoir of love and patience, and she had now established her own life and friends apart from him.[9] Although Ansel wanted to remain in the marriage, Virginia filed for divorce while he was in New York during that late summer of 1941.[10] Ansel was devastated.

Through his agonizing, Ansel realized how important it was for him to have the assurance of a wife, home, and family. The letters he wrote in an attempt to persuade Virginia to stay in the marriage resounded with his love for her and the children, but there were no words for her alone, *separate* from the children. Ineptly thinking she would find it reassuring, Ansel explained that she must understand that it was not her fault, that no one person could be the only answer for him. She replied that though she still cared for him, it was more as a friend. Because he was never home, the responsibility of Best's Studio had fallen to her, just when she most longed to devote her energies to home and family.

She hoped for a marriage partner who would share her life at least eleven months out of the year. She dreaded Ansel's coming home: each time it was a major disruption of the calm pattern she had established for herself and her children.[11]

Rather than stay and work on their relationship, Ansel once more abandoned the situation, convinced he must leave to work on the Mural Project. To demonstrate his commitment to his family, however, he offered to take eight-year-old Michael along with him and Cedric—small comfort for Virginia.

After loading the station wagon with boxes of camera equipment and camping supplies, Cedric, Ansel, and Michael departed on October 10, 1941. From Yosemite, they followed a route that took them through Death Valley, Boulder Dam, Zion National Park, the Grand Canyon, Walpi Mesa, and Canyon de Chelly. Just seven miles out of Bluff, Utah, they were beset by huge storms that flooded the roads.[12] After surviving more perils than Pauline (and with the benefit of a new clutch in the car), they made it first to Colorado's Mesa Verde National Park and then to Santa Fe, a safe harbor with a borrowed darkroom.[13]

In a funk, Ansel wrote Virginia that he hoped his distress over the condition of their relationship would not be reflected in his photographs.[14] Later, he asked her to buy her own Christmas present from him, suggesting a new icebox. After thirteen years of real-life experience, Ansel still needed to enroll in remedial Marriage 101.

But the grand spirit of the landscape soon overpowered Ansel's depression. In a letter to Newton Drury, the director of the National Park Service, he proclaimed that all it would take to unite the waffling American public in patriotism was the revelation of the staggering resources possessed by their country, in terms of both aesthetics and materials.[15] Ansel believed the photographs he was making on that very trip expressed all of that. His mission was to make murals for the Department of the Interior, but the scope of possibilities extended before him.

One Sunday, Ansel, Michael, and Cedric left their motel, the Orchard Court, drove north out of Santa Fe, and spent a day off in the

Chama River Valley, near the Ghost Ranch. When Ansel had stayed there in 1937, he had found the landscape both challenging and photographically productive, but not so today. The sky held no promise, only the photographer's nightmare of bright, empty, blue expanses (almost as bad as steady rain).

By this point in the trip, Cedric was dragging. He thrived in the Sierra but found deserts discouraging, and he was having little success with his camera. He moped about the periphery of Ansel's vision. For quite some time, Ansel wrestled, photographically speaking, with a recalcitrant tree stump that refused visualization. He finally surrendered, writing off the day as a total loss.[16]

Dusty, weary, and hungry, they piled into the car and headed back to Santa Fe. They had not traveled far when Ansel glanced over his left shoulder to witness an ordinary miracle. Before him, the nearly full moon rose above Hernandez; the small cemetery with its simple white crosses reflected the last rays of the sun that was setting behind the clouds and mountains at Ansel's back. The scene provided what Ansel called an "inevitable photograph." He simultaneously steered the car into a ditch and slammed on the brakes, yelling all the while for Cedric and Michael to help him set up his eight-by-ten view camera. Nearly frantic, he knew he had only seconds to act before the sun's light vanished.

Tripod. Camera secured. Twenty-three-inch component of his Cooke Triple-Convertible lens attached (providing a mild two-power telephoto effect). Isopan ISO 64 sheet film inserted. But in all the rush, no one could find the Weston exposure meter. Perhaps only Ansel Adams could have recalled under such pressure that the luminance of the full moon is 250 candles per square foot, and then calculated the exposure formula; his years of hard work and technical mastery of photography had readied him for this moment. (Ansel's favorite aphorism paraphrased Louis Pasteur: "Chance favors the prepared mind.") He mentally inserted the moon's luminance into the exposure formula, whereby the approximate square root of the film's ISO number (that is, its relative sensitivity) becomes the key stop. The ISO of the film Ansel was using was 64, so f/8 would be the stop.

At around this time, Ansel was trying to devise various photographic

teaching tools that would enable students to develop their own vision, independent of the teacher. He codified a method that he called the Zone System, which assigned visible light to eleven zones numbered from zero (absolute black) to Roman numeral ten (absolute white).[17] Now, with the light on Hernandez tenuous and his exposure meter nowhere to be found, Ansel visually estimated that the moon's value was equivalent to Zone VII, a pale white with gray details. The quantity of foot-candles determined the shutter speed, so in this case, the exposure for Zone VII would be 1/250 at f/8. But overall exposure is based not on the extremes but on the middle zone, Zone V, requiring two stops' more exposure. At the predetermined f/8, then, the necessary shutter speed would be 1/60 of a second.

Although depth of field was not a great problem in this instance since the nearest objects—the sagebrush—were many yards away from the camera, Ansel wanted to ensure that the negative was sharply focused throughout, so he chose to use a considerably smaller aperture, progressing four stops past f/8, beyond 11, 16, and 22, to f/32. That, in turn, called for an equivalent, longer exposure of 1/4 second.

Further compounding the difficulties of the situation, Ansel inserted a "G" deep-yellow filter in front of the camera's shutter, which served to darken the blue sky and lighten all yellow values, including the adobe church, the houses, and the golden, autumnal hues of the changing trees. The filter reduced the amount of light reaching the film by a factor of three, so the exposure time was increased to 3/4 of a second. Since there is no exposure setting for 3/4 of a second, the choice was either 1/2 or one full second; Ansel chose the latter. The final exposure was f/32 at one second. All of these computations were made in his head, and very quickly.

Ansel removed the dark slide, then released the shutter. Worried that the exposure was insufficient, he reversed the film holder for a second, safety exposure, but just then the sun sank below the clouds behind him, and the magic essential light evaporated.[18] The creation of *Moonrise* was serendipitous: while a painter or sculptor can work from stored memories and imagination, something must happen in the real world in order for a photographer to make a photograph.

Sensing that the negative was going to give him trouble because of the extreme contrast of the subject itself, Ansel had to try to contain the dynamic range of the scene within the tonal scale of the film. The scene presented to him had a contrast range of perhaps a thousand to one—that is, the highlights of the crosses and clouds were a thousand times brighter than the shrubs in the foreground. He knew that his film could record a range only of a hundred to one, and the printing paper only fifty to one.

Back in the darkroom, calling on his experience and virtuosity as a technician, Ansel relied on water-bath development, now considered arcane. He immersed the film first in the developer, then in a tray of plain water. As the negative, its emulsion saturated with molecules of developer, rests in the water bath, the developing action occurs more in the shadows and less in the highlights. After a minute, the molecules of developer in the emulsion become exhausted, and another immersion in developer is necessary to continue the development process. Moving back and forth ten times between the developer and water, Ansel labored to make a printable negative. Near the end, he inspected the developing film under a weak green safelight, relying on his experienced eye to detect when the highlights were becoming overdeveloped. It was then time to stop and fix the negative in a hypo bath.

Despite this extreme processing finesse, room light revealed a less-than-perfect negative, with a severely underexposed foreground, flat and thin, and an overexposed band of clouds so brilliant that its portion of the negative approached total blackness, or maximum density. Ansel knew instantly that *Moonrise* would be a challenge to print.

Soon after that day in the Chama Valley, Cedric gave up on the Southwest and returned home to his beloved California. Father and son (who must have been a great kid to endure this father-centered trip) then proceeded south so Ansel could photograph Carlsbad Caverns for the Mural Project and do the commercial job for U.S. Potash. Michael developed appendicitis and had to undergo an emergency appendectomy; he recuperated in the hospital and then at the home of gracious friends while his father continued his assignments.[19]

Ansel spent days in the potash mines, grappling to capture the del-

icate amethyst hue of the ore on color film. Many images showed the miners poised on scaffolds, wielding heavy tools. When Ansel submitted his photographs to the company, all hell broke loose: the scaffolds in every single picture had been constructed in violation of mining-safety laws. A few months later, after the mine's superintendent had been fired and the scaffolding made legal, Ansel was asked to begin again. He did, receiving double the pay.[20]

Ansel was actually happy to return home after this journey. Shortly after he arrived in San Francisco on November 27, he made his first attempt to print *Moonrise*. From the beginning, he found the negative so extreme in its contrast as to make it nearly impossible to achieve an acceptable print, and for the rest of his life, it remained his most difficult negative. However, he thought highly enough of that first effort to carry it with him to New York City in late February 1942 to show Beaumont and Nancy. They liked it very much indeed. Three months later, when Ansel left New York, that first *Moonrise* stayed behind as a gift to MoMA.

Edward Steichen served as "Photo Judge" for the *U.S. Camera Annual* of 1943. His research extended to MoMA, where he selected *Moonrise*, using that one print as the actual reproduction print. Although Ansel thought him a philistine, Steichen's eye for images was legendary. Spread across two pages and bled (run to the paper edge) on three sides, preceded by a factory scene patriotically entitled *Brawn of a Nation* and followed by what was described as an "expressive" portrait of a tortoise, *Moonrise* was an oasis in the desert of the annual.[21]

Inaccurate stories have circulated about *Moonrise* since its first publication. The *U.S. Camera* caption read by thousands worldwide began the tradition, as the copywriter "quoted" Ansel as stating that the image had been made after sundown, and provided an extensive (and, of course, inaccurate) account of his use of his light meter on this difficult subject. The technical description was also wrong, listing incorrect film, brand of camera, and size of lens.

Tracking *Moonrise*'s trail through time, one can also catch a glimpse of it in the cover photograph of the *Bulletin of the Museum of Modern Art* for October–November 1943, where a view of the museum's pho-

tography print room, library, and experimental gallery shows the image casually displayed, propped against a wall.

Moonrise was formally exhibited for the first time, again in this same print, in 1944's *Art in Progress* show, where it was one of fifteen photographs reproduced in the exhibition catalog.[22] MoMA got a lot of mileage out of this one, lonely print, and it is evident in its myriad surface scratches and dings.[23]

People saw *Moonrise*. People wanted *Moonrise*. Right from the get-go, Ansel knew that it was among the very best photographs he had ever made.[24] But it was extraordinarily difficult to make a good print of it, and in fact he believed he had yet to achieve its best expression. Its physical handicaps were great enough to cause him to want to just forget about it, make no prints at all. With the exception of one print he produced for McAlpin, who ordered it in early 1943 after seeing the reproduction in *U.S. Camera*, Ansel shelved *Moonrise* during World War II and made few, if any, new prints from it over the next six years.[25]

In 1948, Ansel received at least three orders for *Moonrise*. Money still was hard to come by, and he knew the photograph could be a good seller if only he could make it easier to print. Sometime before Christmas, he attempted to improve the negative by intensifying its low-density foreground. (A clear negative—that is, one with no density—prints black.) First he refixed and washed the negative to ensure no impermanent silver remained, and then he immersed the bottom quarter of the film, up to the black horizon line beneath the mountains, in a tank of Kodak IN-5 intensifier, a solution that increased the density proportionally to the amount of density already there. Admittedly, the foreground of the image held little information, but Ansel nonetheless believed that the negative was slightly improved by this treatment (though it is difficult to differentiate prints made before from those made after).

After intensifying the negative, in December 1948 Ansel made at least six prints of *Moonrise* to give away or sell. One print was a Christmas present for Kodak executive George Waters, and another for Beaumont and Nancy. Writing to the Newhalls on December 17, Ansel

joyfully proclaimed that the curse on *Moonrise* had been lifted: he had finally produced prints that made him happy.[26]

Still, he had yet to achieve his strongest interpretation of the negative. Visual inspection of the Newhall print discloses that both the bright bank of clouds and the dark mountains on the horizon are almost detail-free, not normal in an Adams print. The foreground sagebush and village, even postintensification, remain a heavy gray.

In 1927, Ansel had discovered visualization with *Monolith*. Fifteen years later, when he made the *Moonrise* negative, he lacked the necessary luxury of time to visualize the final print. It would take him years, on a steep learning curve, to settle upon his final expression; in the meantime, Ansel firmly believed that his most recent print, possessing the maturity of his expression and craft, was his best.

Ansel's interpretation of this negative evolved steadily through the years as he worked to achieve greater detail and drama. He often borrowed a simile derived from his study of music, saying that the negative was like the score and the print the performance of that score. The sky in the earliest version of *Moonrise* contains numerous pale streaks of cloud, whereas in Ansel's last interpretations of the image, made in 1980, no hint of cloud mars the fully blackened heavens, save for the thick layer settled low behind the Truchas Mountains, a ribbon that glows with glorious light, well described by subtleties of tone.

I spent the morning of Thursday, February 21, 1980, in the darkroom with Ansel as he printed *Moonrise* for what he hoped would be the last time, a historic occasion that he was generous enough to let me witness. *Moonrise* was so difficult that the master, at the age of seventy-eight, sometimes took two or three days to make the first good print. His horizontal enlarger had been built from an old view camera and had a Ferrante Codelight source that projected the image against a metal wall. With the flip of a toggle switch, both the enlarger and the wall could move electrically on rails, enabling Ansel to increase the distance between them to make very large, mural-sized prints, though he normally used printing paper no bigger than sixteen by twenty inches.

The day before, Ansel had removed the eight-by-ten-inch negative of *Moonrise* from his storage vault and placed it in the negative carrier.

After carefully brushing it to remove the inevitable small dust particles, he set the negative, in its carrier, in the enlarger, positioning it between the light source and the lens. In each darkroom session, certain variables affect the length of the exposure of the negative, including the degree of enlargement desired, brightness of the light source, f/stop, particular box of printing paper used, dilution and temperature of the developer, and so on. Ansel tried to control as many of these as he could by using the best equipment and a consistent routine, but variations—however minimal—always existed. Although at first glance they may all look alike, every *Moonrise* is in fact as unique as a snowflake or a fingerprint.

On this day John Sexton, Ansel's photographic assistant, stood at the enlarger and slowly adjusted its focus as Ansel, four feet away, monitored the projected image on the wall with a fifty-power focusing lens, directing, "A little more. Back a bit." It took them several minutes to get the focusing perfect. Ansel's house and studio were perched on a granite hill on the edge of the Pacific Ocean, and the vibrations from the waves breaking against the shore would knock the focus out during the night; every printing session thus had to begin with a focus check. Today's huge storm surf had put it further out of whack than usual.

After the focus had been corrected, John left the darkroom. Ansel printed his own photographs and preferred not to have anyone with him in the darkroom because of the distraction. I stayed, sitting out of the way on a stool in a corner, quietly taking notes in the dim yellow safelight.

Next, a test exposure was made. This usually took the form of a test strip, or partial sheet of printing paper given several different exposures. The test strip was developed, stopped, and fixed, and then the room light was turned on and the strip inspected. One of the exposures on the strip should look nearly perfect, though a bit light: prints always dry darker than they look when wet, and that critical difference, known as the dry-down effect, must be taken into account in making a final print.

A decade earlier, Ansel had discovered a quick way to determine

what the dry-down effect would be: he used a microwave oven. After taking the test strip out of the fix, he would wash it briefly and then walk out of the darkroom and into the kitchen, where he would bake the strip in the microwave. In a minute or two it would be dry and darker, and a conclusive printing time could be established.

While this general printing time forms the basic exposure, certain areas of the print will receive exposures that are shorter—occasionally much shorter, as with that underexposed foreground—or longer, as with the overexposed clouds. On this specific day, the general exposure time was to be about thirty seconds.

Ansel diluted the chosen paper developer, Kodak Dektol, with four parts water to one part developer. He then switched on the electronic metronome, an echo from his musical past, set to broadcast a steady sixty beats a minute. Ansel did not use a clock to time the printing steps because he did not want to remove his eyes from the paper for even a second; the metronome allowed him precisely to calibrate the passage of time. From a light-tight box, he pulled out a sheet of sixteen-by-twenty-inch Ilford Gallerie #3 double-weight gelatin-silver printing paper, which he slipped into the right-angled bracket attached to the wall, running his hand along the edges of the paper to make sure they were contained and flat, and placing magnets (his favorites looked like chocolate bonbons) on the outer corners to hold them down. Since he would be unable to see *Moonrise*'s moon during the printing, he had stuck strips of luminescent tape to the wall to point to the area of the paper where the moon would be.

Ansel began making a general exposure of the entire image, but because he wanted to limit the exposure to the lower foreground, he began to dodge (that is, cover) that section after a few seconds. He used a small handmade dodging tool (a section of coat-hanger wire with a circle of cardboard the size of a fifty-cent piece taped to one end) to block the part of the image that he had attempted to intensify thirty-two years earlier. Holding the tool only inches from the paper, Ansel kept in constant motion: stopping the movement even for a second could result in an area of uneven tone.

Ansel quickly picked up a large piece of cardboard—the side of an

ordinary corrugated box—in which he had cut a three-inch slit. For the rest of the exposure, he shielded the printing paper with the cardboard, selectively burning (or giving more exposure to) specific areas of the image. Ansel counted to ten under his breath, his lips moving, then counted to twelve, then five, then seventeen. His hands flew about the picture, stopping to burn for precise second counts while varying the cardboard's distance from one to three feet from the paper. There was nothing static about the making of a *Moonrise*; the total printing time for each print was about two minutes.

He exposed six prints before placing them in the developer. It took twelve and a half minutes to print this batch and then another twelve and a half to develop, stop, and fix them, then gently slide them into a holding tray of plain water. His concentration was focused totally upon each print as he carefully inspected it, destroying any that revealed a less-than-perfect dodge or burn exposure or any other flaw.

These last prints of *Moonrise* were being made for his Museum Set project. The decision to include the image in every such set meant that during 1979 and 1980, Ansel was required to make over one hundred perfect prints, a daunting number at his age.

In all, Ansel produced approximately thirteen hundred original prints from this negative during his lifetime, far more than from any of his others. The reason was simple: he printed on demand, and he received more orders for *Moonrise* than for any other image. Most of these prints were about sixteen by twenty inches, with a few larger, including some murals, and a few smaller. The great majority were made after 1970.

But more than either its historical or its technical details, the most discussed aspect of *Moonrise* is its price. In 1980, Boston photography dealer Carl Siembab quipped, "Ansel's pictures are a new form of currency; instead of dealing in gold, we deal in *Moonrise*s."[27] More dollars, pounds, marks, and yen have been spent on *Moonrise* than on any other image in the history of photography. A rough estimate puts Ansel's receipts in the neighborhood of half a million dollars for the sale of fine prints of *Moonrise* alone, most of that amount from 1975 onward.[28] This is but a fraction of the profit realized by collectors and

dealers in the later resale market. Once a photographer sells a fine print, he or she never sees another penny from its further sales, even if the original price is fifty dollars and ten years later it is sold for fifty thousand.

In fact, in 1948, fifty dollars was Ansel's normal price for a sixteen-by-twenty-inch *Moonrise*, including shipping. This was double the price of his other prints of similar size. Ansel's fee for a *Moonrise* was raised only slowly, to sixty dollars in 1962, seventy-five dollars in 1967, and then $150 in 1970.[29]

As the decade of the seventies unfolded and photography grew more and more popular as a "collectible," Ansel was swamped by requests for *Moonrise*. He stopped taking print orders as of December 31, 1975, his decision having been spurred on by the increased demand. The negative had never become any easier to print, and it took him three years to fill the orders in hand. His last selling price for *Moonrise* was twelve hundred dollars; after the supply was curtailed at its source, the price of a sixteen-by-twenty-inch print escalated in the secondary market of auctions and galleries to ten thousand dollars in 1980 and twenty thousand by 1996.

When significant numbers of investors began entering the photography market for the first time in the late 1970s and early 1980s, business magazines took notice. One article reported that in December 1979, the sale of a *Moonrise* for twenty-two thousand dollars at the Sotheby Parke Bernet auction house had set three sales records: it was the most ever paid for a photograph by a living photographer; the most for a twentieth-century print; and the most for a photographic work on paper. Up to that time, only a daguerreotype self-portrait by nineteenth-century photographer Albert Sands Southworth, on a silver-plated copper sheet, had brought more, selling for thirty-six thousand dollars.[30] The *Wall Street Journal* even published a bar chart that allowed its investment-minded audience to compare the selling prices of *Moonrise* for the years 1977 through 1981.[31] The current total value of all the *Moonrise* prints that Ansel made is in excess of twenty-five million dollars.

As is the case for so many of Ansel's images, the precise dating of

Moonrise has been problematic. When collectors and historians demanded to know when he had made the negative, Ansel assigned it dates ranging from 1940 to 1944, with 1944 most often favored. Leading the chorus of plaintiffs was Beaumont Newhall, who was driven crazy by his friend's inexactitude. To settle the matter, Beaumont contacted David Elmore, a young astronomer, who accepted the challenge, drove to New Mexico, and, using evidence provided by the picture itself (from which he extrapolated the moon's altitude and azimuth) coupled with data acquired in Hernandez (e.g., the position of Ansel's camera tripod), returned to his computer and devised and ran a program that eventually determined that *Moonrise* had been made on October 31, 1941, at 4:03 P.M.[32] Ansel was totally delighted with these findings and just wished there were more moons in his other pictures so he could know when they, too, had been made.

The saga continued, however, when another astronomer, Dennis di Cicco of *Sky & Telescope* magazine, became obsessed with *Moonrise*.[33] He had recently written a computer program based on celestial coordinates that calculated azimuth and altitude for any time or place in the world. His attempts at dating *Moonrise* did not confirm October 31, 1941, 4:03 P.M. Could the tripod position have been incorrectly determined? he wondered. Di Cicco traveled to Hernandez and noticed an old road behind and above the current modern highway. Elmore's calculations had been made with the camera placed in the middle of the new highway, which di Cicco guessed had not yet been built in 1941 His hunch was right: when we visited Hernandez together in June 1980, Ansel told me that he had made *Moonrise* from the old road.

Even after all of this, the correct time was not easy to come by. Di Cicco eventually isolated two dates, one in 1939 and one in 1941, but he was bothered by the fact that the moon in *Moonrise* appears slightly less full than it should have been on either of those occasions. When he read a description of how Ansel printed *Moonrise*, however, the light-bulb went on: he realized that when Ansel burned in the sky with such intensity, the margins of the moon must inevitably have been singed, making it appear to be in an earlier phase. Close examination of the negative of *Moonrise* confirms that the moon was indeed almost full,

certainly fuller than it seems to be in the exhibition-quality prints. After another trip to Hernandez and ten years of sleuthing, di Cicco published his conclusion: *Moonrise* was made on November 1, 1941, at 4:49:20 P.M. Mountain Standard Time.

Dating has not been the only controversy about *Moonrise*. The question has been posed, if it was made with Mural Project funding, does *Moonrise* rightfully belong to the American people?[34] Letters from the time between Ansel and the Department of the Interior clearly state that Ansel acknowledged the government's ownership of the negatives.[35] Further, in a letter dated August 18, 1942, Ansel indicated that the negatives would remain in his custody for as long as he could personally print them and that he would store them in a government vault. Following his death, the negatives were to be sent to the Secretary of the Interior.[36] The government agreed, reiterating that the negatives "are the property of the United States Government."[37]

Due to World War II, the Mural Project was canceled as of June 30, 1942. Ansel delivered 225 small work prints to the Department of the Interior in November of that year, representing the output of his two extended trips; he kept the negatives so that he could make the murals when the project was, he hoped, reactivated following the war. The work prints presented a full array of subjects for the potential murals. In truth, a number of the images had not been made during the past year; some, notably those from the Sierra, came from negatives dating back to the mid-1920s.[38]

In 1946, Harold Ickes, whose personal project the murals had been, left office, and that spelled their demise. Nothing was done with Ansel's photographs until 1962, when they were transferred to the National Archives, where they still reside and where anyone can obtain a copy print for ten dollars. These mass-produced prints are made on high-gloss, lightweight paper from a copy negative that was itself made from Ansel's original print. The quality of such photographs is abysmal, not coming anywhere close to that of an original print, and yet anyone can publish them in books, posters, or calendars. Unfortunately, all too many undiscerning souls are willing to plunk down their money on inferior items.

As to the question of whether Ansel kept negatives that rightfully belonged to the Department of the Interior, the answer is complex. Ansel never delivered any negatives at all to the Interior Department. He knew in what disregard negatives and photographs were held by the National Archives, and he did not want to allow such a fate to befall his treasures. Throughout his lifetime, he stonewalled any inquiry on this matter, providing various excuses as to the whereabouts or suggesting they had been destroyed in his darkroom fire in Yosemite—an impossibility, given that the fire was in 1937 and the negatives in question were made in 1941 and 1942.[39]

At the beginning of the Mural Project, Ansel labeled all of the Interior Department negatives "NPS," for National Park Service; the fact that for many years he continued to use that same label on negatives made of the national parks and monuments only serves to confuse the issue. However, *Moonrise* was never given an NPS classification. The negative number is 1-SW-30, denoting an eight-by-ten-inch negative, Southwest subject matter, negative number 30.

It was Ansel's custom to reserve days for his own personal work in the midst of a commercial assignment. He was scrupulous about accounting for his time. The bill he submitted to the Department of the Interior for the autumn 1941 trip totaled $232.97; he traveled for forty-seven days, yet charged the government for only eight and a half days of work and per diem, and for only forty miles of travel.[40] Ansel charged nothing for November 1, the day on which we now know *Moonrise* was made. *Moonrise* belonged to Ansel.

That is not the case, however, for a number of other famous negatives by him. In April 1983, Ansel and I went through all of his NPS negatives and concluded that 229 of them were from the Mural Project. Such well-known images as *The Tetons and the Snake River*, *Leaves*, *Mt. Rainier*, *White House Ruin*, *The Grand Canyon*, and his great series of Old Faithful are all rightfully the property of the U.S. Government. Ansel was uneasy about the subterfuge he had to engage in to hide the negatives, though he believed it was justified. He intended to petition the government to allow them to be kept with the rest of his negatives, in his archive at the Center for Creative Photography, University of Ari-

zona, where they would be properly cared for and accessible—within limits—to the public. Meanwhile, he would be happy to provide the government with prints at its request. But time, and his life, ran out before he found a sympathetic ear in Washington.

Ansel could not make *Moonrise* again today. The view of the village from U.S. Highway 84 is quite different than it was in 1941. The original church, embellished in the early 1950s with a bell tower and a peaked tin roof, has been largely abandoned on behalf of a new one built in 1972 of steel and concrete; the old church appears uncared-for, forlornly abutting the Rio Arriba County road-equipment storage yard, complete with its metal shed, bulldozers, and road graders. Hernandez, never rich, is now economically depressed. Few bother growing crops that can be easily purchased at markets in nearby Española. The new Highway 84 is heavy with the traffic of bedroom commuters traveling to work in booming Santa Fe. Earthen adobe homes have been replaced by immobile double-wides. On his last visit to Hernandez, in 1980, Ansel remarked, "I would never stop and photograph that mess today. There's nothing there that I could visualize."[41] *Moonrise* is a sublime memory of what once was, a reminder that some progress is dubious.

But on the positive side, Ansel discovered that his photograph was a source of pride to the small village; many people had hung reproductions of it on their walls. Ansel sent an original print to the Hernandez Elementary School inscribed, "For the people of Hernandez."[42]

Just five weeks after Ansel made *Moonrise*, the Japanese bombed Pearl Harbor, and the United States was finally at war. Ansel reacted with intense patriotism, writing again to Park Service Director Newton Drury to suggest that he himself could best serve by making photographs to motivate Americans, images that would communicate the great and pure beauty of their land, whose freedom was now in serious jeopardy.[43] This concept was beyond the consideration of a government more intent, at the moment, on the survival of the country.

Ansel's intimate and quiet vision of the 1930s gave way to a more expansive one in the 1940s with *Moonrise* and the Mural Project. Image after dramatic image expressed the grandeur, strength, and purity of the motherland. Mountains tower and extend from horizon to horizon; boulders are monumental. Embellished with a catalog of

clouds, the sky is full of promise, the air crisp and clear, the sunlight revelatory. *Moonrise, Winter Sunrise, The Tetons and the Snake River, Old Faithful,* and *Mt. Williamson from Manzanar*—with these photographs, Ansel bore witness to the country behind the flag. To the question, what are we fighting for? these images were Ansel's fervent response.

14

GUGGENHEIM YEARS

Under contract to write a series of books on photographic technique, Ansel began work on them when Lee Benedict arrived as scheduled in Yosemite in late May 1945.[1] Nancy had well prepared the young woman for her Girl Friday position. Attractive and vivacious, Lee dressed in the Yosemite-appropriate blue jeans and bright shirts and immediately took to Ansel's rock-climbing lessons. If he hiked up to Vernal Falls, Lee came along and took dictation while he photographed. If he took a trip, she went with him, sitting in the front passenger seat, her stenographer machine on her lap as Ansel spoke the books.[2] This rather strange technique worked. The first two slim volumes, *Camera and Lens* and *The Negative*, were published in 1948, followed by *The Print* in 1950.

Six weeks after Lee's arrival in 1945, Ansel wrote to Nancy that he was in love again: his heart was afire, and the world was fresh and

new.[3] When he was in love, his energies were at their peak; he could move mountains, at least mountains of work, and he did. In September, in a letter to Edward, Ansel thanked him for his hospitality during his latest visit, when the two men, Lee, and Charis had all danced long into the evening. In what was perhaps a joking aside, Ansel suggested that he and Edward trade women for a month or two.[4]

Ansel's portrait of Lee catches her staring straight into his lens, dressed in a pleated skirt and jewel-neck sweater, her feet in sandals, arms crossed against her chest, her right leg casually hooked about her left knee. She seems to be waiting for something—probably for Ansel to get back to work on the text.[5] By November, Ansel's passion had grown, but he quashed it with the sobering reality of his marriage.[6] Lee Benedict, like others before and after her, became history.

Although Ansel had convinced Virginia less than four years earlier, in 1941, to withdraw her divorce petition, he never stopped his flirtatious ways, seeking out one object of desire after another. Women loved Ansel, not because he was a particularly handsome specimen—he was not—but because he was so alive.[7] This quality attracted men as well as women, and in truth, it is difficult to find anyone who knew Ansel who did not like him.

Most of the women who became romantically linked with him worked for him in some capacity or other, as darkroom assistants or secretaries. (After learning this, I understood why many people wrongly assumed I was Ansel's mistress.) He craved female attention for himself, not to run Best's Studio, maintain a home, raise his children, or care for his parents; those were Virginia's realm. His amours provided energy, compassion, and inspiration, qualities he hungered for.

His liaisons typically stopped just short of intercourse, though observers of the time hold this as a question mark. Repartee and shared experiences of climbing, hiking, and photographing, with some necking thrown in for good measure, seemed to have been enough for him, though the rumor mill worked overtime.[8] Times were different then,

and though affairs certainly occurred, the 1930s and 1940s were eons distant in terms of social mores from the sexual permissiveness so prevalent later in the century. What seemed adventurous, indeed scandalous, in Ansel's heyday would probably be considered innocent today.

Ansel's passions were time and again fired and then damped, whereupon he would return to Virginia's hearth. In a 1944 letter to Nancy Newhall, who had begun work on his biography, Ansel outlined his life story in a list that included his appreciation of Virginia's understanding about his other women.[9] One of Ansel's old flames recalled asking, a few months into their developing relationship, if he intended to marry her. He quickly replied that he would always stay with Virginia, whom he defended as a "fine woman." Her hopes of marriage to Ansel dashed, the young woman immediately concluded that her future lay elsewhere.[10] A similar progress of events ended more than one such unconsummated affair.

Ansel's amorous pursuits, insofar as they were directed at his employees, were clearly sexual harassment, even though potential conquests' refusals were accepted and did not negatively affect their working relationship with him. Interviews with many of his assistants, both female and male, confirmed that he was not sexually active during his last twenty years. The Ansel I knew was warm and generous—you knew he cared for you—but made no advances whatsoever. Whether this change in behavior was based on emotional growth or impotence following his 1962 prostate surgery is unanswerable.

Ansel eventually wrote two more books to complete the Basic Photo Series, *Natural-Light Photography* in 1952 and *Artificial-Light Photography* in 1956. Through these difficult-to-digest tomes, he became known to a large audience of photographers as THE expert. He realized little in royalties, even though the books sold well. Chronically strapped for cash, the publisher, Morgan & Lester, secured an agreement with each of its authors to delay payment of royalties; eager to have his books published, Ansel agreed to these terms and never did get paid.[11]

Ansel taught photography not only through books but in person as

well. In San Francisco, the California School of Fine Arts (CSFA) had assembled an incredible painting faculty that included Elmer Bischoff, Mark Rothko, and Clyfford Still. Richard Diebenkorn was only one among an esteemed group of students. An air of excitement permeated the school, and Ansel decided that it would be just the place to establish an equally distinguished department of photography. In a departure from pedagogic methods practiced at other photographic institutions, which were in essence no more than trade schools, Ansel conceived of teaching students how to express themselves individually through photography by giving them all the technical tools paired with an aesthetic approach.[12] With his friend Ted Spencer pulling strings from his power position as president of the San Francisco Art Association, in January 1946 Ansel taught a one-month course to prove to the school's trustees that serious study of photography was both needed and wanted. They agreed to set up a department of photography on the condition that Ansel raise ten thousand dollars to cover startup expenses. The Columbia Foundation came through with the funds, and full-time classes were slated to begin that fall.[13]

Up to his ears in carpenters, Ansel supervised the building of the darkroom he had designed. He immediately began lobbying to expand the department to include the instruction of photographic history, hoping to create a position for the out-of-work Beaumont. But Beaumont and Nancy had other plans, and anyway, they could not conceive of being so far from New York, the hub of their universe. Nancy was hard at work on a book with Strand, and Beaumont was churning out articles as a freelance writer and teaching photography workshops for Chicago's Institute of Design (at Moholy's behest) and Black Mountain College.[14]

His students at CSFA (now called the San Francisco Art Institute) found Ansel a tremendous teacher, full of inspiring energy even as he piled on a heavy load of technique.[15] Most students dove right in, though Ansel's presentation could be daunting: he often started his instruction with the conclusion of a subject and slowly meandered back to its beginning.[16] His critiques crackled with incisive criticism,

though since his workshop in Detroit in 1941, he had learned to place more emphasis on what was right about a print, and less on what was wrong.

His students were an unusually dedicated group. The war had forced most of them to put their personal dreams on hold; now they were highly motivated, ready to get on with their lives. A close camaraderie developed between pupils and teacher, cemented by their common commitment to photography. Well aware that theory went only so far, Ansel contracted actual assignments for his classes, which sent them into the field on a commission for Pacific Gas & Electric for an interpretive study of the Feather River power plants.[17]

But even before the first class matriculated, Ansel realized that his active involvement in the school could not last for long. In early April of 1946, he had been awarded a Guggenheim Fellowship of three thousand dollars to prepare a book of photographs and text on the national parks and monuments of the United States,[18] and he was ready, determined that nothing would stand in the way of his carrying out the project. Since Edward's 1937–38 grant, only four other photographers had received the prestigious Guggenheim: Walker Evans, Dorothea Lange, Eliot Porter, and Wright Morris.

Ansel had applied before. In 1933, he proposed not one but two projects: "A Photographic Record of the 'Pioneer' Architecture of the Pacific Coast" and "Research in Contemporary Photography" (an open-ended subject if ever there was one).[19] The experienced word on getting a Guggenheim was (and still is) that a photographer must expect to get turned down at least the first time, and possibly many more times; it was (is) all just part of the process.[20]

With the temptations of the Guggenheim-funded open road before him, Ansel had to find and train his CSFA replacement over the summer, in time to teach the first full class in September. Beaumont and Nancy thought they knew just the right person: Minor White, the same man whose photographs and name had captured all their attentions during the *Image of Freedom* competition. After Minor left the service at the end of the war, he traveled to New York and interned under Beaumont and Nancy at MoMA. They became very fond of him

and were impressed with both his intellectual and his photographic skills. When Beaumont resigned, Steichen asked Minor to assume his former position as curator, but to his everlasting credit, Minor refused, choosing instead to stick by his mentor. The Newhalls now shipped off their protégé to teach with Ansel during CSFA's summer session.[21]

Somehow, though they were very different men, Ansel and Minor developed a strong friendship based on mutual respect. As much as he could, Ansel conducted his life, and especially his photographic life, on the basis of scientific fact and objectivity. He believed that a student should be taught the craft of photography to the point of fluency, but he also felt that the essence of seeing was beyond words. He had little tolerance for those who analyzed photographs, imposing psychoanalytical meaning upon every mountain and tree.

Minor's mind traveled in a completely opposite direction, though he, too, imparted excellent technique to his students. While enrolled at Columbia University in 1945, he had attended two seminars taught by the great art historian Meyer Schapiro, who had inculcated him in the use of Freudian analysis to decipher art and the artist's intent.[22] Minor insisted on verbally investigating the meaning of every aspect of an image, and he did not stop with Freud, either. He would place a print before the class and ask each student to stand behind another and draw the feelings elicited by the photograph on the back of the person in front of them. A few years later, prospective students would be required to submit their birth time and place along with their application so that Minor could have their horoscopes drawn up.

Just as Ansel thought it all ridiculous, so Minor held that Ansel ignored the deepest meaning of art. Their students came to love the barely controlled explosive dynamics between their two teachers,[23] and Minor and Ansel themselves were sensitive enough to see that their combination of extremes worked.

Back in New York, on Saturday, July 6, 1946, bearing a melting chocolate ice cream cone as a gift, Beaumont and Nancy arrived at An American Place to find Stieglitz all alone, slumped on his cot.[24] He had just called his doctor, and they stayed with him until help came.

Stieglitz had suffered a heart attack. The following Wednesday, he was taken to the hospital in a stroke-induced coma from which he never awoke. After receiving a telegram in New Mexico, O'Keeffe boarded the first airplane out and kept flying until she had to switch to a train, arriving before his death at one-thirty in the morning on Saturday, July 13.[25]

That hot summer morning, O'Keeffe picked out a simple pine coffin for her husband's remains. She ripped out its offensive pink satin lining and then sat alone all afternoon and long into the night, handstitching a white linen replacement. As Stieglitz had instructed, he was cremated without benefit of a service or music. O'Keeffe drove his ashes to the family country house on Lake George and took them down to the shore, where she mixed them with the earth at the base of an old tree whose roots were lapped by water.[26]

The truest praise of Stieglitz, Ansel felt, could be found reflected in the poem "For Him I Sing," by Walt Whitman:

> For him I sing,
> I raise the present on the past,
> (as some perennial tree out of its roots, the present on
> the past),
> With time and space I him dilate and use the
> immortal laws,
> To make himself by them the law unto himself.[27]

Stieglitz himself had been much less solemn when contemplating his own demise, suggesting that his tombstone should read, "Here lies Alfred Stieglitz. He lived for better or for worse, but he's dead for good."[28]

Bad news came in bunches. Edward Weston was not well and had not been for some time, caught in a downward cycle that no one could diagnose. He felt terrible, his hands shook, he was unsteady on his feet, he developed a stoop, and his face grew inexpressive. In late 1945, Charis left him, partly because of his disintegrating health and

partly because of her desire to have children. Within two years she had remarried and was pregnant.[29]

Ansel worried about Edward, wrote frequently to him, and often traveled to Carmel to spend a few days with him, after which he would bring him back over to Yosemite with him for a week's visit.[30] In early 1948, Edward was finally diagnosed with Parkinson's. (Known as the photographer's disease, it was also to afflict Margaret Bourke-White.) Unable to carry his camera, which had to be hoisted around for him by his youngest son, Cole, he made his last negative that year, a deceptively simple composition of small rocks set against the gray sand of Point Lobos.[31]

Ansel drafted a group of loyal friends to raise money for Edward, first by securing commercial sales of his images to Kodak and others, then by selling fine prints. In 1950, Ansel and Virginia published Edward's last book, *My Camera on Point Lobos*, oversized and beautifully printed with thirty images from his "Yosemite."[32] Virginia personally put up the money and advanced Edward a thousand dollars in royalties.[33] Edward was more than pleased: "With *the* book in hand, a dream is fulfilled. . . . For all the love, time, and labor you put into this superb job. If I started to indulge in superlatives, I just couldn't finish."[34] Although *My Camera on Point Lobos* was judged one of the "50 Best Books of the Year," sales were dismal. Virginia absorbed a loss upward of fifteen thousand dollars;[35] the book's distributor, Houghton Mifflin, remaindered it in 1953 at four dollars a copy, down from the original ten.[36] Today a single copy is worth several hundred dollars.

Tenderly cared for by his sons so that he could stay at his home in the Carmel Highlands, surrounded by his huge tribe of cats, Edward would live ten more progressively infirm years before his heart finally stopped beating on January 1, 1958. At the time of his death, his bank account boasted three hundred dollars.[37]

Although Aunt Mary had died in 1944, Ansel's aging parents still lived right next door in San Francisco. Shortly after their fiftieth wedding anniversary, in July 1946, Ollie fell and broke her hip. The injury refused to heal, and she was confined to a wheelchair for the remaining four years of her life; never a happy woman, she complained constantly.

Ansel traded houses with his parents since his was primarily on one floor, making things much easier for his mother and thus his father as well. Their old home became a rooming house of sorts, with Minor White and a changing cast of students usually in residence. Ansel slept next door with his parents, in the upstairs loft; when he was out of town, Minor kept an eye on the old folks.[38]

Before Ansel could take off on his Guggenheim, he would have to make enough money to support everyone: three thousand dollars was hardly sufficient to cover his and his parents' expenses and whatever Virginia and the children needed to supplement her Best's Studio earnings. He engaged in a flurry of work, from conducting a San Diego workshop to teaching part-time with Minor to completing assignments for Kodak and *Fortune*. Two jobs for Kodak, in August and September, paid more than his entire Guggenheim stipend.[39]

The Standard Oil Company purchased reproduction rights to a number of his color landscapes for its project "See Your West." Those of a certain age can remember when gas stations vied for the public's business, offering such tantalizing items as a pound of sugar, a jar of jam, or a color photographic reproduction with every fill-up. At Standard stations in 1947 and 1948, patrons could collect a whole series of views of America that were to be placed between hardboard covers with benefit of a plastic spiral ring. A number of the images were by Ansel.[40]

By the end of November, Ansel felt secure enough financially to leave CSFA, appointing Minor as the head of the photography department. He directed the Bracebridge Dinner at Christmas in Yosemite, brought Edward over for a visit, finished up some odds and ends, and finally declared his decks clear for the Guggenheim, ten months after he received the grant.

Ansel drove off in January 1947, his station wagon packed to capacity, for a full fifty days all alone. Not solo by choice, he had tried unsuccessfully to entice Edward or the Newhalls to accompany him. He traveled seven thousand miles, through Death Valley, Joshua Tree, Organ Pipe, Saguaro, White Sands, Carlsbad, and Big Bend National

Park in Texas, whose largely ignored, undeveloped spaces were a revelation to him.[41] At night he typed out stacks of letters to Park Service Director Drury, evaluating each park and inserting insistent and continuous plugs for the elevation of Death Valley National Monument to national-park status.[42]

Ansel returned to Yosemite and San Francisco for almost two months to check in with his students and family, and to earn some more money, before again setting off in late May on another two-month Guggenheim drive. This time he had company: Nancy and Beaumont, himself a new Guggenheim fellow with his project to expand his earlier museum catalog to become the authoritative *History of Photography*, came west to accompany him on the first leg of his journey.[43]

In Yosemite, Nancy presented Ansel with a special gift. When using a view camera, a photographer must place a dark cloth over his or her head and the camera's ground glass in order to compose and focus the image. Ansel had never been able to find the right focusing cloth, which had to be comfortably large, completely opaque, nonslippery, and heavy enough not to be disturbed in a wind.[44] Knowing this, Nancy had sewn a focusing cloth that answered all his specifications and was black on the inside for darkness and white, for sun reflectance, on the outside. It was a great present for Ansel, who would use it for the rest of his life.

On May 28, 1947, Ansel, Beaumont, and Nancy pulled out of the valley and over the Tioga Road, Ansel insisting that the two New Yorkers ride on his rooftop rack to gain the best, if scariest, view.[45] Nancy christened Ansel's car Helios in honor of Eadweard Muybridge, who had signed his photographs with that name. They camped the first night on the shores of Mono Lake, its spindly tufa towers unlike anything the Newhalls had ever seen.

True to form, Ansel had packed so much that there was scarcely room for his passengers. Among many, many other items, he had his eight-by-ten camera, three lenses, four filter sets, and twenty-four film holders. He also brought his five-by-seven, three-and-a-quarter-by-four-and-a-quarter, and Graflex cameras, with their concomitant accessories, three tripods, and every smaller gadget known to a photog-

rapher, plus both black-and-white and color film for all those cameras. Of course, Nancy and Beaumont also had cameras, as well as some few clothes, sleeping bags, and cooking gear and food.[46]

Ansel was prepared for any eventuality. Once, he had found himself out in the middle of Southwestern nowhere when the axle of his car broke. He got towed into the nearest town and was informed by the mechanic, "Mr. Adams, it will take me one day to go get a new axle, one day to bring it back, and at least another to install it in your car." Ansel swore he would never let that happen again, so he never left on an extended photo safari without taking along an entire spare axle, wrapped in greasy paper and occupying a significant amount of space.[47]

This trip was an adventure for Beaumont, who was more at home in a library than under the stars. Knowing that his friend cared deeply about food and drink, and the quality thereof, Ansel planned to take special care of his needs. The evening of May 29, Ansel established their camp in Death Valley at Dante's View, affording a magnificent panoramic vista. He set up both his Coleman stoves on the car's tailgate, mixed cocktails to start things off, then fried up some thick steaks flavored with curry powder and bay leaves. Other nights he served such fare as chicken chasseur and oysters with tomato sauce.[48] Intrusive as it might seem today, Ansel's car sported a high-intensity spotlight with which he swept the valley below for the Newhalls' benefit, a dramatic bedtime spectacle.[49]

Since early morning and late afternoon provided the best photographic light, soft and revealing rather than harsh, as at midday, Ansel arose at dawn and made a big pot of coffee before rousing his guests with his personal version of an alarm clock: the old, reliable donkey's bray. All three photographed until the light became less friendly, and then it was off to the nearest diner for a big breakfast, no holding back: steak, eggs, toast dripping with butter and jelly, and more cups of hot coffee.

Their trip extended nearly two thousand miles, including a stop at Bryce Canyon, which at first looked like nothing much to Beaumont. Ansel parked the car and bade the Newhalls walk with him to the

canyon edge, where they immediately saw Bryce's hidden beauty: thin, tall towers of eroded rock that the Native Americans had likened to men from some strange tribe. The trio all pulled out their cameras.

That night, Beaumont again dozed fitfully in his sleeping bag on the ground, only to be roused at the indecent hour of four A.M. by Ansel the Donkey. After a morning of photography, Beaumont longed for a nap, but Ansel and Nancy talked about further camera work. Beaumont had been up too long with too little sleep for too many days. In disgust, he blurted, "What, nature again? I've never seen so much nature. We sleep on it, we look at it in the morning and the afternoon and by moonlight and by sunrise and sunset. I'm looked out!"[50] Ansel and Nancy conceded the rest of the day to Beaumont. They booked motel rooms and took naps in beds, then enjoyed a meal cooked by Nancy. According to Beaumont, "Nancy made fine ham, and with that inside me and nothing to look at but ordinary domestic trees I felt a good deal better."[51]

They drove to both north and south rims of the Grand Canyon and then arrived at the grand finale, splendid Sunset Crater. Ansel deposited them at the train station in Williams, Arizona, on June 7.

During their travels, the first of Ansel's Guggenheim photographs were published in *Fortune*, along with the work of four painters, to accompany an article entitled "The National Parks," by Bernard De Voto.[52] The painters were a respected group: Max Ernst, Jane Berlandina, Dong Kingman, and David Fredenthal. Flipping through a copy of *Time* one morning at a café while they waited for their breakfast, Ansel spotted a review that not only sang the praises of his photographs but judged them superior to any of the paintings in the piece.[53] With clinks of their coffee cups, Beaumont, Nancy, and Ansel toasted this as an important milestone for all of photography.

Soon after the Newhalls' departure, Ansel picked up his son, Michael, now fourteen, at the station. Ansel had finally sensed that he was largely a stranger to his children, and he wanted to change that. He reckoned the problem could be solved by occasionally taking one of

them with him on his travels—this time Michael, for six full weeks. Ansel treated his children as adults, expecting them to respond with mature language and behavior at all times. He never thought to tailor the trip around his teenage son; there was serious work to be done. After returning home for a month or so, Ansel was back on the road by himself to photograph the Smokies, the Blue Ridge Parkway, and Shenandoah National Park, then it was back to Yosemite for Christmas and the Bracebridge.

In January 1948 it was Anne's turn. She accompanied her father for five weeks in New York and an array of eastern destinations. They stayed with George and Betty Marshall in their elegant four-story town house on Beekman Place. George was an important attorney who was active in both photography and environmental work, and the Marshall daughters were close in age to twelve-year-old Anne, which freed Ansel from a great deal of child care.

Near the end of this stay, Ansel arrived at the Newhalls' front door clutching his chest. They helped him to a chair and called their doctor. Ansel was hospitalized with a diagnosis of a spasm of the coronary arteries; happily, the electrocardiogram detected no permanent damage to his heart. Forbidden to climb stairs or mountains for the next few weeks, Ansel recuperated at the home of friends whose house was equipped with an elevator. As he struggled to keep calm and still, he was tortured by the thought that he would no longer be physically able to enjoy the high altitudes of Yosemite and the Sierra.[54] But a miracle of sorts occurred: it turned out that Ansel had been misdiagnosed. His heart was not the problem; he had a hiatal hernia that was producing symptoms mimicking those of a heart attack.[55] Although the hernia would bother him for the rest of his life, he knew it was not life-threatening, and the mountains could still be his.

The time with Anne proved less than successful. Reacting as would most normal twelve-year-olds, she was profoundly embarrassed by her very weird father, who did not dress or act like any of her friends' dads. Her disapproval distressed Ansel, who did not want to hurt her but nonetheless refused to change into the type of father she would have

preferred. Anne decided that the best way to handle the situation was to keep her distance. Ansel was rarely home anyway.[56]

Finding it impossible to dedicate all his time to a full year of nothing but Guggenheim work, he was relieved when the trustees renewed his grant for the year 1948. In a whirlwind of productivity, Ansel published *Yosemite and the Sierra Nevada*, which featured selections from the writings of John Muir accompanied by a portfolio of sixty-four Adams photographs.[57] Ansel sequenced his images in a travelogue, literally following his footsteps (or tire tracks) from San Francisco (*The Golden Gate Before the Bridge*), across the Pacheco Pass (*In the Mount Diablo Range*) to the San Joaquin Valley (*Rain Clouds over the San Joaquin Valley*), into the Sierra foothills (*Slate Outcroppings, Sierra Foothills, West of Mariposa*, and two other pictures), and then, in plate 7, to the splendor of Yosemite Valley from Inspiration Point (*Yosemite Valley*).

Kodak commissioned two more projects from Ansel that he easily combined with his continuing Guggenheim trips. Both proved to be financially the best kind of assignment—that is, ongoing. One was a series of landscapes to be taken in the national parks, with each image to include a photogenic couple poised to snap a picture with their Kodak camera. The second project was to make large, colorful panoramic transparencies that the technicians back in Rochester would enlarge to an incredible sixty feet long and eighteen feet high. The Kodak Colorama, as it was named, became a New York City tradition, exhibited continuously at Grand Central Station. Using a seven-by-seventeen-inch banquet camera, Ansel made his first Coloramas in late 1948 and Kodak used about twelve of them.[58]

It was Ansel's intention to photograph every single national park, and most of the monuments. He spent from mid-April to mid-May of 1948 by himself in Hawaii, underwriting the trip by making pictures for the Matson Line of passenger ships that cruised from the mainland to Hawaii. He photographed on Oahu and visited Hawaii National Park on the Big Island as well as Maui, Lanai, and Kauai. He hated Hawaii. When his ship was a day away from the islands, he swore he could smell a sweet stench that pervaded the air. Nary a palm tree found its

way onto his film; believing that vacations were literally immoral, Ansel saw palm trees as a symbol of indolence, shading people who lay around on beaches when they should be working.[59] He found Hawaii just too soft in comparison to the Sierra or the rugged California coast: the water warm as dishwater, the skies hazy, the clouds graceless, the volcanic rock amorphous.[60] For all his protests that Hawaii was not his kind of country, he did make some strong images of the crater of Haleakala and views from its heights across to the neighboring volcanoes, Mauna Loa and Mauna Kea on the Big Island.[61]

In late June 1948 it was Michael's turn as his companion; Ansel drove them to Seattle and they boarded the S.S. *George Washington*, bound for a six-week trip to Alaska. It was a grand tour from Skagway to Mount McKinley and then on to Anchorage, Fairbanks, Sitka, Juneau, and Glacier Bay.[62] They were even feted by Alaska's governor. Unfortunately, constant rain, that bane of the photographer, was there to greet them on their arrival and to bid adieu when they left. Most of Ansel's Alaskan photographs were, by necessity of circumstance, forest details, with the rain's evidence everywhere, whether in droplets or in heavy mist. Picture after picture from this trip was simply titled *Leaves, Alaska*, though each negative was exquisitely different and detailed by quiet light.

When they got to Mount McKinley, they might just as well have been in plain, flat tundra. The clouds were so dense that the mountain itself was invisible, quite a cloud cover considering that McKinley is an atmosphere-busting 20,320 feet high, or nearly three times higher than Half Dome, a fact Ansel found most impressive.[63]

Summer was in full swing, for Alaska. The sun set at eleven-thirty at night and rose about two hours later. Mosquitoes were the chief form of animal life; Ansel was thankful that his continuous encounters with them resulted only in welts and not in illness, as might have been the case in tropical countries. If Alaskan mosquitoes carried disease, he mused, Alaska would be uninhabitable.[64]

At McKinley, as elsewhere on Ansel's Guggenheim journeys, the National Park Service, prepped by letters from VIPs in Washington, provided whatever support they could. Ansel and Michael stayed at

the ranger cabin on the shores of Wonder Lake, thirty miles from McKinley's base.

Ansel went to bed after an early dinner, arising again at midnight to hike up the hill above the lake. He positioned his eight-by-ten-inch view camera on its big wooden tripod base and attached the twenty-three-inch component of his Cooke Series XV lens, the combination of equipment with which he made most of his greatest images, and after much personal debate added a deep-yellow filter.

Shifting the camera so that his ground glass, reflecting the scene before him upside-down and backward, defined the strongest composition, he made what would become another of his masterpieces. Fully exposed in the light of sunrise, McKinley appeared as a benign mass, a skin of snow stretched tightly over its lumpy skeleton, every nuance of form revealed in chiaroscuro. The huge mountain filled the sky but not the bottom half of the picture, its scale diminished by Ansel's choice of a long-focus lens. In the finished print, Wonder Lake seems equal in size to McKinley, though the light on each is totally different. Wonder Lake has an amorphous, pearly glow, its edges defined by dark shoreline; though it is much closer to the camera than McKinley, its surface details are not revealed. *Mount McKinley and Wonder Lake* is sublime.[65]

After spending two months with his son, Ansel found Michael as difficult as he had Anne. Michael remained cool toward him throughout the trip; his inexperienced father had no idea whether it was just because Mike was a teenager or if it truly described his feelings. It dawned on Ansel that his years of neglect might be impossible to erase. He did not know that Virginia had warned her children never to trust their father.[66]

When Ansel and Michael returned to the lower forty-eight, Virginia joined them to deliver the fifteen-year-old to boarding school, the Wasatch Academy outside Salt Lake City. His parents hoped that the education and discipline of the military-style institution would ensure a better future for him than would the small, easygoing Yosemite Valley school.

Ansel dropped Virginia back in Yosemite and was soon off on his

annual fall trip to the East Coast. In September 1948, Beaumont moved to Rochester, in upstate New York, to accept a position as curator of the new George Eastman House (GEH), the first museum devoted exclusively to photography. Previously the home of Kodak's founder, in its new incarnation the building that housed GEH was to serve as a memorial to his life, as well as an institution for the collection and exhibition of photography. In 1958 Beaumont would become its director, a position he would hold until 1971.

Nancy stayed behind in the city to pack up their apartment. Good friend Ansel came to her rescue, carrying load after load down to the illegally parked car, filling every nook and cranny, leaving just enough space so that Euripides the cat could be squeezed in under the dome light. Hampered by traffic, then by thick fog, they stopped to call Beaumont every hour and assure him of their safety, until he finally ordered them to let him sleep.[67]

Ansel stayed for the opening of the Eastman House on November 19. He brought some of his national-park photographs to show Beaumont, hoping to be given an exhibition at the museum. After much deliberation, Beaumont said no. They had criticized Steichen for his blockbuster theme shows at MoMA, all aimed at the lowest common denominator, pandering to human emotions. Beaumont felt that his exhibitions at GEH must not smack of propaganda of any sort. He believed that showing Ansel's photographs of the national parks would be pleading a cause, and he would have no part in that.[68]

Ansel returned to California, uneasy about Beaumont's rejection but too busy to pay it much mind. For years he had contemplated showing a small group of his prints that would together represent the scope of his photographic vision—some details from nature, a few portraits, and at least one big thundercloud[69]—and now he decided to produce just such a portfolio. Before the end of the year, he completed nine hundred small fine prints, enough to fill seventy-five portfolios. He titled it simply *Portfolio One, Twelve Photographic Prints by Ansel Adams*, and dedicated it to Alfred Stieglitz, whose portrait was the sole one among twelve spectacular images. Priced at a hundred dollars, *Portfolio One* sold out quickly.[70] Today the

sale of one portfolio alone would bring easily two hundred times that amount.

There were two architectural studies, one great landscape (*Mount McKinley and Wonder Lake*), two smaller landscapes (including the nearly abstract *Refugio Beach* and the haunting *Oak Tree, Snowstorm*), five details from nature, one portrait (*Alfred Stieglitz*), and the wispy, white *Clouds Above Golden Canyon, Death Valley*.[71] The quality of the prints was superb, with each photograph the best interpretation that Ansel ever achieved of that negative; the tones were balanced, not yet betraying the often overly dramatic qualities that soon began to dominate his work.[72] Some of the special beauty of *Portfolio One* may be attributable to the recent death of Stieglitz, whose inspiration floated in Ansel's memory throughout the making of the prints.

Ansel still had not completed his Guggenheim project, and he continued to travel as time allowed, even though two more books were now added to his schedule. One was a reprint of Mary Austin's text *The Land of Little Rain*, with a selection of Ansel's photographs, and the other a large-format, beautifully printed picture book called *My Camera in Yosemite Valley*, which Ansel dedicated to Edward Weston. Virginia was the publisher of record, with the assurance that the distributor, Houghton Mifflin, would purchase a large number of books.

The spring of 1949 was dominated by trips to make photographs for *The Land of Little Rain*, but come summer Ansel went back to Alaska, this time alone. He hoped for better weather than they had had the year before, but he was out of luck: again it rained, day after day. To escape the wet, he eagerly accepted an invitation to take a nine-hundred-mile flight in a Grumman amphibious airplane that was to drop supplies from the U.S. Geological Survey for the Juneau Ice Field Expedition. Ansel insisted that the cargo door be removed for the flight so that he could better photograph; the result was that he almost froze to death. To make amends for that misadventure, the same crew offered to fly him to Glacier Bay and helicopter him out in a couple of days, but once they got there, bad weather socked in the airstrip, making flying impossible and stranding him for nearly a week. Damp but undaunted, Ansel returned home three weeks later with another raft of

fine negatives of forest details reflecting the dismal weather conditions.[73]

Technically, Ansel was to have completed his Guggenheim national-park project by the end of 1948, but he stretched it across 1949 to bag Maine's Acadia National Park; that he was unable to make it to the Everglades in Florida became a lifelong regret. Ansel purposely chose to travel to Maine in November: he wanted stormy weather with surging seas, and he got it, though he found the form of the Maine coastline less striking than that of California's, so he focused on the ocean, not the land.

The Newhalls acted as his guides on this trip. Since they adored lobster, many meals were centered upon that delicacy. But after a visit to a lobster pound, where the surface of the water was thick with green algae, Ansel could no longer enjoy the crustacean, claiming its predominant flavor was penicillin.

The effects of decades of loneliness on Virginia are hard to gauge, since she is rather quiet by nature. But years later, seated at a table at the Old Bookbinder's restaurant in Philadelphia, she recalled how Ansel had talked of his lobster dinners with the Newhalls. Since then, any reference to lobsters had served as a keen personal reminder of just how much she had missed while she stayed at home to parent their children and keep the doors of Best's Studio open. Now, thirty-three years later, she was finally eating her first live Maine lobster. Ansel sat across the table and ordered chowder, warning her that she was making a mistake: the lobster would taste like medicine.

By August 1949, Ansel estimated he had made 2,250 negatives specifically for the Guggenheim project, over and above the six hundred he had taken in 1941 and 1942 for the Department of the Interior.[74] Nearly three thousand negatives is an amazing number and accomplishment, all the more so in that they were all large-format; none was in the convenient and quick 35mm format.

It had been ten years since Ansel's retrospective at San Francisco's Museum of Modern Art. A sixty-print show, mostly of work made since that exhibition, opened at the same museum in June 1949. Ansel exhibited *Mount McKinley and Wonder Lake* for the first time; a price list

stated that all five prints of *Surf Sequence* could be purchased directly from the artist for a hundred dollars.[75] The public attended in droves, and the critics ran out of synonyms for *superlative*.

Ansel's Guggenheim odyssey had taken him some seventy-five thousand miles,[76] to twenty-three different national parks and monuments, the preponderance of which were western. His definitive photographic statements on the national parks finally appeared in 1950 with the publication of *My Camera in the National Parks* and *Portfolio Two: The National Parks and Monuments*. The book was another beauty, identical in presentation to both *My Camera in Yosemite Valley* and Edward's *My Camera on Point Lobos*: in large format, on heavy paper stock, with special varnish coating each photographic reproduction, the images of large size and brilliant reproduction, the whole spiral-bound so that the pages could lie completely flat. Ansel dedicated the book to Virginia, acknowledging her patience with his wandering ways in pursuit of his art.[77]

After Virginia published the three *My Camera* books, the Park Service informed her that it did not approve of this expansion into the publishing business on the part of its concessionaire Best's Studio. In 1952, Ansel and Virginia formed a separate company, 5 Associates, to act as an independent publishing house. This entity was the publisher of some of Ansel's books during the 1950s and 1960s, and also printed a whole line of postcards and notecards.[78]

Portfolio Two: The National Parks and Monuments was issued in an edition of 105, each comprising fifteen prints from negatives made throughout the 1940s. Ansel dedicated the portfolio to the memory of Albert Bender, who had believed in "Ansel the Photographer" right from the beginning.[79]

Those first years after the end of the war were the most measurably productive of Ansel's life, with a parade of excellent books, articles, and portfolios that earned him national recognition and high regard from both the larger world of art and the smaller one of photography. Art critic Alfred Frankenstein proclaimed that Ansel's 1949 San Francisco exhibition "could easily fill the whole museum without repetition or satiety, for the photographer in question is Ansel Adams."[80] A more

deeply personal reaction to his work came to Ansel in a letter from Imogen Cunningham, who wrote, "If anyone admired only one of my prints with the intent interest and appreciation I put on every print except one [photograph not identified] in your present exhibition, I should feel a big reward had come my way. You make us all feel so inadequate and futile. What shall I do."[81]

15

A DOCUMENTARY APPROACH

Ansel wanted to believe he could do it all. He could not be satisfied with becoming merely the most celebrated landscape photographer of all time so long as the whispering voice of Stieglitz in his subconscious argued that it was a time not to photograph rocks and trees but to turn his camera, instead, on the most important subject: man.[1] Ansel longed to make his mark in the great documentary tradition with true and revealing photographs of people and their lives. He reasoned that the subject should be his for the taking.

One of the most committed documentary photographers, Dorothea Lange, worked closely with Ansel over many years, though their relationship followed a bumpy road. Born in 1895, Dorothea was seven years older than Ansel. After working for photographer Arnold Genthe and studying at the Clarence White School of Photography in New York, she had stopped in San Francisco in 1918 on her way to the Far

East, but found herself stranded when all her money was stolen. She was hired by a photo-finisher and soon met many Bay Area photographers, including Imogen Cunningham and Consuela Kanaga. Within a year she had opened her own commercial studio and was in demand as a portrait photographer of the city's well-to-do. She married Maynard Dixon, an illustrator and painter, and had two sons, keeping her portrait business alive all the while.[2]

One day in 1933, with the Depression at its nadir, Dorothea glanced down from her studio window and noticed a young unemployed laborer standing at the corner, looking about in every direction as if to find a way out of his personal predicament. Moved by the scene, Dorothea picked up her Graflex camera and walked down the steps, out the door, and into her new life as a documentary photographer, later stating, "I was compelled to photograph as a direct response to what was around me."[3]

Ansel soon became Dorothea's second champion, and maybe her most important, mentioning her name at every opportunity in print as well as in person.[4] (Her first had been Albert Bender, who encouraged her creative works during the 1920s and was the first person to purchase her photographs based on their artistic merit.)[5] Dorothea's photographic maturation, just beginning in 1933, came only a little too late for the compatriots of Group f/64 to include her in their initial 1932 show.

Ansel reproduced *White Angel Breadline* in his 1935 book *Making a Photograph*, the only image by someone other than himself and the first time one of Dorothea's photographs was published for its intrinsic value, not simply to illustrate an article. When this image was made, the year was 1933, and fourteen million Americans were out of work.[6] A dejected old man stands at the picture's center, his back turned away from a sea of others who wait for the food being handed out by a woman dubbed the White Angel. The old man's stained and crushed hat is pulled down low on his forehead; a dark, shapeless coat hangs from his shoulders, which droop with resignation. He hugs an empty tin cup. Here was a picture truly worth a thousand words.

Dorothea was recruited in 1935 onto the first team of photographers

to document the effects of the Depression on America for the Resettlement Administration. Joining her were photographers Walker Evans, Russell Lee, Arthur Rothstein, Ben Shahn, and, eventually, Marion Post Wolcott. Their unit, led by Roy Stryker, was renamed the Farm Security Administration (FSA) in 1937. In 1936, Dorothea made the photograph that would become an icon for both the Depression and the efforts of the FSA, the very poignant *Migrant Mother*. By the project's end, in 1942, over 270,000 negatives documenting the Depression's effects had been made, all of which are now archived at the Library of Congress.[7]

Weary from a month spent on the road, driving from one place of misery to another, Dorothea paid scant attention to a primitive hand-lettered sign indicating a Pea Pickers Camp. Shrugging it off as just another place like all the others, and eager to get home to her family and out of the rain, she sped straight past. Nagging at her, however, was the feeling that she must go back. After fighting her intuition for twenty miles, she turned around and entered the rain-soaked camp, where she immediately discovered an apparently abandoned mother with her three children.[8]

Migrant Mother was a close-up portrait, the last image in the series of exposures that Dorothea made that afternoon. With a dirty and tousled child huddling against each shoulder and a sleeping, grimy-faced baby nestling at her breast, the mother looks off into the distance, her face deeply etched with worry. She seems to be asking herself, how much longer can I continue?

The crops had frozen in the fields, and with nothing to pick, the family had been living on peas and whatever birds the children could catch. The mother had just sold the tires off her car, and they were now stranded and desperate. Dorothea spent only ten minutes photographing, and her only subjects in the entire camp were this one family. She did not write down the mother's name, merely the information that she was thirty-two years old.

That was the story that Dorothea told, the one that became history, repeated in articles and Lange biographies. The mother did have a name; it was Florence Thompson, and over time she grew angry that

her picture kept appearing year after year in various publications for which she received no credit or money. Her version of the story, not known until after Dorothea's death, was quite different.[9]

Thompson, her husband, and their eight children had been driving from the Imperial Valley, where they had been picking beets, north to Watsonville to harvest lettuce. When their car broke down, her husband and the two oldest boys had deposited the rest of the family at the Pea Pickers Camp, building them a rough shelter before heading into the nearest town to get the car fixed. She had not sold the tires; they stayed in the camp only that one day; and it was not raining.[10]

What was worse, Dorothea had posed the subject. This was not a problem for a portrait photographer, which she certainly had been, but it broke the implicit rules of documentary photography, which purports to tell the whole truth and nothing but. Dorothea made six exposures; in each successive image, something concrete has been changed—a chair moved, child removed, the baby nursing in only the third frame, the two other children directed to turn away from the camera in the last exposure.[11]

Thompson's life did not get much better, but she and her children endured. She became a union organizer in the camps. After they were grown, her children came to believe that she was unhappy with Dorothea's portrait because it portrayed her as helpless and hopeless, rather than as the strong and proud woman they knew. Many have mistakenly credited Lange's photograph with saving the family: soon after she sent these images to Washington, ten tons of emergency food were shipped to the camp. By then, Thompson and her family were long gone.[12]

Lange created an instant icon for the Depression with *Migrant Mother*, although today we might be tempted, given her staging of its creation, to see it more as a docudrama. Like Alexander Gardner, who moved the body of a sharpshooter for pictorial effect, Lange used a real location, real people, and a real situation but believed their message could be better communicated if she rearranged things just a bit. For Dorothea, the end justified the means: later Ansel would say that some of her photographs, including this one, were among the greatest ever made.[13]

Unable to process her negatives while on the road—which was where she was most of the time—Dorothea hired Ansel in 1935 on a per diem basis to develop her films and make occasional prints. She soon came into conflict with her boss, Stryker, who insisted that all FSA photographers mail in their undeveloped films directly to him in Washington. Dorothea rebelled, explaining that she needed to know what she was getting. Ansel agreed that Stryker's rule was not in her best interests and met with him on her behalf. He was at least partially successful: Stryker agreed to let Dorothea (or Ansel, as her assistant) develop the negatives and make three prints from each. All would then be sent to Washington, with one print from each negative to be returned to Dorothea.[14]

Ansel continued to work occasionally for Dorothea throughout the 1930s, receiving a small fee for his services.[15] In the summer of 1938, while shooting for the FSA, she sent him all her films for three straight months. Explaining this extravagance, she wrote to Stryker, "It will cost me a lot of money but since I cannot for lack of time develop in the field I've decided to make no compromise on quality and there is no technician in the country to match him."[16] Ansel in turn respected the depth of Dorothea's passion for photography, feeling that she was one of the few photographers as committed as he to the medium. He seconded her philosophy that "if our work is to carry force and meaning to our view we must be willing to go all-out."[17]

Almost surely it was Ansel who brought Dorothea's work to the attention of Beaumont at MoMA. Although she was not included in *Photography 1839–1937*, she was represented in 1939's *Documents of America* by nine prints—more than any other photographer.[18] But it was only in 1940 that Dorothea fully arrived on the art scene, with her selection for Ansel and Beaumont's first show for the Department of Photography, *Sixty Photographs*. Ansel asked her to write the statement for the documentary section of his catalog for *A Pageant of Photography*, which also featured her photographs, and invited her to join his faculty for *U.S. Camera*'s Yosemite Photographic Forum in June 1940, though she ended up not teaching due to low enrollment. He promoted her at every possible opportunity.

In late 1942, Ansel joined the faculty of the Art Center School in Los Angeles because he believed that the Signal Corps would soon send its soldiers there for training. More direct involvement in the war did not materialize, as the Signal Corps never came aboard; instead, Ansel found himself teaching basic technique to photo-lab workers for West Coast defense factories.[19] At odds with the head of the school and most of his fellow teachers, all of whom had a commercial bias, he resigned on March 23, 1943. His last class was held at the Los Angeles city morgue, where he instructed civil-defense workers on the preferred technique of photographing corpses.[20]

Ansel retreated to Yosemite. He had received a letter from the publisher of *U.S. Camera*, Tom Maloney, who warned him that photographs of nature had no relevance during wartime.[21] No one seemed to agree with, or understand, Ansel's conviction that beauty was salvation.[22]

With perfect timing, an old Sierra Club friend named Ralph Merritt arrived in Yosemite. Merritt was the newly appointed director of the Manzanar Relocation Camp on the eastern side of the Sierra. When he invited Ansel to document the camp, Ansel seized the opportunity.[23]

World War II, it is generally agreed, was a necessary war. But while America, the symbol of democracy, joined the Allies to stop the nightmare of fascism from engulfing the world, at home it was not freedom for all. In 1942, the American government, led by President Franklin Roosevelt, instituted racism on a federal level, directed solely at one physically identifiable group: people of Japanese ancestry.

Immediately following the bombing of Pearl Harbor, there was great fear that the Japanese would invade the mainland United States. Terror was greatest along the West Coast, where Japanese submarines were sighted from shore. On February 24, 1942, there was a report of Japanese airplanes over Los Angeles; one antiaircraft unit opened fire, and hearing that, others joined in the shooting. Although the report had been false, and there had been no invasion by Japanese planes, people were in a panic, and every Asian was suspected of being a spy.[24]

Executive Order 9066 was signed by President Franklin D. Roosevelt on February 19, 1942. It decreed that military zones should be established

from which any or all persons may be excluded, and with
respect to which, the right of any person to enter, remain
in, or leave shall be subject to whatever restrictions the
Secretary of War . . . may impose in his discretion.[25]

The states of California, Oregon, and Washington were declared mili-
tary zones. With great speed, orders were issued that all Japanese, cit-
izens or not, were to be rounded up and placed in "relocation camps."
From there jobs would be found for them by the War Relocation Au-
thority (WRA, the government agency founded to administer the
camps) in less sensitive areas in the country's interior. It amounted to
nothing less than a vast diaspora; neither Americans of German ances-
try nor those of Italian ancestry were imprisoned because of their eth-
nic background.

Twenty-five thousand young Nisei (first-generation American-born
Japanese-Americans) volunteered to serve in the armed forces during
the war, and the most decorated fighting unit in United States military
history was the heroic 100th Battalion of the 442d Regiment combat
team, composed entirely of Japanese-Americans.[26] Not one person of
Japanese ancestry was ever convicted of treason during World War II.
Nonetheless, it took the end of the war to stop the camps.

Nine relocation camps were established. Manzanar, in California's
Owens Valley, opened its gates in March 1942.[27] Soon more than
110,000 people in all were interned in the camps, 10,046 of these at
Manzanar alone at one point.[28] The official government line was that
the purpose of the camps was to protect the people inside from the
angry citizens outside, but the gun towers that surrounded each camp
were turned inward, on the inmates, not outward to protect them.[29]

The evacuation was swift and uncompromising, the roundup cap-
turing people found to be of even one sixty-fourth Japanese ancestry.[30]
Under such outrageous conditions, people were forced to sell their
homes, close their businesses, and store all their belongings on only a
few days' notice. Needless to say, property and goods were sold off at
below-bargain-basement prices; most people lost almost everything.
Each was allowed to take but a few small suitcases.

The camps were all sited in isolated places. Manzanar, the Spanish name for "apple tree," has become a symbol for all of the camps. Originally a fertile land graced with apple orchards, the valley had grown dusty and barren since much of the water had been diverted far away for urban needs. The five-hundred-acre site of the camp was loaned to the federal government by its owner, the Los Angeles Department of Water and Power.[31] It was the challenge facing the Japanese internees to plant fields that would provide produce both for themselves and for others outside the barbed wire.[32] Irrigation ditches were dug by hand, and crops did indeed grow. Crude tarpaper barracks were constructed, along with a hospital and a school.

Dorothea had photographed Manzanar before Ansel; hired by the WRA to provide a visual record of the implementation of 9066, she covered the evacuation and first days of internment.[33] Completely opposed to the relocation (her new, second husband, social scientist Paul Taylor, was an outspoken champion of the civil rights of the Japanese-Americans), she believed her work with the camera represented the national conscience.[34] Her nearly eight hundred images graphically depict the personal devastation caused by 9066's uprooting of bewildered, innocent families.[35] The Manzanar that Dorothea saw was raw, not yet softened by the determined hands of its internees. For her, the dramatic backdrop of the Sierra only seemed to heighten the harshness of the windblown, desiccated landscape.

Although internees were not allowed to have cameras, Toyo Miyatake, a Los Angeles portrait photographer, smuggled in a lens and crude parts out of which he constructed a simple camera. His photographs of the camp, taken from the inside, show a surprisingly vital community, the people coping with their tragedy with great courage, living life each day as best they could.[36]

Ansel was Manzanar's third photographer. For many years, his parents had employed Harry Oye, who was a Japanese national, or Issei, and thus unable to become a citizen. Harry was picked up by the authorities two days after Pearl Harbor and, due to his poor health, incarcerated in a hospital far away in Missouri.[37] His imprisonment outraged Ansel, who came to Manzanar in October 1943, stayed for a

week, then returned for another week and another. Unlike Dorothea, he was not on a paid assignment that led him to believe he could be more objective: even though she was employed by the government, Dorothea had refused to soften the situation she found, which may be why the WRA largely buried her negatives.[38]

A key element in the evolution of Manzanar from the Spartan camp that Dorothea had experienced to the vibrant village that Ansel found was its director, Ralph Merritt. From the time Manzanar opened until Merritt took over that November, there had been a string of unsuccessful directors. Two weeks after Merritt's arrival, a riot erupted between those who believed that cooperation with the government was the best course and those who seethed with anger about having been placed in such an untenable situation. The new director called in the soldiers stationed outside the camp, who began firing wildly, some determined to kill a Jap here if they could not get sent to the Pacific to do the deed. Two blameless young Japanese-American boys were killed. Merritt vowed to never let anything like that happen again and began immediately to work directly with the internees, establishing a self-governing democracy and bending the rules whenever possible.[39] Ralph Merritt, personally convinced of the utter wrongness of the camps, became a hero through his humanistic administration. His invitation to Ansel was extended in the hope that through his work, the people of Manzanar might be recognized for their loyalty to America even in the face of such gross mistreatment.[40]

In his photographs, Ansel emphasized that these were individuals, as American as any other citizen. He made portraits in close-up of person after person, each undeniably unique and human under his scrutinizing lens; these are emphatically not anonymous faces that all look alike. He photographed families living in their simple quarters, no longer bare but spruced up with creative, homey touches. His pictures show hardworking people who in their former lives held respected jobs—one a nurse, another an accountant, a businessman, a lawyer, a designer. At Manzanar they established a newspaper, *The Free Press*, played that all-American game, baseball, even erected a small Pleasure Park with a pond and a hand-built bridge and gazebo.

Although the faces of the people in Ansel's photographs were smiling, he also showed the impersonal rows of bleak barracks and people lined up for meals. One particularly strong image reveals a simple still life of a tabletop in the Yonemitsu family's quarters covered with a small lace doily. A framed picture of a Caucasian Jesus leans against a portrait of their son, Bob, a PFC in military uniform, with three letters from him tucked to the side. Ansel quietly captured the irony of the son fighting for a country that had imprisoned the parents. In the spring of 1944, Ansel would come back to Manzanar for the express purpose of photographing visiting daughters and sons in their military uniforms.

Nancy Newhall accompanied Ansel on one trip and was surprised by what she found. They drove into the camp one evening, knocked on a door, and were met by welcoming waves of children and adults, most bent on hugging Ansel and hearing his latest jokes. Over many visits, Ansel had become very well liked.

For one week in late January 1944, Ansel mounted an exhibition of these photographs right at Manzanar for those who he believed should be their first audience, the internees themselves.[41] When he arrived in New York in the spring of 1944, he carried with him sequenced photographs mounted on boards, with his own accompanying text. Not permitted to show the watch towers, barbed-wire fences, or guns, Ansel had decided that he must tell the grimmest parts of the story in words. At MoMA, Nancy viewed the combination of words and images with great enthusiasm and within a day and a half had an exhibition scheduled and planned.

Ansel also presented the project to his recent critic Maloney, who agreed to publish it as a book. *Born Free and Equal: The Story of Loyal Japanese-Americans* was issued in late 1944 at a price of one dollar. Due to wartime exigencies, the softcover book was poorly printed on cheap paper, but the power of Ansel's message came through loud and clear.

Ansel trod an extremely fine line. He believed it was essential to cloak himself in righteousness by clearly defining the victims as "loyal" Japanese-Americans and steeping the text in history and the

writings of the unimpeachable (Abraham Lincoln and Walt Whitman). *Born Free and Equal* is a story that wends its way from the brutal beginnings of relocation through the blossoming of democratic civilization not to be denied at the mature Manzanar. Wherever Ansel photographed, his core beliefs were reaffirmed, even at such a place as Manzanar, where human dignity rose above tragedy under the Sierra's potent benevolence.

Ansel wrote most of the book's text, an objective description of a horrible situation coupled with an impassioned plea for his country to right this heinous wrong. He chose to conclude with a single, powerful sentence by the director of the WRA, Dillon S. Myer:

> If we are to succumb to the flames of race hate, which
> spread with fury to every markedly different group within
> a nation, we will be destroyed spiritually as a democracy,
> and lose the war even though we win every battle.[42]

The exhibit, meanwhile, foundered in rough waters. Ten days before its scheduled opening in November 1944, the museum administration notified Nancy that the show was not acceptable, that it was more propaganda than art. But the background mutterings overheard were that *Born Free and Equal* provided succor to the enemy. After bitter wrangling, with hard negotiating by Nancy and cross-country telephone calls by Ansel, the exhibition of sixty-one prints was allowed to open in a basement display space, under the following conditions: the show's title must be changed to simply *Manzanar*, and the Fourteenth Amendment, Lincoln's statement, and the information on the many Japanese-Americans who were serving their country with valor must all be removed.[43]

Both the book and the exhibit were favorably received by the press, with articles appearing in major newspapers coast to coast. The First Lady, Eleanor Roosevelt, wrote in her newspaper column of the book, "It is one of the publications designed to temper one of our prejudices, and I think it does it very successfully."[44] *Born Free and Equal* was on the *San Francisco Chronicle*'s best-seller list throughout March and

April of 1945, at one point making it to the number-three spot for non-fiction.

But copies were hard to come by. Ansel wrote to Maloney in December 1944 to complain that there was not one *Born Free and Equal* to be purchased on the West Coast.[45] To Nancy he grumbled that *U.S. Camera* had got cold feet at the last minute and refused to promote the book. Maloney was never forthcoming on where the books were; eventually, the story spread that thousands of copies had been burned publicly or in secret by either the Army or *U.S. Camera*.[46] There is no evidence for this whatsoever.[47] For one thing, the government knew all about the book, and the WRA authorized its publication; moreover, Harold Ickes himself, then still the Secretary of the Interior, wrote the foreword. It has been impossible to ferret out exactly where this tale began, but all trails seem to lead to Ansel, who told me such stories more than once.[48] The most likely scenario is that, with paper hard to get, Maloney simply did not print enough books and was too embarrassed to admit his error.

Born Free and Equal was not embraced by all. Ansel found he was shunned by many of the military who lived in Yosemite. The Ahwahnee Naval convalescent hospital sheltered patients who had been wounded while fighting the Japanese, and many were still convinced that all Japanese were evil.[49]

Ansel and Dorothea engaged in a lifelong argument. She thought that photographs should be made with clear social intent, to benefit humanity, while Ansel believed that a photographer could not place such restrictions upon his or her work without weakening it. Art should be made for art's sake, he felt, and then if it could be used for a good cause, all the better.[50]

When she saw *Born Free and Equal* in early 1945, Dorothea was appalled. Her own photographs of Manzanar directly mirrored her anger at the situation, communicating misery first and foremost. For her, doing anything less was being soft, and she dismissed Ansel's work there as "shameful."[51] It irked her that he could find beauty in such an immoral setting. For his part, Ansel believed that the landscape surrounding Manzanar, with the spectacular Sierra to the west and the

Inyo Range to the east, provided the internees with crucial emotional sustenance.

A more recent critic has charged that "Adams' documentation was used to advocate internment as essential to the safety and well-being of all Americans, including those of Japanese descent."[52] That is bunk. *Born Free and Equal* was a courageous undertaking in 1944, and nearly all the condemnation voiced would be stilled if the book itself were read cover to cover. Ansel's goal was to convince Mr. and Mrs. America that the very same freedom for which their sons were fighting was being violated here at home.

In a startling turn of events, after it ordered the camps to close by the date of April 29, 1945, the government had a difficult time persuading a number of internees to leave Manzanar. They had built a community with their own backs and brains in less than three years, and some had found greater happiness there than at their former homes, where, due to prejudice, they lived largely segregated from their neighbors.[53] Manzanar finally ceased functionally to exist some six months later, on November 21, 1945.[54]

Years later, Ansel concluded about *Born Free and Equal* that "from the social point of view [it was] the most important thing I've done or can do."[55] Nancy regretted that neither the book nor the exhibition did justice to his efforts.[56] Ansel gave almost all the negatives he made of Manzanar to the Library of Congress, while Dorothea's work showing the relocation can be found at the National Archives.

In 1990, almost half a century later, survivors of the camps were paid twenty thousand dollars apiece in reparations, though a great many died before this concrete apology was offered. The elements have obscured almost all remaining traces of what was briefly Manzanar, but in 1991 California senator Alan Cranston introduced legislation to preserve it as a national historic site so that "we will at least symbolically remove some of the tarnish left on our Constitution by the forced internment of more than 100,000 Japanese-Americans."[57] The National Park Service took control of the Manzanar site on April 29, 1995, fifty years to the day after the official closing of the camps.[58]

Divorced from his text, most of the photographs Ansel made at Man-

zanar cannot stand individually. One negative that he did not donate with the others from Manzanar was *Winter Sunrise, The Sierra Nevada, from Lone Pine*, an image that projects the nurturing elements he clearly saw in the landscape.[59] Probably made during his second visit to the camp, at Christmas 1943, *Winter Sunrise* has become one of his most famous photographs.

One very cold morning, before dawn, Virginia and Ansel arose from their cots at Manzanar, grabbed a thermos of coffee, and drove ten miles south to the northern outskirts of the small town of Lone Pine. Ansel had been photographing the Sierra from this general area for the past four years, but he had yet to get the picture he wanted. His earlier efforts had all been quite literal, with the summertime Sierra and nearby Alabama Hills in full light, without benefit of winter's more dramatic conditions.[60] Ansel knew when he arrived at his chosen location that this was the day for the picture.

In the darkness he climbed up on the car's camera platform and set up his favorite equipment, the eight-by-ten-inch view camera with the twenty-three-inch component of his Cooke lens, Wratten no. 15 (G) filter, on a heavy tripod.[61] Shivering, he jumped back into the car and sipped the steaming coffee that Virginia poured as they waited together for the light.

When the sun's first rays fell upon the highest peaks before them, including Mount Whitney and the Whitney Pinnacles (which would form the background of the picture), Ansel ventured once more into the freezing cold to frame his image. Covered in snow, the jagged silhouette of the Sierra was revealed slowly, inch by inch, as the sun rose. In the middle ground, the curving form of the Alabama Hills lay at the Sierra's feet, still slumbering in shadow. Just then, a shaft of light illuminated the foreground meadow. But as it did so, it also shone brightly on one of several grazing horses, whose backside was turned defiantly toward Ansel's camera. As has already been mentioned, Ansel was not given to prayer, but he later admitted that at this moment, he placed his hands together and cast his gaze heavenward to entreat God to move that horse. As if by divine intervention, the light became perfect, the horse turned in profile, and Ansel made his exposure.[62]

Winter Sunrise appeared as the final landscape in *Born Free and Equal*. It sings of Ansel's mature signature artistic devices, especially the effect of a long-focus lens used from a great distance, not to zero in on one subject but to compress the spaces between the various elements, emphasizing two, not three dimensions, as he had done with *Frozen Lake and Cliffs* and *Surf Sequence*. As in many of his greatest photographs, nearly solid bands of tone travel across the image surface in broad horizontal stripes: at the bottom, a narrow, dark foreground punctuated by an equally narrow band of sunlight; above that, the deep color of the Alabama Hills; then the bright whiteness of the Sierra; and finally the middle tone of the warming sky.

Ansel never intentionally included a human or an animal in his creative landscapes. For him, nature was Teflon-coated; man did not stick. Given his choice, he would not have had horses in *Winter Sunrise*, but they were there, and he made the most of them; they added an earthly touch to the unearthly beauty of the scene. Control, as absolute as possible, was at the heart of Ansel's photography. Mountains stayed put, but people and animals were wild cards, potentially unmanageable moving variables in Ansel's highly structured approach to his art.[63] For Ansel, the critical variable was light.

There are many stories about *Winter Sunrise*. A favorite one can be verified only in an original print by Ansel, and not a book or poster reproduction. The high school students in Lone Pine traditionally placed whitewashed rocks forming the letters *L* and *P* on the side of the Alabama Hills, which just happen to be included in the left-hand side of *Winter Sunrise*. Ansel judged those rocks a blight on one of the greatest and otherwise most pristine landscapes in America, and in all of his prints of *Winter Sunrise*, he had his print finisher spot out the "LP" with ink so that it would become invisible (unless you know it's there).[64]

In the spring of 1943, Ansel had his first camera platform constructed for his car. From that time on, many of his best-known images would be made from this perch, which eliminated the clutter of an immediate foreground and enabled his camera to see a greater distance, making possible the expansive vistas for which he became famous. The camera platform ensured that Ansel would always have a raised, spe-

cial view; with the construction of this important tool, he rarely again gained entrance to the natural world on foot.

Between Manzanar and the Sierra lies an amazing field of boulders, rising above which is 14,376-foot-high Mount Williamson, so gigantic that at sunset it casts a shadow seven miles long, fully engulfing the site of the internment camp. In the last days of Manzanar, during August 1945, Ansel drove his Pontiac along the dirt tracks that crisscross the boulder field, climbing toward Mount Williamson. He found his spot, climbed up on the platform, and positioned the eight-by-ten with a mild long-focus lens. The bird's-eye viewpoint allowed him to tilt the camera down slightly to include the huge rocks that stretched from the car to the mountain, its summit now cloaked with clouds pierced by rays of light from an unseen source—the sun, outside the picture area.[65] The sense of scale in the final image is surreal, with the foreground rocks seeming as large as the truly gigantic mountain behind them. *Mount Williamson from Manzanar* is ripe with the mystical and holy presence that Ansel believed permeated the area surrounding the camp.

In 1944, the editors of *Fortune* hired some of the best California photographers, including Edward, Ansel, and Dorothea, to illustrate a single theme issue to be called "The Pacific Coast." Ansel and Dorothea decided to pool their energies, with the understanding implicit between them that he would do the big scenes and she the people. They produced five articles together, comprising a total of twenty-four photographs, and Ansel did one story completely on his own.[66] Because they shared credit for the five done jointly, there is now no way to determine who made which image. The article that Ansel photographed solo was "The El Solyo Deal," about a huge, 4,400-acre corporate ranch. Dorothea refused to photograph agribusiness; she had spent the last ten years documenting the plight of family farms, which were disappearing at a fearsome rate as they were absorbed by corporations. Ansel, for his part, had no moral problems with the assignment.[67]

Dorothea and Ansel's goal in "Richmond Took a Beating" was to demonstrate the effects of wartime industry on an East Bay town. Before the war, Richmond had been a rather sleepy place of twenty-four

thousand people, but with an important shipyard at its hub, it had seen its population mushroom in just three years to a hundred thousand, a number beyond the coping mechanisms of the old small-town bureaucracies. The idea of the *Fortune* editors was to shoot the story over one twenty-four-hour period (a predecessor of the contemporary "Day in the Life" concept).

Their working together on this story proved a severe test of Ansel and Dorothea's relationship. An observer at the time commented, "What an impossible team! They were so unlike one another."[68] When Ansel picked her up, Dorothea had her one camera, a Rolleiflex, strapped around her neck, and was carrying a film bag and a notebook. He, in contrast, had as usual loaded his big station wagon with everything he might need and more, including four cameras. When they arrived in Richmond, Dorothea hopped out of the car and disappeared into the throngs of workers as each shift came and went. While she acted invisible with her quiet little camera, Ansel stood on top of his car with his big black beard and ten-gallon hat, the center of his intended subjects' attention; in such a situation he found it very difficult to capture meaningful people images. Mountains and trees were not disturbed by his eccentric appearance and ways, but people surely were.[69]

During this assignment, Dorothea grew angry because Ansel kept shooting people (her world) and did not stick to the distant view (his). Her vision definitely rubbed off on him, at least for a few minutes; it was at Richmond that he made the keenly sensitive portrait *Trailer Camp Children*, an image more Langelike than Adamsesque.[70]

Ansel and Dorothea together happened upon the three ragged children in a gritty Richmond trailer camp. The older brother, still a child himself, had been left to care for his two sisters while their father and mother were working at the shipyard. Realizing that his eight-by-ten-inch view camera was hardly the vehicle for an intimate environmental portrait, Ansel borrowed Dorothea's Rolleiflex and made only one exposure.[71]

Gently lit by available light, the brother cradles his younger sister in one arm while the baby clings to his knee. The eyes of the three children tell all. The boy looks away from the camera, into space and be-

yond, to a certain future of endless days of desperation—rather like Dorothea's *Migrant Mother*, though his face is not yet furrowed by time. His sister is wide-eyed, staring into the horror of her present. The baby, however, looks directly at the camera, without fear and with a remnant of hope in her attitude. Providing visual resolution, at the bottom corner of the image, in dim light, the gently curled fist of the older brother lies next to the hand of the baby.

Trailer Camp Children was not the image of Richmond that *Fortune* wanted to project. The editors chose pictures that showed the robustness of this wartime city, not its consequences. The strongest image from the entire shoot, *Trailer Camp Children* was not selected for the article.

At this time, any photographer who claimed a social conscience joined New York's Photo League. Founded in 1936, the Photo League was something well beyond the usual camera club, its roots firmly planted in the leftist movement in Depression-era America.[72] Members of the Photo League commonly shared the philosophy that photography's best use was as a tool for social change. Although they were primarily documentary photographers, as the years progressed, their discourse broadened to include those with other viewpoints, such as Ansel, Beaumont, and Nancy, who found the Photo League's newsletter, *photo notes*, a worthy vehicle for occasional articles.

No stranger to the Photo League, Ansel most likely joined when, trying to drum up support for MoMA's new photography department, he gave a lecture to the group in November 1940. He returned to lecture again at eight-thirty in the evening on November 28, 1947, on the topic "The Interpretation of the Natural Scene." He proposed classifying photography into four categories: 1) Record, as the name implies, simple records such as passport photos; 2) Reportage, that is, journalistic assignments from without; 3) Illustration, including advertising and portraits; and 4) Expressive, or creative photography. An audience member described the proceedings: "Ansel Adams leads with his chin. One member after another takes a swing. He's up. He's down. The crowd roars. Mr. Adams is a brave man. He asks for argument."[73] A noisy chorus begged to differ with Ansel, asserting that his definitions

denigrated their work: it was entirely possible to have expressive re-portage, and they were the living proof.

Ansel relished the give and take of this debate, which continued in letter form. Famed *Life* photographer Philippe Halsman berated him for taking such a narrow view of photography, insisting that he acted as if everything of consequence must fit within his confining parameters.[74] Ansel's reply was two single-spaced pages full of friendly steam, denying any such parochialism.[75] The Photo League was nothing if not lively.

But the postwar years were also the dangerous era of Senator Joseph McCarthy and his House Un-American Activities Committee, or HUAC, with its slogan "Better dead than Red." (Ansel and the Newhalls called it the House Un-American Committee.) Just one week after Ansel's lecture, the Photo League was blacklisted by the United States Attorney General, joining a catalog of groups that were judged to be subversive, beginning with the Communist party.[76] At first members rallied, and letters of support poured in from Edward, Dorothea, Eliot Elisofon, Ben Shahn, Paul Strand, and Ansel, each confirming his or her allegiance to country as well as to Photo League. Ansel's letter pro-claiming that he would stand by the organization—"I am a member of the PHOTO LEAGUE and proud of it"—also took pains to assert that he was certainly no Commie![77] He challenged the other members to "dust off your lenses and get going! . . . The constant, dynamic affirmation of the camera must be devoted to the support of the democratic potential. Do not feed the wrath of the stupid; bring shame to them through im-ages of the truth."[78]

As the months rolled by and belonging to a blacklisted group be-came dicier, Ansel, among others, asked the board to announce offi-cially that it had no ties to the Communist party. Photographer Barbara Morgan telephoned him to warn that Communists had taken over the board of directors; she advised him to join her in resigning.[79] In testi-mony before HUAC, it was revealed that one of the leaders of the Photo League was indeed a Communist.[80] Ansel believed that the contempo-rary practice of communism in Stalinist Russia was in the same league of repression and persecution as fascism;[81] when the board refused to issue any statement, and did not even respond to his query, he quit,

writing a formal letter of resignation and sending a copy to the FBI.[82] The league, virtually memberless, finally folded in 1951.

Soon after the completion of Ansel and Dorothea's *Fortune* assignment on Richmond, she became very ill with a duodenal ulcer. Over the next few years, it laid waste to her. Surgery followed surgery, and then she underwent extended radiation treatments. Always a small woman, Dorothea became emaciated, too weak to photograph. It took her a long time to regain enough strength to begin working again.

In 1954, nine years after her last major job, she asked Ansel to join her in photographing three Mormon towns in Utah. He realized how important this story was to her, and sensed that she did not feel strong enough to complete it herself.[83] Together they would describe the hard life won by the people who lived in this desolate though magnificent landscape, a land more conducive to contemplation than the provision of a livelihood through farming and ranching.

At first Dorothea and Ansel thought of an exhibition, but financial realities forced them to secure financial backing by selling the story to *Life*. *Life*'s editors were not particularly excited about doing a photographic essay on Mormon towns in Utah, but they were intrigued by the unlikely team of Lange and Adams, both world-famous but for opposite achievements: the document versus the landscape.[84] Ansel welcomed the rare opportunity to show his work in *Life*'s exalted pages, and as for Dorothea, what better venue for her comeback effort?

Ansel and Dorothea, accompanied by her husband, Paul Taylor, and son, Dan Dixon, who would write the text, arrived in southern Utah on August 24, 1953, to find their subjects uncooperative and suspicious. Lange and Taylor reassured them—and Ansel as well—that all permissions had been granted by the church fathers in Salt Lake City. Tensions dissolved, and the team went to work.

There was never any doubt in Dorothea's working relationships with others that she was in charge. She gave the orders, and when Ansel balked, she threatened to quit. In the truest spirit of friendship, Ansel acceded to her throughout the three weeks of shooting—not his usual modus operandi.[85]

Ansel and Dorothea completed an extensive document of the towns

of Tocquerville, St. George, and Gunlock. After they returned home, Ansel suggested that Nancy be brought in to assemble the images and text. Dorothea bristled, as usual demanding full control. Ansel demurred to her, afraid to tax her small energies in any way.

Dorothea flew to New York and handed in to *Life*'s editors the story of the three towns in 135 photographs.[86] Unfortunately, much of the space reserved for the article was preempted at the last minute by fast-breaking stories, resulting in the publication of a severely truncated version on September 6, 1954.[87] Reduced to thirty-four images, "Three Mormon Towns" became a caricature.

Letters of outrage poured into *Life*'s New York offices from Utah. It turned out that Lange and Taylor had not mentioned the *Life* article to the church elders but had obtained permission only for the exhibition.[88] Dorothea had also neglected to obtain any model releases, believing that the practice undermined the relationship of trust that must be built with each subject.[89] One woman demanded a thousand dollars as recompense for the use of her photograph without her consent.[90] In addition, many residents of Tocquerville, described as living in a dead-end town, were deeply angered by what they felt was a misleading depiction of their home sweet home.[91]

Ansel was stung by the criticism. A central element in his self-identity was the conviction that his life must be lived ethically. He had cooperated with Dorothea at every turn, yet she had lied to him, as well as to the Mormons.[92] He rarely courted conflict and believed that Dorothea and Paul had placed him squarely in a mess of their making. In an unusual move for him, Ansel wrote to tell Dorothea directly how personally angry and disappointed he was with her.[93]

It may have added to Ansel's feelings of betrayal that only a quarter of the photographs in the article were his, and three-quarters Dorothea's. Since she had met with the editors in New York on the layout, Ansel may have thought she pushed her images over his own. Years later, the *Life* editor in charge of "Three Mormon Towns" recalled that fewer of Ansel's pictures had been used because it was felt that the magazine's poor reproduction quality would not serve them well, whereas Dorothea's photographs were already grainy and would not be hurt.[94]

Dorothea dismissed the problems with the permissions and releases as simply coming with the territory of journalistic photography, and certainly the editors at *Life* did not seem to hold it against her. Almost immediately, she left for Ireland on another assignment. The resulting story, "Irish Country People," was also published in *Life*, but only after the editors had ironed out yet another enormous hassle: Dorothea returned with lots of fine pictures, but again with no names of people nor any permissions. Two researchers flew to Ireland and attempted to match photographs with faces, eventually obtaining enough information to allow the article to run.[95]

When Dorothea asked Ansel to work with her on a story about the Berryessa Valley, whose homes and farms were about to be flooded for a new dam, he gracefully declined, recommending the photographer Pirkle Jones in his stead.[96] "Three Mormon Towns" was the last project they did together.

Dorothea never really regained her health, but instead gradually worsened. Her scarred esophagus grew so constricted from the surgeries and radiation that eating became a trial for her. Pain was her constant companion. During these years, her friendship with Ansel, which had cooled after their *Life* assignment, began to revive. In 1962, when he was hospitalized for removal of an enlarged prostate, she cabled,

> It is my turn to tell you that I wish for you the very best under all circumstances and also that I have loved you right or wrong. Dorothea.[97]

After years of suffering, Dorothea was diagnosed with inoperable cancer of the esophagus in the summer of 1964.[98] Ansel remembered,

> About two or three weeks before she died I went over to see her. I took a camera. She didn't look well, but she was still marvelous and sparkling and talking. Her gestures were incredible and I've got five or six series. I don't think they're great shakes as photographs, but they have some-

thing of her spirit. Not perfectly sharp, but . . . the older she got the more beautiful she got. Absolute sexless beauty. Rather frightening sometimes. I mean, she became sort of chiseled, sort of a . . . tragic quality, stronger and more luminous.[99]

Dorothea died on April 11, 1965.

Following the debacle surrounding "Three Mormon Towns," Ansel for all intents and purposes gave up his ten-year personal crusade to develop a documentary side to his vision. He had tried mightily to skip out of his established "Nature Boy" groove, and many would say he partially succeeded. Perhaps the creation of such images as *Winter Sunrise* and *Mount Williamson*, two of the greatest landscapes of all time, allowed him to realize that in his groove he was the best at what he did. In the world of photojournalism, there were better.

16

CONCLUSIONS

By early 1950, Ollie, now eighty-seven years old and bedridden, was failing fast. In January, Ansel hired a night nurse for his mother so that his father, her very conscientious caregiver, could get some sleep. Suffering from pneumonia, Ollie sank into a coma, her eyes opening only at the time of her death, as if to see into the beyond. Her body shook in a death rattle as she released her last breath in her own bed on the evening of March 22, son and husband by her side.[1] Later, the two men sat together by the fire, drinking hot toddies. Ansel knew his grieving father would not understand the relief he felt at his mother's death.[2]

Carlie never recovered from the loss of his wife, sliding quickly toward his own death less than a year and a half later, on August 9, 1951. Ansel held his hand during the final hours as the family's longtime cook and gardener, Harry Oye, dressed in his ceremonial robes as a

Buddhist priest, lighted candles and silently prayed. Carlie's passing was peaceful and warmed by the love he left on earth.[3]

The bodies of both Charles and Olive Adams were cremated, their ashes mixed together and buried unmarked under the thick green grass at the base of a woody thicket in the family plot at Cypress Hill Cemetery, in Colma, California. Carlie's brother-in-law Ansel Easton, who had been instrumental in his financial ruination, is also buried there, with his family, though an impressive carved granite obelisk towers over their remains.

Throughout the stressful months of his parents' last days, Ansel poured out his heart in a torrent of letters to Nancy and Beaumont, confessing that he cried for the first time in his life when his father died.[4] With great empathy, Beaumont wrote to Ansel about the death of his own father:

> I could only wish for your father and for you so peaceful an ending. . . . I wanted to tell you about my father because I do not know how else to tell how much I owe to him. If it had not been for [his] deep understanding, his confidence, his belief in what lay unknown and unexpressed within me, I would not have been able to develop the way I have.
>
> So I think I know, Ansel, how you feel about your father. To look back over the years, to measure that love, is almost too much.[5]

Ansel's letters to Beaumont and Nancy were usually covered with doodles and accented with a red typewriter ribbon. To one such letter, he attached a full-page drawing that summed up the Newhalls' central importance to him: in a sketch of a heart, the right atrium held the initials BN, the left atrium was marked AA, and across both ventricles was inscribed NN.

Nancy was the one person with whom Ansel could be most himself. Her friendship grew rather than faded as she learned of the qualities he kept hidden from almost everyone else, such as his confirmed mysticism. Although he did not practice any formal religion, Ansel believed

that there was another reality beyond the one we usually experience, that there existed some nonhuman power that could be glimpsed only on the rarest of occasions. He most often encountered it while lying in his sleeping bag and gazing at the night sky from the top of some Sierra peak. He was convinced that each of us is born with a program of possibilities encoded in our brain and that few are able to express the incredible potential of that gift. He had known from childhood that he was special, but he thought that everyone else was, too, if only they would recognize it.[6]

One mystery that he could never unravel was what he called spirit writing. At times Ansel felt literally forced to sit down and write a poem; in a trance, he would set down the words without thought, as they flowed through him but not from him, emerging whole and complete. He was confused by this, and a bit chagrined, unable even to discern whether the results were good or bad.[7] For a man who held dear what he called the objective approach, these events were unsettling. At first with embarrassment, he talked to Nancy about this phenomenon; later, secure in her acceptance, he would refer casually to spirit writing in his letters.[8]

At the end of his life, Ansel remembered a number of telepathic experiences: a voice in his ear commanding him to stop just before a huge piece of concrete fell from above, crashing directly in front of him; sudden impulses, though his car evidenced no problems, to pull into garages, only to find that the steering was about to fail, or that the tires had developed explosive bulges. Once, driving with Beaumont and Nancy, Ansel swerved the car into a ditch without warning and waited; moments later, two trucks came careening around the bend, racing down the two-lane road side by side.[9]

Ansel and the Newhalls seemed to be involved in everything of value, photographically speaking. Their intertwined lives can be easily traced because of their voluminous correspondence. They wrote not only about events but about their reactions to the work of other photographers, their ideas about the future of photography, and their philosophies of art.

They dreamed of the projects they might work on together. When *Arizona Highways*, an advertisement-free magazine published by the

Arizona Highway Commission to promote travel to that fair state, contracted with Ansel for a series of articles on Southwestern parks, he recommended Nancy to write the text. This first publishing collaboration between them became ongoing, with six major stories published in the magazine between 1952 and 1954: "Canyon de Chelly," "Sunset Crater," "Tumacacori," "Death Valley," "Organ Pipe," and "Mission San Xavier del Bac."[10] The editor, Raymond Carlson, always provided generous space for each article, enabling the pair to convey the particular atmosphere of each special place. In addition to writing the text, Nancy acted as the stories' editor and designer, selecting the images as well as creating the layout in a drama-building sequence for which she became recognized.[11] Two of the stories, "Death Valley" and "Mission San Xavier del Bac," grew into complete books published in 1954 by 5 Associates.[12] The coauthors traveled together to each of the locations save one; in that instance, Nancy amazed Ansel by producing a descriptive and effective text about Canyon de Chelly without actually ever having been there.[13]

With the *Arizona Highways* project, Ansel and Nancy discovered how easily they worked together. Each was a dynamo, and together they were more than the simple sum of two. In 1952, Nancy wrote to Ansel,

> I am sure you didn't know when you were kind and hospitable to a guy from the MoMA and his wife, back in 1940, that somehow you gave me a faith and a hope that I needn't die with everything undone and unsaid because there was no connection between me and the world and no one who believed in me. I had already decided that somehow, for all my early promise, I could never speak for myself; therefore, whatever I had I would give to others to help them speak. . . . But you let in a crack of living sun and air. I could see there were still horizons. Since then, there have been twelve long years. The door is open, now. I do not think anything but an act of God can close it.
>
> And that, my dear, is only a little of what you have given me.[14]

As much as Ansel adored Nancy, many of his longtime friends regarded her with irritation, claiming she acted stuck-up. They also assumed the two were having an affair. At Ansel's fiftieth-birthday bash, wall-to-wall with friends awash in booze and nibbling on a sumptuous buffet prepared by Harry Oye, Nancy drifted about the house ignored by the Sierra Club majority, who protectively surrounded their own Virginia. Oblivious, Ansel held forth at the piano, rolling oranges strategically across the keys while Cedric lay beneath his feet, pumping away with his hands on the foot pedals.[15]

Ansel and Nancy were in each other's pockets, creatively speaking, for many intensive years. The American Trust Company hired Ansel and Nancy to author a book in 1954 to commemorate its one hundred years in banking.[16] In 1956, Ansel and Nancy curated the landmark exhibition *This Is the American Earth* for the Sierra Club, and followed it up with a best-selling book of the same name in 1960. The first film about Ansel, *Ansel Adams, Photographer*, with script by Nancy and narration by Beaumont, was released in 1957.[17] Nancy and Ansel also produced the books *Yosemite Valley* (1959), *A More Beautiful America* (1965), *Fiat Lux: The University of California* (1967), and *The Tetons and the Yellowstone* (1970).[18]

In October 1951, the Aspen Institute for Humanistic Studies hosted the Conference on Photography, the faculty of which was an assemblage of the best and brightest in the field. Ansel, Beaumont, Nancy, Minor, and Dorothea joined such compatriots as Berenice Abbott, Herbert Bayer, and Frederick Sommer—before an audience of only about sixty participants.[19] The small numbers, though a financial disappointment, allowed for intense discussions accommodating all present. Abbott, a gifted photographer of the architecture of New York City as well as the discoverer, preserver, and printer of the photographs of Atget, presented a paper bemoaning the dearth of profound photographic publishing.[20] A consensus was reached that creative photography needed the forum of a serious journal.

America was awash in magazines in which photography played a central role. The mother of all was *Life*, whose first issue appeared on November 23, 1936, during Ansel's exhibition at An American Place.

A huge hit with the American public, its initial press run of 466,000 copies sold out almost instantly.[21] The magazine's glossy paper had been chosen to best serve pictures, not words, and photographers were given bylines, while few writers gained equal recognition in *Life*'s hallowed pages. Ansel himself was not immune to *Life*'s siren song. Whenever a possibility of a story for the magazine arose, his letters would bristle with excitement about the project, though few of these came to fruition.

Whereas in the early part of the century having one's photographs chosen for *Camera Work* had been the ultimate accolade, from 1936 through much of the 1960s, *Life* inherited the mantle of prestige. There were almost no similarities between the two publications except that each, in its own individual way, was devoted to photography. *Camera Work* presented art photography, while *Life* published photography as reportage, which in some cases attained the level of art. In 1949, an average issue of *Life* was seen by a staggering fifty-five million people;[22] at its demise, in 1917, *Camera Work* could claim only thirty-seven subscribers.[23]

In addition to *Life* and its rival *Look*, there was a panoply of magazines aimed at the amateur, including *U.S. Camera, Camera Craft, Minicam, Modern Photography*, and the most successful of the group, *Popular Photography*, with a readership of four hundred thousand—a far cry from *Life*'s base, but a significant number nonetheless.[24] For Ansel, Beaumont, and Nancy, however, the popular press reflected few of their photographic concerns. They had begun talking of starting a journal in the spirit of *Camera Work* in 1945, soon including Minor in their plans.[25] At the conclusion of the Aspen conference, a small core group composed of Ansel, Nancy, Beaumont, Minor, and Dorothea determined to get the magazine of their dreams published. Their ranks soon swelled with a handful of others, among them Barbara Morgan and Dody Warren, an assistant at various times to both Edward and Ansel.[26]

After playing with possible titles such as *Photo-Briefs, Photography Monographs, Photo-Digest*, and *Photographer*, Ansel suggested *Aperture*, perhaps an unconscious reference to Group f/64, itself named for

a lens aperture by Ansel thirty years earlier.[27] Nancy was not enamored of Ansel's choice, writing Minor, "[The] new title . . . gives rise to ribald thoughts!"[28]

Minor's students at CSFA, meanwhile, had been pleading with him to publish his lectures. Recognizing that *Aperture* could serve that purpose, he volunteered to act as editor, an action heartily supported by all the other founders, each of whom was unwilling to consider undertaking an unpaid post.

Aperture was announced at a party at Ansel's house on February 27, 1952, attended by forty potential supporters, many of them students at CSFA.[29] Subscriptions to *Aperture* were offered at $4.95 for four issues; those who contributed twenty-five dollars would in addition receive an original, signed Adams print of *Door, Chinese Camp*, Ansel's generous idea and donation.[30] By March, twenty-five people had joined at the sustaining level, including *Life* founder Henry Luce.[31]

The first issue appeared in April and began with a quote from Ansel (by way of Marx): "We have nothing to lose but our photography."[32] A Dorothea Lange photograph that had been made in Aspen during the conference appeared on the cover. Inside, along with a scant seven photographs, could be found two articles, Minor's "The Exploratory Camera," about the use of the 35mm camera for creative purposes, and Nancy's "The Caption: The Mutual Relation of Words/Photographs," a remarkable essay on the interplay between words and pictures.

First and foremost, the founders intended to develop a new language to define photography, rather than relying upon the traditional art-historical terms constructed for other media. A secondary goal was to show the work of photographers who had not been able to break into the pages of *Life* or *Popular Photography*. Often this meant unknown artists, but not always: *Aperture*'s fourth issue ran a portfolio of Edward Weston's last photographs, made in 1948. Reflecting the artist's mood, they were difficult images of death—leafless trees, a decaying pelican—and not his easier-to-look-at nudes, vegetables, or shells.[33]

Like Group f/64, *Aperture* declared itself with a manifesto, signed by its founders but most likely authored primarily by Minor White:

> *Aperture* is intended to be a mature journal in which pho-
> tographers can talk straight to each other, discuss the
> problems that face photography as profession and art, share
> their experiences, comment on what goes on, decry the
> new potentials. We, who have founded this journal, invite
> others to use *Aperture* as a common ground for the ad-
> vancement of photography.[34]

At Ansel's behest, for many years and many issues the Polaroid
Corporation provided important financial support by purchasing *Aper-
ture*'s back cover, often using the space to showcase a recent Polaroid
photograph by Ansel himself. One night, after a dinner of Chinese beef
and mushrooms that he had proudly cooked in his new wok, Beaumont
sat down with a Scotch to read the latest issue. The back cover, Ansel's
very quiet photograph of a dead tree, stopped him cold. Beaumont
looked at Nancy and said, "Ansel is the greatest photographer that
there has ever been."[35]

Although the original founders were at first pleased with *Aperture*,
each soon grew disillusioned. Minor used the journal to promote his
personal theories, not leaving room for the lively discourse the others
had envisioned. With the appearance of only its second issue, the oth-
ers saw the journal becoming more precious and less committed to the
broader view of creative photography that they shared.[36] When Minor
continued to completely disregard their criticisms, they gave up, with-
drawing from active participation, though Ansel and the Newhalls con-
tinued to contribute financial support.

Despite these defections, Minor persevered, and *Aperture* survived.
A financial angel, Shirley Burden, underwrote *Aperture* for many years,
and Minor stayed on as editor, with total control of all aspects of each
issue, until 1971, when the reins were placed in the hands of Michael
Hoffman. Since then, the once-tiny periodical has branched out to be-
come one of the largest publishers of photographic books, boasting a
New York gallery, even as the journal itself, now a substantial, finely
reproduced quarterly production, continues to be deeply valued by
most who are serious about photography.[37]

Ansel, Nancy, and Beaumont had not lost their itch to establish an independent photographic center. It was a given, between the three of them, that their center would be headquartered in the West, where there was still too little to be found in support of creative photography: *Aperture*, GEH, and MoMA all claimed Eastern residences.

The Newhalls spent New Year's 1967 with Ansel and Virginia. At their annual New Year's Day party, the crowd of friends included both Brett Weston and his brother Cole, then the manager of Carmel, California's Sunset Cultural Center. Listening to the Newhalls and Ansel talk about finding a place for photography, Cole offered space in his complex. With that stimulus, they quickly went to work. By the end of the month, a name had been chosen (Friends of Photography), officers elected (Ansel president and Brett vice president), and nonprofit status applied for.[38]

Gun-shy about publishing after their *Aperture* experience, and in any case not wanting to be in direct competition with their former journal, they established exhibitions and workshops as their first priorities. The founding trustees fought against the parochialism of West Coast photographic vision by showing the work of photographers from around the world. During the first year alone, the Friends mounted exhibitions by Paul Strand, W. Eugene Smith, Bruce Davidson, Eugène Atget, Wynn Bullock, Imogen Cunningham, Dorothea Lange, Brett Weston, Edward Weston, Minor White, and Ansel Adams. Ansel soon discovered that the audience in Carmel, though relatively small, was enthusiastic. Workshops and publishing enabled the Friends to reach out to a wider geographical base.

It was a struggle. During the first ten years, the Friends survived only through the determination of Ansel, who gave not only of his time, work, and prestige but just as importantly, of his cash. My husband, Jim Alinder, was brought in as director in 1977 and charged with moving the Friends into a healthy financial position so that it would not have to depend on Ansel for its very existence. Working side by side over the next seven years, Ansel, Jim, and an effective board of trustees built the Friends into the largest nonprofit photographic organization in the world, with fifteen thousand members and active exhibition, work-

shop, and awards programs. It became a major publisher of photographic books, with press runs of ten to twenty thousand copies four times each year. Ansel, Nancy, and Beaumont all continued as trustees until the ends of their lives.[39]

In 1971, Beaumont retired as director of George Eastman House, having built it into an institution of international renown with a suitable new name, the International Museum of Photography. He and Nancy moved to Albuquerque, New Mexico, where he joined the highly regarded University of New Mexico Department of Art to teach the history of photography.

The steady friendship between Ansel and Beaumont and Nancy finally faltered. As Ansel aged and became more determined to live as long as he could, he drank less and gave up smoking completely. Beaumont and Nancy, meanwhile, continued to puff up a storm and drink with abandon. Nothing is worse than a reformed whatever: suddenly, cigarette smoke bothered Ansel a great deal. He believed that he had developed an allergy to it and felt it was an extreme hazard to his health.[40] When the Newhalls were houseguests—which was now more infrequent—Ansel would beg them to smoke outside, but after they left, their bedroom always stank of cigarettes. Even after days of airing, Ansel would swear he could smell it still.

Whether due to some genetic flaw, because of the incurable sadness she felt at the death of their baby and their inability to have another, or her years of what she felt was banishment in icy Rochester, Nancy found her greatest comfort in liquor. Her descent into alcoholism was infinitely sad to witness for all who loved her. When she stayed with Ansel and Virginia in 1969 during the completion of the Tetons book, she would climb the stairs each morning at eleven to begin work with a drink already in her hand.[41] She regularly endured falls, bumps, and sprains. Ansel tried counseling her on many occasions, in person and by mail, but she took no heed.[42] Although they spent less and less time together, in an interview on July 1, 1972, Ansel would still proclaim of the Newhalls, "They're my closest friends."[43]

To celebrate their thirty-eighth wedding anniversary in 1974, Nancy arranged a vacation in the Tetons. A priority for any trip to that terri-

tory is rafting down the Snake River, secure in the hands of veteran guides, in what is normally a gentle experience. On this occasion, however, heavy rains had fallen, and the river was swollen so high that it eroded the roots of a huge spruce tree that smashed down on the Newhalls' raft.[44] All the passengers were thrown into the river without benefit of life jackets, but Nancy was the only one hit. Her ankle nearly severed, she suffered heavy blood loss. The raft had no two-way radio and scant emergency supplies, but help finally arrived and Nancy was transported to the hospital in Jackson Hole, where she stabilized and began the process of recovery. On July 1, Beaumont brought champagne to her bedside, and they toasted their anniversary. Less than a week later, on July 7, out of the blue, a blood clot tore loose and blocked Nancy's pulmonary artery, and suddenly she died.[45] Beaumont immediately called Ansel, and they grieved in shock together.[46]

Ironically, the place where the tree struck the Newhalls' raft was quite near the bend of the Snake River featured in Ansel's famous photograph *The Tetons and the Snake River*. After that, every time he looked at that image, Ansel saw the site of Nancy's accident. That negative was the very last one he printed before his death, in 1984.

Beaumont brought Nancy's ashes to Carmel. On August 18, 1974, after a short service at their home, Ansel and Virginia walked down with Beaumont to the beach below and watched as he waded out into the cove and slowly sowed the Pacific with Nancy's remains.[47]

If Ansel had a soul mate, it probably was Nancy. She was everything he ever hoped to find in a woman: brilliant, independent, full of energy and enthusiasm, physically attractive, and devoted to photography. There has been speculation for years about whether she and Ansel were lovers, but neither Virginia nor Beaumont believed that anything physical had happened between them.[48] Nancy adored Beaumont, and he her. Ansel possessed many old-fashioned morals. True, he was not always a faithful husband, but he drew the line at affairs with married women, and especially when the married woman was the wife of his best friend.

Beaumont, as Nancy had long known, was not a man to live alone.

Writing to Ansel in 1973, she informed him that if she died before Beaumont, some fine woman would soon be caring for him, and with her complete blessing. On May 22, 1975, he married Christi, who filled his life with "affection and very thoughtful companionship."[49] Beaumont and Christi built a house in Santa Fe designed around both their work, with one wing for him, another for her, and a central shared living area. Christi planted gorgeous gardens of flowers and vegetables that Beaumont loved to photograph.

While he had earned his reputation as a historian, Beaumont had also been a serious photographer, though he had refused to promote his own images as long as he worked in museums. He now hired as his assistant David Scheinbaum, an able young photographer who not only made prints from his old negatives but assisted him in the making of new ones. Much to Beaumont's pleasure, galleries began to exhibit and sell his work.

Although they were divorced in 1985, Beaumont and Christi continued to share their house; as his health declined, her supportive presence enabled him to remain at home. He spent his last years writing his autobiography; *Focus: Memoirs of a Life in Photography* was published posthumously in the autumn of 1993.

In August 1992, the Getty Center for the History of Art and the Humanities in Los Angeles acquired Beaumont's and Nancy's archives. That same month, Christi adopted a baby, whom she named Theo.[50] Beaumont was proud to claim him as his son, and he made a delightful addition to his last months. Beaumont died on February 26, 1993, after suffering a stroke.[51] With him, those generations so crucial to the advancement of photography as a fine art in the twentieth century, led by Stieglitz, Strand, Weston, Cunningham, Lange, Steichen, White, and Nancy and Ansel, came to an end. The string had run out, but the battle had been won.

17

ANOTHER PATH

A glance over any list of Ansel's greatest photographs reveals that after 1949, he made few images of consequence, nothing like the abundance of masterpieces he produced before that time. Simply put, Ansel was burned out: the muse of inspiration had moved on. And he knew it, confessing to Beaumont and Nancy in 1952 that making photographs had become a bore.[1] He had come to believe that all artists moved through these stages—rise, plateau, and descent—and he saw himself as being in the final phase. He thought that perhaps he had accomplished all he could and it was now time to follow another path, as had been the case twenty-five years earlier with his musical career.[2] As the 1950s progressed into the 1960s, Ansel turned his still-considerable energies to writing, making portfolios, consulting, and teaching.

Commercial assignments did not require the inner spark so crucial

to his creative work, and they continued to supply his basic income.[3] From 1949 until the end of his life, working as a consultant for the Polaroid Corporation kept him busy and gainfully, if but part-time, employed.[4]

Ansel and Polaroid's founder, Edwin Land, developed a mutual admiration society. Both were brilliant men who had never graduated from college but had nonetheless huge success by marching to their own drummers. Known as Din to his close friends and Dr. Land to everyone else, Land was a real maverick, just like Ansel. He was addressed as "Dr." Land because of the great respect accorded him as well as the honorary degrees that had been bestowed upon him. Just as Georgia O'Keeffe was always spoken of as Miss O'Keeffe, so Edwin Land, a formal, reserved man, was Dr. Land.

Although Ansel's walls, too, would be hung with prestigious honorary doctorates, no one who knew him, and most especially Ansel himself, would have considered for a minute calling him Dr. Adams. From the moment of meeting, he was "Ansel" to everyone, regardless of age or achievements in life.

Land knew at age seventeen that he would be a scientist and began a search to find a field in which he could make a contribution of consequence. He decided upon optics, and specifically the invention of manmade polarizing lenses to eliminate the natural scatter of light and its glare by allowing only parallel rays to pass through. The best his predecessors in science had been able to come up with was a mixture of dog urine, iodine, and quinine; the resultant tiny crystals did polarize light, but it was a fragile and less than aesthetic solution.[5]

Following his freshman year at Harvard, Land dropped out, to the great disappointment of his parents, announcing that he would use his school money (tuition was just three hundred dollars a year) to fund his independent quest to learn everything about the polarization of light. By 1935, when he was but twenty-six years old, Land had produced an effective synthetic polarizing filter that was quickly picked up by Kodak for placement in front of the camera lens. Sunglasses were just becoming commonly available, and Land jumped in with polarizing lenses, which proved immediately popular and the prime money maker

for his fledgling company, incorporated in 1937 as the Polaroid Corporation. Land also introduced 3-D movies, the kind that must be viewed through special glasses.[6]

The World War II years were filled with extremely important war-related projects for Polaroid, but still Land's restless mind never stopped. During a few days over Christmas of 1943, when his wife, Terre, absolutely insisted that he stay at home and enjoy the holidays—an enforced break from his obsessive, round-the-clock laboratory life—he brought out a camera and made some family snapshots. His daughter Jennifer innocently queried, "Why can't I see the pictures now?" Since Land could not provide an answer, he was driven to find one.[7]

On February 21, 1947, at a conference of the Optical Society of America in New York City, Land demonstrated his new instant photography, producing a self-portrait in just fifty seconds, much to the astonishment of the audience and the delight of the press. The achievement was heralded on the front page of the next day's *New York Times*.[8]

Forever and always a techie, Ansel wanted a Polaroid camera from the first word he heard of it in 1947, but he could not justify spending $89.75 for a snapshot camera.[9] In February 1948, while in New York, he took the train up to Boston and went straight to Polaroid's research laboratory, where Land made a picture of him with the new camera. Ansel and Din began to talk and could not stop, finding a coincidence of parallel intellect. To continue their discussion, Land brought Ansel home to dinner. By the end of the evening, Ansel was hooked on Polaroid.[10]

Returning to New York, he wrote Land a letter just busting with questions about the new process. After first assuring him that he saw great aesthetic potential, Ansel ripped into what he saw as some of the possible problems. How permanent would the prints be? Could they be dry-mounted? What would be the effect of filters? He suggested that these were all questions he could answer through testing. Land did not respond to that letter or to the others that Ansel continued to send. Nor was any camera forthcoming—until Land purchased Ansel's *Portfolio One* in late 1948 and then followed up with a letter of admiration and the shipment of camera and film as a gift of appreciation.[11]

In November 1949, in the East to photograph in Maine with the Newhalls, Ansel spent the sixteenth with the Lands. When Beaumont and Nancy came to pick him up the next day to begin their trip, he announced with delight that Land had hired him as a consultant, complete with a budget and a monthly retainer.[12] Although it was unusual for a corporation to place an artist on its payroll, Ansel earned every penny paid him, and much more. (For most of his tenure at Polaroid, he received a hundred dollars a month plus expenses.)[13]

First and foremost, it was understood, if not formalized by contract, that Ansel's use of Polaroid products would place upon them a seal of approval, similar to *Good Housekeeping*'s. The large audience of *Modern Photography* magazine was soon treated to Ansel's article "How I Use the Polaroid Camera."[14] From Cambridge to California were shipped films and cameras in their early stages. Ansel tested them in the field and wrote back lengthy reports in more than three thousand memos all told.

As a teacher, Ansel found the instant feedback afforded by the Polaroid camera extremely valuable. He could individualize his students' learning experience: on the spot, each student could see, using the print he or she had just made, what could be improved, and then another exposure could be made, the entire process serving to refine the student's visualization.[15]

The full weight of Ansel's influence upon photographers around the world via his technical books would eventually come into play on behalf of Polaroid. In his 1948 *Camera and Lens*, Ansel dedicated but a few sentences to Polaroid, only very briefly describing the effects of polarizing filters.[16] By the publication of the fourth book in the series, *Natural-Light Photography*, in 1952, he gave four pages to the same subject.[17] His audience building, Ansel in 1963 produced a substantial manual devoted to Polaroid products, entitled *Polaroid Land Photography*, which was substantially revised and released again in 1978.

Ansel was not content simply to demonstrate Polaroid products; he insisted upon being involved in their development as well. The first Polaroid prints were brown and white, not black and white. Ansel objected to the color, believing that professional photographers would not

take Polaroid seriously until it produced a true black-and-white photograph.[18]

A new Polaroid film (Type 41) that produced black-and-white prints was introduced in late 1950. Disconcertingly, six months later a wail of complaints arose: prints were already fading and were easily scratched. Land wrestled with the two problems and in less than a month, with camera returns piling up and the company's survival at stake, came up with a solution.

The first Polaroid photographs were completed in the camera, in what advertisements proclaimed as a one-step process. After a prescribed time, the sepia-toned photograph was peeled away from its negative in the camera, already developed, fixed, and resistant to scratching. When removed from the camera, the new black-and-white prints carried with them a thicker layer of light-sensitive emulsion, which proved delicate as well as incompletely fixed. Land devised a coating stick that the camera operator wiped across the picture surface to achieve permanence along with a protective plastic coating.[19] It was messy and smelly and required a second step, but it worked, and that was the way Polaroid prints were made for many years.

Ansel's next push was for the creation of a professional line of products, especially a Polaroid film pack that could be used in any standard four-by-five-inch view camera. By 1956, Ansel was testing such a product, which was released for sale in 1958. By 1970, the four-by-five Polaroid film pack was generating sixteen million dollars annually in sales, a small but nonetheless significant amount for what had by now become a major corporation.[20]

When Ansel wondered why a negative could not be obtained from the process, as well as a print, the result was the introduction of Type 55 P/N (positive/negative) film in 1961. There was a definite problem, though: if correct exposure was given for the negative, the print would be too light, and if the print looked good, the negative would be too thin, or underexposed. Always honest, Ansel counseled in *Polaroid Land Photography* that the photographer must make two exposures, one for the negative and one for a print.[21]

Another of Ansel's responsibilities was to induce other respected

photographers to work with Polaroid materials. He sent out free cameras and film to the chosen, including Charles Sheeler, Dorothea, and Imogen, who, after a suitable period, sent him back a Polaroid self-portrait of herself apparently passed out on her bed, surrounded by piles of flack for the process, including Ansel's own *Polaroid Manual*. Her accompanying note warned, "Herewith I am giving you notice that I am practically dropping dead from overexposure to POLAROID."[22]

Ansel made thousands of Polaroid photographs, most of them close-up studies suited to a small four-by-five-inch print: spruce needles against rough bark, a lichen-encrusted branch curling across pine boughs, wild grasses set amid ruffled leaves. He used the four-by-five Type 55 P/N film differently, however. Since he could obtain an excellent negative for enlargement, he did not hesitate to make images of a wide variety of subjects, just as he would with any four-by-five film. One of his major projects in 1961 had him making murals from his Polaroid negatives to prove their fine grain quality.[23]

Ansel's last great photograph, *El Capitan, Winter Sunrise*, was made in 1968 with Type 55 P/N film. This particular day dawned on a frosty Yosemite, dusted with snow as the sun played tag with the fast-moving clouds. The dramatic weather roused Ansel, and before the snow could melt, he was out driving around the valley looking for pictures. He stopped and parked when he came to the El Capitan pullout, which provided what he felt was the best view of that natural monument. Ansel had made many exposures from this spot, though the growth of trees over the years had encroached upon a formerly expansive view. Before him loomed El Cap, its great granite face glazed with ice and wreathed in shifting bands of fog.

He chose his favorite lens at the time, a Schneider 121mm Super Angulon, which would give him greater convering power for this broad scene while maintaining a normal perspective.[24] Again, by setting up the camera on top of his car, Ansel was able to frame the image with minimal foreground, entirely removing the Merced River below. It was so cold that the film would not develop, and so Ansel ended up back in his Yosemite darkroom to process the negatives.[25]

What makes *El Capitan, Winter Sunrise* so wonderful is Ansel's

courageous choice of tonalities. A full half of the image is taken up with the somber near-monotone of the dark-gray trees that frame two sides. Snow gently traces each branch, exquisitely detailed in a tone of slightly lighter gray, kept from its natural whiteness by full shadow. The prime subject—the gigantic, granitic El Capitan—is nearly translucent in the morning light of sunrise, its waist gracefully obscured by a low-hanging cloud.

The occasion of Ansel's 1974 retrospective exhibition at New York's Metropolitan Museum of Art, his first solo museum exhibition in that city since 1936, demanded an accompanying catalog. Unfortunately, Ansel was about to publish his first very-large-format book, *Images: 1923-1974*, which was much too expensive to serve as the catalog. The exhibition's sponsor, Ansel's old friend David McAlpin, found his four-by-five-inch unique Polaroid contact prints enchanting. An entire section of the Metropolitan show was to be devoted to them, so why not a catalog based on these little-known images? This idea took hold, and the slim and inexpensive softcover catalog *Singular Images*, containing fifty-three of Ansel's Polaroids made between 1954 and 1973, was published.[26]

In a short, rather convoluted essay for the book, Land concluded that it was an act of the greatest bravery as well as of wisdom for Ansel to photograph the landscape, a subject dismissed by many as just a lot of rocks, trees, or twigs. Ansel achieved greatness by beginning with the ordinary and creating something new and extraordinary.[27]

The easy camaraderie between Land and Ansel eventually grew distanced. At one time the Lands proposed building a small museum outside Boston devoted to Ansel's photographs, and his friend Ted Spencer was engaged to draw up plans. He designed a remarkable building constructed in the shape of a nautilus shell: on entering, the visitor would be drawn in through the inward-spiraling corridor to the center of the building, as well as deeper into Ansel's photography. When all seemed ready to proceed, the Lands abruptly withdrew their support, to Ansel's depressed consternation. He never figured out what had happened to cause such a swift change.[28]

Still, the basic respect each man held for the other remained. In 1982, when Land could not attend Ansel's eightieth-birthday celebra-

tions, he sent a witty, heartfelt poem in his stead.[29] And, in 1983, when Ansel was sentenced to a month of bed rest, the longest and most revealing letter he wrote was to Land.[30]

In the late 1970s, Polaroid experienced great success with its instant color camera, the SX-70, but this was leavened by Kodak's entry into the market with a copycat color camera that ate deeply into what should have been Polaroid's sales. Although Polaroid would eventually win a huge settlement in court, the interim years would prove costly. Greatly adding to its financial woes would be another one of Land's personally backed products, Polavision, instant color movies without benefit of sound. The timing was bad: too little, too late. Videotape recorders and playback units were then also just hitting stores, and we know who won.[31] In August 1982, Land retired without fanfare, quietly announcing that he would devote the rest of his life to pure research at his just-founded Rowland Institute for Science, Inc. He died on March 1, 1991.[32]

Although Ansel served Polaroid with devotion, he never took a vow of chastity, and he worked on many projects for rival Eastman Kodak at the same time. Shortly after he became a consultant for Polaroid, Ansel accepted a similar position with the Swedish camera company Hasselblad. After meeting its founder, Dr. Viktor Hasselblad, in New York in 1950, Ansel arrived home to find one of their first cameras awaiting him—a far cry from the suspense he endured expecting a Polaroid.[33] All the people at Hasselblad asked was that Ansel let them know how he liked it. He responded eagerly with a deluge of reports detailing both the good and the bad.[34]

And he did find problems. Hasselblad had brilliant engineers, but no one there really knew about the requirements of making photographs. With that first camera, Ansel discovered if it was not carried and stored in the upright position, the internal mirror would fall out; the engineers had not understood that cameras may be stuffed into backpacks and cases, ending up in all kinds of positions.[35] Hasselblad was grateful for Ansel's suggestions and criticisms and through the years shipped him each new model camera as it was produced, along with whatever lenses he might be interested in.

With age, arthritis and gout began to afflict Ansel, and his larger

view cameras became increasingly cumbersome for him to operate. He found it necessary to have an assistant to carry and set up his equipment; even making the necessary adjustments before an exposure was difficult for him. The Hasselblad proved to be the perfect camera for him at just the right time. He did not need the help of an assistant because it was relatively small and light in weight, and he could position it himself on a tripod. Its negative size was decent—two and a quarter inches square—and the quality of the negatives he obtained was superb. The Hasselblad became his preferred camera for most of the rest of his life. (The year before his death, Ansel also enjoyed using a Leica, whose ease of use and very small size were hugely attractive to him at eighty-plus years of age.)

The Hasselblad Foundation awarded Ansel its gold medal in 1981.[36] The ceremony was held at MoMA, and the honor presented by King Carl XVI Gustaf of Sweden, in the presence of four hundred guests and nearly as many photographers, whose jostling and electronic flashes transformed the festivities into a battlefield. Afterward, Ansel retired happily to a small private reception hosted by Mrs. Hasselblad. It was an ultimate party, featuring unlimited quantities of champagne (Roederer Cristal) and caviar (Beluga Malassol), though Ansel himself preferred the simpler combination of a vodka and a few crackers.

Moon and Half Dome, Yosemite National Park (1960) remains the most famous photograph that Ansel made with the Hasselblad. Although he continued to live primarily in San Francisco, he always spent the Christmas holidays with his family in Yosemite, seeing to his Bracebridge Dinner responsibilities. One afternoon, on his way to a rehearsal at the Ahwahnee, Ansel spotted the nearly full moon rising over Half Dome. He immediately visualized an image and parked his car. With Hasselblad and tripod across his shoulder, he hiked a couple of hundred yards out into the middle of the meadow east of the hotel.

He knew that the image he was about to make would end up as a vertical, even though the Hasselblad produced a square negative. His eye cropped the image he saw through the viewfinder. He experimented with both a wide-angle and a telephoto lens, finally deciding upon the latter, a 250mm Zeiss Sonnar that made the moon appear bigger in relation to Half Dome and moved the image toward abstraction

by flattening the picture planes, a device he had used successfully for most of his life.

Ansel placed a dark-orange filter before the lens to increase the tonal contrasts, heightening the drama of the picture by deepening the dark values while brightening the whites.[37] He squeezed the cable release at 4:14 P.M. on December 20, 1960 (another date and time arrived at thanks to a feat of curiosity, persistence, and computer wizardry).[38] The resulting image is almost a tonal reverse of his 1927 *Monolith*, in which the face of Half Dome is dark, boldly thrusting skyward from its setting of brilliant white snow. In *Moon and Half Dome*, the cliff is brightly lit, its every detail described by the full rays of the setting sun; Half Dome's shape is modulated by the dark presence of Washington Column in the left foreground and by the shadows that creep up its base. The nearly full moon completes the composition. *Moon and Half Dome* is both visually arresting and popular, if not quite as soulful as *Monolith*, made thirty-three years earlier.

In 1959, Ansel was awarded his third, and final, Guggenheim: a grant of three thousand dollars a year for two years.[39] His project was to make prints from the thousands of negatives that he had never found time to print. Whereas his first two Guggenheims, in the 1940s, had funded the making of new images, this last grant reflected Ansel's continuing feeling that the best use of his time now lay in revealing what he had already accomplished, not in the increasingly futile effort to create new photographs.

The result of the third Guggenheim was piles of prints from a lifetime's worth of negatives, with no place to go until San Francisco's M. H. de Young Memorial Museum offered Ansel an exhibition, his first solo show there since 1932.[40] Although he had many smaller exhibitions every single year, for Ansel, as for most artists, major installations at the best museums were few and far between.

The Sierra Club was eager to publish Ansel's biography that Nancy Newhall had been chugging along on for nearly twenty years. Rather than wait any longer, the club published *The Eloquent Light*, the first volume of a proposed two-volume set, covering Ansel's life from his birth until 1938, in 1963.

After reading the manuscript, Ansel suggested that she include

more about the difficulties he had encountered, including in his personal life. He told Nancy not to worry, that he was strong enough to take the truth, and he believed it would make him seem more human and more real to the reader.[41] Nancy, however, remained protective; her narrative provided only slight evidence of his family troubles, and even that much was more between the lines than in them.

The Eloquent Light became a classic and remains in print thirty-plus years later. Its limitations are serious, inasmuch as it covers only the first thirty-six years of Ansel's life and is devoid of source notes or index, but they are far outweighed by Nancy's ability to spin out Ansel's story in poetic prose. It is an amazingly dense book, chockful of people and events.

Ansel loved the book's title and suggested to Nancy that she curate his 1963 de Young show, which they also called *The Eloquent Light*. It was the largest exhibition he ever had, and at a phenomenal 530 pieces, simply too big for anyone to absorb in one or even two visits. Throughout the nine galleries, Nancy interspersed artifacts to create a sympathetic environment for Ansel's images. Arrangements of needled and leafy branches, sugar pine cones, and stones piled in corners joined Indian baskets and pots, sagebrush and cactus, large branches blasted by lightning and slabs of veined granite. For Ansel, "It was probably the best show I've ever had or will have."[42]

The second volume of Nancy's biography, to be entitled *The Enduring Moment*, became mired in the quicksand of personal involvement. Since the lives of the Newhalls and Ansel had been so intertwined from 1939 onward, her text told the tale of the three together, not of Ansel individually, but it stopped in just 1950. Never published, after Nancy's death it sat locked away in Beaumont's files. He would not allow such rough text to be printed, though he did use selections in her posthumous book *From Adams to Stieglitz*, as well as in his own autobiography, *Focus*.

In the decades of the fifties and sixties, Ansel pursued a variety of commercial jobs above and beyond his work for Polaroid and Hasselblad and the articles for *Arizona Highways*. Each of these was a sizable project, one seeming to grow from another. With the hundredth an-

niversary of the University of California looming in 1968, President Clark Kerr engaged Ansel to produce a book describing all the institution's campuses, with Nancy slated to write the text. Kerr had been impressed with their joint 1954 book, *The Pageant of History in Northern California*, and believed Ansel was exactly the right person for *Fiat Lux*, the title taken from the university's Latin motto, "Let there be light." Ansel was paid the princely sum of seventy-five thousand dollars, but this enormous task would take him three years and demand six thousand negatives.[43]

Ansel walked a fine line between his working life as a commercial photographer and his activity as an environmentalist. Plain and simple, he was a photographer for hire, occasionally accepting jobs from those whom his fellow Sierra Clubbers would designate "mindless developers." Near Sacramento, he produced a promotional booklet for the Sunset Petroleum Corporation, which built its twelve-thousand-acre namesake community of Sunset, California, on former ranch lands. At Laguna Niguel, another development south of Los Angeles, Ansel was promised that his photographs would provide information to guide the designers toward a more environmentally sensitive outcome. "They absolutely ruined the place; it didn't guide the development at all!" was Ansel's conclusion.[44]

Most of his assignments were for more responsible developers. On California's north Sonoma Coast, he photographed the dramatic headlands where they met a rough Pacific Ocean at Timber Cove, before the land was split into lots for vacation homes. Together with his former CSFA student Pirkle Jones, he made an extensive document of the building of Paul Masson's champagne cellars in Saratoga, California; out of their work came an exhibition, Story of a Winery, which traveled around the world under the auspices of the United States Information Service and illustrated a book entitled *Gift of the Grape*.[45]

The Redwood Empire Association, a chamber-of-commerce-type group that encouraged tourism in northwestern California, commissioned an extensive portrait of that area with its majestic redwoods.

In addition, Ansel published two portfolios, *Portfolio Three: Yosemite Valley* and *Portfolio Four: What Majestic Word*, which appeared in 1960

and 1963, respectively. These were huge undertakings, requiring him to complete 3,328 fine, signed prints for *Portfolio Three* and 3,900 for *Portfolio Four*. Both portfolios were underwritten financially, but the sheer time and physical work involved were awesome.[46]

Since the mid-1930s, Ansel had hired help only as he needed it, for a few months here or a few weeks there, but with the combination of his commercial jobs, the third Guggenheim, and the portfolios (and always, another book), Ansel became a business, and full-time employees were essential. Every few years, as the business grew, so did the staff. No one who worked for him found it to be just another job.

In 1955, like many others before and after him, Don Worth brought a portfolio of photographs to show Ansel, whose technical books had been his guide. In Don's experience, "With great dignity, Ansel focused his entire attention upon what the student showed him. He never put people down but was always supportive and positive." Ansel's comments on Don's work were generous and warm, a welcome incentive for any photographer. The two men also had music in common, since Don, too, was a classically trained pianist. Don suggested that the piano and photography were parallel arts, both requiring clear definition and precision, quite different from the long, singing tones characteristic of the violin. It made sense to Ansel. In Ansel, Don found a friend and teacher who cared deeply about others, a rare trait in an artist.[47]

Don was a natural to become Ansel's full-time photographic assistant. With the occasional assistance of Gerry Sharpe, who worked primarily at Best's Studio, from 1956 to 1960, he traveled with Ansel in search of Kodak Coloramas, assembled reproduction prints for books, conducted research for Polaroid, and finished prints for *Portfolio Three*. Since Ansel stored his negatives in a vault at the Bank of California in downtown San Francisco, a significant portion of Don's time was spent shuttling them to and fro. He really did it all for Ansel, even writing the musical score for the 1958 documentary *Ansel Adams, Photographer*. Eventually he moved on to become an excellent photographer in his own right and a professor of art at San Francisco State University for thirty years.

After living in San Francisco his entire life, in early 1961 Ansel de-

cided to move to Carmel. Richard (Dick) McGraw, heir to the Chicago-based McGraw Edison fortune, owned several contiguous lots on a hillside overlooking the Pacific in Carmel Highlands, five miles south of Carmel-by-the-Sea and 120 miles south of San Francisco. McGraw planned to build his home there and intended to surround himself with friends to make it a small artists' enclave. A student from the Art Center School days of 1942–43, he had become a great admirer of Ansel's and offered him a large adjoining lot. Still living on the edge of financial desperation despite all his success, Ansel had for years been routinely refinancing the two San Francisco houses, whose sale would thus bring little equity.[48] But McGraw wanted Ansel for his next-door neighbor and provided him with a loan of a hundred thousand dollars to build a house/studio, a loan that he generously forgave over time.[49] He also set aside a piece of land for the Newhalls, which for Ansel was the icing on the cake.

Ansel's photography business had long since outgrown his funky basement darkroom in San Francisco, festooned as it was with spiderwebs and impossible to keep clean.[50] The completion of *Portfolio Three* had proved a severe challenge in such a poor space, and carrying the mountains of obligatory supplies from the car, across the garden, and down the stairs was a considerable chore.[51]

Ansel decided that a big change was just what he needed, even though he was a bit concerned about living right in the midst of Edward Weston territory. Weston was dead, but his spirit seemed to be everywhere: his beloved Point Lobos State Reserve would be just a mile north of the new house. Ansel acknowledged that anything that looked like it might make a good picture there had already been used by Edward.[52]

Ted Spencer designed a place that had aesthetics similar to those of Ansel's San Francisco home but was more completely responsive to his work. The building itself was seated quietly down into the hillside, projecting only a small profile in proportion to its true mass. Ansel was proud that no trace of the house could be seen from the ocean.

For the past fifteen years, Ansel's estrangement from Virginia had continued, even as their actual marriage endured. While Ansel was

centered in San Francisco, she still resided primarily in Yosemite.[53] Ansel's connection with his children was not much better: from Michael's point of view, his relationship with Ansel (he never called him Dad) had been emotionally distanced for as long as he could remember.[54]

During the 1950s, as Michael and Anne had moved into adulthood, they had both established independent and successful lives. Michael attended Stanford University but left in the midst of his studies to join the Air Force in December 1953, becoming a fighter pilot on an F-86F Sabre. On July 28, 1962, exactly sixty-one years after his Best grandparents were married, Michael wed Jeanne Falk, whom he had met while both worked one summer at Tuolumne Meadows. Although he loved flying, Michael decided to add a medical degree to his education, courtesy of the Air Force. While Jeanne gave birth to their two children—Sarah, in 1965, and Matthew, in 1967—Michael attended Washington University Medical School in St. Louis, graduating in 1967. He rejoined the Air Force with the rank of captain and served as one of only twenty-five flight surgeons, the name given to doctors who also fly for the military. When his required time of service was fulfilled in 1971, he and his family settled in Fresno, California, where he served a residency in internal medicine and then established a private practice. He maintained his air hours by joining the California Air National Guard.[55]

Anne, possessed of both brains and a delicate beauty, also attended Stanford, earning a degree in English in 1956. Shortly before graduation, she married Charles (Chuck) Mayhew, of course in Yosemite. Soon the young couple were a family of five, with three daughters, Virginia (Ginny), Alison, and Sylvia, born in 1959, 1960, and 1963. Anne stayed at home with the girls while Chuck held a variety of jobs, including managing Ansel and Virginia's publishing concern, 5 Associates.

One July afternoon in 1966, Anne's young husband took a friend's motorcycle for a spin around the block and never came back: he was killed in a horrible accident. Made of the same stern stuff as her mother, though with an even gentler temperament, Anne went to work, taking over the management of 5 Associates, and raising her daughters by herself. Very happily, Anne fell in love with the minister of her Unitarian Church in Redwood City, and he with her. They were

married in 1971, bringing together her three daughters and his three sons.[56]

Anne has suffered more than her share of tragedy. When she was a young child, a pan of hot peas was knocked off the stove and severely burned her neck. The wound was treated with radioactive paste (as had been Ansel's leg). Eventually, she developed a cancer that had to be removed from the right side of her lower face and throat. In the early 1980s, she was diagnosed with cancer once more, this time breast cancer. Anne again fully recovered.

Shortly before Ansel completed his new Carmel house in May 1962, Virginia announced that she would move in with him. This was a definite surprise; in fact, no bedroom had even been built for her, so she took what would have been a small downstairs study, without a bath, while Ansel had the main, large bedroom with bath. Farther down the hall were two guest rooms with a shared bath. The Carmel house became the site of their marital truce, where they lived together for twenty-two years. They were almost always civil to each other in public, but in private they endured a life of quiet antagonism, each only barely tolerating the presence of the other.

Virginia confined herself for most of the day to her little room, devoting herself to reading. She would climb the stairs at eight in the morning to prepare a simple breakfast of oatmeal mush, toast, juice, and coffee for them both as they studied the paper, then would descend to her room again until she returned upstairs to make lunch. Afternoons saw a quick return to reading, fully dressed, propped up in bed. Then back upstairs to set out the drinks for cocktail time.

The Carmel house was Ansel's dream home, a place intended to potentiate the future business of his photography. The entrance was pure Ansel, eclectic as all get-out. Inside the front door, made of simple frosted sliding glass, hung a mobile with fingers pointing in all directions. Bookshelves lined the entry, holding volumes on architecture and artists' monographs. Smack-dab in the middle of these books sat a hologram of a pretty young brunette blowing you a kiss. The Adams family's old grandfather clock, whose wooden works the four-year-old Ansel had played with after the "oh-six" earthquake left it in pieces, steadfastly ticked away next to a Piranesi engraving of an aqueduct.

Much to Virginia's chagrin, the guest bath, just inside the front door, sported Ansel's diploma from grammar school—"Mrs. Kate M. Wilkins Private School, San Francisco, Grammar School, June 8, 1917"— grandly framed in beveled gilt splendor next to his Kentucky Colonel certificate. Virginia did not think her husband should flaunt the fact that this was the sum total of his formal education.

To great benefit, Virginia presided over almost all the rest of the interior decoration. For years, she acquired fine Native American pots, baskets, and Navajo rugs in natural colors of brown, gray, and black; her personal favorites were of a pale yellow. The new house profited immensely by Virginia's collections, with her handsome rugs punctuating the dark wood floors and her pots and baskets lining shelves and mantle. Downstairs, one guest-room wall was filled with Virginia's marvelous group of miniature ceremonial baskets, beaded, feathered, and plain.

Teal was Virginia's color. The living-room drapes and sofas were of that vibrant hue, set off by black tables on which pink camellias floated in small crystal bowls. Most all of the furniture had been given to them years before by Ansel's parents or Albert Bender. A carnival of mismatched chairs lined the walls of the gallery, including Ansel's high chair from when he was a child. A new exception to these pieces was a rusty-colored, overstuffed recliner that I bought for Ansel when he had leg surgery.

The windowsill below the large north-facing window displayed Virginia's phalenopsis orchids, most of them white, seemingly perpetually in bloom. In later years, the blossoms hid a bronze bust of Ansel that, though less than becoming or true, had been a thoughtful gift from a friend. Occasionally a hat would appear on the poor thing's head, or a bandanna or bolo tie about its neck, just to humanize it a little.

Besides contributing the basic design, Ansel chose the varying shades of gray for the walls and ceiling, whose light-gray slats were spanned by massive old bridge beams painted Zone VI (or medium gray). In a contrarian touch, the long, west-facing wall with its potentially great view of the ocean held but one window and a huge stone fireplace with a twenty-four-foot-long mantel. At the mantel's center

presided Ansel's mammoth Chinese temple drum, nearly six feet in diameter, long since acquired from William Colby. This drum, the same one he had played at the Parillia in 1938, was the heart of the house. Its rim, now hundreds of years old, had originally been in the drum tower of the Black Pagoda in Beijing, and its stretched skin bore a colorfully painted, ornate dragon set against a red background. When Ansel decided that the evening was over, he would bang the drum, sounding a huge bass thump that would cause both floors and, by that time of night, bibulous livers to tremble. Without question, everyone would know it was time to go.

The fireplace, with its large black andirons from the San Francisco house, was flanked by wooden bookcases holding photography books on the left and natural history and Sierra Club coffee-table books on the right. Two of Ansel's proudest possessions sat among the books: a marble bust of a young woman and an amazing ammonite he had picked up at a rock shop in Utah.

Projecting from the living room was the gallery, to one side of which was the big gray work table where Phyllis Donohue spotted prints for more than twenty years. A mural of *Monolith*, three by five feet, commanded one wall, and Ansel's Mason and Hamlin piano, the same one he had bought in 1924, took up the room's opposite end, next to a three-panel screen of *Leaves, Mills College*, with hanging panels for photographs—an ever-changing exhibit held in place with pushpins—occupying the walls in between. On unusually warm days, the gallery would heat up courtesy of the skylights, and the dreaded sound of "ping!" "ping!" "ping!" "ping!" then "flop!" would announce that key pushpins had popped out of the board and an unprotected picture had hit the floor. There would be a mad scramble to take the rest of the prints down before they suffered the same fate.

The gallery's third wall consisted of very tall sliding doors concealing deep storage shelves for prints. Photographs were hung wherever there was space, with a dozen in frames right on the closet doors. Only a few pictures by other photographers ever appeared on these walls; Ansel had to really like an image to accord it such an honor. He was never shy about the fact that his favorite photographer was himself. On

the main floor nearly all the prints were his own, save for a Bill Brandt nude and a J. B. Greene salt print of the Colossus of Memnon, dating from the late 1840s, a gift from art dealer Harry Lunn. The lower, bedroom floor was another story. Downstairs there was nothing by Ansel. Most of the photographs were by Gerry Sharpe, who had died young and tragically and whose prints seemed a living memorial.

Ansel's small office back on the main floor, on the other side of the wall behind the piano, featured an unpretentious metal desk covered in green linoleum. Next to it, camouflaged with papers, was a heavy wooden table that gave no indication of its history as the Sierra Club's original meeting table, over which John Muir had once presided. Beyond was the original garage, which of necessity had become makeshift staff office space for at times upward of four people. Parallel with the gallery lay the work room, where Ansel's photographs were dried, trimmed, mounted, and stamped. At one end, and within talking distance of Ansel's office, was the desk for the current photographic assistant; at the other, large-capacity drying screens were stacked almost to the ceiling. A very long, dark-gray Formica table occupied much of the room, with storage for printing paper and mount board along one wall and a deep counter for the dry-mount presses, copy camera, and other essentials along the other.

The spick-and-span darkroom with its black-painted walls was entered via a heavy sliding door leading off the workroom. Like much of the rest of the house, it had nothing luxurious about it. Ansel's big horizontal enlarger for large-format negatives and two vertical enlargers for smaller ones were spaced along the left wall. The opposite wall was lined with deep sinks for processing, toning, and washing. Ansel's Carmel house worked for him very well.

In 1963, with the nearly four thousand prints of *Portfolio Four* breathing down his neck, Ansel lamented to Brett Weston that he could find no one to spot them. With a twinkle in his eye, Brett assured him that he knew just the right person for the job. When Ansel asked if she could start today, Brett demurred, saying she would come tomorrow. The next day Liliane De Cock appeared at Ansel's door, a young, intense woman who proved to be a champion spotter. Not until much later

did Ansel learn that she had known nothing about spotting when he had called Brett, who had taught her everything in the one-day grace period before she began work. Liliane served as Ansel's chief assistant for longer than anyone else, from 1963 until her marriage, in 1972, to Doug Morgan, son of Willard and Barbara Morgan and Ansel's publisher at the time.[57]

Liliane's prior experience in photography consisted of making snapshots; Ansel taught her technique in a natural and slow progression. She began with the scutwork of rinsing prints in the darkroom and progressed to developing, then to matching a master copy determined by Ansel, and then, finally, to taking full charge of the Yosemite special-edition prints, from exposure through shipping. After her boss loaned her a four-by-five-inch camera, Liliane discovered that she had not only a knack for photography, but a passion for it as well. As she eagerly attacked a new career, she recognized that Ansel had little creative spark left. In the nine years that Liliane worked for him, he made only one significant new image, *El Capitan, Winter Sunrise*.[58]

Why an artist stops creating is often impossible to understand, but a persistent nightmare that troubled Ansel may provide an important clue:

> [I get into] a taxi and [am] driving to a music hall or an opera house or a symphony hall, and seeing great placards screaming that Ansel Adams is going to play the *Brahms Second Concerto* with the Boston Symphony. It's all very real. I'm in a terrible state because I don't know the Brahms Second Concerto at all. But I nevertheless am disgorged at the stage entrance and go in. All the musicians are there backstage, tuning up and talking, and the conductor comes forward and says, "I'm so glad to see you. Our rehearsal was encouraging." And I sit there, and a slight feeling of perspiration—"What am I doing here?" I take a glimpse, and the hall is completely packed with hundreds or thousands of people. Finally the conductor invites the orchestra to go out on the stage, and they go out

and take their places. And I'm supposed to lead, so I walk
out and the conductor follows me, and I get as far as the
piano. And the conductor bows and we all bow, and he
steps to the podium.

And at that time I wake up from the situation with the
screaming heeby-jeebies because I don't know the work, I
don't know anything about it, even the first notes! I'm ab-
solutely incapable of doing it. . . . And I keep getting this
dream over and over again.[59]

Ansel had become world-famous, his name synonymous with both
photography and the growing environmental conscience. He had cre-
ated an awesome string of important images that spoke only of his vi-
sion and no one else's. But with time, an ambivalence grew deep inside
him, his past achievements both a flower and a thorn in his side, a
source of monstrous performance expectations from the public, the
critics, and himself. Ansel's creative genius had become paralyzed by
fear—the fear of failure.

18

MORTAL COMBAT

Over the years, many environmental skirmishes and battles found Ansel at their center. He came to wield political clout as did no other environmentalist. For decades he personally knew each Secretary of the Interior and director of the National Park Service; his pleas did not end up at the bottom of a pile on some underling's desk. Fluent with photograph, pen, and tongue, he bombarded Washington with telegrams, letters, personal appearances, and phone calls. Persistence was his most important trait. He attended meetings day after day, year after year. His commitment lasted a lifetime.

Since the 1920s, when he became an active member, both Ansel and the Sierra Club had grown up. Central to the maturity the club achieved in this century was the leadership of David Brower. The two men had first met while hiking in the Sierra in 1933, when Ansel was thirty-one and David twenty. Their lives held many similarities. Both

had been bright, awkward, and lonely children. Brower's early love of nature took root as he played in and about Strawberry Creek in Berkeley, while Ansel traced his environmental beginnings to his daily wanderings along Lobos Creek in San Francisco. Both boys felt physically self-conscious: Brower's front teeth were missing from an early accident, and even Ansel's broken nose could not distract the eye from his prominent ears. Each had discovered the powers of the Sierra in his youth, and both were determined to preserve that experience for future generations.[1]

Before World War II, Brower had enjoyed a brief career as the publicity manager for YP&CC, where he worked with Ansel and his photographs. Closely observing the younger man, Ansel was greatly impressed by his energy and abilities. He had long believed that the Sierra Club needed a full-time executive director, and he began a campaign to appoint Brower to that position. Before this could be accomplished, however, the war intervened.

Following his discharge from the Army, Brower assumed the editorship of the *Bulletin*. In 1947, the purposes of the Sierra Club were still, as they had been since its founding, "To explore, enjoy, and render accessible," et cetera. Later that year, Brower published the first *Sierra Club Handbook*, which opened with a call to members to examine the club's goals. With Brower's encouragement, the organization finally began to consider the direct linkage between accessibility and destruction of wilderness. In 1948, the phrase "to render accessible" was omitted, leaving as the remaining goals "to explore and enjoy." By 1967, under Brower's leadership, the shift was complete: the club's aim was "To explore, enjoy, and preserve. . . . "

Largely due to Ansel's insistence, Dave Brower was appointed the club's first executive director in 1952. He led the transformation of the Sierra Club (sometimes kicking and screaming) from a provincial, rather elitist group concerned mainly with keeping the mountains of the Sierra intact for its own enjoyment into an entity dedicated to a new philosophy of preservation for the sake of the earth, which would be touched in places by no more than an occasional soft footprint. He achieved this

success through the force of his brash character and the abiding belief that he was in service to the greatest cause.

Brower was very fond of a certain Thoreau quote that spoke for Ansel's sentiments as well: "In Wildness is the preservation of the World."[2] Brower considered it the club's mission to reach as many people as possible with that message, and to that end, he began an expanded publishing program. Through his efforts, the membership began to reflect a national constituency; its numbers exploded from ten thousand in 1956 to fifteen thousand in 1960 to over fifty-seven thousand in 1967.[3]

In 1954, the Park Service notified the club that the continued operation of the LeConte Memorial Lodge was no longer justified in Yosemite Valley; it was suggested that it be transformed into a geology museum since its namesake had been a famed geologist. Ansel firmly believed that the Sierra Club should keep the site open as a center for effective conservation education. He felt that if club members could explain the spiritual benefits of wilderness—beyond the obvious physical importance of pure water and clean air—the full impact of the need for preservation could be made clear.[4]

Ansel's idea found expression in *This Is the American Earth*, an exhibition of inspirational photographs accompanied by a lyrical free-verse text by Nancy. In 1950, Nancy had collaborated with Strand on the book *Time and New England*,[5] pairing his photographs with a selection of texts, both historical and contemporary The photographs were not used to illustrate the text but instead maintained a separate identity. The combined effect was powerful and quite different from that of either the photographs or the words alone. Ansel's term for this was "synaesthetic," denoting two discrete creative forms brought together to create a third, and independent, expression.[6] The idea, begun with Nancy and Strand, grew to maturity in *This Is the American Earth*.

More than a year of intensive work was required before the show's 103 photographs were mounted, along with Nancy's text, on panels built for touring. Most of the prints (fifty-four by Ansel and thirty-nine obtained from the usual cast of characters, including Edward and Brett

Weston, Eliot Porter, Minor White, William Garnett, and Margaret Bourke-White) had been made by Ansel to meet exacting size and tonal requirements.[7]

That summer of 1955, *This Is the American Earth* opened at the LeConte Lodge, where enthralled crowds jammed the small space to slowly savor each magnificent image amplified by Nancy's moving ballad. Ansel himself marveled at the power of her words.

This Is the American Earth traveled to Stanford University and Boston's Museum of Science before coming under the direction of the Smithsonian Institution, which then circulated it throughout the country. Four duplicate sets of the exhibit were made by Ansel, to be sent about the world under the aegis of the United States Information Agency.[8]

Ansel and Nancy worked with Brower to package *This Is the American Earth* into the ultimate traveling exhibition: a coffee-table book. After substantial changes (of the eighty-four photographs included, less than a third had appeared in the exhibition), *This Is the American Earth* was published in 1960 as the first of the Sierra Club's large-format books. It became a long-lived best-seller, with seventy thousand copies sold before it went out of print over a decade later.[9]

In the early 1980s, the club moved to reissue *This Is the American Earth*, but Ansel put a stop to the plan, suggesting that it was time for a new book by another generation of photographers and writers. In 1992, this classic of the environmental movement was brought back into print. Some still say it is the finest conservation book ever.

This Is the American Earth was not the only show of its kind that year. Also in 1955, Ansel and Nancy's old nemesis, Edward Steichen, presided over the mother of all photography-as-entertainment exhibitions: *The Family of Man* broke all attendance totals at MoMA and traveled to sixty-nine countries, where it was seen by nine million people.[10] A companion book sold a phenomenal two and a half million copies.[11]

Although Nancy and Ansel were blind to the similarities, the two shows had much in common. Both were intended not just to educate or delight but to motivate the viewer: in the case of *This Is the American*

it was nearly insolvent: though the fees accrued from the growing membership swelled the coffers, Brower's multifarious projects proved fully capable of draining them again.

While the accomplishments on behalf of the environment were sweet, Ansel remembered the failures with great pain. In 1957, the National Park Service, acting under a directive dubbed "Mission 66" (whose stated purpose was to make the parks more accessible by 1966), announced that major improvements would be made to the Tioga Road, which connects the Owens Valley, via Yosemite, with the highly populated San Joaquin Valley. The construction would bring the middle section of twenty-one miles up to the same high-speed-highway quality of the roads on either end. But while a straight road marks the shortest distance between two points, as the young Ansel had observed in 1915, nature comes fully equipped with curves. The old Tioga Road traced a winding course that respectfully followed its majestic footings; the new route could be achieved only by dynamiting pristine granite domes along the shores of Tenaya Lake.[15]

The idea of blasting a highway in such a place infuriated Ansel; it required immediate action. He demanded that the Sierra Club's board take up the cause of protecting the Tenaya wilderness. Disheartened by the trustees' timid response, he resigned from the board, believing he could carry Tenaya's banner more effectively alone than with a waffling Sierra Club.[16]

After the "improvement" began, he pleaded for the three most critical miles, along the glacier-polished shores of Tenaya Lake, to be spared. In 1958, work on the road stopped while Ansel was granted an on-site meeting with regional officers of the Park Service and Yosemite's superintendent. An inspection by Conrad Wirth, director of the National Park Service, soon followed. Ansel left the discussion feeling confident that the most important stretch of domes would be spared. Returning to Yosemite from a trip some weeks later, he was appalled to discover the road had been completed with full devastation. In the meantime, the Sierra Club board had refused to accept his resignation, and he returned to its midst.

Ansel was determined never to let himself forget the Tenaya defeat,

Earth, to save the earth; in that of *The Family of Man*, to save mankind. Ansel and Nancy had long ago tried, convicted, and hung Steichen for his use of photography as emotional propaganda; it did not seem to occur to them that they themselves might be guilty of the same charge.

The disrespect that Steichen showed for the aesthetic quality of a creative photograph removed any possibility that Ansel could truly "see" his show. He cringed when he went to *The Family of Man*. Steichen had insisted on having all the prints made to his specifications, right in New York, and had even asked Ansel to send his negative of *Mount Williamson from Manzanar* so that it could be turned into a gigantic mural. Not only would Ansel never have allowed anyone else to make a print for exhibition from one of his negatives, but this particular negative bore his inadvertent fingerprint in its sky due to a mistake in processing. The bigger the enlargement, the more apparent was this flaw. When Steichen refused to let Ansel make the mural himself, Ansel sent him a copy negative to work from. He literally became ill when he viewed the results: *Mount Williamson* had been cropped (an absolute Ansel artistic no-no, a decision only he could make), and the fingerprint was so big it looked like the mark of a wrathful God.[12]

For *This Is the American Earth*, Ansel had insisted on the very same conditions as Steichen, requiring that the participating photographers send him their negatives for printing. Perhaps with well-merited darkroom arrogance (he possessed one of the few darkrooms equipped to handle large murals), Ansel believed he could make better prints and murals than the images' originators, and he was held in such high esteem as a printer that most of his fellow photographers agreed to his demands. Even Edward Weston relinquished his negatives, though his son Brett held firm and sent only finished prints, shocked that Ansel would make such a request.[13]

Throughout this time, Ansel continued to serve as a member of the Sierra Club's publication committee, though he was sensitive to even the hint of personal profiteering. (He and Nancy split just 5 percent royalties based on retail price; typical royalties are double that.)[14] *This Is the American Earth*'s earnings helped to save the club at a time when

and instead used it to spur himself onward. As he assessed the damage, he recalled bittersweetly how it had all looked to him when he was twenty years old, a vast wilderness showing almost no evidence of man, save for a trail he could choose either to follow or to ignore. He soon had a rubber stamp made proclaiming "Remember Tenaya!!!" (Ansel was a major practitioner of exclamation points) and used it to brand his correspondence. Finally, he wrote an elegy, "Tenaya Tragedy," that appeared in the 1958 *Bulletin*, a lament to the irretrievable loss of magic.[17]

The national parks are peppered with unprotected lands, some privately held and others administered by the Forest Service. Sequoia National Park contained one such Forest Service–managed property named Mineral King, a gorgeous fifteen-thousand-acre alpine bowl surrounded by Sierra peaks. When Sequoia was designated a national park, in 1890, Mineral King was not included because it was experiencing a brief silver rush, complete with cabins, mines, smelters, and mills.[18]

The Forest Service put Mineral King out for development bids in 1965; the Walt Disney Company won with its bid to construct a Swiss village that would service up to fourteen thousand people a day, with overnight accommodations for three thousand visitors and a thousand employees. The lift capacity could support over eleven thousand skiers per hour.[19]

For years there had been a tacit understanding between the Forest Service and the board of the Sierra Club that Mineral King would eventually be developed for skiing; many of the board members were ardent skiers and believed this was good use. But the times they were a-changin'. The Disney proposal was far larger than any of the Sierra Clubbers had anticipated, and the directors were deeply divided over what their course of action should be. Many of the older board members felt that they had given their word years before and that it would be setting a bad precedent for a new board to overturn an earlier decision. The younger members argued that times and conditions were different now, and it was imperative to adopt a new position against any development of Mineral King. It was a matter of principle to both sides.[20]

Because Mineral King was almost literally an island, nearly surrounded by a national park, the access road for the thousands of skiers expected daily would have to cut directly through the park itself. Still smarting from the Tioga Road disaster, Ansel knew that the road and its hurtling traffic would change Sequoia forever. He had served on the board for thirty-one years and was definitely a constituent of the older group, many of whom had been his close friends for decades, but he now joined with the Young Turks, led by Martin Litton and Fred Eissler, and voted to oppose Disney and the Forest Service.[21] Not threatened by new ideas, Ansel continued to grow and change with his times.

The club brought legal suit to block the development of Mineral King, and though in the end it proved unsuccessful in the courts, Disney (now Walt-less) finally gave up, victim to the attrition of time. Mineral King was absorbed into Sequoia National Park in 1978.[22]

It seems incredible now, but during the 1960s, the government tried to mess with the Grand Canyon. Both Phoenix and Tucson were growing at a phenomenal rate and more electricity was essential if the growth was to continue. The Bureau of Reclamation decided to build two more dams to control the flow of the Colorado River. Although the dams would be outside Grand Canyon National Park, their effects would reduce the river at its heart to two lakes connected by a trickle. The dam plan had powerful support, beginning with Arizona Congressman Morris Udall and his brother, Stewart, the Secretary of the Interior, both of whom had reputations as liberal Democrats. In an interesting twist, Arizona senator and conservative Republican Barry Goldwater opposed the dams.[23]

Glen Canyon, a spectacular though isolated region on the Colorado River in southern Utah, had been flooded in 1963. Brower believed himself and the club partly responsible, having done too little, too late, and he vowed to learn from that sad lesson by increasing the organization's vigilance and activism. Protecting the Grand Canyon became his top priority.[24] Brower's most significant initiative was the decision to run a series of full-page ads in the *New York Times* beginning on June 9, 1966, complete with coupons to be filled in and sent to the Presi-

dent, Secretary Udall, and the chair of the House Interior Committee. The Internal Revenue Service arrived at the club's San Francisco offices the very next day and threatened to revoke its nonprofit status for engaging in legislative lobbying.[25] The club pounced on this bullying and turned it into news. Brower later said, "People who didn't know whether or not they loved the Grand Canyon knew whether they loved the IRS."[26] Membership doubled from thirty-nine thousand before the first ads to seventy-eight thousand within three years. However, the price was high: the club lost its tax-deductible status.

The most famous Sierra Club ad, which appeared later that summer, asked, "SHOULD WE ALSO FLOOD THE SISTINE CHAPEL SO TOURISTS CAN GET NEARER THE CEILING?" Although the Bureau of Reclamation had never intended to fill the Grand Canyon with water, the ad proved potent. Ansel, though he never got credit, inspired the copy: in a July 2 letter to Brower and board president George Marshall, Ansel wondered, if the Grand Canyon could be flooded, what was to stop someone from filling the Sistine Chapel two-thirds full with water so that tourists could better view Michelangelo's murals?[27]

With an alarmed American public barraging Washington with letters and phone calls, President Lyndon Johnson made it known that he would veto any bill put before him to dam the Grand Canyon. The next year, Congress passed legislation protecting the canyon from future exploitation. Victory!

In 1962, the Pacific Gas and Electric Company (PG&E) announced plans to build a nuclear power plant on the Nipomo sand dunes overlooking the Pacific Ocean north of Santa Barbara. Sand dunes comprise a fragile ecosystem, and such oceanside dunes are rare in California. With Ansel spearheading the Sierra Club's protest, PG&E agreed to move the reactor to a less sensitive site. He continued to assert his long-held belief that cooperation was NOT compromise: the best way lay in working *with* business and government to solve problems together, rather than in obstinately assuming an adversarial position.

The majority of the Sierra Club board felt it had won on the Nipomo issue, but Brower led the minority in protesting the building of *any* nuclear power plant. He believed it was impossible to work with PG&E

without becoming corrupted; in his view, they were all crooks.[28] Ansel's good friend Doris Leonard, wife of his fellow Sierra Club director Dick Leonard, served on PG&E's board and worked as a liaison between the club and the company. A lifelong environmentalist who had directed the club's biennial wilderness conference for many years, she felt it was imperative not only to save the dunes but to move the reactor away from the populous Nipomo area.[29]

The site PG&E finally chose was an empty stretch of privately held property seven miles from Nipomo and directly on the ocean, which was essential to provide the enormous amounts of water needed to cool the reactors. Brower publicly attacked Leonard, accusing her of having been bought.[30] He burned his bridges with old friends and longtime congressional allies as well as with those who would have been against him anyway. Everything and everybody was either right or wrong; there was no in-between. He treated fellow environmental groups as enemies, unwilling to share any of the glory even though it had been won, at least in part, by others.

Brower insisted that the question be put to the entire membership of the Sierra Club. The result was a resounding vote of support for Ansel's compromise position, rather than Brower's extreme stand. PG&E proceeded to build the plant at Diablo Canyon, an installation now infamous for its construction very near a seismic fault.

Although in his view this had been a fight to protect lands, not to discourage or promote nuclear energy, it might seem contradictory that Ansel, the great environmentalist, championed nuclear power. But he believed that nuclear-generated energy was preferable to the burning of fossil fuels, with its subsequent pollution of air, forest, rain, and water. In the year before his death, he was to twice visit the Lawrence Livermore Laboratories to photograph its facilities for magnetic fusion, which he believed represented the future solution to the provision of clean, self-generated power.

Even after the club's membership voted to support the board's Diablo Canyon/Nipomo dunes position, Brower refused to give up the fight.[31] He had become completely impatient with having to answer to a board of directors, and his ego and desire for power grew apace

with his enthusiasm for his cause, reaching manic proportions. He announced that he would run for the board and assembled a group of four other candidates to stand in the coming April 1969 elections. His slate dubbed itself the ABC, which stood at first for "Aggressive Brower-style Conservationists," then for the less ego-driven "Active, Bold, Constructive" Sierra Club. Others suggested that "Aggressive Berserk Conservationists" or "Ave Brower Caesar" might be closer to the mark.[32] To the outrage of many of the old-time board members, Brower also initiated a petition to bring the matter of Diablo Canyon before the entire membership yet again. The Sierra Club was in a mess.

Ansel was up for reelection, as were five of the fifteen board members each year. For the first time since 1934, the nominating committee, now comprised of Brower backers, did not nominate him. Ansel formed an independent, opposing slate of five candidates that called itself the CMC, "Concerned Members for Conservation," translated by the ABC as "Conservatives for Minimum Conservation."[33]

Convinced that the end justified the means, Brower made numerous unilateral decisions. When the Publications Committee rejected a book on the Galapagos Islands, Brower ignored its recommendation and committed to two volumes. He engaged the services of a printer in England, obtained a gift of seventy-eight thousand dollars from a British donor, deposited the money in a London bank, set up Sierra Club offices in that city, and published the Galapagos books, all without the knowledge or permission of his board.

When his twenty-thousand-dollar discretionary fund was placed under the control of the board president, Brower wrote into the next book contract a 10 percent royalty for himself. When his action was discovered, he charged that the board had driven him to it, claiming he had intended only to replace his sequestered expense account.[34] Ansel pleaded with him to reassess the situation and allow the elected board to assume its rightful duties.[35] Disregarding all such advice, Brower continued on his chosen course.

Things went downhill from there. Ansel and two fellow directors, Dick Leonard and Richard Sill, made charges against Brower at the

October 19, 1968, board meeting. Each presented an individual indictment, ranging from unlawful use of funds to blatant disregard of board and committee decisions. The board president, Edgar Wayburn, authorized an investigation.[36]

Brower had dug his own grave, and dug it deep. On January 14, 1969, a one-and-a-half-page ad appeared in the *New York Times*, totally of Brower's own doing and, as was now his pattern, without the knowledge of the board. The text, which proposed the establishment of an "EARTH NATIONAL PARK," dumbfounded the board members, to whom this idea was just as new as it was to the rest of the *Times*'s readership. This proved to be the last straw. First, Brower was stripped of his power to make financial commitments on behalf of the club; then, at the February meeting of the board, he was asked to take a leave of absence until after the elections.[37]

The results were humiliating to Brower's ABC group. Each of the five CMC candidates collected more votes than did Brower himself, and on the Diablo Canyon issue, the membership once again overwhelmingly sided with Ansel's faction, by an even larger majority than in 1967.[38]

On May 3, 1969, the new board took office. Hundreds of members attended the meeting, which was held in the Empire Room of San Francisco's Sir Francis Drake Hotel. As they waited for what was inevitably to come—the dismissal of Brower—many became mesmerized by that morning's edition of the *San Francisco Chronicle*. The famous drive-through giant sequoia in the southern part of Yosemite had fallen. It was front-page news, illustrated by a photograph made by Ansel thirty-odd years before, showing the tree with a Pierce Arrow automobile parked in its middle and a couple of people posing for scale. The caption read, "A Fallen Giant." One of the models in the picture was David Brower.[39]

After decades of sound sleep following numerous battles, Ansel was immensely distressed by the conflict with his old friend Brower and the years of strife over Diablo Canyon, even though he had "won." He could no longer enjoy the Sierra Club; everything seemed spoiled. Marj Bridge Farquhar, another club leader, had come to the same conclu-

sion, later remarking, "It was too bad, and it really split the thing up. It finished the Sierra Club as it had been. It has never been the same."[40] Ansel submitted his resignation on September 13, 1971, one year shy of the end of his term.

While most souls would have been undone by such wrenching turmoil, Brower has remained strong and committed, never wavering from his convictions. Unlike Ansel, whose edges were gentled by age, Brower maintains a sharp hardness. He survives as the grand old man of the environmental movement, outliving and outtalking his critics, devoting his still-potent energies to the future of man and earth. Brower has never lagged behind or dwelled on the issues of the past, but neither does he forget the failures, seeing them instead as errors that may still be corrected. One of his great campaigns is to pull the plug on Hetch Hetchy by removing the dam and allowing the waters of the Tuolumne to flow free once more.[41] Charmingly, David Brower thinks of just such incredible possibilities, and every once in a while he pulls them off, making his transgressions seem paltry in comparison.

Shortly after Ansel's resignation from the board, the *Sierra Club Bulletin* published Philip Hyde's moving commemoration of his years of service:

> It has been said that nature photography, and many photographers, have worked in Ansel Adams' shadow. Nonsense! The man radiates light—he doesn't cast a shadow. And that radiation has warmed and prospered the Sierra Club's efforts in many directions through Ansel's nearly four decades of service on its Board of Directors. . . . He brought to the Board a balance. His voice, expressing the importance of emotional and intangible values, has provided the kind of influence and counsel so badly needed in a world hastening toward greater technology and the dominance of so-called practical values. Ansel has been our artist-in-residence on the Board so long it is hard to imagine a balanced Board without him. Surely, his footprints on the Sierra Club trail will be hard to fill.[42]

After Ansel's death, the club created the Ansel Adams Award, given "for superlative use of still photography to further the conservation cause."

Like Brower's, Ansel's environmental energies never flagged, continuing to be expressed through venues other than the Sierra Club, but mostly in his role as a private citizen, with all the rights and privileges thereof. A lifelong Democrat, Ansel nonetheless tolerated his Republican friends with good humor, believing they were just slightly dense. From 1960 onward, Ansel's counsel was sought by every President save for Nixon. Even Ronald Reagan asked to meet with him.

In 1965, the huge success of *This Is the American Earth* captured the imagination of President Lyndon Johnson, and he asked Ansel and Nancy to prepare a volume of photographs and excerpts from his environmental speeches to emphasize his commitment to the American natural scene. The privately published *A More Beautiful America* is a remarkable testament to President Johnson's great love for America, long overshadowed by the tragic events of the Vietnam War. In this book, the President wrote, "Above all, we must maintain the chance for contact with beauty. When that chance dies, a light dies in all of us."[43] This reads like vintage Ansel Adams, and in fact the President did enjoy two long and conversation-filled meetings with him.

When President Carter requested that Ansel make his official presidential portrait—the first time a photographer, not a painter, was selected—Ansel felt greatly honored. He recalled, "The painters, of course, were very mad. It was a break in nearly two hundred years of tradition."[44]

It seems difficult to believe, but Ansel Adams was nervous that something would go wrong—the exposure would be incorrect, the focus blurred, on and on. Din Land put his worries to rest by loaning him one of Polaroid's twenty-by-twenty-four-inch cameras so that Ansel could see instantly if the picture was good. No little machine, the camera required a crew of two full-time technicians and was moved about the country in a special truck.

President Carter had his own concerns, confessing to Ansel that his smile did not come off in most portraits. With a grin, Ansel told him not

to worry, just to relax.[45] During the "shoot," the two men became friends. In the 1970s, Ansel had joined the Wilderness Society's campaign to safeguard portions of Alaska, and scarcely a week now passed without letters between him and the President, Ansel's full of his distress over a vanishing wild Alaska. Soon a White House wall was adorned with Ansel's greatest Alaskan photograph, *Mount McKinley and Wonder Lake, Denali National Park.* Just before leaving office in December 1980, President Carter signed the Alaska National Interest Lands Conservation Act, protecting over 104.3 million acres, the largest land-preservation act in history.[46]

Closer to home, Ansel worked to stop Humble Oil of Texas from building a huge refinery near the fishing village of Moss Landing on Monterey Bay. As was his custom, he inundated newspapers with letters to the editor, passionately urging readers to "Oppose this refinery project with all your strength of mind and heart!"[47] He and a fellow Carmelite activist named Tom Hudson became acquainted with the president of Humble Oil and politely explained to him why they felt the Moss Landing location would be dangerous, jeopardizing as it would the agricultural bounty of the Salinas Valley. That was all it took for Humble Oil to pull up stakes and move the project north to Benicia, though how thrilled that city was with the turn of events, the Carmelites did not know.[48] Here was Ansel's ideal environmental protest: he acted as a gentleman, and so did his opponent. Rational minds prevailed, and Ansel won.

The dramatic and largely lonely Big Sur coast stretches out southward from below Ansel's Carmel Highlands house, its curvaceous landscape echoed by sinuous Highway One. Few other manmade things impede the eye from that vantage, but though Ansel lived there for his last twenty years, he made few photographs and even fewer successful ones.

The preservation of Big Sur was Ansel's last battle, one that still has not been resolved. Both the Big Sur Land Trust and the Big Sur Foundation were formed during meetings in Ansel and Virginia's living room, in 1973 and 1977, respectively.[49] Ansel served as the foundation's vice president until his death. Following the model of Cape Cod,

where homes and towns are seen as important elements, reflective of their setting, he worked tirelessly alongside Senator Alan Cranston, then-Congressman Leon Panetta, and Assemblyman (now Congressman) Sam Farr, as well as the Wilderness Society, to create a Big Sur National Scenic Area. Ansel often said that Big Sur was of national importance, and therefore deserving of national protection.[50]

Sadly, the Yosemite that cured the young Ansel proved unhealthy for the old one. The valley's floor is over four thousand feet above ocean level, an altitude that tested his heart, now compromised by age. His visits there grew shorter and less frequent. Ansel saw Yosemite Valley as a great seven-square-mile concert hall with a fixed number of seats; he knew the performance had been oversold when bumper-to-bumper cars poked their way up and down the narrow valley floor. Automobiles, he felt, must be banished, and the number of visitors limited. The most important thing was that the Yosemite experience be preserved for those who sought it. Crowds may trample the central trails and high heels occasionally, somehow, make it up the Mist Trail, but still, on most summer days, few hikers can be found on the many miles of trails that branch out from the valley in all directions.

More than four million people, more than the population of twenty-eight states, passed through the park's entrance gates in 1994, staying on average only a day and a half and most never venturing beyond the valley's flat bottom.[51] On most of the weekends during the summer of 1995, with record crowds admiring the tumultuous waterfalls (the runoff from an unusually heavy snowpack), Yosemite's new superintendent, B. J. Griffin, courageously judged the park full to capacity (determined to be twenty thousand people) and for the first time closed the gates to further visitors.[52] The time is nearing when advance reservations will be necessary for all visitors, an idea that seemed radical to many when Ansel first espoused it in the 1950s but whose implementation is vital to perpetuating any semblance of a contemplative Yosemite encounter. Griffin has said, "What I would hope for this park one day is a very quiet experience."[53] Ansel would have been her most vocal supporter.

Unwilling to miss any opportunity to publicize the cause, in 1970,

when cars were banned from the extreme eastern corner of the valley at Mirror Lake, Ansel set up his camera and tripod to record a bulldozer tearing up the asphalt of a no-longer-needed parking lot. His presence made the event newsworthy: the *San Francisco Examiner* sent out a reporter and photographer to do a story, in which Ansel was quoted as saying it was an act of historic importance.[54] He had great hopes that this would be just the first step. But no other roads have been taken out of public use in the valley, and a proposal is now on the table to build a huge parking garage in the shadow of El Capitan.[55]

Ansel joined the years-long effort to create a master plan for Yosemite. One such plan, completed by 1980, called for automobiles to be replaced by shuttles and all commercial operations to be minimized. Falling victim to the change of administrations from Carter to Reagan, caught up in the tangle of bureaucracy, it was never implemented.[56]

Until the end of his life, Ansel loved to stand at Inspiration Point with the valley's length stretched before him. In some respects, Yosemite was cleaner and better than it had been when he first saw it, in 1916. From this vantage point, there was still no sign of the hand of man, and there were no more pool halls, bowling alleys, or golf course. All in all, for him, Yosemite was largely an example of what was right with our national parks.

Although Ansel's photographs were used as banners to rally the public for the protection of Yosemite, Kings Canyon, Big Sur, and Alaska, he clearly and repeatedly stated that he never directly made a picture for an environmental cause.[57] He resented the implication that photography had no value unless the artist's underlying motivation was to use his or her art as a tool to solve social and political problems.[58] For Ansel, it was an added benefit if photographs could be used in the service of mankind, but aesthetic response must be the photographer's primary motivation. By his definition, artists created beauty and, through it, affirmed life. It was here that the purposes of the artist and the environmentalist joined: in the affirmation of life on this planet.[59]

Ansel did, however, provide photographs to promote tourism in Yosemite and places like it, even as he worked to preserve its essential qualities. At Best's Studio, Virginia struggled for many years to make a

living dependent upon the Yosemite tourists; when visitation was down, so was income. In the end, Ansel was as culpable as John Muir had been before him, attracting ever larger numbers of people bent on witnessing for themselves what was revealed in his pictures, most of them not realizing that those images were the essences of the scene, not the more mundane reality, which, however splendid, rarely measured up. Ansel's photographs have spurred thousands to visit, with all the subsequent impact that has had.

19

PRICE RISE

In late 1970, still nursing fresh wounds from the Brower war, Ansel was awarded a Chubb Fellowship at Yale University. He spent his required days on the New Haven campus in late November, meeting with students and presenting a formal lecture to the School of Forestry titled "The Aggressive Persuasion: A Credo for Survival," in which he emphasized that the value of the wilderness could not be measured or really explained but instead must be experienced.[1] Ansel drew vital nourishment from the Yalies, who hung onto his every word and, in so doing, reassured him that as a conservationist, he still had important things to say and do.

William A. Turnage, a graduate student in the School of Forestry, was responsible for Ansel's care and feeding during his visit. In 1970, with Vietnam much on America's mind, students were advised not to trust anyone over thirty, but Bill listened raptly to the sixty-eight-year-

old Ansel, finding in him a real-life hero as devoted to environmental concerns as himself. In turn, Ansel was complimented by the young man's admiration and attention. Always insecure about his lack of even a high school diploma, Ansel was impressed by Bill's Ivy League education but even more impressed that he had not allowed it to afflict him with effeteness; instead, Bill was a rugged man who loved the outdoors. For Ansel, it was almost like going out on a first date and discovering so many shared interests that he could move immediately into a serious relationship.

Throughout the week, their discussions kept returning to Ansel's circumstances. A frustrated Ansel confided that though he was working as fast as he could, financial security still eluded him; he then listened as Bill began brainstorming and came up with various business plans. Bill had the combination of high energy and organizational skills that Ansel lacked, and this was just the opportunity that would make the most of his abilities. In no time, Ansel hired Turnage to manage his career.[2] They agreed that he would be paid only a nominal salary but would receive a commission on any income he produced.[3]

Bill left Connecticut for California in April 1971. Ansel wrote to Beaumont and Nancy of his hopes that by some divine intervention, Bill had been sent to assume some of his heaviest burdens. And assume them Bill did, within days relieving Ansel of the day-to-day dealing with business, permitting him for the first time to concentrate on just his own work (such was the plan, at least). By September, with incredible efficiency and speed, he had become central to all of Ansel's projects.

Ansel soon applied the "Turnage treatment" to every aspect of his life.[4] In 1972, Bill was appointed the first executive director of the Friends of Photography.[5] He held this position for only a few months, just long enough to set up administrative procedures and name a capable successor before leaving Carmel for Yosemite, where he became resident manager, charged with the challenge of moving Best's Studio successfully into the future.[6] After analyzing the situation, Bill convinced Ansel that Virginia should relinquish ownership to their son, Michael, and daughter-in-law, Jeanne, and change the name to the

"Ansel Adams Gallery, operated by Best's Studio, Inc.," to take advantage of Ansel's burgeoning fame.[7]

Virginia Adams felt pushed out. She had spent every summer of her childhood at her father's studio in Yosemite, and then most of the year after it was winterized. It had been her business since Harry's death, in 1936, and she had raised her children there, almost by herself. But if she was hurt by what was happening, she could not begrudge handing the business over to her beloved son. Since Michael was understandably busy with his medical practice, Jeanne took over the newly renamed Ansel Adams Gallery and proved to be a dedicated and savvy manager. For his part, Bill saw himself as a devoted Ansel advocate; he was concerned with doing what was best for his boss, and if that meant he must tread on family members, so be it.

The backbone of the gallery's inventory was and is its special edition prints, or SEPs, a selection of Ansel's Yosemite images printed by an assistant as a high-quality souvenir. Ansel himself began the practice in 1937, when he sold the prints for a few dollars apiece.[8] Measuring approximately eight by ten inches, each carries a stamp on the back of the mount identifying it as a Special Edition Print. Up until 1972, Ansel affixed his full signature to all prints, then initialed them from 1972 to 1974, when he became convinced that he was only confusing people, and he stopped signing them altogether.[9] SEPs are worth but a fraction of what prints made and signed by Ansel himself bring; when articles appear touting the prices of Ansel's original prints, many people get excited, mistakenly thinking they own one of these valuable photographs rather than a much more common SEP.

The price of a SEP eventually rose to $15, then $25, $50, $75 and $125 in 1996 and can be purchased exclusively at the Ansel Adams Gallery in Yosemite. Alan Ross, who served as Ansel's photographic assistant from 1974 to 1979 and who has printed SEPs for over twenty years, calculated that by the end of 1994 he had turned out over fifty thousand Special Edition Prints, including four to five hundred each year of *Moon and Half Dome* alone.[10] Simple math suggests that this one aspect of the business has grossed impressive amounts. A superb printer himself, Alan consistently matches Ansel's high standards.

Having seen to Ansel's peripheral worries, Bill returned to Carmel to set to work as his business manager. Shortly thereafter, the Datsun (now Nissan) automobile company signed Ansel to star in a television commercial; as an enticement to consumers, Datsun promised to plant one tree for every test drive taken.[11] This was the first real evidence of a cult of personality surrounding Ansel, now encouraged by Bill: the ad used not a famous Ansel Adams photograph but the old man of un-questioned principles himself.

Chatting on the nation's television screens about the need to reseed our imperiled national forests with trees, even if in a car advertisement, did not strike Ansel as something to be ashamed of.[12] He believed that his participation in the commercial did as much for the U.S. Forest Service as it did for Datsun.[13] Ansel was told that 160,000 seedlings were planted thanks to this ad campaign.[14]

Although *Time* praised "Drive a Datsun, Plant a Tree" as being in particularly good taste, Ansel took a lot of heat from others for his role as an automobile advertising spokesperson.[15] He was hurt and puzzled by the chorus of criticism.[16] To the accusation that he was now promot-ing the very thing he had been working to eliminate in Yosemite, Ansel responded that almost all of us depended on our cars and that the Dat-sun was less polluting and more fuel-efficient than most.[17] Because he needed huge cars to carry all his camera equipment, he himself was sentenced always to drive gas guzzlers, among them a big Pontiac, a Cadillac, and, at this time, a Ford LTD.

Imogen Cunningham felt it was just one more instance of Ansel's selling out. In 1969, he had allowed one of his winter views of Yosemite Valley to be printed on three-pound cans of Hills Brothers coffee; with her trademark caustic wit, she had sent him one of the cans filled with manure and sprouting a very healthy marijuana plant, terming it "pot in a pot."[18] Now collector's items, these Adams coffee cans sell for hun-dreds of dollars, without Imogen's embellishment.

The negative reaction of friends and public to "Drive a Datsun, Plant a Tree" disillusioned Ansel, and he swore he would never again permit himself or his work to be used to promote a commercial prod-uct.[19] He stuck to his word, though not before completing the contract that Bill had arranged for him with Wolverine Worldwide, an American

manufacturer of hiking boots that paid him seventeen thousand dollars in 1972 and fifteen thousand in 1973 (plus some swell shoes) for the commercial use of his photographs, along with some prints for the corporate offices.[20]

As the decade of the seventies progressed, interest in fine photography skyrocketed. As a hobby, photography exploded, with sales of photographic equipment doubling over the course of the decade. Newsstands offered a wide variety of specialized magazines, and most colleges added photography courses to their curricula, producing thousands of photo majors.[21]

This newfound popularity, combined with a booming economy and the fact that an original photograph by an important photographer still cost far less than comparable works in most other media, contributed to the first broad interest in the purchase of photographs as art. Sales picked up as a handful of new galleries opened their doors, including Witkin in New York City, Siembab in Boston, Halsted in Detroit, and Focus in San Francisco, soon followed by such galleries as LIGHT in New York, Lunn in Washington, Weston in Carmel, Grapestake in San Francisco, and G. Ray Hawkins in Los Angeles. Major auction houses such as Sotheby's, Christie's, Swann, and Butterfield's began to hold biannual photography auctions.

Photography collecting rapidly gained momentum, and Ansel was perfectly positioned to benefit. Immediately, his photographs led the market, with sixteen-by-twenty-inch prints selling for $150 each in the early seventies—certainly a significant increase from their 1932 price of ten dollars, but still very affordable.[22]

There was a big downside to the new demand for Ansel's prints, however: Ansel had to make them. The more popular the image—one of the group he called his "Mona Lisas"—the more prints he had to make, and the more disheartened he got, chained to his darkroom trying to keep up with orders. Even when Bill raised print prices to five hundred dollars on September 1, 1974, sales, far from slowing, only soared.[23] The *Collectibles Market Report* pronounced, "Nothing goes up forever, but [an] Adams has the qualities of a blue chip like [a] Renoir."[24]

In the spring of 1975, Bill issued a press release announcing that as

of December 31 of that year, Ansel would accept no more print orders. Until that time, all sixteen-by-twenty-inch prints would cost eight hundred dollars, except *Moonrise,* which would cost twelve hundred.[25] The idea was to give individuals and dealers one last opportunity to buy Ansel's work and then free him to move on to other projects.

By the deadline, they were stunned by orders for thirty-four hundred prints, 1,960 from Lunn Gallery alone.[26] "[Harry Lunn] got his mitts on Ansel Adams . . . and the rest is history,"[27] a newspaper article later asserted. Within four years, Lunn could report that he had fewer than 250 prints remaining.[28] By that time, Ansel's photographs were selling for many multiples of their original price, and major money was being made in the secondary market.[29]

Harry Lunn is a fabled art broker, a dealer's dealer who often acts as middleman in the sale of spectacular nineteenth-century photography albums. For many years, he was also the major player in the Ansel Adams market. In the past quarter century, few photographic projects of the highest magnitude have been carried out without Harry's involvement in one stage or another.

A tall, rangy man with imperious bearing, Harry looks just a bit like an Amish farmer who happens to dress with impeccable sophistication. It is commonly understood (and has never been denied by Harry himself) that he was at one time a CIA operative, which certainly adds to his aura of intrigue.[30] Once, Jim and I met Harry for dinner at Au Trou Gascon in Paris. We arrived first and were seated, but Harry insisted on trading places with me so that his back would not face the door. It made me a believer in the myth.

Harry was anything but shy about his methods of building up a market for a particular artist. In Ansel's case, he held a huge inventory with multiple copies of what he believed were the best pictures. He selected nine images as Ansel's masterpieces and refused to sell them, promoting the other images and building a market and prices. After he had established those, he finally released his top nine, at "marvelously enormous prices. That's when you make all your money."[31]

Some of the Ansel Adams prints that he worked his best magic on, the ones that he tantalizingly listed on his gallery's August 8, 1978, in-

ventory sheet followed by the notation NFS (not for sale), were *Moonrise; Mount Williamson; Clearing Winter Storm; Moon and Half Dome; Mount McKinley and Wonder Lake; Oak Tree, Snowstorm; Tenaya Creek, Dogwood, Rain; Aspens* (horizontal); and *Sand Dune, Sunrise,* each one an Adams masterpiece.[32] Harry and other dealers established market prices based on the photographs' individually perceived comparative value, as determined by auction results, buyer demand, and their own taste.

When the deadline for orders passed, Ansel issued a form letter to answer the requests for prints that continued to flood his studio. He listed as the reasons for his decision 1) his desire to proof and print the thousands of neglected negatives of his that had yet to see the light of an enlarger; 2) the need to write a new series of technical books; and 3) the obligations of lecturing and teaching his annual Yosemite workshops.[33]

Ansel knew that to fill the orders in hand, he would have to devote all of his time and energy for the next few years to making prints. He hired a second photographic assistant so that the darkroom could be in operation seven days a week and set a daily production goal of forty sixteen-by-twenty-inch prints or sixty eleven-by-fourteens.[34] Only such a phenomenal darkroom technician as Ansel could meet those numbers with no diminution of print quality.

Continuing to put Ansel's business house in order, in 1974 Bill presented the idea of an exclusive publishing agreement to Tim Hill, editor in chief of the New York Graphic Society (NYGS) imprint of Little, Brown and Company. The contract would give NYGS the right of first refusal on any of Ansel's publishing projects. Hill knew immediately that this was an opportunity not to be missed. Recently hired to improve NYGS's bottom line—its historical emphasis on books about painters and painting had put it on thin ice financially—Hill had presciently switched the imprint's thrust from painting to photography, which he saw as less elitist and appealing to a much larger market. Eastern and erudite, the hardworking Hill proved his mettle. With a careful analysis in hand, he approached the revered president of Little, Brown, Arthur Thornhill, Jr., and reminded him that the company al-

ready had Robert Frost in poetry, Norman Rockwell in illustration, and Andrew Wyeth in painting. Ansel Adams would, he argued, make a fitting and prestigious addition to their distinguished roster. Thornhill readily agreed.[35]

With David Vena, the attorney he had hired on Ansel's behalf, Bill devised a strong contract that assured his boss of a fair royalty share, gave him the power to select the designer, printer, paper, and binding to be used, and allowed him actively to supervise the printing.[36] This was an unusual requirement for an author to make of a publisher, and even more unusual for a publisher to accept, but these were extremely important considerations to Ansel, who insisted on the highest-quality reproduction and ensured that he got it by personally checking printed sheets as the presses rolled. From his earliest efforts, Ansel had been committed to producing the best books possible; the association of excellence with the name Ansel Adams had been hardearned.

Images: 1923–1974, his first volume with NYGS, was published that very year. In full control, Ansel produced his ideal book, comprising his personal choice of pictures, state-of-the-art reproduction, graceful words, and elegant design. He selected the 115 photographs that he believed best represented the range of his vision, choosing (as he always did when it was up to him) a wide spectrum of portraits, details, abstracts, and occasional quirky subjects, as well as a smattering of his grand landscapes.

He invited close friends to join with him in the project. The design, by Adrian Wilson, afforded expansive white borders and spare, clean typography, all in service to the photographs. The foreword was finely crafted by Pulitzer Prize–winning writer and former Sierra Club director Wallace Stegner. George Waters, Ansel's old comrade from his years working for Kodak, supervised both the making of the plates and the actual printing.

Physically, *Images* was ponderously large, nearly a yard long when opened. Good old Imogen complained that she could peruse it only when propped up in bed with pillows supporting both the book and her. Released at sixty-five dollars and soon raised to seventy-five,

Images was both a great aesthetic and a commercial success, elected as one of the 50 Books of the Year by the American Institute of Graphic Arts and awarded first prize at the World Book Fair in Leipzig, Germany.[37]

In the early planning stages for the retrospective exhibition at the Metropolitan Museum of Art in 1974, David McAlpin warned Ansel that the New York audience was different from that of the West Coast; few Easterners had actually visited a national park.[38] He also suggested that portraits were more interesting than empty, if beautiful, landscapes.[39] Although Ansel heeded his advice and included more people pictures, the New York critics generally raked him over the "Nature Boy" coals. The critic for the *New York Times* sniffed, "For myself, the look on the face of Georgia O'Keeffe—in the 1937 photograph included here—is worth all the views of Yosemite Valley ever committed to film."[40]

During the production of the Metropolitan exhibition, Ansel and Bill worked closely with the young assistant to the curator of prints and drawings. Andrea Gray Rawle was intelligent, dynamic, and beautiful. Bill swept Andrea off her feet; by June 15, 1974, she had moved to Carmel, assured of a job with Ansel.

Andrea proved to be a godsend to Ansel. She was a meticulous organizer and served as an excellent buffer between him and much of the rest of the world, which seemed to want something from him every minute of the day. She had such amazing vitality that just being around her made Ansel feel more alive; she was fun and ready to do anything that needed to be done or to travel anywhere at the drop of a hat. They developed a wonderful relationship, and she was quickly promoted from secretary to chief assistant.

Ansel did not believe in vacations and proudly declared that he had never taken one (those months spent on Sierra Club outings, he reckoned, were nothing less than serious work). When Bill learned that his boss had never been to Europe, he came up with an important excuse for a trip: in July 1974, the two went to France for a week so that Ansel could participate in the annual Arles Festival of Photography. Ansel enjoyed the festival itself—an event unsurpassed by any other in the

medium, directed by the engaging photographer Lucien Clergue, who welcomed his American colleague with Gallic kisses on both cheeks and a full itinerary laced with good times—but he did not enjoy much else during these travels, especially his one morning in Paris, when he was flabbergasted at the price of a simple cup of coffee.[41]

Two years later, Andrea and Bill, now married, convinced Ansel to give Europe one more try. Ansel and entourage—Andrea, Bill, Virginia, and Anne's youngest child, the teenage Sylvia—sallied forth. Since this could not smack of the word *vacation*, their heavy schedule included yet another stint at the Arles Festival and the opening of Ansel's important solo exhibition at the Victoria and Albert Museum in London, perceptively curated by Mark Haworth-Booth. The Turnages were also hoping that Ansel would find some exciting new subjects, so the group did some touring in France, England, and Scotland as well.

But though he dutifully toted about his Hasselblad, Ansel saw only visual disappointments. Aside from Scotland (which he liked a lot because it reminded him of home), the only places that appealed to him were the Matterhorn (he thought it at least had an interesting shape, though not as fine as Half Dome's) and Chartres Cathedral, mostly for its windows. The pictures he brought back were good but not especially inspired.[42]

Ansel met with photographers Bill Brandt and Brassaï in London and Man Ray in Paris, and looked forward to catching up with Henri Cartier-Bresson in Arles.[43] They were both present at a festival reception, but when Ansel tried to make his way across the room, the great French photographer disappeared. Ansel thought it was an intentional snub until he received a letter of apology from Cartier-Bresson, who explained that he had become overwhelmed by the press of people and had fallen to his knees and crawled out of the room.[44] Ansel returned home to Carmel breathing a sigh of relief and vowing never again to venture to foreign shores—a promise he would keep.[45]

As Bill and Ansel began trying to tie up the details of Ansel's long and complex life, the question of what should happen to his negatives was paramount. Ansel offered his archive (comprising nega-

tives, prints, collections of books and photographs, correspondence, awards, and memorabilia) to the University of California, but much to his embarrassment (and their later profound regret), the administration and trustees refused it, excusing themselves for lack of funds.

Word soon caught the ear of John Schaefer, president of the University of Arizona, where Ansel had enjoyed a large solo exhibition in 1973. A chemist by education but a photographer at heart, John caught the next plane to Carmel and eagerly offered to acquire the archive. Ansel agreed, provided that the university establish an archive and research center for creative photography, using his collection as its cornerstone.[46] His conditions were met, and the Center for Creative Photography at the University of Arizona was born. The Center is now home to more than thirty full archives—each including the artist's complete negatives, prints, and papers—and 150 partial ones. Its print collection boasts some eighty thousand photographs by two thousand photographers.[47]

It was Ansel's wish that the Center be just one component of a broader learning program, and so inspire not only students in creative photography and its history but also working photographers and the interested public. It was to be not a graveyard of long-departed photographers but a place of lively discourse that would publish and exhibit the work of photographers both living and dead.[48]

It was important to Ansel to know that after his death, his negatives would be used to teach young photographers. In this respect and others, the university setting was perfect. Although the Center now cares for Ansel's negatives, and selected students under careful supervision may study them, no one is allowed to sell prints made from them, ensuring that no more "original" Ansel Adams photographs will show up.[49]

Together, Bill Turnage and Dave Vena structured the future for then and forever for Ansel, his family, his art, and his finances.[50] In 1975, the Ansel Adams Publishing Rights Trust (AAPRT) and the Ansel Adams Family Trust were formed. Ansel himself described the former as the director of future publishing projects and reproduction rights, and the latter as the recipient of the funds generated.[51] Ansel, Bill,

Dave, and Arthur Thornhill, Jr., president of Little, Brown, served as the first trustees of the AAPRT. Thornhill would resign shortly before Ansel's death, to be replaced by John Schaefer.

In addition to everything else he was doing in his photographic life, Ansel published his last three portfolios during the 1970s. *Portfolio Five* (1970), *Portfolio Six* (1974), and *Portfolio Seven* (1976) appeared in editions of 110, 110, and 115, respectively. His only portfolios of large-scale prints, each image measuring about sixteen by twenty inches, they were all accompanied by a statement proclaiming that no further prints would be made from the negatives represented therein. Ansel was as good as his word: in what he later saw as an ill-considered gesture, he ran each of the *Portfolio Six* negatives through a Wells Fargo Bank check canceler to effectively destroy them and absolutely guarantee that no more prints could be made from them. He regretted this act almost immediately, deciding that he had usurped a basic photographic property: the ability of a negative theoretically to produce an infinite number of prints. Using electronic retouching, the AAPRT is now resurrecting those negatives, pixel by pixel, so that new reproduction prints can be made.[52]

In the short span of five years after he came on board in 1971, Bill effectively reordered Ansel's entire life. By 1976, Ansel was a millionaire, an achievement that he credited to Bill.[53] There had been a concurrence of propitious events, and probably any good financial manager could have done as well in the same situation, given a client who was a great artist with no history of personal management, and given the coincident photography boom. There is some indication that Ansel may have felt overmanaged; on one occasion, he told an interviewer, "Turnage is really doing extremely well by me, but he's doing a little more than I can handle. I have to watch things very carefully."[54] In fact, the last years of Ansel's life were to be a grueling treadmill of money-making projects, what with the huge Museum Set Project, a series of finely reproduced posters, annual calendars, and a new book coming out almost every year.[55] Ansel Adams had become a gold mine.

Bill brought out both the best and the worst in Ansel. Money had always been Ansel's Achilles' heel, and he had had to scramble for it most of his life. Ansel's old friend and sometime harshest critic, Dorothea Lange, once mused, "Ansel . . . has always been able to attract, to magnetize, money and people with money. . . . I'm sure, I swear, that Ansel doesn't know that he goes where the money is. Just like a homing pigeon."[56] And now here was Bill, devising project after money-making project for him. The rewards were so high that it proved nearly impossible for Ansel to admit that the demands on him were just too great.

Besides money, Ansel and Bill also shared another passion, for the natural environment, and in this area, too, Bill potentiated Ansel. In late 1974, Harry Lunn gave President Ford a copy of *Images*, which prompted an invitation for Ansel to visit the White House. On January 27, 1975, Ansel and Bill arrived bearing a gift print of *Clearing Winter Storm*. Realizing that this was an opportunity for more than mere small talk, however, they also brought an itemized memorandum headed "New Initiatives for the National Parks."[57]

The national parks had suffered years of neglect under the Nixon administration, but Ansel wanted to give the new Republican, Ford, the benefit of the doubt, especially since he was obviously an Adams fan. Ansel was impressed with the President's willingness to listen, but though they seemed to agree on most of the issues, nothing much came out of their meeting other than First Daughter Susan Ford's attending Ansel's Yosemite Workshop that summer.[58]

By late 1977, Bill was well and truly bored. He believed that his work for Ansel was essentially over; the rest would be just "bean counting." Then, too, he had broken up with Andrea. Bill left Ansel's full-time employ on December 1, 1977, skedaddling off to the mountains of Wyoming with the Garboesque announcement that he wanted some time alone to plan his future.

The next year, championed by Ansel and California's Senator Alan Cranston, Bill was selected to be the executive director of the Wilderness Society in Washington, D.C. Ansel was so proud that he was popping buttons on his nonexistent vest; having never developed a close

relationship with Michael, he saw Bill as the son he would have invented if he could have started over.

Ansel had been a supporter of the Wilderness Society for many years, but Bill now drew him into its inner circle. His photographs were used promotionally, to increase membership and as gifts for major donors. Ansel and his images brought added prestige to an already respected environmental group, albeit one that was nominally in the shade of the giant Sierra Club.

In the early 1980s, Ansel would be a leading figure in the society's "Stop Watt" campaign, aimed at removing from office Reagan's destructive Secretary of the Interior James Watt. Ansel was appalled by what he saw as Watt's fundamentalist conviction that we might as well use up all our natural resources now since the apocalypse could come at any time.[59] The wall just outside Ansel's darkroom door in Carmel sported a dartboard with Watt as the target.

While Ansel had had the ear of politicians for many years, Bill now brought him even greater access. At the behest of the Wilderness Society, senators came calling in Carmel and responded with genuine warmth when Ansel visited Washington; one, Alan Cranston, a congressional environmental hero, became a personal friend. For Ansel, such associations were incredibly satisfying.

The 1970s ended with a bang. *Images* had proved such a success that in 1976 another large-format volume, *Yosemite and the Range of Light*, was added to Ansel's NYGS schedule. Slated for 1979 publication, the book provided a view into the heart of Ansel's work, his wellspring: Yosemite and the Sierra.[60]

The Metropolitan Museum exhibition had not satisfied his craving for acceptance by the East Coast art establishment. The Met was the old guard; the Young Turks were at MoMA, where Ansel still had never had a solo exhibition (discounting *Born Free and Equal*, in 1944). John Szarkowski, the director of photography at MoMA since Steichen's retirement in 1972, had never pretended that he admired Ansel's photographs. On the contrary, he had championed a series of photographers whose works were about as different from Ansel's as they could be while still being, at least nominally, in the same medium—in-your-

face images, from Diane Arbus's disturbing portraits to Garry Winogrand's quickly grabbed street shots. Ansel was well aware that his aesthetic was not held in high regard at MoMA.

In 1976, when he dedicated *Portfolio Seven* to David McAlpin, Ansel knew that McAlpin had been busy divesting himself of his art collection through gifts.[61] Ansel had already donated his one original photograph by Stieglitz, given to him by O'Keeffe after Stieglitz's death, to McAlpin's primary beneficiary, Princeton University; now, spreading the wealth, he sent a copy of the portfolio to MoMA in McAlpin's name.[62] In return, he received a surprisingly cordial letter of thanks from Szarkowski, who spoke in glowing terms of *El Capitan, Winter Sunrise* and referred to the horizontal *Aspens* as an "old friend."[63]

By year's end, Szarkowski had offered Ansel a solo show for 1979, to be called *Ansel Adams and the West*.[64] At first, the plan was to assemble the exhibit directly from the museum's own collection, but the show expanded into a retrospective of 153 photographs after Szarkowski spent a week in Carmel sifting through boxes and boxes of prints and proofs.[65]

Ansel found Szarkowski's curatorial style a bit unnerving. He had become used to having near-total control over which of his works would be shown, reproduced, and known through his selection of images for magazines and books and through his virtual monopoly as director—in substance if not in name—of his own exhibitions; few museums had staff who were familiar with photography, so most gladly handed over the reins to him. When it came to *Ansel Adams and the West*, however, Szarkowski was clearly the boss. Taking the opposite position from McAlpin's on Ansel's Met show, Szarkowski resolved that the exhibition should have a single focus: landscapes and natural still-lifes. By way of explanation, he stated, "I think [the landscapes] are [Ansel's] greatest pictures and I think that's where his most original, most intense work has been done. Ultimately that's going to be how we remember him."[66]

And Szarkowski was right.

Since *Yosemite and the Range of Light* was in production and due to

be published at the time of Ansel's MoMA opening, Bill (then still working for him) suggested that a smaller-format version, including appropriate wraparound additions and a text by Szarkowski, might do as the show's catalog. It was a match.[67]

In March 1977, Bill arranged for Ansel and Virginia to establish a quarter-of-a-million-dollar curatorial fellowship at MoMA in honor of Nancy and Beaumont Newhall, with the funds to be used to support the training of young photographic scholars.[68] A grateful Szarkowski wrote the Adamses that their endowment was the most important contribution ever made to the Department of Photography.[69]

There followed an uneasy period filled with rumors of a quid pro quo. The supposition in some parts of the photographic community was that Ansel's MoMA exhibit had been bought. After all, he had just had a huge New York exhibition in 1974 at the Met, and it was (and still is) highly unusual for an artist to have major shows at competing museums in the same city within such a short time. But perhaps this long overdue recognition by MoMA of such an important, and aging, artist could no longer be postponed.

Opening in New York on September 8, 1979, *Ansel Adams and the West* was a brilliant presentation of the artist's photographic best, and it proved to be extremely popular, breaking attendance records at the other museums to which it traveled over the course of the next few years. The show began with a splendid mural of *Clearing Winter Storm*, followed by a series of other photographs that Ansel had made from the same vantage point over many seasons and years. Throughout the exhibition, examples of recently made prints were hung next to vintage prints from the same negative, demonstrating the change effected in Ansel's expression, or performance, over forty years or more. (Generally, his prints from the 1930s and 1940s are softer in tone than his later prints, whose increased contrast serves to emphasize the drama of each scene.)

Some important and common photographic terms do not have clear definitions. One such is "vintage," an adjective often used erroneously to describe an old photograph, rather than to refer (correctly) to a print made soon after the making of the negative. A vintage print is thus the photographer's initial interpretation of a negative. (Such a print may be

but is not necessarily better than one made many years later; Ansel in fact frequently claimed that the most recent print he had made from any negative was the best, because it benefited from his additional years of experience.)

The reviews for this exhibition were more cheering than those Ansel had suffered in 1974 for his Metropolitan show. In the *Village Voice*, photography critic Ben Lifson agreed with Szarkowski's assessment that Ansel's late style was epic.

> It's epic . . . in its idea of heroism.
> Adams's hero is himself, and although his world is vast, as an epic world must be, it stops at the earth and the sky; no heaven, no hell; modern. Adams's struggle (and this makes it epic, not romantic) is . . . as someone whose feelings don't shape the world but proceed from his being in it.[70]

With a superb essay by conservationist and publisher Paul Brooks (former editor in chief of Houghton Mifflin, home to a number of Ansel's earlier books, and one of the first two non-Californians to serve on the Sierra Club board) and a wonderful design by Lance Hidy, *Yosemite and the Range of Light* again set new publishing standards. George Waters directed the printing at Pacific Lithograph in San Francisco, with Ansel standing over the presses. All plates were made using laser-scanned negatives and duotone printing; each image sang on the page.

The choice of a cover image can be vital to the success of any book, and even more so for a picture book. When Ansel suggested a closely detailed and textured tree trunk, everyone involved was more than a little taken aback. Certain that putting that picture on the jacket would spell disaster, Tim Hill recommended substituting the quintessential Yosemite photograph *Clearing Winter Storm*, to which choice Ansel replied with a sigh, "Everyone's seen that." It took some doing, but Hill finally convinced Ansel to trust the publishing experts.[71]

Yosemite and the Range of Light rode the crest of the Ansel Adams

popularity wave, selling approximately a quarter of a million copies in hardcover and softcover editions in its first five years.[72] Ansel's publishing success was without precedent in the history of photography: by 1983, his books had sold over a million copies in total.[73] By way of contrast, most photography books have press runs of five thousand copies or fewer, and even then, the remainder table too often beckons.

With *Images*, NYGS had offered a deluxe edition that included an original Ansel Adams print, and the same treatment was now applied to *Yosemite and the Range of Light*, though on a larger scale: the purchaser could choose one of five images, each available in an edition of only fifty. Priced at twenty-five hundred dollars a copy, the deluxe edition of *Yosemite and the Range of Light* sold out immediately, with the individual prints soon beginning to surface in the secondary market for as much as three times the book's release price.[74]

To top off the year 1979, Ansel's grizzled face, crowned by his crumpled old Stetson, graced the cover of *Time* on September 3, backed up inside by a substantial profile by art critic Robert Hughes. Other major articles on him appeared almost simultaneously in *Newsweek* and *Esquire*. Ed Bradley and a television crew from "Sixty Minutes" visited. Ansel was now well and truly famous.

By 1979, Andrea needed to leave, and she knew it. Ever since the breakup of her marriage to Bill, she had been losing patience with Ansel, and the bloom was off the Carmel rose for her. Working for him had its benefits, but it also took its toll: assistants burned out regularly. (I was an exception, I suspect, only because Ansel died before I reached that point.)

As a good friend of Andrea's, I pleaded with her not to leave, but she was convinced that it was time. It was then that Ansel offered me her position. After Andrea assured me that she was absolutely, positively going, I agreed. I gave notice at the Weston Gallery, where I had been manager, and Andrea moved back to New York.

I began working full-time for Ansel on December 1, 1979. At thirty-three, I was now chief of staff to one of the great artists of the twentieth century, and my unusual background as a writer/editor and nurse

turned out to be the perfect mix for him. But I had no time to wax philosophical: Ansel and I had an autobiography to write, and a ton of other projects in the works. While I was bursting with energy, the next few years—truly golden years—would be chockful and both totally exhilarating and utterly draining.

20

TOO LITTLE TIME

My first day working for Ansel was a corker. He led me to a stack of fifty prints of *Moonrise* and told me to check them carefully for defects and destroy any that were less than perfect. Fresh from the Weston Gallery, I was well aware that each print had a value of ten thousand dollars, at that time the highest price for any photograph by a living artist. As I stood there, stunned, Ansel quickly reassured me that he would not just throw me into the deep end but would teach me how to swim in these particular waters.

He picked up the first *Moonrise* and talked with me in considerable detail about what he wanted to achieve in the finished print, pointing out specific areas of the picture where he often had problems. He advised me to look first at the moon and clouds to ascertain that they had both detail and brilliance; next, he suggested that I move to the bottom of the print and work my way up. He required the foreground sagebrush

and the space above the church and village to be open: the viewer should be able to see *into* those places. The sky in each of these prints was uniformly black and unvarying, a characteristic shared by all of his late *Moonrises* because he had determined that it was essential to the most powerful expression of the negative.

He also showed me how properly to check for physical damage by scanning each print in a bright, glancing light, searching for print-emulsion breaks, scratches, or paper flaws. Because the black areas of a gelatin-silver print retain evidence of everything that has ever touched them, just the necessary processing and finishing of a print ensured that all of the black skies would have surface mars. Usually, however, these were very minor—almost imperceivable—and thus acceptable.

I pulled on a pair of clean white cotton gloves and stood at the big gray table under the skylights in Ansel's gallery, next to the living room. I scrutinized each of the prints with reverence, unable to bring myself to tear up even one; I couldn't help prosaically thinking that the income from the sale of even one print could feed a starving family for a year. Ruefully, I confessed to AA, the staff's nickname for him, that I was a failure. Wasn't there something that could be done with *Moonrise* seconds? I wondered. Putting his hand on my shoulder, Ansel chuckled and looked me straight in the eye. He said he was entrusting me with his reputation for producing only the most beautiful prints; he needed an objective someone besides himself to make that decision because, he, too, could barely stand to destroy a print.

Buoyed by his confidence in me, I returned to the gray table and stood for fifteen minutes holding one print in my hand, trying to gather up my courage. This particular one bore a pattern of circular indentations in its surface, as if a pencil point had been repeatedly pressed into it. The first rip was the toughest. Final print inspection would remain one of my job responsibilities throughout my time with Ansel.

My worst quality-control experience came one day in late 1980 when I began to inspect *Winter Sunrise*. It had taken Ansel two weeks to produce the prints in front of me, but I found that nearly all were afflicted with blisters bubbling through the emulsion from multiple flaws

in this particular batch of paper. With his permission, I tore up nearly a hundred prints. In all the years I knew Ansel, that was the angriest I ever saw him. Not directed toward me, his anger instead seemed to move inward and implode. The situation was extremely depressing, and it was a few weeks before Ansel regained the spirit to print *Winter Sunrise* again, this time on entirely different paper, with excellent results.

Ansel had yet to pen one sentence of his planned autobiography. Most definitely fecund of word, by 1979 he had written and published thirty-six other books, but the autobiography's 1978 deadline had come and gone. By the time I was hired, there was a feeling of desperation surrounding the project. When I asked him why he was at such an impasse, he groaned that he did not think anyone would be interested in such a book; he had kept the personal separate from the professional his whole life long and now found it impossible to conceive a volume that would marry these two (allegedly) disparate aspects.

Ansel seemed to thrive on multiplicity. The autobiography was not the only book to which he was committed; he was also in the midst of writing a new series of technical books and kept saying yes to lectures and book signings across the country. Within the first two weeks of my employ, I accompanied him to the opening of Ansel Adams and the West at the Oakland Museum (where he had a quiet conniption when he discovered that there was an exhibition of pictorialist works by the hated William Mortensen on the next floor) and flew with him to Tucson for his lecture at the University of Arizona.

I soon concluded that Ansel had consented to so many projects at least in part to avoid having to think about the autobiography. He (and, by extrapolation, I) had too much work and too little time; I could see the memoir vanishing into the vague and distant future.

What had sent Ansel back to the darkroom at this juncture was the Museum Sets, the most demanding photographic printmaking enterprise of his life. I had been working at the Weston Gallery when the project was devised, and from the get-go it had perplexed me. I wondered how it could be in Ansel's best interest, given that for years, his fondest wish had been to move on in his photography, to have the time

either to go out into the world to make new images or to print from his tens of thousands of unknown existing negatives. At seventy-seven, he probably no longer had the physical strength to fulfill the first wish—it takes tremendous energy to create new work of consequence—but he was certainly up to the second.[1] Instead, the Museum Set project sentenced him to hard labor in the darkroom, making prints of many of the same images that had caused him to stop taking print orders some years before.

Clearly, though for the sake of outward appearances he gave it a positive spin, Ansel felt ambivalent about the making of new photographs. When he went out with his camera now, it was almost always with the goal of illustrating some specific aspect of a new volume of his technical series—what he termed an assignment from without. Of course, it was a matter of priorities, as well, with the making of new images having slipped lower and lower on his list throughout the fifties, sixties, and seventies. During Ansel's most brilliant and productive years as an artist, the decades of the thirties and forties, image making had been a full-time job for him.[2] Few artists enjoy more than a decade of true creativity; Ansel had at least two.

By the late 1970s, photographs that Ansel had once sold for a few hundred dollars were commanding thousands in the resale market.[3] In 1979 alone, it was estimated that combined sales of his photographs amounted to half the total brought by all fine-art photographs sold that year.[4] Museums had been slow to get on the bandwagon—a number were just beginning to form photographic collections in the late seventies—and Ansel was concerned that he would not be represented in the permanent collections of many since his photographs had become priced out of their market.[5]

In the form letter that he sent out in 1976 to those who tried in vain to order photographs from him, Ansel mentioned that he intended to print sets of up to three hundred of his most important images specifically for museums and similar institutions.[6] Maggi Weston, owner of the Weston Gallery, proposed that her gallery represent this project, but Bill Turnage insisted that Harry Lunn must be included in any such arrangement. Maggi and Harry were thus ap-

pointed the sole agents for the Museum Sets, though before long Harry bowed out.[7]

Margaret Woodward Weston is just as much a legend as Harry in the world of photograph dealing. She is a Weston by marriage: her first husband, and the father of her son, Matt, born in 1964, was Cole Weston, Edward's youngest son. Although a native of England, she was sent to live in South Africa for safety's sake during World War II. After enduring a nightmarish childhood, like some fairy-tale princess, she became a popular singer in South Africa, arriving back home in England to perform at such venues as London's Palladium. Her next stop was the United States, where she appeared on "The Ed Sullivan Show" in New York. She also performed in Las Vegas and Los Angeles and was hired to play the lead in a Monterey production of *Pipe Dream*, directed by one Cole Weston. With love and marriage to Cole, Maggi placed her singing career on permanent hold.

Later, following their divorce, Maggi debated whether to return to show business, turning to family friend Ansel for advice. Instead, he persuaded her to open a serious photography gallery in Carmel, promising to consign a broad selection of his own prints. Using her life's savings of two thousand dollars, Maggi opened the doors of the Weston Gallery in 1975 with photographs not only by Ansel but by other friends as well, including Imogen Cunningham, Wynn Bullock, and Brett Weston.

Maggi has many strengths, but she is most respected for her unerring eye. When her bidding paddle goes up at an auction, competitors have been seen to break out in an unbecoming sweat because they know she will not stop until she gets what she wants. In 1979, she made the pages of *Newsweek* when she bought her former father-in-law's *Shell, 1927*, for ten thousand dollars, the most ever paid for a single photograph at auction up to that time (not long after, *Moonrise* would break that record). The print is worth at least twenty times that amount now.

In addition to her other qualities, Maggi is gorgeous, with a tumbling mane of red hair, and always beautifully dressed. It is best to enter a museum opening or restaurant behind her, because she sweeps into a room with dramatic flair; heads swivel, and everyone knows she is *someone*.

As the deadline for final print orders from Ansel drew near at the end of that year, Maggi decided that she must buy a substantial inventory, bravely mortgaging her house to raise the necessary funds.[8] Ansel was impressed by her willingness to place her financial future on the line because of her belief in his work, and he never forgot it. She earned a very special place in his heart. The Weston Gallery has flourished, becoming one of the most successful photography galleries in the world, known for its collection of rare nineteenth-century prints as well as its exceptional selection of images by Edward Weston, Paul Strand, and Ansel Adams.

Every Museum Set contained the same core of ten famous images (*Moonrise; Winter Sunrise; Monolith; Clearing Winter Storm; The Tetons and the Snake River; Mount Williamson from Manzanar; Sand Dune, Sunrise; Tenaya Creek, Dogwood, Rain; Aspens, Northern New Mexico* [vertical]; and *Frozen Lake and Cliffs*), plus fifteen variables to be chosen from a list of sixty possibilities. The few who bought all seventy prints received, in addition, *Surf Sequence*, Ansel's 1940 five-print masterpiece.

It has long been standard practice in the commerce of art to sell entire portfolios for substantially less than the various prints included would command if sold separately. A twenty-five-print Museum Set could accordingly be purchased in 1980 for fifty thousand dollars, far under the total market value of its individual photographs.[9] By 1981, the price had been raised to seventy-five thousand.[10]

On Valentine's Day 1979, Ansel had had open-heart surgery that included a valve replacement and a triple coronary bypass. Appalled to learn that he had received no instruction for rehabilitation following the surgery, "Nurse Mary" quickly found the patient a new doctor and then ordered him to begin an exercise program. Our enforced afternoon walks together, along the country roads of Monterey County from Big Sur north, gave me an opportunity to ask Ansel about his life and preserve his answers with a small tape recorder that I carried in my hand. Unfortunately, sometimes wind noise overpowered his voice, but he did get some exercise, and at least we had started work on the autobiography.

In June 1980, we flew to Washington, D.C., where President Carter

was to present Ansel with the Medal of Freedom. The ceremony was conducted on a stage erected on the lawn of the White House; it was a hot and sunny day, and the audience of family and friends fanned themselves with programs as they waited for the event to begin. Ansel, sweltering in the heat in his good, British-made wool suit, sat facing the audience with the rest of the fourteen honorees, who included Eudora Welty, Tennessee Williams, Admiral Hyman Rickover, and Beverly Sills. Lady Bird Johnson, Muriel Humphrey, and Mrs. John Wayne were there to accept posthumous awards on behalf of their husbands.[11] One by one, each was called forward. When his name was announced, Ansel stood and walked slowly to the podium—his head held high, chest slightly puffed out, and bent nose as straight as it ever had been—where President Carter placed the handsome, beribboned gold medal about his neck, proclaiming,

> At one with the power of the American landscape, and renowned for the patient skill and timeless beauty of his work, photographer Ansel Adams has been visionary in his efforts to preserve this country's wild and scenic areas, both on film and on Earth. Drawn to the beauty of nature's monuments, he is regarded by environmentalists as a monument himself, and by photographers as a national institution. It is through his foresight and fortitude that so much of America has been saved for future Americans.[12]

After an interminable receiving line, a wonderful luncheon was served at large round tables that filled more than one White House room. The Johnson family's table was right next to Ansel's, and soon after Ansel was seated, former First Daughter Lynda Bird Johnson swooped down on him, her big brown eyes full of admiration and adoration. Ansel loved the attention and autographed her program with extra embellishments. The festivities proceeded with course following course and wine glasses kept constantly replenished. Afterward, the guests were bade welcome to explore the rooms on the main floor, and President Carter obligingly offered a peek at the Oval Office. As everyone slowly gathered momentum to leave, Tennessee Williams, up-

holding his reputation for inebriation, had to be carried out in a hori-
zontal position on the shoulders of spirited friends. Still, nothing could
dampen the day, or Ansel's spirits, which were sky-high.

But the month was just beginning. After leaving Ansel's employ late
the previous year, Andrea had undertaken to produce a movie on her
former boss for public television,[13] along with a coproducer, John
Huszar of FilmAmerica, who was also to direct. Shooting was sched-
uled to occupy much of June.

Ansel was not convinced of the importance to history of this movie,
but he did want to help Andrea. As with the autobiography, he ques-
tioned how interested people would really be in his life as distinct from
his art, and he was uncomfortable and self-conscious throughout the
filming. It might seem likely that a photographer would be good at pos-
ing for the camera, but Ansel rarely relaxed in front of another's lens;
most portraits of him look mannered.

The crew arrived on June 1 and filming began in Carmel the next
day. One scene had Ansel in his darkroom making prints, while an-
other required his old friend Rosario Mazzeo, a retired Boston Sym-
phony Orchestra musician and amateur photographer, to interview him
as he sat at his old Mason and Hamlin piano. Unbeknownst to Ansel,
Rosie had been directed to get him to play. Time and arthritis had bent
Ansel's fingers; where once he had enlivened every party with his play-
ing, he now only rarely (and then only late at night and after a number
of martinis) allowed anyone to hear him perform. He had always been
noted for his exquisite touch, but his fingers could no longer physically
produce the quality of sound that his ears still required. Nevertheless,
as directed, Rosie cajoled and prodded, and finally Ansel relented.
When he saw the finished video, Ansel was greatly pained by that
scene. Not only was the music itself flawed, but Huszar had zoomed in
on his gnarled hands; Ansel felt it made him seem old and infirm.

Filming moved next to his birthplace, San Francisco, where during
a break he took me to the spot where he had made *The Golden Gate Be-
fore the Bridge*. Almost at once, we were off to Albuquerque, where we
rented a car and headed for Santa Fe. As I drove, Ansel grew increas-
ingly restless, until he said resignedly, "I just feel punk."

We checked into the La Fonda Hotel for a good night's sleep before

the next day's shoot in Abiquiu with Georgia O'Keeffe. At six-thirty in the morning, I was awakened by a phone call from Ansel, who said he wasn't feeling well. I pulled on some clothes and went to his room. His anxiety was evident as I wrapped my blood-pressure cuff about his arm, plugged a stethoscope in my ears, and assumed my nurse's role. Although he was resting in bed, his blood pressure was elevated to 182 over 80 from his normal 134–140 over 58–62, and his pulse was racing at 110 rather than his usual 60. But even more significant to me were his complaints of tightness in his chest, dizziness, and difficulty in breathing.

When I woke up Ansel's doctor back home to get a referral in Santa Fe, he agreed with me that he should be seen right away. On rousing Andrea and Huszar to let them know that I was taking Ansel to the emergency room of Saint Vincent's Hospital, however, I received an unexpected response: they became extremely upset and accused me of encouraging Ansel's easily stimulated hypochondria, not to mention destroying their shooting schedule and blowing their budget. Only two days of filming had been budgeted for New Mexico, which included a scene with O'Keeffe, one with Beaumont, and a third at the little village of Hernandez, where Ansel had made *Moonrise*.

When Ansel and I arrived at the hospital, we were engulfed by a ready staff of Adams fans. An EKG showed no new damage to his heart; the consensus was that Ansel was suffering from the effects of an abrupt change in altitude, from sea level in Carmel and San Francisco to sixty-eight hundred feet in Santa Fe. Doctor's orders were to return to the hotel and rest in bed. If Ansel felt well enough, he could participate in filming the next day, but only so long as he felt up to it. Always a trouper and conscientious about (most) deadlines, Ansel was showered and ready early the next morning, Stetson and bolo tie in place. With only one day to shoot, the question on everyone's mind was, could everything be accomplished?

The first stop was Abiquiu. Ansel and O'Keeffe had maintained a friendship since their first meeting, in 1929. The script called for the two to stroll arm-in-arm in the courtyard of her home and then to sit down and reminisce about their travels together and about Stieglitz.

Ansel's arm was needed because O'Keeffe was nearly blind, her sight terribly diminished by the decade-long progress of macular degeneration. She had no central vision, only peripheral; whenever she addressed someone, she would look at him or her not directly but rather sideways, in an attempt to see even a bit. Likewise, when painting, she turned her face oblique to the surface of the canvas.

After all these years, Ansel still held O'Keeffe in awe, and he fidgeted throughout their scenes together, scenes that did not seem to reflect the participants' real personalities. The image of the two longtime friends talking and walking may have made for a sweet vignette, but O'Keeffe was by design not a sweet woman. Directed to sit side by side with Ansel as they reminisced, O'Keeffe stared straight ahead so as to better see him with her peripheral vision, but on film it looked as if she were refusing to make eye contact with him. While it is a treat to view these two great artists together, the film reflects the unreality of the occasion.

Juan Hamilton, then O'Keeffe's chief assistant, was very much in evidence throughout our visit; as I watched his "handling" of her, I made a personal vow to be the complete opposite in my work for Ansel. O'Keeffe had hired him as an occasional handyman when he appeared on her Abiquiu doorstep in 1972, handsome, strapping, dark-mustached, and fifty-nine years her junior. He eventually took charge of every aspect of O'Keeffe's life and business, doing all those things that she did not want to do herself, as Bill Turnage had once done for Ansel. Eventually no one could talk to her without his say-so, a power he wielded with gusto. (In complete contrast, Ansel often beat everyone else to the phone when it rang, though he answered with a disguised voice.)

By the late 1970s, it was widely rumored that O'Keeffe and Juan were married. At a 1978 dinner at Ansel's, O'Keeffe had clung to Juan's arm, her face beaming with adoration. When someone asked if they were husband and wife, they both dodged the question just coyly enough to make us continue to wonder.

Physically, Juan treated O'Keeffe with great brusqueness. During the filming in 1980, he pulled her clothes into straighter lines with rough tugs, chastising her for her appearance as she, a woman of her-

alded and revolutionary independence, sat meekly without saying a word.

Later that year, it was revealed that far from having married his employer, Juan had in fact been secretly wed to a young woman named Anna Marie. At first furiously jealous, O'Keeffe eventually mellowed. In 1981, in celebration of her ninety-fourth birthday, we gave a dinner at our house attended by O'Keeffe, Ansel and Virginia, Juan, his bride, and their baby, Albert (not Alfred, as in Stieglitz). That night I learned a new respect for Juan. With O'Keeffe settled into our rocking chair by the fireplace before dinner, young Albert crawled about, finally seizing on her leg to pull himself up to a standing position. Such delight appeared on O'Keeffe's face as she enjoyed the child or grandchild she had never had! She and Juan were family, and he brought her a measure of happiness in her last years.

Following the morning of filming with O'Keeffe, we moved on to Hernandez, New Mexico, where, in one of the movie's strongest sequences, Ansel is shown once again driving the same route he had taken nearly forty years earlier, when he made *Moonrise*. Through the eyes of this movie, we can imagine what it was like that darkening autumn afternoon, and it becomes clear how truly remarkable Ansel's vision was, because the actual landscape (even discounting the changes wrought by the passage of time) bears little resemblance to the completed photograph.

The Saint Francis Church at Ranchos de Taos provided the backdrop for the scene with Beaumont. Close comrades for four decades, Ansel and Beaumont were warm and relaxed, both reflecting on their lives, so much of which they had shared. Their moments together are one of the highlights of *Ansel Adams, Photographer*.

The scare over Ansel's health in New Mexico may have caused all of us some anxious moments, but the seventy-eight-year-old refused to let it disrupt his typical whirlwind schedule. From Santa Fe, we decamped for Yosemite, where he would teach his annual workshop and continue to participate in filming.

The movie's Yosemite scenes capture Ansel at his best. In one of these, he stands before his view camera among the boulders and trees

near the Ahwahnee Hotel, surrounded by attentive students whom he patiently instructs on the subtleties of framing an image; another shows him sitting at the base of a granite cliff and nostalgically paging through a photo album filled with his earliest Yosemite pictures, made when he was fourteen years old. Only in these shots does Ansel finally seem genuinely at ease. We left the valley three weeks later; the film and workshops had together consumed one month of his time.

For Ansel, the weeks set aside annually for his Ansel Adams Yosemite Workshops, in operation since 1955, were inviolable. He loved all aspects, from teaching and the students themselves to his cherished Yosemite. Each year, as a bellman trundled in his trunks full of equipment and his one small suitcase, Ansel would move through the lobby and halls of the Ahwahnee Hotel greeting the many people whom he had known for years and who now ran up to welcome him home with a hug, a warm handshake, a slap on the back, or an old chestnut of a joke hoarded in the teller's memory in anticipation of his next appearance.

Ansel was never pretentious about himself or his art. One employee of Best's Studio cooked up such great chocolate fudge (a real Ansel weakness) that he offered to trade his photographs for them, square inch for square inch; when she brought him an eleven-by-fourteen-inch pan of the candy he would give her a print of the same size. No fool, one summer she presented him with a whopping sixteen-by-twenty-inch extravaganza of fudge and received a *Moonrise* print in the same size. Ansel thought it a fair trade.[14]

Ansel enjoyed the routine of each workshop and led sessions most mornings, after consuming a sizable breakfast in the Ahwahnee dining room at a table filled with students and faculty. One day was always reserved for a road trip, usually up to Tuolumne Meadows and then down to Mono Lake, with the return journey to Yosemite by moonlight. At Tenaya Lake, while an assistant set up Ansel's camera and tripod so that he could conduct a demonstration by the side of the road, Virginia would climb up a smooth-surfaced dome, dotted with twisted junipers, to get the best view she could, outdoing many of her younger companions.

The students hung on Ansel's every word, and everyone followed his advice to walk to the base of Yosemite Falls during the full moon to witness a moonbow, like a rainbow but composed of shades of gray. Throughout the park, photographers stumbled about with gray viewing cards in front of their faces, peering through simple cardboard windows, another Ansel invention that helped students learn to frame an image by seeing in terms of a rectangle.

Traditionally, Ansel and Virginia hosted the entire population of each workshop, including significant others, at a grand cocktail party held in the yard of their old Yosemite home, behind the Ansel Adams Gallery. Fumiye Kodani, their cook in Carmel, would arrive with a carload of food and drink and commence preparations for a crowd of 150. The spread inevitably included a great variety of cheeses, fresh vegetables with a dill dip, water chestnuts wrapped and baked in bacon, and thin slices of buttered toast. Ansel especially savored Fumiye's cheese puffs, though a review of the ingredients therein (white bread, mayonnaise, green onions, and Parmesan cheese baked until golden) might cause the sensitive to shudder.

Returning to Carmel from Yosemite in 1980, Ansel sought the comforting refuge of his bed. His lifetime pattern was to work with extreme intensity and then to collapse for a few days' recovery. He *liked* being in bed, and for years balanced a typewriter on his lap to maintain his voluminous correspondence. An insomniac, he spent his nights alternately dozing and reading, his bedroom light always left on. He was usually into at least three books at any given time, one a humor or joke book, one a scientific tome, and (near the end of his life, and under my influence) one a detective novel. Piles of magazines shared space and time with the books, among them *Scientific American*, *The New Yorker*, and both *Newsweek* and *Time*. San Francisco's KGO radio's Ray Taliaferro's late-night talk show claimed him as a regular listener and caller.

Sitting at my desk that July, I calculated that I had been working for Ansel for 213 days (weekends did not mean days off) and that we had been out of town for sixty-two of those days. It was clear to me that he needed someone else to say, "No more travel," since he himself seemed unable to refuse any invitation.

Ansel was in constant demand as a lecturer, but with his stamina in decline, he had begun to find it difficult to give the combination slide show–lecture presentation on his life and work; a few minutes into the talk, his voice would weaken and his words become a mumble. His schedule had been planned well into the future by the departed Andrea, who loved traveling, but when we discussed the situation, he realized that unless he stayed at home, he would never be able to write his autobiography or complete the Museum Sets. He gave me the green light to turn on the stoplight, and I immediately canceled a two-week lecture tour booked for October, as well as a trip to Brazil. There were many calls of complaint (which I fielded), but Ansel was hugely relieved.

All too painfully aware that everything else was taking precedence over the autobiography, I decided that the book's best chance lay in Ansel's getting those Museum Sets and technical books completed and not allowing some new project to cut in. But there were always special circumstances and obligations, and I came to see that as much as he complained of being overwhelmed by so many responsibilities, Ansel thrived on variety. With this in mind, I began to look for any opportunity to insinuate work on the autobiography into his life.

Ansel had an extraordinary ability to take on a number of difficult tasks simultaneously, but in this he was also assisted by a hardworking, professional staff. We all used to marvel at how busy he kept us, like a circus juggler with ten balls in the air at once. Two of his most important employees at this time were John Sexton and Phyllis Donohue.

John had attended the 1973 Yosemite workshop and impressed Ansel with his already keen photographic eye and technique as well as his confident manner. After assisting at subsequent workshops, he joined the staff (not long before I came aboard) as Ansel's photographic assistant, responsible for ordering supplies, schlepping and setting up the heavy equipment, prepping the darkroom, washing and toning prints, and carrying out many of the tests for the technical books. John found a great mentor in Ansel, who left him a memo on his first day stating, "The place is yours. Organize it yourself, then tell me where things are."[15] Under Ansel's tutelage, John became a more masterful

photographer and brilliant printer. He grew so proficient at explaining the Zone System that Ansel turned over that lecture at his workshops to him, the ultimate compliment.

Phyllis worked for Ansel for years. She was our print technician and probably the best spotter in the world; she also had a knack for finding the unfindable negative or reproduction print. Ever serene, Phyllis would tackle impossible piles of SEPs or Museum Sets with the patience of Job, sitting for hours each day on a stool placed in front of an easel propped on the gray worktable, spotting photograph after photograph.

As careful and fastidious as Ansel was, he could not change the fact that all negatives attract dust and are easily scratched, small imperfections that usually find their way onto the finished print as tiny white spots. Like other spotters, Phyllis had a variety of permanent inks that she carefully diluted and used to cover over, or "spot," the white dots (or the "LP" in *Winter Sunrise*) so they would match the surrounding area. On rare occasions, she might also etch out a black scratch with a very sharp blade and then spot the space. She was absolutely the best at what she did, and fast!

Miscellaneous projects were forever popping up, but some of these were less taxing than others. In 1980, Little, Brown's sister company Time-Life Books (both were owned by Time Inc.) requested that Ansel authorize the mail-order sale of twenty thousand autographed copies of *Yosemite and the Range of Light.* The initial plan called for him to actually sign each copy himself, but we quickly discovered that there was no way we could physically cope, either personnel-wise or space-wise, with so many books (and this was no small volume). Ansel spent the better part of his nondarkroom time for two months signing labels that would then be stuck onto the appropriate page. Since he preferred working at every moment, even when he was "flu'ed up" in bed, Ansel adored this do-anywhere assignment.

For the first few months I got along just fine with the trustees, my reputation as an "uppity" woman having somehow not preceded me. I do not think it began intentionally, but over time, things seemed naturally to evolve to a point where Bill was invariably on one side of an

issue and I was on the other, with Ansel in the middle. As I saw it, Bill was urging Ansel to agree to a number of potentially lucrative projects not unlike the Museum Sets, which seemed to have little else to recommend them besides profit; Ansel really did not need the money, and his time and energy were increasingly limited. But my questioning any one of Bill's decisions did not endear me to him one whit.

Then, too, Bill also made significant demands on Ansel's time in his role as executive director of the Wilderness Society, insisting that he meet with influential members of Congress, give interviews, hold press conferences, and travel, all to a greater extent than Ansel wanted. Under such pressures, his old robust and sure strength was crumbling. Sometimes, in a small voice, Ansel would whisper to me, "Help!"

It was at around this time that Bill booked Ansel on the PBS television show "Crossfire." Ansel's side of the discussion was taped in a San Francisco studio, while his inquisitors were recorded in the home studio in Washington. They could see him, but he could see nothing except the television camera in his face; with no one to react to directly, Ansel grew disoriented and struggled with the series of pointed questions piped in through his earpiece. As much as he wanted to do these things on behalf of the cause, his weakening health, combined with his contracted photographic responsibilities, left him feeling beleaguered.

Ansel did not give up all of his travels. He continued to insist on hovering over the presses during the first printing of each of his books, which meant encamping in San Francisco or southern California for a few weeks at a time. In 1981, Ansel and I went to Gardner Lithograph in Buena Park, California, for the printing of the new edition of *The Portfolios of Ansel Adams*. Since the battle to save Mineral King, Ansel had held all things Disney in contempt; he had never even set foot in Disneyland, though it was within shouting distance of the printing plant. I thought that the little boy in Ansel, who took up a healthy portion of the man, might enjoy a few hours there as we waited for the presses to roll. Ansel cautiously agreed, while expressing concern that he might not be up to walking very far.

I called to arrange for a wheelchair, and when we arrived, Mickey Mouse himself was there to greet us. After the de rigueur publicity pho-

tos were taken (by now I was feeling terrible about what I had done; an embarrassed, squirming Ansel forced to pose with Mickey was not a pretty sight), we scooted off. Because he had been recognized, Ansel refused the wheelchair, only adding to my guilt.

We trooped through the Haunted House and experienced the Pirates of the Caribbean. Ansel adored the holograms in the former, and as we swooped down a water chute in the latter venue, he laughed so hard that he caught a mouthful of water. I could only pray that he wouldn't have a heart attack. Months later, when asked about this visit, Ansel was scornful of Disneyland, but while we were on those rides, he loved it.

Other legitimate excuses for a needed break or a change of scenery were provided by offers of honorary degrees (requiring a personal appearance) or book signings—events that gave Ansel the maximum pleasure with the minimum physical strain. How wonderful it was for him, then, when at Harvard on June 4, 1981, though wearing a mortarboard rather than a Stetson, Ansel was instantly recognized by the students who rose to their feet and began clapping, stomping, and cheering. Ansel's eyes, unaccustomed throughout his entire life to emotional expression, reddened with the effort needed to fight back tears. At the luncheon following the awards, the great diva Leontyne Price, likewise the recipient of an honorary degree, got up on her chair and sang "America the Beautiful" a cappella, with such conviction and perfection as to make the hair on the nape of Ansel's neck stand on end. So few great artists seem to enjoy fame in their lifetime; happily, this was not the case for Ansel Adams.

Ansel was unfailingly kind to everyone who showed up at his book signings. Often there would be hundreds of people in line, winding around blocks and up and down stairs, always to the astonishment of the bookstore or museum, which usually ran out of books early even though we had done our best to prepare the staff. Although most signings were scheduled to run for only two hours, we often stayed four to get to the end of the line, and even then it was not always possible to accommodate everyone. In 1982, at San Francisco's Academy of Sciences, a group of young people camped out all night in sleeping bags

in front of the door just to be first in line. Ansel basked in this rock star–style popularity.

I coordinated the signings and then stood at Ansel's side as he sat at a table, a special pen filled with permanent ink in hand. After first advising each autographee that Ansel could not personalize the inscription—information that was met with crestfallen faces and more than a little protest—I would open each book to the particular page that Ansel had decided was the most appropriate so as not to transgress upon the design. Only one specific page would do, and it was not always the title page. I would then return it to the person, who was by now often relating to Ansel in rapid fire (the line was pressing behind) how he had changed his or her life, or reminding him that they had once met on some Sierra trail, or pleading, "Please look at my photographs!" (pulled out from under an arm and placed with a flourish under Ansel's nose). It was rejuvenating for Ansel to feel the affection that so many people had for him and his work.

In 1981, the Museum Set project was still dragging on. Ansel was supposed to have completed 110 or so sixteen-by-twenty-inch prints of each of the basic ten images, as well as thirty-five to fifty each of the sixty variables, plus ten of *Surf Sequence*. This added up to a total of at least thirty-five hundred fine, original prints, an enormous number even for a more robust person. For his third and fourth portfolios he had to make just as many prints, but they were all small eight-by-tens, whereas the Museum Sets included many sixteen-by twenties. Ansel made his fine, signed photographs by himself. Printmaking is arduous, physical work, and each day spent in the darkroom on behalf of the Museum Set was a personal marathon.

Ansel was deeply concerned with ensuring that his photographs would last as long as possible, and the Museum Sets were no exception. He was always in the vanguard of research into archival standards for gelatin-silver photographic papers, his and most serious photographers' preferred medium. The biggest threat to permanency is incompletely fixed (that is, unstable) silver; Ansel's first technical book, 1935's *Making a Photograph*, stressed the use of two separate fixing baths to make permanent the exposed silver, and recommended wash-

ing for a minimum of one hour, with frequent changes of water, to completely flush the remaining free silver and the processing chemicals from the paper. Ansel was a very early champion of this careful darkroom technique, and as a result, his photographs will be longer-lived than those by many of his compatriots.

By the 1950 publication of *The Print*, he was advocating the use of two or three fixing baths to achieve the best permanence. In the revised edition of the same book, published in 1983, he advised toning all prints with selenium, not only to warm their color (as he had counseled since the late thirties) but to increase their stability, since selenium had in the interim been found to bind with migratory silver. Ansel was justifiably proud of having selenium-toned his prints for so many years.

In his books, Ansel cautioned against the overuse of selenium, which produces an obvious color. But as the 1950s progressed, his own photographs became more and more tonally dramatic, and as he chose to build contrast, obtaining blacker blacks and whiter whites, so, too, he began to rely more and more on selenium (which increases tonal densities) to nourish the details.

To complicate complexity, during the making of the Museum Sets, Ansel's eyesight seemed to be dimming—a terrifying prospect for any photographer, as sight is the last of the five senses someone in that profession wants to lose. He had his eyes checked out on a regular basis, but the problem was growing worse. In 1977, Bill and Andrea had had a renowned Washington eye surgeon examine Ansel, but he had found nothing physically wrong with him. During the years that I worked for him, Ansel developed cataracts in both eyes, though they never got far enough along to be removed.

Sometimes, when John and I scanned the day's batch of dried Museum Set prints, we would look at each other and sigh. Ansel, so famous for the luminous tones he could coax out of any negative, was now producing print after print that was dark and heavy. Ansel himself was the first to admit that sometimes he went overboard,[16] but still, I was worried. Some of the prints looked not rich to me, but poor.

Since no one else dared question Ansel about the problem, I decided I must. Our relationship became so close because Ansel felt to-

tally secure with me and believed I would take care of him in sickness as well as in health. He knew I loved and respected him and could always be relied upon to be truthful with him. On one long, chatty afternoon drive to San Francisco, he told me, "I can hear you, but I cannot hear most women." He had had a great deal of practice tuning out the voices of his mother, his aunt, and his wife.

Directly addressing the problem of his vision, I now brought out two prints of *Clearing Winter Storm*. One had been toned to his orders, but I had asked John to slip the other out of the selenium a bit early. I just could not enjoy a white winter scene transformed selenium purple, as the first print was; to myself, I had christened it *Clearing Chocolate Sundae*. The second, less toned print was crisp and bright, with black blacks and brilliant whites, like a cold, snow-frosted winter day.

Ansel looked, listened, and acknowledged my criticism. I was happily relieved when he agreed to reduce the toning, but it never happened. John and I made a pact: we encouraged Ansel to rest after lunch and let John and Phyllis do the toning, and on certain rare occasions (such as when *Surf Sequence* was threatened), we rescued prints from their selenium sentence. Ansel continued to examine every print after it dried; that he never rejected our less-toned efforts helped to ease our qualms about interfering with a great artist's expression.

It was not just museums that could no longer afford Ansel's prints; he received a steady stream of complaints that his photographs were just too expensive for the many ordinary folk who loved them. Pondering alternatives, he decided to produce a series of posters replicating as closely as possible the quality of his originals.

Ansel chose three images to begin with—*Moonrise, Clearing Winter Storm*, and *Aspens* (vertical)—and made extra-large prints of each so that they could be directly laser-scanned with no enlargement. Each poster was designed to highlight a recent book. Ansel's favorite printer, David Gardner of Gardner Lithograph, made superb duotone reproductions on heavy, coated stock, and the combination of laser-scanning and exquisite printing resulted in an image with a huge range of clearly defined tones. I accompanied Ansel as he supervised the first press runs; the posters were so good that he chuckled that the one of *Aspens*

in particular looked better than a print made in the darkroom. Though this was a bit of an exaggeration, it reflected the esteem in which he held Gardner's achievements.

Priced at twenty-five dollars, the posters became instant best-sellers. Each year a few more images were added, so that now there are over two dozen different posters in the Adams series. The most popular is *Oak Tree, Snowstorm*, with more than 208,000 copies sold by 1993.[17]

The posters' popularity eventually inspired the creation of a deluxe version, with the same first three images printed with a warmer combination of inks on an even heavier stock, in an edition of 350. Each reproduction was trimmed and dry-mounted on a sheet of handmade paper bearing an "AA" watermark, which was then numbered and signed by Ansel. While I was all for the poster project, believing that it would give the public access to Ansel's images with minimum compromise in quality from an original print, I was opposed to issuing the deluxe posters because I felt it made us seem like the Franklin Mint of photography, creating new "collectibles" by the month. For his part, Ansel saw no compromise and was happy as a clam to collect the semiannual royalties they generated.

Next we proceeded to calendars. Having argued, unsuccessfully, that Ansel was making his photographs ubiquitous, and that familiarity often bred boredom as well as contempt, I found myself in charge of an annual wall calendar first published in 1984. As usual, Ansel insisted upon the highest quality, even though the publisher initially complained (calling it the Rolls-Royce of calendars) that at $12.95, it would be substantially more expensive than any of its mass-market rivals. The worry was unfounded: Ansel's calendar was a phenomenal success, a contender for champion right up there with the *Sports Illustrated* swimsuit calendar, teddy bears, and Garfield.

While the Museum Sets consumed Ansel's mornings, his afternoons were spent on the New Ansel Adams Photography Series. For all of his earlier technical books, Ansel himself had acted as both writer and editor, but in 1977, at Bill's wise insistence, he had hired a professional technical writer to assist him on *Polaroid Land Photography*. Robert Baker, a graduate of MIT who had worked at Polaroid as a liaison with

Ansel, proved so adept that he continued as Ansel's collaborator on *The Camera* (1980), *The Negative* (1981), and *The Print* (1983). The field of photography had grown so huge that it was impossible for one person, or even two, to know everything, so Ansel also asked my husband, Jim, to serve as a technical adviser.

Bob, who approaches life with calm deliberation, was a perfect foil for the easily distracted Ansel. When Ansel attacked a subject, it was his practice to type to the end of a page, then turn it and fill up the right margin, then turn it again and fill the left. At that point he would almost always consider himself done, whether or not the original objective had been met.[18] This was certainly a difficult way to go about writing a whole book, but Bob kept to the task, huddling at the dining-room table with Ansel with such steady persistence that the works progressed in record time, considering Ansel's other commitments. Whereas the volumes in the earlier Basic Photo Series were slim, concentrated, and difficult for all but the true cognoscenti to decipher, Bob constructed Ansel's text so that even the layman could truly learn from the master.

Next to viewing the sun setting over the western edge of America spread before his picture windows, with martini in hand, Ansel's favorite and most-anticipated moment of each day was the arrival of the mailman in his little truck. This particular vehicle fortuitously possessed a set of squealing brakes that Ansel's alert ears nearly always detected. If he was not in the darkroom, he would be out the door in a flash and hiking the short distance up the driveway to the huge mailbox, his treasure chest of news, offers, and enticements. Back in the house, protocol was observed: Ansel would hand everything over to Virginia, who would sort it on the coffee table into suitable piles, properly slit each envelope with an opener, and then pass each pile to its recipient.

A sucker for anything bearing a postage stamp, Ansel always entered the Publishers Clearing House Sweepstakes (though he never won) and once even filled out a very lengthy Scientology questionnaire that I begged him not to return. After he ignored my pleas, it took a few weeks and a number of firm answers to their dogged phone calls to convince the Scientologists that he did not want to become involved in

their religion: he simply liked the process of answering questions.

The mail usually arrived shortly before lunch (punctually served between twelve and twelve-fifteen). On occasion, Ansel, newly sprung from a morning of darkroom duties, would stroll up to the mailbox on the off chance that the noisy brakes had finally been fixed on the mail truck. One such morning, Ansel discovered the mailbox empty save for a single slip of paper: a typewritten death threat warning him to stop his work to bring federal protection to Big Sur, or else!

Such vicious intimidation was entirely new to Ansel, and it sickened and also scared him. With this one, isolated incident, a central presumption of his life was destroyed; though he knew the world held evil people, they had never before entered his world. A modicum of the trust and innocence that had survived for all his eighty years evaporated through that one destructive gesture. Ansel turned the note over to the police, but they were never able to link it to anyone.

Although in the end, very happily, nothing came of the threat, its effects nonetheless quickly reverberated throughout the household, which soon sprouted defenses familiar to many urban dwellers: every door and window was alarmed, with iron bars applied over the more vulnerable windows; pressure alarms were laid under rugs; and motion and infrared detectors blinked quietly from corners. But if the death threat caused some changes in Ansel's life, he never considered withdrawing from the fight for Big Sur; in fact, if anything, the episode only enforced his resolve.

Meanwhile, I kept plugging away at the autobiography. During my first years with Ansel, I spent all my spare time—which was not much, given the complicated circumstances—reading the thousands of letters accumulated by him, his parents, and Virginia. With amazing prescience, they had all saved everything he ever wrote, beginning with his first letters, at the age of twelve. Some were ordered neatly in files and others stashed in total chaos in a variety of boxes, including shoe; I learned to dig down to the very bottom of every closet. It took me more than a year to read through everything, but then I hit cruising speed: not only did I know what questions to ask Ansel, but I remembered enough of what had happened to jog his memory.

When the mounting pile of cassette tapes from our daily walks was transcribed by a typist, Ansel was not pleased with the results. He cared a great deal about the quality of the written word, and these spoken memoirs seemed just too informal and offhand. But the making of the tapes did serve a purpose in convincing him that there could be no easy way out: he must indeed write his autobiography.

Most mornings when I arrived at work, a three-by-five card from Ansel would be waiting on my desk, often embellished with drawings and a variety of rubber-stamp imprints: a pig wearing Lolita-style sunglasses, a donkey braying, the nonsense term *Poot*, or PERSONAL in big red letters. As silly as their adornments appeared, the cards would concisely describe whatever was bothering him, whether it was his health, business, or his books. By nine, he had often already been at his desk and written for a while wrapped in a robe, and was now downstairs showering and dressing for the day. Without even seeing him, I could tell from the detailed cards on my desk what the day held in store. Picking up on his system, each night *I* began leaving *him* at least one three-by-five card inscribed with questions for the autobiography, which would provide a focus for his early thoughts.

Determined that writing must somehow be made less of a task for him, to ease what he felt was the enormous burden of this book, I convinced Ansel that we should buy two computer word processors, one for each of us. (This was in 1980, at the very beginning of the PC revolution.) Although Ansel was a gadget junkie, he was sure that he was too old a dog to learn such a new trick. Not so: he took to his IBM Displaywriter like the proverbial duck to water, though he still used his typewriter for his steady stream of three-by-five cards.

Inevitably, there were repercussions. Ansel's typewritten memos had become legendary at Polaroid, where they were regularly passed around, not only for the great ideas they sometimes contained but also for their ubiquitous and very funny typos. Correspondence produced on the new computer, with its built-in spelling checker, was met by long faces and yearning for Ansel's messy, exuberant, error-filled missives of yore. At Polaroid, it was not seen as beneficial progress.

Ansel's chosen title for the autobiography, *The Other Side of the*

Lens, found no takers, as it had not in 1963, when he suggested it to Nancy Newhall for her biography of him. Playing with alliteration, a natural urge with the name Ansel Adams, I drew up a list of other possibilities. He finally gave me an "A" for *Ansel Adams: An Autobiography*, plain and simple.

As was expected by the AAPRT trustees, as well as by Little, Brown, I had constructed an outline for the autobiography that was both simple and chronological (and that we rarely referred to or used). Since my outline was proving worthless, I quizzed Ansel further on how he conceived of the book's structure. Time and again, he would only say, "Spokes of a wheel." He could not verbalize more clearly what that meant; it was a question mark for him and for me.

I considered and reconsidered. He had taken part in many important events in both twentieth-century photography and the conservation movement, but he saw himself as having been only one player, and not necessarily the star, on a very large stage. He felt that it was essential to credit all of the others who he believed had contributed as substantially as he. Eureka! Although it now seems obvious, it was this realization that at last enabled me to see what he had in mind. This would not be a chronologically developed, traditional autobiography; instead, Ansel would be the hub of the story, with different events and people in his life being followed to their conclusion, their substance kept whole. We were both relieved at finally knowing where we were headed—now if only we could get there in time!

The maintenance of a routine was crucial to our chances of making any progress on the text, even though that routine was constantly being interrupted by Ansel's other commitments. What with the Museum Sets and workshops and press interviews and Friends of Photography and Big Sur Foundation meetings and hospital stays, the autobiography was forever in limbo and then active and then in limbo again. It took all my determination to keep it alive and keep Ansel interested in it. He preferred projects that had a definite end in sight, normally completing books in a period of months; this one took much more sculpting, care, and time than had any before it.

Another major complication soon presented itself. As Robert Baker

can testify, there was no way to get Ansel to just sit down and write a chapter; he could produce only bits and pieces. With a measure of exasperation, his closest associates referred to his habit of "chasing rabbits": one idea would prompt another and then another, and at the end the original question would remain unanswered. For the text of the autobiography, I had to get very specific with Ansel. I honed my daily questions to be answered in order—one, two, and three.

> AA,
>
> GROUP f/64—NEED MORE!
> Members: Edward Weston, Willard Van Dyke, Imogen Cunningham, Sonya Noskowiak, Henry Swift, John Paul Edwards and You.
> 1. How was the name chosen?
> 2. Whose idea was it?
> 3. Who wrote the manifesto?
> In the interest of science,
> Me.

Sometimes the questions would provoke a torrent of words; at other times, as with the query about how the name Group f/64 had been chosen, Ansel's memories were fuzzy. In such instances, I would dig up everything I could find on the subject, write it up, and place it on Ansel's desk as a mini-refresher.

I learned, too, that some subjects normally considered essential to the telling of a life's story were taboo in this case. When it came to his personal life, Ansel had decided to take only the highest road; according to his autobiography, Dave Brower in retrospect was a swell guy, Virginia was his only romance, and his life had been one of total fulfillment.

An entire bonus book grew out of our work on the autobiography. The second most frequent question I was asked was, "How did Ansel make that picture?" Aware that people wanted to know the stories behind *Moonrise, Monolith,* and *Moon and Half Dome,* I outlined a description of the making of ten of his best-loved images for a chapter in

the autobiography. Ansel found it easy to write and became so excited that he could not stop; what began as a chapter grew into *Examples: The Making of 40 Photographs*, published in 1983. Since I was swamped as it was, Ansel brought in Robert, who had just finished the last book in the technical series, *The Print*, to pull things together. Voilà! We presented Little, Brown with an instant, unplanned book.

After a few years of our system of Q&A, I had a thick sheath of disconnected pages and paragraphs: the autobiography. I had previously disliked jigsaw puzzles, but it was obvious to me that I must now become accomplished at piecing together a multitude of segments into the whole of a written life. Ansel took heart as the book gained shape and substance, and the autobiography came to take priority over almost everything else. By the early spring of 1984, we had almost completed the manuscript.

21

LIFE AND DEATH

Ansel's favorite time of the day was five o'clock. As the hands of the old grandfather clock announced the hour, Virginia would begin setting up the bar. From the adjoining offices, we could hear the tinkle of ice as she filled the glass bucket and the thunk of the bottles as she laid out the usual libations: soft drinks, Scotch, bourbon (Jack Daniels), gin (Tanqueray), and vodka (a changing cast of characters as Ansel and I taste-tested our way through the world's offerings). Formerly a Scotch and bourbon drinker, Ansel had now switched to vodka because it had less effect on his gout. Jim, a wine partisan, made sure that Ansel and Virginia were well supplied with an excellent selection of California chardonnays and cabernets.

Virginia preferred to mix her own gin-and-tonics, which consisted mostly of gin, diluted with only a thimble of tonic. Ansel loved vodka martinis, as did I. His treasured recipe came from the bartender at the

Sonesta Hotel in Cambridge, Massachusetts, where he frequently stayed while working at Polaroid. Ansel took to carrying tiny cards with the precise instructions on them, and he presented them to mixologists uninitiated in his drinking requirements: Drop broad strips of lemon peel into a glass of good vermouth and allow to marinate for a few days. Take a glass, fill with ice cubes, rub lemon peel about the rim and drop in. Pour vodka over all. The result: a very dry martini.[1] Decades earlier, Ansel had liked his martinis straight up, but more recently he had determined that a generous supply of ice prolonged his drinking pleasure.

The entire staff was welcome, and often expected, to stay for a drink. Guests would soon begin arriving at the door to join the daily cocktail celebration. Ansel was always listed in the telephone book, but to avoid disturbing the workday, callers (both known and unknown) were generally asked to drop by at five.

Often the first visitor would be some young photographer, black portfolio box stuck under his or her arm, come to ask the great man for his blessing. Ansel would look at each print with measured care and offer praise wherever something praiseworthy could be found. He usually made only one stab at constructive criticism, knowing that any more than that would be too much.

Sometimes, however, Ansel's humor would get the better of him, and pity the poor photographic supplicant who had to experience that. When Ted Orland was Ansel's full-time photographic assistant, from 1972 to 1974, a wink from the boss during a print review was his clue to go into the workroom and return with an unmounted print of *Moonrise*. Following Ansel's unwritten script, Ted would turn to the young photographer and exclaim, "Why, your photograph is much better than *Moonrise!*" And with that he would tear the *Moonrise* in half, stupefying the photographer. This trick never failed to elicit a huge belly laugh from Ansel, if usually just a nervous chuckle from his audience; of course, the ripped-up *Moonrise* had been a hopelessly damaged print.[2]

As sunset approached, the green-flash vigil would begin. Everyone would stand, drinks in hand, gazing out through the large, west-facing

window, across the unbroken tops of pines and cypress to the Pacific. Just as the sun disappeared below a clear horizon, Ansel and Virginia would sometimes gasp, "Did you see that?" They would then describe the exquisite puff of emerald green they had just witnessed—the fabled green flash. At first I thought it was a snipe hunt, but even after they convinced me it was real, I never saw one.

After a few months of being trapped in the dead calm of a flashless existence, I arrived at work to find my daily note from Ansel, but this one was different. He suggested that I go with him to visit his eye doctor that afternoon; he had already made the appointment. He was certain I was color-blind. When physical impairment was ruled out, Ansel found an article in *Scientific American* that he presented to me as proof that the green flash was real. Still, as sun after sun passed from sight, I never beheld this phenomenon.

One cold, very clear day a few months after Ansel's death, when Jim and I were sitting on a picnic bench at the ocean in Pebble Beach with Andrea and her new husband, Stanley—both of whom were also green-flash virgins—the flash was so big we couldn't miss it. Since then we have seen it several more times.

The scientific explanation goes something like this: as sunset approaches, the sun's rays must pass through a volume of atmosphere much greater than when the sun is directly overhead. This thick layer of atmosphere acts like a prism and bends, or refracts, the light, separating it into the colors of the spectrum. As in a rainbow, the lowest color, and thus the first to disappear, is red. Next to go are orange and yellow, their intensity weakened by their natural absorption by ozone and water vapor in the atmosphere. Then come green and blue. The blue is refracted more than any other color, its light broadly scattered by our atmosphere, which makes our sky blue but greatly reduces its intensity. Green is therefore the last color that we can usually detect. When, on a very clear, fogless day, the green is unimpeded (as are orange, yellow, and blue), the sun departs with a green flash.

Ansel and Virginia were lucky to have the services of the gifted cook Fumiye Kodani for nearly twenty years. Because she was of

Japanese ancestry, she had been imprisoned during World War II at Poston, Arizona. There was one good thing that came out of that experience: it was there that she met her future husband, Seizo. We all treasured Fumiye's peaceful spirit and her beautiful cuisine, and she, in turn, enjoyed cooking for Ansel, modestly saying, "It was easy to cook for him. He was good about eating anything." Ansel's favorite meal was probably sorrel soup followed by roast lamb with fresh mint sauce and hominy-grits casserole, though he also loved to escape into Carmel in the late afternoon for a "meeting" with Robert Baker—actually an excuse for a forbidden root-beer float.

Just as Ansel and Virginia had embraced me as family, they also became family to my own; our children fondly remember Ansel as an unusual grandpa. The Adamses came to dinner at our home at least once a month through the years. The morning after one such occasion, I found a typed greeting from Ansel addressed to "Dear Little Mother of All," followed by a list of appreciative adjectives ending with a burp.

Ansel rarely cooked and never set foot in a grocery store. Since he had nearly always employed a cook, those kinds of responsibilities had never been a part of his life, except perhaps when he was on the road. I knew how much he had missed us when Jim and I returned from a rare two-week vacation to find our dining-room table covered with jars and boxes of the most outlandish foods; Ansel had gone shopping because he knew our larder would be bare. We were all set with such staples as Bavarian mustard, pickled beans, bottled artichokes, hot-fudge topping, and a box of Hamburger Helper. It was an infinitely sweet gesture.

Thriftiness was a habit with Ansel. Our work area was walled with storage boxes, stacks of metal drawers, and cubbyholes. We were instructed to keep everything, including the rubber bands that bound the daily papers. Defective photographs were torn apart and then sent for silver reclamation. Ansel was thrilled when I followed his suggestion to reply to most correspondence using Adams picture postcards; seconds from Museum Graphics, the cards were free to Ansel by the boxful, saving on both expensive letterhead stationery and postage.

Ansel's personal needs were simple. He always felt well dressed if

he had doused his beard, bald head, chest, and underarms with his beloved Vitalis, believing that all women within his wafting power were now susceptible to his charms. When it came to dress, the biblical Joseph had nothing on Ansel, who used his body to display an amazing combination of colors. He had one suit and a handful of sports coats, his favorite a maroon polyester number that he paired with a mustard-hued, short-sleeved sport shirt or one in a green and white Provençal print, loosely cinched at the neck with a choice of bolo ties. He owned four pairs of shoes: desert boots, lace-up canvas-and-rubber hiking boots, black dress shoes, and house slippers.

When he was photographing, he wore the respected uniform of a photographer's vest, fitted with pockets of every size and shape for his light meter, miscellaneous filters, and a few horehound drops or wintergreen Lifesavers. In fact, he had two vests, one in khaki and the other in a more Anselesque shade of red. Of course, a white Stetson hat was his signature finishing touch for any occasion, substituted some years before for his black one. He had four hats—three in well-lived-in states of disrepair and one that we had bought him and made him keep for dress occasions.

Ansel proudly wore a $29.95 digital wristwatch that kept time better than any fancy one and what was more, served as his personal edema measuring device. If the watchband was tight in the morning, he knew he had ingested too much salt the day before.

Ansel was never one for holidays. Christmas and birthdays as a child were not very cheering, and he especially hated New Year's, when just to spite convention, he would go to bed extra early. Come the next morning, of course, he would feel terrific and be ready to celebrate, and he and Virginia had a long-standing tradition of giving an annual blowout on New Year's Day. January first is the worst day of the year to give a party: half the world is hung over, and the other half is depressed because it had such a lousy New Year's Eve. The Adams festivities, a gigantic open house, began at four-thirty in the afternoon. This would be a working day for me, so I would arrive at three to help hostess. There were never invitations; people just knew, and hundreds showed up each year.

Ansel's eightieth birthday, in 1982, was a community-wide affair. Having decided that the best celebration would be of his work, we arranged for exhibitions of his photographs to open in three different Monterey Peninsula venues. The Weston Gallery in Carmel mounted a "greatest hits" show; Jim curated *The Unknown Ansel Adams*, featuring a group of little-known or previously unexhibited photographs, at the Friends of Photography; and I assembled *The Eightieth Birthday Retrospective* for the Monterey Peninsula Museum of Art.

All three premiered on Friday night, February 19. The streets were thronged with hundreds of people. As his birthday gift from the staff, I had a computerized electronic horn that could play fifty different tunes installed in his big old white Cadillac decorated with a "Save Mono Lake" bumper sticker. Ansel got a huge kick out of this toy, and after each opening, the streets in front jammed with people singing impromptu "Happy Birthday"'s, he would drive musically away with "When the Saints Go Marching In," "I'm a Yankee Doodle Dandy," or "The Marseillaise," leaving smiles of astonishment in his wake. For Ansel, it was a grand evening.

His birthday dinner the next night was an extravaganza for two hundred, hosted by the Friends of Photography and organized by Jim and me. We wanted it to be an evening of great fun, leavened with the surprise bestowed on the birthday boy, by the French Consul, of the title of Commander of Arts and Letters of the Republic of France. Toasts were offered by such luminaries as Richard Oldenburg, director of the Museum of Modern Art in New York, and Jehanne Salinger, a dear friend of Ansel's for fifty years and mother of the famous Pierre.

The meal, cooked by Ansel's favorite caterer, Michael Jones of Carmel's A Moveable Feast, began with Ansel's beloved sorrel soup and ended with an untraditional birthday cake. In full regalia, the marching band of a local high school escorted the cake grandly past the tables and presented it, ablaze with eighty candles, to Ansel. The cake was to have been a vertical, three-dimensional chocolate version of Half Dome, but too late we discovered that the pastry chef had never been to Yosemite; the resultant creation more closely resembled Devil's Tower in Wyoming as seen in *Close Encounters of the Third*

Kind, but it was nonetheless a delicious mountain of chocolate, and Ansel blew out the candles with humor and gusto.

I had spent months trying to figure out what to give Ansel, who professed not to really want anything for this momentous birthday. And then one day it came to me: he had instructed me that when he died, he did not want a funeral, adding, "If you must do something, have some music for my friends."

With great excitement, I ran downstairs to share my idea with Virginia. Why not have the music with friends while Ansel was still alive? His favorite pianist was Vladimir Ashkenazy. There were many technical virtuosos, Ansel felt, but Ashkenazy's touch was the most extraordinary, and his interpretation truest to the music—and perhaps, as well, closest to how Ansel himself would have liked to play it.

I asked Virginia if she might be willing to split the cost with me. She was as delighted with the idea as I was and clasped both of my hands in hers as we both literally danced in a little circle of joy. In a more sober moment, I worried that I could not afford my half of the fee, but then I decided what the hell. Somehow I would get the money. It would be worth it.

We knew *of* Ashkenazy; we did not *know* Ashkenazy. I found the name and address of his agent in New York and sent a letter asking if the pianist would play a private concert at Ansel and Virginia's home in celebration of Ansel's eightieth birthday. Amazingly, we soon received a handwritten reply from Ashkenazy himself. He was a fan of Ansel Adams's! He would be pleased to perform, though he had never before agreed to a private concert.

We kept all of this a secret from Ansel for as long as we could, but finally it had to come out: Ashkenazy was to arrive two days early to practice, and before that we had to remove Ansel's treasured Mason and Hamlin piano and replace it with a Steinway. Ashkenazy is a Steinway artist, and he also told us he might destroy Ansel's old piano with the force of his playing. His only other stipulation was that we engage his piano technician in San Francisco to tune and maintain the instrument until the performance. I tracked down a suitable and rentable Steinway and corralled the technician.

Ansel was completely happy; it was the perfect gift. Ashkenazy practiced all day long for two days, and we listened with our full attention to every minute. It was such a privilege to hear him play and replay, again and again, the same troubling passages, though they sounded quite perfect to us. Everyone kept hidden in adjoining rooms so as not to distract him.

I finally decided I must get closer to where he was playing and feel the music move through my body. Quietly and oh so slowly, I crawled on my hands and knees from the workroom across the entry, but just when I thought I was safe, rounding the corner toward the kitchen, my lowered head met up with a pair of shoes. Tilting my head upward, I saw Ansel, hiding himself in a small recess. Both of us were guilty as charged, Ansel trying to stifle his laughter.

At two in the afternoon on Thursday, April 29, 1982, Vova (we now addressed Ashkenazy by his nickname) performed Beethoven's Sonata in A Major, op. 101, no. 28, and Sonata in E Major, op. 109, no. 30. After an intermission, he presented five pieces by Chopin, Nocturne in B-flat Minor, op. 9, no. 1; Nocturne in B Major, op. 9, no. 3; Polonaise in F-sharp Minor, op. 44; Impromptu in F-sharp Major, op. 36; and Scherzo in C-sharp Minor, op. 39, no. 3.

It was a transcendent performance. Led by Ansel, we all flew to our feet and clapped and bravoed until we no longer could. It was time to party! I had asked Ashkenazy what his favorite food was, and Russian that he is, he had replied, "Caviar." We had a kilo of caviar airfreighted to Carmel.

Following the concert, I walked back to the office to check on our children, whom I had closeted close enough that they could hear but far enough away that they wouldn't have to sit still the whole time. I found Jasmine, Jesse, and Zachary staring in perfect awe at Ashkenazy, who was seated cross-legged on top of my desk with the big tin of caviar in one hand and a spoon in the other, intent on leaving no evidence. Although not the biggest of bodies, he polished off the entire kilo with a smile.

This event concluded with a fantasy ending for me. Ansel, greatly moved by both the performance and the days spent with Vova,

took Ashkenazy into the workroom and asked him to pick out his two favorite photographs. That was the only payment (besides the caviar) that the pianist would accept; my fear of having to take out a second mortgage on our house to pay for my share of the concert evaporated.

Broad-ranging though his interests could be, Ansel was not well acquainted with pop culture in any form. The last movie he had seen was probably in the thirties, his taste in music allowed for few composers born in this century, and his reading material was usually of a serious nature. Television was a late addition to the Adamses' Carmel household and rarely turned on except for the six-o'clock news.

If Ansel was quite aware of current politicians, he was absolutely in the dark when it came to celebrities. He just did not care. In early 1982, Clint Eastwood, another Carmel resident, telephoned and asked if he could come by and get some advice from Ansel about photographs for the upcoming U.S. Open at Pebble Beach. As he would to any such request, Ansel generously replied, "Sure, come on over tomorrow afternoon," having no idea who Eastwood was until nearly the entire staff swooned.

The appointed hour chimed, the doorbell rang, but Ansel was back in the darkroom, excited about a print in progress. Although there were five people working, not one consented to answer that darn door, so the "painful" task was up to me. I slid the door open, and the man in the movies stood facing me. I ushered him in and explained that Ansel would be out soon, but just how soon, I did not know—once he was in the darkroom, there was no telling. I showed Eastwood around the gallery and began yammering to him at length about the various photographs. (He was not one to make small talk.) After forty-five grueling minutes of my spiel (my normal loquaciousness was definitely challenged), with hardly one intervening word from Eastwood, Ansel at last emerged, grasped the actor's hand in a firm shake, and sat him down for their little talk, which was far more brief than my monologue. Exit Eastwood.

Garry Trudeau and Jane Pauley fared better. While trekking in the Himalayas, Trudeau had run into the photographer Marion Patterson,

who discovered that her longtime friend Ansel was one of Trudeau's heroes. She supplied him with AA's address, and Trudeau scribbled a postcard with a cartoon showing himself and his wife contemplating nature. "Doonesbury" was, in turn, Ansel's very favorite comic strip, the first thing he turned to in the morning paper, and he was hugely tickled to learn that *Trudeau* respected *him*. He invited the two to come out for a visit, which they soon did, causing Ansel to smile like the Cheshire cat. Garry's gift of all the "Doonesbury" books instantly enriched Ansel's sleepless nights with a hefty ration of laughter. After Ansel died, Garry very generously donated a large number of original strips to be sold to raise money for the Friends of Photography's Ansel Adams Center in San Francisco.

In 1983, then-Mayor Dianne Feinstein suggested that a large exhibition of Ansel's photographs be sent to San Francisco's sister city, Shanghai, China. Jim, Robert Baker, and I were honored to be appointed the experts to accompany the show. The Chinese hosts installed the nearly two hundred prints with great sensitivity, hanging them on brightly lighted and freshly painted white walls above polished floors with welcome pots of greenery in the corners of each of the many galleries. Ansel's show proved extraordinarily popular—tickets were sold out by eight o'clock each morning. Thousands of people moved slowly in reverential silence through the exhibition, staring rapt for long periods at image after image; there was no problem with translation. The show, *Ansel Adams: Photographer*, was then invited to move to the National Museum of Art in Beijing, where it became the first exhibition by an American artist to be so honored since the Chinese revolution.

Some friendships combined work and pleasure. After wrestling with the Museum Sets and finally completing them in 1982, Ansel began once more to hear the call of photography, which for him meant the call of the outdoors.[3] He had always enjoyed having companions along while he photographed in the Sierra, on the trail with Cedric or other members of the club. Sometimes on a rare free Saturday or Sunday, when the quiet of his house proved too much for him to bear, Ansel would call Jim to ask if he would like to go photographing. Ansel and Jim had become good friends by this time, seeing themselves as com-

rades under the darkcloth, so to speak, though neither was using a view camera. Ansel knew that since he assumed the leadership of the Friends, Jim had had little time for his own photography and welcomed any chance to expose some rolls. Together, they drove over most of the roads of Monterey County, stopping when either one saw something he liked.[4]

On our periodic trips to San Francisco, Virginia and I would take the backseat of Ansel's 1977 Caddie, each with plenty of reading material, while the boys sat up front. Just as Ansel and Jim were camera buddies, Virginia and I were book buddies. Their cameras and tripods stashed in the trunk, Jim drove and Ansel navigated, an open bag of cookies and a sack of hard candies between them.

The men followed every devious route and back road possible, so that what should have been a three-hour trip often took most of a day. They did not need much of an excuse to pull over, get out, walk around, and confer with great seriousness about a scene's photographic possibilities. Without saying a word, Virginia and I would just pick up our books and continue where we had left off.

Often we would wend our way up Highway One all the way to the city. Ansel loved to stop for lunch at Duarte's, an old tavern in Pescadero that had knotty-pine walls and a bar with pool tables and served artichoke soup and homemade olallieberry pie à la mode.

Home base in San Francisco was the house of Otto and Sue Meyer, steadfast friends of Ansel and Virginia's who lived just two doors away from Ansel's old family abode in West Clay Park, on Twenty-fourth Avenue. With affection, Ansel dubbed their place the Meyerhof; he had recuperated there for two full weeks following his open-heart surgery in 1979.[5] The Meyers always welcomed Ansel and Virginia and their supporting cast with open arms. As president of Paul Masson Vineyards, Otto had hired Ansel in 1961 to document the building of the company's new champagne cellars in Saratoga. He was a longtime trustee of the Friends of Photography and a pillar of the San Francisco opera community.

By all appearances the spark plug that kept Otto's engine going, Sue was in addition herself a leader in the arts community, having blazed the trail for the acceptance of contemporary crafts as

art in San Francisco with her ground-breaking Fort Mason gallery Meyer, Breier, Weiss, next door to the famous vegetarian restaurant Greens.

One morning at breakfast in late 1982, when Alinders and Adamses were all comfortably ensconced at the Meyers', Ansel suggested that he and Jim go out and make a day of it. Agreed. Virginia and I snuck sly smiles at each other, already luxuriating in the peaceful day before us.

Ansel dressed in attire appropriate to the occasion: lug-soled boots, dark trousers, bold plaid shirt, red photographer's vest, and Stetson set at a jaunty angle. With their dueling Hasselblads and various lenses, our intrepid men rode off. (It was to Jim's benefit that they both used the same camera, as it allowed him to borrow Ansel's complete assortment of the latest lenses if the image dictated it.)

Ansel directed Jim across the Golden Gate Bridge and up along the headlands that oppose San Francisco. At a turnout, they turned in. Almost every place they photographed on these camera trips, Ansel had been to before, often many times. In the Bay Area as in Yosemite, his best pictures were made at locations that he knew very well, though changes of season, light, and weather could make all the difference.

They both photographed the Golden Gate Bridge. Ansel made some particularly strong compositions, including one looking through the bridge's north tower and vertical suspension cables to the gray silhouette of the city beyond, which I later selected for his autobiography.[6] Ansel found this viewpoint a bit mournful. As a boy, he had often taken the ferry across to these same steep hills, where he had thought nothing of hiking up and down and up again. These memories sadly reminded him of his age and precarious health. Confined to the pavement, he suggested to Jim that they drive on.[7]

Their next stop was an abandoned military gun emplacement, empty and cold but with gray concrete bunkers enlivened by particularly energetic, almost refined, graffiti. Although this was unlikely Adams subject matter, Ansel's eye stopped as he began visualizing first one image, then another. His enthusiasm building, Ansel exposed four

negatives. Jim made a portrait of an obviously happy and relaxed Ansel sitting in a recess of the bunker, smiling right at the camera.

Another reason that Ansel and Jim had such a good time together was that they were both always ready to eat, and neither was terribly fussy about what or where. Now, with their dinner bells ringing, Ansel knew exactly where to go for lunch: with pride he guided Jim to an old building in Sausalito, the former site of a famous brothel, now home to particularly succulent hamburgers.

Sated for the moment, they drove north and into the hills about San Rafael, where Ansel remembered a fine cemetery that he wanted to photograph again. They cruised street after street, but to no avail. After photographing an old white church sans graveyard, Ansel gave up, and they headed west to the ocean near Bolinas. After a couple of exposures of the weathered side of a building, it was time for a snack—an ice cream cone would do just fine. Nothing further appealed to them visually, however, and they wandered back to Hotel Meyer for short naps before dinner.

When he returned to his darkroom in Carmel a couple of days later, Ansel was still excited about the graffiti photographs. Having developed the negatives and made two large prints of a luminous orb of paint underlined with quick brushstrokes at its center, he tacked one print up with pushpins in the gallery area of the house and, after some deliberation, sat down and began to write about it.

For Ansel, the graffiti represented the power and beauty of art that could never be put into words. He had no idea why it had been painted or by whom, but to him, that made no difference. Recalling Stieglitz's view, Ansel saw this picture as a symbol of the elusiveness of trying to define art, the basic quality that cannot be verbalized. *Graffiti, Abandoned Military Installation, Golden Gate Recreational Area, California, 1982* became a chapter in 1983's *Examples: The Making of 40 Photographs.*[8]

Ansel and Jim continued to photograph together all through 1983, perhaps a day every other month, Ansel's health permitting. One Saturday morning in February 1984, just as I was opening my eyes, I heard a sharp knock on our front door. Wrapping a robe about myself,

I answered it to find Ansel on the other side. Almost bashfully, he asked, "Can Jim come out and photograph?" though I knew he would have liked to say "play."

He came in and stood behind the couch watching cartoons with the kids as Jim and I got dressed. Eager to get going, his fancy not caught by "Scooby Doo," Ansel wandered out onto our back deck. Fog covered the Monterey Peninsula, our house included. The sun's light was severely diffused and flat through this damp shroud.

Jim habitually made portraits of the many great photographers who came to our house over the years, and for just this purpose, he had attached an old movie screen under an eave on the deck that he could unroll and use as a plain backdrop. He now pulled out a kitchen stool and asked Ansel if he would sit for him. Ansel kindly obliged, and with his trusty Hasselblad on a tripod, Jim made the best portrait of Ansel that ever was. It was the unanimous choice for the cover image of Ansel's autobiography, and I have always thought that one of the major reasons that the book became a best-seller was the warmth of his face in that photograph. Ansel himself seems to come right through the image and into life.

Next, Ansel picked up his own camera and photographed Jim and me. And then they were out the door and down the road to the oldest grove of Monterey cypress in the world, tramping around and making exposure after exposure—all in all, a fine way to spend a Saturday.

An expanding list of ailments had been besieging Ansel for years, with accelerating frequency. While he was still in his twenties, his teeth plagued him so much, the pain especially severe on freezing High Sierra nights, that he had them all pulled. He was afflicted with arthritis and gout. His prostate had been removed, a hernia had been repaired, and his heart had a new valve and a triple coronary bypass. As a long-lasting side effect of the surgery, he suffered from vertigo.

Most proud that his new heart valve was of direct porcine descent, Ansel occasionally allowed this new body part to announce itself with a brotherly hoglike snort, which sometimes proved quite startling to those unfamiliar with his love of a good joke.

By far my biggest failing as far as Ansel was concerned, even bigger than my inability to see the green flash, was my mental density when it came to jokes. Ansel had certain friends whom he would ring up almost daily to regale with his latest story and to coax a new one from. Since I was almost always with him, I was his closest audience. As with the green flash, he never gave up on me, but too many times, I just didn't get it. Even worse, I could never remember or retell a joke told to me so AA could add it to his repertoire.

The one joke that he probably told more times than any other—including to Mrs. Ford at the White House—I wrote down one night so that I wouldn't forget it. (Props and sound effects were added bonuses when Ansel told a joke.) At the end of dinner, Ansel took his napkin and plopped it on his head like a doily on the crown of a sweet old lady. Setting the stage, he explained that a hen had just fled across the yard, pursued by a randy rooster. Ansel then went into character and commenced rocking, his hands miming knitting motions. With just slightly crossed eyes, his first old woman exclaimed, "Dearie me, would you look at that!" A second old lady (who looked just like the first) responded, "Oh, my!" Our narrator returned to relate frantically that the hen, in her terror, had fled across the highway, been hit by a truck, and was now reduced to drumsticks. Rocking and knitting again, Ansel coyly demurred, "See? She'd rather die!" No matter how many times he told this joke, it always made him bellow with laughter, and everyone else too. His great enjoyment was infectious.

In September 1981, Ansel had an angiogram, one of the many tests he readily submitted himself to each year. This time it showed partial blockage in the arteries that had been operated on in 1979, though it was not yet serious enough to require them to be either replaced or reamed out. Perhaps because I am a registered nurse, all of Ansel's physicians were unfailingly kind about including me in every consult, exam, and test. It reassured Ansel to have me with him; for the angiogram I even donned sterile clothing and accompanied him into surgery.

Each year we seemed to spend more time in the hospital, but work always continued. We established a regular routine, and in fact, I

chided him that the only time I could get him to work on the auto-
biography was when he was confined to bed. A great deal of the book
was written within the walls of the Community Hospital of the Mon-
terey Peninsula, where Ansel was cared for by a bevy of top-notch
doctors and spoiled by the nurses. He was extraordinarily lucky to
have such a great hospital close by. Designed by Edward Durrell Stone,
it is a model of patient-centered care, with each room graced by a
balcony overlooking the forest and a huge fish pond at the hospital's
center. Ansel even enjoyed the food there, especially the lemon
meringue pie.

Ansel intended to live as long and as well as he could. In 1981,
on the advice of Senator Alan Cranston, he embarked on an antiaging
program promoted by Dr. Harry Demopoulos, who prescribed large
amounts of beta carotene and vitamin E to go with Ansel's usual phar-
macy of pills. After a few days, Ansel looked like a six-foot carrot.
He had turned orange from too much beta carotene; his dosage was
reduced.

For my part, I wanted Ansel to see health specialist Nathan
Pritikin. He was more than dubious, but I did get them together once
on the phone. Pritikin was critical of Dr. Demopoulos's vitamin
therapy. Ansel's morning note to me said that Pritikin had suggested
he eat beans, veggies, and grains, have no butter or margarine and no
alcohol, and drink rose-bud or linden tea. Deprive Ansel of his mar-
tini *and* his hamburger? The name Pritikin did not cross my lips
again.

One Sunday afternoon in September 1982, I arrived at the house to
help with a benefit reception for a young Democratic candidate and
discovered Ansel still in bed. He clearly was not feeling well. I mea-
sured his blood pressure, checked his pulse and lungs, and monitored
his heart with my stethoscope. I thought I could detect an irregularity;
certainly I was hearing something other than what I usually heard. I
called his doctor, who agreed to meet us at the hospital.

I went upstairs and informed the candidate's advance crew that
Ansel would not be attending the party. They were keenly upset at
the news and let me know it. They demanded to talk to Ansel, sure

they could convince him to stay for the event. But I was even angrier and more outraged than they were, and I told them to clear out of the way and not say one word to Ansel when we came through. That was the last I heard out of them. I helped Ansel dress and pack a small suitcase, and then we went upstairs and got quietly into his car.

In ER, it was determined that Ansel had a life-threatening arrhythmia. He was wheeled into surgery and almost as quickly wheeled back out with a pacemaker stitched into his chest. Crisis solved.

Ansel was soon home and back to a normal schedule. Within ten days of this incident, he participated in a book signing in Carmel and was filmed by the BBC, interviewed by the *Wall Street Journal*, and given an award by the Association of International Photographic Art Dealers.

Playboy asked Ansel to be the subject of its monthly in-depth interview for May 1983. His first reaction was "No!" but I believed that the magazine's huge audience had not heard his messages on photography and the environment, and that proved to be a convincing argument.

Although he was willing to participate, Ansel as usual insisted upon keeping his work day inviolate, so the two interviewers were invited to come for cocktails every afternoon for two weeks to talk with him as he relaxed over drinks. The interview as published was excellent, communicating Ansel's humor as well as his serious side. While Adams photographs did not replace the centerfold, *Playboy*'s editors did run a multipage spread of Ansel's work in black and white.

Ansel received some criticism for the interview, or rather its venue, along the lines of "How could you?!"[9] He replied that while he knew the magazine contained much trash, *Playboy* did publish some of the best interviews around and was read by twelve million people, who might now understand a bit about the strengths of photography and the importance of environmental activism.[10]

One morning in June 1983, I arrived at work to find Ansel quite lathered up. He reported that Michael Deaver, President Reagan's majordomo, had called earlier to say that the President wanted to know

why Ansel Adams did not like him. Reagan wanted to meet with Ansel to show him how much they had in common. I thought it must be a crank call.

I found it bizarre that the Carter White House phone numbers on my Rolodex still worked in the Reagan administration, but they did, and I got right through to Michael Deaver. Everything Ansel had related was true. I later figured out that President Reagan must have read Ansel's *Playboy* interview, a large portion of which centered upon the disastrous performance of his government in the areas of the arts and the environment.[11]

Neither Ansel nor Reagan wanted to be seen in enemy territory: Carmel or the White House. It was agreed that they would meet on neutral ground. The Presidential Suite at the Beverly Wilshire Hotel in Los Angeles was designated the no-man's-land.

Deaver was adamant that we not conduct a news conference immediately following the meeting. He was surprised when we acquiesced. I was worried about Ansel's health and concerned that this event would sap all his available energies; the pacemaker kept his heart steady, but the heart muscle itself was weakening, and Ansel's doctors thought it best that he not undergo the rigors of a press conference. Instead, much to the later ire of the White House, Ansel agreed to an exclusive post-meeting interview with a reporter from the President's least favorite newspaper, the *Washington Post*.

Deaver had a further demand: Ansel must not be accompanied by an environmental heavyweight. This disqualified Bill Turnage, who had hoped to accompany his old boss. Virginia, Jim, and I, deemed nonthreatening, were welcome to come along.

We flew down to Los Angeles the night before, had a quiet dinner in our hotel, and all went to bed early. The next day, uncharacteristically, Ansel bore no gift of a photograph or book for the President. As the four of us were escorted down the hallway toward the Presidential Suite, Reagan's photographer, Michael Evans, popped his head out of a doorway and commandeered Jim and me to look at his photographs. We couldn't say no. I hoped he had only a few pictures; he had a whole portfolio.

We had been briefed that the schedule allowed for only a fifteen-minute meeting. After we had been with Evans for half an hour, I began to fear we had missed it all, but at last he took us into the other room. Virginia was sitting off to one side, by herself. Ansel and the President were perched on opposite ends of a sofa, as far apart as they could get without falling on the floor. The unusually gaping social distance between the two told me everything I needed to know about what had occurred. Ansel looked tense, though he visibly relaxed when I gave him a big smile.

Their meeting lasted fifty minutes in all. Ansel had come prepared to discuss issues; he had even boned up. But Reagan talked nonstop for the first twenty minutes, determined to let the other know what a committed environmentalist he, Reagan, was. Ansel was both shocked by the President's approach (never, ever would Ansel have classified Reagan as an environmentalist) and increasingly uneasy that his fifteen minutes had run out without his ever having been allowed to enter the fray.

When Ansel finally did speak, he felt that Reagan listened but did not hear. As a leader of the Wilderness Society's "Stop Watt" campaign, Ansel talked about the damage he believed James Watt was inflicting across the country, and touched on topics ranging from acid rain to the conduct of the Environmental Protection Agency to the plummeting morale in the National Park Service to his pet project, magnetic fusion technology. He later regretted not having had time to bring up the protection of the Big Sur coast.[12]

Pictures were made of everyone assembled, and then there was time for small talk as we got ready to leave. Deaver proudly shared that he had purchased Ansel's photograph *Clearing Winter Storm* a few years earlier for $250 and was very pleased to have later sold it for $6,000. I thought it in poor taste to tell an artist that one had 1) sold his work and 2) profited by it, but I bit my tongue. I knew that Deaver wasn't so smart: *Clearing Winter Storm* now brought $10,000.

To the White House's dismay, the Adams-Reagan meeting was front-page news in the *Washington Post* for Sunday, July 3. Ansel re-

lated to reporter Dale Russakoff that the President had caught him a bit unawares. Instead of the tall, commanding actor from the movies, he had found a small, slight man, comfortably dressed in slacks and a starched white shirt embellished with monogrammed double Rs. Ansel was shocked by Reagan's surprisingly warm and human-sized personality, as well as by his undivided attention, giving every indication that he listened to what Ansel said, though Ansel brushed that off as good acting. Each time Ansel would attempt to charge Watt with another serious transgression—"I told him Mr. Watt is the most dangerous element in the country today"—the President would rise to his defense. Ansel summarized his own performance, "I expressed myself as forcefully as I could . . . I was braver than I expected to be."[13] With great satisfaction, Ansel read the newspaper headlines proclaiming Watt's resignation later that year.

During the spring of 1983, a lesion on Ansel's leg—legacy of the burn he had received while photographing a factory in 1945—flared up and refused to settle down again. Concerned, his dermatologist sent us on to a plastic surgeon. In March, a biopsy came back negative, but another, in September, showed a squamous-cell tumor. The doctors cut out the malignancy and put Ansel on complete bed rest for four weeks to allow his leg to heal.

This was a tough month for me, too, since Jim had back surgery at about the same time that Ansel was hospitalized. They were each on bed rest at their respective homes. Whenever I was with one of them, I felt great guilt about not being with the other; though it was a no-win situation for me, they both recuperated fairly well.

Ansel began to sense that his time was limited. Even though I was with him constantly, he wrote me long letters about the things he found too difficult to say out loud. He wanted assurance that there would be sufficient income for Virginia when he died. Knowing that his leg was threatened, he resolved that even if he lost it, he would still direct the printing of his negatives. And finally, if he should die he wanted me and his photographic assistant, Chris Rainier, to supervise

the making of prints from "important" negatives that had never been printed, placing his confidence in our perception of his life's work.[14]

A lump developed high on Ansel's leg, and a biopsy revealed that the cancer had spread. The positive lymph node was surgically removed in early March 1984, and radiation followed. Ansel was a champ throughout the ordeal, never complaining, not even once.

After the birthday concert in 1982, Vova Ashkenazy and Ansel had become friends. Whenever he was in town, Ashkenazy would pop in to practice gently on Ansel's old Mason and Hamlin: he loved the acoustics of the house. Ansel felt compelled to photograph his friend at work, and the results became two of the pianist's next album covers, a solemn portrait for Beethoven's "Hammerklavier" and a relaxed and cheerful one of Vova at the piano in Carmel surrounded by Ansel's photographs for Mussorgsky's "Pictures at an Exhibition."[15] Vova had brought his wife, Dody, and children to Carmel to visit and decided to buy a house just up the hill from Ansel's.

During the winter of 1983–84, Vova called to suggest that it was time for another concert. We jumped on his gracious offer and set Easter Day, April 22, 1984, for his return performance. Vova said that his fee had gone up: he would like caviar *and* sushi. Agreed!

On Friday, two days before the scheduled concert, Ansel began experiencing a feeling of pressure in his chest and shortness of breath. As so many times before, I called his doctor and was told to bring him in to the hospital. This time, though, Ansel did not get dressed but instead stayed in his pajamas and robe; that in itself was very unusual for him. Virginia packed him a small bag.

As we drove to the hospital for what I believed would be just another few days' stay for Ansel, I began to sense that he was looking at this very familiar countryside as if for the last time. This man who had always checked into hospitals with great cheer, as though starting a new and fun adventure, was subdued. There was an old dead tree on a hillside south of the Carmel River that he remarked almost every time we passed it over the years, admiring the physical endurance it displayed even though, at least outwardly, it was no longer alive. Now

he just looked at the tree bleakly. Ansel's mood was pervasive; I felt a pang of trepidation.

He was admitted for observation and tests, but I remained optimistic that he would be released in time for Sunday's concert. Ansel's appetite had grown poor, so I added beer, an appetite stimulant, to my shopping list for him, along with all the new magazines on the newsstand that might interest him.

The first tests to come back on Saturday indicated that Ansel was experiencing congestive heart failure, or CHF: when the heart is too weak to pump it effectively through the lungs, blood backs up, and fluids begin to drown the lungs. Although Ansel's circulation was compromised, his electrocardiogram showed no change from one made a few weeks earlier, meaning he had not had a heart attack.

His blood gases—that is, the relative levels of oxygen and carbon dioxide in the blood—were OK; if anything, he was a bit hyperventilated (too much oxygen). But an inflamed vein in his left leg was cause for some concern about blood clots.

New X rays revealed lentil-sized densities scattered across both lungs, perhaps small blood clots or pockets of dust, a consequence of all of those years on the shusty Sierra trails. (*Shust* was Ansel's word for the odiferous, nature-made combination of mule shit and dust.) A battery of physicians analyzed all the data and agreed that Ansel's primary problem was CHF.

Later that afternoon, Ansel suffered a minor heart attack. It was not a painful episode; he felt only increased pressure in his chest. He was moved into the intensive-care unit so he could be constantly monitored.

Vova called. He had arrived in town, but he did not want to proceed with the concert if Ansel could not attend. From his bed in the ICU, Ansel's voice was strong and jovial. He apologized in advance for his absence and told Vova he hoped he would play anyway for his family and friends; he would be there in spirit, and after the performance, I would bring the pianist and his wife to visit him in the hospital. Vova acquiesced.

More tests were ordered. That night, Saturday, April 21, Ansel's

doctor, Tom Kehl, pulled me aside and informed me that there had been a change in the reading of the X rays. Ansel's lungs were not full of blood clots or dust; they were riddled with cancer. I felt as if I had been dropped over the side of the Golden Gate Bridge. I knew what this meant: Ansel was almost dead. I ran to the sink and kept splashing cold water on my face until I could stop myself from crying.

A whole platoon of gifted doctors applied themselves to figuring out some way to extend Ansel's life. It was decided that he would not be told of his condition until they knew more. I could not let Ansel see that I had been crying. I went to a phone and called Michael Adams and asked him to tell his sister, Anne. Dr. Kehl called Virginia.

I stayed late with Ansel that night and returned early the next morning. He seemed to be doing quite well: his appetite was better, and he was looking forward to seeing his friends and family after the concert. After lunch, as concert time drew near, Ansel absolutely-positively insisted that I go. His other physician, John Morrison, assured me that he would stay with him until I returned.

A palpable pall was hanging over Ansel and Virginia's house when I arrived. Although no one else had been apprised of the seriousness of Ansel's condition, people seemed to know that this concert was to be his unscripted elegy. Vova was gravely concerned and asked me to tell him all about his friend. I talked positively, but Ashkenazy's face remained set in melancholy.

Vova had chosen Schubert's Sonata in B-flat Major, Schumann's *Papillons* op. 2, and Chopin's Ballade op. 52, no. 4, and Scherzo op. 54, no. 4. For an encore, he played Schubert's haunting Impromptu op. 90, no. 3. The music was sublime, reminding us of Ansel's own lifelong devotion to beauty. I felt as if the notes were floating gently to heaven; the concert provided a protected island in time where nothing bad could happen.

We had planned this Easter, a day of sunshine and warmth, as a celebration. Following the performance, the guests milled about outside, where assorted food and drink stations offered the best California wines and Russian vodka, raw oysters shucked to order, home-cured

salmon, locally made grilled sausages, a sushi bar presided over by a Japanese master, and, of course, a kilo of Malossol Beluga caviar for Vova. No one ate much. No one had much fun.

After we had stayed an acceptable length of time, I drove Vova and Dody to the hospital. Earlier, when I left, Ansel had seemed quite weak, but now, as we entered his room in the ICU, he sat straight up in bed, extended his arms with a dramatic flourish, and, in a powerful voice, boomed, "Ashkenazy! So great of you to come!" There followed big bear hugs between the two men, and much joking and laughter. Ansel acted like his old self; he was so vital that it was impossible to believe he could be seriously ill. Vova presented Ansel with his latest recording on cassette tape, of Brahms's Second Piano Concerto.

The Ashkenazys departed, and then Otto and Sue Meyer arrived. Thoughtfully, they stayed only a few minutes. Ansel ate a bit of dinner, and then almost his whole family came in: Virginia, Michael and his wife, Jeanne, and their two, Sarah and Matthew; and Anne and her husband, Ken, with two of her three daughters, Ginny and Alison (only Sylvia was missing). Ansel was in great spirits, drawing happiness and energy from them as they surrounded his bed with stories from the day and laughter.

I talked with Michael and tried to convince him to stay through his father's immediate crisis, believing that Ansel and Virginia needed him both as their son and as a physician. He chose instead to drive home to Fresno. Ansel had provided him with little emotional sustenance throughout his life, and he simply did not have it to give back now. Anne and Ken also left. Maybe none of them could believe that Ansel was really mortal or perhaps the only way they could deal with the situation was to deny what was happening.

Knowing that the Ashkenazys were coming to our house for dinner, Ansel said, "Good-bye, dahlinnk," in his best Russian accent as I left. I told him I would return later to tuck him in.

At about nine-thirty that night, as I was preparing to go back to the hospital, Dr. Morrison called and said that Ansel was having some problems. I was out the door in a flash, and ten minutes later I ran into

the ICU. Ansel's room was full of doctors and nurses, his bed barricaded behind a battery of machines. Without thinking, I quickly squirmed through the complex paraphernalia, under tubes and between wires, and climbed up on Ansel's bed. I hugged him as best I could and placed my cheek next to his, my lips at his ear.

A clear plastic oxygen mask covered his mouth and nose, and lines seemed to be attached all about his body. I started softly talking to Ansel, explaining to him what was going on. I told him that he was going to be fine, that he had been through many things in his life and would get through this, too.

Dr. Morrison asked if he was conscious and responsive. As I whispered in his ear, Ansel briefly squeezed my hand. He tried to talk but couldn't. I put my face right in front of his, nose to nose, and kept eye contact with him. He looked at me with resignation.

Ansel's Walkman was on the bed next to him, its earphones dangling over the side; he had been listening to the Brahms tape when struck by a severe heart attack. Ashkenazy's giving him that recording on this day was a bizarre coincidence: the Second Piano Concerto was the featured music in Ansel's recurring nightmare of failure, the piece he did not know how to play.

Dr. Morrison now asked me if Ansel still wanted to live. If he did, he would have to be intubated, with a breathing tube inserted down his throat so he could be placed on artificial respiration. There was no way that Ansel could tell me himself, but I knew he was not a quitter and would want to fight for his life, so I said yes.

It was just at this time that I looked up at Dr. Morrison and asked, "Where's Virginia?" I realized it was she who should be making this decision, but in the midst of the crisis no one had thought to call her. She was immediately telephoned.

After I said yes to the intubation, Dr. Morrison insisted that I leave the room while the procedure was performed. He said it would be difficult, and the staff would need to be all around Ansel's head. I hugged Ansel to me and told him I would be just outside. He looked at me, his eyes now seeming to plead that he needed to die, but I had already set the wheels of medicine in motion.

I stood in the hallway, somehow holding on to a wall, and totally broke down. Virginia arrived just as Dr. Morrison came out to give us the sad news: Ansel had died during the intubation. Virginia went in to be alone with him for a short while; when she emerged again, she was ready to go home.

By this time, Anne's daughter Ginny, who had driven her grandmother to the hospital, was waiting with me outside the room, as were Jim and a few other friends of Ansel's, including Maggi Weston. While most chose not to go in for a last visit, Maggi and I both wanted to. I got back up on the bed on one side and Maggi got up on the other. We both put our arms around him, just as I had done a few minutes before. He was still warm. Knowing that hearing is often the last sense left intact, I placed my cheek next to his once more and whispered that it was time for him to go. I thanked him for fighting so hard to stay with us and told him that I loved him and that he would always be with me. Maggi stroked Ansel's hand and murmured in his other ear. I had a strange feeling, and turning around, I saw Ansel up in the corner of the room looking down at us. Maggi saw him, too. It may be that our need to detain this courageous and magnificent man was so great that from the depths of our beings we envisioned him as still with us; or perhaps the evidence provided by our eyes was for real, and we saw AA as he left his body.

Ansel's death certificate states that he died at 10:18 P.M. on April 22, 1984. An autopsy revealed that the immediate cause of death was respiratory arrest due to cardiogenic shock and congestive heart failure caused by acute myocardial infarction, or heart attack. Under the circumstances, it was a great comfort to know he had died so quickly.

One of Ansel's last wishes was that after he died, tissue samples should be taken to determine what effects the years of photographic chemistry had had on his body; he was sure that some of the more toxic chemicals, such as selenium, had preembalmed him. Dr. Morrison complied with his request, but months later we learned that nothing of significance had been found.

Virginia wanted closure. Ansel's body was taken the next day to the Little Chapel by the Sea in neighboring Pacific Grove, and that after-

noon, his family, his staff, and a few friends gathered for the cremation. Ken Helms, Virginia and Ansel's son-in-law and a former Unitarian minister, said a few well-chosen and beautiful words, and then Virginia was presented with her husband's ashes in a cardboard box, tied with a string and still radiating heat. We drove to our house and poured stiff drinks, and I put Virginia in our recliner with her feet up as we all watched the national and local news. Ansel's death was the lead story on every channel.

22

AND SELL

Most biographies would end here, but not this one, because Ansel Adams did not well and truly die on April 22, 1984. With great artists, the art lives on. Ansel's photographs have proliferated, perhaps even saturated the world, since his death. From mall to mall, posters, wall calendars, and desk calendars are sold by the thousands, and "new" books "by" Ansel continue to be published every year.[1] By 1993, total sales of the calendars had reached more than 3.4 million copies.[2] Ansel's images, in original fine prints and in reproduction, may be the most widely available and frequently purchased by any visual artist in history.

Although the man himself was gone, the machine he had set in motion with the establishment of the Ansel Adams Publishing Rights Trust kept rolling full speed ahead. Ansel was my boss until that Easter Sunday night, when the trustees, Bill Turnage, Dave Vena, and John

372

Schaefer, took full control. Within a couple of days of Ansel's death, Dave and John flew in to Carmel. They suggested we meet over dinner at the Highlands Inn. I remember sitting there not eating, not believing that they could be calmly talking about future business plans for the trust. I was in shock, and I needed time to absorb the loss of Ansel. I longed to reminisce with them, to recall his vitality and brilliance. But that was not on their agenda.

A few days later, we had another meeting, this time over lunch on the patio of Club XIX at the Lodge in Pebble Beach. It was a beautiful day, with a quiet Pacific Ocean stretched out all blue and bright before us. The discussion was 100 percent business. In the middle of the meal, we were rudely jolted by a sizable earthquake, which I really thought might be Ansel, trying to shake some sense into them. (The next day, an editorial cartoon in the local paper suggested an alternative explanation for the quake: God was finally straightening out Ansel's broken nose.) My clashes with the trustees would soon increase in frequency and intensity.

Ansel and I had almost completed the autobiography manuscript when he died. Bent on meeting our fall deadline, I did not skip a beat but kept on organizing his text, filling in the gaps with a minimum of my own writing. After years of total immersion in his life, I discovered that I could write almost like him, and if my efforts lacked his soaring inspiration, they nonetheless served to stitch his pieces into what I hoped was a seamless, finished narrative.

Most of Ansel's books were published under Little, Brown's art imprint, the New York Graphic Society (now Bulfinch Press), with whose staff I worked very closely both before and after his death. I was on the phone daily to Janet Swan Bush, an unsung hero who skillfully coordinated all aspects of the autobiography from editorial through production. Early on, Little, Brown had assigned senior editor Ray Roberts to the project, flying him out to Carmel with company president Arthur Thornhill, Jr., in April of 1981 to introduce us. I was concerned about how much control Ray would want to have over the book, but Ansel was even more worried than I: he thought the boys back East were sending a watchdog. It turned out that Ray was really there to help us. Never

negatively interfering, he provided sage counsel that resulted in a much better book.

I shipped off the unillustrated manuscript to Ray and Janet on October 12, 1984, making a note to myself that after five years of gestation and labor, the newborn weighed five and a half pounds. I had come right down to the wire but managed to complete the text by the deadline, having spent two weeks in an isolation cell (OK, it had a view of the Pacific), with my hands grafted to the keyboard, wearing the same flannel nightgown day in and day out. Not a pretty sight.

At the time of his death, Ansel had begun work on the selection of photographs for only one chapter, "Yosemite." Resolved that his autobiography would not be illustrated by the same images that had appeared time and again in earlier books, he had wanted to put off making any decisions until all his thousands of negatives could be proofed. It might seem astonishing that they had not all been proofed years before, but it had been his lifelong habit to move from project to project so quickly that he had time to examine most of his negatives only peremptorily, and to print only a fraction of them. When he died, we were still completing their proofing, making uncorrected, rough contact prints directly from the negatives.[3] Ansel saw both the autobiography and the projected book of letters (*Ansel Adams: Letters and Images*, published by Little, Brown in 1988) as showcases for his unknown photographs, providing him with a compelling reason to make new prints.[4]

Chris Rainier had first come to Ansel's attention as an eager young student (and recent graduate of the Brooks Institute) in his 1980 Yosemite Workshop. After the departure of John Sexton in 1982, Chris became Ansel's last photographic assistant. The incredibly capable John was a very hard act to follow, but Chris had his own strengths and made the job his own; while he seemed a centered presence at all times, a huge bonus when the pressure was on, his recurrent nightmare was of accidentally dropping *Monolith*'s glass plate right in front of Ansel, watching in horror as it hit the floor, shattering irrevocably in slow motion.[5] It was Chris's responsibility to proof all the negatives and make most of the reproduction prints for the autobiography. Because we were overwhelmed with work, shortly before Ansel's death, I hired

Rod Dresser, a former Navy officer and photographer by avocation, to help us out. He was to prove invaluable during the difficult years that followed, assisting in the production of both the autobiography and the letters, our next major book.

After Ansel left San Francisco, where he had had to store his negatives in a bank vault for safekeeping, he always liked to keep them close at hand, ready for action. When he built his Carmel house, he had a concrete bunker burrowed into the hillside right outside his office door. Although it was designed as a nuclear fallout shelter, there was never so much as a bottle of water or a package of freeze-dried food within its walls. Its impressive metal-clad door bore the silk-screened message DANGER, HIGH VOLTAGE emblazoned in red paint to discourage break-ins. Encased in the earth, the vault maintained a stable, cool temperature year-round, and a dehumidifier kicked in when necessary, so Ansel felt justified in describing it as humidity- and temperature-controlled.

Inside, the vault was lined with steel filing cabinets and cardboard boxes holding his nearly forty thousand negatives, of which only about two thousand had ever been printed. The remaining thirty-eight thousand were anything but lousy; in fact, Ansel was convinced that a large number of them were as fine as anything he had ever made. Right along, he had destroyed all those negatives that he did not think were any good, since to print them would be a waste of considerable time and effort.

Not long after sending in the manuscript, I began reviewing the many containers of reproduction prints, and then I tackled the forty thousand proofs. Ansel had been so clear in his instructions that I felt as if he were Jiminy Cricket sitting on my shoulder and guiding the selection of each image. In the end, a full 40 percent of the pictures used in the autobiography had never before been seen. Ansel had not wanted the photographs chosen to be merely illustrative; they were also to communicate a mood, an attitude. With this in mind, for the "Family" chapter, about his difficult childhood and critical mother and aunt, I selected dark and moody images, while lyrical pictures that seemed to sing on their own found a home in the "Music" chapter, which opened with a booming waterfall.

Chapter 5, "Yosemite," began with a full-page reproduction of *The Cliff of El Capitan*, an image that only Ansel himself could have picked out (somehow I wouldn't have heard his little voice in my ear on this one). This was one of the few photographs that I knew he definitely wanted to include. For me, the spirit of Yosemite is best communicated in his views of the entire valley, but for Ansel himself, Yosemite was granite walls, and this image shows just that: the flat, gray cliff of El Capitan, framed by his camera without top or bottom, visually independent of both heaven and earth. There is no sense of El Capitan's enormous scale, just of its rockness, the essence of Ansel's Yosemite.

All of our deadlines were met, and *Ansel Adams: An Autobiography* appeared in bookstores in October 1985, in time for the gift-giving season, when fully half of all books are sold. If the autobiography was not quite as handsome as Ansel's purely photographic books, in quality paired with quantity it was a milestone: 400 pages filled with 250 illustrations, released at a retail price of fifty dollars.

Shortly before the actual publication date, I received a phone call from the head of Little, Brown's publicity department. He had read the manuscript and with some excitement told me, "This will make the *New York Times* best-seller list!" He had a great feel for the book, and I could tell he really liked it. He placed the resources of Little, Brown behind the autobiography, springing for significant advertising. Life was good. I sent him a dozen long-stemmed red roses.

The book was released to coincide with a major exhibition of Ansel's work at the National Gallery of Art in Washington. In his stead, I had to represent the book as best I could, giving interviews on National Public Radio and on "Today," the most important morning television show in terms of book sales.

The only task I dreaded was lecturing at the National Gallery. The museum had scheduled a full day of Ansel-related activities, including one speech before mine, by John Szarkowski of MoMA. Whoever it was who cautioned against following children or animals obviously never met John, a consummate speaker and photographic intellect. I stayed in my hotel room during his lecture; I knew if I listened to him I would never have the confidence to go out there on my own. But despite my

abject fear that the audience would walk out, my lecture went just fine. The next day, I commenced a tour around the country to promote the book.

The autobiography found a huge and responsive audience, and the reviews were terrific. As predicted, it did appear on the *New York Times* best-seller list, for six weeks—the most expensive book to achieve that honor, and the first (and so far only) book of Ansel's. It probably would have stayed on the list much longer had Little, Brown not sold out of books, making it unavailable in many markets for much of the holiday season. It continues to sell, in softcover as well as hardcover, even now, a decade later. In 1990, *Ansel Adams: An Autobiography* was selected as one of the hundred most important books of the decade by the American Library Association.

My involvement in this book brought me great rewards, far beyond the financial. Nearly once a week someone still tells me how much he or she loved the book and was moved by it; on occasion I have even been told it was "life-changing"! I hear such comments in my heart.

The National Gallery exhibition was another Adams coup. That museum had traditionally been the stuffiest of the stuffy in terms of photography, but the administration had at last relented and deemed the photographs of Alfred Stieglitz, then Paul Strand, and finally Ansel Adams worthy of its hallowed walls. This was definitely not a risk-taking institution. For such an occasion, a catalog was essential, but it had to be something that would neither compete nor conflict with the autobiography.

The National Gallery exhibition was sponsored by Pacific Telesis, a California communications company that had purchased one of the last complete Museum Sets just before Ansel died. This was not a mere matter of handing over the money: Ansel insisted on interviewing the president of the company and the president and director of the foundation to personally assess their intentions. Over drinks at his home, Ansel questioned them for over an hour before giving his consent. They promised they would actively tour their photographs, and they kept their word: their Museum Set was the core of the National Gallery exhibition, supplemented by murals and screens carefully chosen by

Nick Cikovsky, the eminent curator of American Art. Ansel's show enjoyed the fifth-largest attendance in the museum's history (651,652), far greater than that for any other photography exhibition and outstripped only by the crowds for such blockbusters as the treasures of King Tut.[6]

Pacific Telesis also underwrote the catalog, a record of all seventy-five Museum Set images with an essay on the sets by Cikovsky and another on Ansel by Jim, who contributed a detailed chronology as well. A year later, it was reissued by Little, Brown in slightly different form, under the title *Classic Images*.

When Ansel died, we were just finishing the second set of deluxe posters, this time of *Monolith, Frozen Lake and Cliffs*, and *Winter Sunrise*. Dave Gardner's reproductions had been fully approved by Ansel, but he had not yet signed them. AA's initials were embossed in place of the signature.

Although I again protested, this time to the trustees rather than to Ansel himself, by 1987 a desk calendar had joined the lengthening Ansel Adams publishing list. As much as I loved Ansel's work, I thought it was proliferating ridiculously. Still, every time I began preparations for a new edition of either calendar, I would find myself once again caught up in the joy of working with his photographs. Each spring I would lay out my proposed calendar images and ask everyone present in the house to comment: Phyllis, Fumiye, Chris, Rod, our bookkeeper Judy Siria, and especially Virginia. I respected all their opinions, and with Ansel no longer physically around, I wanted them to feel a part of each publishing project, much as I might later wish I hadn't: criticism is easier to request than to accept.

My earlier disagreements with the trustees had been genuine enough, but they were nothing compared to the clash over the Rockwell affair. In late 1985, Rockwell International, creator and manufacturer of defense/offense hardware, asked the AAPRT to grant it the right to use three of Ansel's images in its advertising in exchange for a "substantial fee."[7] The images in question were *Winter Sunrise, Clearing Winter Storm*, and *Redwoods, Bull Creek Flat*, all Adams icons, permanently intertwined with the world's perception of Ansel as a man

of unblemished integrity who had until his dying day done his utmost to protect the earth. The trustees agreed to the deal.

In keeping with the company (Rockwell, that is), I went ballistic. Ansel had had his limits when it came to how he made money, and I knew that this went far beyond what he would have found acceptable, whatever the price.[8] Obviously, though, the trustees held a different view. John Schaefer rationalized, "Adams was a patriot. He believed in a strong defense."[9]

I telephoned and retelephoned the trustees, then sent a strong letter begging them to call off the Rockwell deal. By way of reply, I was informed that they did not want to hear one more word on the subject, but if Virginia instructed them not to proceed, they would comply. Virginia had a long history of avoiding conflict of any kind, no matter how grave the circumstances. But not this time—hallelujah! I called Dave Vena and handed her the phone, and she told him loud and clear that she was against the Rockwell ad campaign. Ignoring her wishes, the trustees stayed their course.

I spent the weekend at home agonizing over the situation, knowing full well I should quit. But in the end I did no such thing; instead, I stopped arguing and went back to work. It was I who talked with staffers at Rockwell's ad agency daily; it was I who picked out suitable reproduction prints and shipped them off to the agency in Detroit. The reason I gave myself for staying on was *Ansel Adams: Letters and Images, 1916–1984,* a companion book to the autobiography, and the last task Ansel had left me. How many times can one woman be wrong?

Soon enough, *Clearing Winter Storm* was dramatically splashed across magazine pages and captioned, "Like Yosemite National Park, Tactical Weapons Systems are a national resource."[10] Alongside *Winter Sunrise*, Ansel's grand expression of his "Range of Light," the Sierra, were the words "Another American Asset: B-1B. The U.S. Air Force Long-Range Combat Aircraft."[11] There must have been a slogan shortage in Detroit; *Redwoods, Bull Creek Flat* illustrated a wan variation on the first theme: "Like the California Redwoods, NASA's Space Shuttle is a national resource."

The Rockwell ads were published in defense-related publications,

where I fervently hoped they would garner little notice. Wrong again: they were soon discovered by *Mother Jones* magazine, which reckoned that the campaign made Ansel an "arms peddler."[12] The exposé quickly became an Associated Press wire story, picked up and published in newspapers from coast to coast, including the *Washington Post*, where it ran on the front page of the business section. A representative of the Sierra Club judged the ads to be a profound humiliation to Ansel.[13] *Outside* magazine's piece, illustrated with *Winter Sunrise* and headlined "YOUR AD HERE,"[14] contained a brief statement by Dave Vena to the effect that the AAPRT had agreed to the association only with the space shuttle, not with the military hardware. But although the "original pitch" may have been for the space shuttle, the trustees had in fact approved each of the three ads before it appeared, and had known full well that the subjects were also tactical weapons and the B-1B bomber.[15]

Throughout this period, I buried my head in the sand, in the form of *Ansel Adams: Letters and Images*. I knew the letters backward and forward from my years of research for the autobiography, and I had memorized parts of some that I found especially moving. Our publisher cautioned that books of correspondence were neither sexy nor potential best-sellers. But I hoped that in this case those rules would not apply, because Ansel's letters were uncommonly wonderful.

Andrea, now living in New York with her new husband, was to be my coeditor. She and I agreed that the letters should tell their own story, so we included some to Ansel as well as from him, reasoning that this would better communicate the quality of his relationships with such greats as Stieglitz, Weston, Strand, and the Newhalls, along with Presidents and senators. We imposed as little of our own editorial presence as possible. Through the careful chronological sequencing of letters, whole stories naturally developed intact, allowing the reader to experience firsthand the making of photographic and environmental history—to my mind, exciting stuff. This approach necessitated the elimination of some important, though not crucial, events and friendships. Other decisions were made for more delicate reasons: since Ansel had declined to mention his romantic wanderings in the autobi-

ography, for example, we included no letters to Patsy English. The book was and is an excellent read, but as Little, Brown had warned, there was far less interest in it than there had been in the memoir.

The blue-lines arrived for the letters book in May 1988. Blue-lines are printing proofs showing the entire book in blueprint form, assembled by hand, signature by signature; they are the very last stage before the actual printing. It was my duty to read them with attention to every detail, from typos to dust spots in the reproductions, and make any last-second changes; signing off on the blues was the final job I was contracted to complete. I finished, shipped the blue-lines to Dave Gardner, left the trust's employ, and crashed, falling into a depression so dark that it would be eighteen months before I again saw a bit of light. I had not let up since I had begun working for Ansel, almost a decade earlier. I had had no idea that I was under such extraordinary stress.

Ansel Adams: Letters and Images was the last book personally planned by Ansel, but since its publication, in 1988, the trustees have published a steady stream of new Adams titles. Following his departure from the Wilderness Society, and two brief stints in the business sector, Bill Turnage returned to apply his full-time energies to the trust. Andrea and Bill collaborated on *Ansel Adams: The American Wilderness*, published in 1990. In response to an avalanche of unauthorized Adams books whose cheap prices were matched by cheap quality, in 1992 they published the inexpensive softcover *Ansel Adams: Our National Parks*. The trustees then decided that Ansel's technical series, completed in 1983, was out of date, so trustee John Schaefer began as author of a new series of technical books, the first titled *An Ansel Adams Guide: Basic Techniques of Photography*. Since the *Letters* book, every single one of the AAPRT's "authorized" publications has been produced by one of the trustees themselves.

In practice, the trustees have taken the position that they will not cooperate on any project involving Ansel that they do not control. This reprehensible policy has quashed scholarship on Ansel. When curator Emily Medvec assembled a re-creation of *Born Free and Equal* for a traveling exhibition following Ansel's death in 1984, the trustees refused to grant permission for Ansel's words to be used, nor did they

allow use of his writing in the 1988 book *Manzanar*; most would agree that this position has gravely weakened the importance of Ansel's achievement. His words are very powerful, and they are meant to be read alongside the photographs. When Jonathan Spaulding asked to use Adams quotes in his Ph.D. dissertation, published in 1995 by the University of California Press as *Ansel Adams and the American Landscape*, the AAPRT denied him permission, nor would it allow him to reproduce even a handful of Ansel's representative photographs. He felt forced to instead use only those images that the trustees had already acknowledged were in the public domain. In this serious, studious biography, Ansel's photography is visually represented by only "B"-grade images. Significant consideration of his art and the impact of his activism is necessary to the evolution of a historical evaluation of Ansel Adams the man, and to this end, scholarship of all kinds should be encouraged.

When I began examining negatives and proofs for the autobiography in 1983, I discovered a few boxes of color transparencies and negatives in the back of the storage vault. Even though Ansel had photographed using color materials since 1935, he dismissed all of this work as unimportant, made only to fulfill commercial assignments "from without," not aesthetic ones "from within." I could see that after the passage of so many years, much of the color material was physically in jeopardy: the color negatives were severely faded, and many of the transparencies seemed headed for that fate as well, though they still had some life. I did not have time to deal with this problem, and discussed it with Jim. After a careful review of the work, he asked Ansel if he could investigate having prints made before they all disappeared. Ansel, though not excited about the prospect, agreed, and Jim contracted Michael Wilder, an outstanding Cibachrome printer, to make some test prints. Michael talked at length with Ansel, made some prints, went back to Ansel for his comments, and then returned to his darkroom to reprint them according to Ansel's instructions.

Only a handful of photographs were made before Ansel put a stop to it. He called Jim and me in and sat us down. Easing us into his decision, he said, "Kids, I love you" (this was a very atypical choice of

words for Ansel, so it really got our attention), "but I *hate* this color. My reaction is like fingernails on a chalkboard. I can't stand it! Please stop." And we did. Ansel made his decision loud and clear, and the trustees were informed that he forbade any further exploitation of his color work.

Contrary to Ansel's final instructions, *Ansel Adams in Color*, produced by John Schaefer and Andrea, was published in 1993.[16] The text ends with a selection of Ansel's writings on color; curiously, the last letter in the book is one that Ansel wrote to Jim and me just six weeks before his death, telling us to forget his color work.[17]

To legitimize *In Color*, the trustees brought in a whole slew of respectable names, presumably on the Charlie-the-Tuna principle that "if they like it, it *must* be in good taste." The great photographer Harry Callahan selected the images, though he admitted in his editor's note that he knew Ansel once likened color photography to an out-of-tune piano. James Enyeart, past director of the Center for Creative Photography and the International Museum of Photography, wrote the introduction, and John Szarkowski and David Travis, curator of photography at the Art Institute of Chicago, were acknowledged as having lent their "wise counsel." No other Ansel Adams book has been given the seal of approval of a phalanx of experts, because no other Ansel Adams book has needed it.

Color posters, with initial press runs of ten thousand each, followed on the heels of the book, though the trust appeared to have some doubt as to how Ansel's public would react:[18] "We're still kind of holding our breath to see how these color photos are received," said an anonymous staffer.[19]

The most obvious problem with Ansel's color work is that, in a complete departure from his inviolate practice with black-and-white, Ansel never processed his color films or made his own color prints.[20] So much of Ansel's expression in photography was dependent upon his darkroom ability to choreograph new tonal relationships not found in real life—sometimes not found in the negative, either—but created when he made the print. Printmaking is that critically important second half of the photographic process.

A technical note appended to *In Color* acknowledges that a computer was used on certain of the images to correct the color, and stresses that no cropping of the photographs was allowed. The AAPRT hired a San Francisco digital imaging company to restore and retouch sixty-two transparencies.[21] Correcting the color is not some easy task to be dismissed as being of little importance; Ansel did not leave us his color prescription, but one look at the garish, cheap-postcard hues of some of the images in *In Color* is all it takes to know that this interpretation is really wrong.

Burning and dodging were techniques that Ansel used on all of his prints. But his color photographs, as represented in this book, do not benefit from those skills, nor are they cropped, another practice that Ansel applied to nearly all of his prints. Rarely would an image fit the camera format so perfectly that he felt no change was necessary.

A case in point is *Fresh Snow*.[22] As a black-and-white photograph, it is among Ansel's strongest, showing a closely viewed forest thicket, all branches from small to large burdened with snow and drooping groundward with graceful curves. A high-contrast image based on white (snow) and dark gray (branches), *Fresh Snow* is exquisitely simple in tone but chaotic in form. It was a personal favorite of Ansel's; he used its negative for two of his thirteen screens and also chose it in 1974 for inclusion in *Portfolio Six*. Within the pages of *In Color* a second version of *Fresh Snow* is revealed. With messy edges that distract the eye (Ansel would have trimmed them off), this image is nowhere near as fine as Ansel's black-and-white of the same subject.

The reviewer for the *New York Times Book Review* described *Ansel Adams, In Color* as a "misfire" that "reveals the much-admired landscape photographer's scenic tendencies."[23] Al Weber taught for eighteen years in Ansel's annual Yosemite workshops and was a longtime trusted colleague. Reviewing the color book, he wrote,

> Color wasn't his thing. He said it again and again. . . .
> Take away the Adams signature, and I find only a dozen
> photographs that warrant printing. That's twelve out of fifty
> out of forty years photographing in color, which resulted in

a file of 3,000 transparencies. . . . Trying to foist the color photography of Ansel off as fine art is pretty feeble. There is an aroma of money. There is dilution of a grand image.[24]

The trustees were put in place by Ansel as his instrument to develop appropriate publishing uses for his photographs. Their decisions should be reflective of his wishes and in his best interests; his artistic legacy should be considered no less carefully than its financial counterpart. During Ansel's life, I saw myself as a counterbalance to Bill, but it was always Ansel who held the reins. With his death, Bill became a runaway.

23

AFTERIMAGE

It has taken me some time to come to terms with Ansel, in life and in death, but now I understand that what he accomplished while he was alive is important enough to carry beyond anything others may do in his name. In the longest run, his reputation will rest on both his photographs and his actions. His example is indelibly engraved upon many souls.

History will remember Ansel for three significant contributions: his art; his role in the recognition of photography as a fine art; and his work as an environmental activist. Ansel affirmed what it means to live life fully as an artist, disproving the painter Robert Motherwell's statement that "all artists are voyeurs, not people of action."[1]

What makes an Ansel Adams photograph an Ansel Adams? Ansel's breakthrough images are not direct reflections of the reality before his lens, but rather interpretations of the subject through his deeply felt

emotional response. They are, in effect, products of his imagination. His artistic inspiration was passion, pure and simple, whether for a woman, for an America perceived to be under threat by fascist conquerors, or, most often and most significantly, for the land itself.

Technically, Ansel achieved his unique vision through a combination of elevated viewpoint, flattening of image, depth of field, elegant composition, and extensive detail captured through a remarkable tonal range. As the work of the greatest photographic technician of this century, his pictures demonstrate an astonishing virtuosity.

Whether by lugging his camera up thousands of feet to gaze upon Half Dome (*Monolith*), setting up his tripod on an elevated cliff or roadside above the scene (*Moonrise, Clearing Winter Storm*, and *Surf Sequence*), or photographing from a platform built on top of his car especially for the purpose (*Winter Sunrise, Mount Williamson*), Ansel managed to eliminate the close, low foreground and force the already expansive landscape to become heroic in scale.

A long-focus lens has the effect of compressing space, making distant objects seem larger than they appear to the eye. In Ansel's hands, the result was often a horizontal layer of tonal bands: foreground, middle, far, and distant. Depth of field, or sharpness from foreground to infinity (unlike human vision, with focus only in the center of the visual field), is difficult to achieve consistently, but it became a hallmark of his photographs. Close examination of each tonal area reveals subtle worlds of phenomenal detail. Each of his masterpieces comprises a tonal range from very black to very white, with a seemingly limitless expression of grays in between—bravura photographic performances.

This is not to say that all forty thousand of Ansel's negatives, nor even the two thousand from which he made fine prints, are truly important. Nonetheless, such photographs, mostly epic landscapes, as *Monolith; Frozen Lake and Cliffs; Clearing Winter Storm; Surf Sequence; Moonrise; Winter Sunrise; Mount Williamson from Manzanar; Sand Dunes, Sunrise; Mount McKinley and Wonder Lake; Aspens* (both horizontal and vertical versions); and *El Capitan, Winter Sunrise* (I could go on) speak clearly and strongly in the voice of one artist: Ansel

Adams. They are masterpieces of photography that cannot be denied, beautiful without being sentimental.

Beauty in art may come into and go out of fashion with the critics, but it is forever the first—and last—quality sought by most people. Perhaps an artist's major challenge is to picture places of overwhelming beauty. In an ultimately brave act, Ansel chose this most difficult subject; when he began, at the age of twenty or so, he had no preconceptions to scare him away.

Ansel had a greater impact upon creative photography than any other person in this century. To become fully acknowledged as a fine art, the medium needed a messenger, someone whose photographs were so clearly art, so patently breathtaking, that there could be no doubt left in the public mind as to its value. For the small, established art audience, Stieglitz was an extremely successful proselytizer, but he had no interest in spreading his gospel far and wide. In contrast, Ansel sought a huge, inclusive audience, and in so doing converted millions of the general populace. Ansel was creative photography's messenger. Through hundreds of exhibitions of his photographs, over decades of dogged determination by means of books, lectures, and workshops, he opened the door wide enough to let the entire medium step through, finally and forever.

Ansel was also one of our most important environmentalists, and here, too, his contributions were multidimensional. He took his citizenship seriously and became an exemplar of sustained, responsible activism. Over his thirty-seven years of service as a Sierra Club director, he became that organization's conscience, first and always concerned with preserving the intangible qualities of the natural world, while others zeroed in on one specific project after another. He forced the environmental movement in America to remain aware of the bigger picture and the effects of action and inaction.

Through his books, posters, and calendars, Ansel brought visually powerful evidence of our endangered American wilderness into hundreds of thousands of homes and offices, so that people could see on a daily basis what now exists but may soon be gone. His driving philosophy, "Witness the magic that is our world," was joined by a second

hope: "Protect the land that I have photographed so that it may be experienced by your children's children."

And what of Ansel's own children, and *their* children? Virginia was a perfect mate for him in many ways. Unfortunately for both of them, his decision to marry her was based more on his ideas of idealistic love than on the sort of passion she felt for him. Virginia seemed made-to-order for Ansel, an intelligent, well-read woman who knew and loved Yosemite and its trails as well as he. Music was central to her life, and she was blessed with a fine voice. She worked during most of their marriage, giving birth to their two children without benefit of his presence and often raising them under similar conditions. She inherited a permanent home and studio for Ansel in the absolute nucleus of his idea of heaven: Yosemite. As far as Ansel might wander, he knew he had the stability of Virginia to return to. He underestimated her importance, for she was critical to his success.

Ansel could not have asked for finer children, and yet he was never really comfortable with them. Dr. Michael Adams retired from the Air National Guard in 1993 with the rank of Major General. His two children, Sarah and Matt (who looks a great deal like his grandpa), are both bright, dynamic, and successful. Sarah Adams directs the fine-print department of the Ansel Adams Gallery while Matt Adams is working toward a master's degree in business administration.

Anne Adams Helms, whose life has been far from easy, developed the family business, 5 Associatos, into Museum Graphics, an important publisher of fine-art note cards and postcards. Her oldest daughter, Virginia Mayhew, is a gifted jazz saxophonist who plays with bands all around the world. Her second daughter, Alison Mayhew Jaques, a young wife and mother of two children, directs Museum Graphics, while the youngest, Sylvia Mayhew Dessin, also married and the mother of two, is active in community affairs.[2]

There were, I think, two holes in Ansel's soul: he never found emotional happiness, and some small part of him continued to equate success with an ever-growing bank balance. Other than that, to me Ansel seemed nearly perfect. But humans have no business trying to be saints, nor do I think Ansel wanted to be canonized, though he is often

painted that way. I prefer to remember him in a Stetson rather than a halo. Perhaps his flaws were necessary to ensure that he was earthbound like the rest of us, but I wish his life could have been more full of love. Surely, through his extraordinary contributions, he earned that right.

"Ansel's mind and vision, his reverence, his delicacy and strength," said Wallace Stegner, "will have power to move and enhance and enlarge us as long as walls exist for photographs. . . . He is not a man to be merely remembered."[3]

Both the environmental and photography worlds celebrated Ansel with posthumous recognition of his achievements. Not far from the Museum of Modern Art and several other museum spaces in the Yerba Buena area, the Friends of Photography created the Ansel Adams Center, now a major arts resource for the San Francisco Bay Area. Although Ansel is honored with a permanent display of photographs, the center's larger purpose is to foster the appreciation of contemporary photography through exhibitions in its several gallery spaces. Active publishing and educational programs represent another significant aspect of the restructured Friends of Photography.

In 1984, very soon after Ansel's death, California senators Alan Cranston and Pete Wilson—a Democrat and a Republican, respectively—joined together to sponsor legislation to designate the Ansel Adams Wilderness, an awe-inspiring 229,334 acres adjoining the John Muir Wilderness and Yosemite National Park.[4]

With elevations ranging from seven to thirteen thousand feet, much of it above tree line, the Ansel Adams Wilderness is the world of High Sierra granite that Ansel so loved. Resplendent with mountains, studded with lakes, it includes such sites as the Minarets near Mammoth Lakes, where he took Edward Weston in 1937, and the west face of Banner Peak, the subject of his first memorable grand landscape. The North, the Middle, and part of the South Fork of the San Joaquin River all lie within its boundaries. The Ansel Adams Wilderness Area is more accessible than most such protected lands, with both the Pacific Crest and John Muir trails traversing its expanse.[5]

A year and a day after Ansel died, that nameless mountain over-

looking his favorite place in the Sierra, the Lyell Fork of the Merced River, officially became Mount Ansel Adams.[6] Lying against Yosemite's southeast boundary, its eastern flank set into the Ansel Adams Wilderness, Mt. AA tops out at a substantial 11,760 feet. Two full days of hiking from either Yosemite Valley or Tuolumne Meadows are required to reach its base. For most, it is best to enjoy the mountain from a camping spot near the banks of the Lyell Fork, as the scaling of Mt. AA is not easily accomplished. The mountain is composed of flaking shale whose crumbling texture becomes dangerous underfoot as its summit is neared. Only experienced mountaineers can attain its peak, an area no bigger than eight by ten feet, dropping off on all sides, two thousand feet straight down. It is here that Michael, a capable climber, placed his father's ashes.

Great works of art can bridge the gap between each of us and the eternal, and Ansel's photographs are such transcendent expressions. By revealing our natural treasures, among them Yosemite and the High Sierra, Ansel placed the responsibility for their safety squarely in our hands. His photographs clearly show us that if the affairs of mankind have no cosmic significance, they nevertheless have earthly consequence.

Ansel's afterimage burns brightly.

NOTES

Throughout the Notes section, the Center for Creative Photography, University of Arizona, Tucson, is abbreviated as CCP.

1. SAN FRANCISCO

1. Nellie Mulcare had been hired as Ansel's nurse on June 17, 1902, at a salary of twenty-five dollars a month. Nancy Newhall, Notes about Adams Family History, CCP.
2. Gladys Hansen and Emmet Condon, *Denial of Disaster* (San Francisco: Cameron and Company, 1989), 13.
3. Gordon B. Oakeshott, "San Andreas Fault in the California Coast Ranges Province," in *Geology of Northern California*, Edgar H. Bailey, ed. (San Francisco: California Division of Mines and Geology, U.S. Geological Survey, Bulletin 190, 1966), 361.
4. Hansen and Condon, *Denial of Disaster*, 13–15.
5. Notice by the Board of Public Works that the Adamses' chimney had passed inspection, July 9, 1906, CCP.

6. Ansel Adams, interview on the history of West Clay Park, 1974, tape recording. Collection of Sue Meyer.

7. Nancy Newhall, *The Eloquent Light* (Millerton, N.Y.: Aperture, 1980), 25–26.

8. Ibid.

9. William Bronson, *The Earth Shook, the Sky Burned* (San Francisco: Chronicle Books, 1986), 89.

10. Ansel Adams with Mary Street Alinder, *Ansel Adams: An Autobiography* (Boston: New York Graphic Society, 1985), 9.

11. Telegram sent by C. H. Adams from Green River, Wyoming, to Charles E. Bray in Carson City, Nevada, April 22, 1906, 5:05 P.M., CCP; telegram sent by C. H. Adams from Reno, Nevada, to Charles E. Bray in Carson City, Nevada, April 22, 1906, 8:01 P.M., CCP; note sent by J. M. McCormack on behalf of Charles E. Bray to C. H. Adams, April 23, 1906, CCP.

12. C. H. Adams's pass through the lines in San Francisco, by order of the governor of California, April 23, 1906, CCP.

 Eventually the house was moved farther back on the land, on a new foundation. Ansel Adams interview.

13. James Alinder, "Ansel Adams: A Chronology," in Melinda Wortz, *Ansel Adams: Fiat Lux* (Irvine, Calif.: The Regents of the University of California, 1991), 101.

14. Nancy Newhall, "Additions to Ansel Adams Chronology," CCP.

15. San Francisco Directory, 1870 (San Francisco: H. S. Crocker, 1870), San Francisco Public Library.

16. J. Alinder, "A Chronology," 101.

17. San Francisco City Directory, 1886 (San Francisco: H. S. Crocker, 1886), San Francisco Public Library.

18. William Issel and Robert W. Cherny, *San Francisco, 1865–1932* (Berkeley: University of California Press, 1986), 132.

19. "Death summons another pioneer," undated obituary notice for William J. Adams, copied in undated typewritten notes by Nancy Newhall and in notes about the Adams family history, CCP.

 Charles's streetcar line was probably bought out in 1885 by San Francisco's powerful Big Four—Leland Stanford, Charles Crocker, Collis Huntington, and Mark Hopkins—who had all been merchants in Sacramento before moving to San Francisco, where they monopolized the city's public transportation. Issel and Cherny, *San Francisco, 1865–1932*, 30.

20. N. Newhall, *Eloquent Light*, 22–23.

21. Ibid.

22. Ibid.

23. Virginia Adams, interview with James Alinder, August 26–27, 1994, Carmel, tape recording.

24. A. Adams with M. Alinder, *Autobiography*, 4–5.

25. Virginia Adams interview.

26. In Nancy Newhall's notes for *The Eloquent Light*, CCP, she twice mentions that another son was born to the Adamses before Ansel but did not survive. This child was not buried at the family plot in the Cypress Hill Cemetery in Colma, California, which suggests that Olive may have miscarried relatively early in her pregnancy, though late enough that the fetus's sex was evident.

 Issel and Cherney, *San Francisco, 1865–1932*, 66.

 For the first three years of their marriage, Carlie and Ollie lived at Fair Oaks in Menlo Park. In 1899, they moved to 3049 Washington Street in San Francisco, which they rented for forty dollars a month, and then relocated to 114 Maple in 1900. CCP.

 (As an aside, John Steinbeck was born exactly one week after Ansel Adams.)

27. Charles Adams to Ansel Adams, March 25, 1944, CCP.

28. Ansel Adams interview.

29. Ibid.

30. N. Newhall, *Eloquent Light*, 23.

31. Ansel Adams, interview with Nancy Newhall, May 10 and 13, 1947, CCP.

32. A. Adams with M. Alinder, *Autobiography*, 13–14.

33. N. Newhall, "Additions to Adams Chronology," CCP.

34. N. Newhall, *Eloquent Light*, 27.

35. Charles Adams, interview with Nancy Newhall, May 18, 1947, CCP.

36. Ron Chernow, *The House of Morgan* (New York: Atlantic Monthly Press, 1990), 121–130.

37. N. Newhall, Notes about Adams Family History, CCP.

38. N. Newhall, "Additions to Adams Chronology," CCP.

39. Ansel Adams to Aunt Mary, August 21, 1911, transcribed by Nancy Newhall, CCP.

40. R. G. Aitken, "In Memoriam, Charles Hitchcock Adams, 1868–1951," *Publications of the Astronomical Society of the Pacific* 63 (December 1951), 283–284. The credit given to C. H. Adams for the invention of the process of alcohol extraction from sawdust may not be deserved; there are some indications that he in fact secured the U.S. rights to a Swedish process.

41. A. Adams with M. Alinder, *Autobiography*, 40.

42. N. Newhall, Notes about Adams Family History, CCP.

43. Ansel Adams, "Conversations with Ansel Adams," an oral history conducted 1972, 1974, 1975 by Ruth Teiser and Catherine Harroun, Regional

Oral History Office, The Bancroft Library, University of California, Berkeley, 1978, 11. This interview was conducted in twenty-six sessions between May 12, 1972, and February 23, 1975.

44. Virginia Adams interview.

45. Charles Adams to Ansel Adams, October 8, 1912, CCP.

 A. Adams with M. Alinder, *Autobiography*, 41.

46. Aitken, "In Memoriam, Charles Hitchcock Adams," 285.

47. F. J. Gould, ed., *The Children's Plutarch* (New York and London: Harper & Bros., 1910).

48. These books, inscribed by Aunt Mary to Ansel, are in the Adams family library in Carmel.

49. A. Adams, "Conversations," 165. Courtesy of The Bancroft Library.

50. Brooks Atkinson, *The Selected Writings of Ralph Waldo Emerson* (New York: The Modern Library, 1968), xx.

51. Alfred Kazin and Daniel Aaron, eds., *Emerson* (New York: Dell, 1958), 56–57.

52. Emerson's importance for Carlie was made clear to me by Ansel in many conversations we had over the years, and it was evident, as well, in those of his father's books that were still in his possession.

53. "Robert Green Ingersoll," *Bulletin* (San Francisco: April 20, 1896).

54. Robert G. Ingersoll, *The Ghosts and Other Lectures* (Washington, D.C.: C. P. Farrell, 1881).

55. "Robert Green Ingersoll."

56. A. Adams with M. Alinder, *Autobiography*, 11.

57. Sue Meyer, interview with the author, September 12, 1995.

58. Ansel Adams interview.

59. N. Newhall, *Eloquent Light*, 28.

60. Charles Adams to Cassandra and Cassie Adams, May 17, 1914, excerpt transcribed by Nancy Newhall, CCP.

61. Anthony Storr, *Music and the Mind* (Riverside, N.J.: Free Press, 1992).

62. Donna Ewald and Peter Clute, *San Francisco Invites the World* (San Francisco: Chronicle Books, 1991).

63. Charles Adams to Ansel Adams, March 25, 1944, CCP.

64. A. Adams, "Conversations," 28–29. Courtesy of The Bancroft Library.

65. Ewald and Clute, *San Francisco Invites the World*, 74.

66. A. Adams with M. Alinder, *Autobiography*, 19–21.

67. Ben Macomber, *The Jewel City* (San Francisco and Tacoma: John H. Williams, 1915), 107.

68. Beaumont Newhall, *The History of Photography* (New York: The Museum of Modern Art, 1964), 109.

69. James Alinder, "Ansel Adams, American Artist," in *Ansel Adams: Classic Images* (Boston: Little, Brown and Co., 1985), 8.

70. Ben Macomber, "Weird Pictures at P.P.I.E. Art Gallery Reveal Artistic Brainstorms," *San Francisco Chronicle Sunday Magazine*, August 8, 1915.

71. Bruce Altschuler, *The Avant Garde in Exhibition* (New York: Harry N. Abrams, 1994), 68.

72. A. Adams, "Conversations," 29.

73. Charles Adams interview, CCP.

2. YOSEMITE

1. J. M. Hutchings, *In the Heart of the Sierras* (Boston: W. H. Thompson & Co., 1887). The Spanish word *sierra* refers to one mountain range; Hutchings's addition of the letter *s* is incorrect.

2. Donna Ewald and Peter Clute, *San Francisco Invites the World* (San Francisco: Chronicle Books, 1991), 94.

3. Shirley Sargent, *Yosemite: The First 100 Years, 1890–1990* (Yosemite National Park: Yosemite Park and Curry Company, 1988), 10–12.

4. Linda Wedel Greene, *Yosemite: The Park and Its Resources* (Yosemite National Park: U.S. Department of the Interior/National Park Service, 1987), 2.

5. Alfred Runte, *Yosemite: The Embattled Wilderness* (Lincoln and London: University of Nebraska Press, 1990), 10.

6. Quoted in Hutchings, *In the Heart of the Sierras*, 56–57.

7. Jim dale Vickery, *Wilderness Visionaries* (Merrillville, Ind.: ICS Books, 1986), 65.

8. Paul Brooks, "Yosemite: The Seeing Eye and the Written Word," in Ansel Adams, *Yosemite and the Range of Light* (Boston: New York Graphic Society, 1979), 19.

9. Runte, *Yosemite: The Embattled Wilderness*, 12; Greene, *Yosemite: The Park and Its Resources*, 22–23.

10. Sargent, *Yosemite: The First 100 Years*, 19.

11. Runte, *Yosemite: The Embattled Wilderness*, 3.

12. Quoted in Greene, *Yosemite: The Park and Its Resources*, 53.

13. Brooks, "Yosemite: The Seeing Eye and the Written Word," 18.

14. Nancy Newhall, *The Eloquent Light* (Millerton, N.Y.: Aperture, 1980), 29.

15. Ansel Adams with Mary Street Alinder, *Ansel Adams: An Autobiography* (Boston: New York Graphic Society, 1985), 51.

16. Greene, *Yosemite: The Park and Its Resources,* 516.

17. Ibid., 97.

18. Statement made by Yosemite's Acting Superintendent Benson in 1908. Greene, *Yosemite: The Park and Its Resources,* 429.

19. A. Adams with M. Alinder, *Autobiography,* 51–53.

20. Michael Reese II, *A Travel Letter—1871: The Yosemite & Napa Valley* (San Francisco: Cloister Press, 1988), unpaginated.

21. Shirley Sargent, *Yosemite & Its Innkeepers* (Yosemite: Flying Spur Press, 1975), 22.

22. Greene, *Yosemite: The Park and Its Resources,* 652.

23. Sargent, *Yosemite & Its Innkeepers,* 59.

24. Ibid., 42.

25. A. Adams with M. Alinder, *Autobiography,* 53.

26. N. Newhall, *Eloquent Light,* 31; Ansel Adams to Mary Bray, summer 1917, in Mary Street Alinder and Andrea Gray Stillman, eds., *Ansel Adams: Letters and Images, 1916–1984* (Boston: Little, Brown and Co., 1988), 1.

27. Olive Adams to Charles Adams, June 13, 1917, CCP; Charles Adams to Olive Adams, June 13, 1917, CCP; Charles Adams to Olive Adams, June 18, 1917, CCP; Olive Adams to Charles Adams, June 20, 1917, CCP.

28. Ansel had fond memories of this story and its teller.

29. Ansel Adams, "Francis Holman, 1856–1944," *Sierra Club Bulletin* (San Francisco: Sierra Club, October 1944), 47–58.

30. A. Adams and M. Alinder, *Autobiography,* 54, 56–57.

31. Ansel Adams to Olive Adams, May 26, 1918, in *Ansel Adams: Letters and Images,* 2–3.

32. Ibid.

33. Ansel Adams, "Conversations with Ansel Adams," an oral history conducted 1972, 1974, 1975 by Ruth Teiser and Catherine Harroun, Regional Oral History Office, The Bancroft Library, University of California, Berkeley, 1978, 236. Courtesy of The Bancroft Library.

34. Jon Stewart, "San Francisco's Ferocious Flu Season: 1918–19," *San Francisco Chronicle,* "This World" section, November 5, 1989, 13.

35. A. Adams with M. Alinder, *Autobiography,* 54.

36. Ibid.

37. Virginia and Ansel Adams, *Illustrated Guide to Yosemite Valley* (San Francisco: H. S. Crocker Co., Inc., 1940), 76.

38. A. Adams, "Francis Holman."

39. A. Adams with M. Alinder, *Autobiography,* 54.

40. A recent scientific study to quantify the effects of nature upon man concluded that "as well as sustaining life, natural environments help foster . . . inner peace and a renewal of mental energy." Terry Hartig, Marlis Mang,

Gary W. Evans, "Restorative Effects of Natural Environment Experiences," *Environment and Behavior* 23, no. 1 (January 1991): 3–26.

41. A. Adams, "Francis Holman." Uncle Frank died in Carmel, California, on January 16, 1944.

42. John Muir, *My First Summer in the Sierra* (Boston: Houghton Mifflin Co., 1911), 116–117.

43. Horace M. Albright, *The Birth of the National Park Service,* as told to Robert Cahn (Salt Lake City: Howe Brothers, 1985), 5.

44. Brooks, "Yosemite: The Seeing Eye and the Written Word," 28.

45. Runte, *Yosemite: The Embattled Wilderness,* 3.

46. Sargent, *Yosemite: The First 100 Years,* 30.

47. "Act of August 25, 1916 (39 Stat.L.,535)—An Act to Establish a National Park Service . . . ," reprinted in Stanford E. Demars, *The Tourist in Yosemite 1855–1985* (Salt Lake City: University of Utah Press, 1991), 2.

48. Runte, *Yosemite: The Embattled Wilderness,* 12.

49. Ansel confessed that Muir bored him in a letter to David McAlpin, October 2, 1939, CCP.

50. David and Victoria Sheff, "The Playboy Interview," *Playboy,* May 1983.

3. THE DEVELOPMENT OF VISION

1. Peter E. Palmquist, "Carleton E. Watkins: Notes from the Historical Record," in *Carleton E. Watkins* (San Francisco: Fraenkel Gallery, 1989), 213–217.

2. Peter E. Palmquist, *Carleton E. Watkins, Photographer of the American West* (Albuquerque: University of New Mexico Press, 1983), 12.

3. Ibid.

4. Shirley Sargent, *Yosemite: The First 100 Years, 1890–1990* (Yosemite National Park: Yosemite Park and Curry Company, 1988).

5. Mary S. Alinder, "Carleton Watkins," in *The Focal Encyclopedia of Photography,* 3d ed. (Boston and London: Focal Press, 1993), 865.

6. Palmquist, *Carleton E. Watkins,* 217.

7. Ted Orland, *Man and Yosemite* (Santa Cruz: The Image Continuum Press, 1985), 56–58.

8. Weston J. Naef, *Era of Exploration: The Rise of Landscape Photography in the American West, 1860–1885,* in collaboration with James N. Wood (Buffalo and New York: Albright-Knox Art Gallery and The Metropolitan Museum of Art, 1975), 175.

9. Ibid., 167–176.

10. J. J. Reilly, who specialized in stereographs, established the first photography studio in the valley in 1875. Linda Wedel Greene, *Yosemite: The Park*

and Its Resources (Yosemite National Park: U.S. Department of the Interior/National Park Service, 1987), 147, 149.

11. Thomas Curran, *Fiske, the Cloudchaser* (Oakland and Yosemite: The Oakland Museum and the Yosemite Natural History Association, 1981), unpaginated.

12. Greene, *Yosemite: The Park and Its Resources,* 676.

13. Leonard Shlain, *Art & Physics: Parallel Visions in Space, Time & Light* (New York: William Morrow & Co., 1991), 100.

14. John Szarkowski, *American Landscapes* (New York: Museum of Modern Art, 1981), 6.

15. Gordon Hendricks, *Albert Bierstadt: Painter of the American West* (New York: Harrison House, 1988), 231–309.

16. Ibid., 262.

17. Ansel Adams, "The Horace M. Albright Conservation Lectureship: The Role of the Artist in Conservation," lecture given at University of California, Berkeley, College of Natural Resources, Department of Forestry & Conservation, March 3, 1975, 2.

18. Information gathered by the author in the course of many conversations with Ansel on the subject during the preparation of his autobiography.

19. Ansel Adams with Mary Street Alinder, *Ansel Adams: An Autobiography* (Boston: New York Graphic Society, 1985), 49.

20. Ansel Adams to Mary Bray, June 23, 1916, in Mary Street Alinder and Andrea Gray Stillman, eds., *Ansel Adams: Letters and Images, 1916–1984* (Boston: Little, Brown and Co., 1988), 1.

21. An entire page from the album, including the two photographs discussed, is reproduced in M. Alinder and Stillman, *Letters and Images,* facing page 1.

22. A. Adams with M. Alinder, *Autobiography,* 69.

23. Ansel Adams, "Conversations with Ansel Adams," an oral history conducted 1972, 1974, 1975 by Ruth Teiser and Catherine Harroun, Regional Oral History Office, The Bancroft Library, University of California, Berkeley, 1978, 228.

24. Ibid., 37–38.

25. Ansel Adams to Mary Bray, Summer 1917, in M. Alinder and Stillman, *Letters and Images,* 1.

26. Greene, *Yosemite: The Park and Its Resources,* 447–448.

27. Ansel Adams, *Examples: The Making of 40 Photographs* (Boston: New York Graphic Society, 1983), 49.

28. Nancy Newhall, *The Eloquent Light* (Millerton, N.Y.: Aperture, 1980), 31.

29. "Awards—Architectural Subjects, Closed October 31, 1918," *Photo-Era: The American Journal of Photography* 42 (January 1919): 32. The photograph by Ansel was not reproduced.

30. Imogen Cunningham, *Imogen Cunningham: Photographs* (Seattle and London: University of Washington Press, 1970), pl. 4.

31. Ansel Adams to Charles Adams, June 8, 1920, in M. Alinder and Stillman, *Letters and Images*, 6–8.

32. Virginia and Ansel Adams, *Illustrated Guide to Yosemite Valley* (San Francisco: H. S. Crocker Co., Inc., 1940), 45.

33. *Diamond Cascade* is reproduced in A. Adams with M. Alinder, *Autobiography*, 72.

34. H. Wallach, "Bromoil Process," in *The Focal Encyclopedia of Photography*, 62; Ansel Adams to Virginia Best, September 28, 1923, in M. Alinder and Stillman, *Letters and Images*, 17–19.

35. *Sierra Club Bulletin* 11, no. 3 (1922), plates XCI and LXXXV.

36. The earliest *book* in which Ansel's photographs appear is Katherine Ames Taylor, *Lights and Shadows of Yosemite* (San Francisco: H. S. Crocker Co., Inc., 1926).

37. *Overland Monthly* 78, no. 6 (December 1921), 23; R. R. Greenwood, "Whisperings," ibid.

 A poem by Ansel's uncle Dr. William L. Adams, who had died in 1919, appeared two pages earlier.

38. This is how Ansel usually described the situation when he lectured.

39. A. Adams with M. Alinder, *Autobiography*, 160–161.

40. Both the photograph and its verso with Ansel's handwritten price list are reproduced ibid., 161.

 Ansel did not purchase his Korona view camera with its 6½ x 8½ inch format until about 1923, but his price list of prints for the Baptist Chinese Kindergarten is written in his child's hand rather than in the studied, flowing script he had adopted by 1923, which dates this assignment to about 1920. The 6½ x 8½ camera was probably borrowed for the occasion.

41. A. Adams with M. Alinder, *Autobiography*, 73.

42. Ibid.

43. A. Adams, "Conversations," 256–258. Courtesy of The Bancroft Library.

44. Ibid.

45. Ansel Adams to Virginia Best, September 28, 1923, in M. Alinder and Stillman, *Letters and Images*, 17–19.

46. Ibid.

47. Lady Elizabeth Eastlake, "Photography," *Quarterly Review* 101 (April 1857): 442–468. Reprinted in Beaumont Newhall, *Photography: Essays & Images* (New York: The Museum of Modern Art, 1980), 91.

48. Peter Henry Emerson, *Photograms of the Year 1900*, reprinted in Beaumont Newhall, *The History of Photography, from 1839 to the Present Day* (New York: The Museum of Modern Art, 1949; rev. ed. 1980), 105.

49. Sue Davidson Lowe, *Stieglitz: A Memoir/Biography* (New York: Farrar, Straus & Giroux, 1983).

50. Doris Bry, *Alfred Stieglitz: Photographer* (Boston: Museum of Fine Arts, 1965), 14.

51. Alfred Stieglitz, "The Photo-Secession," reprinted in B. Newhall, *Photography: Essays & Images,* 167.

52. Edward Steichen, *A Life in Photography* (Garden City, N.Y.: Doubleday & Co., 1963), unpaginated.

53. Sadakichi Hartmann, "A Plea for Straight Photography," reprinted in B. Newhall, *Photography: Essay & Images,* 185–188.

54. Bry, *Alfred Stieglitz: Photographer,* 15.

55. Steichen, *A Life in Photography;* Grace M. Mayer, "Biographical Outline," in *Steichen the Photographer* (New York: The Museum of Modern Art, 1963), 69–75.

56. Maria Morris Hambourg, *The New Vision: Photography Between the Wars* (New York: The Metropolitan Museum of Art, 1989), 7.

57. Sarah Greenough, *Paul Strand: An American Vision* (New York and Washington, D.C.: Aperture Foundation and National Gallery of Art, 1990), 32–33.

58. A fine selection of Strand's photographs, including those mentioned above, are reproduced in Greenough, *Paul Strand.*

59. Paul Strand, "Photography," *Seven Arts* 2 (August 1917): 524–525, reprinted in B. Newhall, *Photography: Essays & Images,* 219–220.

60. Paul Rosenfeld, *Musical Chronicle (1917–1923)* (New York: Harcourt, Brace and Company, 1923). Inscribed in this book in Ansel's library, in his own hand, is, "Ansel E. Adams from Mrs. Sabin—Dec. 25–1925."

61. A. Adams with M. Alinder, *Autobiography,* 145.

62. Ibid., 32–37.

63. Ibid., 34.

64. Ansel Adams, foreword to Cedric Wright, *Cedric Wright: Words of the Earth,* Nancy Newhall, ed. (San Francisco: Sierra Club, 1960), 9.

65. Edward Carpenter, *Angel's Wings: A Series of Essays on Art and Its Relation to Life* (London: Swan Sonnenschein & Co., Ltd., 1898), 42–45, 64.

66. Edward Carpenter, *Towards Democracy* (London: Swan Sonnenschein & Co., Ltd., 1909).

67. Ibid., 260–261.

68. Adams, *The Role of the Artist in Conservation,* 8; A. Adams with M. Alinder, *Autobiography,* 381–385.

69. Ansel Adams to Virginia Best, September 30, 1925, reproduced in M. Alinder and Stillman, *Letters and Images,* 25–26.

70. N. Newhall, *Eloquent Light,* 34–35.

71. Nancy Newhall dates the meeting precisely to April 10, 1927, in *The Eloquent Light*, 47. However, Albert in turn introduced Ansel to the poet Robinson Jeffers, who presented the photographer with an inscribed volume of *Roan Stallion* to mark the occasion, dated June 26, 1926, suggesting that the Albert-Ansel meeting took place earlier.

72. Catherine A. Johnson, wall label for exhibition *A Time of Change: Northern California Women Artists, 1895–1920*, M. H. de Young Memorial Museum, 1991.

73. Oscar Lewis, *A Day with AMB* (San Francisco: privately published, 1932), unpaginated, in the collection of Stanford University.

74. Virginia Adams remembered that much of her jewelry, and combs for her hair, as well as a variety of objets d'art in her home, all came from Albert. Every time she saw him, he would extract some bauble from his pocket for her. She found him sweetly endearing.

75. A. Adams with M. Alinder, *Autobiography*, 84.

76. Ibid., 81–82.

77. Ibid.

78. Lewis, *A Day with AMB*.

79. N. Newhall, *Eloquent Light*, 47.

80. A. Adams with M. Alinder, *Autobiography*, 82.

81. N. Newhall, *Eloquent Light*, 30.

82. "July Contributors in Brief," *Overland Monthly* 85, no. 7 (July 1927).

83. Gump's hired Ansel in 1929. Nancy Newhall, Notes for *The Eloquent Light*, CCP.

84. Dorothea Lange, "The Making of a Documentary Photographer," an oral history conducted 1960–1961 by Suzanne B. Riess, Regional Oral History Office, The Bancroft Library, University of California, Berkeley, 1968, 113, 115. Courtesy of The Bancroft Library.

4. MONOLITH

1. Charles Adams to Ansel Adams, July 5, 1922, in Mary Street Alinder and Andrea Gray Stillman, eds., *Ansel Adams: Letters and Images, 1916–1984* (Boston: Little, Brown and Co., 1988), 13–15.

2. Anne Adams Helms, *The Descendants of David Best and Jane Eliza King Best* (Monterey, Calif.: Anne Adams Helms, 1995), 42–63.

3. In 1906, Yosemite's superintendent used Best's Studio as an example of "flimsy construction work in the valley." Linda Wedel Greene, *Yosemite: The Park and Its Resources* (Yosemite National Park: U.S. Department of the Interior/National Park Service, 1987), 468.

4. Both Harry Cassie Best paintings are reproduced in Helms, *The Descendants of David Best and Jane Eliza King Best*, 55.

5. Anne Rippey Best died July 9, 1920.

6. Virginia Adams, interview with the author, May 9, 1989.

7. Ansel Adams, "Conversations with Ansel Adams," an oral history conducted 1972, 1974, 1975 by Ruth Teiser and Catherine Harroun, Regional Oral History Office, The Bancroft Library, University of California, Berkeley, 1987, 228. Virginia Adams in conversation with the interviewers. Courtesy of The Bancroft Library.

8. Ansel Adams to Charles Adams, July 7, 1922, in M. Alinder and Stillman, *Letters and Images*, 16.

9. Nancy Newhall, *The Eloquent Light* (Millerton, N.Y.: Aperture, 1980), 37.

10. Ansel Adams to Virginia Best, September 28, 1923, in M. Alinder and Stillman, *Letters and Images*, 17–19.

11. Ansel Adams to Virginia Best, March 26, 1923, transcription by Nancy Newhall, CCP.

12. N. Newhall, *Eloquent Light*, 42.

13. Ansel Adams to Virginia Best, November 15, 1923, in M. Alinder and Stillman, *Letters and Images*, 19–20.

14. Helen LeConte, "Reminiscences of LeConte Family Outings, the Sierra Club, and Ansel Adams," an oral history conducted 1972, 1974, 1975 by Ruth Teiser and Catherine Harroun, in "Sierra Club Women II," Sierra Club History Committee, Sierra Club, San Francisco, 1977, 66. Courtesy of The Bancroft Library.

15. Ibid.

16. Ansel Adams to Virginia Best, September 30, 1925, in M. Alinder and Stillman, *Letters and Images*, 25–27.

17. Dorothy Minty, interview with Nancy Newhall, June 23, 1947, CCP.

18. Ansel Adams, records of his music students, CCP.

19. Dorothy Minty interview, CCP.

20. Ansel Adams to Virginia Best, March 11, 1927, in M. Alinder and Stillman, *Letters and Images*, 29–30.

21. Letters from Virginia Adams to Ansel Adams, April 1927, in the possession of Virginia Adams. In 1989, Virginia told me that she had a number of letters from Ansel that I had never seen and asked if I would care to read them. Of course, I said yes. Although I did not make photocopies of them, she let me take notes. We had no idea these letters existed when we made the selection for *Ansel Adams: Letters and Images*.

22. Ansel claimed that *Monolith* had been made on April 17, 1927. When I subsequently learned that April 17 that year was Easter, and the romantic day

that Ansel and Virginia had spent in Carmel, I knew he had been mistaken.

In *The Eloquent Light*, Nancy Newhall stated that *Monolith* was first reproduced on April 16, 1927, in the *Stockton Record.* The kindly central reference librarian, Sjaan VandenBroeder, of the Stockton Public Library, sent me a photocopy of the article in question (see n. 29 below). Illustrating the story are four photographs, all credited to Arnold Williams, not Ansel Adams. One is a near twin of Ansel's *Monolith*, but Williams's version has slightly different cropping, and the sky is very pale, certainly not the beneficiary of a red filter. A comparison of a vintage print of *Monolith* with the newspaper clipping reveals that Williams set up his tripod and 5 x 7-inch view camera a few feet to the left of Ansel's. Based on the date of the *Stockton Record* article, *Monolith* must have been made before April 16. The Sunday immediately before, the 10th, is most likely, since it appears that Sunday was their regular hiking day.

23. Virginia and Ansel Adams, *Illustrated Guide to Yosemite Valley* (San Francisco: H. S. Crocker Co., Inc., 1940), 18.
24. Ibid.
25. Ibid., 59.
26. Ansel Adams with Mary Street Alinder, *Ansel Adams: An Autobiography* (Boston: New York Graphic Society, 1985), 74.
27. Ansel Adams, *Examples: The Making of 40 Photographs* (Boston: New York Graphic Society, 1983), 3.
28. I am grateful to "the" Yosemite historian, Shirley Sargent, for her memory of Arnold Williams and his Yosemite connection.
29. James V. Lloyd quoting Arnold Williams, "Photographic Party Climbs Diving Board, Unusual Views Obtained from Side of Half Dome Near Top," *Stockton Record*, April 16, 1927, "Out-O-Doors" section, 1.
30. Ibid.
31. Snapshot of Ansel Adams and Virginia Best, in A. Adams with M. Alinder, *Autobiography*, 74.
32. A. Adams, *Examples*, 3–5.
33. A. Adams with M. Alinder, *Autobiography*, 74–75. Also, photograph by Arnold Williams, "Virginia Best Standing behind the 'Diving Board,'" to illustrate his article "World's Highest Diving Board," ibid.
34. Ansel Adams, *On the Heights*, reproduced in A. Adams with M. Alinder, *Autobiography*, 75.
35. Edward Carpenter, *Angel's Wings: A Series of Essays on Art and its Relation to Life* (London: Swan Sonnenschein & Co., 1898), 42–45, 64.

Ansel had not yet seen *Camera Work*, so he could not be familiar with de Zayas's statement from 1911.

36. The first exposure is reproduced in A. Adams with M. Alinder, *Autobiography*, 76, and also in Ansel Adams with Robert Baker, *The Negative* (Boston: Little, Brown and Co., 1981), 4.

37. A. Adams with R. Baker, "Visualization and Negative Values," in *The Negative*, 1–7.

38. Reproduced, with the story of its making, in A. Adams, *Examples*, 48–51.

39. Frederick R. Karl, *Modern and Modernism: The Sovereignty of the Artist 1885–1925* (New York: Atheneum, 1985), xii.

40. Edward Weston, "Random Notes on Photography," in Beaumont Newhall, *Photography: Essays & Images* (New York: The Museum of Modern Art, 1980), 223–227.

41. Ansel Adams, "The New Photography," in *Modern Photography 1934–35: The Studio Annual of Camera Art* (London and New York: The Studio Publications, Inc., 1934), 14.

42. Special dispatch to the *Chronicle*, dateline Yosemite, April 24, "Party's Trek from Verdant Valley Takes Seven Hours," *San Francisco Chronicle*, April 27, 1927.

43. LeConte, "Reminiscences," 97.

44. N. Newhall, *Eloquent Light*, 50.

45. A. Adams, "Conversations," 97. Courtesy of The Bancroft Library.

46. A. Adams with M. Alinder, *Autobiography*, 82–83.

47. Ansel Easton Adams, *Parmelian Prints of the High Sierras* (San Francisco: Jean Chambers Moore, 1927).

48. Conversation between Ansel Adams and the author.

49. Ansel Adams, Record of Expenses, CCP.

50. Virginia Adams to Ansel Adams, April 1927, in the possession of Virginia Adams.

51. Ibid. Her letters to Ansel stand in sharp contrast to his to her. Hers are full of emotions, passion, and yearning, while his describe his achievements and plans for the future.

52. Dorothy Minty interview, CCP.

53. Letter from Olive Adams to Mary Bray, January 2, 1928, in the possession of Virginia Adams.

54. Dorothy Minty interview, CCP. Bacon became a noted composer and conducted the San Jose Symphony in his own *Elegy for Ansel Adams* soon after Ansel's death.

55. N. Newhall, *Eloquent Light*, 50.

56. A. Adams with M. Alinder, *Autobiography*, 100–101.

57. Excerpt from Mariposa, California, newspaper clipping, "Miss Virginia Best Claimed as Bride," CCP.

58. Virginia Adams, interview with the author, February 1, 1988.

59. Ibid.

60. *Sierra Club Bulletin,* February 1928; Virginia Adams, interview with James Alinder, August 26–27, 1994. Virginia Adams recalled that Ansel never made motion pictures, though she thought he would have if someone had asked him to. Virginia, however, did use a movie camera, and carried one on the hike that resulted in *Monolith.*

61. A. Adams, "Conversations," 585. Courtesy of The Bancroft Library.

62. N. Newhall, *Eloquent Light,* 62.

5. SOUTHWEST

1. Ansel Adams, "Conversations with Ansel Adams," an oral history conducted 1972, 1974, 1975 by Ruth Teiser and Catherine Harroun, Regional Oral History Office, The Bancroft Library, University of California, Berkeley, 1978, 72–73.

2. Ansel Adams with Mary Street Alinder, *Ansel Adams: An Autobiography* (Boston: New York Graphic Society, 1985), 85–87.

3. Ansel Adams, *Robinson Jeffers,* frontispiece to Robinson Jeffers, *Poems by Robinson Jeffers* (San Francisco: Grabhorn Press for The Book Club of California, 1928). 310 copies were produced.

4. George Waters, *Ansel Adams 1902–1984: A Tribute by His Roxburghe Club Friends* (San Francisco: Roxburghe Club, 1984).

5. A. Adams with M. Alinder, *Autobiography,* 87–89; Nancy Newhall, *The Eloquent Light* (Millerton, N.Y.: Aperture, 1980), 47–49; Ansel Adams, *Photographs of the Southwest* (Boston: Little, Brown and Co., 1976), vii–ix.

6. N. Newhall, *Eloquent Light,* 48.

7. A. Adams, "Conversations," 184. Courtesy of The Bancroft Library.

8. Mary Austin to Ansel Adams, February 23, 1929, in Esther Lanigan Stineman, *Mary Austin* (New Haven and London: Yale University Press, 1989), 190.

9. Ibid.

10. Page Stegner, *Outposts of Eden* (San Francisco: Sierra Club Books, 1989), 23.

11. Genny Schumacher Smith, ed., *Deepest Valley* (Los Altos, Calif.: William Kaufmann Inc., 1969); Galen Rowell, *Mountain Light* (San Francisco: Sierra Club Books, 1986), 20.

12. Elliot Diringer, "The True History of the Owens Valley," *San Francisco Chronicle,* June 8, 1993, A7.

13. Taos Tribal Tourism Director, *Taos Pueblo: A Thousand Years of Tradition* (Taos, N.Mex.: Taos Pueblo, 1994).

14. Letter from Albert Bender to Mary Austin, March 23, 1929. Courtesy of F. W. Olin Library, Mills College, Bender Collection.

15. Lois Palken Rudnick, *Mabel Dodge Luhan: New Woman, New Worlds* (Albuquerque: The University of New Mexico Press, 1984), 182.

16. N. Newhall, *Eloquent Light,* 60; Ansel Adams to Charles Adams, May 26, 1929, CCP.

17. Mary Austin and Ansel Adams, *Taos Pueblo* (San Francisco: The Grabhorn Press, 1930), unpaginated.

18. Stineman, *Mary Austin,* 197.

19. Weston J. Naef, afterword to Austin and A. Adams, *Taos Pueblo* (facsimile edition; Boston: New York Graphic Society, 1977), unpaginated.

20. A. Adams, "Conversations," 570–571.

21. Reproduced in A. Adams with M. Alinder, *Autobiography,* 93, 95.

22. Ibid., 92.

23. Reproduced in Ansel Adams, *Ansel Adams: Classic Images* (Boston: New York Graphic Society, 1986), pl. 4.

24. Conversation between Ansel and Virginia Adams in 1981, while the author was present.

25. A. Adams with M. Alinder, *Autobiography,* 90.

 In July 1995, an original volume of *Taos Pueblo* sold for $21,850 at San Francisco's Pacific Book Auction. *Pacific Currents* (The Pacific Book Auction Galleries) 4, no. 1 (September 1995): 2.

26. *California Arts and Architecture* review of *Taos Pueblo,* reproduced in N. Newhall, *Eloquent Light,* 65; Stineman, *Mary Austin,* 194.

27. Bruce Altschuler, *The Avant Garde in Exhibition* (New York: Harry N. Abrams, 1994), 72.

28. Rudnick, *Mabel Dodge Luhan,* 155.

29. Mabel's house is now a bed-and-breakfast. Visitors can choose among Mabel's own room, Tony's (down a back hallway), O'Keeffe's almost monastic cell, or a whole variety of others. One of the bathrooms still sports glass windows painted in vibrant colors by D. H. Lawrence. To book a room, call 1-800-84 MABEL.

30. A. Adams, "Conversations," 180. Courtesy of The Bancroft Library.

31. Rudnick, *Mabel Dodge Luhan,* 191.

32. Ibid., 298–299.

33. A. Adams, "Conversations," 190.

34. N. Newhall, *Eloquent Light,* 60.

35. A. Adams, "Conversations," 563.

36. A. Adams with M. Alinder, *Autobiography,* 309–310.

37. Van Deren Coke, *Taos and Santa Fe: The Artist's Environment 1882–*

1942 (Albuquerque: The University of New Mexico Press, 1963), 86–88.

38. Barbara Rose, *American Painting: The Twentieth Century* (New York: Rizzoli International Publications, 1986), 29–31.

39. Ansel Adams to Virginia Adams [late August 1930], in Mary Street Alinder and Andrea Gray Stillman, eds., *Ansel Adams: Letters and Images, 1916–1984* (Boston: Little, Brown and Co., 1988), 46.

40. A. Adams with M. Alinder, *Autobiography*, 275.

41. Ibid., 237–238.

42. A. Adams, "Conversations," 181.

43. Ibid., 109.

44. Ansel Adams to Alfred Stieglitz, October 9, 1933, in M. Alinder and Stillman, *Letters and Images*, 58–61; Ansel Adams to Paul Strand, September 12, 1933, ibid., 56.

45. N. Newhall, *Eloquent Light*, 62.

46. Ansel Adams to Virginia Adams [late August 1930], in M. Alinder and Stillman, *Letters and Images*, 46.

6. STRAIGHT PHOTOGRAPHY

1. "Pictorial Photographer Show," *Washington Post*, January 11, 1931.

2. In 1923, an album of forty-five of Ansel's photographs had been included in an exhibit at the Sierra Club. Nancy Newhall, *The Eloquent Light* (Millerton, N.Y.: Aperture, 1980), 87. Beginning in 1928, Ansel had solo exhibitions at the Sierra Club's San Francisco offices: October 1–8, 1928; September 12–23, 1929 (and from September 30 to October 7 at the club's Los Angeles headquarters); and October 20–27, 1930. His annual exhibitions at the club continued through 1935.

3. Michael P. Cohen, *The History of the Sierra Club, 1892–1970* (San Francisco: Sierra Club Books, 1988), 44.

4. Francis P. Farquhar, "Mountain Studies in the Sierra: Photographs by Ansel Easton Adams with a Note about the Artist by Francis P. Farquhar," *Touring Topics* (Automobile Club of Southern California) 23 (February 1931). Ten photographs of Sierra mountains illustrate the article. Courtesy of the Farquhar family.

5. N. Newhall, *Eloquent Light*, 68–69.

6. Ansel Adams with Mary Street Alinder, *Ansel Adams: An Autobiography* (Boston: New York Graphic Society, 1985), 142. This was a total and final change, with one exception: he frugally used up his stock of Dassonville

Charcoal paper for his four Sierra Club Outing portfolios, the last made to commemorate the 1932 expedition.

7. *Anchors, San Francisco* (1931), reproduced in Andrea Gray, *Ansel Adams: An American Place* (Tucson: The Center for Creative Photography, 1982), pl. 42; *Ropes Drying on Fisherman's Wharf, San Francisco* (1931), exhibited in *Ansel Adams: One with Beauty,* at the M. H. de Young Memorial Museum, San Francisco, 1987 (private collection).

8. Reproduced in A. Adams with M. Alinder, *Autobiography,* 131; Ansel Adams, "An Exposition of My Photographic Technique," *Camera Craft* 41 (January 1934): 20.

9. Leslie Calmes, assistant archivist at the Center for Creative Photography, has determined that the *Fortnightly* first appeared on September 11, 1931, and ceased publication on May 6, 1932.

10. Ansel wrote six columns for the *Fortnightly,* only four of which were published before the magazine folded.

11. Ansel Adams, "Photography," *The Fortnightly,* November 6, 1931, 25.

12. Ansel Adams, "Photography," *The Fortnightly,* December 4, 1931, 25.

13. Reproduced in Ansel Adams with Robert Baker, *The Negative* (Boston: New York Graphic Society, 1981), 184.

14. Ansel Adams, *The Portfolios of Ansel Adams* (Boston: New York Graphic Society, 1977), pl. 6.

15. Reproduced in Ansel Adams, *Ansel Adams: Classic Images* (Boston: New York Graphic Society, 1986), pl. 7.

16. Jasmine Alinder, interview with the author, March 17, 1995.

17. Edward Weston to Ansel Adams, January 28, 1932, in Mary Street Alinder and Andrea Gray Stillman, eds., *Ansel Adams: Letters and Images, 1916–1984* (Boston: Little, Brown and Co., 1988), 48–50. Ansel Adams Archive, CCP. © Center for Creative Photography, Arizona Board of Regents, 1995.

18. Ansel Adams, "Photography," *The Fortnightly,* February 12, 1932, 26.

19. Johannes Molzahn, "Nicht mehr lesen, Sehen," *Das Kunstblatt,* 1928; reprinted in Naomi Rosenblum, *A World History of Photography* (New York: Abbeville Press, 1984), 432.

20. Richard Lorenz, *Imogen Cunningham: Ideas without End, a Life in Photography* (San Francisco: Chronicle Books, 1993), 24.

21. Nicholas Callaway, ed., *Georgia O'Keeffe: One Hundred Flowers* (New York: Alfred A. Knopf, 1987).

22. Lorenz, *Imogen Cunningham: Ideas without End,* 26–27.

23. "All Around the Town," *The Argonaut,* February 5, 1932, 10.

24. Untitled statement for solo exhibition, M. H. de Young Memorial Museum, San Francisco, February 1932, in Nancy Newhall, Notes for *The Eloquent Light,* CCP.

25. Junius Cravens, "The Art World," *The Argonaut,* February 12, 1932, 14.

26. "Yosemite Studies by Adams," *San Francisco Examiner,* June 26, 1932.

27. Virginia Adams, interview with James Alinder, August 26–27, 1994.

28. Richard Dillon, *California Trees Revisited* (Berkeley: University of California, 1981).

29. "California Trees Competition," *Camera Craft* 39 (November 1932): 481.

30. Leslie Calmes of the CCP brought to my attention an undated page, titled "ANNOUNCEMENT," in the center's William Holger Archive. This seems likely to have been the meeting that gave birth to Group f/64.

 In an article published in 1935, Group f/64 member John Paul Edwards wrote, "In August 1932 a group of photographic purists met informally at a fellow worker's studio for a discussion of the modern movement in photography." When trying to piece together history from a distancing future, one rarely finds that the story is neat and clean, though I do believe that the above "ANNOUNCEMENT" provides the more likely date. John Paul Edwards, "Group F:64," *Camera Craft* 42, no. 3 (March 1935): 107.

31. Willard Van Dyke, "Autobiography," unpublished manuscript, CCP. Read with the kind permission of Barbara Van Dyke.

32. Willard Van Dyke, Ansel Adams, and Beaumont Newhall, interview with the author, June 21, 1983.

33. "November 8, 1932," in Nancy Newhall, ed., *The Daybooks of Edward Weston: California* (New York and Rochester, N.Y.: Horizon Press and George Eastman House, 1966), 264–265.

34. James Alinder, "The Preston Holder Story," *Exposure,* February 1975, 2.

35. Van Dyke, Adams, and Newhall, interview.

36. An example of Ansel's musical writing style for the letter *f* can be seen in Ansel Adams to Beaumont Newhall, July 11, 1949, in M. Alinder and Stillman, *Letters and Images,* 210.

37. Edward Weston to Ansel Adams, n.d., CCP. From the content it is clear that this letter was written either in late September or the first two weeks of October 1932.

 In 1958, George M. Craven wrote a Master of Fine Arts thesis for Ohio University entitled "Group f/64 and Its Relation to Straight Photography in America." The San Francisco Museum of Modern Art published Craven's essay "The Group f/64 Controversy" in 1963. Following his death, Craven's wife, Rachel, was kind enough to give my husband, Jim, and me his Group f/64 files. A copy of this letter was included therein.

38. Therese Thau Heyman, "Perspective on Seeing Straight," in Therese Thau Heyman, ed., *Seeing Straight: The f.64 Revolution in Photography* (Oakland, Calif.: The Oakland Museum, 1992), 29.

39. Susan Ehrens, *Alma Lavenson Photographs* (Berkeley, Calif.: Wildwood Arts, 1990).

40. Holder became a professor of anthropology and chairman of that department at the University of Nebraska, where we became good friends during the 1970s. A brilliant and accomplished teacher, he would have been the first to admit that photography had been only a passing hobby when he knew Willard.

41. Ansel Adams, Cash Receipts, 13. CCP.

42. "Group F.64 Manifesto," in Heyman, ed., *Seeing Straight*, 53.

43. Included in Craven's files was a photocopy of the final draft of the Group f/64 manifesto with corrections in Ansel's hand.

44. For his December 18, 1931, review for the *Fortnightly*, the typed manuscript Ansel submitted contained the spelling *technic*, which the magazine's editor changed to *technique* in the published piece. Ansel's later manuscripts for the *Fortnightly* contain the Americanized spelling of *technique* to conform with the magazine's style.

45. Herm Lenz, "Interview with Three Greats," *U.S. Camera* 18, no. 8 (August 1955): 87.

46. Imogen Cunningham, "Interview with Imogen Cunningham," an oral history conducted 1972, Donated Oral Histories Collection, The Bancroft Library, University of California, Berkeley, 8. Courtesy of The Bancroft Library.

 Thirteen years earlier, Cunningham had remembered things differently: "In the main, the person who started this was Willard. I've been told that Ansel Adams claims he started it, but I would swear on my last penny that it was Willard who did it." Imogen Cunningham, "Portraits, Ideas, and Design," an oral history conducted 1959 by Edna Tartaul Daniel, Regional Oral History Office, The Bancroft Library, University of California, Berkeley, 1961, 139. Courtesy of The Bancroft Library.

47. Van Dyke, Adams, and Newhall, interview.

48. Ibid.

49. Ibid.

50. Edwards, "Group F:64," 108.

51. Ibid.; Ansel Adams, "Discussion on Filters," *U.S. Camera* 11 (October 1940): 57.

52. Ansel Adams, *Table Set*, reproduced in *Making a Photograph: An Introduction to Photography*, vol. 8 in the How to Do It Series (New York and London: The Studio Publications, Inc., 1935), pl. 23.

53. Cf. *Bridal Veil Fall, Yosemite National Park* (ca. 1927), reproduced in A. Adams, *Classic Images*, pl. 3.

54. Caption for *Nevada Fall, Yosemite Valley,* "The New Photography," in *Modern Photography 1934–35: The Studio Annual of Camera Art* (London and New York: The Studio Publications, Inc., 1934), 33.

55. Reproduced in A. Adams, *Classic Images,* pl. 11.

56. Ansel Adams, *Examples: The Making of 40 Photographs* (Boston: New York Graphic Society, 1983), 18–21.

57. A. Adams, *Making a Photograph,* pl. 23.

58. Reproduced in A. Adams, *Examples,* 10.

59. John Szarkowski, "Kaweah Gap and Its Variants," in *Ansel Adams: 1902–1984* (Carmel: The Friends of Photography, 1984), 15.

60. Ibid.

61. Lloyd LaPage Rollins to Edward Weston, March 29, 1935, CCP.

62. *California Arts and Architecture* 43 (May 1933): 6.

63. James Thurber, "Has Photography Gone Too Far?" *The New Yorker,* August 11, 1934, reprinted in Vicki Goldberg, ed., *Photography in Print: Writings from 1816 to the Present* (Albuquerque: University of New Mexico Press, 1981), 335–338.

64. Lorenz, *Imogen Cunningham: Ideas without End,* 24.

65. Whitney Chadwick, *Women Artists and the Surrealist Movement* (London: Thames and Hudson, 1985).

66. Barbara Rose, *American Painting: The Twentieth Century* (New York: Rizzoli International Publications, 1986), 23.

67. Van Dyke, Adams, and Newhall interview.

68. J. Alinder, "The Preston Holder Story," 2.

69. Ansel Adams to Edward Weston, November 29, 1934, in M. Alinder and Stillman, *Letters and Images,* 72–74; Edward Weston to Ansel Adams, December 3, 1934, ibid., 75–76.

70. Amitav Ghosh, "The Ghosts of Mrs. Gandhi," *The New Yorker,* July 17, 1995, 40.

71. A portion of this chapter was first published in Mary Street Alinder, "The Limits of Reality: Ansel Adams and Group f/64," in Heyman, ed., *Seeing Straight,* 42–50.

7. SIERRA

1. Ansel Adams, "The Horace M. Albright Conservation Lectureship: The Role of the Artist in Conservation," lecture given at University of California, Berkeley, College of Natural Resources, Department of Forestry & Conservation, March 3, 1975, 1.

2. During the summer of 1919, Ansel managed the LeConte Lodge for about ten days when that season's custodian took ill.

3. Ansell [*sic*] E. Adams, Custodian LeConte Lodge, "LeConte and Parsons Memorial Lodges," *Sierra Club Bulletin* 12, no. 1 (1921): 201–202.

4. Ansel Adams, "LeConte Memorial Lodge—Season of 1923," *Sierra Club Bulletin*, 1924, 83. Linda Wedel Greene, *Yosemite: The Park and Its Resources* (Yosemite National Park: U.S. Department of the Interior/National Park Service, 1987), 84–85.

5. Ansel Adams, "Conversations with Ansel Adams," an oral history conducted 1972, 1974, 1975 by Ruth Teiser and Catherine Harroun, Regional Oral History Office, The Bancroft Library, University of California, Berkeley, 1978, 252–253.

6. The club's statement of purpose was published in every issue of the *Sierra Club Bulletin*.

7. Doris Leonard, interview with the author, September 11, 1995.

8. Lillian Hodghead and Ada Clement, "Sierra Log, Summer of 1931," typewritten manuscript illustrated with corner-mounted snapshots. Courtesy of Sita Dimitroff Milchev, Gualala, California.

9. Ibid., 91.

10. "Exhaustos" proved to be such a hit that it was produced at least one more time, on the 1940 outing, when the "gripping Sierra tragedy, was performed by an all-star cast." Weldon F. Heald, "High and Dry—1940," *Sierra Club Bulletin* 26, no. 1 (1941): 22.

11. Hodghead and Clement, "Sierra Log," 94–95.

12. Ibid., 93.

13. Ansel and Virginia Adams, Eastman Studio Cash Book (July 30, 1931–January 6, 1936), CCP.

14. Doris Leonard interview.

15. Ansel Adams, "The Photography of Joseph N. LeConte," *Sierra Club Bulletin* 29, no. 5 (October 1944): 41–46; J. N. LeConte, "Parmelian Prints of the High Sierras," *Sierra Club Bulletin* 13 (February 1928): 96.

16. "She Won—or Maybe He Did; Anyway, He Got the Job," *San Francisco Chronicle*, 1934.

17. Ansel Adams, "TO THE BOARD OF DIRECTORS OF THE SIERRA CLUB," September 1968, in Mary Street Alinder and Andrea Gray Stillman, eds., *Ansel Adams: Letters and Images, 1916–1984* (Boston: Little, Brown and Co., 1988), 298–300.

18. Nancy Newhall, *The Eloquent Light* (Millerton, N.Y.: Aperture, 1980), 114–120. The Pacific Crest Trail became a 2,650-mile-long reality, stretching from the border of Mexico to the Canadian border. Tom Stienstra, "Pacific Coast

Trail Leads to Wonder," *San Francisco Examiner,* July 24, 1994, A1, A12.

19. Ansel Adams, "Record of Comment on Yosemite Conservation Forum," June 23, 1935, CCP.

20. The first water from Hetch Hetchy did not flow into San Francisco reservoirs until October 24, 1934, but it continues to serve today as the water-storage facility for the Bay Area's nearly two and a half million people. Carl Nolte, "Hetch Hetchy at 60 Is Still Causing Controversy," *San Francisco Chronicle,* October 27, 1994, A19–20.

21. Ansel Adams to Virginia Best, August 3, 1925, in M. Alinder and Stillman, *Letters and Images,* 22. Hikers gave letters they wanted to mail to others they met along the trail who were on their way home. This tradition was part of an unwritten code of behavior.

22. Robert L. Lipman, "The 1935 Outing," *Sierra Club Bulletin* 21, no. 1 (February 1936): 34–39.

23. Francis P. Farquhar, "Legislative History of Sequoia and Kings Canyon National Parks," *Sierra Club Bulletin* 26, no. 1 (February 1941): 55.

24. *Yosemite (California) National Park* (Washington: United States Department of the Interior, 1936).

25. Ansel Adams, *Sierra Nevada: The John Muir Trail* (Berkeley, Calif.: The Archetype Press, 1938).

26. Tom Turner, *Sierra Club: 100 Years of Protecting Nature* (New York: Harry N. Abrams, Inc., 1991), 123–125. By design, few services were allowed within Kings Canyon National Park. It remains the least developed national park in the lower forty-eight.

8. RECOGNITION

1. Andrea Gray, *Ansel Adams: An American Place, 1936* (Tucson: Center for Creative Photography, 1982), 13.

2. "Many Banks FDR Shut Will Reopen" [March 12, 1933]. Clifton Daniel, ed. *Chronicle of the 20th Century* (Mount Kisco, N.Y.: Chronicle Publications, 1987), 418.

3. Virginia Adams to Mr. and Mrs. C. H. Adams, March 29, 1933, CCP.

4. Ibid.

5. Ibid.

6. Ansel Adams, "The New Photography," in *Modern Photography 1934–35: The Studio Annual of Camera Art* (London and New York: The Studio Publications, Inc., 1934), 12.

7. Albert Bender to Ansel Adams, April 4, 1933, CCP.

8. Benita Eisler, *O'Keeffe and Stieglitz: An American Romance* (New York: Doubleday and Co., 1991), 406–408.

9. Ibid., 408–412.

10. Doris Bry, *Alfred Stieglitz: Photographer* (Boston: Museum of Fine Arts, 1965), 17–20.

11. Alexandra Arrowsmith and Thomas West, eds., *Georgia O'Keeffe & Alfred Stieglitz: Two Lives* (New York: HarperCollins Publishers/Calloway Editions, 1992).

12. Alfred Stieglitz, from the catalog of an exhibition of photographs by Alfred Stieglitz held at the Anderson Galleries, New York, 1921. Reprinted in Beaumont Newhall, *Photography: Essays & Images* (New York: The Museum of Modern Art, 1980), 217.

13. Gray, *An American Place*, 14.

14. Ansel Adams, "Conversations with Ansel Adams," an oral history conducted 1972, 1974, 1975 by Ruth Teiser and Catherine Harroun, Regional Oral History Office, The Bancroft Library, University of California, Berkeley, 1978, 55.

15. Richard Whelan, *Alfred Stieglitz: A Biography* (Boston: Little, Brown and Co., 1995), 537–548.

16. Ibid.

17. Gray, *An American Place*, 14.

18. Nancy Newhall, *The Eloquent Light* (Millerton, N.Y.: Aperture, 1980), 85.

19. Ansel Adams with Mary Street Alinder, *Ansel Adams: An Autobiography* (Boston: New York Graphic Society, 1985), 78.

20. Maria Morris Hambourg, *The New Vision: Photography between the Wars* (New York: The Metropolitan Museum of Art, 1989), 10; Marius de Zayas, "Pablo Picasso," *Camera Work* 34–35 (April–July, 1911): 65–67.

21. Whelan, *Alfred Stieglitz*, 431–434.

22. Ibid., 451.

23. Ansel Adams to Alfred Stieglitz, June 22, 1933, in Mary Street Alinder and Andrea Gray Stillman, eds., *Ansel Adams: Letters and Images, 1916–1984* (Boston: Little, Brown and Co., 1988), 50–52.

24. Virginia Adams to Ansel Adams, August 2, 1933, ibid., 54.

25. Ansel Adams to Cedric and Rhea Wright, August 5, 1933, ibid., 56.

26. Ansel Adams to Alfred Stieglitz, October 9, 1933, ibid., 58.

 In addition to the show at the de Young and the one at the Ansel Adams Gallery (September 1–16, 1933), through the efforts of Van Dyke, a traveling exhibit of Group f/64 work toured to: the Denny-Watrous Gallery, Carmel, January 1933; the Fine Arts Gallery, San Diego, July–August

1933; the Seattle Art Museum, October 4–November 6, 1933; and the Portland Museum of Art, November 1933.

With arched eyebrows, a reviewer in San Diego opined, "To be sure, the public will like them, but is it not the part of the Gallery to raise, which it does in most cases, instead of meet, the taste of the public?" Katharine Morrison Kahle, "San Diego Art and Artists," *San Diego Sun,* August 2, 1933.

27. Paul Strand to Ansel Adams, October 14, 1933, in M. Alinder and Stillman, *Letters and Images,* 61–62.

28. Alfred Stieglitz to Ansel Adams, June 28, 1933, ibid., 52–53.

29. Charles Sheeler to Ansel Adams, September 25, 1933, CCP.

30. Ansel Adams to Jean Charlot, October 7, 1933, CCP.

31. Ben Maddow, *Edward Weston: Fifty Years* (Millerton, N.Y.: Aperture, 1973), 281.

32. Howard DeVree, "Other Shows," *New York Times,* November 19, 1933.

33. John Paul Edwards, "Group F/64," *Camera Craft* 42, no. 3 (March 1935), 107–108, 110, 112–113.

34. Ansel Adams, "An Exposition of My Photographic Technique," "Landscape," "Portraiture," and "Applied Photography," *Camera Craft* (January, February, March, and April 1934).

35. Adams, "The New Photography," 9–18.

36. Beaumont Newhall, "Modern Photography, 1934–5," *The American Magazine of Art* (January 1935), 58.

37. Ansel Adams, *Making a Photograph: An Introduction to Photography,* vol. 8 in the How to Do It series (New York and London: The Studio Publications, Inc., 1935).

38. Alfred Stieglitz to Ansel Adams, May 13, 1935, in M. Alinder and Stillman, *Letters and Images,* 77. Ansel Adams Collection. Used with the permission of the Center for Creative Photography, Arizona Board of Regents.

39. Ansel and Virginia Adams, Eastman Studio Cash Book (July 30, 1931–January 6, 1936), CCP.

40. Ansel Adams to Virginia Adams, March 9, 1935, in M. Alinder and Stillman, *Letters and Images,* 76.

41. Reproduced in Gray, *An American Place,* 12 and 21.

42. N. Newhall, *Eloquent Light,* 124.

43. Ansel Adams to Virginia Adams, January 17, 1936, in M. Alinder and Stillman, *Letters and Images,* 80–81.

44. Ansel Adams, "The Meaning of Exposure: Practical Exposure," *Zeiss Magazine* 3 (June 1937): 107–109, 120; Ansel Adams, "Landscape Photography: Exposure and Development," *Zeiss Magazine* 3 (December 1937): 236–237, 243.

45. Louise Hewlett, "The 1936 Outing," *Sierra Club Bulletin* 22 (February 1937): 58–68.

46. Ibid., 60.

47. Reproduced in Gray, *An American Place*, pl. 31.

48. Ibid., pl. 38.

49. Ibid., 22.

50. Mrs. Patricia English Farbman, interview with the author, May 17, 1994, tape recording.

51. Ansel Adams to Alfred Stieglitz, October 11, 1936, in M. Alinder and Stillman, *Letters and Images*, 84.

52. Stieglitz presented solo exhibitions of his own work in 1932 and 1934–35. Whelan, *Alfred Stieglitz*, 524.

53. Gray, *An American Place*, 38.

54. Howard DeVree, "A Reviewer's Notebook: Among New Exhibitions," *New York Times*, November 1936, sec. 10, p. 9.

55. Gray, *An American Place*, 29.

56. Alfred Stieglitz to Ansel Adams, December 16, 1936, in M. Alinder and Stillman, *Letters and Images*, 88–89.

57. *The White Tombstone, Laurel Hill Cemetery, San Francisco, California* (ca. 1936) is reproduced in N. Newhall, *Eloquent Light*, 128.

58. Ansel Adams to Virginia Adams, November 11, 1936, transcribed by Nancy Newhall, CCP.

59. Ansel Adams, "My First Ten Weeks with a Contax," *Camera Craft* 43, no. 1 (January 1936), 14–20.

60. Comment attributed to Dorothy Norman, Sue Davidson Lowe, *Stieglitz: A Memoir/Biography* (New York: Farrar, Straus & Giroux, 1983), 302.

61. Ansel Adams to Alfred Stieglitz, November 27–28, 1936, in M. Alinder and Stillman, *Letters and Images*, 85–88.

9. LOSING HEART

1. Mrs. Patricia English Farbman, interview with the author, May 17, 1994, tape recording.

2. Patsy English was paid $175 from August 13 to October 31, 1936. Ansel and Virginia Adams, check register, August 10, 1934–April 2, 1937, CCP.

3. Farbman interview, 1994.

4. Ibid.

5. Ibid. In 1981, Virginia informed my husband, Jim, and me of the abortion.

6. Mrs. Farbman learned just how similar they were when she read *Ansel Adams: Letters and Images, 1916–1984* published in 1988, four years after

Ansel's death. Out of consideration for Virginia, her letters were chosen for publication, to the exclusion of the ones to Patsy.

Mrs. Farbman has given fifty-two of Ansel's letters to her, written in 1936–1938, to the Center for Creative Photography. Ansel wrote eleven letters to her during the month of November 1936 alone.

7. Ansel Adams to Alfred Stieglitz, December 15, 1936, Beinecke Library, Yale University.

8. Ansel Adams to Alfred Stieglitz, December 1936, Beinecke Library, Yale University. Dante Hospital was located at the corner of Van Ness Avenue and Broadway in San Francisco.

9. Farbman interview, 1994.

10. Ansel Adams to Cedric Wright [late December 1936], in Mary Street Alinder and Andrea Gray Stillman, eds., *Ansel Adams: Letters and Images, 1916–1984* (Boston: Little, Brown and Co., 1988), 92–93.

11. Patricia English Farbman, interview with the author, September 7, 1995; Adams to Stieglitz, December 1936, Yale University.

12. Farbman interview, 1994.

13. Adams to Wright [late December 1936], ibid.

14. Ansel Adams to Alfred Stieglitz, January 29, 1937, Beinecke Library, Yale University.

15. Ansel and Virginia Adams, check register, August 10, 1934–April 2, 1937, CCP.

16. Ansel Adams to Alfred Stieglitz, February 10, 1937, Beinecke Library, Yale University.

17. Ansel Adams to Alfred Stieglitz, February 17, 1937, Beinecke Library, Yale University.

18. Ansel Adams to Alfred Stieglitz, March 3, 1937, Beinecke Library, Yale University. They lived at 2730 Buena Vista Way.

19. Ansel Adams to Alfred Stieglitz, March 21, 1937, Beinecke Library, Yale University.

20. Ansel Adams to Alfred Stieglitz, January 3, 1937, Beinecke Library, Yale University.

It seems likely that Ansel's parents, Harry Best, or Albert Bender picked up the tab for Dante Hospital, as Ansel and Virginia's check register for that time records only one payment of $15 from them. They did pay St. Francis Hospital a total of $209.80, with three checks dated between February 2, 1937, and March 30, 1937. Ansel and Virginia Adams check register, August 10, 1934–April 2, 1937, CCP.

21. Notes from interview with Virginia Adams by Nancy Newhall, May 12, 1947, CCP.

22. Virginia Adams, interview with the author, May 17, 1988.

23. Ibid.

24. Farbman interview, 1994.

25. Ibid.

26. Ibid.

27. Nancy Newhall, *The Eloquent Light* (Millerton, N.Y.: Aperture, 1980), 134.

28. Shirley Sargent, *Yosemite & Its Innkeepers* (Yosemite: Flying Spur Press, 1975), 82–83.

29. Ibid, 44–45.

30. Edwin Kiester, Jr., "A Christmas That Never Was," *Modern Maturity*, December 1991–January 1992, 30–34, 88–91.

31. Shirley Sargent, *The Ahwahnee Hotel* (Yosemite: Yosemite Park and Curry Company, 1990), 40–41.

32. Andrea Fulton, *The Bracebridge Dinner* (Yosemite: Yosemite Park and Curry Company, 1983), 7.

33. Ansel Adams with Mary Street Alinder, *Ansel Adams: An Autobiography* (Boston: New York Graphic Society, 1985), 182–183.

34. Donald B. Tresidder to Ansel Adams, November 18, 1929, Yosemite National Park Research Library (hereinafter cited as YNPRL).

35. Fulton, *The Bracebridge Dinner*, 31–33.

36. Ibid., 33–35. Ansel finally retired from the Bracebridge in 1973, having missed only the years of World War II and two occasions when winter flooding interfered. The Bracebridge Dinner has become so popular that seats can only be had through a public lottery.

37. *Life* 5, no. 26 (December 26, 1938), cover, 16.

38. Ansel Adams to Donald B. Tresidder, November 1, 1929, YNPRL.

39. Donald Tresidder to Ansel Adams, November 18, 1929, YNPRL.

40. Sargent, *Yosemite & Its Innkeepers*, 119–121.

41. Ansel Adams to Virginia Adams, February 28, 1930, in M. Alinder and Stillman, *Letters and Images*, 42–45; Ansel Adams, "Ski-Experience," *Sierra Club Bulletin* 16 (February 1931): 44–46, plus six photographic reproductions.

42. Tresidder's original set of ski pictures by Ansel is in the collection of the Museum of Art, Stanford University. Reproductions can be seen in "Ski-Experience," *Sierra Club Bulletin*, February 1931; A. Adams with M. Alinder, *Autobiography*, 187; and M. Alinder and Stillman, *Letters and Images*, 43.

43. Records of Yosemite Park and Curry Company, YNPRL.

44. Ansel Adams, "Conversations with Ansel Adams," an oral history conducted 1972, 1974, 1975 by Ruth Teiser and Catherine Harroun, Regional Oral History Office, The Bancroft Library, University of California, Berkeley, 1978, 375.

45. Robert. Silberman, "Scaling the Sublime: Ansel Adams, the Kodak Colorama and 'The Large Print Idea'" in Michael Read, ed., *Ansel Adams: New Light* (San Francisco: The Friends of Photography, 1993), 33–41; Lincoln Kirstein and Julien Levy, *Murals by American Painters and Photographers* (New York: Museum of Modern Art, 1932).

46. Richard Whelan, *Alfred Stieglitz: A Biography* (Boston: Little, Brown and Co., 1995), 537.

47. A. Adams with M. Alinder, *Autobiography*, 187.

48. Ansel Adams, "Photo-Murals," *U.S. Camera* 1, no. 12 (November 1940), 52–53, 61–62, 71–72.

49. Ansel Adams to Donald B. Tresidder, July 3, 1938, YNPRL.

50. Ibid. Virginia Adams to Stanley Plumb, August 29, 1938, YNPRL.

51. Ansel Adams to Alfred Stieglitz, November 12, 1937, in M. Alinder and Stillman, *Letters and Images*, 101–103.

52. Ansel Adams to Yosemite Park and Curry Company, November 21, 1938, YNPRL.

53. Donald B. Tresidder to Stanley Plumb, August 15, 1938, YNPRL.

54. Ansel Adams to Donald B. Tresidder, November 21, 1938, YNPRL.

55. Tresidder to Plumb, August 15, 1938, YNPRL.

56. Photographed by Ansel Adams, Edited by Stanley Plumb, *The Four Seasons in Yosemite National Park: A Photographic Story of Yosemite's Spectacular Scenery* (Yosemite: Yosemite Park and Curry Company, 1936).

57. Ansel Adams, witnessed by Virginia Adams, to Donald B. Tresidder, April 25, 1939, YNPRL.

58. Eliot Porter, *Eliot Porter* (Boston: New York Graphic Society, 1987), 27.

59. Ibid., 30. Three of Porter's photographs that were exhibited at An American Place are reproduced, on pages 28, 29, and 31.

60. Andrea Gray, *Ansel Adams: An American Place, 1936* (Tucson: Center for Creative Photography, 1982), 32.

61. David McAlpin to Alfred Stieglitz, January 7, 1939, Beinecke Library, Yale University.

62. Nancy Newhall, "Alfred Stieglitz: Notes for a Biography," in *From Adams to Stieglitz: Pioneers of Modern Photography* (New York: Aperture, 1989).

10. FRIENDS

1. Nancy Newhall, *The Eloquent Light* (Millerton, N.Y.: Aperture, 1980), 131.

2. Beaumont Newhall, *Focus: A Life in Photography* (Boston: Little, Brown and Co., 1993), 20–39.

3. Ibid., 45.

4. Beaumont Newhall, *Photography 1839–1937* (New York: The Museum of Modern Art, 1937), 11–27.

5. B. Newhall, *Focus,* 34–37.

6. Ibid., 46–47.

7. Analysis of the checklist of *Photography 1839–1937.*

8. Beaumont Newhall to Ansel Adams, January 3, 1937, CCP; N. Newhall, *Eloquent Light,* 131.

9. B. Newhall, *Focus,* 45.

10. Excerpt from review of exhibition by Edward Alden Jewell, in B. Newhall, *Focus,* 51.

11. Henry McBride, review in *New York Sun,* in B. Newhall, *Focus,* 52–53.

12. N. Newhall, *Eloquent Light,* 136; Ansel Adams, "The New Expanding Photographic Universe," in Willard D. Morgan and Henry M. Lester, eds., *Miniature Camera Work* (New York: Morgan & Lester, 1938), 69–75.

13. N. Newhall, *Eloquent Light,* 134–135.

14. Francis P. Farquhar, foreword to the first edition, and Richard M. Leonard, "Walter A. Starr, Sr.," in Walter A. Starr, Jr., *Starr's Guide to the John Muir Trail and the High Sierra Region* (San Francisco: Sierra Club Books, 1974).

15. Ansel Adams to Patsy English, July 19, 1937, CCP.

16. Charis Wilson Weston and Edward Weston, *California and the West* (New York: Duell, Sloan and Pearce, 1940), 13. This is an account of their Guggenheim travels, text by Charis and photographs by Edward.

17. N. Newhall, *Eloquent Light,* 136.

18. "Notes on Art," *San Francisco Examiner,* August 15, 1937, E5.

19. Rondal Partridge, interviews with the author, March 25, 1988, and November 13, 1995. Partridge was Ansel's photographic assistant from 1937 to 1939.

20. Ansel Adams to Arno B. Cammerer, Director, National Park Service, May 29, 1937, Yosemite National Park Research Library.

21. C. and E. Weston, *California and the West,* 59.

22. Ibid., 60–61. Courtesy of Charis Wilson.

23. Edward Weston, *Charis, Lake Ediza,* reproduced as a plate between pages 48 and 49 of *California and the West.*

24. Ansel Adams, *Detail, Devil's Postpile,* pl. 8; Ansel Adams, *Sierra Nevada: The John Muir Trail,* plate xiii.

25. C. and E. Weston, *California and the West,* 64. Courtesy of Charis Wilson.

26. Ibid., 65–66.

27. Rondal Partridge interviews.

28. Ibid.

29. C. and E. Weston, *California and the West,* 66. Courtesy of Charis Wilson.

30. Edward Weston to Ansel Adams [1937], Mary Street Alinder and Andrea Gray Stillman, eds., *Ansel Adams: Letters and Images, 1916–1984* (Boston:

Little, Brown and Co., 1988), 104. Ansel Adams Archive, CCP. © Center for Creative Photography, Arizona Board of Regents, 1995.

31. Rondal Partridge interviews.
32. Ibid.
33. Ansel Adams to Nancy Newhall, April 15, 1961, in M. Alinder and Stillman, *Letters and Images*, 273.
34. Ansel Adams to Alfred Stieglitz, September 21, 1937, ibid., 98.
35. Roxana Robinson, *Georgia O'Keeffe: A Life* (New York: Harper & Row Publishers, 1989), 406–429.
36. Ansel Adams to Alfred Stieglitz, September 21, 1937, in M. Alinder and Stillman, *Letters and Images*, 98.
37. Ansel Adams to Patsy English, September 22, 1937, CCP.
38. Robinson, *Georgia O'Keeffe*, 417.
39. Ansel Adams, *Examples: The Making of 40 Photographs* (Boston: New York Graphic Society, 1983), 152–157. *Georgia O'Keeffe and Orville Cox* is reproduced on page 152.
40. The 35mm proof sheet is reproduced in M. Alinder and Stillman, *Letters and Images*, 99.
41. Ansel Adams with Mary Street Alinder, *Ansel Adams: An Autobiography* (Boston: New York Graphic Society, 1985), 196. *Aspens, Dawn, Dolores River Canyon* is reproduced on page 234 of the same book.
42. Georgia O'Keeffe to William Einstein, July 19, 1938, in Jack Coward and Juan Hamilton, with letters selected and annotated by Sarah Greenough, *Georgia O'Keeffe: Art and Letters* (Washington, D.C.: National Gallery of Art, 1987), 224, 226.
43. Ansel Adams to David McAlpin, April 4, 1938, CCP.
44. Ansel Adams to Alfred Stieglitz, March 15, 1938, CCP.
45. Nancy Newhall, "The Enduring Moment" [unpublished manuscript draft for the proposed second volume of her biography of Ansel Adams], 145. Beaumont Newhall provided the author with a copy of the manuscript.
46. Ansel Adams to David McAlpin, July 11, 1938, in M. Alinder and Stillman, *Letters and Images*, 104–107.
47. N. Newhall, *Eloquent Light*, 154.
48. Michael Robertson, "Beaux Arts Ball: Time to Celebrate City's Life and Joy," *San Francisco Chronicle*, November 7, 1989.
49. N. Newhall, *Eloquent Light*, 150.
50. "Architectural Masquerade," *Northern California Home & Garden*, November 1990, 48–50.
51. N. Newhall, *Eloquent Light*, 150.
52. A. Adams with M. Alinder, *Autobiography*, 185.
53. Handwritten notes by Nancy Newhall for *The Eloquent Light*, CCP.

54. Ansel Adams to Alfred Stieglitz, July 30, 1938, CCP.

55. Ansel Adams to Georgia O'Keeffe, July 30, 1938, CCP.

56. Ansel Adams to Patsy English, July 13, 1938, CCP.

57. David Hunter McAlpin, "Photographic Experiences with Ansel Adams," in Ansel Adams, *Singular Images* (Boston: Little, Brown and Co., 1974), unpaginated.

58. Ansel Adams to Alfred Stieglitz, September 10, 1938, in M. Alinder and Stillman, *Letters and Images*, 107–108.

59. A. Adams with M. Alinder, *Autobiography*, 228–230.

60. McAlpin, "Photographic Experiences with Ansel Adams."

61. A. Adams with M. Alinder, *Autobiography*, 229–230.

62. Ibid., 231.

63. N. Newhall, *Eloquent Light*, 163.

64. Ansel Adams, "Conversations with Ansel Adams," an oral history conducted 1972, 1974, 1975 by Ruth Teiser and Catherine Harroun, Regional Oral History Office, The Bancroft Library, University of California, Berkeley, 1978, 570.

65. "Ansel Adams Speaks at League!" *photo notes* (Photo League, December 1940), 3.

66. Ansel Adams, "Letter to the Editor," *U.S. Camera* 11 (October 1940): 9.

67. Ansel Adams to Georgia O'Keeffe, November 11, 1938, CCP; Ansel Adams to Edward Weston [November 1938], CCP; Ansel Adams to David McAlpin, November 4, 1938, CCP.

68. N. Newhall, *Eloquent Light*, 162.

69. Wilder Bentley, "Photography and the Fine Book," *U.S. Camera* 14 (February 1941): 67–68, 72.

70. N. Newhall, *Eloquent Light*, 165.

71. Alfred Stieglitz to Ansel Adams, December 22, 1938, in M. Alinder and Stillman, *Letters and Images*, 111; Georgia O'Keeffe to Ansel Adams, December 22, 1938, CCP.

72. Francis Farquhar, "Sierra Nevada by Ansel Adams," *Sierra Club Bulletin* 24, no. 3 (June 1939): 140. Courtesy of the Farquhar family.

11. PROGRESS

1. Beaumont Newhall, *Focus: A Life in Photography* (Boston: Little, Brown and Co., 1993), 57–58; Beaumont Newhall to Ansel Adams, February 7, 1939, in Mary Street Alinder and Andrea Gray Stillman, eds., *Ansel Adams: Letters and Images, 1916–1984* (Boston: Little, Brown and Co., 1988), 113; Ansel Adams to David McAlpin, February 14, 1939, ibid., 113–114.

2. N. Newhall, "The Enduring Moment" [unpublished manuscript], 26–27.

3. B. Newhall, *Focus*, 57–58.

4. Ansel Adams, "Conversations with Ansel Adams," an oral history conducted 1972, 1974, 1975 by Ruth Teiser and Catherine Harroun, Regional Oral History Office, The Bancroft Library, University of California, Berkeley, 1978, 63.

5. N. Newhall, "The Enduring Moment," 43.

6. "Vision in Motion: The Photographs of László Moholy-Nagy," The J. Paul Getty Museum Calendar, summer 1995.

7. László Moholy-Nagy, *Vision in Motion* (Chicago: Paul Theobald and Company, 1965), 177.

8. Krisztina Passuth, *Moholy-Nagy* (New York: Thames & Hudson, 1985).

9. László Moholy-Nagy, *The New Vision and Abstract of an Artist* (New York: Wittenborn and Company, 1946), 72.

10. Moholy-Nagy, *Vision in Motion*, 28.

11. N. Newhall, "The Enduring Moment," 38.

12. B. Newhall, *Focus*, 56; Ansel Adams with Mary Street Alinder, *Ansel Adams: An Autobiography* (Boston: New York Graphic Society, 1985), 194–195.

13. N. Newhall, "The Enduring Moment," 39–40.

14. Ibid.

15. B. Newhall, *Focus*, 57.

16. Ibid., 56.

17. Ansel Adams to David McAlpin, November 4, 1938, in M. Alinder and Stillman, *Letters and Images*, 108–111.

18. Belinda Rathbone, *Walker Evans: A Biography* (New York: Houghton Mifflin Co., 1995), 39–40.

19. Ansel Adams to David McAlpin, October 2, 1939, CCP; Ansel Adams to Alfred Stieglitz, October 2, 1939, CCP.

20. Ansel Adams to David McAlpin, July 29, 1939, CCP.

21. Ansel Adams to Alfred Stieglitz, August 10, 1939, CCP.

22. Virginia and Ansel Adams, *Michael and Anne in the Yosemite Valley* (New York and London: The Studio Publications, Inc., 1941).

23. Virginia and Ansel Adams, *Illustrated Guide to Yosemite Valley* (San Francisco: H. S. Crocker Co., Inc., 1940); Virginia and Ansel Adams, *Illustrated Guide to Yosemite* (San Francisco: Sierra Club Books, 1963).

24. A. Adams, "Conversations," 408–409.

25. Checklist for the exhibit Recent Photography of Ansel Adams, San Francisco Museum of Art, September 19–October 15, 1939, museum files.

26. Alfred Frankenstein, "Three Men and a Master," *San Francisco Chronicle*, "This World" section, October 1, 1939, 22.

27. Jack James and Earle Weller, *Treasure Island, "The Magic City," 1939–1940: The Story of the Golden Gate International Exposition* (San Francisco: Pisani Printing and Publishing Company, 1941), 3.
28. A. Adams, "Conversations," 114.
29. Ibid. Courtesy of The Bancroft Library.
30. Ansel Adams, *A Pageant of Photography* (San Francisco: Crocker-Union, 1940), unpaginated.
31. A. Adams, "Conversations," 114. Courtesy of The Bancroft Library.
32. James and Weller, *Treasure Island*, XLIV.
33. Beaumont Newhall, "Photography as an Art," in A. Adams, *A Pageant of Photography*.
34. A. Adams, "Conversations," 396. Courtesy of The Bancroft Library.
35. Ibid.
36. V. and A. Adams, *Illustrated Guide to Yosemite Valley*, 102.
37. Ansel Adams to Arno B. Cammerer, Director, National Park Service, October 2, 1939, Yosemite National Park Research Library.
38. N. Newhall, "The Enduring Moment," 71–72.
39. "The U.S. Camera Yosemite Photographic Forum," *U.S. Camera* 1, no. 9 (April–May 1940): 49–60.
40. N. Newhall, "The Enduring Moment," 94.
41. Ibid., 96.
42. Ibid., 98.
43. Ansel Adams, *Examples: The Making of 40 Photographs* (Boston: New York Graphic Society, 1983), 22–27.
44. I witnessed Ansel's last printing of *Surf Sequence* in 1982.
45. N. Newhall, "The Enduring Moment," 100.
46. Ibid., 101–102.
47. Ibid., 102.

12. A DEPARTMENT OF PHOTOGRAPHY

1. Beaumont Newhall, *Focus: A Life in Photography* (Boston: Little, Brown and Co., 1993), 64.
2. David McAlpin to Ansel Adams, September 7, 1940, in Mary Street Alinder and Andrea Gray Stillman, eds., *Ansel Adams: Letters and Images, 1916–1984* (Boston: Little, Brown and Co., 1985), 119–120.
3. B. Newhall, *Focus*, 65; Nancy Newhall, "The Enduring Moment" [unpublished manuscript], 124.
4. Ansel Adams to David McAlpin, September 9, 1940, CCP.
5. Nancy Newhall, "The Photographer and Reality" [unpublished manuscript,

ca. 1951], 6. Beaumont Newhall generously allowed me to make a copy of this manuscript.

6. N. Newhall, "The Enduring Moment," 124–141.

7. Ibid., 145.

8. David H. McAlpin, "The New Department of Photography," in *The New Department of Photography* (New York: The Museum of Modern Art, 1940), 3.

9. B. Newhall, *Focus*, 65.

10. "Checklist," in *The New Department of Photography*, 6–7.

11. N. Newhall, "The Enduring Moment," 140.

12. B. Newhall, *Focus*, 65.

13. Beaumont Newhall to Ansel Adams, January 1, 1941, in M. Alinder and Stillman, *Letters and Images*, 123–124.

14. *Time* magazine, January 6, 1941.

15. Tom Maloney, "Museum of Modern Art's Photo Department," *U.S. Camera* 1, no. 14 (February 1941): 28, 82.

16. Ibid.

17. Nancy Newhall, "Alfred Stieglitz: Notes for a Bibliography," in *From Adams to Stieglitz* (New York: Aperture, 1989), 97. Copyright Nancy Newhall, Beaumont and Nancy Newhall Estate, courtesy of Scheinbaum & Russek Ltd., Santa Fe, New Mexico.

18. N. Newhall, "The Enduring Moment," 142.

19. Ansel Adams to David McAlpin, March 4, 1941, CCP.

20. N. Newhall, "The Enduring Moment," 163–164.

21. Ansel Adams, "Conversations with Ansel Adams," an oral history conducted 1972, 1974, 1975 by Ruth Teiser and Catherine Harroun, Regional Oral History Office, The Bancroft Library, University of California, Berkeley, 1978, 353–354.

22. N. Newhall, "The Enduring Moment," 172–173.

23. Ibid., 176.

24. Beaumont Newhall to Ansel Adams, July 22, 1941, CCP.

25. John Pultz, "Ansel Adams and Harry Callahan: A Case Study of Influence," in Michael Read, ed., *Ansel Adams: New Light* (San Francisco: The Friends of Photography, 1993), 43–49.

26. Quote from workshop participant Don Shapero, ibid., 45.

27. Ibid. For visual comparisons of *Surf Sequence* (1940) to Callahan's *Highland Park, Michigan* (1941), and the below-mentioned Adams image *Grass and Water, Tuolumne Meadows, Yosemite National Park* (1935) to Callahan's *Weeds in Snow* (1943), see pl. 10–13.

28. N. Newhall, "The Enduring Moment," 179–180.

29. Maloney, "Museum of Modern Art's Photo Department," 28.

30. N. Newhall, *From Adams to Stieglitz*, 101.

31. Ansel Adams to Beaumont and Nancy Newhall, October 26, 1941, CCP. An abridged version without his remarks on the death of their baby is reproduced in M. Alinder and Stillman, *Letters and Images*, 131–133.

32. N. Newhall, "The Enduring Moment," 188.

33. A. Adams, "Conversations," 351–352.

34. Ansel Adams to Edward Steichen, June 1942, N. Newhall, "The Enduring Moment," 207.

35. K. Patrick Conner, "Horace Bristol: Photographs" [unpublished manuscript], San Francisco, 1995.

36. Ansel Adams to Nancy Newhall, 1943, in M. Alinder and Stillman, *Letters and Images*, 143; Ansel Adams with Mary Street Alinder, *Ansel Adams: An Autobiography* (Boston: New York Graphic Society, 1985), 257.

37. Ansel Adams, *Half Dome and Cannons, Yosemite National Park* (ca. 1943), reproduced in A. Adams and M. Alinder, *Autobiography*, 258.

38. "Exhibitions, Photography Center, American Photographs at $10, December 3, 1941–January 4, 1942," *Bulletin of the Museum of Modern Art* 2, no. 11 (October–November 1943): 14–16.

39. Beaumont Newhall, *The History of Photography, from 1839 to the Present Day* (New York: The Museum of Modern Art, 1949), 85.

40. Ibid., 89–90. Copyright Beaumont Newhall, Beaumont and Nancy Newhall Estate, courtesy of Scheinbaum & Russek Ltd., Santa Fe, New Mexico.

41. David Scheinbaum, interview with the author, October 3, 1995.

42. William H. and William N. Goetzmann, *The West of the Imagination* (New York and London: W. W. Norton & Co., 1986), 170–182.

43. B. Newhall, *Focus*, 68.

44. N. Newhall, "The Enduring Moment," 199; B. Newhall, *Focus*, 68.

45. N. Newhall, "The Enduring Moment," 199.

46. B. Newhall, *Focus*, 71–97.

47. Beaumont Newhall to Ansel Adams, August 18, 1942, CCP; N. Newhall, "The Enduring Moment," 212.

48. N. Newhall, "The Enduring Moment," 212.

49. Ansel Adams to Nancy Newhall, September 14, 1942, in M. Alinder and Stillman, *Letters and Images*, 137–138.

50. Ansel Adams to Nancy Newhall, September 14, 1942, in N. Newhall, "The Enduring Moment," 214.

51. B. Newhall, *Focus*, 137.

52. Edward Steichen, *A Life in Photography* (Garden City, N.Y.: Doubleday & Co., 1963), unpaginated.

53. "Exhibitions, Photography Center," *Bulletin of the Museum of Modern Art* 2, no. 11:16.

54. Edward Alden Jewell, "Road to Victory," *New York Times,* May 21, 1942, reproduced in Grace M. Mayer, "Biographical Outline," in *Steichen the Photographer* (New York: The Museum of Modern Art, 1961), 73.

55. Beaumont Newhall to Ansel Adams, June 3, 1942, in M. Alinder and Stillman, *Letters and Images,* 134.

56. *Art in Progress* (New York: The Museum of Modern Art, 1944). Exhibition catalog.

57. N. Newhall, "The Enduring Moment," 301.

58. A portrait of Stieglitz made that day is reproduced in Ansel Adams, *Ansel Adams: Classic Images* (Boston: New York Graphic Society, 1986), pl. 18. One of Ansel's photographs of Nancy and Stieglitz from that afternoon is reproduced in M. Alinder and Stillman, *Letters and Images,* 159.

59. Nancy Newhall to Beaumont Newhall, June 7, 1944, quoted in B. Newhall, *Focus,* 105–106.

60. N. Newhall, "The Enduring Moment," 254.

61. Nancy Newhall to Beaumont Newhall, June 4, 1944, quoted in B. Newhall, *Focus,* 120. Copyright Nancy Newhall, Beaumont and Nancy Newhall Estate, courtesy of Scheinbaum & Russek Ltd., Santa Fe, New Mexico.

62. N. Newhall, "The Enduring Moment," 256–257.

63. Ibid., 261, 264.

64. Ibid., 262.

65. Ibid.

66. Ibid., 263.

67. Ibid., 271.

68. Ibid., 273.

69. A. Adams, "Conversations," 354–355.

70. "Ansel Adams Teaches," *The Art Digest,* February 1, 1945, 14.

71. N. Newhall, "The Enduring Moment," 296.

72. Ansel Adams to Beaumont Newhall, February 9, 1945, CCP.

73. N. Newhall, "The Enduring Moment," 297.

74. Ibid., 301.

75. Ibid., 306.

76. Clifton Daniel, ed., *Chronicle of the 20th Century* (Mount Kisco, N.Y.: Chronicle Publications, 1987), 592.

77. B. Newhall, *Focus,* 143.

78. Peter C. Bunnell, interview with the author, November 5, 1995. Bunnell holds the David H. McAlpin Chair in the History of Photography and Modern Art at Princeton University.

79. B. Newhall, ibid., 149.

80. Beaumont Newhall to Ansel Adams, February 23, 1946, quoted in B. Newhall, *Focus,* 373.

81. Ansel Adams to Beaumont Newhall, February 28, 1946, quoted in B. Newhall, *Focus*, 378.
82. Beaumont Newhall to Ansel Adams, March 7, 1946, in M. Alinder and Stillman, *Letters and Images*, 167–168. Copyright Beaumont Newhall, Beaumont and Nancy Newhall Estate, courtesy of Scheinbaum & Russek Ltd., Santa Fe, New Mexico.
83. N. Newhall, "The Enduring Moment," 382.
84. Bunnell interview.

13. MOONRISE

1. Reproductions of *Moonrise* are easy to find, from the laser-scanned, duotone poster to plates in many of Ansel's books, including *Examples*, p. 40; *Classic Images*, pl. 32; and *Ansel Adams: An Autobiography*, p. 274.
2. Marty Esquivel, "Moonrise over Hernandez," *New Mexico*, October 1991, 84–89.
3. Ansel Adams with Mary Street Alinder, *Ansel Adams: An Autobiography* (Boston: New York Graphic Society, 1985), 382.
4. Peter Wright and John Armor, *The Mural Project* (Santa Barbara: Reverie Press, 1989), iv.
5. Ibid.
6. Ansel Adams, *Fresh Snow, Yosemite Valley, California,* is reproduced in *The Portfolios of Ansel Adams* (Boston: New York Graphic Society, 1977). Ansel made a total of only thirteen screens; they are very special and rare.
7. Hiring Card for Ansel Adams, Yosemite National Park, Calif., by the U.S. Department of the Interior, National Park Service, Yosemite National Park, October 14, 1941, Yosemite National Park Research Library (hereinafter YNPRL).
8. Nancy Newhall, "The Enduring Moment" [unpublished manuscript], 188.
9. Virginia Adams, interview with Nancy Newhall, May 12, 1947, CCP. This has also been confirmed by a number of friends and colleagues of Virginia and Ansel's from that time.
10. Notes by Nancy Newhall for "The Enduring Moment," CCP.
11. Virginia Adams to Ansel Adams, September 20, 1941, in the possession of Virginia Adams. See note 21 on page 404.
12. Ansel Adams to Beaumont and Nancy Newhall, October 21, 1941, in Mary Street Alinder and Andrea Gray Stillman, eds., *Ansel Adams: Letters and*

Images, 1916–1984 (Boston: Little, Brown and Co., 1985), 131–133; N. Newhall, "The Enduring Moment," 188.

13. A. Adams with M. Alinder, *Autobiography*, 272–273.

14. Ansel Adams to Virginia Adams, October 28, 1941, in the possession of Virginia Adams.

15. Ansel Adams to Newton Drury, October 20, 1941, quoted in N. Newhall, "The Enduring Moment," 182.

16. A. Adams with M. Alinder, *Autobiography*, 273.

17. Ansel's first version had ten zones. In 1980, with the publication of *The Negative*, he changed to the more symmetrical eleven zones, roman numerals 0–X.

18. Ansel Adams, *Examples: The Making of 40 Photographs* (Boston: New York Graphic Society, 1983), 40–43.

19. Ansel Adams to Virginia Adams, November 1941, in the possession of Virginia Adams.

20. Ansel Adams, "Conversations with Ansel Adams," an oral history conducted 1972, 1974, 1975 by Ruth Teiser and Catherine Harroun, Regional Oral History Office, The Bancroft Library, University of California, Berkeley, 1978, 380–381; A. Adams with M. Alinder, *Autobiography*, 275–276.

21. Photo Judge: Lt. Comdr. Edward Steichen, U.S.N.R., *U.S. Camera, 1943*, T. J. Maloney, ed. (New York: Duell, Sloan & Pearce, 1942), 88–89.

22. *Art in Progress* (New York: The Museum of Modern Art, 1944), 147.

23. Registration card for the Department of Photography, Museum of Modern Art, New York, #688.43.

24. Ansel Adams to David McAlpin, January 10, 1943, in M. Alinder and Stillman, *Letters and Images*, 141.

25. I believe that at least two other very early *Moonrise* prints made before 1948 still exist. One is in the collection of Ansel's son, Michael; the other is currently in a private collection.

26. Ansel Adams to Nancy Newhall, December 17, 1948, in M. Alinder and Stillman, *Letters and Images*, 200.

27. Stewart McBride, "Ansel," *American Photographer* 4, no. 6 (December 1980): 60.

28. This amount was arrived at by simply multiplying 1,300 by an average price of $400. Ansel sold *Moonrise* for prices ranging from fifty dollars, in the beginning, to twelve hundred during the last months that he took print orders, in 1975. Most of the prints made from 1970 onward were sold through dealers, who normally gross 50 percent of each sale.

29. Ansel Adams, "Information on Professional Work," 1967, CCP. A check of catalogs and price lists over the years from such businesses as the Witkin

Gallery, LIGHT gallery, Graphics International, the Weston Gallery, Carl Siembab Gallery, Grapestake, the Ansel Adams Gallery, G. Ray Hawkins, Sotheby's, Christie's, Swann, and Butterfield & Butterfield yielded this information.

30. "Pictures Are Worth More Than Just Words," *World Business Weekly*, December 15, 1980, 46–47.

31. Cynthia Salzman, "Photograph Market Retreats from Highs; Even Ansel Adams's Work Is Vulnerable," *Wall Street Journal*, June 1981.

32. Sean Callahan, "Countdown to Moonrise," *American Photographer*, January 1981, 30–31.

33. Dennis di Cicco, "Dating Ansel Adams' *Moonrise*," *Sky & Telescope* 82, no. 5 (1991): 531.

34. Allan Parachini, "The Disputed Legacy of Ansel Adams: Someone Could Also Ask, Who Owns 'Moonrise'?" *Los Angeles Times*, June 5, 1989, section 6, 1, 12.

35. Ansel Adams to Mr. E. K. Burlew, First Asst. Secretary, and Mr. Newton Drury, Director of the National Park Service, U.S. Dept. of the Interior, March 4, 1942. YNPRL; Ansel Adams to E. K. Burlew, August 18, 1942, YNPRL; E. K. Burlew to Ansel Adams, September 30, 1942, YNPRL.

36. Ansel Adams to E. K. Burlew, August 18, 1942, YNPRL.

37. E. K. Burlew to Ansel Adams, September 30, 1942, YNPRL.

38. Of the eighty-six pictures reproduced in Peter Wright and John Armor, *The Mural Project* (Santa Barbara: Reverie Press, 1989), plate 84, *North Palisade from Windy Point, Kings River Canyon, California;* plate 92, *Junction Peak, Kings River Canyon, California*; plate 100, *Roaring River, Kings Region, Kings River Canyon, California*; plate 106, *Clouds—White Pass, Kings River Canyon, California*; and plate 107, *Kearsarge Pinnacles, Kings River Canyon, California* were made well before Ansel was employed by the Department of the Interior.

39. Allan Parachini, Los Angeles Times Service, "Document Says Adams Gave U.S. Wrong Information on Negatives," *Monterey* (Calif.) *Sunday Herald*, June 18, 1989, 9A.

40. Ansel Adams, "Statement of Time, Etc. Devoted to the Photographic Mural Project, Department of the Interior Appointment, Ansel Adams, Yosemite, October 14th through November 29th, 1941," submitted December 2, 1941, YNPRL.

41. David Roybal, "Ansel Adams Gives 'Moonrise' to Hernandez," *New Mexican*, June 12, 1980.

42. Ibid.

43. N. Newhall, "The Enduring Moment," 191.

14. GUGGENHEIM YEARS

1. Nancy Newhall, "The Enduring Moment" [unpublished manuscript], 297.
2. Ibid., 312–313.
3. Ansel Adams to Nancy Newhall, Wednesday, [mid-July] 1945, CCP.
4. Ansel Adams to Edward Weston, September 19, 1945, in Mary Street Alinder and Andrea Gray Stillman, eds., *Ansel Adams: Letters and Images, 1916–1984* (Boston: Little, Brown and Co., 1985), 161. A short excerpt from Edward's letter of response is reproduced in Amy Conger, *Edward Weston: Photographs* (Tucson: Center for Creative Photography, 1992), 41.
5. Ansel Adams, *Natural-Light Photography* (New York: Morgan and Morgan, 1952), pl. 38.
6. Ansel Adams to Nancy Newhall, November 25, 1945, CCP.
7. Doris Leonard, interview with the author, September 11, 1995.
8. My conclusions are based on many interviews with a number of Ansel's compatriots, including some of the "women in his life."
9. Ansel Adams to Nancy Newhall, July 15, 1944, in M. Alinder and Stillman, *Letters and Images,* 152.
10. This person asked to remain anonymous.
11. Ansel Adams with Mary Street Alinder, *Ansel Adams: An Autobiography* (Boston: New York Graphic Society, 1985), 323–324.
12. Peter C. Bunnell, *Minor White: The Eye That Shapes* (Princeton: The Art Museum, Princeton University, 1989), 5.
13. A. Adams with M. Alinder, *Autobiography,* 317.
14. Beaumont Newhall, *Focus: A Life in Photography* (Boston: Little, Brown and Co., 1993), 153.
15. Pirkle Jones, interview with the author, September 12, 1995.
16. Ruth Marion Baruch, interview with the author, September 12, 1995.
17. Pirkle Jones interview.
18. N. Newhall, "The Enduring Moment," 382–384.
19. Ansel Adams to the Guggenheim Foundation, November 13, 1933, Sandra S. Phillips, "Ansel Adams and Dorothea Lange: A Friendship of Differences," in Michael Read, ed., *Ansel Adams: New Light* (San Francisco: The Friends of Photography, 1993), 54.
20. Liliane De Cock, interview with the author, September 20, 1995.
21. Nancy Newhall, *From Adams to Stieglitz: Pioneers of Modern Photography* (New York: Aperture, 1989), 93–95.
22. Bunnell, *Minor White,* 16.
23. Pirkle Jones interview.

24. Richard Whelan, *Alfred Stieglitz: A Biography* (Boston: Little, Brown and Co., 1995), 572.

25. Nancy Newhall to Ansel Adams, July 15, 1946, in M. Alinder and Stillman, *Letters and Images,* 175–177.

26. Sue Davidson Lowe, *Stieglitz: A Memoir/Biography* (New York: Farrar Straus & Giroux, 1983), 377–378.

27. Walt Whitman, "For Him I Sing," in *Leaves of Grass: The Complete Poems* (Middlesex, England: Penguin Books Ltd., 1986), 43.

28. Ansel Adams, "Conversations with Ansel Adams," an oral history conducted 1972, 1974, 1975 by Ruth Teiser and Catherine Harroun, Regional Oral History Office, The Bancroft Library, University of California, Berkeley, 1978, 565. Courtesy of The Bancroft Library.

29. Conger, *Edward Weston: Photographs,* 41.

30. N. Newhall, "The Enduring Moment," 781.

31. Conger, *Edward Weston: Photographs,* fig. 1826/1948.

32. Edward Weston, *My Camera on Point Lobos* (Yosemite National Park: Virginia Adams, 1950).

33. Conger, *Edward Weston: Photographs,* 43.

34. Edward Weston to Ansel Adams, Virginia [Adams], Dody [Thompson], "in fact all concerned with 'my C[amera] O[n] P[oint] L[obos],'" May 8, 1950, quoted in Conger, *Edward Weston: Photographs,* 43. Ansel Adams Archive, CCP. © Center for Creative Photography, Arizona Board of Regents, 1995.

35. Ibid.

36. N. Newhall, "The Enduring Moment," 758–759. Two of Ansel's books also suffered the same "remaindered" fate: *Yosemite and the High Sierra* and *The Land of Little Rain.* Teiser and Harroun, *Conversations with Ansel Adams,* 430.

37. Conger, *Edward Weston: Photographs,* 43.

38. N. Newhall, "The Enduring Moment," 401, 442.

39. Ibid., 405–408.

40. "See Your West," a series of twenty-five color photographic reproductions for 1946, at least two of which were by Ansel Adams; and "See Your West," a series of fifty-four color photographic reproductions for 1947, nine by Ansel Adams.

41. Ansel Adams to Francis Farquhar, February 16, 1947, in *Letters and Images,* 181–182.

42. Ansel Adams to Newton Drury, February 26, 1947, quoted in N. Newhall, "The Enduring Moment," 422, 426.

43. B. Newhall, *Focus,* 154.

44. Ansel Adams with Robert Baker, "Focusing Cloth," in *The Camera* (Boston: Little, Brown and Co., 1980), 174.

45. N. Newhall, "The Enduring Moment," 459.

46. Ibid., 464–465.

47. This was a favorite story often told by Ansel.

48. B. Newhall, *Focus,* 185.

49. N. Newhall, "The Enduring Moment," 462.

50. B. Newhall, *Focus,* 185. Copyright Beaumont Newhall, Beaumont and Nancy Newhall Estate, courtesy of Scheinbaum & Russek Ltd., Santa Fe, New Mexico.

51. Ibid. Copyright Beaumont Newhall, Beaumont and Nancy Newhall Estate, courtesy of Scheinbaum & Russek Ltd., Santa Fe, New Mexico.

52. Bernard De Voto, "The National Parks," *Fortune,* June 1947, 120–135.

53. *Time,* June 2, 1947.

54. N. Newhall, "The Enduring Moment," 527–528.

55. A. Adams with M. Alinder, *Autobiography,* 365.

56. Ansel Adams to Virginia Adams, April 1948, quoted in N. Newhall, "The Enduring Moment," 526–527.

57. Ansel Adams and John Muir, *Yosemite and the Sierra Nevada* (Boston: Houghton Mifflin Co., 1948).

58. N. Newhall, "The Enduring Moment," 586–591.

59. Don Worth, interview with the author, September 20, 1995.

60. Ansel Adams to George and Betty Marshall, May 8, 1948, CCP. Ansel Adams to Edward Weston, April 10–14, 1948, in M. Alinder and Stillman, *Letters and Images,* 190–192; Edward Weston to Ansel Adams, April 1948, ibid., 192.

61. Ansel Adams, *The Crater of Haleakala, Clouds, Hawaii National Park, Maui, T.H.,* reproduced in *My Camera in the National Parks* (Yosemite National Park: Virginia Adams, 1950), pl. 26; Ansel Adams, *Mauna Kea and Mauna Loa on the Island of Hawaii, from Haleakula, in Hawaii National Park, Maui,* in *The Islands of Hawaii* (Honolulu: Bishop National Bank, 1958), pl. 65.

62. Ansel Adams to Beaumont and Nancy Newhall, June 20, 1948, in M. Alinder and Stillman, *Letters and Images,* 195.

63. Ansel Adams to Beaumont and Nancy Newhall, July 21, 1948, in N. Newhall, "The Enduring Moment," 568–569.

64. Ansel Adams, *Examples: The Making of 40 Photographs* (Boston: New York Graphic Society, 1983), 75–77.

65. Ibid.

66. Virginia Adams, interview with Nancy Newhall, May 12, 1947, CCP.

67. N. Newhall, "The Enduring Moment," 586–587.

68. Ibid., 659–663.

69. Ansel Adams to David McAlpin, February 7, 1941, in M. Alinder and Stillman, *Letters and Images,* 129.

70. Lee D. Witkin and Barbara London, *The Photograph Collector's Guide* (Boston: New York Graphic Society, 1970), 278.

71. Ansel Adams, *The Portfolios of Ansel Adams* (Boston: New York Graphic Society, 1977).

72. Ansel printed *Portfolio One* on a bromo-chloride projection paper developed in Metol-Glycin and lightly toned in selenium. Eight of the twelve images were contact-printed (that is, the negative was placed in direct contact with the printing paper—there was no enlargement), providing the maximum rendition of detail.

73. N. Newhall, "The Enduring Moment," 647; A. Adams with M. Alinder, *Autobiography,* 287.

74. N. Newhall, "The Enduring Moment," 656–657. Newhall appears to have overestimated the number of negatives made for the Mural Project (see the preceding chapter, *"Moonrise"*). The figure Ansel and I arrived at was 229.

75. List of prints with prices for Ansel Adams Exhibition, San Francisco Museum of Modern Art, June–July 1949. From the museum's files.

76. N. Newhall, "The Enduring Moment," 778.

77. Copyright page for Ansel Adams, *My Camera in the National Parks* (Yosemite and Boston: Virginia Adams and Houghton Mifflin Co., 1950).

78. A. Adams with M. Alinder, *Autobiography,* 103; A. Adams, "Conversations," 500.

79. Ansel Adams, *Portfolio Two: The National Parks & Monuments,* in *The Portfolios of Ansel Adams.*

80. Alfred Frankenstein, "Around the Local Art Galleries," *San Francisco Chronicle,* "This World" section, July 3, 1949, 9.

81. Imogen Cunningham to Ansel Adams, August 1, 1949, CCP. Courtesy of the Imogen Cunningham Trust.

15. A DOCUMENTARY APPROACH

1. Ansel Adams to Alfred Stieglitz, December 25, 1944, in Mary Street Alinder and Andrea Gray Stillman, eds., *Ansel Adams: Letters and Images, 1916–1984* (Boston: Little, Brown and Co., 1985), 153–155.

2. Milton Meltzer, *Dorothea Lange: A Photographer's Life* (New York: Farrar, Straus & Giroux, 1978), 3–50; Sandra S. Phillips, "Dorothea Lange: An American Photographer," in *Dorothea Lange: American Photographs* (San Francisco: Chronicle Books, 1994), 11–12.

3. Dorothea Lange, interview with Richard K. Doud, May 22, 1964 (Washington: Archives of American Art, Smithsonian Institution), 57. Quote reproduced in Elizabeth Partridge, ed., *Dorothea Lange: A Visual Life* (Washington and London: Smithsonian Institution Press, 1994), 104.

4. Ansel Adams, "Statement for *Camera Craft*, 1933," in Therese Thau Heyman, ed., *Seeing Straight: The f.64 Revolution in Photography* (Oakland, Calif.: The Oakland Museum, 1992), 55–56; Ansel Adams, "Applied Photography," *Camera Craft*, April 1934, 173–183.

5. Meltzer, *Dorothea Lange: A Photographer's Life*, 56–57.

6. Ibid., 70–72.

7. Beaumont Newhall, *Dorothea Lange Looks at the American Country Woman* (Fort Worth: The Amon Carter Museum, 1967), 6.

8. Dorothea Lange, "The Assignment I'll Never Forget," *Popular Photography* 46 (February 1960): 42, 126. Reproduced in Beaumont Newhall, ed., *Photography: Essays & Images* (New York: The Museum of Modern Art, 1980), 262–265.

9. Geoffrey Dunn, "Photographic License," *Metro* 10, no. 47 (Santa Clara, Calif., January 19–25, 1995): 20–24.

10. Ibid.

11. Ibid.

12. Ibid.

13. David and Victoria Sheff, "The Playboy Interview," *Playboy*, May 1983, 72.

14. Ansel Adams to Dorothea Lange, January 25, 1936, CCP.

15. Adams, Eastman Studio Cash Book (July 30, 1931–January 6, 1936), CCP.

16. Meltzer, *Dorothea Lange: A Photographer's Life*, 183.

17. Ibid., 264.

18. Therese Thau Heyman, "A Rock or a Line of Unemployed: Art and Document in Dorothea Lange's Photography," in Phillips, *Dorothea Lange: American Photographs*, 57 and 73 n. 13.

19. Ansel Adams, "Conversations with Ansel Adams," an oral history conducted 1972, 1974, 1975 by Ruth Teiser and Catherine Harroun, Regional Oral History Office, The Bancroft Library, University of California, Berkeley, 1978, 570. 352– 353.

20. Ansel Adams to Edward Weston, 1943, in M. Alinder and Stillman, *Letters and Images*, 139–141; A. Adams, "Conversations," 105.

21. Nancy Newhall, "The Enduring Moment" [unpublished manuscript], 235.

22. There is an exception: the U.S. Coordinator for War Information assembled an exhibition entitled "Photographs of America by Ansel Adams," a diverse selection of imagery ranging from landscape to industry that was circulated in England. Soon afterward, though that country was still in the midst of war, a movement began to establish national parks there. It is probable that

Ansel's photographs had some influence on this effort. N. Newhall, "The Enduring Moment," 208–209.

23. A. Adams, "Conversations," 23–24.

24. John Hersey, "A Mistake of Terrifically Horrible Proportion," in John Armor and Peter Wright, *Manzanar* (New York: Times Books, 1989), 50.

25. An excerpt of Executive Order 9066, reproduced in Maisie and Richard Conrat, *Executive Order 9066* (San Francisco: California Historical Society, 1973), 5.

26. Annie Nakao, "Remembering the 100th/442nd," *San Francisco Examiner*, October 4, 1992, D-6.

27. M. and R. Conrat, *Executive Order 9066*, 22.

28. Ansel Adams, *Born Free and Equal: Photographs of the Loyal Japanese-Americans at Manzanar Relocation Center, Inyo County, California* (New York: U.S. Camera, 1944), 29; Masumi Hayashi, "American Concentration Camps," *See: A Journal of Visual Culture* 1, no. 1 (San Francisco: The Friends of Photography, Winter 1995): 32–43.

29. Armor and Wright, *Manzanar*, 89.

30. Meltzer, *Dorothea Lange: A Photographer's Life*, 240.

31. "Internment Camp Site Preserved in Owens Valley," *San Francisco Chronicle*, April 28, 1995, A-26.

32. Mary Austin and Ansel Adams, *The Land of Little Rain* (Boston: Houghton Mifflin, 1950), 110.

33. Meltzer, *Dorothea Lange: A Photographer's Life*, 238–245.

34. Roger Daniels, "Dorothea Lange and the War Relocation Authority," in Partridge, *Dorothea Lange: A Visual Life*, 49.

35. Meltzer, *Dorothea Lange: A Photographer's Life*, 241.

36. Graham Howe, Patrick Nagatani, and Scott Rankin, *Two Views of Manzanar* (Los Angeles: Frederick S. Wight Art Gallery, UCLA, 1978), 10–11.

37. A. Adams, "Conversations," 25.

38. Karin Becker Ohrn, *Dorothea Lange and the Documentary Tradition* (Baton Rouge and London: Louisiana State University Press, 1980), 146, 148.

39. Pete Merritt (son of Ralph Merritt, who lived at Manzanar), interview with the author, September 25, 1989; A. Adams, "Conversations," 23–24.

40. Ansel Adams to Nancy Newhall, 1943, in M. Alinder and Stillman, *Letters and Images*, 143–145.

41. Armor and Wright, *Manzanar*, xx.

42. A. Adams, *Born Free and Equal*, 5, 110.

43. Nancy Newhall, "Ansel Adams, *Born Free and Equal*," *photo notes*, June 1946 (New York: The Photo League), 3–5.

44. Eleanor Roosevelt, "My Day," United Feature Syndicate, 1945.

45. Ansel Adams to Nancy Newhall, December 24, 1944, CCP.

46. Armor and Wright, *Manzanar,* xviii.

47. Pete Merritt remembers that one incensed citizen bought as many copies of *Born Free and Equal* as he could find and then burned them in his garage. Pete Merritt interview.

48. Karin Becker Ohrn, in her book *Dorothea Lange and the Documentary Tradition,* relates that in a letter Ansel wrote her on April 2, 1975, he stated that *U.S. Camera* had intentionally destroyed copies of *Born Free and Equal.*

49. A. Adams, "Conversations," 415–416.

50. Ansel Adams to Dorothea Lange, May 15, 1962, in M. Alinder and Stillman, *Letters and Images,* 281–282.

51. Dorothea Lange, "The Making of a Documentary Photographer," an oral history conducted 1960–1961 by Suzanne B. Riess, Regional Oral History Office, The Bancroft Library, University of California, Berkeley, 1968, 200–201.

52. Karin Becker Ohrn, "What You See Is What You Get: Dorothea Lange and Ansel Adams at Manzanar," *Journalism History* 4, no. 1 (spring 1977): 22.

53. N. Newhall, "Ansel Adams, *Born Free and Equal,*" 4.

54. Hayashi, "American Concentration Camps," 32–43.

55. A. Adams, "Conversations," 26.

56. N. Newhall, "Ansel Adams, *Born Free and Equal,*" 5.

57. Senator Alan Cranston, "S.621 The Manzanar National Historic Site Act," Senator Alan Cranston Reports to California, spring 1991.

58. "Internment Camp Site Preserved."

59. Ansel Adams, *Examples: The Making of 40 Photographs* (Boston: New York Graphic Society, 1983), 162–167.

60. An example, *Mount LeConte and Lone Pine Peak, from the Owens Valley, California* (ca. 1940), is reproduced in Ansel Adams with Mary Street Alinder, *Ansel Adams: An Autobiography* (Boston: New York Graphic Society, 1985), 263.

61. A. Adams, *Examples,* 164.

62. Ibid., 162–165; A. Adams with M. Alinder, *Autobiography,* 262–263.

63. This interpretation is the idea of Tim Hill, editor in chief of the New York Graphic Society, Ansel's publisher from 1974 to 1979. Tim Hill to Mary Alinder, April 10, 1995.

64. A. Adams, *Examples,* 164–165.

65. Ibid., 66–69; Ansel Adams with Robert Baker, *The Camera* (Boston: New York Graphic Society, 1980), fig. 1-1.

66. Photographs by Dorothea Lange and Ansel Adams for "The Golden West," "The Grandeur That Was Home," "After the Battle," "Detour through Purgatory," and "Richmond Took a Beating"; photographs by Ansel Adams for "The El Solyo Deal." All six articles in *Fortune* 32, no. 2 (February 1945).

67. A. Adams with M. Alinder, *Autobiography*, 170.

68. Meltzer, *Dorothea Lange: A Photographer's Life*, 247–249.

69. Ibid.

70. Ansel Adams, *Trailer Camp Children, Richmond, California*, reproduced in Ansel Adams with Robert Baker, *The Print* (Boston: New York Graphic Society, 1983), fig. 8-9, 184–185.

71. Ibid.

72. Anne W. Tucker, "The Photo League," in *The Photo League 1936–1951* (New York: The College Art Gallery, The College at New Paltz State University of New York, and Photofind Gallery, n.d.), 2–4.

73. Lester Taikington, "Ansel Adams at the Photo League," *photo notes*, March 1944 (New York: The Photo League): 4–6.

74. Philippe Halsman to Ansel Adams, December 1, 1947, in M. Alinder and Stillman, *Letters and Images*, 185.

75. Ansel Adams to Philippe Halsman, December 8, 1947, ibid., 186–187.

76. *photo notes*, January 1948 (New York: The Photo League): 1.

77. Ansel Adams to the Photo League, *photo notes*, January 1948, 5.

78. Ibid.

79. A. Adams, "Conversations," 155.

80. N. Newhall, "The Enduring Moment," 627.

81. Ansel Adams to Walter Rosenblum, May 23, 1949, quoted in N. Newhall, "The Enduring Moment," 632–636.

82. A. Adams, "Conversations," 49.

83. David L. Jacobs, "Three Mormon Towns," *Exposure* 25, no. 2 (summer 1987): 5.

84. Maitland Edey, "Three Mormon Towns," in Maitland Edey and Constance Sullivan, *Great Photographic Essays from LIFE* (Boston: New York Graphic Society, 1978), 154.

85. Jacobs, "Three Mormon Towns," 7.

86. Ibid., 16.

87. Dorothea Lange and Ansel Adams, "Three Mormon Towns," *Life*, September 6, 1954, 91–100.

88. Jacobs, "Three Mormon Towns," 7.

89. Meltzer, *Dorothea Lange: A Photographer's Life*, 246.

90. Paul S. Taylor, *Paul Schuster Taylor: California Social Scientist*, vol. 1 (Berkeley: University of California, 1973), 242–244.

91. Jacobs, "Three Mormon Towns," 21–22.
92. A. Adams with M. Alinder, *Autobiography*, 268.
93. Ansel Adams to Dorothea Lange, October 25, 1954, CCP.
94. Edey, "Three Mormon Towns," 154.
95. Meltzer, *Dorothea Lange: A Photographer's Life*, 291–292.
96. Completed under the title "Death of a Valley," the story was published by *Aperture* in 1959 and exhibited at the San Francisco Museum of Art that same year. Ibid., 301–303.
97. Dorothea Lange Collection, Oakland Museum. Courtesy the Dorothea Lange Collection, The Oakland Museum of California.
98. Ohrn, *Dorothea Lange and the Documentary Tradition*, 217–218.
99. Therese Thau Heyman, "Ansel Adams Remembers Dorothea Lange," in Partridge, *Dorothea Lange: A Visual Life*, 159. With permission of Therese Thau Heyman, The Oakland Museum of California.

16. CONCLUSIONS

1. Ansel Adams to Beaumont Newhall, March 23, 1950, CCP.
2. Ansel Adams with Mary Street Alinder, *Ansel Adams: An Autobiography* (Boston: New York Graphic Society, 1985), 44–45.
3. Ibid., 47.
4. Stewart McBride, "Ansel," *American Photographer* 4, no. 6 (December 1980), 59.
5. Beaumont Newhall to Ansel Adams, August 4, 1951, in Mary Street Alinder and Andrea Gray Stillman, eds., *Ansel Adams: Letters and Images, 1916–1984* (Boston: Little, Brown and Co., 1988), 220–221. Copyright Beaumont Newhall, Beaumont and Nancy Newhall Estate, courtesy of Scheinbaum & Russek Ltd., Santa Fe, New Mexico.
6. A. Adams with M. Alinder, *Autobiography*, 381–385.
7. Nancy Newhall, "The Enduring Moment" [unpublished manuscript], 753–754.
8. Ansel Adams to Nancy Newhall, December 14, 1952, CCP.
9. A. Adams with M. Alinder, *Autobiography*, 383.
10. Ansel Adams and Nancy Newhall, "Canyon de Chelly National Monument, Arizona," *Arizona Highways*, June 1952, 18–27; "Sunset Crater," *Arizona Highways*, July 1952; "The Shell of Tumacacori," *Arizona Highways*, November 1952, 4–13; "Death Valley," *Arizona Highways*, October 1953, 16–35; "Organ Pipe," *Arizona Highways*, January 1954; "Mission San Xavier del Bac," *Arizona Highways*, April 1954, 12–35.

One other collaborative article was published in 1968, though Nancy did not have any creative control over its presentation, as she had with the others: Ansel Adams and Nancy Newhall, "Mary Austin's Country," *Arizona Highways*, April 1968, 6.

11. Malin Wilson, "Walking on the Desert in the Sky," *The Desert Is No Lady* (New Haven: Yale University Press, 1987), 57–60.

12. Ansel Adams and Nancy Newhall, *Death Valley* (Redwood City, Calif.: 5 Associates, 1954); Ansel Adams and Nancy Newhall, *Mission San Xavier del Bac* (Redwood City, Calif.: 5 Associates, 1954).

13. A. Adams with M. Alinder, *Autobiography*, 214–215.

14. Nancy Newhall to Ansel Adams, June 17, 1952, CCP. Copyright Nancy Newhall, Beaumont and Nancy Newhall Estate, courtesy of Scheinbaum & Russek Ltd., Santa Fe, New Mexico.

15. Doris Leonard, interview with the author, September 11, 1995.

16. Ansel Adams and Nancy Newhall, *The Pageant of History and the Panorama of Today in Northern California* (San Francisco: American Trust Company, 1954).

17. *Ansel Adams, Photographer.* Script by Nancy Newhall; produced by Larry Dawson; directed by David Meyers, 1957.

18. Ansel Adams, *Yosemite Valley,* ed. Nancy Newhall (San Francisco: 5 Associates, 1959); Ansel Adams and Nancy Newhall, *A More Beautiful America* (New York: American Conservation Association, 1965); Ansel Adams and Nancy Newhall, *Fiat Lux: The University of California* (New York: McGraw-Hill Book Company, 1967); Ansel Adams and Nancy Newhall, *The Tetons and the Yellowstone* (Redwood City, Calif.: 5 Associates, 1970).

19. Peter C. Bunnell, *Minor White: The Eye That Shapes* (Princeton: The Art Museum, Princeton University, 1989); Walter P. Paepcke, "Memorandum of Conversation with Mr. Edward Steichen, Museum of Modern Art, Regarding September 1–8 Photo Seminar at Aspen" [July 1952], CCP.

20. Berenice Abbott, "Objectives for Photography," Aspen Institute Conference on Photography, October 6, 1951.

21. K. Patrick Conner, "Horace Bristol: Photographs" [unpublished manuscript], San Francisco, 1995.

22. *A Study of the Accumulative Audience of LIFE,* survey conducted for *Life* magazine (New York: Alfred Politz Research, Inc., 1950), 20. For much of the information about the founding of *Aperture* and its relationship to the world of publishing, I am indebted to the scholarship of my daughter Jasmine Alinder.

23. Marc Silver, "*Aperture* Magazine under the Editorship of Minor White 1952–1964," Master's thesis, University of Pittsburgh, 1989, 12.

24. Theodore Peterson, *Magazines in the Twentieth Century* (Urbana, Ill.: University of Illinois Press, 1964), 350.
25. Ansel Adams to Nancy Newhall, November 25, 1945, CCP.
26. Bunnell, *Minor White,* 7.
27. Jasmine A. Alinder, "The Conception and Founding of *Aperture,*" Junior thesis, Princeton University, 1990, 5–6.
28. Nancy Newhall to Minor White, February 27, 1952, Minor White Archive, Princeton University. Copyright Nancy Newhall, Beaumont and Nancy Newhall Estate, courtesy of Scheinbaum & Russek Ltd., Santa Fe, New Mexico.
29. Jasmine Alinder, "The Conception and Founding of *Aperture,*" 24.
30. Beaumont Newhall to Ansel Adams, March 15, 1952, CCP.
31. Ansel Adams to Nancy Newhall, March 10, 1952, CCP.
32. Minor White, ed., *Aperture* 1, no. 1.
33. Jasmine Alinder, "The Conception and Founding of *Aperture,*" 28–29.
34. Minor White, Dorothea Lange, Nancy Newhall, Ansel Adams, Beaumont Newhall, Barbara Morgan, Ernest Louie, Melton Ferris, Dody Warren, "1952: About Aperture," *Aperture* 1, no. 1.
35. Beaumont Newhall to Ansel Adams, July 13, 1960. Copyright Beaumont Newhall, Beaumont and Nancy Newhall Estate, courtesy of Scheinbaum & Russek Ltd., Santa Fe, New Mexico.
36. Nancy Newhall to Minor White, June 23, 1952, Minor White Archive, Princeton University; Ansel Adams to Nancy Newhall, July 2, 1952, CCP; Ansel Adams to Nancy Newhall, August 30, 1952, CCP.
37. Fortieth Anniversary Issue, *Aperture,* fall 1992 (New York: Aperture Foundation Inc.).
38. Beaumont Newhall, "The Beginning," Peter C. Bunnell, "Why The Friends?" and James G. Alinder, "The Friends: A Retrospective View," *Light Years, Untitled* 43 (Carmel: The Friends of Photography, 1987).
39. Ibid.
40. Ansel Adams to Beaumont and Nancy Newhall, March 11, 1974, CCP. Letter reprinted in A. Adams with M. Alinder, *Autobiography,* 218, without his charges about their smoking.
41. Liliane De Cock, interview with the author, September 20, 1995.
42. Ansel Adams to Nancy Newhall, January 25, 1961, in M. Alinder and Stillman, *Letters and Images,* 268–269; Ansel Adams to Beaumont and Nancy Newhall, September 13, 1973, ibid., 318–321.
43. Ansel Adams, "Conversations with Ansel Adams," an oral history conducted 1972, 1974, 1975 by Ruth Teiser and Catherine Harroun, Regional Oral History Office, The Bancroft Library, University of California, Berkeley, 1978, 404. Courtesy of The Bancroft Library.
44. Ibid., 740.

45. Beaumont Newhall, *Focus: A Life in Photography* (Boston: Little, Brown and Co., 1993), 245–246; A. Adams with M. Alinder, *Autobiography*, 218–219. Some of the details of Nancy's death I learned only in conversation with Beaumont in 1987.

46. Ansel Adams to Beaumont Newhall, July 10, 1974, in M. Alinder and Stillman, *Letters and Images*, 333.

47. Letter from Ansel Adams to Beaumont Newhall, August 18, 1974, ibid., 334; Virginia Adams, interview with the author, March 21, 1993.

48. Virginia Adams, interview with the author, May 17, 1988; David Scheinbaum, interview with the author, October 3, 1995.

49. B. Newhall, *Focus*, 246–247. Copyright Beaumont Newhall, Beaumont and Nancy Newhall Estate, courtesy of Scheinbaum & Russek Ltd., Santa Fe, New Mexico.

50. Ibid., 247–248.

51. Christi Newhall and David Scheinbaum to Jim and Mary Alinder, April 23, 1993.

17. ANOTHER PATH

1. Ansel Adams to Beaumont and Nancy Newhall, September 30, 1952, CCP.

2. Ansel Adams to Nancy Newhall, June 20, 1952, CCP.

3. Ansel Adams with Mary Street Alinder, *Ansel Adams: An Autobiography* (Boston: New York Graphic Society, 1985), 159.

4. Ansel Adams, "Conversations with Ansel Adams," an oral history conducted 1972, 1974, 1975 by Ruth Teiser and Catherine Harroun, Regional Oral History Office, The Bancroft Library, University of California, Berkeley, 1978, 118.

5. Peter C. Wensberg, *Land's Polaroid: A Company and the Man Who Invented It* (Boston: Houghton Mifflin Co., 1987), 25–30.

6. Ibid., 64–65.

7. Ibid., 83.

8. "A summary of some of the important dates in the history of Polaroid Land photography," Cambridge, Mass.: Polaroid Corporation. Brochure.

9. Ansel Adams to Nancy Newhall, December 8, 1948, CCP.

10. A. Adams, "Conversations," 117. In *Ansel Adams: An Autobiography*, 293, writing some thirty years after the event, Ansel recalled being taken to the Lands' for a party and the next morning going to the lab. In a 1972 interview for his oral history, Ansel said that he was present at the Optical Society of America meeting at which Land first introduced the Polaroid process, but

this cannot be true, because on February 21, 1947, he was actually in Big Bend National Park, Texas.

11. In a 1945 letter, Ansel wrote to Nancy Newhall that Polaroid had invited him to come visit the plant in Cambridge and make photographs using Polaroid materials, but nothing seems to have come of this. Ansel Adams to Nancy Newhall, November 25, 1945, CCP.

12. From Beaumont Newhall's journal, reproduced in Nancy Newhall, "The Enduring Moment," [unpublished manuscript], 673.

13. A. Adams, "Conversations," 118; David and Victoria Sheff, "The Playboy Interview," *Playboy*, May 1983, 84.

14. Ansel Adams, "How I Use the Polaroid Camera" (illustrated with twelve photographs), *Modern Photography*, September 1951, 36–39, 80, 82.

15. Ansel Adams, "Introduction," in Ansel Adams with Robert Baker, *Polaroid Land Photography* (Boston: New York Graphic Society, 1978), ix–x; A. Adams, "Conversations," 120; Mary Street Alinder, "Ansel Adams' Polaroid Connection, Part II," *The Polaroid Newsletter for Photographic Education* 4, nos. 3 and 4 (summer–fall 1987): 3.

16. Ansel Adams, *Camera & Lens* (New York: Morgan and Lester, 1948).

17. Ansel Adams, *Natural-Light Photography* (New York: Morgan and Morgan, 1952).

18. Ansel Adams to Edwin Land, January 10, 1950, quoted in A. Adams with M. Alinder, *Autobiography*, 295–296.

19. Wensberg, *Land's Polaroid*, 129–132.

20. A. Adams, "Conversations," 39.

21. A. Adams with Baker, *Polaroid Land Photography*, 45–47.

22. Imogen Cunningham to Ansel Adams, quoted in A. Adams with M. Alinder, *Autobiography*, 301. Courtesy of the Imogen Cunningham Trust. Her self portrait is reproduced on page 300 of the same book.

23. Ansel Adams to Beaumont and Nancy Newhall, April 15, 1961, CCP.

24. A. Adams, "Conversations," 522.

25. Ansel Adams, *Examples: The Making of 40 Photographs* (Boston: New York Graphic Society, 1983), 44–47.

26. Ansel Adams, *Singular Images* (Boston: New York Graphic Society, 1974).

27. Edwin Land, "Private Ruminations on Looking at Ansel Adams' Photographs," ibid.

28. Ansel confessed to me his great bewilderment at the Lands' canceling the museum; he was too embarrassed to ask them for an explanation.

Terre Land was the kind financial sponsor of twenty-one of the twenty-six interviews conducted in 1972–1975 for Ansel's oral history, on behalf

of The Bancroft Library, University of California. The Sierra Club paid for the remaining five interviews. Ruth Teiser, "Remembering Ansel Adams," *Bancroftiana* 99 (Berkeley: University of California, October 1989): 2.

29. Edwin Land to Ansel Adams, quoted in Mary Street Alinder and Andrea Gray Stillman, eds., *Ansel Adams: Letters and Images, 1916–1984* (Boston: Little, Brown and Co., 1988), 374.

30. Ansel Adams to Edwin Land, September 22–27 and October 2, 1983, in M. Alinder and Stillman, *Letters and Images*, 383–384.

31. Wensberg, *Land's Polaroid*, 223–241.

32. "Dr. Edwin Land, Photography Pioneer 1909–1991," *International Photography Hall of Fame & Museum Bulletin* 7, no. 2 (spring 1991): 1.

33. A. Adams with M. Alinder, *Autobiography*, 375.

34. A. Adams, "Conversations," 341.

35. Ibid.

36. A. Adams with M. Alinder, *Autobiography*, 376.

37. A. Adams, *Examples*, 132–135.

38. Donald W. Olson and Russell L. Doescher, ed. Roger W. Sinnott, "Dating Ansel Adams's Moon and Half Dome," *Sky & Telescope*, December 1994, 82–86.

39. Ansel Adams to Din and Terre Land, April 10, 1959, quoted in A. Adams with M. Alinder, *Autobiography*, 298.

40. A. Adams, "Conversations," 501.

41. Ansel Adams to Beaumont and Nancy Newhall, July 8, 1962, CCP.

42. A. Adams, "Conversations," 537, 721. Courtesy of The Bancroft Library.

43. Clark Kerr, "The Yosemite of Higher Education," in Melinda Wortz, *Ansel Adams: Fiat Lux* (Irvine, Calif.: Regents of the University of California, 1991), 12; Liliane De Cock, "Working with Ansel on *Fiat Lux*," ibid., 30.

44. A. Adams, "Conversations," 70.

45. Lloyd Eric and Alice Means Reeve, with photographs by Ansel Adams and Pirkle Jones, *Gift of the Grape, Based on Paul Masson Vineyards* (San Francisco: Filmer Publishing Company, 1959).

45. A. Adams, "Conversations," 70.

46. Ibid., 518; A. Adams with M. Alinder, *Autobiography*, 298. *Portfolio Three* was sponsored by the Sierra Club, and *Portfolio Four* by the Varian Foundation in memory of its cofounder Russell Varian with the proceeds to benefit Castle Rock State Park.

47. Don Worth, interview with the author, September 20, 1995.

48. Ibid.

49. Liliane De Cock, interview with the author, September 20, 1995; Dorothea Lange, "The Making of a Documentary Photographer," an oral history con-

ducted 1960–1961 by Suzanne B. Reiss, Regional Oral History Office, The Bancroft Library, University of California, Berkeley, 1968, 299.

50. Don Worth interview.
51. Ansel Adams to Nancy Newhall, April 10, 1962, CCP.
52. Ansel Adams to Beaumont and Nancy Newhall, November 1, 1961, CCP.
53. Ansel Adams to Beaumont and Nancy Newhall, August 5, 1961, CCP; Don Worth interview.
54. Stewart McBride, "Ansel," *American Photographer* 4, no. 6 (December 1980): 59.
55. Anne Adams Helms, *The Descendants of David Best and Jane Eliza King Best* (Monterey, Calif.: Anne Adams Helms, 1995), 70–76.
56. Ibid., 77–91.
57. Liliane De Cock interview.
58. Ibid.
59. A. Adams, "Conversations," 261–262. Courtesy of The Bancroft Library. Another version is recounted in McBride, "Ansel," 59.

18. MORTAL COMBAT

1. David Brower, *For Earth's Sake: The Life and Times of David Brower* (Salt Lake City: Peregrine Smith Books, 1990), 258.
2. Ibid.
3. *Sierra Club Bulletin,* handbook edition, December 1967, 54–55.
4. Robert Cahn, "Ansel Adams, Environmentalist," *Sierra,* May–June 1979, 36, 45.
5. Paul Strand with Nancy Newhall, *Time in New England* (New York: Oxford University Press, 1950).
6. Ansel Adams with Mary Street Alinder, *Ansel Adams: An Autobiography* (Boston: New York Graphic Society, 1985), 215.
7. David Featherstone, "This Is the American Earth: A Collaboration by Ansel Adams and Nancy Newhall," in Michael Read, ed., *Ansel Adams: New Light* (San Francisco: The Friends of Photography, 1993), 62–73.
8. Ibid., 72–73.
9. Ibid., 63, 68, 69; Ansel Adams and Nancy Newhall, *This Is the American Earth* (San Francisco: Sierra Club, 1960).
10. Edward Steichen, *A Life in Photography* (Garden City, N.Y.: Doubleday & Co., Inc., 1963), unpaginated.
11. Edward Steichen, *The Family of Man* (New York: The Museum of Modern Art, 1955).

12. A. Adams with M. Alinder, *Autobiography*, 209–210.

13. Brett Weston to Nancy Newhall, March 5, 1955, quoted in Featherstone, "This Is the American Earth," 67.

14. Ansel Adams, "Conversations with Ansel Adams," an oral history conducted 1972, 1974, 1975 by Ruth Teiser and Catherine Harroun, Regional Oral History Office, The Bancroft Library, University of California, Berkeley, 1978, 476.

15. Alfred Runte, *Yosemite: The Embattled Wilderness* (Lincoln and London: University of Nebraska Press, 1990), 196.

16. A. Adams with M. Alinder, *Autobiography*, 154–156; Ansel Adams to Harold Bradley, Richard Leonard, and David Brower, July 27, 1957, in Mary Street Alinder and Andrea Gray Stillman, eds., *Ansel Adams: Letters and Images, 1916–1984* (Boston: Little, Brown and Co., 1988), 246–249; Ansel Adams to Fred Seaton, Sinclair Weeks, and Conrad Wirth, July 7, 1958, ibid., 251; Ansel Adams to Nancy Newhall, July 11, 1958, ibid., 251–252.

17. Ansel Adams, "Tenaya Tragedy," *Sierra Club Bulletin*, November 1958, 1–4 and photo insert.

18. Tom Turner, *Sierra Club: 100 Years of Protecting Nature* (New York: Harry N. Abrams, Inc., 1991), 186–190.

19. Ibid.

20. Michael P. Cohen, *The History of the Sierra Club* (San Francisco: Sierra Club Books, 1988), 339–345.

21. Ibid.; Ansel Adams to Phil Berry, president, the Sierra Club, April 27, 1969, The Bancroft Library, University of California.

22. Tom Turner, *Wild by Law* (San Francisco: Sierra Club Legal Defense Fund, 1990), 3–23.

23. Cohen, *History of the Sierra Club*, 357–365.

24. Montgomery Brower, "David Brower," *People*, April 30, 1990, 103–106.

25. Ibid.

26. Turner, *The Sierra Club: 100 Years of Protecting Nature*, 178.

27. Ansel Adams to Sierra Club, Attention: George Marshall & David Brower, in M. Alinder and Stillman, *Letters and Images*, 292.

28. Doris Leonard, interview with the author, September 11, 1995.

29. Cohen, *History of the Sierra Club*, 124.

30. Doris Leonard interview.

31. Cohen, *History of the Sierra Club*, 423–434.

32. Ibid., 423.

33. A. Adams, "Conversations," 689; Cohen, *History of the Sierra Club*, 423.

34. Richard Leonard, "Sierra Club White Paper," undated [probably October 1968], The Bancroft Library, University of California, Berkeley.

35. Ansel Adams to David Brower, November 9, 1966, in M. Alinder and Stillman, *Letters and Images,* 293.

36. Cohen, *History of the Sierra Club,* 421–422. Ansel had been calling for Brower's removal as executive director for more than a year. Ansel Adams to the directors of the Sierra Club, February 15, 1967, The Bancroft Library, University of California, Berkeley.

37. Cohen, *History of the Sierra Club,* 424–428.

38. "Sierra Club Annual Organization Meeting May 3–4," *Sierra Club Bulletin* 54, no. 5 (May 1969): 3.

39. John McPhee, *Encounters with the Archdruid* (New York: Farrar, Straus & Giroux, 1971), 208–220.

40. Marjorie Bridge Farquhar, "Pioneer Woman Rock Climber and Sierra Club Director," an oral history conducted 1977 by Ann Lage, in "Sierra Club Women II," Sierra Club History Committee, Sierra Club, San Francisco, 1977, 45. Courtesy of The Bancroft Library.

41. Glen Martin, "In Defense of the Earth," *San Francisco Examiner and Chronicle,* Sunday Interview, May 7, 1995, 3.

42. Philip Hyde, "Ansel Adams," *Sierra Club Bulletin,* October/November 1971, 20–21. Courtesy of Philip Hyde.

43. President Lyndon Johnson, in Ansel Adams and Nancy Newhall, *A More Beautiful America* (New York: American Conservation Association, 1965).

44. David and Victoria Sheff, "The Playboy Interview," *Playboy,* May 1983, 82.

45. Ibid.

46. Ansel Adams to President Jimmy Carter, November 8, 1979, in M. Alinder and Stillman, *Letters and Images,* 355–356; Ansel Adams to President Jimmy Carter, July 16, 1980, ibid., 359–361; Ansel Adams to President Jimmy Carter, November 9, 1980, ibid., 363; President Jimmy Carter to Ansel Adams, November 9, 1979, ibid., 357; President Jimmy Carter to Ansel Adams, February 15, 1980, ibid., 357; President Jimmy Carter to Ansel Adams, August 25, 1980, ibid., 362.

47. Ansel Adams to the Editor, *Monterey Peninsula Herald,* September 1, 1965.

48. A. Adams, "Conversations," 659.

49. Craig Juckniess, "A Tribute: Ansel Adams," *Ecology Law Quarterly* 14, no. 1 (1987): 5.

50. A. Adams with M. Alinder, *Autobiography,* 352–355.

51. Bill Barich, "Bound for Glory," *San Francisco Examiner Magazine,* May 1, 1994, 30.

52. Dateline Fresno, Associated Press, "Visitors May Need Reservations in Park," *San Francisco Chronicle,* July 27, 1995, A16; Tom Stienstra, "Rationing Paradise," *San Francisco Examiner and Chronicle,* August 6, 1995, C-1, C-6.

53. Stienstra, "Rationing Paradise."

54. James Schermerhorn, "Curbing the Auto's Reign at Yosemite," *San Francisco Examiner,* July 12, 1970, A4.

55. Michael McCabe, "Giant Parking Garage Proposed for Yosemite," *San Francisco Chronicle,* September 14, 1994, A-18.

56. A. Adams, "Conversations," 422.

57. Milton Esterow, "Ansel Adams: The Last Interview," *ARTnews* 83, no. 6 (summer 1984): 89.

58. Ansel Adams to Dorothea Lange, May 15, 1962, in M. Alinder and Stillman, *Letters and Images,* 281, 283.

59. Ansel Adams, "The Horace M. Albright Conservation Lectureship: The Role of the Artist in Conservation," lecture given at University of California, Berkeley, College of Natural Resources, Department of Forestry & Conservation, March 3, 1975, 6.

19. PRICE RISE

1. Ansel Adams, "The Aggressive Persuasion: A Credo for Survival," Chubb Fellowship Lecture, Yale University, CCP; Robert Turnage, "The Role of the Artist in the Environmental Movement," *The Living Wilderness,* March 1980, 13.

2. Ansel Adams with Mary Street Alinder, *Ansel Adams: An Autobiography* (Boston: New York Graphic Society, 1985), 156–157.

3. Jonathan Spaulding, *Ansel Adams and the American Landscape* (Berkeley: University of California Press, 1995), 351.

4. Liliane De Cock, interview with the author, September 20, 1995.

5. Ansel Adams, "Conversations with Ansel Adams," an oral history conducted 1972, 1974, 1975 by Ruth Teiser and Catherine Harroun, Regional Oral History Office, The Bancroft Library, University of California, Berkeley, 1978, 301.

6. Ansel Adams to Marion Patterson, September 19, 1972, in Mary Street Alinder and Andrea Gray Stillman, eds., *Ansel Adams: Letters and Images, 1916–1984* (Boston: Little, Brown and Co., 1988, 317–318.

7. A. Adams with M. Alinder, *Autobiography,* 106, 157.

8. Ibid., 103–104.

9. Ibid.

10. James G. Alinder, "Adams Family Values," *View Camera,* March–April 1995, 16–19.

11. A. Adams with M. Alinder, *Autobiography,* 178.

12. "Drive a Datsun, Plant a Tree," Datsun television commercial (1972), CCP.

13. A. Adams to M. Patterson, September 19, 1972.

14. A. Adams with M. Alinder, *Autobiography,* 178.

15. "The New Tree Sell," *Time,* August 21, 1972, 65.

16. A. Adams, "Conversations," 645.

17. A. Adams to M. Patterson, ibid.

18. A. Adams with M. Alinder, *Autobiography,* 179.

19. Ibid., 361.

20. Invoices from Ansel Adams to Wolverine Worldwide, 1972 and 1973, CCP; letters between Bill Turnage and Wolverine Worldwide, 1972 and 1973, CCP. Wolverine published a portfolio of reproductions of eleven of Ansel's black-and-white photographs under the title *Ansel Adams' America.*

21. Richard D. James, "Artist of Light," *Wall Street Journal,* July 31, 1978, 1.

22. Ibid.

23. Carole Lalli, "Portrait of the Photographer as a Grand Old Man," *Esquire,* September 1979, 46.

24. Jim Powell, "The Most Sought-After Photographs Today—Should You Consider Buying Them? An In-depth Look at the Ansel Adams Market," *Collectibles Market Report,* January 1980.

25. A. Adams with M. Alinder, *Autobiography,* 362; "A.A. to Stop Printing," *Exposure, Journal of the Society for Photographic Education* 13, no. 3 (September 1975): 32.

26. Nicolai Cikovsky, Jr., "Notes on the Museum Set," in Ansel Adams, *Ansel Adams: Classic Images, The Museum Set* (Washington: National Gallery of Art, 1985), 26; A. Adams with M. Alinder, *Autobiography,* 362; James, "Artist of Light," 7.

27. Elizabeth Bumiller, "Images of Harry Lunn: The Photo Mogul & His Developing Empire," *Washington Post,* August 5, 1980, B1, B9.

28. Powell, "The Most Sought-After Photographs Today."

29. Lalli, "Portrait of the Photographer as a Grand Old Man," 46.

30. Bumiller, "Images of Harry Lunn."

31. Ibid.

32. "Announcement of Ansel Adams Photograph Prices Effective August 8, 1978," press release, Washington, D.C., Graphics International Ltd.

33. Ansel Adams to Dear Friend, 1976, Alinder collection.

34. J. Alinder, "Adams Family Values."

35. Tim Hill, interview with the author, March 29, 1995.

36. Stewart McBride, "Ansel," *American Photographer* 4, no. 6 (December 1980), 60.

37. Ansel Adams to Beaumont Newhall, December 5, 1975, CCP.

38. David McAlpin to Ansel Adams, January 26, 1972, CCP.

39. David McAlpin to Ansel Adams, January 16, 1972, quoted in A. Adams with M. Alinder, *Autobiography,* 231.

40. Hilton Kramer, "Ansel Adams: Trophies from Eden," *New York Times,* May 12, 1974, 23.

41. A. Adams with M. Alinder, *Autobiography,* 368–370.

42. Ibid. A reproduction of *Cemetery, Edinburgh, Scotland* (1976) can be found on page 368. Ansel Adams to Beaumont Newhall, October 1, 1976, CCP.

43. A. Adams with M. Alinder, *Autobiography,* 368–370.

44. Henri Cartier-Bresson to Ansel Adams, August 1974, CCP.

45. A. Adams with M. Alinder, *Autobiography,* 370.

46. Ansel Adams to John P. Schaefer, March 23, 1975, in M. Alinder and Stillman, *Letters and Images,* 334–336; Ansel Adams to John P. Schaefer, May 19, 1975, ibid., 336–339.

47. Terry Pitts, interview with the author, October 4, 1995. Mr. Pitts is the director of the Center for Creative Photography.

48. Ibid.

49. The exceptions are the Yosemite special-edition prints.

50. A. Adams with M. Alinder, *Autobiography,* 360.

51. Ibid.

52. J. Alinder, "Adams Family Values."

53. McBride, "Ansel," 60.

54. A. Adams, "Conversations," 569. Courtesy of The Bancroft Library.

55. *Photographs of the Southwest* (1976); *The Portfolios of Ansel Adams* (1977); *Taos Pueblo* (facsimile edition of the 1930 book, 1977); *Ansel Adams: Fifty Years of Portraits* (1978); *Polaroid Land Photography* (1978); *Yosemite and the Range of Light* (1979); *The Camera* (1980); *The Negative* (1981); *Examples: The Making of 40 Photographs* (1983); *The Print* (1983).

56. Dorothea Lange, "The Making of a Documentary Photographer," an oral history conducted 1960–1961 by Suzanne B. Riess, Regional Oral History Office, The Bancroft Library, University of California, Berkeley, 1968, 201. Courtesy of The Bancroft Library.

57. A. Adams with M. Alinder, *Autobiography,* 346–347; Ansel Adams to President Gerald Ford, "New Initiatives for the National Parks," CCP.

58. President Gerald Ford to Ansel Adams, April 8, 1975, CCP.

59. David and Victoria Sheff, "The Playboy Interview," *Playboy,* May 1983, 86, 223.

60. Tim Hill interview.
61. David McAlpin to Ansel Adams, June 10, 1976, CCP.
62. Ansel Adams to John Szarkowski, June 22, 1976, in M. Alinder and Stillman, *Letters and Images*, 339–341.
63. John Szarkowski to Ansel Adams, June 28, 1976, ibid., 341, 343.
64. A. Adams with M. Alinder, *Autobiography*, 370; Ansel Adams to John Szarkowski, December 27, 1976, CCP.
65. A. Adams with M. Alinder, *Autobiography*, 370.
66. James, "Artist of Light," 7.
67. Tim Hill interview.
68. Lalli, "Portrait of the Photographer as a Grand Old Man," 46.
69. John Szarkowski to Ansel and Virginia Adams, March 11, 1977, CCP.
70. Ben Lifson, "Adams as Epic Hero," *Village Voice*, September 24, 1979, 88. Permission granted by the author and the *Village Voice*.
71. Tim Hill interview.
72. A. Adams with M. Alinder, *Autobiography*, 370.
73. D. and V. Sheff, "The Playboy Interview," 67.
74. Powell, "The Most Sought-After Photographs Today."

20. TOO LITTLE TIME

1. Milton Esterow, "Ansel Adams: The Last Interview," *ARTnews* 83, no. 6 (summer 1984): 89.
2. These ideas developed in conversation with Tim Hill, March 29, 1995.
3. Richard D. James, "Artist of Light," *Wall Street Journal*, July 31, 1978, 1.
4. James Alinder, "Ansel Adams, American Artist," in Ansel Adams, *Ansel Adams: Classic Images* (Boston: New York Graphic Society, 1986), 23.
5. Nicolai Cikovsky, Jr., "Notes on the Museum Set," in *Ansel Adams: Classic Images, The Museum Set* (Washington: National Gallery of Art, 1985), 25.
6. Ansel Adams to Dear Friend, 1976, Alinder collection.
7. Maggi Weston, interview with the author, November 7, 1995.
8. Ansel Adams with Mary Street Alinder, *Ansel Adams: An Autobiography* (Boston: New York Graphic Society, 1985), 363.
9. Jim Powell, "The Most Sought-After Photographs Today—Should You Consider Buying Them?" *Collectibles Market Report*, January 1980.
10. Elizabeth Bumiller, "Images of Harry Lunn: The Photo Mogul & His Developing Empire," *Washington Post*, August 5, 1980, B9.
11. The fourteen who received the Medal of Freedom that day were: Ansel Adams, photographer; Lucia Chase, ballerina; Archbishop Iakovos, Greek Orthodox Church; Clarence Mitchell, retired director of the NAACP's

Washington bureau; Roger Tory Peterson, ornithologist; Beverly Sills, opera singer; Robert Penn Warren, writer; Eudora Welty, author; Tennessee Williams, playwright; and, posthumously, Rachel Carson, scientist and author; Senator Hubert H. Humphrey; President Lyndon Baines Johnson; and John Wayne.

12. President Jimmy Carter, Ansel Adams Citation: Medal of Freedom.
13. *Ansel Adams Photographer*, a production of FilmAmerica, Inc., presented on PBS by KQED/San Francisco, 1981. It is available on VHS cassette.
14. Ted Orland, interview with the author, November 7, 1995.
15. James G. Alinder, "Adams Family Values," *View Camera*, March–April 1995, 16–19.
16. David and Victoria Sheff, "The Playboy Interview," *Playboy*, May 1983, 76.
17. Ted Appel, "Treasures on Display," *Press Democrat* (Santa Rosa), November 28, 1993, E1, 36.
18. Robert Baker, interview with the author, September 19, 1995.

21. LIFE AND DEATH

1. David and Victoria Sheff, "The Playboy Interview," *Playboy*, May 1983, 226.
2. James G. Alinder, "Adams Family Values," *View Camera*, March–April 1995, 16.
3. D. and V. Sheff, "The Playboy Interview," 73.
4. Jim Alinder, interview with the author, never ending.
5. Sue Meyer, interview with the author, September 12, 1995.
6. Ansel Adams, *The Golden Gate Bridge from the Marin Hills, California* (1982), reproduced in Ansel Adams with Mary Street Alinder, *Ansel Adams: An Autobiography* (Boston: New York Graphic Society, 1985), 367.
7. Ansel Adams, *Examples: The Making of 40 Photographs* (Boston: New York Graphic Society, 1985), 167.
8. Ibid., 166–170.
9. Peter Griffin to Ansel Adams, May 1983, in Mary Street Alinder and Andrea Gray Stillman, *Ansel Adams: Letters and Images, 1916–1984* (Boston: Little, Brown and Co., 1988), 377–378.
10. Ansel Adams to Peter Griffin, May 16, 1983, ibid., 378.
11. D. and V. Sheff, "The Playboy Interview," 87.
12. A. Adams with M. Alinder, *Autobiography*, 352.
13. Dale Russakoff, "The Critique: Ansel Adams Takes Environmental Challenge to Reagan," *The Washington Post*, July 3, 1983, 1, 6.

14. Ansel Adams to Mary Alinder, August 22, 1983, CCP.
15. Ansel Adams, *Vladimir Ashkenazy, In Our Home, Carmel Highlands* (1983), reproduced in A. Adams with M. Alinder, *Autobiography,* 379.

22. AND SELL

1. In addition to his autobiography (1985) and book of letters (1988), both planned by Ansel, since his death the AAPRT has published the following "authorized" (i.e., by them) books on Ansel: *Classic Images* (1986); *The American Wilderness* (1991); *Our National Parks* (1992); *Basic Techniques of Photography* (1992); *Ansel Adams in Color* (1993); *Yosemite Valley* (1994), *Yosemite* (1995).
2. Ted Appel, "Treasures on Display," *Press Democrat* (Santa Rosa), November 28, 1993, E1, 36.
3. Ansel Adams to Mary Alinder, October 10, 1981, CCP.
4. Ansel Adams to Mary Alinder, October 4, 1981, CCP.
5. Chris Rainier, interview with the author, November 6, 1995.
6. Russell Ash, "Best-Attended Exhibitions at the National Gallery, Washington, D.C.," in *The Top 10 of Everything* (London, New York and Stuttgart: Dorling Kindersley, 1994), 136.
7. "Rockwell Ads Irk Environmentalists: Ansel Adams' Photos Used to Tie Defense to National Resources," *Washington Post,* December 30, 1986, Business sec., 1.
8. For years, Ansel had not allowed his photographs to be exploited to sell commercial products, though he authorized their use on behalf of causes in photography or the environment that he believed in. His position was clearly stated on page 361 of his autobiography. Soon after I began working for him, a whiskey company asked to use *Winter Sunrise* in a billboard campaign; Ansel refused the request because he believed it would be inappropriate, though he certainly had nothing against the product itself.
9. "Ansel Adams, Arms Peddler?" *Time,* January 12, 1987, 57.
10. "Like Yosemite National Park, Tactical Weapons Systems Are a National Resource," advertisement for Rockwell International, *National Journal* 18, no. 35 (Times Mirror Magazines, August 30, 1986): 2066–2067.
11. "Another American Asset," advertisement for Rockwell International, *Aviation Week & Space Technology* 125, no. 3 (McGraw-Hill) (July 21, 1986): 54–55.
12. Bill Wyman, "Ansel Adams, Arms Peddler," *Mother Jones,* January 18, 1987.

13. Associated Press, *Washington Post,* December 30, 1986.

14. Richard Steven Street, "Your Ad Here," *Outside,* May 1988, 24.

15. That the trustees continue to create a revisionist history is evidenced by an article published in 1993 in which Bill Turnage asserted that during his lifetime Ansel had never stopped selling his work for commercial purposes; he used as his example the 1972–73 Wolverine campaign, which was in fact followed by no other advertising projects over the next decade. The trustees also still maintain that Rockwell linked Ansel's photographs to tactical weapons systems without their permission. Renée Haip, "Forging the Wilderness Ideal," in Michael Read, ed., *Ansel Adams, New Light* (San Francisco: The Friends of Photography, 1993), 80.

16. *Ansel Adams in Color,* ed. Harry M. Callahan with John P. Schaefer and Andrea G. Stillman (Boston: Little, Brown and Co., 1993).

17. Ansel Adams to Mary and Jim Alinder, March 9, 1984, quoted ibid., 128–129.

18. Appel, "Treasures on Display," E6.

19. Quotation from "a staffer at the Ansel Adams Publishing Rights Trust," ibid.

20. Ansel Adams, "Some Thoughts on Color Photography," *photo notes* (New York: Photo League, spring 1949 and spring 1950), 10–11, 14–15. In this article Ansel conceded that he had not yet made a color print. He never did.

21. "When the Ansel Adams Trust Needed 62 Original Transparencies Retouched Digitally, They Turned to TX UNLIMITED, INC.," advertisement in *ASMP Digital Imaging Directory* (March–April 1993): 42.

22. *Fresh Snow* in black-and-white is reproduced in Mary Street Alinder and Andrea Gray Stillman, eds., *Ansel Adams: Letters and Images, 1916–1984* (Boston: Little, Brown and Co., 1988), 205, and in Ansel Adams, *Portfolios of Ansel Adams* (Boston: New York Graphic Society, 1977), V1.

 The color version of *Fresh Snow* is reproduced in *Ansel Adams in Color,* 87.

23. Andy Grundberg, "Photography," *The New York Times Book Review,* December 5, 1993, 85.

24. Al Weber, "Seven Books I Like; Two I Don't," *Al Weber Newsletter—For Those Addicted to Light-tight Boxes, Hypo Fumes and Being Broke* (Carmel, Calif., March 1994), unpaginated. Copyright Al Weber Photography, 1994.

23. AFTERIMAGE

1. "Robert Motherwell and the New York School: Storming the Citadel," in *American Masters,* television program (New York: WNET, 1991).

2. Anne Adams Helms, *The Descendants of David Best and Jane Eliza King Best* (Monterey, Calif.: Anne Adams Helms, 1995), 70–89.

3. Wallace Stegner, *Miraculous Instants of Light: Ansel Adams 1902–1984*, ed. James Alinder (Carmel, Calif.: The Friends of Photography, 1984), 51–52.

4. *National Wilderness Preservation System*, brochure (San Francisco: Sierra Club, March 1985), 5.

5. George Wuerthner, *Yosemite: A Visitor's Companion* (Mechanicsburg, Pa.: Stackpole Books, 1994), 208–209.

 The closest road access to a trail head in the Ansel Adams Wilderness is at a distance of two miles from its border. Wilderness permits are necessary for hiking. Information can be obtained by calling the North Fork Forest Service at (209) 877-2218.

 From April to November in most years (depending upon weather conditions), Southern Yosemite Mountain Guides lead trips of three to ten days into the Ansel Adams Wilderness. For more information write to SYMG, P.O. Box 301, Bass Lake, California 93604, or phone (800) 231-4575. Maria Streshinsky, "A Backcountry Hike in the High Sierra," *Motorland, Travel and News Magazine of the West* 116, no. 3 (California State Automobile Association, May–June 1995): 40–42.

6. "Mount Ansel Adams in the Lyell Fork," *Yosemite Sentinel* 11, no. 4 (Yosemite Park and Curry Company, April 1985): 1.

SELECTED
BIBLIOGRAPHY

All of the books and articles by Ansel Adams, with or without coauthors, are listed under his name, chronologically.

Adams, Ansel. And Mary Austin. *Taos Pueblo.* San Francisco: Ansel Adams, 1930. Facsimile edition, Boston: New York Graphic Society, 1977.

———."Photography." *Fortnightly,* November 6, December 4, and December 18, 1931.

———. "The New Photography." In *Modern Photography 1934–35, The Studio Annual of Camera Art.* London and New York: The Studio Publications, Inc., 1934.

———. "An Exposition of Technique" (January), "Landscape" (February), "Portraiture" (March), and "Applied Photography" (April). *Camera Craft,* 1934.

———. *Making a Photograph.* London and New York: The Studio Publications, 1935.

———. "A Personal Credo." *Camera Craft,* January 1935.

————. *Sierra Nevada: The John Muir Trail.* Berkeley: Archetype Press, 1938.

————. Ed. Stanley Plumb. *The Four Seasons in Yosemite National Park: A Photographic Story of Yosemite's Spectacular Scenery.* Yosemite, Calif.: Yosemite Park and Curry Company, 1936.

————. Ed. Willard D. Morgan and Henry M. Lester. "The New Expanding Photographic Universe." In *Miniature Camera Work.* New York: Morgan & Lester, 1938.

————. "Discussion of Filters" and "Photo-Murals." *U.S. Camera,* 1940.

————. And Virginia Adams. *Michael and Anne in Yosemite Valley.* London and New York: The Studio Publications, 1941.

————. *Born Free and Equal: Photographs of the Loyal Japanese-Americans at Manzanar Relocation Center, Inyo County, California.* New York: U.S. Camera, 1944.

————. And Virginia Adams. *Illustrated Guide to Yosemite.* San Francisco: H. S. Crocker, 1946.

————. *Camera and Lens.* New York: Morgan & Morgan, 1948.

————. *The Negative.* New York: Morgan and Morgan, 1948.

————. *Yosemite and the High Sierra.* Ed. Charlotte E. Maul. Boston: Houghton Mifflin Co., 1948.

————. *The Print.* New York: Morgan & Morgan, 1950.

————. *My Camera in Yosemite Valley.* Yosemite, Calif., and Boston: Virginia Adams and Houghton Mifflin Co., 1950.

————. *My Camera in the National Parks.* Yosemite, Calif., and Boston: Virginia Adams and Houghton Mifflin Co., 1950.

————. And Mary Austin. *The Land of Little Rain.* Boston: Houghton Mifflin Co., 1950.

————. *Natural-Light Photography.* New York: Morgan & Morgan, 1952.

————. With Nancy Newhall: "Canyon de Chelly National Monument" (June 1952), "Sunset Crater" (July 1952), "The Shell of Tumacacori" (November 1952), "Death Valley" (October 1953), "Organ Pipe" (January 1954), "Mission San Xavier del Bac" (April 1954), and "Mary Austin's Country" (April 1968). *Arizona Highways.*

————. And Nancy Newhall. *Death Valley.* Palo Alto, Calif.: 5 Associates, 1954.

————. And Nancy Newhall. *San Xavier del Bac.* Palo Alto, Calif.: 5 Associates, 1954.

————. And Nancy Newhall. *The Pageant of History in Northern California.* San Francisco: American Trust Company, 1954.

————. *Artificial-Light Photography.* New York: Morgan & Morgan, 1956.

————. And Edward Joesting. *The Islands of Hawaii.* Honolulu: Bishop National Bank of Hawaii, 1958.

————. And Nancy Newhall. *Yosemite Valley.* Palo Alto, Calif.: 5 Associates, 1959.

————. And Nancy Newhall. *This Is the American Earth.* San Francisco: Sierra Club, 1960.

————. And Edwin Corle. *Death Valley and the Creek Called Furnace.* Los Angeles: Ward Ritchie, 1962.

————. *These We Inherit: The Parklands of America.* San Francisco: Sierra Club, 1962.

————. *Polaroid Land Photography.* New York: Morgan & Morgan, 1963.

————. And Edward Joesting. *An Introduction to Hawaii.* Palo Alto, Calif.: 5 Associates, 1964.

————. And Nancy Newhall. *A More Beautiful America.* New York: American Conservation Association, 1965.

————. And Nancy Newhall. *Fiat Lux: The University of California.* New York: McGraw-Hill, 1967.

————. And Nancy Newhall. *The Tetons and the Yellowstone.* Palo Alto, Calif.: 5 Associates, 1970.

————. Ed. Liliane De Cock. *Ansel Adams.* New York: Morgan & Morgan, 1972.

————. *Images: 1923–1974.* Boston: New York Graphic Society, 1974.

————. *Singular Images.* New York: Morgan & Morgan, 1974.

————. *The Horace M. Albright Conservation Lectureship: The Role of the Artist in Conservation.* Berkeley: University of California, College of Natural Resources, Department of Forestry & Conservation, 1975.

————. *Photographs of the Southwest.* Boston: New York Graphic Society, 1976.

————. *The Portfolios of Ansel Adams.* 1977. New edition. Boston: New York Graphic Society, 1981.

————. "Conversations with Ansel Adams," an oral history conducted 1972, 1974, 1975 by Ruth Teiser and Catherine Harroun, Regional Oral History Office, The Bancroft Library, University of California, Berkeley, 1978. This interview was conducted in twenty-six sessions between May 12, 1972, and February 23, 1975.

————. With Robert Baker. *Polaroid Land Photography.* Boston: New York Graphic Society, 1978.

————. *Yosemite and the Range of Light.* Boston: New York Graphic Society, 1979.

————. With Robert Baker. *The Camera.* Boston: New York Graphic Society, 1980.

————. With Robert Baker. *The Negative.* Boston: New York Graphic Society, 1981.

————. With Robert Baker. *The Print.* Boston: New York Graphic Society, 1983.

————. *Examples: The Making of 40 Photographs.* Boston: New York Graphic Society, 1983.

————. With Mary Street Alinder. *Ansel Adams: An Autobiography.* Boston: New York Graphic Society, 1985.

————. *Ansel Adams: Classic Images.* Boston: New York Graphic Society, 1986.

————. Ed. Mary Street Alinder and Andrea Gray Stillman. *Ansel Adams: Letters and Images, 1916–1984.* Boston: Little, Brown and Co., 1988.

————. *The American Wilderness.* Boston: New York Graphic Society, 1991.

————. *Our National Parks.* Boston: New York Graphic Society, 1992.

————. And John P. Schaefer. *Basic Techniques of Photography: An Ansel Adams Guide.* Boston: Little, Brown and Co., 1992.

————. Ed. Harry M. Callahan. *Ansel Adams in Color.* Boston: Bulfinch Press, 1993.

————. *Yosemite Valley.* Boston: Little, Brown and Co., 1994.

————. *Yosemite.* Boston: Little, Brown and Co., 1995.

Albright, Horace M. *The Birth of the National Park Service.* As told to Robert Cahn. Salt Lake City: Howe Brothers, 1985.

Alinder, James. *Ansel Adams: 50 Years of Portraits.* Carmel, Calif.: The Friends of Photography, 1978.

————. "Adams Family Values." *View Camera,* March–April 1995, 16–19.

————, ed. *Ansel Adams: 1902–1984.* Carmel: The Friends of Photography, 1984.

————, ed. *Light Years, Untitled 43.* Carmel: The Friends of Photography, 1987.

————. *The Unknown Ansel Adams.* Carmel: The Friends of Photography, 1982.

Alinder, Jasmine. "The Conception and Founding of *Aperture.*" Junior thesis, Princeton University, 1990.

Alinder, Mary Street. *Ansel Adams: The Eightieth Birthday Retrospective.* Monterey, Calif.: Monterey Peninsula Museum of Art, 1982.

————. "Ansel Adams' Polaroid Connection." Part I, Part II. *The Polaroid Newsletter for Photographic Education* 3 and 4 (1987).

————. With James Alinder. "Ansel Adams: American Artist." In *One with Beauty.* San Francisco: M. H. de Young Memorial Museum, 1987.

————. "Picturing Yosemite." *Places: A Quarterly Journal of Environmental Design* 6, no. 3 (The Design History Foundation, spring 1990).

————. "The Limits of Reality: Ansel Adams and Group f.64." In *Seeing Straight,* ed. Therese Thau Heyman. Oakland: The Oakland Museum, 1992.

Altschuler, Bruce. *The Avant Garde in Exhibition.* New York: Harry N. Abrams, 1994.

Aperture. Millerton, N.Y.: Aperture Foundation. Complete run.

Armor, John, and Peter Wright. *Manzanar.* New York: Times Books, 1989.

Arrowsmith, Alexandra, and Thomas West, eds. *Georgia O'Keeffe and Alfred Stieglitz: Two Lives.* New York: HarperCollins Publishers/Calloway Editions, 1992.

art in progress. New York: The Museum of Modern Art, 1944. Exhib. cat.

Atkinson, Brooks. *The Selected Writings of Ralph Waldo Emerson.* New York: The Modern Library, 1968.

Bronson, William. *The Earth Shook, the Sky Burned.* San Francisco: Chronicle Books, 1986.

Brower, David. *For Earth's Sake: The Life and Times of David Brower.* Salt Lake City: Peregrine Smith Books, 1990.

Bry, Doris. *Alfred Stieglitz: Photographer.* Boston: Museum of Fine Arts, 1965.

Bunnell, Peter C. *Minor White: The Eye That Shapes.* Princeton: The Art Museum, Princeton University, 1989.

Cahn, Robert. "Ansel Adams: Environmentalist." *Sierra* (Sierra Club), May–June 1979.

Callahan, Sean. "Countdown to Moonrise." *American Photographer,* January 1981, 30–31.

Camera Work. New York: Alfred Stieglitz. Complete run.

Carpenter, Edward. *Angel's Wings: A Series of Essays on Art and Its Relation to Life.* London: Swan Sonnenschein & Co., Ltd., 1898.

———. *Towards Democracy.* London: Swan Sonnenschein & Co., Ltd., 1909.

Chadwick, Whitney. *Women Artists and the Surrealist Movement.* London: Thames and Hudson, 1965.

Cikovsky, Nicolai, Jr. "Notes on the Museum Set." In *Ansel Adams: Classic Images, The Museum Set.* Washington: National Gallery of Art, 1985.

Cohen, Michael P. *The History of the Sierra Club.* San Francisco: Sierra Club Books, 1988.

Coke, Van Deren. *Taos and Santa Fe: The Artist's Environment 1882–1942.* Albuquerque: The University of New Mexico Press, 1963.

Conger, Amy. *Edward Weston: Photographs.* Tucson: Center for Creative Photography, 1992.

Conner, K. Patrick. "Horace Bristol: Photographs." Unpublished manuscript, 1995.

Conrat, Maisie, and Richard Conrat. *Executive Order 9066.* San Francisco: California Historical Society, 1973.

Cunningham, Imogen. An oral history conducted 1972 by Ruth Teiser, Donated Oral Histories Collection, The Bancroft Library, University of California, Berkeley. Courtesy of The Bancroft Library.

———. "Portraits, Ideas, and Design," an oral history conducted 1959 by Edna Tartaul Daniel, Regional Oral History Office, The Bancroft Library, University of California, Berkeley, 1961.

Curran, Thomas. *Fiske, The Cloudchaser.* Oakland and Yosemite: The Oakland Museum and The Yosemite Natural History Association, 1981.

Demars, Stanford E. *The Tourist in Yosemite 1855–1985.* Salt Lake City: University of Utah Press, 1991.

De Voto, Bernard. "The National Parks." *Fortune,* June 1947, 120–135.

di Cicco, Dennis. "Dating Ansel Adams' *Moonrise.*" *Sky & Telescope* 82, no. 5 (1991): 480, 529–533.

Edey, Maitland, and Constance Sullivan. *Great Photographic Essays from LIFE.* Boston: New York Graphic Society, 1978.

Edwards, John Paul. "Group F:64." *Camera Craft,* March 1935.

Ehrens, Susan. *Alma Lavenson Photographs.* Berkeley: Wildwood Arts, 1990.

Eisler, Benita. *O'Keeffe and Stieglitz: An American Romance.* New York: Doubleday, 1991.

Esterow, Milton. "Ansel Adams, The Last Interview." *ARTnews* 83, no. 6 (summer 1984): 89.

Esquivel, Marty. "Moonrise over Hernandez." *New Mexico,* October 1991, 84–89.

Evans, Walker. *American Photographs.* New York: Museum of Modern Art, 1938. Reprinted 1988.

Ewald, Donna, and Peter Clute. *San Francisco Invites the World.* San Francisco: Chronicle Books, 1991.

Farquhar, Francis P. "Mountain Studies in the Sierra: Photographs by Ansel Easton Adams with a Note about the Artist by Francis P. Farquhar." *Touring Topics.* Automobile Club of Southern California, February 1931.

Farquhar, Marjorie Bridge. "Pioneer Woman Rock Climber and Sierra Club Director," an oral history conducted 1977 by Ann Lage, in "Sierra Club Women II," Sierra Club History Committee, Sierra Club, San Francisco, 1977.

Fulton, Andrea. *The Bracebridge Dinner.* Yosemite, Calif.: Yosemite Park and Curry Company, 1983.

Goldberg, Vicki, ed. *Photography in Print: Writings from 1816 to the Present.* Albuquerque: University of New Mexico Press, 1981.

Gray, Andrea. *Ansel Adams: An American Place, 1936.* Tucson: Center for Creative Photography, 1982.

Greene, Linda Wedel. *Yosemite: The Park and Its Resources.* Yosemite National Park: U.S. Department of the Interior/National Park Service, 1987.

Greenough, Sarah. *Georgia O'Keeffe, Art and Letters.* Washington: National Gallery of Art, 1987.

———. *Paul Strand: An American Vision.* New York and Washington: Aperture Foundation and National Gallery of Art, 1990.

Hambourg, Maria Morris. *The New Vision: Photography between the Wars.* New York: The Metropolitan Museum of Art, 1989.

Hansen, Gladys, and Emmet Condon. *Denial of Disaster.* San Francisco: Cameron and Company, 1989.

Hayashi, Masumi. "American Concentration Camps." *See: A Journal of Visual Culture* 1, no. 1 (San Francisco: The Friends of Photography, winter 1995).

Helms, Anne Adams. *The Descendants of David Best and Jane Eliza King Best.* Monterey, Calif.: Anne Adams Helms, 1995.

Hendricks, Gordon. *Albert Bierstadt: Painter of the American West.* New York: Harrison House, 1988.

Hodghead, Lillian, and Ada Clement. "Sierra Log, Summer of 1931." Unpublished manuscript, 1931.

Holme, C. G., ed. *Modern Photography 1937–8.* London and New York: The Studio Limited and Studio Publications, 1937.

Howe, Graham, Patrick Nagatani, and Scott Rankin. *Two Views of Manzanar.* Los Angeles: Frederick S. Wight Art Gallery, 1978.

Hughes, Jim. *W. Eugene Smith: Shadow & Substance.* New York: McGraw-Hill, 1989.

Hughes, Robert. "Master of the Yosemite." *Time* 114, no. 10 (September 3, 1979).

Hutchings, J. M. *In the Heart of the Sierras.* Boston: W. H. Thompson & Co., 1887.

Ingersoll, Robert G. *The Ghosts and Other Lectures.* Washington: C. P. Farrell, 1881.

James, Jack, and Earle Weller. *Treasure Island: "The Magic City," 1939–1940: The Story of the Golden Gate International Exposition.* San Francisco: Pisani Printing and Publishing Company, 1941.

Jeffers, Robinson. *Poems by Robinson Jeffers.* San Francisco: Grabhorn Press for The Book Club of California, 1928.

Juckniess, Craig. "A Tribute: Ansel Adams." *Ecology Law Quarterly* 14, no. 1 (1987): 5.

Karl, Frederick R. *Modern and Modernism: The Sovereignty of the Artist 1885–1925.* New York: Atheneum, 1985.

Kazin, Alfred, and Daniel Aaron, eds. *Emerson.* New York: Dell, 1958.

Kirstein, Lincoln, and Julien Levy. *Murals by American Painters and Photographers.* New York: Museum of Modern Art, 1932.

Lalli, Carole. "Portrait of the Photographer as a Grand Old Man." *Esquire,* September 1979, 46.

Lange, Dorothea. "The Making of a Documentary Photographer," an oral history conducted 1960–1961 by Suzanne B. Riess, Regional Oral History Office, The Bancroft Library, University of California, Berkeley, 1968.

LeConte, Helen. "Reminiscences of LeConte Family Outings, the Sierra Club, and Ansel Adams," an oral history conducted 1972, 1974, 1975 by Ruth

Teiser and Catherine Harroun, in "Sierra Club Women II," Sierra Club History Committee, Sierra Club, San Francisco, 1977. Courtesy of The Bancroft Library.

Lewis, Oscar. *A Day with AMB*. San Francisco: privately published, 1932.

Lorenz, Richard. *Imogen Cunningham: Ideas without End*. San Francisco: Chronicle Books, 1993.

Lowe, Sue Davidson. *Stieglitz: A Memoir/Biography*. New York: Farrar, Straus & Giroux, 1933.

Macomber, Ben. *The Jewel City*. San Francisco and Tacoma: John H. Williams, 1915.

Maddow, Ben. *Edward Weston: Fifty Years*. Millerton, N.Y.: Aperture, 1973.

Mayer, Grace M. "Biographical Outline." In *Steichen the Photographer*. New York: The Museum of Modern Art, 1963.

McBride, Stewart. "Ansel." *American Photographer* 4, no. 6 (December 1980): 60.

McPhee, John. *Encounters with the Archdruid*. New York: Farrar, Straus & Giroux, 1971.

Meltzer, Milton. *Dorothea Lange: A Photographer's Life*. New York: Farrar, Straus & Giroux, 1978.

Moholy-Nagy, László. *The New Vision and Abstract of an Artist*. New York: Wittenborn and Company, 1946.

———. *Vision in Motion*. Chicago: Paul Theobald and Company, 1965.

Morgan, Willard D., and Henry M. Lester, eds. *Miniature Camera Work*. New York: Morgan & Lester, 1938.

"Mount Ansel Adams in the Lyell Fork." *Yosemite Sentinel* 11, no. 4 (Yosemite National Park: Yosemite Park and Curry Company, April 1985).

Muir, John. *My First Summer in the Sierra*. Boston: Houghton Mifflin Co., 1911.

Naef, Weston J., and James N. Wood. *Era of Exploration: The Rise of Landscape Photography in the American West, 1860–1885*. Buffalo and New York: Albright-Knox Art Gallery and The Metropolitan Museum of Art, 1975.

Newhall, Beaumont. *Photography 1839–1937*. New York: The Museum of Modern Art, 1937.

———. *The History of Photography, from 1839 to the Present Day*. New York: The Museum of Modern Art, 1949. Revised edition 1980.

———. *Dorothea Lange Looks at the American Country Woman*. Fort Worth: The Amon Carter Museum, 1967.

———. *Photography: Essays & Images*. New York: The Museum of Modern Art, 1980.

———. *Focus: A Life in Photography*. Boston: Little, Brown and Co., 1993.

Newhall, Nancy. *The Eloquent Light*, text by Nancy Newhall. San Francisco: Sierra Club, 1963. Reprinted Millerton, N.Y.: Aperture, 1980.

————. "The Enduring Moment." Unpublished manuscript.

————. *From Adams to Stieglitz: Pioneers of Modern Photography*. New York: Aperture, 1989.

Oelschlaeger, Max. *The Idea of Wilderness*. New Haven and London: Yale University Press, 1991.

Ohrn, Karin Becker. *Dorothea Lange and the Documentary Tradition*. Baton Rouge and London: Louisiana State University Press, 1980.

Olson, Donald W., Russell L. Doescher, and Roger W. Sinnott, eds. "Dating Ansel Adams's *Moon and Half Dome*." *Sky & Telescope*, December 1994, 82–86.

Orland, Ted. *Man and Yosemite*. Santa Cruz, Calif.: The Image Continuum Press, 1985.

Palmquist, Peter E. *Carleton E. Watkins: Photographer of the American West*. Albuquerque: University of New Mexico Press, 1983.

Partridge, Elizabeth, ed. *Dorothea Lange: A Visual Life*. Washington and London: Smithsonian Institution Press, 1994.

Passuth, Krisztina. *Moholy-Nagy*. New York: Thames & Hudson, 1985.

Peterson, Theodore. *Magazines in the Twentieth Century*. Urbana, Ill.: University of Illinois Press, 1964.

Phillips, Sandra S. *Dorothea Lange: American Photographs*. San Francisco: Chronicle Books, 1994.

Porter, Eliot. *Eliot Porter*. Boston: New York Graphic Society, 1987.

Rathbone, Belinda. *Walker Evans: A Biography*. New York: Houghton Mifflin Co., 1995.

Read, Michael, ed. *Ansel Adams: New Light*. San Francisco: The Friends of Photography, 1993.

Reese, Michael, II. *A Travel Letter—1871, The Yosemite & Napa Valley*. San Francisco: Cloister Press, 1988.

Reeve, Lloyd Eric, and Alice Means Reeve. *Gift of the Grape, Based on Paul Masson Vineyards*. San Francisco: Filmer Publishing Company, 1959.

Ritchin, Fred. *In Our Own Image*. New York: Aperture Foundation, 1990.

Robinson, Roxana. *Georgia O'Keeffe: A Life*. New York: Harper & Row, 1989.

Rose, Barbara. *American Painting: The Twentieth Century*. New York: Rizzoli International Publications, 1986.

Rosenblum, Naomi. *A World History of Photography*. New York: Abbeville Press, 1984.

Rowell, Galen. *Mountain Light*. San Francisco: Sierra Club Books, 1986.

Rudnick, Lois Palken. *Mabel Dodge Luhan: New Woman, New Worlds*. Albuquerque: The University of New Mexico Press, 1984.

Runte, Alfred. *Yosemite: The Embattled Wilderness*. Lincoln and London: University of Nebraska Press, 1990.

Sargent, Shirley. *Yosemite: The First 100 Years, 1890–1990.* Yosemite National Park: Yosemite Park and Curry Company, 1988.

———. *The Ahwahnee Hotel.* Yosemite: Yosemite Park and Curry Company, 1990.

———. *Yosemite & Its Innkeepers.* Yosemite: Flying Spur Press, 1975.

Sheff, David, and Victoria Sheff. "The Playboy Interview." *Playboy,* May 1983, 68, 72.

Shlain, Leonard. *Art & Physics: Parallel Visions in Space, Time & Light.* New York: William Morrow & Co., 1991.

Sierra Club Bulletin. Complete run.

Smith, Genny Schumacher, ed. *Deepest Valley.* Los Altos, Calif.: William Kaufmann, 1969.

Spaulding, Jonathan. *Ansel Adams and the American Landscape.* Berkeley: University of California Press, 1995.

Starr, Walter A., Jr. *Starr's Guide to the John Muir Trail and the High Sierra Region.* San Francisco: Sierra Club Books, 1974.

Stegner, Page. *Outposts of Eden.* San Francisco: Sierra Club Books, 1989.

Steichen, Edward. *The Family of Man.* New York: The Museum of Modern Art, 1955.

———. *A Life in Photography.* Garden City, N.Y.: Doubleday & Co., 1963.

Stineman, Esther Lanigan. *Mary Austin.* New Haven and London: Yale University Press, 1989.

Storr, Anthony. *Music and the Mind.* Riverside, N.J.: Free Press, 1992.

Strand, Paul. *Time in New England.* With Nancy Newhall. New York: Oxford University Press, 1950.

———. *Paul Strand: A Retrospective Monograph, The Years 1915–1946.* Millerton, N.Y.: Aperture, 1972.

Street, Richard Steven. "Your Ad Here." *Outside,* May 1988, 24.

Szarkowski, John. *American Landscapes.* New York: Museum of Modern Art, 1981.

Taylor, Katherine Ames. *Lights and Shadows of Yosemite.* San Francisco: H. S. Crocker Co., Inc., 1926.

Taylor, Paul S. *Paul Schuster Taylor: California Social Scientist.* Berkeley: University of California, 1973.

Teiser, Ruth. "Remembering Ansel Adams." *Bancroftiana* 99 (Berkeley: University of California, October 1989).

Turnage, Robert. "The Role of the Artist in the Environmental Movement." *The Living Wilderness,* March 1980, 13.

Turner, Tom. *Wild by Law.* San Francisco: Sierra Club Legal Defense Fund, 1990.

―――. *Sierra Club: 100 Years of Protecting Nature.* New York: Harry N. Abrams, 1991.

Van Dyke, Willard. "Autobiography." Unpublished manuscript.

Vickery, Jim dale. *Wilderness Visionaries.* Merrillville, Ind.: ICS Books, 1986.

Waters, George. *Ansel Adams 1902–1984: A Tribute by His Roxburghe Club Friends.* San Francisco: Roxburghe Club, 1984.

Watkins, Carleton. *Carleton E. Watkins.* San Francisco: Fraenkel Gallery, 1989.

Wensberg, Peter C. *Land's Polaroid: A Company and the Man Who Invented It.* Boston: Houghton Mifflin Co., 1987.

Weston, Charis Wilson, and Edward Weston. *California and the West.* New York: Duell, Sloan and Pearce, 1940.

Weston, Edward. *My Camera on Point Lobos.* Yosemite National Park: Virginia Adams, 1950.

―――. *The Daybooks of Edward Weston.* Volume 1: *Mexico.* Rochester, N.Y.: George Eastman House, 1961.

―――. *The Daybooks of Edward Weston.* Volume 2: *California 1927–1934.* Rochester, N.Y.: George Eastman House, 1966.

Whelan, Richard. *Alfred Stieglitz: A Biography.* Boston: Little, Brown and Co., 1995.

Wilson, Malin. "Walking on the Desert in the Sky." In *The Desert Is No Lady.* New Haven: Yale University Press, 1987.

Witkin, Lee D., and Barbara London. *The Photograph Collector's Guide.* Boston: New York Graphic Society, 1979.

Wortz, Melinda. *Ansel Adams: Fiat Lux.* Irvine, Calif.: The Regents of the University of California, 1991.

Wright, Cedric. *Cedric Wright: Words of the Earth.* Edited by Nancy Newhall. San Francisco: Sierra Club, 1960.

Wright, Peter, and John Armor. *The Mural Project.* Santa Barbara: Reverie Press, 1989.

Wuerthner, George. *Yosemite: A Visitor's Companion.* Mechanicsburg, Pa.: Stackpole Books, 1994.

Wyman, Bill. "Ansel Adams, Arms Peddler." *Mother Jones,* January 18, 1987.

INDEX

Photo Credits

The author and publisher deeply appreciate the permission given by the following individuals and institutions to reproduce the following photographs:

Copyright Jim Alinder: *Imogen Cunningham, 1967; Ansel and Virginia Adams at MoMA opening, New York, 1979; Ansel with two* Moonrises *in the gallery of his home, Carmel Highlands, California, 1981; Ansel in his darkroom, Carmel Highlands, California, 1981; Ansel Adams, Golden Gate National Recreation Area, California, 1982; Ansel Adams, Point Lobos, California, 1982; Ansel and Half Dome, Yosemite National Park, 1983;* and *Ansel Adams in Community Hospital two days before he died, Carmel, California, 1984.*

Copyright The Imogen Cunningham Trust: *Alfred Stieglitz, Photographer, 1934.* Photograph by Imogen Cunningham © 1970, 1978 The Imogen Cunningham Trust.

Courtesy The Bancroft Library: *Ansel, Albert Bender, and Virginia Best Adams,* c. 1929, photographer unknown.

Courtesy The Carter Presidential Library: *President Jimmy Carter awarding Ansel Adams the Presidential Medal of Freedom, the White House, 1980.*

Copyright 1981 the Center for Creative Photography, Arizona Board of Regents: Edward Weston, *Ansel Adams, 1943.*

Courtesy of Margaret H. Cohn: Alfred A. Cohn, *Ansel Adams unloading his camera equipment,* c. 1952. Reproduction print provided by the Center for Creative Photography, Arizona Board of Regents.

Courtesy of the Farquhar family: Francis P. Farquhar, *Ansel Adams in the Sierra Nevada, 1927;* Francis P. Farquhar, *Ansel Adams in the Sierra Nevada, 1932;* Marj Bridge (M. B. Farquhar), *The Sierra Club Outing of 1934.*

Courtesy of the Holgers family: William Holgers, *Edward Weston and Ansel Adams, 1940* U.S. Camera *Yosemite Workshop.* Reproduction print furnished by the Center for Creative Photography, Arizona Board of Regents.

Copyright Philip Hyde: *Ansel Adams and students, 1976 Ansel Adams Yosemite Workshop.*

Courtesy of Library of Congress: Ansel Adams, *On the North Farm, Manzanar Relocation Camp, Owens Valley, California, 1943.*

Copyright Pirkle Jones: *Nancy and Beaumont Newhall in Ansel's garden, San Francisco, May 1947.*

Copyright Nancy Newhall, Beaumont and Nancy Newhall Estate, courtesy of Scheinbaum & Russek Ltd., Santa Fe, New Mexico: *Ansel Adams photographing with his eight-by-ten-inch view camera from his camera platform on top of his car,* c. 1944; *Ansel Adams leaning on his tripod in Death Valley, 1947.*

Copyright the Dorothea Lange Collection, The Oakland Museum of California, The City of Oakland, gift of Paul S. Taylor: Paul S. Taylor, *Portrait of Dorothea Lange in Texas on the Plains,* c. 1934; Dorothea Lange, *Ansel Adams, Photographer,* c. 1935.

Courtesy the Yosemite National Park Research Library: *Ansel as the Jester, Bracebridge Dinner, Ahwahnee Hotel, Yosemite National Park, 1928.* Photograph by Ralph Anderson.

Courtesy of Tom Zito: *Ansel and Mary in Yosemite, 1980.* Photograph by Tom Zito.

Special thanks for their generous efforts on behalf of the reproductions for this book are due Leslie Calmes, Linda Eade, Peter Farquhar, Drew Johnson, Dianne Nilsen, Ron and Elizabeth Partridge, Amy Rule, David Scheinbaum, and Jonathan Spaulding.